The Grove Dictionary of Art

From Expressionism to Post-Modernism

Styles and Movements in 20th-century Western Art

Edited by Jane Turner

GROVEart

From Expressionism to Post-Modernism
Styles and Movements in 20th-century Western Art

Copyright © 2000 by Jane Turner

St. Martin's Press, Scholarly and Reference Division
175 Fifth Avenue, New York, NY 10010

First published in the United States of America in 2000

Printed in Great Britain

ISBN: 0-312-22976-3

Library of Congress Cataloging-in-Publication Data applied for

Contents

Preface

In these days of information glut, *The Dictionary of Art* has been a godsend, instantly relegating all its predecessors to oblivion. Within its stately thirty-four volumes (one for the index), the territory covered seems boundless. Just to choose the most amusingly subtitled of the series, *Leather to Macho* (vol. 19), we can learn in the first article not only about the way animal skins are preserved, but about the use of leather through the ages, from medieval ecclesiastical garments to Charles Eames's furniture. And if we then move to the last entry, which turns out to be a certain Victorio Macho, we discover that in the early 20th century, he graced Spanish cities with public sculpture, including a monument to the novelist Benito Pérez Galdós (1918) that many of us have passed by in Madrid's Parque del Retiro. And should we wish to learn more about Macho, there is the latest biblio-graphical news, bringing us up to date with a monograph of 1987.

Skimming the same volume, we may stumble upon everything from the art of the Lega people in Zaïre and the use of artificial Lighting in architecture to somewhat more predictable dictionary entries such as Lichtenstein, roy; London: westminster abbey; Lithography; or Los angeles: museums. If browsing through one volume of *The Dictionary of Art* can open so many vistas, the effect of the whole reference work is like casting one's net into the waters and bringing back an unmanageable infinity of fish. Wouldn't it be more useful at times to single out in one place some of the myriad species swimming through the pages of *The Dictionary*? And then there is the question of cost and dimensions. In its original, complete form, the inevitably stiff price and the sheer size of all thirty-four volumes meant that it has fallen mostly to reference libraries to provide us with this awesome and indispensable tool of knowledge.

Wisely, it has now been decided to make this overwhelming databank more specialized, more portable, and more financially accessible. To do this, the myriad sands have been sifted in order to compile more modest and more immediately useful single volumes that will be restricted, say, to Dutch painting of the 17th century or to a survey of major styles and movements in Western art from the Renaissance to the end of the 19th century. So, as much as we may enjoy the countless delights of leafing through the thirty-four volumes in some library, we can now walk off with only one volume that suits our immediate purpose, an unparalleled handbook for a wide range of readers, especially for students and scholars who, rather than wandering through the astronomical abundance of art's A to Z, want to have between only two covers the latest words about a particular artist or 'ism'.

The great art historian Erwin Panofsky once said 'There is no substitute for information'. This new format of *The Dictionary of Art* will help many generations meet his sensible demands.

<div align="right">

Robert Rosenblum
Henry Ittleson jr Professor of Modern European Art
Institute of Fine Arts
New York University

</div>

List of Contributors

Ades, Dawn
Allen Svede, Mark
Alley, Ronald
Andreotti, Libero
Andreyeva, Yekaterina
Anfam, David
Bölling, Claudia
Börsch-Supan, Helmut
Büttner, Claudia
Baffa Rivolta, Matilde
Bajkay, Éva
Banham, Reyner
Bann, Stephen
Baron, Wendy
Batári, Ferenc
Behr, Shulamith
Benito, Pilar
Bentkowska, Anna
Berman, Patricia G.
Bird, Alan
Blundell Jones, Peter
Bohan, Ruth L.
Bohm-Duchen, Monica
Boorman, Helen
Bosman, Jos
Bowlt, John E.
Boyd Whyte, Iain
Braun, Emily
Bruyn, Jean-Pierre De
Burnett, David
Button, Virginia
Bydžovská Lenka
Cardinal, Roger
Cardyn-Oomen, D.
Cast, David
Christian, Mary
Churchill, Nick
Coen, Ester
Cooper, Philip
Corris, Michael
Craven, David
Crum, Roger J.
Cumming, Elizabeth
Düchting, Hajo
Demosfenova, G. L.
Doig, Allan
Escobar, Ticio

Fenske, Gail
Fort, Ilene Susan
Fraquelli, Simonetta
Freeman, Judi
Gagnon, François-Marc
Gale, Matthew
García Barragán, Elisa
Geiger, Ursula
Gellér, Katalin
Gergova, Ivanka
Giraudon, Colette
Gisler, Johanna
Goldberg, Roselee
Gollek, Rosel
Green, Christopher
Grisebach, Lucius
Gruetzner Robins, Anna
Guenther, Peter W.
Guerman, Mikhail
Hannesen, Hans Gerhard
Harker, Margaret
Harris, Mary Emma
Hartney, Mick
Hay, Kenneth G.
Heinze-Greenberg, Ita
Held jr, John
Heller, Martin
Heller, Nancy G.
Henkels, H.
Hopkins, Justine
Howard, Jeremy
Irwin Lewis, Beth
Jiménez-Blanco, M. Dolores
Jones, Caroline A.
Kühnel, Anita
Kalenberg, Angel
Kendall, M. Sue
Kern, Sepp
Kingsley, Hope
Kleijn, Marloes
Lachnit, Edwin
Lahoda, Vojtěch
Lamb, Robert J.
Lehmann, Ulrike
Levin, Gail
Lewis, Adrian
Lichtenstern, Christa

Livingstone, Marco
Lodder, Christina
Lorenz, Marianne
Lorenz, Richard
Máčel, Otakar
Makela, Maria
Maréchal, Els
Marstine, Janet
Massey, Anne
Masters, Christopher
Meneguzzo, Marco
Michaels, Barbara L.
Mikina, Ewa
Mikuž, Jure
Miller Koslow, Francine
Milner, John
Morales, Leonor
Moravánszky, Ákos
Moravánszky-Gyöngy, Katalin
Moszynska, Anna
Mudrak, Myroslava M.
Musgrove, John
Nash, Deborah
Nedeva-Wegener, Juliana
Nulli, Andrea
Oliveras, Jordi
Pérez-Tibi, Dora
Pacquement, Alfred
Parton, Anthony
Perazzo, Nelly
Pontual, Roberto
Popper, Frank
Powers, Alan
Prossinger, Cynthia
Radford, Robert
Rajka, Susanne
Raphael Rubinstein, Meyer
Reading, Malcolm
Rhodes, Colin

Rivosecchi, Valerio
Robbins, Daniel
Rosenblum, Naomi
Ruigrok, Robbert
Rusinko, Elaine
Safons, Horacio
Sedlákováradomíra
Shone, Richard
Smith, Terry
Smith, Walter
Sokol, David M.
Sokolov, M. N.
Solàmorales, Ignasi De
Spalding, Frances
Spence, Rory
Spens, Janet
Sprague, Paul E.
Srp, Karel
Stare, Jacqueline
Steen, John
Stiles, Kristine
Stokvis, Willemijn
Swenson, Ingrid
Szobor-Bernáth, Mária
Tibbits, George
Tibol, Raquel
Tise, Suzanne
Todd Jr, James G.
Todts, Herwig
Vogt, Paul
Włodarczyk, Wojciech
Want, Christopher
Wegner, Nicholas
Weininger, Susan S.
Werkner, Patrick
Wick, Rainer K.
Wiese, Stephan Von
Wilson, Andrew
Zygas, K. Paul

General Abbreviations

The abbreviations employed throughout this book do not vary, except for capitalization, regardless of the context in which they are used, including the bibliographical citations and for locations of works of art. For the reader's convenience, separate full lists of abbreviations for locations, periodical titles and standard reference books and series are included as Appendices.

AD	Anno Domini	*d*	died	**inc.**	incomplete
addn	addition	**ded.**	dedication,	**incl.**	includes,
a.m.	ante meridiem		dedicated to		including,
	[before noon]	**dep.**	deposited at		inclusive
Anon.	Anonymous(ly)	**destr.**	destroyed	**Incorp.**	Incorporation
app.	appendix	**diam.**	diameter	**inscr.**	inscribed,
Assoc.	Association	**diss.**	dissertation		Inscription
attrib.	attribution,	**Doc.**	Document(s)	**intro.**	introduced by,
	attributed to				introduction
		ed.	editor, edited (by)	**inv.**	inventory
B.	Bartsch [catalogue	**edn**	edition	**irreg.**	irregular(ly)
	of Old Master	**eds**	editors		
	prints]	**e.g.**	*exempli gratia* [for	**jr**	junior
b	born		example]		
bapt	baptized	**esp.**	especially	**kg**	kilogram(s)
BC	Before Christ	**est.**	established	**km**	kilometre(s)
bk, bks	book(s)	**etc**	*et cetera* [and so on]		
BL	British Library	**exh.**	exhibition	**l.**	length
BM	British Museum			**lb, lbs**	pound(s) weight
bur	buried	**f, ff**	following page,	**Ltd**	Limited
			following pages		
c.	circa [about]	**facs.**	facsimile	**m**	metre(s)
can	canonized	**fasc.**	fascicle	**m.**	married
cat.	catalogue	*fd*	feastday (of a saint)	**M.**	Monsieur
cf.	confer [compare]	**fig.**	figure (illustration)	**MA**	Master of Arts
Chap., Chaps		**figs**	figures	**MFA**	Master of Fine Arts
	Chapter(s)	*fl*	*floruit* [he/she	**mg**	milligram(s)
Co.	Company;		flourished]	**Mgr**	Monsignor
	County	**fol., fols**	folio(s)	**misc.**	miscellaneous
Cod.	Codex, Codices	**ft**	foot, feet	**Mlle**	Mademoiselle
Col., Cols	Colour;			**mm**	millimetre(s)
	Collection(s);	**g**	gram(s)	**Mme**	Madame
	Column(s)	**gen.**	general	**Movt**	Movement
Coll.	College	**Govt**	Government	**MS., MSS**	manuscript(s)
collab.	in collaboration	**Gt**	Great	**Mt**	Mount
	with, collaborated,	**Gtr**	Greater		
	collaborative			**N.**	North(ern);
Comp.	Comparative;	**h.**	height		National
	compiled by,	**Hon.**	Honorary,	**n.**	note
	compiler		Honourable	**n.d.**	no date
cont.	continued			**NE**	Northeast(ern)
Contrib.	Contributions,	**ibid.**	*ibidem* [in the	**nn.**	notes
	Contributor(s)		same place]	**no., nos**	number(s)
Corp.	Corporation,	**i.e.**	*id est* [that is]	**n.p.**	no place (of
	Corpus	**illus.**	illustrated,		publication)
Corr.	Correspondence		illustration	**nr**	near
Cttee	Committee	**in., ins**	inch(es)	**n. s.**	new series
		Inc.	Incorporated	**NW**	Northwest(ern)

Occas.	Occasional	**red.**	reduction,		Santissimi
op.	opus		reduced for	**St**	Saint, Sankt,
opp.	opposite; opera	**reg**	*regit* [ruled]		Sint, Szent
	[pl. of opus]	**remod.**	remodelled	**Ste**	Sainte
oz.	ounce(s)	**repr.**	reprint(ed);	**suppl., suppls**	supplement(s),
			reproduced,		supplementary
p	pence		reproduction	**SW**	Southwest(ern)
p., pp.	page(s)	**rest.**	restored,		
p.a.	per annum		restoration	**trans.**	translation,
Pap.	Paper(s)	**rev.**	revision, revised		translated by;
para.	paragraph		(by/for)		transactions
pl.	plate; plural	**Rev.**	Reverend;	**transcr.**	transcribed
pls	plates		Review		by/for
p.m.	post meridiem				
	[after noon]	**S**	San, Santa,	**unpubd**	unpublished
Port.	Portfolio		Santo, Sant',		
Posth.	Posthumous(ly)		São [Saint]	**v**	*verso*
prev.	previous(ly)	**S.**	South(ern)	**var.**	various
priv.	private	**SE**	Southeast(ern)	**viz.**	*videlicet*
pseud.	pseudonym	**sect.**	section		[namely]
pt	part	**ser.**	series	**vol., vols**	volume(s)
pubd	published	**sing.**	singular	**vs.**	versus
pubn(s)	publication(s)	**sq.**	square		
		SS	Saints, Santi,	**W.**	West(ern)
R	reprint		Santissima,	**w.**	width
r	*recto*		Santissimo,		

Note on the Use of the Book

This note is intended as a short guide to the basic editorial conventions adopted in this book.

Abbreviations in general use in the book are listed on pp. x–xi; those used in bibliographies and for locations of works of art or exhibition venues are listed in the Appendices.

Author's signatures appear at the end of the articles. Where an article was compiled by the editors or in the few cases where an author has wished to remain anonymous, this is indicated by a square box (□) instead of a signature.

Bibliographies are arranged chronologically (within a section, where divided) by order of year of first publication and, within years, alphabetically by authors' names. Abbreviations of periodical titles are in Appendix B. Abbreviated references to alphabetically arranged dictionaries and encyclopedias appear at the beginning of the bibliography (or section).

Cross-references are distinguished by the use of small capital letters, with a large capital to indicate the initial letter of the entry to which the reader is directed; for example, 'He commissioned LEONARDO DA VINCI...' means that the entry is alphabetized under 'L'. Given the comprehensiveness of this book, cross-references are used sparingly between articles to guide readers only to further useful discussions.

Abbaye de Créteil

Community of French writers, artists and composers in operation from November 1906 to February 1908, located iTn a villa on the banks of the Marne at Créteil, south-east of Paris. Their choice of name paid homage to François Rabelais, whose Gargantua had established the Abbey of Thelema as a model monastery, a self-supporting commune whose members devoted part of each day to group labour and the rest to perfecting the self intellectually. The Abbaye de Créteil numbered among its members the painters Albert Gleizes, Charles Berthold-Mahn and Jacques d'Otemar, the poets Charles Vildrac (b 1882), Georges Duhamel (1884–1966), René Arcos, Alexandre Mercereau, Jules Romains, Henri-Martin Barzun (b 1881), the composer Albert Doyen, and the printer Lucien Linard, whom Gleizes had met while doing his military service. It was through Linard's trade of printing and publishing that the Abbaye hoped to secure its material future.

Only a few of the Abbaye's members lived there full-time, with cells available for associates who were only occasionally in residence. Until March 1907 Mercereau was in Russia, where as Eshmer Valdor he served as secretary to the review *Zolotoye Runo*; Romains, still a medical student, may have particularly identified with the poet-physician Rabelais. Romains's collection of poems *La Vie unanime*, the first publication printed at the Abbaye, gave rise to the impression that all the members of the community subscribed to Unanimism, a belief that the reality of modern group life had permanently altered individual experience. In general the themes explored by the group's members did relate to the interconnected, epic qualities of modern life, to cities, crowds, machines, commerce, agriculture and shared emotions, especially in work done after the dissolution of the Abbaye, such as Gleizes's *Football Players* (1912–13; Washington, DC, N.G.A.). The multiplicity and simultaneity of experience, however, suggested not only new themes but also new methods in writing and painting, entailing a simplicity of imagery and a search for basic volumes. Filippo Tommaso Marinetti, who visited the Abbaye in the summer of 1907, drew much of his programme for Futurism from the thinking of Romains and the Abbaye circle.

Its radical nature notwithstanding, the Abbaye's programme nevertheless owed much to an older generation of late Symbolist poets, especially to Emile Verhaeren, Paul Adam and René Ghil (1862–1925), all of whom were active supporters of the Abbaye. Verharen's modern literary themes were borrowed by Romains, while Adam's idea of multiple perspectives, formulated as early as 1905, and Ghil's emphasis on elemental sounds, divorced from their customary linguistic meaning, were sources for abstract art and an influence on the subsequent work of Gleizes.

During its brief existence, the Abbaye published important works by Roger Allard, who later made his name as a supporter of Cubism, and Pierre-Jean Jouve. Its spirit survived in a circle around the review *Les Bandeaux d'or* in Paris, through which Gleizes met Henri Le Fauconnier in 1908. Gleizes and other former members later attained prominence as artists or men of letters. The group's influence was recognized in England in the lead article of the first issue of *Rhythm*, a review inaugurated by John Middleton Murray and Katherine Mansfield. The Abbaye idea, an optimistic mix of modernism and late medievalism, of Symbolism and ideas leading to Cubism, of individual creativity blended into group activity, continued to exert appeal until World War I.

Bibliography

F. Goodyear: 'The New Thelema', *Rhythm*, i/1 (1911)

A. Gleizes: 'The Abbaye of Créteil: A Communistic Experiment', *The Modern School*, ed. C. Zigrosser (Stelton, NJ, 1918)

A. Mercereau: *L'Abbaye et le bolchevisme* (Paris, ?1922)

H. Clouard: *Histoire de la littérature française, du Symbolisme à nos jours, 1885–1914* (Paris, 1947), pp. 542ff

G. Duhamel: *Le Temps de la recherche* (1947), iii of *Lumières sur ma vie* (Paris, 1947)

D. Robbins: 'From Symbolism to Cubism: The Abbaye of Créteil', *A. J.* [New York], xxiii (Winter 1963–4), pp. 111–16

DANIEL ROBBINS

Abstract art

Term applied in its strictest sense to forms of 20th-century Western art that reject representation and have no starting- or finishing-point in nature. As distinct from processes of abstraction from nature or from objects (a recurring tendency across many cultures and periods that can be traced as far back as Palaeolithic cave painting), abstract art as a conscious aesthetic based on assumptions of self-sufficiency is a wholly modern phenomenon.

1. Origins and early experiments, to c. 1913

In the late 19th century, and particularly in Symbolist art and literature, attention was refocused from the object to the emotions aroused in the observer in such a way that suggestion and evocation took priority over direct description and explicit analogy. In France especially this tradition contributed to the increased interest in the formal values of paintings, independent of their descriptive function, that prepared the way for abstraction. In his article 'Définition du néo-traditionnisme', published in *L'Art et critique* in 1890, Maurice Denis proclaimed, in words that have since been much quoted, that 'It is well to remember that a picture, before being a battle horse, a nude woman or some anecdote, is essentially a flat surface covered with colours assembled in a certain order.' This definition of painting, which stresses the independence of form from its descriptive function while stopping short of a complete severing of links with perceived reality, continued to characterize the moves towards a more fully abstract art in France in the early 20th century.

A combination of circumstances helped lead a number of European artists towards abstract art in the years preceding World War I. The opening of ethnographic museums furthered an interest in art from other cultures and civilizations, which in turn encouraged artists to free themselves from conventional methods of representation. By looking to the arts of Africa and Oceania as much as to Cézanne, the major figures associated with Cubism were among the first to rethink the approach both to figure and space. In Picasso's *Female Form* (1910; Washington, DC, N.G.A.), for example, multiple views of the figure are incorporated in such a way that forms are fractured, and the surface is fragmented to the point where any link to the subject is so tenuous that it can be reconstructed only with the aid of the title. Although Picasso, like Braque, retained his commitment to subject-matter (see col. pl. XV and fig. 14), other artists took the formal implications of Cubism to an even more abstract conclusion: around 1913 Giacomo Balla in Italy and Mikhail Larionov and Natal'ya Goncharova in Russia combined Cubist fragmentation of form with a representation of movement derived from Futurism to create abstract paintings. Certain artists associated with Dada, notably Hans Arp and Kurt Schwitters, later applied Cubist collage techniques to abstract compositions.

The first abstract paintings in the strict sense, dating from *c.* 1910, were underpinned by a strong philosophical undercurrent derived from 19th-century German Idealist thought, which posited the supremacy of mind over matter. Such beliefs were especially important to two of the earliest practitioners of abstract art, Vasily Kandinsky (see col. pl. XVIII) and František Kupka (see col. pl. XXVIII), and to other influential figures of the period such as Piet Mondrian and Theo van Doesburg. Kupka, who as early as 1911 in France was producing abstract paintings such as *Nocturne* (Vienna, Pal. Liechtenstein), was also among the first to elaborate theories about abstract art; in unpublished notebooks written between 1910 and 1914, he expressed a belief in the capacity of abstract form and colour to embody an 'idea' of universal significance beneath the surface of appearance. In Munich by 1910, the contested date of his first abstract watercolour, Kandinsky was formulating the theoretical possibility of abstract art in a text published in 1912, *Über das Geistige in der Kunst*. This proved to be one of the most influential and widely read theoretical treatises on the subject over the next 30 years and beyond.

The ground for abstract art was also prepared by 19th-century scientific theories. The descriptions of optical and prismatic effects of pure, unmixed colour initiated by Johann Wolfgang von

Goethe in his *Farbenlehre* (1810) and extended by colour theorists such as Michel-Eugène Chevreul and Ogden Rood had a direct impact on such artists as Robert Delaunay, who extended Chevreul's term 'simultaneous contrasts of colour' to suggest that colour could be the means by which not only form but also the illusion of movement could be created in abstract paintings. In *Simultaneous Windows on the City* (1912; Hamburg, Ksthalle) and related works (see col. pl. I), and in the *Circular Form* series, for example *Circular Forms: Sun and Moon* (1913; Amsterdam, Stedel. Mus.), Delaunay reduced the emphasis on representing objects so as to increase the impact of colour and light; both his work and his writings, which were quickly made available in German translation, influenced the Blaue Reiter artists Franz Marc (see col. pl. IX) and August Macke. It was the Italian artists associated with FUTURISM, however, whose development of an abstract language was most clearly conditioned by the challenge of representing speed and motion. Gino Severini, for example, developed the associative power of abstraction by fusing remembered experience with current sensation in paintings such as *Dynamic Hieroglyphic of the Bal Tabarin* (1912; New York, MOMA). During the same period in England, similar ideas were explored within the movement known as VORTICISM. In his drawings and prints of 1912, for example, Wyndham Lewis transformed machine parts into cylindrical and geometric shapes in order to capitalize on the associations provoked by machinery independent of their forms. Around 1913 two American painters working in Paris, Stanton Macdonald-Wright and Morgan Russell, the instigators of a movement labelled SYNCHROMISM, created colour abstractions concerned with the twisting movement of form. Marcel Duchamp and Francis Picabia, two of the leading painters in a variation on Cubism christened ORPHISM by Guillaume Apollinaire, produced mechanomorphic paintings that transmuted vaguely mechanical and sexual parts into abstract forms. Duchamp's *The Bride* (1912; Philadelphia, PA, Mus. A.) and Picabia's *Udnie* (1913; Paris, Pompidou; see fig. 35) invited the spectator to interpret the forms imaginatively from clues provided by their titles. During the same period another painter associated with Orphism, Fernand Léger, used abstract pictorial equivalents to capture the dissonant contrast of manmade machines set against the natural landscape. In spite of the central position of Paris in the development of a modernist avant-garde aesthetic, the continued devotion among French artists to recognizable subject-matter, combined with the absence of a firm metaphysical or theoretical basis for their experiments, ultimately restrained them from developing a full abstract language.

2. Pioneers, 1912–20

By the end of World War I such artists as Kandinksy, Mondrian and Kazimir Malevich were creating paintings that were less reliant on appearances, perception and physical sensation and that instead obeyed their own laws of colour and form. Stylistically, this encompassed a wide range from a loose, free-form approach, as in Kandinsky's *Improvisations*, to a tight geometric abstraction as practised by Mondrian and the DE STIJL group. In spite of their differences, however, these artists shared an interest in esoteric doctrines that underpinned their commitment to abstract art.

Kandinsky's early writings were particularly influential for their analysis of colour, notably in *Über das Geistige in der Kunst*, and of form, which was the subject of an essay, 'Über die Formfrage', published in *Der Blaue Reiter Almanach* in 1912. Basing his approach to colour on the empirical theories of Goethe, Kandinsky went further in suggesting that colour, like music, can evoke certain emotional and psychological responses even when used non-representationally in a painting. Similarly, he argued that formal content was determined not by external appearances but by the 'inner necessity' of the artist's emotional response. In providing a theoretical justification for expressive abstraction, Kandinsky developed the notion of the affective purpose of art, basing this on the assumption that art must possess 'soul' in order to elicit a response from the spectator, and that this soul, manifested in the balance of colours and composition, is in turn dependent on

the integrity of the artist. While Kandinsky's pictures of this period generally continued to combine apparently abstract forms with shapes suggestive of figures, animals and landscapes (see col. pl. XVIII) in certain works, such as *Composition VII* (1913; Moscow, Tret'yakov Gal.), he approached pure abstraction.

The spiritual and moral dimensions of Kandinsky's art and theory, grounded in part on his understanding of Theosophy, were shared by Mondrian even before World War I. It was not until 1917, however, that Mondrian developed the basis of his geometric abstraction and a theoretical justification for it. In his essay 'Natuurlijke en abstracte realiteit' (1919), Mondrian followed the mystic philosopher M. H. J. Schoenmaekers, whom he had met in 1916–17, in elaborating a theory of universal beauty by renouncing the 'particulars of appearance' and embracing the 'abstraction of form and colour' within the precise formulation of the 'straight line and the clearly defined primary colour'. For Mondrian, as for Schoenmaekers and the Theosophists, the orthogonal, in line with a long history of divine geometry, was cosmically pre-eminent, as it expressed the mystical concept of life and immortality in a harmonious relationship. By 1921 Mondrian had conceived the basis of a style that he termed NEO-PLASTICISM, which was based on the use of a black linear grid and on asymmetrically placed zones of primary colour. In such paintings as *Grey, Red, Yellow and Blue* (1920–26; London, Tate; see col. pl. II), 'dynamic equilibrium' is achieved by the juxtaposition of lines, planes and narrow bands of flat colour held in taut relation to each other.

The development by Malevich of a form of abstract painting known as SUPREMATISM was also stimulated by topical esoteric concerns. He first exhibited 35 such paintings, each consisting of flat shapes such as quadrangles against light grounds, at the exhibition *Poslednaya futuristicheskaya vystavka kartin: 0.10* ('The last Futurist exhibition of paintings: 0.10'), held at the Dobychina Gallery in Petrograd (now St Petersburg) in 1915. The titles of many of the works referred to the concept of the Fourth dimension, which was evolved partly in response to Russian mystical philosophy, as a new form of consciousness that provided an escape into the world of the spirit. To effect cosmic integration, Malevich, following the philosopher Pyotr Uspensky, affirmed the necessity of venturing into a new space–continuum by replacing the forms derived from nature with 'non-objective'—that is to say completely abstract—forms (see col. pl. XXXIII). The rectilinear planes featured in such paintings as *Untitled* (1915; Amsterdam, Stedel. Mus.) make no reference to things external to the picture, other than to mathematical figures such as parallelograms, yet despite this resolute flatness and expunction of associations, the disposition of overlapping forms against a white ground inevitably creates a sense of ebb and flow. In 1919, immediately after painting his *White on White* series of 1917–18, Malevich wrote about the use of white in terms of space travel, and in 1920 he even suggested the possibility of building a Suprematist satellite. During this period other artists in Russia, such as Il'ya Chashnik (1902–29), El Lissitzky and Gustav Klucis, began to develop their own variants of Suprematism. After the Revolution of 1917, Suprematism quickly came to be regarded as one of the major new artistic tendencies to challenge the conservative traditionalism of the old Tsarist order, leading abstract art to gain official support, if only temporarily, for the first time in its history.

Other artists, especially those based in central Europe, sought to counter the barbaric realities of World War I through abstraction. Both Hans Arp and Sophie Taeuber (later Taeuber-Arp) sought to approach eternal values and to deny human egotism in a series of *Duo-collages* made as collaborations in 1918. They hoped that the impersonal technique employed in these works made with paper-cutters, together with the geometric rigour of presentation, would help to transcend human imperfections and in so doing 'cure' people of the frenzy of the period. In common with other Dadaists, such as Kurt Schwitters in the pictures and reliefs he called *Merzbilder*, from 1916 to 1919 Arp also produced more random arrangements that championed chance as the governing factor.

Artists working in France in the 1920s, such as Joan Miró and André Masson, came under the influence of Surrealism (and in particular its elevation of irrational forces) and began to explore 'pure psychic automatism', as defined in André Breton's *Manifeste du surréalisme* (Paris, 1924), employing such techniques as psychic improvisation, BIOMORPHISM and Automatism. Conceiving of their pictures as reflections of the workings of the subconscious mind, in works such as Miró's *Painting* (1927; London, Tate; see fig. 46) they created a form of improvised abstract painting that anticipated the gestural aspects of Abstract Expressionism referred to as action painting.

3. European movements of the 1920s

The dissemination of the theory and practice of abstract art in Europe after World War I was greatly aided by the banding together of artists into associations and by the establishment of schools and periodicals. Notable among them were De Stijl (1917–31) in the Netherlands, Vkhutemas (1920–30) and Inkhuk (1920–26) in Russia and the Bauhaus (1919–33) in Germany. Most of these were formed in a spirit of reconstruction after the devastation of war, with abstract art, like the machine, coming to be equated with both modernity and progress as a rejection of the old order and an embrace of a new future. The French periodical *L'Esprit nouveau* (1920–25), established by Le Corbusier and Amédée Ozenfant as the official organ of their movement, Purism (*see* PURISM, §1), conveyed a new aesthetic based on mathematics and geometry and inspired other artists to take up abstraction. In Europe, in response to debates concerning the role of art in effecting changes in society, abstract art came to be seen as an instrument with which to improve the quality of life. For artists who conveyed these views, including Theo van Doesburg in the Netherlands, Aleksandr Rodchenko in Russia and László Moholy-Nagy at the Bauhaus, abstract art became as important an issue for design as for painting. These developments, coupled with a concern for broadening their audience, led to an expanding of definitions of abstract art and to the introduction of new terms, such as CONSTRUCTIVISM and CONCRETE ART, to describe forms of abstract art based on the rigorous and non-referential use of geometric forms. Van Doesburg's insistence that the principles of De Stijl, also referred to as Neo-plasticism, be applied not only to easel painting, as exemplified by Mondrian, but also to architecture, furniture and interior design was symptomatic of this wider definition of abstract art. Van Doesburg urged collaboration between the practitioners of different disciplines in the hope of creating total environments capable of reaching a wide audience. However, the poor reception given to the Café de l'Aubette project in Strasbourg, on which van Doesburg collaborated in 1926–8 with Hans Arp and Sophie Taeuber-Arp, showed that the public was not to be easily persuaded.

Disagreements about how best to reach a general audience were vividly exemplified in Russia just after the Revolution of 1917. Artists such as Malevich, Kandinsky (who had returned to Russia in 1914) and the sculptor Naum Gabo strongly believed that abstract art had a vital contribution to make to society in raising human consciousness and that this transformation could be effected in the traditional media of painting and sculpture. Gabo's work, for example, demonstrated that sculpture could be reinvented by using new materials to represent space and movement so as to concentrate attention on effects of light and on the apparent dissolution of solid mass. By contrast, Vladimir Tatlin and Rodchenko, both of whom had conducted important experiments with abstract forms in the pre-revolutionary period, came to regard the continuation of traditional fine art after the Revolution as contrary to the spirit of the urgent requirements of the day, judging that it should be replaced by self-evidently utilitarian forms of construction. By the time Tatlin exhibited his maquette for the *Monument to the Third International* (1919–20; destr.) the notion of the 'artist' was giving way to that of the 'artist–technician' among Soviet Constructivists, with abstraction channelled largely through posters, textiles, ceramics and stage designs rather than through paintings (see col. pl. XIV). While the education system before the introduction of the first Five-year Plan in 1928

could allow the two factions to exist simultaneously for a time, increasing political opposition to what were deemed the obfuscations of abstract art led to arguments for a more easily understood and propagandistic realist art, culminating in the adoption of Socialist Realism as the official style in 1934.

In Germany an almost parallel sequence of events took place at the Bauhaus, albeit under different political circumstances. Paul Klee and Kandinsky, who had joined the teaching staff in 1920 and 1922 respectively, both rationalized further their theory and practice of abstract art. In *Punkt und Linie zu Fläche* (Munich, 1926) Kandinsky complemented his earlier theories about colour with an analysis of composition, retaining a belief in emotional expressiveness but acknowledging the need for intellectual control that was a major factor in his adoption at this time of a geometric idiom. Klee's *Pädagogisches Skizzenbuch* (1925) is a methodical study of compositional methods that reflects the increasingly 'scientific' bias of the Bauhaus at this stage; in the later 1920s his paintings became more overtly abstract, although he never fully severed his links with representational subject-matter (see col. pl. VIII). Kandinsky's affirmation in 1932 that both he and Klee were 'painters of spiritual essence', coupled with Klee's belief in intuition, were pitted against the cool rationalism of Hannes Meyer, who as the Bauhaus's director from 1927 introduced rigid Constructivist principles along Soviet lines; he asserted that form was a product of arithmetic and that no aesthetic factor was involved in design. In the event, neither view triumphed: with the ascendancy to power of the Nazis, the Bauhaus was closed in 1933, and abstract art in Germany came to be suppressed, if only temporarily, as 'degenerate art' (*see* ENTARTETE KUNST), while a largely neo-classicist-inspired realism became the officially promoted style.

4. Concrete art and geometric abstraction, 1930–45

The ideological opposition to abstract art that developed in Germany and the USSR led many abstract artists to gravitate to Paris, which gradually became the most important centre for abstract art, despite the antipathy of the French art establishment to its stricter forms. Even before Kandinsky's arrival in 1933, a great range of Europeans had already established themselves in and around Paris, including the Russians Lissitzky, Gabo, Antoine Pevsner and Jean Pougny; Dutch artists associated with De Stijl, such as Mondrian, van Doesburg (who died in 1931), Georges Vantongerloo and César Domela; Hans Arp and Sophie Taeuber-Arp; the Poles Henryk Stażewski, Władysław Strzemiński and Katarzyna Kobro; and the Italian Enrico Prampolini. Most of these artists were among those who formed the nucleus of new groups and periodicals established in Paris during the 1930s to promote abstract art. Taeuber-Arp's *Composition with Rectangles and Circles on Black Ground* (1931; Basle, Kstmus.) was typical of the geometric rigour of their work. One of the most important sculptors working in Paris during this period was Constantin Brancusi, who favoured forms of extreme simplicity abstracted from nature; although he was not identified with any movement, he had a lasting influence on the development of abstract sculpture well into the 20th century.

Arguments for the total autonomy of abstract art, which had gathered momentum during the 1920s, were vehemently expressed in a manifesto formulated by van Doesburg and published in April 1930 in the only issue of a new periodical based in Paris, *Art concret*. In it van Doesburg argued that a picture should be 'constructed entirely from purely plastic elements, that is to say planes and colours' and that as 'a pictorial element has no other significance than itself' the picture as a whole similarly has 'no other significance than itself'. This formalist emphasis reflected van Doesburg's familiarity with Constructivist tenets during the 1920s and illustrates the extent to which he had departed from Mondrian's mystical justifications. This rationale for Concrete art quickly gained followers, who used the term in preference to abstract because they agreed with van Doesburg that 'nothing is more real than a line, a colour, a surface'. Jean Hélion, who also signed the manifesto, sought in his *Equilibrium* series (1932–4) to express the

effects of space and movement on geometric elements, while during the same decade Domela and Vantongerloo developed an impersonal, severe, mathematically based art (see fig. 45); Arp, Strzeminski, Kobro and Max Bill were among those who proposed their own interpretations of Concrete art at this time, with Bill popularizing the concept in Switzerland and South America.

More catholic tendencies were embraced in the 1930s by an association based in Paris, ABSTRACTION-CRÉATION, which promoted its ideas through a magazine of the same name, and by another group and periodical, CERCLE ET CARRÉ, which flourished only briefly. The very diversity of Abstraction-Création, however—its members included Arp, Delaunay, Albert Gleizes, Hélion, Auguste Herbin, Kupka, van Doesburg and Vantongerloo—was also its weakness. Disagreements arose over exhibition policy: the dominant faction supported only 'pure' abstraction and would accept no painting containing any suggestion of an outside reference; those who resisted were eventually compelled to resign over what they considered an excessively rigid approach. Debates also raged in their magazine over how abstract art could best serve society in the face of political events abroad. Some left-wing contributors argued that abstract art was too remote from the general population to succeed in such aims, while others argued for aesthetic freedom on the basis that the objective of Communism was to liberate the individual. If the two sides of the argument seemed irreconcilable, the editorial stance of the magazine at least promoted the view that commitment to abstract art represented independence and opposition to totalitarianism.

With the increasing threat of war in Europe, many European artists were forced to uproot themselves again. Towards the end of the 1930s England was perceived as a safer refuge. For a brief period after the arrival of Walter Gropius, Marcel Breuer, Moholy-Nagy, Gabo and Mondrian, the north London suburb of Hampstead and St Ives in Cornwall became centres of abstract and especially Constructivist art; English artists such as Ben Nicholson and Barbara Hepworth moved in their own work towards a greater degree of abstraction, while the cause of international abstract art was publicized through the touring exhibition *Abstract and Concrete Art* in 1936 and through the publication in 1937 of the collection of essays *Circle: International Survey of Constructive Art*. However, the British public showed little interest in abstract art, and with the outbreak of World War II many of the Europeans decided in any case to leave for the USA, where they continued to encourage the development of abstract art.

5. Abstract Expressionism, Art informel and related tendencies, mid- to late 1940s and 1950s

After World War II the geometric abstraction of artists such as Albers, Arp and Bill was shown widely in Europe, notably at the exhibition *Art concret* in 1945 (Paris, Gal. Denise René), organized with the help of Theo van Doesburg's widow, Nelly van Doesburg, and at the Salon des Réalités Nouvelles, which over the following ten years became the largest exhibiting forum in Paris. After the traumas of World War II, however, many other artists found the geometric order too limiting to reflect their particular psychological experiences; in their search for a more immediate expression, they turned to a looser and often more gestural form of abstract painting. Inspired partly by influential exhibitions at the Galerie René Drouin and the work of Jean Fautrier, Jean Dubuffet and Wols, the painting that resulted was exhibited and promoted in Paris under a plethora of names, including lyrical abstraction, ART INFORMEL, MATTER PAINTING and TACHISM. Expressive abstraction soon became an international phenomenon, encompassing ZEN 49 (founded 1949) and QUADRIGA (founded 1952) in Germany, the painters associated with COBRA (1948–51) and a group of younger English painters based primarily in ST IVES, such as Patrick Heron and Peter Lanyon, while related developments also took place in Italy, Spain, South America and in Japan with the Gutai group. In the USA a separate but related phenomenon, ABSTRACT EXPRESSIONISM, flourished at this time.

These groups shared several characteristics: an emphasis on impulsiveness and spontaneity that rejected predetermined composition and that

frequently equated drawing with painting; a concentration on the individual mark or 'tache', as opposed to the straight line or carefully circumscribed shape; a concern for the expressive potential of paint and its textured or optical effect; and a sense of immediacy in the execution. Qualities of freshness and urgency led to a physical awareness of the artist's contact with the picture surface and of the act of painting itself, manifested in the USA by ACTION PAINTING.

In spite of the common features, there were significant differences among the various post-war groups and problems even in naming them. For example the terms *Art informel* and Tachism are often used interchangeably, even though the painters associated with *Art informel*, such as Jean Fautrier, Jean-Paul Riopelle, Antoni Tàpies and Jean Dubuffet (who approached abstraction in his *Texturologies*), generally preferred to use thick accretions of layers of paint, hence the term matter painting; whereas the Tachists, such as Georges Mathieu (who coined the word), Hans Hartung and Henri Michaux, concentrated on the swift execution of the painted stroke or gesture (see fig. 5). The degree or type of abstraction varied from group to group. Artists associated with St Ives, such as Lanyon and Terry Frost, produced atmospheric abstractions of the Cornish landscape, whereas many of the Cobra artists tended to create hybrid forms reminiscent of the mythological animals they admired in Nordic art and legend. Even within groups, the degree of abstraction was seldom clearcut, depending more on the individual proclivities of each artist. During this period, especially in Paris, tendencies were often named and promoted by critics and writers rather than by the artists themselves, thus helping to disseminate the work but also bracketing tendencies into a rather amorphous, international expansion of *Art informel* and Tachism from around 1956.

Confusion also arises from the application of the term Abstract Expressionism to American artists, as it has been used to encompass both the gestural action painting of artists such as Jackson Pollock, Willem de Kooning (see fig. 1) and Franz Kline and the COLOUR FIELD PAINTING of Mark Rothko, Barnett Newman and Ad Reinhardt; it is also used

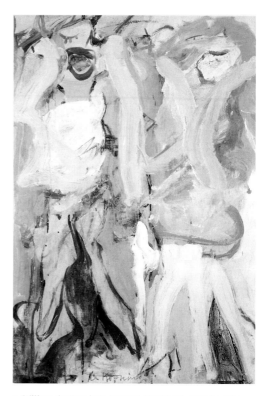

1. Willem de Kooning: *Women Singing II*, 1966 (London, Tate Gallery)

to describe paintings by artists who do not fit strictly into either category, such as Clyfford Still, Robert Motherwell and Hans Hofmann, or those whose work contains residual figuration, such as Adolph Gottlieb, William Baziotes and Arshile Gorky. Given this disparity, some critics and historians have preferred to refer to the New York school (as in the title of a major exhibition at Los Angeles, CA, Co. Mus. A., 1965), in response to the term Ecole de Paris, and to the role played by these American artists in transferring the centre of power from Paris to New York; even this term, however, is not wholly accurate, since most of the major painters originated from outside New York and in many cases continued to work in other places. Whatever name is given to these developments, the fact remains that they emerged not only as a reaction against dominant trends of

realism within American painting but also from a knowledge and assimilation of European models, particularly Cubism and the Surrealist technique of automatism, and (in the case of Pollock and others) from Native American and Mexican art. The psychoanalytic theories of Sigmund Freud and Carl Gustav Jung provided an intellectual context for their search for a new subject-matter underpinning the raw and impressive physical presence of their paintings.

While the Abstract Expressionists made reference to shared influences and intentions, great formal differences nevertheless underlie such works as Pollock's *Autumn Rhythm* (1950; New York, Met.) and Newman's *Vir heroicus sublimis* (1950–51; New York, MOMA). Pollock placed his unstretched canvas on the floor and literally poured paint on to the surface to produce weaving, linear arabesques that create an 'all-over' effect (see also fig. 2). Newman and other artists associated with colour field painting, on the other hand, evenly covered the canvas with a flat application of paint so that the viewer's field of vision is saturated with colour; no allowance is made for individual 'gesture' within this unmodulated surface. Like the Surrealists, Pollock believed that the basic artistic impulse was grounded in the unconscious, and it was this concept, interpreted in Existentialist terms, that led the critic Harold Rosenberg to devise his definition of action painting. For Newman, as for Rothko, painting was a means of expressing the sublime, of creating a transcendent art that had its origins in Old Testament theology. Thus Rothko's zones of colour were conceived not as decoration but as a means of effecting a revelatory and emotional experience for the spectator (see col. pl. III). Such levels of meaning, however, were not taken into account by formalist criticism, especially as promoted by Clement Greenberg, who vaunted the new painting for its supercession of Cubist space. Abstract Expressionism came to be seen as essentially different from European painting because of its vitality, use of large scale, intense physicality and holistic quality, by which the entire picture surface pre-empted its segmentation into parts. A case was soon made by American critics for the superiority of this art, which was promoted internationally through exhibitions and publications in such a way that New York came to be generally recognized as the most important centre of artistic production after World War II.

6. Geometric and monochrome abstractions of the 1950s

Just as the various forms of expressive abstraction became established as an international style in the late 1950s, the weakening of the original impetus had led towards a certain mannerism. In New York, for example, de Kooning's many imitators, labelled the 10th Street school because of the preponderance of galleries representing them in that area, used the techniques of Abstract Expressionism more as surface embellishments than as signs of underlying content. Inevitably there was a reaction against this lapse of a once avant-garde style into a new kind of academicism. In its wake, artists developed styles that eschewed the personal touch, such as Minimalism, hard-edge painting and Post-painterly Abstraction as well as Pop art.

In Europe geometric abstraction remained a force to be reckoned with. The Groupe Espace was formed in 1949 after the success of the *Art concret* exhibition of 1945 and the founding of the Salon des Réalités Nouvelles in Paris in 1946. The Groupe Espace sought to promote Constructivism as an influence on the urban environment. Their anti-expressive bias was shared by an international network of other groups such as MOVIMENTO ARTE CONCRETA (MAC) in Milan (1948), ART ABSTRAIT in Belgium (1952), LES PLASTICIENS (1955, from 1959 Les Nouveaux Plasticiens) in Canada and Equipo 57 in Spain (1957), all of which promoted alternatives to *Art informel* and pursued a programme of geometric abstraction. Josef Albers explored perception and the illusory aspects of colour from 1950 in his *Homages to the Squares*, a series he worked on until his death. In Switzerland Karl Gerstner (*b* 1930) and Richard Paul Lohse continued the teachings of Max Bill in their investigation into the mathematical aspects of colour programming, which they called Kalte Kunst in 1954, while in Britain ties with Dutch Constructivism were

established through the magazine *Structure* (1958–64) and through a shared interest in the theories of the American Charles Biederman.

During the 1950s a number of artists experimented with single-colour abstractions, including Lucio Fontana in his *Spatial Concepts* (from 1948), Piero Manzoni in his *Achromes* (exhibited from 1957), Yves Klein in blue monochromes (exhibited from 1956; see col. pl. XXVII), Robert Rauschenberg in series of monochromes, including white paintings (exhibited in 1951) and Ad Reinhardt in his blue, red and ultimately 'black' paintings (c. 1954–67). Such works constituted the ultimate reduction of painting, but the artists' intentions were varied. To Rodchenko in 1921 the monochrome had represented the last venture in painting before he turned to Constructivism. By contrast, Rauschenberg wished to create an empty screen against which the moving shadows of spectators could be projected, while Fontana established the flat uniform surface only to pierce it spatially with holes and later slits; Manzoni seems to have been motivated by more purely nihilistic purposes; while for Klein blue was so potent and mysterious a hue that the canvas surface needed to be covered only in paint of that colour. Reinhardt's intention with his 'black' canvases was to make the 'first paintings which cannot be misunderstood'. Whatever the motive, the monochrome experiments of the 1950s offered a severe form of abstraction that both paved the way for Minimalism in the 1960s and for the ongoing critical debates concerning the 'end of painting'.

7. Post-painterly Abstraction, Op art, Minimalism and other objective forms of the 1960s

Abstract art enjoyed its greatest success in terms of support in the 1960s, in major exhibitions staged in Europe and the USA and through international art magazines. Broadly speaking, European artists explored scientific discoveries and experimentation, while Americans developed a more purely formal language. Both directions were characterized by a more objective and impersonal approach that transcended the individual imprint of the artist.

In Europe these new developments were encompassed largely by KINETIC ART, OP ART and art using electric light sources. All these were among the trends referred to as NOUVELLE TENDANCE, an umbrella term used in the early 1960s to describe the diverse Constructivist tendencies and movements that opposed expressive abstraction. Artists working with light, and kinetic and Op artists, all tended to depersonalize the art object, using materials and techniques borrowed from industrial science, exploiting direct stimuli such as light, sound and real movement, encouraging spectator involvement and generally subverting traditional aesthetic standards. Among the groups to develop these interests within *Nouvelle tendance* were the GROUPE DE RECHERCHE D'ART VISUEL (GRAV) in Paris, ARTE PROGRAMMATA, GRUPPO N and GRUPPO T in Italy, ZERO Group in Germany, NUL in the Netherlands and Equipo 57 in Spain. One of the most influential pioneers of Op art, however, was an English painter, Bridget Riley (see fig. 33), and GRAV included Victor Vasarely as well as Jésus Soto and other South Americans among its members.

In the USA the direction towards a more objective abstract art was restricted largely to painting and sculpture, although there were also important American Op artists such as Richard Anuszkiewicz and at least one major artist working with light, Dan Flavin. Various exhibitions of American painting held in the USA during the 1960s, such as *Toward a New Abstraction* (1963), *Post-painterly Abstraction* (1964) and *Systemic Painting* (1966), brought together works that shared an ordered and structured composition, clearly defined edges and linear clarity. The two most commonly used terms for these developments are POST-PAINTERLY ABSTRACTION and HARD-EDGE PAINTING. Morris Louis, Kenneth Noland, Ellsworth Kelly and Frank Stella, who were included in all these exhibitions, may be taken as paradigms of this new direction.

Louis and Noland worked in Washington, DC (*see* WASHINGTON COLOR PAINTERS), not in New York, and they were inspired by the stain paintings of helen Frankenthaler rather than by Pollock. Both used acrylic paint for a kind of painting that allowed for no reworking. Louis, for example, in his *Unfurleds* series (1960–61), poured thinned

paint on to unprimed or selectively sized canvas so that it sank into and stained the weave, making the image and its support inseparable and eliminating the gestural marks and tactile surface of action painting, thereby concentrating attention on the purely visual experience of colour. Similar techniques were employed by Noland but applied to more structured motifs of concentric circles or parallel bands of colour. Kelly, who had spent his formative years in Europe from 1948 to 1954, took his hard-edge shapes from nature or architecture and abstracted them to the point of unrecognizability. Stella was the most extreme of all in stressing the flatness of the picture plane, denying illusionism and other levels of meaning; he insisted that there were no suggestions in his paintings beyond the structure expressed on their surface. This emphasis on the work of art as a physical object was a reaction against the values of the previous generation but also part of a wider interest at the time in Phenomenology.

MINIMALISM emerged in the 1960s as a highly influential development in abstract sculpture, especially in the USA. The *Primary Structures* exhibition (1966) brought together British and American artists, many of them trained as painters, who had begun to produce objects of extreme formal simplicity largely after the example of Brancusi. The Americans, notably Carl André and Donald Judd, used rigidly geometrical prefabricated industrial units often displayed according to serial principles; Judd's *Untitled* (1968; Toronto, A.G. Ont.) is a characteristic example (see also figs 26 and 27). They renounced what they considered to be a European preference for relational methods of composition, as Stella used in his paintings, favouring instead the use of regular grid structures or centralized formats so that the shape of the work as a whole could be apprehended at once. Along with Judd, Robert Morris provided a theoretical premise for Minimalist sculpture by stressing the presence or factuality of the work itself, the object's autonomy and the mind's powers of perception. In Britain a group of sculptors associated with the St Martin's School of Art, London, under the tutelage of Anthony Caro, explored new forms of abstract

sculpture that were witty in conception and painted in bright colours. Phillip King, Tim Scott and William Tucker were among those who established their reputations at the exhibition *New Generation: 1965* (1965). Like the American Minimalists, they used industrially manufactured and synthetic materials, including sheet metal, glass, plastic and fibreglass, but unlike them they maintained a referential quality in their choice of both motifs and titles. In spite of the growing internationalism, national tendencies continued to be discernible.

8. Abstract art after the emergence of conceptual art, 1970s and after

By the end of the 1960s the boundaries between abstract and representational art, as with so many other categories, began to break down. The international developments encompassed by the term CONCEPTUAL ART, which emerged in part as a reaction against the marketable art object, were closely related to movements important in the development of abstract art. LAND ART and ARTE POVERA, for example, drew attention to the environment and sought to transcend the distinction between sculpture and object and between abstraction and representation, while artists involved with PROCESS ART took as their main theme the methods by which their work was made. Land artists such as Robert Smithson, Richard Long and Jan Dibbets favoured abstract patterns or primary forms similar to those employed by the Minimalists, using nature as their raw material and often documenting their ephemeral or large-scale works in photographs. Smithson's *Spiral Jetty* (1970)—a coil 457 m long of mud, salt crystals, rocks and water at the Great Salt Lake in Utah—is typical of this synthesis. The work was seen directly by few people other than the artist, but it was recorded in photographs and film, undercutting traditional expectations and resisting categorization. In Germany the most influential figure, both as an artist and teacher, was Joseph Beuys, who emphasized the largely personal associations of particular natural materials such as fat and felt, with form as their by-product rather than as a predetermined factor.

Conceptual attitudes, especially in the USA, revived in abstract art a concern for mental constructs and logic. As with artists of the *Nouvelle Tendance*, planning and programming became essential, and the work of art itself was frequently the fulfilment of a verbal construct or mathematical formula. Sol LeWitt, as a general principle, used written instructions as the starting-point of his art. In LeWitt's abstract *Wall Drawings*, for example, which consist of pencilled lines or coloured shapes, the impersonality of the idea logically entailed the collaboration of assistants for their execution. The client was often sold only the instructions, thus again calling into question the uniqueness of both the creator and the work itself. Although such strategies were not new to art, given the earlier example of artists such as Duchamp and Moholy-Nagy, their alliance in the 1970s with contemporary developments in critical theory and linguistics gave them a particular weight.

The challenge presented by conceptual art during the 1970s to traditional forms of painting and sculpture was met by a number of artists who continued to work in these media. In the context of these largely individual investigations, Supports–surfaces, a group of painters based in France, was unusual in emerging as a cohesive movement; they were not alone, however, in their concern with material structure, physical attributes and use of decorative patterns, since these were shared by other Europeans such as Gillian Ayres and by Americans such as Miriam Schapiro and Robert Zakanitch (*b* 1936), loosely referred to as 'dekor' or 'pattern painters'. Agnes Martin, Robert Ryman and Brice Marden, three American abstract painters tangentially related to Minimalism, showed that formalism and metaphysical concerns could be intertwined, while a rearticulation of the compositional and relational tradition of Constructivism was to be found in the work of Beuys's pupils Blinky Palermo and Imi Knoebel.

The pluralism that increasingly dominated the evolution of art during the 1970s and 1980s created a climate in which abstract and representational forms were equally acceptable and sometimes even interchangeable. Many artists, such as Georg Baselitz, used referential imagery but conceived of their paintings as abstract, while others, such as the American sculptor Joel Shapiro (*b* 1941), took as their starting-point forms associated with abstract art but endowed them with suggestions of objects and of the human figure. Cy Twombly extended the language and meaning of gestural Abstract Expressionism by adding scrawled words embued with poetic and mythic associations to the other marks contained in his non-figurative canvases and drawings, while Gerhard Richter produced both figurative and abstract paintings, which by the particular nature of their painted surface and reference to the ambiguities of photography, seemed to call into question what is abstract and what is 'real': both lines of pursuit have since influenced and exercised many other artists. The pluralism of the period found numerous outlets even within the bounds of wholly non-referential work, and these could each be traced to earlier 20th-century movements as diverse as Constructivism and Abstract Expressionism. The relationship to earlier models could be as sincere as the emulation of Hans Hofmann by John Hoyland or as ironic in its appropriation of Op art and hard-edge painting as the parodies by American painters labelled Neo-Geo, such as Philip Taaffe (*b* 1955) or Peter Halley (*b* 1953). A widespread loss of faith in the concept of the avant-garde during this period brought with it a move away from the candour and utopian optimism that characterized abstraction in early modernism, to the extent that modernism itself was seen by some to have run its course and to have given way to the more eclectic impulses of Post-modernism. In this context, abstract art has generally changed both its meaning and its function while continuing to exploit the diverse forms and approaches associated with its history. Increasing access to information concerning art made outside western Europe and America prompts the need also for a greater awareness of other traditions and of new perspectives on abstraction that might be offered. In terms of the art discussed to date, it still remains to be resolved whether Post-modernism marked a moment of

clear and decisive rupture in the history of abstract art, as proposed by much of the North American, English and French literature, or alternatively, whether the same moment was characteristic of a shift from a high to a late modernism in art, a position often argued for in German literature of the same period. While the Post-modern arguments of rupture lead to a discontinuous and variable problematization of abstract art and its history, the latter narrative offers the positive and diachronic advantages of an unfolding critical model and of continuous period histories into early–high–late types of abstract art production.

Bibliography

periodicals and reviews

De Stijl, i/1–viii/90 (1917–32)
Veshch–Gegenstand–Objet, 1–3 (1922)
Z. Elem. Gestalt (1923)
Bauhaus: Z. Bau & Gestalt. (1926–31)
A. Concr. (1930)
Cerc. & Carré (1930)
Abstraction, Création, A. Non-Fig., i–v (1932–6)
Axis, 1–8 (1935–7)
Réalités Nouv., 1–9 (1947–55)
Cobra: Rev. Int. A. Expermntl (1948–51)
Structure (1958–64)
Zero, 1–3 (1958–61)

artists' writings and statements

V. Kandinsky: Über das Geistige in der Kunst (Munich, 1912)
——: 'Über die Formfrage', Der Blaue Reiter Almanach (Munich, 1912, 2/1914), pp. 74–100
——: 'Rückblicke', Kandinsky, 1901–1913 (Berlin, 1913), pp. iii–xxix
K. Malevich: Ot kubizma i futurizma k suprematizmu: Novyy zhivopisnyy realizm [From Cubism and Futurism to Suprematism: the new realism in painting] (St Petersburg, 1915, rev. Moscow, 3 and 4/1916)
P. Mondrian: 'Natuurlijke en abstracte realiteit', De Stijl, ii (1919), no. 8, pp. 85–9; no. 9, pp. 97–9; no. 10, pp. 109–13; no. 11, pp. 121–5; no. 12, pp. 133–7; iii (1919), no. 2, pp. 15–19; iii (1920), no. 3, pp. 27–31; no. 5, pp. 41–4; no. 6, pp. 54–6; no. 7, pp. 58–60; no. 8, pp. 65–9; no. 9, pp. 73–6; no. 10, pp. 81–4; repr. and Eng. trans. in The New Art—The New Life: Collected Writings of Piet Mondrian (London, 1987), pp. 82–123

Desyataya gosudarstvennaya vystavka: Bespredmetnoye tvorchestvo i suprematizm [Tenth state exhibition: non-objective creation and Suprematism] (exh. cat., essay by K. Malevich, Moscow, 1919)
P. Mondrian: Le Néo-plasticisme: Principe général de l'équivalence plastique (Paris, 1921); repr. in The New Art—The New Life (London, 1987), pp. 132–47
P. Klee: Pädagogisches Skizzenbuch, ed. W. Gropius and L. Moholy-Nagy (Munich, 1925; Eng. trans., New York, 1944, 2/1953)
V. Kandinsky: Punkt und Linie zu Fläche (Munich, 1926) [pubd as a Bauhaus bk]
P. Klee: 'Exakte Versuche im Bereich der Kunst', Bauhaus: Z. Bau & Gestalt., ii/2–3 (1928)
N. Gabo: 'The Constructive Idea in Art', Circle: International Survey of Constructive Art (London, 1937), pp. 1–10
P. Mondrian: 'Plastic Art and Pure Plastic Art (Figurative Art and Non-Figurative Art)', Circle: International Survey of Constructive Art (London, 1937), pp. 41–56
G. Mathieu: 'La Liberté, c'est le vide' (exh. cat., Paris, Gal. Colette Allendy, 1947)
H. Arp: Dadaland (Paris, 1948)
A. Calder: 'What Abstract Art Means to Me', MOMA Bull., xviii/3 (1951), p. 8
W. de Kooning: 'What Abstract Art Means to Me', MOMA Bull., xviii/3 (1951), pp. 4–8
R. Motherwell: 'What Abstract Art Means to Me', MOMA Bull., xviii/3 (1951), pp. 12–13
K. Gerstner: Kalte Kunst (Teufen, 1957)
J. Albers: The Interaction of Color (New Haven and London, 1963)
G. Mathieu: Au-delà du tachisme (Paris, 1963)
——: Le Privilège d'être (Paris, 1963)
'Conversation with A. Caro, K. Noland and J. Olitski', Monad (Jan 1964), pp. 18–22 [interview with D. Thompson]
'Questions to Stella and Judd', ARTnews [New York], lxv (1966), no. 5, pp. 55–61 [rev. transcript of original radio broadcast, New York, Feb 1964]
A. Hill, ed.: Data-directions in Art, Theory and Aesthetics (London, 1968)
G. Rickey: Constructivism: Origins and Evolution (London, 1968)
Art in Progress IV (exh. cat. by R. Ryman, New York, Finch Coll. Mus. A., 1969)
G. Mathieu: De la révolte à la renaissance (Paris, 1973)
G. de Vries, ed.: Über Kunst/On Art: Artists' Writings on the Changed Notion of Art after 1965 (Cologne, 1974)
D. Judd: Complete Writings, 1959–1975 (Halifax, NS, and New York, 1975)

A. Reinhardt: *Art as Art: The Selected Writings of Ad Reinhardt* (New York, 1975/R 1991) [intro. by B. Rose]

Fundamenteele schilderkunst/Fundamental Painting (exh. cat., Amsterdam, Stedel. Mus., 1975) [incl. statements by R. Mangold, B. Marden, A. Martin and R. Ryman, among others]

K. Noland: 'Color, Form and Abstract Art', *A. America*, lxv (1977), pp. 99–105 [interview with Diane Waldman]

N. Holt, ed.: *The Writings of Robert Smithson* (New York, 1979)

M. Poirier and J. Necol: 'The '60s in Abstract', *A. America*, lxxi (1983), no. 3, pp. 122–37 [13 statements and an essay]

P. Halley: *Collected Essays, 1981–1987* (Zurich and New York, 1987)

R. Weil, ed.: 'Talking Abstract', *A. America*, lxxv (1987), no. 7, pp. 80–97; no. 12, pp. 112–29 [interviews with American artists in two parts]

B. Newman: *Selected Writings and Interviews* (New York, 1990)

Collected Writings of Robert Motherwell (Oxford, 1993)

For further writings *see* individual biographies.

exhibition catalogues

Cubism and Abstract Art (exh. cat. by A. Barr, New York, MOMA, 1936)

Le Mouvement (exh. cat. by V. Vasarely, Paris, Gal. Denise René, 1955)

Situation (An Exhibition of British Abstract Painting) (exh. cat. by R. Coleman, London, RBA Gals, 1960)

American Abstract Expressionists and Imagists (exh. cat. by H. H. Arnason, New York, Guggenheim, 1961)

Toward a New Abstraction (exh. cat. by B. Heller, New York, Jew. Mus., 1963)

Post-painterly Abstraction (exh. cat. by C. Greenberg, Los Angeles, CA, Co. Mus. A., 1964)

The New Generation: 1965 (exh. cat., preface B. Robertson, intro. and notes I. Dunlop; London, Whitechapel A.G., 1965)

Primary Structures: Younger American and British Sculptors (exh. cat. by K. McShine, New York, Jew. Mus., 1966)

Systemic Painting (exh. cat. by L. Alloway, New York, Guggenheim, 1966)

Geometric Abstraction, 1926–1942 (exh. cat. by M. Seuphor and J. Elderfield, Dallas, TX, Mus. F.A., 1972)

Robert Ryman (exh. cat., London, Whitechapel A.G., 1977)

Abstraction-Création, 1931–1936 (exh. cat., Paris, Mus. A. Mod. Ville Paris; Münster, Westfäl. Landesmus.; 1978)

Origini dell'astrattismo: Verso altri orizzonti del reale (exh. cat. by G. Ballo and others, Milan, Pal. Reale, 1979)

Abstraction: Towards a New Art, Painting, 1910–1920 (exh. cat., London, Tate, 1980)

Arte astratta italiana, 1909–1959 (exh. cat., Rome, G.N.A. Mod., 1980)

The Avant-garde in Russia, 1910–1930: New Perspectives (exh. cat. by S. Barron and M. Tuchman, Los Angeles, CA, Co. Mus. A., 1980)

Brice Marden (exh. cat., London, Whitechapel A.G., 1981)

Abstract Painting and Sculpture in America, 1927–1944 (exh. cat., Pittsburgh, PA, Carnegie Inst., 1983)

Beyond the Plane: American Constructions, 1930–1965 (exh. cat., Trenton, NJ State Mus., 1983)

Kosmische Bilder in der Kunst des 20. Jahrhunderts (exh. cat., ed. S. Holsten; Baden-Baden, Staatl. Ksthalle, 1983)

Action Precision: The New Direction in New York, 1955–60 (exh. cat. by R. Rosenblum and others, Newport Beach, CA, Harbor A. Mus., 1984)

Carte Blanche to Denise René: Geometric and Kinetic Adventure (exh. cat. by A. Glibota and others, Paris, A. Cent., 1984)

Os grandes mestres do abstracionismo brasileiro (exh. cat. by M. R. Rathsam and A. F. Beuttenmuler, São Paulo, Sociedade de Amigos dos Museus do Brasil, [1984–5])

Contrasts of Form: Geometric Abstract Art, 1910–1980 (exh. cat. by M. Dabrowski, New York, MOMA, 1985)

Abstraction Abstraction (exh. cat. by E. A. King and D. Carrier, Pittsburgh, PA, Carnegie-Mellon U.A.G., 1986)

Arte astratta nelle Marche, 1935–1985 (exh. cat. by C. Melloni, Ascoli Piceno, Pin. Civ., 1986)

Konstruktion und Geste: Schweizer Kunst der 50er Jahre (exh. cat. by W. Rotzler and H. Walter-Dressler, Karlsruhe, Städt. Gal. Prinz-Max-Pal., 1986)

Neo-geometry (exh. cat., Munich, Kstver., 1986)

Nuove geometrie (exh. cat. by F. Caroli, Milan, Rotunda Besana, 1986)

The Spiritual in Art: Abstract Painting, 1890–1935 (exh. cat., Los Angeles, CA, Co. Mus. A., 1986)

L'Art en Europe: Les Années décisives, 1945–1953 (exh. cat., Saint-Etienne, Mus. A. Mod., 1987)

New York Art Now: The Saatchi Collection (exh. cat. by D. Cameron, London, Saatchi Col., 1987)

Astratta: Secessioni astratte in Italia dal dopoguerra al 1990 (exh. cat., Verona, Pal. Forti, 1988)

The Image of Abstraction (exh. cat. by K. Brougher, Los Angeles, CA, Co. Mus. A., 1988)

The Presence of Painting: Aspects of British Abstraction, 1957–1988 (exh. cat. by M. Tooby, Sheffield, Mappin A. G., and elsewhere; 1988)

Contemporary Perspectives I: Abstraction in Question (exh. cat. by R. Smith, J. Simm and W. Ferguson, Sarasota, FL, Ringling Mus. A., 1989)

Espagne arte abstracto, 1950–1965 (exh. cat. by J. M. Bonet, Paris, Artcurial, 1989)

The New Sculpture, 1965–75: Between Geometry and Gesture (exh. cat., ed. R. Armstrong and R. Marshall; New York, Whitney, 1990)

Paris 1930: Arte abstracto, arte concreto, Cercle et Carré (exh. cat. by G. Fabré and R. Stanislowski, Valencia, IVAM Cent. Julio González, 1990)

Aparición de lo invisibile: Pintura abstracta contemporánea en Mexico (exh. cat. by M. A. Alamilla and others, Mexico City, Mus. A. Mod., 1991)

Wille zur Form ungegenständliche Kunst, 1910–1938 in Österreich, Polen, Tschechoslowakei und Ungarn (exh. cat., Vienna, Messepalast, 1993)

general

W. Worringer: *Abstraktion und Einfühlung* (Munich, 1908; Eng. trans., London, 1948)

J. L. Martin, B. Nicholson and N. Gabo, eds: *Circle: International Survey of Constructive Art* (London, 1937)

S. Janis: *Abstract and Surrealist Art in America* (New York, 1944)

C. Estienne: *L'Art abstrait, est-il un académisme?* (Paris, 1950)

M. Seuphor: *L'Art abstrait, ses origines, ses premiers maîtres* (Paris, 1950)

T. B. Hess: *Abstract Painting: Background and American Phase* (New York, 1951)

H. Rosenberg: 'The American Action Painters', *ARTnews*, li/8 (1952), pp. 22–3, 48–50

M. Tapié: *Un Art autre, où il s'agit de nouveau d'évidages du réel* (Paris, 1952)

A. Heath: *Abstract Painting, its Origins and Meaning* (London, 1953)

M. Seuphor: *Dictionnaire de la peinture abstraite* (Paris, 1957)

P. Soulages: *Au-delà de l'informel* (Paris, 1959)

C. Greenberg: *Art and Culture* (Boston, MA, 1961)

J. MacTruitt: 'Art Arid, DC, Harbor's Touted "New" Painters', *Washington Post* (21 Dec 1961), p. 20

R. Rosenblum: 'The Abstract Sublime', *ARTnews*, lix/10 (1961), pp. 38–41, 56, 58

C. Gray: *The Russian Experiment in Art, 1863–1922* (London, 1962, rev. 1986)

C. Greenberg: 'After Abstract Expressionism', *A. Int.*, vi/8 (1962), pp. 24–32

J. Paulhan: *L'Art informel* (Paris, 1962)

D. Vallier: *L'Art abstrait* (Paris, 1967)

G. Battcock, ed.: *Minimal Art: A Critical Anthology* (New York, 1968)

G. Celant, ed.: *Arte Povera, Conceptual, Actual or Impossible Art?* (London and Milan, 1969)

S. Ringbom: *The Sounding Cosmos: A Study of the Spiritualism of Kandinsky and the Genesis of Abstract Painting* (Åbo, 1970)

I. Sandler: *The Triumph of American Painting: A History of Abstract Expressionism* (New York, 1970); repr. as *Abstract Expressionism: The Triumph of American Painting* (London, 1970)

M. Tuchman: *The New York School: Abstract Expressionism in the '40s and '50s* (London, [1970])

J. Leymarie and others: *Abstract Art since 1945* (London, 1971)

M. Ragon and M. Seuphor: *L'Art abstrait*, 4 vols (Paris, 1971–4)

C. Blok: *Geschichte der abstrakten Kunst, 1900–1960* (Cologne, 1975)

G. Levin: *Synchromism and American Color Abstraction, 1910–1925* (New York, 1978)

H. Osborne: *Abstraction and Artifice in Twentieth-century Art* (Oxford, 1979)

Towards a New Art: Essays on the Background to Abstract Art, 1910–20, preface M. Compton (London, 1980)

J. Gallego: *Arte abstracto español en la colección de la Fundación Juan March* (Madrid, 1983)

L. D. Henderson: *The Fourth Dimension and Non-Euclidean Geometry in Modern Art* (Princeton, 1983)

C. Lodder: *Russian Constructivism* (New Haven and London, 1983)

R. Pincus-Witten: *Entries (Maximilism): Art at the Turn of the Decade* (New York, 1983); rev. as *Postminimalism into Maximilism: American Art, 1966–1986* (Ann Arbor, 1987)

A. B. Nakov: *Abstrait/Concret: Art non-objectif russe et polonais* (Paris, 1984)

M. A. Prat: *L'Abstraction en France, 1919–1939* (Paris, 1984)

D. Vallier: *L'arte astratta* (Milan, 1984)

R. Krauss: *The Originality of the Avantgarde and other Modernist Myths* (Cambridge, MA, and London, 1986)

J. O'Brian: *The Collected Essays and Criticism*, 4 vols (Chicago and London, 1986, rev. 1993) [Clement Greenberg]

M. Ragon: *25 ans d'art vivant: Chronique vécue de l'art contemporain de l'abstraction au Pop art, 1944–1969* (Paris, 1986)

F. Whitford: *Understanding Abstract Art* (London, 1987)

D. J. Clarke: *The Influence of Oriental Thought on Postwar American Painting and Sculpture* (New York and London, 1988)

J. L. Duval: *Histoire de la peinture abstraite* (Paris, 1988; Eng. trans., London, 1989)

D. Kuspit and others: *Abstrakte Malerei aus Amerika und Europa/Abstract Painting from America and Europe* (Vienna, 1988)

M. Pleynet and M. Ragon: *Art abstrait, 1970–1987* (Paris, 1988)

M. Auping: *Abstraction, Geometry, Painting: Selected Geometric Abstract Painting in America since 1945* (New York, 1989)

D. Anfam: *Abstract Expressionism* (London, 1990)

Y. A. Bois: *Painting as Model* (New Haven, 1990)

G. Boudaille and P. Javault: *L'Art abstrait* (Paris, 1990)

A. E. Gibson: *Issues in Abstract Expressionism: The Artist-run Periodicals* (Ann Arbor and London, 1990)

S. Guilbaut, ed.: *Reconstructing Modernism: Art in New York, Paris and Montreal, 1945–1964* (Cambridge, MA, and London, 1990) [esp. essay by T. de Duve]

A. Moszynska: *Abstract Art* (London, 1990)

R. Paulson: *Figure and Abstraction in Contemporary Painting* (New Brunswick, 1990)

D. Shapiro: *Abstract Expressionism: A Critical Record* (Cambridge, 1990)

A. C. Chave: 'Minimalism and the Rhetoric of Power', *Power: Its Myths and Mores* (exh. cat., Indianapolis, IN, Mus. A., 1991)

M. Cheetham: *The Rhetoric of Purity: Essentialist Theory and the Advent of Abstract Painting* (Cambridge, 1991)

C. Millet: *Conversations avec Denise René* (Paris, 1991)

S. Polcari: *Abstract Expressionism and the Modern Experience* (Cambridge, 1991)

U. Ruberti: *Il post-informale in Europa* (Rome, 1991)

D. Leclerc and M. H. Barclay: *The Crisis of Abstraction in Canada: The 1950s* (Ottawa, 1992)

M. Ragon: *Journal de l'art abstrait* (Geneva, 1992)

C. Harrison, F. Frascina and G. Perry: *Primitivism, Cubism, Abstraction: The Early Twentieth Century* (New Haven and London, 1993)

E. Strickland: *Minimalism: Origins* (Indianapolis, 1993)

A. Kagan: *Absolute Art* (St Louis, 1995)

ANNA MOSZYNSKA

Abstract Expressionism

Term applied to a movement in American painting that flourished in the 1940s and 1950s, sometimes referred to as the New York School or, very narrowly, as ACTION PAINTING, although it was first coined in relation to the work of Vasily Kandinsky in 1929. The works of the generation of artists active in New York from the 1940s and regarded as Abstract Expressionists resist definition as a cohesive style; they range from Barnett Newman's unbroken fields of colour to Willem de Kooning's violent handling of the figure. They were linked by a concern with varying degrees of abstraction used to convey strong emotional or expressive content. Although the term primarily denotes a small nucleus of painters, Abstract Expressionist qualities can also be seen in the sculpture of David Smith, Ibram Lassaw and others, the photography of Aaron Siskind and the painting of Mark Tobey, as well as in the work of less renowned artists such as Bradley Walker Tomlin and Lee Krasner. However, the majority of Abstract Expressionists rejected critical labels and shared, if anything, only a common sense of moral purpose and alienation from American society. Abstract Expressionism has nonetheless been interpreted as an especially 'American' style because of its attention to the physical immediacy of paint; it has also been seen as a continuation of the Romantic tradition of the Sublime. It undeniably became the first American visual art to attain international status and influence.

1. Background, origins and early phase

The roots of Abstract Expressionism lie in the social and artistic climate of the 1920s and early 1930s. Apart from Hans Hofmann, all its major exponents were born between 1903 and 1915 and grew up during a period of American isolationism. Although Europe remained the traditional source of advanced culture, American efforts during the 1920s to develop an aesthetic independence culminated in the direct, homespun realism of Regionalism. Consequently, the development of the art of Willem de Kooning, Arshile Gorky, Jackson Pollock and Clyfford Still, for example, illustrates a complex interaction between tradition, rebellion and the individual talent. European modernism stimulated them deeply, while their desire to retain the impact of personal experience recalled the aims of American Scene painting. Pollock, Still, Smith and Franz Kline were all affected by their native backgrounds in the rural West and in the steel- and coal-producing regions respectively. In other cases Jewish or European origins contributed to an unusual

gamut of ethnic, intellectual and private sources of inspiration.

Between the wars New York offered some notable opportunities to assimilate comparatively recent artistic developments. Its galleries included the Museum of Non-objective Art, which housed the impressive Kandinsky collection, and the Museum of Modern Art, which mounted exhibitions throughout the 1930s and 1940s covering many aspects of 20th-century painting.

Much of the creative intellectual ferment of the time was focused in the theories of the Russian émigré painter and writer John Graham who befriended Gorky, Pollock and others. His book *Systems and Dialectics of Art* (1937) justified abstraction as distilling the essence of reality and traced its roots to primitivism, the unconscious and the painter's empathy with the brushstroke. The younger American artists thus seem to have become highly conscious of their historical position and dictates. Most felt that they had to reconcile Cubist spatial organization with the poetic subject-matter of Surrealism and realized that original art would then need to go beyond both.

The development of Arshile Gorky's art from the late 1920s exemplified the cross-currents in the matrix of Abstract Expressionism. He progressively assimilated the main phases of modern European painting in order to explore his own identity until in *The Artist and his Mother* (c. 1926–34; New York, Whitney) the private world of Gorky's Armenian origins merged with his contemporary stance as heir to the space and forms of Synthetic Cubism, Picasso and Miró. This mood of transition is especially apparent in technical paradoxes, such as the strange contrasts of carefully finished areas with unresolved passages of paintwork that make this double portrait appear as if it were suspended in a process of change. By the early 1940s this tendency (which can be traced back to Paul Cézanne and to Futurism) provided new means of incorporating the tensions of the artist's immediate circumstances into the actual picture. De Kooning, for example, deliberately allowed successive efforts to capture volume and contour to overtake the stability of his figures, as

in *Queen of Hearts* (c. 1943; Washington, DC, Hirshhorn); such figures typify one aspect of early Abstract Expressionism in retreating into a dense, ambiguous visual fabric.

At an early stage Pollock, Still and Mark Rothko established a similar polarity between the figure (or other signs of existence) and external forces. The 'realism' of their early landscapes, interiors and urban scenes undoubtedly reflected the emphasis on locale in American Scene painting, but the expressive symbolism was prophetic. A sense of isolation and gloom probably derived in part from the context of the Depression allied with personal factors. They combined highly sensitive, romantic temperaments with left-wing or radical views so that the social circumstances of the period naturally suggested an approach to art that explored the human predicament. This had already been anticipated by some literature of the 1920s and 1930s, notably the novels of William Faulkner (1897–1962), that placed the self against an inimical environment; contemporary American art, however, offered few successful precedents. On the contrary, the weaknesses of depicting human themes literally had already surfaced in Thomas Hart Benton's anecdotal brand of Regionalism that Pollock, a former pupil of Benton, later described as 'something against which to react very strongly'. Despite the wagons, cowboy and mules in Pollock's *Going West* (c. 1934–5; Washington, DC, N. Mus. Amer. A.), it remains more elemental than anything by Benton. A feeling of almost cosmic tumult is countered by an overall vortex-like unity.

As Pollock's work became more abstract during the 1930s it nonetheless retained an underlying conflict between impulsive chaos and the need to impose some overall sense of order. Yet the common problem of the 1930s was not just evolving a formal language for what Rothko subsequently termed 'pictures of the human figure—alone in a moment of utter immobility' ('The Romantics were prompted': *Possibilities*, 1, winter 1947–8, p. 84) and other contrasting psychological states; the controversy in the USA focused instead upon the definition and priorities of an authentic avant-garde art.

Several future Abstract Expressionists were employed on the Works Progress Administration's Federal Art Project (WPA/FAP). Alongside the practical benefits of financial support and official endorsement, the WPA/FAP allowed opportunities to experiment with new techniques and to tackle the problems of working on a large scale. It also acted as a catalyst for a more cohesive New York community. But the advocacy of Social Realism on the project alerted many to its academic nature, which Gorky summarized as 'poor art for poor people'. From a visual rather than literary standpoint, the humanitarian imagery of a leading Social Realist such as Ben Shahn seemed as barren as the reactionary equivalents in Regionalism. David Smith's *Medals for Dishonor* series (15 plaster models, 1939; e.g. *No. 9—Bombing Civilian Populations*, ex-artist's priv. col., see G. McCoy, ed.: *David Smith*, New York, 1973, fig. 15) and the early paintings of Philip Guston not only engaged anti-Fascist ideas but also revealed a legacy of the radicalism of the 1930s that was never abandoned, despite largely unfounded claims that later the movement was on the whole 'de-politicized'. Smith and Guston, rather, subsequently sought to show how their respective media could signify and not merely illustrate their beliefs about freedom, aggression and constraint. Similarly, Pollock drew almost nothing from the overt Socialism of the Mexican José Clemente Orozco's murals but a great deal from their capacity to embody human strife in the objective pictorial terms of rhythm and surface pattern.

Another alternative in the 1930s was the tradition of 'pure' abstraction, stemming from Piet Mondrian (see col. pl. II) and upheld by the AMERICAN ABSTRACT ARTISTS group (AAA) to which Ad Reinhardt belonged. Reinhardt's eventual divergence from mainstream Abstract Expressionism can be traced to this initial assumption that the liberating potential of non-objective and specifically geometric art lay in its very independence from the social sphere. A more moderate approach was adopted by the painters Hans Hofmann and Milton Avery. Hofmann, born in Bavaria in 1880, provided a link with an earlier phase of European modernism and, through his own school, which he founded in New York in 1934, taught the synthesis of Cubist structure (emphasizing the unity of the picture plane) with the brilliant colours of Fauvism. Avery's more lyrical approach suffused a simple, flat handling of space with light and atmosphere. This inspired Rothko and Adolph Gottlieb, with its Matisse-like balance between observation and the artist's feelings. Moreover, the growing popularity among an emergent New York avant-garde of theories originated by Leon Trotsky tended to discourage strict orthodoxy by stressing the autonomy of art over social and political restrictions. Out of this amalgam of diverse sources and beginnings, Abstract Expressionism during the 1940s sought to integrate the inner world of emotions with the realities of the picture-making process.

2. The 1940s: paths to abstraction

The exhibition *Fantastic Art, Dada, Surrealism* (1936–7; New York, MOMA) heralded a phase when Surrealism and its affinities changed the course of American painting. Furthermore, the arrival of several leading European Surrealists including André Breton, André Masson and Max Ernst in the USA after the outbreak of World War II allowed stimulating personal contacts, Robert Motherwell being one of the first to benefit in this way. This brought an international note to the art scene and reinforced a sense of historical moment: the hegemony of the Ecole de Paris had shifted to New York. As the war continued it also seemed that new subject-matter and accompanying techniques were necessary to confront what was perceived as the tragic and chaotic zeitgeist. Surrealism had partly satisfied such needs by unleashing the disruptive forces of the unconscious, but its tendency towards pure fantasy now appeared irrelevant. In a statement made in 1943 in the *New York Times* (13 June, p. 9), Rothko and Gottlieb declared the new gravity of intent: 'There is no such thing as good painting about nothing. We assert that the subject is crucial and only that subject-matter is valid which is tragic and timeless.'

The pursuit of universal themes continued Surrealist artists' fascination with the omnipotent force of sexuality and explained much apparently

Freudian imagery in paintings of the earlier 1940s. Erotic motifs occur in Gorky's *The Liver is the Cock's Comb* (1944; Buffalo, NY, Albright–Knox A.G.). Interpenetrating or phallic elements characterized Smith's sculptures at times, as well as the paintings of Pollock, Rothko, Still and Theodoros Stamos; the living figure in Motherwell's *Pancho Villa Dead and Alive* (1943; New York, MOMA) is distinguished by his genitalia. Such inconography in fact derived less from Freud than from a more universal symbolism invoking regeneration, fertility and primitive impulses. These themes in twin stemmed from the Abstract Expressionist's overriding concern with subjectivity. To this end the Surrealist use of biomorphism, a formal language of organic curves and similar motifs, was variously exploited. For Gorky it evolved into a metamorphic realm where tendrils, spikes and softer masses referred simultaneously to nature and to human anatomy. Pollock's version was less specific, and in *Pasiphaë* (1943; New York, Met.) it implied womb-like enclosure versus whirling activity. Even de Kooning, the least sympathetic towards Surrealism, reiterated organic contours in his claustrophobic canvases of the mid-1940s as reminders of a strong yet cryptic eroticism. Thus biomorphism served to bridge the figurative modes of the 1940s with a manifold path to abstraction.

Another catalyst in the 1940s was a preoccupation with the concept of myth, especially as interpreted by the Swiss psychologist Carl Gustav Jung, whose writings had gradually gained an American readership. According to Jung, myths gave universal form to basic human truths and related to a profound level of experience that he identified as the 'collective unconscious'. These theories helped several Abstract Expressionists attain more reductive styles because myth, Jung claimed, had a dramatic simplicity expressed through 'archetypes', that is, primal figures and symbols. Primitive art often dealt with myth and became a secondary source at this stage, particularly in the aftermath of exhibitions at the Museum of Modern Art in New York, ranging from prehistoric rock pictures in Europe and Africa (1937) to American Indian art (1941). The totem

was a frequently used primitive motif, aptly fitted to personify the Jungian archetype in the guise of a mysterious, upright entity. In Pollock's *Guardians of the Secret* (1943; San Francisco, CA, MOMA) sentinels at either side of the picture seem to guard a central maze of lines and markings that suggests the chaotic recesses of the collective unconscious. Similarly, Still, Smith and others turned the totem into a visual cipher halfway between a figure and a non-representational emblem.

The great potential of the abstract sign soon became clear: it embodied a kind of terse pictorial shorthand, provocative in itself or, rather like individual script, imbued with the physical impetus of its creator. In 1941 Gottlieb began a series known collectively as *Pictographs* (e.g. *Voyager's Return*, 1946; New York, MOMA). Enigmatic details, including body parts and geometric motifs, were set within a rough gridwork that recalled an archaic sign system or petroglyph. By 1947 Rothko, Stamos and others had created sparse schematic images marked by a shallow, post-Cubist space, and defined in the *Ideographic Picture* exhibition, organized by Barnett Newman for the Betty Parsons Gallery, New York, in 1947, as 'a symbol or character painted, written or inscribed representing ideas'.

Newman's own works of this period reflected the theory that abstraction could convey awesome meanings. Their breakthrough was analogous to that in Aaron Siskind's contemporary photographs, such as *Iron Work I* (1947; see C. Chiarenza: *Aaron Siskind: Pleasures and Terrors*, Boston, 1982, fig. 77), which gained impact from a calculated ambiguity. Their syntax of vertical elements, quivering edges and voids retained the dramatic aura associated with figuration but no longer conformed to either a biomorphic style or to the geometry of Mondrian. Rothko's paintings also progressed in a similar direction already anticipated in 1943 when he wrote, 'We favor the simple expression of the complex thought' (letter to the *New York Times* Art Editor, Edward Alden, 7 June 1943), which was to be achieved through the 'large shape' that could impose its monumentality upon the viewer (see col. pl. III).

This reduction to essentials had widespread consequences during the 1940s. It shifted attention away from relatively graphic symbolism towards the capacities of colour and space to acquire an absolute intensity, not bound to describe events and forms within the picture but free to embody extremes of light and darkness, enclosure, liberation and so on. The dynamics of the act of painting assumed a central role. Gorky's use of very fluid washes of pigment in 1942, under the influence of the Chilean Surrealist Matta (Echaurren), foreshadowed both tendencies. The resultant veils, billows and liquid runs of colour created an unusually complex space, as in *Water of the Flowery Mill* (1944; New York, Met.) that changed from one area to another with the same spontaneity that had previously been limited to Gorky's organic shapes.

Still, Gottlieb, Stamos and Richard Pousette-Dart pursued a different course in the 1940s by stressing tangible paint layers with heavy or unconventional textures. These methods altered their works from the traditional concept of a discrete easel picture to more palpable images whose presence confronted the actual world of the spectator. Dimensions grew in order to accentuate psychological and physical rapport with the viewer. Inevitably, the search for heightened immediacy, for a charged relationship between surface and viewer, meant that a number of artists would regard the painting as an incarnation of the process—the energy, tensions and gestures—that had created it.

The Surrealist technique Automatism again unlocked possibilities for incorporating immediacy with a vivid record of manual activity, and the impulses behind it, into the final work. Automatism had supposedly allowed Surrealists

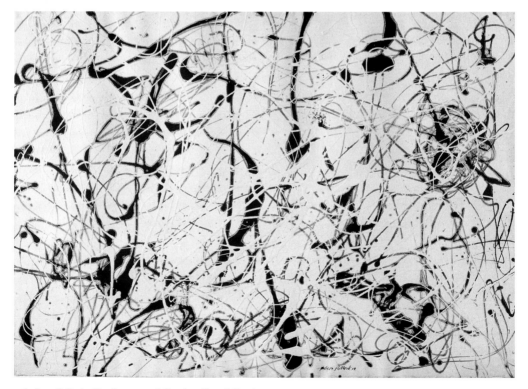

2. Jackson Pollock: *Number 23*, 1948 (London, Tate Gallery)

like Miró and Masson to paint without full conscious control and so essentially stimulated the discovery of unorthodox forms. In contrast, Abstract Expressionism elevated Automatist procedures into a means of reorganizing the entire composition. Hofmann was among the first to pour and drip paint in the early 1940s in order to achieve increased liveliness, but Pollock took the technique to revolutionary limits. By the mid-1940s he painted with such urgency that the remnants of figures and other symbolic details were almost dismembered and lost within the great arcs and whorls formed by his sweeping gestures, for example *There were Seven in Eight* (1945; New York, MOMA). A climax came in 1947 when the restrictions of brushes and the upright format of the easel picture were abandoned as Pollock took to working directly on the floor, dripping paint either straight from the can or with the aid of an implement such as a stick or a trowel. Consequently, in works of this period an astonishing labyrinth of paint traces expand, oscillate and hurtle back upon themselves resembling, as the artist described it, 'energy and motion made visible'. Pollock had reconciled two long-standing though divergent impulses, an obsession with chaotic force and the desire for order, into the vibrant unity of a field, for example *Number 23* (1948; London, Tate; see fig. 2)

This synthesis was unique at the time, but Abstract Expressionist painting in the late 1940s generally approached a threshold where restlessness and flux predominated. The composition dissolved into a seething field of fragments dispersed with almost equal intensity throughout the picture, hence the term 'all-over' was sometimes used to describe this tendency. A type of space evolved that was dense and unstable beyond even that of Analytical Cubism, as in de Kooning's *Painting* (1948; New York, MOMA). This probably owed something to the doubt-ridden anxieties of the post-war years and perhaps the pressures of fast-moving urban life. It certainly also stemmed from the consequences of Automatism, which took even less overtly Abstract Expressionist painters like Reinhardt and Tobey to the stage where a teeming, calligraphic field of brush-

strokes predominated. By the end of the decade the need to reassert meaningful content in unprecedented ways had again become imperative.

3. The 1950s: climax, reaction and later work

Newman's essay 'The Sublime is Now', published in the *Tiger's Eye* (i/6, 1948), called for a new art stripped to its formal essentials that still dealt with 'absolute emotions'. He concluded, 'The image we produce is the self-evident one of revelation, real and concrete.' Within two years Newman, Rothko and Still fulfilled these aims, primarily through a total concentration on colour, a pictorial element loaded with dramatic connotations, simultaneously palpable and metaphysical insofar as its total effect transcends analysis. The deep redness of Newman's *Onement I* (1948; New York, MOMA) no longer describes forms since it comprises an absolute continuum, punctuated, though not broken, by a central vertical band of a brighter hue. Encompassing fields of colour tended to minimize internal pictorial relations and so invite the onlooker's participation, especially when enlarged to the mural scale sometimes adopted in the early 1950s. Small incidents acquired an uncanny prominence; the luminous rifts that escaped from Still's essays in black or the slight haloes around Rothko's rectangles implied the numinous behind the apparently monolithic façades. By 'telling little', as Rothko described it in 1958, these works in fact managed to express more.

COLOUR FIELD PAINTING was championed, using narrow stylistic criteria, by the critic Clement Greenberg as a breakthrough in modernist painting's attitude to space because it superseded the shallow figure-ground relationships found in Cubism. Another interpretation has concentrated upon its elemental conflicts of light and scale, and of void and presence, as extending the Romantic tradition of the Sublime with its predilection for epic revelations. Both readings are valid but overlook the fact that the artists had essentially lifted the symbolic extremes and states of consciousness depicted in their earlier works on to an abstract plane. Moreover, the primal field of colour, accentuating the viewer's isolation and sense of self,

may equally have reflected a need for strong emotional experience in the barrenness of the Cold War during the late 1940s and the 1950s in the USA. Indeed its imagery was not confined to Abstract Expressionist painting and recurred in the photographs of Siskind and Harry Callahan as well as in the expanses of space that engulfed the solitary figures painted by Ben Shahn and Andrew Wyeth.

In 1950 de Kooning abruptly abandoned his increasingly hermetic all-over compositions, such as *Excavation* (1950; Chicago, IL, A. Inst.), to begin a number of female subjects, the first being *Woman I* (1950–52; New York, MOMA; for a later example, see fig. 1). Paradoxically, this return to the figure vied with de Kooning's painting style, where the furious tumult of brushstrokes seemed to possess independence and velocity. The poet and critic Harold Rosenberg traced similarities in the work of Pollock, de Kooning and Franz Kline, who had begun black-and-white abstractions *c.* 1949 that aggrandize the individual brushstroke into enormous vectors appearing to continue beyond the picture's edges. Rosenberg had assimilated the existentialism popular among the New York intelligentsia of the late 1940s and claimed that this art represented the physical traces of its creator's spontaneous working methods. He characterized it as Action painting. Subsequent histories have tended to maintain the consequent division into 'action' or 'gestural' styles and 'colour field painting', although these rather simplistic critical categories were disowned by the artists and overrode many subtle connections.

Newman's *Onement* paintings (which date from *c.* 1948 to 1953) and de Kooning's *Woman* paintings, a theme to which he repeatedly returned, stand at opposite poles of technique and mood, ranging from the exalted to the grotesque. Both nonetheless juxtapose a centralized presence against an ambience, whether of colour or urban chaos. Still's *1957-D-No1* (1957; Buffalo, NY, Albright–Knox A.G.) further demonstrates the shortcomings of critical categories by conferring the graphic contours and energy associated with gestural painting upon grandiose and otherwise almost homogeneous walls of pigment. Alongside

Pollock's 'drip' paintings and the large, linear steel sculptures by Smith of the late 1940s onwards, it established a radical type of Abstract Expressionist work where any static or conventional background ceased to exist and all parts interacted as if galvanized into a network of forces. The viewer's perceptual process had to integrate the pictorial incidents actively, the far-flung extremes of scale, colour and focus and, in Smith's sculptures, the great disparities when seen from different viewpoints. This meant that they had a 'life' beyond what was contained in any one aspect. The dynamic encounter between the work and its audience became a hallmark of Abstract Expressionism.

National recognition increased during the 1950s. The role of dealers, critics and institutions such as the Museum of Modern Art, New York, in this development encouraged the theory that the movement was promoted at home and abroad as a weapon of Cold War ideology to stress the USA's superior freedom of expression. While the claim may be just, the artists themselves were not actively responsible. In fact several challenged such control by avoiding contact with the art establishment or taking their work to conclusions that almost defied critical commentary, such as the progression towards hypnotic monochrome painting by Reinhardt and Rothko in the 1960s.

While Abstract Expressionism's intensity depended partly on its very stylistic terseness, as in Newman's work, or singularity, as in Pollock's, its latter phases tended to pivot around a search to avoid defined limits or to extract the greatest range of meanings from a strictly limited idiom. The notion of working in series allowed nuances and variations to register most forcefully against a fairly constant visual syntax: Newman's group of 14 paintings, *Stations of the Cross* (1958–66), or Smith's *Cubi* series (1961–5) show a creative impulse transcending the parameters of a single act. Themes and images from the 1940s also returned on a grandiose scale. Thus Gottlieb's *Bursts* (which he painted from 1957) refashioned pictograph symbols into newfound explosive gestures and calmer fields of colour. It was Pollock's last period, however, that encapsulated the movement's overall dilemma. At best he summoned earlier mythic imagery, through

methods such as black paint soaked into bare canvas in the remarkable, nightmarish compositions of 1951 and 1952. More often the sheer fusion of audacity and control attained in the 'drip' paintings pre-empted further innovation, and Pollock's death in 1956 reinforced suspicions that a vanguard was now in decline.

In this later phase a community of younger artists emerged to adopt the tenets of spontaneity, improvisation and the importance of process. They included the painters Helen Frankenthaler and Joan Mitchell, poet Frank O'Hara (1926–66) and the sculptors associated with assemblage. However, they replaced the basic urgency and existential vision of their models with a more lyrical and relatively decorative stance, (that could indeed suggest a feminist revision of 'masculine' premises), characterized for example by Frankenthaler's *Mountains and Sea* (1952; artist's col., on loan to Washington, DC, N.G.A.). By then Abstract Expressionism had nonetheless transformed the fundamentals of painting and sculpture in the mid-20th century, and its influence in terms of style and aesthetics extended over a vast spectrum of subsequent art.

Bibliography

C. Greenberg: *Art and Culture* (Boston, 1961)

H. Rosenberg: *The Tradition of the New* (New York, 1961)

Artforum, iv/1 (1965) [issue ded. to Abstract Expressionism]

M. Tuchman, ed.: *New York School* (Greenwich, NY, 1965)

B. Rose: *Readings in American Art Since 1900* (New York, 1968)

W. Rubin: *Dada and Surrealist Art* (London, 1969), pp. 342–410

I. Sandler: *The Triumph of American Painting: A History of Abstract Expressionism* (New York, 1970)

D. Ashton: *The Life and Times of the New York School* (Bath, 1972)

S. Hunter: *American Art of the Twentieth Century* (New York, 1972)

C. Harrison: 'Abstract Expressionism', *Concepts of Modern Art* (London, 1974/1988, ed. N. Stangos), pp. 169–211

W. Andersen: *American Sculpture in Process: 1930–1970* (Boston, MA, 1975)

R. Rosenblum: *Modern Painting and the Northern Romantic Tradition* (London, 1975)

K. McShine, ed.: *The Natural Paradise* (New York, 1976)

J. Wechsler: *Surrealism and American Painting* (New Brunswick, 1977)

E. Carmean jr: *The Subjects of the Artist* (Washington, DC, 1978)

R. Hobbs and G. Levin: *Abstract Expressionism, the Formative Years* (New York, 1978)

I. Sandler: *The New York School* (New York, 1978)

B. Rose: *American Painting* (London, 1980)

A. Cox: *Art-as-politics: The Abstract Expressionist Avant-garde and Society* (Ann Arbor, 1982)

S. Guilbaut: *How New York Stole the Idea of Modern Art* (Chicago, 1983)

W. Seitz: *Abstract Expressionist Painting in America* (Cambridge, MA, 1983)

M. Baigell: *A Concise History of American Painting and Sculpture* (New York, 1984)

P. Turner, ed.: *American Images: Photography, 1945–80* (London, 1985)

M. Auping, ed.: *Abstract Expressionism: The Critical Developments* (New York, 1987)

D. Shapiro and C. Shapiro, eds: *Abstract Expressionism: A Critical Record* (Cambridge, 1989)

D. Anfam: *Abstract Expressionism* (London, 1990)

C. Ross: *Abstract Expressionism: Creators and Critics* (New York, 1990)

S. Polcari: *Abstract Expressionism and the Modern Experience*, (Cambridge, 1991)

D. Thistlewood, ed.: *American Abstract Expressionism* (Liverpool, 1993)

DAVID ANFAM

Abstraction-Création

International group of painters and sculptors, founded in Paris in February 1931 and active until 1936. It succeeded another short-lived group, CERCLE ET CARRÉ, which had been formed in 1929 with similar intentions of promoting and exhibiting abstract art. Its full official title was Abstraction-Création: Art non-figuratif. The founding committee included Auguste Herbin (president), Georges Vantongerloo (vice-president), Hans Arp, Albert Gleizes, Jean Hélion, Georges Valmier and František Kupka.

Membership of Abstraction-Création was in principle open to all abstract artists, but the dominant tendency within the group was towards the geometric formality championed by Theo van Doesburg and by other artists associated with De Stijl. Works such as Jean Hélion's *Ile-de-France*

(1935; London, Tate), which came to typify the group's stance, owed more to the post-war 'rappel à l'ordre' interpreted by the Purists in terms of a 'classic' and 'architectonic' ordering of art, design and architecture, than to the biomorphic abstraction derived from Surrealism. During its brief existence the group published annual *cahiers*. The first issue, edited by Hélion and published in 1932, offered some definitions:

> Non-figuration, that is to say cultivation of pure plasticity, to the exclusion of any explanatory, anecdotal, literary or naturalistic element . . .; abstraction because certain artists have arrived at the conception of non-figuration through progressive abstraction from the forms of nature; creation because artists have achieved non-figuration directly through a conception of purely geometric order.

Over 40 artist-members, including the members of the committee, were represented by reproductions of their non-figurative works, in some cases with accompanying statements. Among them were Willi Baumeister, Alexander Calder, Robert Delaunay and Sonia Delaunay, Otto Freundlich, Naum Gabo, Jean Gorin, László Moholy-Nagy, Piet Mondrian, Antoine Pevsner, Kurt Schwitters, Henryk Stazewski, Theo van Doesburg, Jacques Villon and Edward Wadsworth. It was acknowledged that the Russian artists El Lissitzky, Malevich and Tatlin were 'unable to join'.

If Abstraction-Création had a dominant theme at the outset, this was the idealist tendency in late Cubism (represented by Gleizes, Hélion and Herbin). To this was added the geometrical tendency of De Stijl, represented by Mondrian, van Doesburg and Vantongerloo, and an émigré version of Constructivism (represented by the expatriates Gabo and Pevsner). A commitment to the rationalization of design went hand in hand with a tendency to spiritualize geometry.

By 1935 the association had 'about 50' members, of whom 32 contributed to the annual *cahier*. In the same year a broader category of 'Members and Friends' numbered 410. A breakdown of these by countries was published in the fourth *cahier*. The majority were resident in France, with 209 based in Paris; Switzerland, the Netherlands, Great Britain, Germany, Poland and Italy and a further 10 countries provided the remaining members. Among those who had joined by this time were Josef Albers, Lucio Fontana, Julio González, Arshile Gorky, Barbara Hepworth, Vasily Kandinsky and Ben Nicholson. From December 1933 an exhibition of members' work was held for about a year at an address on the Avenue de Wagram, Paris.

The diverse members of Abstraction-Création were united by their commitment to the identification of abstract art with liberation. Although the association between aesthetic and political freedom was generally idealistic in character, it gained significance from the suppression of modern artistic practice under various totalitarian governments during the 1930s. The following editorial statement was published in 1933:

> The second issue of *Abstraction-Création* appears at a time when, under all régimes, in some countries more effectively than others, but everywhere, free thought is fiercely opposed We place this issue under the banner of a total opposition to all oppression, of whatever kind it may be.

The last *cahier* appeared in 1936 after much deliberation. It must by then have been clear to many of the contributors that abstract art was not the means of saving the world from the forces of oppression. During the prelude to World War II, many of those who had gathered in Paris in the late 1920s and early 1930s travelled to the USA in pursuit of security, their migrations partly encouraged by the network of contacts that Abstraction-Création had established.

Writings

Abstraction-Création: Art non-figuratif, 1–5 (1932–6)

Bibliography

Abstraction-Création, 1931–36 (exh. cat., Paris, Mus. A. Mod. Ville Paris, 1978)

Acmeism [Rus. Akmeizm, from Gr. *akmě*: 'perfection']

Russian poetic movement established in St Petersburg in 1913, which flourished until the early 1920s and was associated with the journal *Apollon*. The leaders and theoreticians of this movement were Nikolay Gumilyov (1886–1921) and Sergey Gorodetsky (1884–1967), and the movement's poets included Anna Akhmatova (1888–1966) and Osip Mandel'shtam (1891–1938). In general terms Acmeism professed a conservatism and a dedication to 'world art' and its preservation in the turbulent period of the October Revolution of 1917, when other literary trends, such as Futurism, were denouncing the past. The primary links between this literary movement and art were forged through Gumilyov and his relationship with Natal'ya Goncharova and Mikhail Larionov. Both artists made portraits of him as well as illustrating his poems.

In the early part of his career Gumilyov wrote three pieces of art criticism for Russian journals, discussing the work of Paul Gauguin and Paul Cézanne, among others. He also wrote an article (unfinished) on African art. During visits to London and Paris, Gumilyov met Roger Fry, worked with the Russian sculptor Boris Anrep (1883–1969) and discussed collaborations with Larionov and Goncharova on a production for Diaghilev. Gumilyov's late Acmeist work shows the probable influence of Rayism. The enthusiasm shared by Gumilyov, Goncharova and Larionov for ethnography and Eastern art forms is felt in their work from the period of their friendship in 1917.

Acmeism also had much in common with the poetic movement Imagism, which rejected Romanticism. The Acmeists were opposed to the mystical vagueness of the Russian Symbolists, and they emphasized craftsmanship and earthly reality. Their poetry was characterized by clarity of language and a visual orientation, some of the best describing objects from the natural world or timeless objects of man's creativity. More concerned with grounding their work in the systems of art and verbal culture than in social reality, the Acmeists filled their verse with allusions to other artistic systems, justifying Mandel'shtam's definition of the movement as 'the yearning for world culture'.

Bibliography

S. Driver: 'Acmeism', *Slav. and E. Eur. Rev.*, xii (1968), pp. 141–56
D. Mickiewicz: 'The Problem of Defining Acmeism', *Rus. Lang. J.*, suppl. (Spring 1975), pp. 1–20
E. Rusinko: 'Russian Acmeism and Anglo-American Imagism', *Ulbandus Rev.*, i (1978), pp. 37–49
——: 'Acmeism, Post-symbolism and Henri Bergson', *Slav. Rev.*, xli (1982), pp. 494–510
A. Parton: 'Goncharova and Larionov—Gumilev's Pantum to Art', *Nikdaj Gumilev, 1886–1986: Papers from the Gumilev Centenary Symposium* (Berkeley, 1987), pp. 225–42

ELAINE RUSINKO

Action painting

Term applied to the work of American Abstract Expressionists such as Jackson Pollock (see fig. 2) and Willem de Kooning (see fig. 1) and, by extension, to the art of their followers at home and abroad during the 1950s. An alternative but slightly more general term is gestural painting; the other division within ABSTRACT EXPRESSIONISM was colour field painting.

The critic Harold Rosenberg defined action painting in an article, 'The American Action Painters' (1952), where he wrote: 'At a certain moment the canvas began to appear to one American painter after another as an arena in which to act. ... What was to go on canvas was not a picture but an event'. This proposition drew heavily, and perhaps crudely, upon ideas then current in intellectual circles, especially in the wake of Jean-Paul Sartre's essay *L'Existentialisme est un humanisme* (Paris, 1946; Eng. trans., 1948), which claimed that 'there is no reality except in action'. In the 1940s Herbert Ferber, Barnett Newman and others had already characterized their creative process in similar terms; Rosenberg was probably also inspired by photographs of Pollock at work (rather than the actual paintings) that emphasized his apparent psychological freedom and physical engagement with materials. 'Action painting' became a common critical term

to describe styles marked by impulsive brushwork, visible pentiments and unstable or energetic composition, which seemed to express the state of consciousness held by the artist in the heat of creation. Action painting thereby shared the spontaneity of Automatism. Although this implicit, direct synthesis of art and consciousness is questionable, the spontaneous methods associated with the concept were paralleled in European movements such as TACHISM and ART INFORMEL.

Bibliography

H. Rosenberg: 'The American Action Painters', *ARTnews*, li/8 (1952), pp. 22–3, 48–50
—: 'The Concept of Action in Painting', *New Yorker*, xliv (25 May 1968), pp. 116–28
F. Orton: 'Action, Revolution and Painting', *Oxford A. J.*, xiv/2 (1991), pp. 3–17
For further bibliography *see* ABSTRACT EXPRESSIONISM.

DAVID ANFAM

Activists [Hung. Aktivizmus]

Hungarian artistic, literary and political group that emerged *c.* 1914, after the disintegration of the group THE EIGHT (iii) in 1912. Though not a cohesive group, the Activists were stylistically united by their reaction to the predominantly Post-Impressionist aesthetic of the Eight. Instead they turned for inspiration to Cubism, Expressionism, Futurism, Dada and Constructivism, and although some of these had previously influenced the Eight, the Activists made most consistent and profound use of these modern movements. The most notable Activists were Sándor Bortnyik, Péter Dobrović (*b* 1890), János Kmetty, János Máttis Teutsch, László Moholy-Nagy, Jószef Nemes Lampérth, Lajos Tihanyi and Béla Uitz, of whom only Tihanyi had previously been a member of the Eight. Many Activists were at some time members of the MA GROUP, which revolved around the writer and artist Lajos Kassák, the main theoretical, and later artistic, driving force behind Hungarian Activism.

Both artistically and politically the Activists were more radical and international than the Eight, a reflection of both the turbulent atmosphere caused by World War I and the revolutionary fervour within Hungary itself. The Activists saw themselves as giving a voice to the working classes and, like the Eight, as agitators for a Utopian, Socialist society. Unlike the members of the Eight, however, many of the Activists were of working-class origin, and while not intellectuals themselves, they received many of their ideas from the Galilei Circle of young Hungarian intellectuals, which organized debates and lectures in Budapest. One of the earliest artistic stimuli on the Activists was the exhibition of Expressionist and Futurist art in the Nemzeti Szalon (National Salon) in Budapest at the beginning of 1913. This show had previously been in Berlin and included work by the Expressionists Oskar Kokoschka, Alexei Jawlenski and Ludwig Meidner, as well as Futurist works by Umberto Boccioni, Carlo Carrà, Luigi Russolo and Gino Severini. This affected both the style and aesthetic of the Activists and, in place of the Eight's call for order and harmony, they posited the tortured, emotional disorder of Expressionism.

On 1 November 1915 the first issue of Kassák's periodical *A tett* ('The deed') appeared in Budapest, modelled on Franz Pfemfert's *Die Aktion*. *A tett* included works by Uitz and Dobrović among others, and in such works as Dobrović's linocut *The Lamentation* (1915; see Szabó, 1971, pl. 13) the rough angularity, medium and subject-matter reveal the debt to German Expressionism. The same influence in painting can be found in such works by Tihanyi as the portrait of *Lajos Kassák* (1918; see 1973 exh. cat., pl. 168). *A tett* also had a strong social message and, as its name suggests, called for individual action as a means of broad social change. This attitude contrasted with the passive nostalgia that marked *Nyugat*, the formerly radical literary forum of the Eight. The subversive, outspoken tone of *A tett* ensured the confiscation of several editions by the authorities; it was banned after 17 issues, on 20 September 1916, accused of publishing 'propaganda hostile to the nation'. Soon after this, Kassák founded the journal *MA* ('Today'), which became the central forum and organizing body for most of the Activists even after its move to Vienna in 1920.

In April 1916 and again in June 1917 a group of Activists called the Fiatalok ('The young'), including Dobrović, Kmetty, Nemes Lampérth and Uitz, exhibited in the Nemzeti Szalon in Budapest. The catalogue for the second exhibition stated that, while starting from Cubism, they aimed at a 'great monumental art of the 20th century'. Nemes Lampérth, for example, was at this time painting highly coloured, near abstract works such as *Landscape* (1917; Pécs, Pannonius Mus.), which, while using Fauvist colour, showed a Cubist-influenced composition from flat planes. During the brief Communist regime of Béla Kun in 1919, the Activists assumed a central role in the country's culture, in particular as teachers of art: Uitz, for example, was made head of the Proletarian Fine Arts workshop. They also produced posters to propagate government messages, as in Uitz's *Red Soldiers, Forward!* (1919; Budapest, N.G.), designed to rouse the army in defence of the unstable Communist regime. On 25 March 1919 some Activists signed a manifesto calling for the establishment of a mass Communist culture. Following the fall of the Kun government, the aesthetic of the Activists began to be subsumed under the Constructivist aesthetic of *MA*, by then exiled in Vienna. Uitz, for example, visited Moscow in 1921 and after leaving the MA group, in autumn 1922 founded, with Aladár Komját, the journal *Egység* ('Unity'), which published Naum Gabo and Antoine Pevsner's *Realistic Manifesto* and other important documents on avant-garde Soviet art.

Bibliography

L. Németh: *Modern Art in Hungary* (Budapest, 1969)

J. Szabó: *A magyar Aktivizmus története* [History of Hungarian Activism] (Budapest, 1971) [with Fr. summary]

Magyar Aktivizmus (exh. cat. by J. Szabó, Pécs, Pannonius Mus., 1973)

K. Passuth: *Magyar művészek az európai avantgarde-ban, 1919–1925* [Hungarian artists in the European avant-garde, 1919–25] (Budapest, 1974)

The Hungarian Avant Garde: The Eight and the Activists (exh. cat. by J. Szabó and others, London, Hayward Gal., 1980)

J. Szabó: *A magyar Aktivizmus művészete, 1915–1927* [Hungarian Activist art] (Budapest, 1981)

S. A. Mansbach: 'Revolutionary Events, Revolutionary Artists: The Hungarian Avant-Garde until 1920', *'Event' Arts and Art Events*, ed. S. C. Foster (Ann Arbor, 1988), pp. 31–60

□

Aeropittura

Italian movement that emerged in the late 1920s from the second wave of Futurism (*see* FUTURISM, §1), which it eventually supplanted. It was announced by the publication on 22 September 1929 of the *Manifesto dell'Aeropittura*, signed by Giacomo Balla, Benedetta (Marinetti's wife, the painter and writer Benedetta Cappa, 1897–1977), Fortunato Depero, Gerardo Dottori, Fillia, Filippo Tommaso Marinetti, Enrico Prampolini, the painter and sculptor Mino Somenzi (1899–1948) and the painter Tato (pseud. of Guglielmo Sansoni, 1896–1974). This text became the key document for the new adherents of Futurism in the 1930s. Although Marinetti had written the first Futurist manifestos, and Balla, Depero and Prampolini were senior figures within the movement, it was Dottori and younger painters who developed the new form most impressively. Building on earlier concerns with the speeding automobile, both Marinetti and the Fascist government gave particular importance to aeronautics in the 1920s, extolling the pilot as a type of Nietzschean 'Superman'.

There were various applications of the new tendency. Painters such as Tato, Ugo Pozzo (1900–1981), Tullio Crali (*b* 1910) and Renato Di Bosso (*b* 1905), who was also active as a sculptor, engaged in a naturalistic representation of the pilot's new perceptions of landscape seen from extreme angles of perspective. Other painters, such as Prampolini in *The Cloud Diver* (1930; Grenoble, Mus. Peint. & Sculp.), evolved a more abstract language of circles, spirals and intersecting shapes to evoke mood and the symbolism of flight. Other exponents of this approach included Fillia, Benedetta and Pippo Oriani (1909–72). Dottori also tended to abstract from reality, while Bruno Munari favoured geometrical abstraction. A third aspect of Aeropittura involved the movement

of the pencil, brush or spray as an analogy for the movement of the aeroplane, as in Di Bosso's *Spiralling towards the Island of Garda* (1934; see G. Lista, *Futurismo*, Paris, 1985, p. 96), in which the giddy plunge to earth is represented by rotating circular forms.

The first exhibition of Aeropittura, held in 1931 at the Galleria Pesaro in Milan, included works by Dottori, Tato, Munari and Fillia. It was followed by an exhibition in Paris in 1932 and in 1934 by one in Berlin sponsored by Joseph Goebbels. By the late 1930s there were manifestos of Aeropoesia and Aeromusica, Prampolini had created Aerodanza Futurista, and manifestations related to Aeropittura had been proposed even for photography, sculpture and architecture. The movement fragmented on Marinetti's death in 1944 and dissolved completely with the collapse of Fascism at the end of World War II.

Bibliography

E. Crispotti: *Il mito della macchina e altri temi del Futurismo* (Trapani, 1969; rev. 1971)
Aeropittura futurista (exh. cat., Milan, 1970)
Aeropittura (exh. cat., London, Accad. It. A. & A. Applic., 1990)

KENNETH G. HAY

Agitprop [Rus. *agitatsionnaya propaganda*: 'agitational propaganda']

Russian acronym in use shortly after the Bolshevik Revolution of 1917 for art applied to political and agitational ends. The prefix *agit-* was also applied to objects decorated or designed for this purpose, hence *agitpoyezd* ('agit-train') and *agitparokhod* ('agit-boat'), decorated transport carrying propaganda to the war-front. Agitprop was not a stylistic term; it applied to various forms as many poets, painters and theatre designers became interested in agitational art. They derived new styles and techniques for it from Futurism, Suprematism and Constructivism.

The characteristics of the new art forms were defined as public, political and communal in purpose and execution. The poet Mayakovsky called for artists to abandon their studios and make the streets their brushes and the squares their palettes. Mass spectacular theatre provided vigorous examples of agitprop either by re-enacting recent events or by providing pageants of the progress of Communism. In 1920, for example, the theatre director Nikolay Yevreinov (1879–1953) re-enacted the *Storming of the Winter Palace* in Petrograd with a cast of 10,000 and an audience of 100,000. Concerts of factory sirens were performed in Petrograd (1918) and Moscow (1923). Trams were decorated with geometric designs, as were banners and posters, and, in response to Lenin's call in 1918 for monumental propaganda, temporary monuments to the Revolution and its heroes appeared in city streets. Tatlin's utopian design for his *Monument to the Third International* (1919–20; unexecuted) was a Constructivist response to this call. Printed works too played a role in agitprop, from the hand-stencilled posters of Mayakovsky's 'ROSTA-windows' (posters published by ROSTA, the Russian Telegraphy Agency, and displayed in shop windows) to Rodchenko's advertisements for state produce. Even sweet wrappers and tableware reflected the aims of agitprop. The state porcelain factory produced a dish elegantly bearing the word *Golod* ('Famine'), Sergey Chekhonin decorated a plate with the slogan *Kto ne s nami, tot protiv nas* ('Who is not with us is against us'), while another by Maria Lebedeva (1895–1942) declared *Kto ne rabotayet, tot ne yest* ('Who does not work does not eat'). Agitational vehicles included the trains *V. I. Lenin No. 1* (1918), *Oktyabr'skaya Revolyutsiya* ('October Revolution', 1919), *Krasnyy Vostok* ('Red East', 1920) and the boat *Krasnaya Zvezda* ('Red Star', 1920).

Bibliography

I. I. Nikonova and K. G. Glont: *Agitatsionno-massovoye iskusstvo pervykh let Oktyabrya* [Agitational mass art of the first years of the October Revolution] (Moscow, 1971)
S. Bojko: *New Graphic Design in Revolutionary Russia*, trans. R. Strybel and L. Zembrzuski (New York, 1972)
The Avant-Garde in Russia, 1910–1930: New Perspectives (exh. cat., ed. S. Barron and M. Tuchman; Los Angeles, CA, Co. Mus. A., 1980)

JOHN MILNER

Aktionismus

Austrian group of performance artists, active in the 1960s. Its principal members were Günter Brus, Otto Muehl and Hermann Nitsch, who first collaborated informally in 1961, and Rudolf Schwarzkogler, who was introduced to the group in 1963. Others associated with the group included Anni Brus, the film maker Kurt Kren, the composer Anetis Logosthetis and the actor Heinz Cibulka. The group were influenced by the work of Adolf Frohner (*b* 1934), Arnulf Rainer and Alfons Schilling (*b* 1934), who were all in turn influenced by American action painting and by the gestural painting associated with Tachism. The members of Aktionismus attached significance, however, not so much to the paintings produced by the artist as to the artist as a participant in the process of production, as a witness to creation rather than as a creator. Muehl, Brus and Nitsch all felt drawn to public performances celebrating and investigating artistic creativity by a natural progression from their earlier sculptural or painterly activities. In 1962 Muehl and Nitsch staged their first *Aktion* or performance, *Blood Organ*, in the Perinetgasse in Vienna. In 1965 Brus produced the booklet *Le Marais* to accompany an exhibition of his work at the Galerie Junge Generation, Vienna. Muehl, Nitsch and Schwarzkogler all contributed, referring to themselves as the Wiener Aktionsgruppe.

The group's interest in exploring sexuality and ritual, and their rejection of convention, aesthetics and morality often led to controversy. Although the participation of Nitsch, Brus and Muehl (as the recently formed Institut für Direkte Kunst) in the Destruction in Art Symposium in London in September 1966 was followed by international acclaim, the *Aktion* organized by Nitsch (*Abreactionplay*) led to the prosecution of Gustav Metzger and John Sharkey, the organizers of the symposium, for an 'indecent exhibition contrary to common law', images of male genitalia having been projected on a lamb's carcass as it was dismembered. Brus's *Art and Revolution* (1968) led to further scandal and the artist's imprisonment. With Brus's departure to Berlin in 1969 and Schwarzkogler's death, the group disbanded.

Each of the four members of Aktionismus approached the realization of his actions from a different perspective, although the basic aims of bringing about a state of cathartic awareness, an unburdening of repressed desires and the recognition and flouting of taboos (including those that reflected Austrian cultural isolation as well as sexual repression) were held by them all, and they often collaborated. However, it was Nitsch alone who continued to work with *Aktionen* after 1970, as part of his work on the *Orgies–Mysteries Theatre*.

Writings

O. Muehl and others: *Die Blutorgel* (Vienna, 1962)
G. Brus and others: *Le Marais* (Vienna, 1965)

Bibliography

P. Weibel and V. Export: *Wien: Bildkompendium Wiener Aktionismus und Film* (Frankfurt am Main, 1970)
L. Vergine: *Il corpo come linguaggio* (Milan, 1974), pp. 9, 21–7, *passim*
R. Fleck: *Avantgarde in Wien: Die Geschichte der Galerie Nächst St Stephan, 1954–1982* (Vienna, 1982), pp. 194–6, 199–202, 226, 240, 304, *passim*
Von der Aktionsmalerei zum Aktionismus: Wien, 1960–1965 (exh. cat., ed. D. Schwarz and V. Loers; Kassel, Mus. Fridericianum; Winterthur, Kstmus.; Edinburgh, N.G. Mod. A.; Vienna, Mus. Angewandte Kst; 1988–9)
Wiener Aktionismus, 1960–71 (exh. cat., ed. H. Klocker; Vienna, Albertina; Cologne, Mus. Ludwig; 1989)

ANDREW WILSON

Allianz

Swiss group of painters and sculptors founded in 1937 from various avant-garde elements, with Max Bill, Walter Bodmer, Richard Paul Lohse, Robert S. Gessner (*b* 1908), Camille Graeser, Fritz Glarner, Max Huber (*b* 1919) and Verena Loewensberg (*b* 1912) among its original members; its president was the painter Leo Leuppi (*b* 1893). The group had no official aesthetic but was not as heterogeneous or politically motivated as the roughly contemporary Gruppe 33, instead displaying a notable bias towards Constructivism and geometric abstraction. The first group exhibition, *Neue Kunst in der*

Schweiz (Basle, Ksthalle, 1938), was followed by a second at the Kunsthaus in Zurich in 1942 and by further group shows at the Galerie des Eaux Vives in Zurich, starting with two in 1944. The *Almanach Neuer Kunst in der Schweiz*, published by the group in 1940, brought together reproductions of their works with those of artists such as Paul Klee, Le Corbusier and Kurt Seligmann. The publication also included texts by Bill, Leuppi, Le Corbusier, Seligmann, Siegfried Giedion and others. Allianz exhibitions continued to be held into the 1950s.

Bibliography

Almanach Neuer Kunst in der Schweiz (Zurich, 1940)

Walter Bodmer im Kunstmuseum Basel (exh. cat. by L. Klotz, C. Geelhaar and D. Koepplin, Basle, Kstmus., 1978)

Dreissiger Jahre Schweiz: Konstruktive Kunst, 1915–45 (exh. cat. by R. Koella and others, Winterthur, Kstmus., 1981)

H. J. Albrecht and others: *Richard Paul Lohse: Modulare und serielle Ordnungen, 1943–1984* (Zurich, 1984)

☐

Allied Artists' Association [A.A.A.]

Organization established in London in 1908, dedicated to non-juried exhibitions of international artists' work. The main impetus for the A.A.A. came from Frank Rutter (1876–1937), art critic of the *Sunday Times*, and the first exhibition was held at the Albert Hall, London. Inspired by the Salon des Indépendants in Paris, Rutter wanted to set up an exhibiting platform for the work of progressive artists. On payment of a subscription, artists were entitled to exhibit five works (subsequently reduced to three) and over 3000 items were included in the first show. Rutter also wanted the A.A.A. to have a foreign section and for the first exhibition collaborated with Jan de Holewinski (1871–1927), who had been sent to London to organize an exhibition of Russian arts and crafts.

Among those involved in the organization of the A.A.A. was Walter Sickert, who urged complete impartiality and insisted that the catalogue should not be alphabetical but decided by ballot. When it was suggested that work by the better artists should be more prominently displayed, Sickert replied: 'In this society there are no good works or bad works: there are only works by shareholders'. By the second exhibition it had been decided that all members should be eligible to serve on the hanging committee and invitations to do so were issued on an alphabetical basis. In this way Charles Ginner met Harold Gilman and Spencer Gore in 1910. Although A.A.A. shows suffered from a lack of quality control, they were refreshingly democratic and allowed Kandinsky's abstract work to be shown for the first time in Britain.

Bibliography

F. Rutter: *Since I was Twenty-five* (London, 1927)

FRANCES SPALDING

American Abstract Artists [A.A.A.]

American group of painters and sculptors formed in 1936 in New York. Their aim was to promote American abstract art. Similar to the Abstraction–Création group in Europe, this association introduced the public to American abstraction through annual exhibitions, publications and lectures. It also acted as a forum for abstract artists to share ideas. The group, whose first exhibition was held in April 1937 at the Squibb Galleries in New York, insisted that art should be divorced from political or social issues. Its aesthetics were usually identified with synthetic Cubism, and the majority of its members worked in a geometric Cubist-derived idiom of hard-edged forms, applying flat, strong colours. While the group officially rejected Expressionism and Surrealism, its members actually painted in a number of abstract styles. Almost half of the founding members had studied with Hans Hoffmann and infused their geometric styles with surreal, biomorphic forms, while others experimented with NEO-PLASTICISM.

The first president was Balcomb Greene (*b* 1904). Among the early members were Ilya Bolotowsky, Willem De Kooning (see fig. 1),

Burgoyne Diller, A. E. Gallatin, Carl Holty (1900–73), Harry Holtzman (*b* 1912), Lee Krasner, Ibram Lassaw, Ad Reinhardt, David Smith and Albert Swinden (1901–61). The group also included a number of European artists living in the USA, among them Josef Albers, Jean Hélion, László Moholy-Nagy and Piet Mondrian (see col. pl. II).

The group, which never dissolved, had its heyday from 1937 to 1942, when it established a suitable climate for the formation of Abstract Expressionism.

Writings

American Abstract Artists, Three Yearbooks (1938, 1939, 1946) (New York, 1969)

Bibliography

G. McNeil: 'American Abstractionists Venerable at Twenty', *Art News*, lv/3 (1956), pp. 34–5, 64–6
S. C. Larsen: 'The American Abstract Artists Group: A History and Evaluation of its Impact upon American Art' (diss., Evanston, IL, Northwestern U., 1975)
Abstract Painting and Sculpture in America, 1927–1944 (exh. cat., ed. J. R. Lane and S. C. Larsen; Pittsburgh, PA, Carnegie Mus. A., 1983)

ILENE SUSAN FORT

American Artists' Congress

Organization founded in 1936 in the USA in response to the call of the Popular Front and the American Communist Party for formations of literary and artistic groups against the spread of Fascism. In May 1935 a group of New York artists met to draw up the 'Call for an American Artists' Congress'; among the initiators were George Ault (1891–1948), Peter Blume, Stuart Davis, Adolph Denn, William Gropper (*b* 1897), Jerome Klein, Louis Lozowick (1892–1973), Moses Soyer, Niles Spencer and Harry Sternberg. Davis became one of the most vociferous promoters of the Congress and was not only the national executive secretary but also the editor of the organization's magazine, *Art Front*, until 1939.

The dual concerns of the American Artists' Congress were the economic distress of artists resulting from the depressions of the 1930s and the effect of Fascism in terms of the use of art as war propaganda and the censorship of art. The Congress endorsed the Works Progress Administration's Federal Art Project (WPA/FAP) based on the economic needs of artists and lobbied for permanent governmental sponsorship of the arts. In 1939 a book of *Twelve Cartoons Defending WPA by Members of the American Artists' Congress* was published. The Congress supported a policy of museums paying rental fees to artists and called for an exhibition boycott of the Olympic Games in Berlin in 1936.

The first American Artists' Congress against War and Fascism was held in New York at the Town Hall and the New School for Social Research on 14–16 February 1936. About 400 delegates attended, including 'leading American artists, academicians and modernists, purists and social realists' (*American Artists' Congress against War and Fascism*), as well as visiting delegations from Mexico, Cuba, Peru and Canada. The opening address was delivered by Lewis Mumford, then chairman of the American Writers' League, which had been organized in April 1935.

Membership of the American Artists' Congress declined in 1940, when a number of members, concerned at the apparent support by the Communist-orientated organization for the Russians' attack on Finland, seceded to form the politically independent Federation of Modern Painters and Sculptors. By 1943 the Congress was defunct.

Writings

American Artists' Congress against War and Fascism: First American Artists' Congress (New York, 1936)
M. Baigell and J. Williams, eds: *Artists against War and Fascism: Papers of the First American Artists' Congress* (New Brunswick, 1986)

M. SUE KENDALL

American Scene painting

Term used to describe scenes of typical American life painted in a naturalistic vein from *c.* 1920 until the early 1940s. It applies to both Regionalism and Social Realism in American painting, but its specific boundaries remain

ambiguous. The phrase probably derived from Henry James's collection of essays and impressions, *The American Scene* (1907), published upon James's own rediscovery of his native land after 21 years as an expatriate. The term entered the vocabulary of fine arts by the 1920s and was applied to the paintings of Charles Burchfield during 1924.

In the two decades following World War I, American writers and artists began to look for native sources for the aesthetic and spiritual renewal of their modern technological civilization. This search engaged and activated many thoughtful and creative people in the 1920s and 1930s and resulted in that flurry of activity that Waldo Frank (1889–1967) discussed as *The Rediscovery of America* (1929; his personal analysis of American life). The phenomenon blossomed during the 1930s, when a generation of artists struggled to find a form and content for their art that would match their own experiences of America. Traditional boundaries of acceptable subject-matter were broad ened to include the everyday lives of average Americans—farmers, office workers, window shoppers and even Franklin D. Roosevelt's 'forgotten man'. From 'ten-cent movies' to fertile farmscapes, factory icons or bathers at Coney Island, images of urban bustle and backwoods folk life were offered up to celebrate and define 'the American Scene' in words and in paint.

Burchfield and Edward Hopper are the names most often associated with American Scene painting in the 1920s. Drawing on memories of his childhood in Salem, OH, Burchfield painted the clapboard houses, Gothic mansions (e.g. *House of Mystery*, 1924; Chicago, IL, A. Inst.), rain-soaked roads and false-fronted shops of provincial America; the art critic Guy Pène du Bois commented on the idea that Burchfield was painting 'the American Scene' in *International Studio* in September, 1924.

In the 1930s the term was closely linked to the art of the Regionalists, Thomas Hart Benton, Grant Wood and John Steuart Curry, whose *Baptism in Kansas* (1928; New York, Whitney) is a typical example. It has also been applied to the work of Reginald Marsh, Isabel Bishop, Alexander Brook

(1898–1980), George Bellows and Moses Soyer and Raphael Soyer. Ben Shahn's paintings, for example that of miners on strike in *Scott's Run, West Virginia* (1937; New York, Whitney), and the work of Stuart Davis also fit the description.

In general, American Scene paintings were characterized by a form of realism that eschewed both radical abstract styles and allegorical academic modes, as in Hopper's *Room in New York* (1932; Lincoln, U. NE A. Gals). As befitted art in a democracy, the subject-matter was both accessible and, as Benton put it, 'arguable in the language of the streets'. Alongside the democratic goal of an 'art for the millions', an interest developed in creating prints for mass distribution. Rooted in the realist tradition of the earlier Ashcan school, American Scene painting was in some ways a reaction against the influence of French modernism that had dominated American art in the early 1920s and it coincided with the growing climate of isolationism during the inter-war years.

See also REGIONALISM.

Bibliography

A. H. Jones: 'The Search for a Usable American Past in the New Deal Era', *Amer. Q.*, xxiii (1971), pp. 710–24

F. V. O'Connor, ed.: *Art for the Millions: Essays from the 1930s* (Boston, 1973)

M. Baigell: *The American Scene: American Painting of the 1930s* (New York, 1974)

J. M. Dennis: *Grant Wood: A Study in American Art and Culture* (New York, 1975)

N. Heller and J. Williams: *The Regionalists: Painters of the American Scene* (New York, 1976)

K. A. Marling: *Wall-to-wall America: A Cultural History of Post Office Murals in the Great Depression* (Minneapolis, 1982)

W. M. Corn: *Grant Wood: The Regionalist Vision* (New York, 1983)

M . S U E K E N D A L L

Amsterdam school

Group of Expressionist architects and craftsworkers active mainly in Amsterdam from *c.* 1915 to *c.* 1930. The term was first used in 1916 by Jan Gratama in an article in a Festschrift for H. P. Berlage. From 1918 the group was loosely centred

around the periodical *Wendingen* (1918–31). They were closely involved in attempts to provide architectural solutions for the social and economic problems in Amsterdam during this period.

The acute need for improved housing stock in the Netherlands was greatest in Amsterdam, where the population had more than doubled (reaching half a million) during the last quarter of the 19th century. A growing number of housing associations were founded, and the standard of the dwellings produced under their auspices was enormously improved by the implementation of Amsterdam's first building code in 1905. The greatest need, but the least profits, were to be found in the provision of good housing for the lowest-income groups. Legislation, subsidies and large-scale council ownership of the land scheduled for development allowed close governmental control, with a minimum of speculation by developers. Responsibility for the overall urban plan for the area known as Amsterdam South was given to H. P. Berlage, who produced a number of schemes between 1902 and 1915. The larger parameters were set, but even the architectural infill and its detailing were scrutinized at every stage by the Schoonheidscommissie ('Commission on Beauty'). Membership of this commission was increasingly dominated by architects associated with the Amsterdam school, and from 1918 the architects employed by both government offices and the housing associations were gradually limited to those included on an approved list. The most prominent architects on this list were J. M. van der Meij, Michel de Klerk and P. L. Kramer, all of whom had trained in the office of Eduard Cuypers.

The Amsterdam school was also influenced by the Dutch tradition of 'fantastic' architecture and owed much to the work of Willem Kromhout, architect of the American Hotel (1898–1901), Amsterdam. This building was contemporary with Berlage's Beursgebouw (1898–1903), which exerted the most direct influence on the school. From the earliest mature designs of de Klerk, van der Meij and Kramer, their stylistic debts are clear. In designs of 1910 for a graveyard complex de Klerk displayed an impressive inventiveness and expressiveness in the brick detailing and roof-line. Like

Berlage there is the use of traditional materials in a renewed formal language. This approach was exemplified in de Klerk's luxury block of flats (1911–12) for the builder Klaas Hille on the Vermeerplein, Amsterdam, further developed in other commissions for Hille, particularly a series of workers' flats: first the block in the Spaarndammerbuurt (1913–15), and then the two blocks for the Eigen Haard housing association around the Spaarndammerplantsoen (1914–16; 1917–20). The second block, one of the most famous works of the Amsterdam school, is on a triangular site. It consists of dwellings, a meeting-hall and a post-office built around the perimeter and containing a central garden. The block has a complicated and picturesque silhouette, culminating in the brick spire over the short façade, intended to alleviate the monotony found in conventional tenement blocks. It is built of variously coloured bricks and tiles laid in different directions and patterns, punctuated by the diverse and idiosyncratic entries and windows.

Between 1912 and 1916 de Klerk and Kramer had worked under van der Meij on the Scheepvaarthuis on the Prins Hendrikkade, a key work of Dutch Expressionism. Highly original brick detailing, stone sculpture and reliefs, ironwork and stained glass are bound together within a strong geometrical framework. No less inventive but certainly cooler and more mature is the work by Kramer and de Klerk for the housing cooperative De Dageraad on the P. L. Takstraat (1920–23; see fig.). Undulations of the brickwork, clear but nuanced articulation of the façade, and the surprising roofscape all confirm the continuous development of the salient stylistic features. Kramer's major body of work was the design of over 400 bridges for the Amsterdam Department of Public Works. The new and renewed quarters of Amsterdam were to a remarkable extent the product of a stylistically unified school.

In 1918 the influence of the Amsterdam school was greatly enhanced by the founding of the periodical *Wendingen* under the editorship of Hendrik Th. Wijdeveld. In 1923, however, de Klerk died and, even more devastating, the Dutch government changed its housing policy by reducing

subsidies. With a smaller budget stylistic vigour was sapped. At the Exposition Internationale des Arts Décoratifs et Industriels Modernes, Paris, in 1925, members of the Amsterdam school represented the Netherlands. Major contributions were made by J. F. Staal, Richard Roland Holst and Wijdeveld. The work was in the best tradition of the school but proved to be controversial, partly through the reaction of Theo van Doesburg, who was incensed that De Stijl had not been given equal status. In 1926 Kramer's masterful Bijenkorf department store in The Hague was completed, but in the same year there was also a complete change in the editorial staff of *Wendingen*. By this time the style had been disseminated throughout the Netherlands, but a decline at its centre had already begun. By the end of the decade the social and political circumstances that had provided the original context for the growth of the group had changed, the economic provision had been reduced and the stylistic impetus had been lost. In some subsequent criticism the Amsterdam school was judged in terms of De Stijl and the International Style. This approach, however, underestimates the accomplishments, both practical and stylistic, of the school and ignores the fact that it was concerned with the development of a modern national, not international, style.

Bibliography

J. Gratama: 'Het werk van Berlage', *Dr H. P. Berlage en zijn werk* (Rotterdam, 1916), p. 49

J. Badovici: 'L'Ecole d'Amsterdam', *Archit. Vivante*, xli (1926), pp. 21–6

R. Banham: *Theory and Design in the First Machine Age* (London, 1960)

G. Fanelli: *Architettura moderna* (1968)

J. J. Vriend: *L'Ecole d'Amsterdam*, Art et Architecture aux Pays-Bas (Amsterdam, 1970)

Amsterdamse school, 1910–1930 (exh. cat. by A. Venema and others, Amsterdam, Stedel. Mus., 1975)

H. Searing: 'With Red Flags Flying: Politics and Architecture in Amsterdam', *Art and Architecture in the Service of Politics*, eds H. A. Millon and L. Nochlin (Cambridge, MA, 1978)

C. Boekraad, ed.: *Architektuur en volkshuisvesting, Nederland 1870–1940* (Nijmegen, 1980)

W. de Wit, ed.: *The Amsterdam School: Dutch Expressionist Architecture, 1915–1930* (New York and London, 1983)

S. S. Frank: *Michel de Klerk, 1884–1923: An Architect of the Amsterdam School* (Ann Arbor, 1984)

ALLAN DOIG

Annandale Imitation Realists

Australian group of mixed-media artists active in 1962. They formed for the purpose of staging an exhibition of the same name. Ross Crothall (*b* 1934), Mike Brown and Colin Lanceley worked together in Crothall's studio in Annandale, a suburb of Sydney, in 1961. They shared an interest in assemblage, collage, junk art, *objets trouvés* and in non-Western art. Brown, who had worked in New Guinea in 1959, was impressed by the use in tribal house decoration and body ornament of modern urban rubbish such as broken plates and bottletops. Crothall delighted in the altered *objet trouvé*, for example egg cartons unfolded to become the *Young Aesthetic Cow*, or pieces of furniture crudely gathered into frontally posed female icons, sparkling with buttons and swirling house-paint, with such titles as *Gross Débutante*. Lanceley was deeply influenced by his teacher John Olsen and through him by Jean Dubuffet. He covered impastoed surfaces with junk materials, often decorating distorted female forms with strings of pearls, broken plates and other items; in *Glad Family Picnic* (1961; Sydney, A.G. NSW) elements combine into a garish visual cacophony.

From 13 February to 1 March 1962 the three artists exhibited together as *Annandale Imitation Realists* at the Museum of Modern Art of Australia in Melbourne. An environment was created out of 212 works installed on chicken-wire structures, on the floor, walls and ceiling, forcing the viewers into direct experience. Each work was conceived as a pun and as an irreverence. Over the entrance was a quotation from W. B. Yeats's 'Sailing to Byzantium'. Hanging at the terminus of the maze was the largest work in the show, one of 32 collective works, presented as a welcoming monster shouting across the ceiling its title *Here in*

Byzantium. At the end of the exhibition many of the works were hammered together into *The Scow*. From 23 May the exhibition was reinstalled at the Rudy Komon Gallery in Sydney and, with the group, was renamed *Subterranean Imitation Realists*. The exhibitions were a form of social satire prompted by a desperation to transcend the confines of both the established art world and everyday mundaneness. They were warmly received by many critics. Although critical discussion soon introduced international comparisons and precedents, in particular contemporaneous movements such as Pop art, Neo-Dada, and Nouveau Réalisme, the initial reception took local inspiration for granted, a sentiment on which the artists insisted. However, being an 'imitation' art event itself, which had been very consciously and ironically staged, the group disbanded before it could develop into a movement or programme.

Crothall went to New Zealand in 1965 and in July 1966 presented *Dayo*, an echo of the Annandale Imitation Realists, at the New Vision Gallery, Auckland, his last known exhibition. Lanceley won a travelling scholarship in 1964 and lived from the following year in London, travelling extensively in Europe until his return to Sydney in 1981. Brown's satirical work attracted both critical attention and the wrath of the law. In 1963 he reworked an Annandale Imitation Realist painting, *Mary Lou* (destr.), to include a bevy of cut-outs from pin-up magazines. This led to the expulsion of the painting from the travelling exhibition *Australian Painting Today*. In 1964 Brown launched a bitter attack on the Sydney art world and its key artists and critics. On his painting *Sydney, February 15, 1964 (Kite)* he scrawled such castigations as 'Colin Lanceley is there, having over the preceding two years refined a number of "Imitation Realist" clichés (such as plastic dolls, visual puns, gaping toothy mouths, and cutely naughty erotic references) and plugged them until they have become fashionably acceptable'. In 1965 Brown's exhibition *Painting a Go-go* at Gallery A, Sydney, led to a long and debilitating trial for obscenity and indecency. Brown was found guilty and fined £20.

Writings
Annandale Imitation Realists (exh. cat., ed. E. Lynn; Melbourne, MOMA, 1962)
Arty Wild Oat (July, 1962) [contains contrib. by Lanceley and Crothall]
Subterranean Imitation Realists (exh. cat., Sydney, Rudy Komon Gal., 1962)

Bibliography
E. Lynn: 'Pop Goes the Easel', *A. & Australia*, i (1963), pp. 166–72
T. Smith, N. Hutchson and T. McGillick: 'Interview: Colin Lanceley', *Other Voices*, i (1970), pp. 36–41
G. Catalano: 'The Aesthetics of the Imitation Realists', *Meanjin*, 35 (1976), pp. 175ff
Mike Brown: A Survey of Work, 1961 to 1977 (exh. cat., Melbourne, N.G. Victoria, 1977)
Irreverent Sculpture (exh. cat., ed. M. Plant; Melbourne, Monash U., A.G., 1985)
Colin Lanceley (exh. cat., intro. R. Hughes, interview W. Wright; Sydney, A.G. NSW, 1987)

<div align="right">TERRY SMITH</div>

Antipodean group

Australian group of artists formed in Melbourne in February 1959 and active until January 1960. The founder-members were the art historian Bernard Smith (*b* 1916), who was elected chairman, and the painters Charles Blackman, Arthur Boyd, David Boyd (*b* 1924), John Brack, John Perceval and Clifton Pugh. They were joined subsequently by the Sydney-based painter Bob Dickerson (*b* 1924). Smith chose the name of the group and compiled the *Antipodean Manifesto*, the appearance of which coincided with the inaugural exhibition, *The Antipodeans*, held in the Victorian Artists' Society rooms in Melbourne in August 1959. The group's main concern was to promote figurative painting at a time when non-figurative painting and sculpture were becoming established as the predominant trend in Australia, as in the USA and Europe. To gain a more prestigious venue to show their work, the group asked Smith to enlist the support of Kenneth Clark, who responded by suggesting the Whitechapel Gallery in London. The Gallery's director, Bryan Robertson (*b* 1925), received British Council support and

made a selection for an exhibition entitled *Recent Australian Paintings* (1961), which featured the work of the group alongside that of Jon Molvig, Albert Tucker, Sidney Nolan, Fred Williams and others. Although the members of the group had experienced much critical opposition, they felt vindicated by their inclusion in this exhibition, which established that contemporary Australian painting had a well-founded and powerful national identity.

Writings

B. Smith: *The Antipodean Manifesto: Essays in Art and History* (Melbourne, 1976)

Bibliography

The Antipodeans (exh. cat. by B. Smith, Melbourne, Victorian Artists' Soc., 1959)
Recent Australian Paintings (exh. cat. by B. Robertson and R. Hughes, London, Whitechapel A.G., 1961)

JANET SPENS

Arbeitsrat für Kunst

Association of radical German architects, artists and critics founded in Berlin in December 1918 by Bruno Taut and dissolved on 30 May 1921. The membership grew rapidly and included the architects Otto Bartning, Walter Gropius, Paul Mebes, Erich Mendelsohn, Hans Poelzig, Paul Schmitthenner, Max Taut and Heinrich Tessenow; the painters César Klein, Erich Heckel, Käthe Kollwitz, Ludwig Meidner, Max Pechstein, Karl Schmidt-Rottluff and Lyonel Feininger; the sculptors Rudolf Belling, Oswald Herzog and Gerhard Marcks; and such critics and patrons as Adolf Behne (1885–1948), Mechtilde von Lichnowsky (1879–1958), Julius Meier-Graefe, Karl Ernst Osthaus and Wilhelm Worringer.

Bruno Taut initially conceived the group as a political pressure group, the artistic equivalent to the workers' and soldiers' councils that held power in November and December 1918. The founding manifesto demanded: 'Art and the people must form a unity From now on the artist alone, as moulder of the sensibilities of the people, will be responsible for the visible fabric of the new state'. The hope of achieving direct political responsibility proved a chimera, however, and an embittered Taut resigned from the leadership of the group at the end of February 1919, to be replaced by Walter Gropius. More pragmatic than Taut, Gropius abandoned any political aspirations and turned the group in on itself, suggesting that the association should regard itself as a community of radical artists who should work together on an ideal building task, the *Bauprojekt*, a temple-like construction that would serve as a focus for social and cultural regeneration. It would also offer the means to achieve the group's prime artistic aim: 'the fusion of the arts under the wing of a new architecture'. Political instability, gathering inflation, material shortages and a lack of artistic direction within the group condemned this noble project to remain on paper.

The hopes for an artistic revival led by architecture were not abandoned, however, and provided the basis of Gropius's programme for the newly established Weimar BAUHAUS in April 1919. With Gropius in Weimar, the administration of the Arbeitsrat für Kunst was taken over by the critic Adolf Behne. Although the *Bauprojekt* was retained as an ultimate goal and linked to schemes for rebuilding in the devastated battle zones in France, the group's only practical activity was limited to publications and exhibitions. In addition to the founding manifesto and Taut's 'Architektur-Programm', which were published in various journals, the group also published two books: *Ja! Stimmen des Arbeitsrates für Kunst in Berlin* (Berlin, 1919), the results of a survey conducted among the membership on such questions as art and design education, exhibition policy, state support of the arts and public architecture; and *Ruf zum Bauen* (Berlin, 1920).

Among the exhibitions organized by the Arbeitsrat were the *Ausstellung für unbekannte Architekten* (April 1919), an exhibition of art by workers and children (January 1920), and *Neues Bauen* (May 1920). The group also arranged exhibitions in Antwerp and Amsterdam. Several of the architects and painters involved in the Arbeitsrat exhibitions were also invited to join Bruno

Taut's correspondence circle, the Gläserne Kette. Although the exhibitions were successful and provoked vigorous critical debate, the finances of the group became increasingly strained during 1920, leading to the final dissolution of the Arbeitsrat für Kunst.

Bibliography

U. Conrads: *Programmes and Manifestos on 20th-century Architecture* (London, 1970)

M. Franciscono: *Walter Gropius and the Creation of the Bauhaus in Weimar* (Urbana, 1971)

Arbeitsrat für Kunst (exh. cat., ed. M. Schlösser; Berlin, Akad. Kst., 1980)

I. Boyd Whyte: *Bruno Taut and the Architecture of Activism* (Cambridge, 1982)

——: *The Crystal Chain Letters: Architectural Fantasies by Bruno Taut and his Circle* (Cambridge, MA, 1985)

IAIN BOYD WHYTE

Archigram

English architectural periodical, group and stylistic tendency of the 1960s. The periodical began as a student 'alternative' information sheet (Architecture+gram) founded in 1960 by Peter Cook, while he was working (1960–62) in the office of James Cubitt and Partners, with the aim of ensuring that student projects would be published. Most of the material illustrated was avant-garde with a strong bias towards what would be called HIGH TECH. Emboldened by the invitation to stage an exhibition, *Living City*, at the Institute of Contemporary Arts (ICA), London, in 1963, Cook and his associates became more ambitious and in 1964 they produced their fourth issue under the title 'Amazing Zoom Archigram 4'.

The success of this issue was immediate and striking. In a manner unabashedly indebted to the pioneer British Pop artists of the ICA Independent Group, it included a highly coloured pop-up tower city in the centre spread. Pages were reproduced in other magazines worldwide and became the model for other radical-formalist movements (e.g. the Italian ARCHIZOOM group). By 1964 Archigram consisted of Cook, together with

Warren Chalk (*b* 1927), Dennis Crompton (*b* 1935), Ron Herron (1930–94), David Greene (*b* 1937) and Mike Webb (*b* 1937). In 1966 they organized a conference in Folkestone, Kent, under the title IDEA (International Dialogues on Experimental Architecture), whose speakers included most of the younger talents of visionary architecture, among them Hans Hollein, Claude Parent and Yona Friedman. Archigram's members were internationally in demand to give lectures, and they were invited to stage a section in the 1968 Triennale di Milano and again at Expo '70 in Osaka, Japan. The high point of their success was marked by their winning a major international competition (1970) for an underground entertainment centre on the sea-front at Monte Carlo.

The characteristic quality of the projects of their most productive period (1963–70), the 'age of Megastructures', apart from high quality draughtsmanship and the use of modern techniques such as photocopying, was an increasing emphasis on the transience and expendability of physical equipment and its direct response to human desires. The sequence of major projects began with the monumental scale of Cook's *Plug-in City* (1963–4; infinitely changeable by plugging or unplugging habitable capsules by means of cranes carried on tracks across vast multi-storied structures) and his *Entertainments Tower* project of the same date. Bryan Harvey (*b* 1936) and Ron Herron's *Walking Cities* project (1964) envisaged very large urban structures set in motion on mechanical legs and was denounced as 'inhuman' by Siegfried Giedion and Constantinos Doxiadis. In 1967 Mike Webb proposed 'cushicle', a technically sophisticated single-seat environment vehicle, and 'suitaloon', a private one-person environmental bubble, which could be worn like a suit when not inflated for occupation. *Archigram 7* carried the warning that 'There may be no buildings at all in *Archigram 8!*'.

The Monte Carlo project, though it proposed the construction of a very flat dome more than 40 m in diameter, continued the anti-monumental theme by placing it entirely underground, so as not to obstruct the view of the Mediterranean,

in striking contrast to most of the other entries that silhouetted (ironically) Archigram-inspired megastructures against the sea. In the end none of these structures was executed and in the changing intellectual and financial climate of the 1970s, which saw a general loss of confidence in large-scale planning and advanced technology, the direct influence of Archigram faded. Cook's Archigram exhibition at the ICA in 1972 marked the end of the group's significant collective activities, although its members all remained active as designers and teachers.

The true influence of Archigram has been most visible in the period since its demise. Habitable capsules were realized in Japan; the basic ideas and formal vocabulary were thoroughly absorbed into the mainstream of modern architecture. Both Richard Rogers and Norman Foster publicly acknowledged its contribution to the development of their high-tech approach to design. The elaborate precision and mechanistic detailing of Archigram draughtsmanship find their most convincing realization in the detailing of buildings such as Foster's Renault spare part centre, Swindon, Wilts (1983), or Rogers's Lloyds of London building, London (completed 1987; see col. pl. XXII), while it has become accepted wisdom that Piano & Rogers's 'Pompidou Centre, Paris, is Archigram's Plug-in City, with its exposed structure and mechanical equipment painted in French blues and reds' (Charles Jencks) (see fig. 3). This is not surprising, as many of the junior members of the Piano & Rogers design team had been students of Cook and Herron.

Bibliography

'A Clip-on Architecture', *Des. Q.*, lxv (1965) [special issue]
P. Cook: *Experimental Architecture* (London, 1970)
——, ed.: *Archigram* (London, 1972)
R. Banham: *Megastructure: Urban Futures of the Recent Past* (London, 1976)

REYNER BANHAM

3. Renzo Piano and Richard Rogers: Centre Georges Pompidou, Paris, 1971–7

Architecta

Finnish association of women architects, founded in 1942. The first female architect to graduate with a degree in Finland was Signe Homborg (1862–1916), who trained as an 'extra student' at the Polytechnic Institute of Helsinki from 1887 to 1890. By the mid-1980s there were some 500 women in a profession numbering 1500 practitioners, and the foundation of Architecta, the first such national women's architectural association, marked the growing importance of women in the profession. Noted members have included Elna Kiljandend (1889–1970), who mostly designed interiors and furniture; Kerttu Rytkönen (*b* 1895), who advanced a Nordic classical style of building; Elsi Borg (1893–1958), designer of numerous ecclesiastical buildings; and Märta Blomstedt (1899–1982), an influential designer of Functionalist architecture. Individual practitioners found great success in their professional careers: Martta Martikainen-Ypä (*b* 1904), who designed factories, schools, hospitals, housing areas and offices throughout Finland, received no less than 29 awards in international competitions between 1930 and 1960.

Bibliography

R. Nikula and R. Jallinoga, eds: *Profiles: Pioneering Women Architects from Finland* (Helsinki, 1983)

□

Architectengroep de 8

Dutch association of architects, based in Amsterdam from 1927 to 1942. It was founded by six former pupils of the School voor Bouwkunde, Versierende Kunsten en Ambachten in Haarlem: Ben Merkelbach, J. H. Groenewegen, Charles Karsten (1904–79), Hans van den Bosch (*b* 1900), Henri E. van de Pauwert (1895–1981) and Pieter Jan Verschuyl (1902–83). The name, probably coined by van de Pauwert during his military service, derived from the command to attention used in the Dutch army—'geef acht', 'acht' in Dutch meaning either 'attention' or 'eight'. In the manifesto of De 8, published in the journal *I 10* (1927), the young architects presented themselves as pragmatic and international, thus taking a stand against the expressive architectural outlook of the Amsterdam school to which their former teachers belonged. The declaration of intent, stimulated by the ideas of H. P. Berlage, De Stijl and contacts with functionalism in Belgium and Germany, attracted other Dutch architects and engineers connected with the Nieuwe Bouwen ('new building') movement of the 1920s. In 1928 Albert Boeken, Johannes Duiker and Jan Gerko Wiebenga (1886–1974) joined the group, the latter two already having designed a number of functionalist buildings. Boeken was mainly active as a publicist. The avowedly functionalist architect Cornelis van Eesteren joined in 1929 and introduced urban planning to the group. They took an active part in international CIAM congresses from 1929, van Eesteren becoming chairman of CIAM in 1930. De 8 soon took a stand in Amsterdam in favour of high-rise building and modern social housing construction. In 1932 De 8 officially joined forces with the Rotterdam group of modern architects DE OPBOUW, whose members included Johannes Bernardus van Loghem and Leendert Cornelis van der Vlugt. While members of the two groups continued to practise individually in the two cities, an editorial team was formed to produce the journal *De 8 en Opbouw*, an important forum for new architecture in the Netherlands. Their ideas gained increasing resonance, and in 1934 the younger architects of Groep 32 joined, as did Mart Stam, Gerrit Rietveld and Sybold van Ravesteyn. The group debated functionalist principles at the end of the 1930s, and a number of members left, including Rietveld and van Ravesteyn. The German occupation paralysed the architects' activities as a group, and publication of *De 8 en Opbouw* ceased in 1942.

Bibliography

De 8 & Opbouw (1935–42)

G. Fanelli: *Moderne architectuur in Nederland, 1900–1940* (The Hague, 1978) [with Eng. summary]

B. Rebel: 'De Amsterdamse architectenvereniging *de 8*', *Het Nieuwe Bouwen, Amsterdam, 1920–1960* (exh. cat., Amsterdam, Stedel. Mus., 1983), pp. 8–51

De 8 en Opbouw, 1932–1943 (R Amsterdam, 1985) [essay by M. Bock]

OTAKAR MÁČEL

Archizoom (Associati)

Italian architectural and design partnership formed in 1966 by Andrea Branzi (*b* 1939), Gilberto Corretti (*b* 1941), Paolo Deganello (*b* 1940) and Massimo Morozzi. These were joined by Dario Bartolini and Lucia Bartolini in 1968. They were based in Florence and were influenced initially by the utopian visions of the English architectural group Archigram. They achieved international prominence following appearances at the *Superarchitettura* exhibitions of radical architecture held at Pistoia (1966) and Modena (1967) and organized with the Superstudio group. Numerous projects and essays reflected the group's search for a new, highly flexible and technology-based approach to urban design, and in the late 1960s exhibition and product design began to form a significant part of their work. The Superonda and Safari sofas, designed for the Poltronova company, combine modular flexibility with kitsch-inspired shiny plastic and leopard-skin finishes. Their central aim of stimulating individual creativity

and fantasy was the focus of installations such as the *Centre for Electric Conspiracy*, with its closed, perfumed meditation areas housing exotic objects from different cultures, and the empty grey room presented at *Italy: The New Domestic Landscape*, an exhibition held at MOMA, New York, in 1972. In the latter a girl's voice describes the light and colour of a beautiful house that is left to the listener to imagine. Dress is the theme of the two films (*Vestirsi è facile* and *Come è fatto il capotto di Gogol*) that the group made shortly before disbanding in 1974 to follow separate careers.

Writings

A. Branzi: *The Hot House: Italian New Wave Design* (London, 1984)

Bibliography

A. George: 'Archizoom Hydra', *Archit. Des.*, xliii (1972), pp. 2–16

C. Jencks: *Modern Movements in Architecture* (Harmondsworth, 1973)

P. Navone and B. Orlandoni: *Architettura radicale* (Milan, 1974)

M. Pidgeon: 'Archizoom', *Space Des.*, 121 (1974), pp. 124–36

☐

a.r. group [Pol. artysci rewolucyjni: 'revolutionary artists']

Polish group of avant-garde artists that flourished between 1929 and 1936. Its members were the sculptor Katarzyna Kobro, the painters Władysław Strzemiński and Henryk Stażewski, and the poets J. Brzękowski and J. Przyboś. It was founded by Strzemiński after he, Kobro and Stażewski left the Praesens group. The group's programme chiefly reflected the views of Strzemiński. In two leaflets entitled *Kommunikaty a.r.* ('a.r. bulletins') the group declared itself in favour of a 'laboratory' version of Constructivism and an avant-garde art that influenced social life in an indirect and gradual manner. It opposed the politicization and popularization of art, which it regarded as a debasement of artistic expression, but the group also believed that rigorous, formal discipline, the organic construction of a work, its coherence,

effectiveness and economy of means, made art somewhat synthetic or contrived. From 1933 the group's announcements regarding its programme appeared in the Łódź art magazine *Forma*.

Among the most important initiatives of the group was the publication of the 'a.r. library' (Biblioteka a.r.) series (Łódź, 1930–36), seven works in all, including the poems of Przyboś and Brzękowski with text designed by Strzemiński and illustrations by Hans Arp and Max Ernst; the theoretical essay by Kobro and Strzemiński, *Kompozycja przestrzeni* ('Composition of space'); and Strzemiński's *Druk funkcjonalny* ('Functional printing'). Even more significant was the creation of the International Collection of Modern Art, which was presented to the municipal museum in Łódź (later the Museum of Art) in 1931. It contained 75 works donated by representatives of the avant-garde of the period (including members of the group Cercle et Carré): Hans Arp, Willi Baumeister, Alexander Calder, Serge Charchoune, Theo van Doesburg, Max Ernst, Albert Gleizes, Jean Gorin, Jean Hélion, Vilmos Huszar, Fernand Léger, Piet Mondrian, Louis Marcoussis, Amédeé Ozenfant, Pablo Picasso, Enrico Prampolini, Kurt Schwitters and Georges Vantongerloo, among others. It was the second public collection of modern art after Hannover. It was conceived by Strzemiński and started with the considerable assistance of Brzękowski, who lived in Paris and was on friendly terms with Cercle et Carré, along with the publishers of the avant-garde journal of painting and poetry, *L'Art contemporain*.

Bibliography

R. Stanisławski and others, eds: *Grupa a.r.: 40-lecie Międzynarodowej Kolekcji Sztuki Nowoczesnej w Łodzi* [The a.r. group: 40th anniversary of the International Collection of Modern Art in Łódź], Łódź, Mus. A. cat., 2 vols (Łódź, 1971) [also contains ess.]

Constructivism in Poland, 1923–1936 (exh. cat., ed. R. Stanisławski and others; Essen, Mus. Flkwang, 1973)

A. Turowski: *Konstruktywizm polski: Próba rekonstrukcji nurtu, 1921–1934* [Polish Constructivism: an attempt to reconstruct its development, 1921–34] (Wrocław, 1981)

EWA MIKINA

Arsenalists [Pol. Arsenałowcy]

Term used to refer to the participants in the *Ogólnopolska wystawa młodej plastyki* ('Polish exhibition of young artists'), which was held in the Arsenal, Warsaw, between July and September 1955 and had as its theme the slogan 'Against War—Against Fascism'. The exhibition was organized on the occasion of the Fifth World Festival of Youth and Students, the first such large-scale international gathering following the period of Stalinist isolation in Poland. The exhibition catalogue lists 249 exhibiting artists and 499 pictures, graphic works and sculptures. The idea of the exhibition was conceived in 1954 by the painters Jan Dziędziora, Marek Oberländer and Jacek Sienicki and the art historian Elżbieta Grabska, all graduates of the Academy of Fine Arts, Warsaw. All the exhibitors made their débuts during the period of Polish Socialist Realism (1950–54). Setting themselves against the imposed doctrine, the organizers resolved during the growing thaw to set up an all-Polish review of the work of young people. Most young artists and exhibitors regarded it as the first demonstration against Socialist Realism, while its enemies saw it as being a more refined continuation of Stalinist doctrine because of the state's sponsorship of the event.

The exhibition was characterized by the expressionist canvases, which were dramatic in both form and content. In contrast to the other exhibitions at the festival, the show at the Arsenal created a stir in the press and in art circles and prompted a wave of discussion about the new artistic situation. The following names were mentioned most frequently by the critics: Marek Oberländer, Izaak Celnikier, Przemysław Brykalski, Waldemar Cwenarski, Barbara Jonscher, Jan Lebensztejn, Jan Tarasin and Jacek Sempoliński. Although it is difficult to find a common denominator in their later work, there was evidence in this group of artists of a tendency towards non-avant-garde art opposed to colourism and Socialist Realism. With the growth of political freedom and the appearance in the mid-1950s of abstract works deeply concerned with Polish life and existential questions, the pictures of the Arsenalists lost their significance. They were not to regain it until the late 1970s and 1980s, when Polish artists of the middle and younger generations were once again able to confront artistic and political problems simultaneously.

Bibliography

Ogólnopolska wystawa młodej plastyki [Polish exhibition of young artists] (exh. cat., Warsaw, Arsenal, 1955)

A. Osęka: *Poddanie Arsenału* [Surrender of the Arsenal] (Warsaw, 1971)

W kręgu Arsenału [About the Arsenal] (exh. cat., Gorzów Wielkopolski, Distr. Mus., 1981)

W. Włodarczyk: *Socrealizm: Sztuka polska w latach, 1950–54* [Socialist realism: Polish art, 1950–54] (Paris, 1986)

WOJCIECH WŁODARCZYK

Art Abstrait

Belgian art group designed to propagate abstract art. It was formed in April 1952 as a successor to JEUNE PEINTURE BELGE by the artists Jean Milo (*b* 1906), Jo Delahaut (*b* 1911), Pol Bury, Georges Carrey (1902–53), Léopold Plomteux (*b* 1920), George Collignon (*b* 1923) and Jan Saverys (*b* 1924), who were joined later that year by Jan Burssens (*b* 1925) and Hauror. The group first exhibited in 1952 at the Cercle Artistique in Ghent, the Galerie Le Parc in Charleroi and the Galerie Arnaud in Paris and also travelled to Britain. The following year it exhibited at the Palais des Beaux-Arts in Brussels, the Association pour le Progrès Intellectuel et Artistique de la Wallonie in Liège and at the Salle Comité voor Artistieke Werking in Antwerp. The members of the group had no unifying style or aesthetic apart from being non-figurative. The abstract styles within the group ranged from thickly impastoed informal works such as Carrey's *Composition* (1953; Brussels, Musées Royaux A. & Hist.) to hard-edged works such as Delahaut's *Besoar* (1953; see 1981 exh. cat., p. 25). In 1954 Delahaut, Bury and the writers Jean Séaux and Karel Elno published a manifesto that introduced the concept of SPATIALISME, thus marking the end of Art Abstrait. Delahaut's ideas about abstraction led to his co-founding the group Formes with the writers Séaux and Maurits Blicke in 1956. This was designed to realize the ideas of the *Spatialisme*

manifesto, as shown, for example, in the abstraction of Delahaut's *Recall to Order* (1955; see 1981 exh. cat., p. 32). Again short-lived, the Formes group exhibited in 1956 at Morlanwelz-Mariemont in Hainaut and in 1957 at the Galerie Accent in Antwerp.

Bibliography

Jo Delahaut (exh. cat. by B. Kerber and others, Ludwigshafen, Hack-Mus. & Städt. Kstsamml., 1981)

K. J. Geirlandt: *L'Art en Belgique depuis 45* (Antwerp, 1983)

☐

Art autre [Fr: 'other art']

Term coined in a book published in 1952 by French writer and critic Michel Tapié to describe the kind of art many intellectuals and artists deemed appropriate to the turbulent mood of France immediately after World War II. He organized an exhibition entitled *Un Art autre* for the Studio Facchetti, in Paris, also in 1952. Inspired in part by the ideas of Vasily Kandinsky, by Existentialist philosophy and by the widespread admiration for alternative art forms (notably child art, psychotic art and 'primitive' non-Western art), Tapié advocated an art that worked through 'paroxysm, magic, total ecstasy', in which 'form, transcended, is heavy with the possibilities of becoming'. He wrote of the need for 'temperaments ready to break up everything, whose works were disturbing, stupefying, full of magic and violence to re-route the public. To re-route into a real future that mass of so-called advanced public, hardened like a sclerosis around a cubism finished long ago (but much prolonged), misplaced geometric abstraction, and a limited puritanism which above anything else blocks the way to any possible, authentically fertile future'. Although the term has been used more or less interchangeably with ART INFORMEL and TACHISM as embodied in the expressive and non-geometric abstract work of artists such as Georges Mathieu, Henri Michaux (see fig. 5) and Wols, it also embraced the more figurative concerns of artists such as Jean Fautrier, Victor Brauner and Jean Dubuffet.

Bibliography

M. Tapié: *Un Art autre* (Paris, 1952)

——: *Morphologie autre* (Paris, 1960)

MONICA BOHM-DUCHEN

Art brut [Fr.: 'raw art']

Term used from the mid-1940s to designate a type of art outside the fine art tradition. The commonest English-language equivalent for *art brut* is 'Outsider art'. In North America, the same phenomenon tends to attract the label 'Grass-roots art'. The French term was coined by Jean Dubuffet, who posited an inventive, non-conformist art that should be perfectly *brut*, unprocessed and spontaneous, and emphatically distinct from what he saw as the derivative stereotypes of official culture. In July 1945 Dubuffet initiated his searches for *art brut*, attracted particularly by the drawings of mental patients that he saw in Switzerland. In 1948 the non-profit-making Compagnie de l'Art Brut was founded, among whose partners were André Breton and the art critic Michel Tapié. The Collection de l'Art Brut was supported for a while by the company but was essentially a personal hobby horse of Dubuffet and remained for three decades an almost entirely private concern, inviting public attention only at exhibitions in 1949 (Paris, Gal. René Drouin) and 1967 (Paris, Mus. A. Déc.). In 1971 Dubuffet bequeathed the whole collection to the City of Lausanne, where it was put on permanent display to the public at the Château de Beaulieu. At the time of opening (1976), the collection comprised 5000 works by *c.* 200 artists, but it grew thereafter.

Dubuffet's criteria for *art brut* were elaborated in a stream of texts, many polemical, some analytical, which include prefaces and letters, studies of individuals published in the house journal *L'Art brut*, and the abrasive tract *Asphyxiante culture* (1968). Dubuffet's ideal of autonomous inspiration rests on a model of the creator being somehow insulated from all social and cultural influences, devoid of all schooling in the arts, and unaware of traditions or preset compositional formulae. The authentic specimen of *art brut* should be the unsolicited fruit of its maker's personal resources,

being of value precisely as an index of the fertility and independence of individual vision. It should furthermore be made without thought of financial gain or public recognition. In due course Dubuffet had to relax his more stringent stipulations, conceding that even the most self-sufficient artist could hardly avoid some exposure to external influences. Nonetheless, he insisted, the concept of *art brut* remained an 'ideal pole' and a significant point of orientation. In practice the selection of items for his collection was sometimes determined by Dubuffet's prejudices and hunches: thus he would occasionally attribute excessive virtue to lacklustre work that happened to meet his other criteria or would somewhat spitefully exclude exciting work by individuals who had transgressed his 'rules' by exhibiting commercially. Although the phenomenon of *art brut* is incontrovertible, debate seems likely to persist with regard to the precise delimitation of its territory. Some difficulties arise because Dubuffet's thinking was focused on the status or posture of the creator rather than on the finished work. A purely aesthetic standard for evaluating works of *art brut* has never been agreed.

If Dubuffet's definition avoided singling out any one medium or style, it can be shown that a remarkable proportion of the artists falling into the category were ill-educated, retiring persons whose impulse to create arose late in life, often under the pressure of an emotional trauma, and took the form of a compulsive proliferation such that an isolated piece is often less telling than the cyclical ensemble. The Swiss psychotic Adolf Wölfli, for example, spent some 30 years amassing in his asylum cell an enormous pictorial autobiography in which imaginary travels on a galactic scale are represented in colourful, tautly knit designs backed by florid captions and a ceaseless textual commentary. The London housewife Maud Ethel [Madge] Gill (1882–1961) claimed inspiration from the spirit world and over four decades produced an astonishing profusion of ink drawings that depict staring female faces caught in uncanny, asymmetrical interiors. The French mental patient Guillaume Pujolle (1893–c. 1965) translated his deliriums into watercolours in

which recognizable forms dipped in eerie tints of black and pink dissolve amid quivering arabesque lines, to create a strong visionary effect. The French farmer Emile Ratier (1894–1984) had to stop work at the age of 66 because he was going blind. His reaction to disability was to fashion toys out of rough wood and nails, and in due course he succeeded in constructing such large-scale working models as a two-metre high Eiffel Tower complete with moving lift and roundabouts on each floor. These crudely finished yet curiously assertive mechanisms have an ambiguous appeal. Whereas the Collection de l'Art Brut is predominantly composed of pictures and relatively small carvings and assemblages, it would seem legitimate to extend the term *art brut* to cover extensive environmental works fashioned in a similar spirit by creators such as Le Facteur (Ferdinand) Cheval (1836–1924) and Simon Rodia. Far removed from the mimetic aspirations of much naive art (with which it has erroneously been bracketed), *art brut* should above all be seen as an art of the subjective, the engrossed pursuit of inner obsessions, sign-systems and configurations. As such, its appeal is idiosyncratic and offbeat, although its marginal position on the general map of art does not preclude its products from exhibiting genuine power and a strange beauty.

Bibliography

A. Brut, 1–9 (Paris, 1964–73), 10– (Lausanne, 1977–)

J. Dubuffet: *Asphyxiante culture* (Paris, 1968)

H. Raynal: 'Un Art premier', *Critique*, 258 (1968), pp. 965–83

R. Cardinal: *Outsider Art* (London, 1972)

J. Dubuffet: *L'Homme du commun à l'ouvrage* (Paris, 1973)

C. Lascault: 'La Pensée sauvage en acte', *L'Herne*, 22 (1973), pp. 218–33

H. Raynal: 'Le Personnage infini', *L'Herne*, 22 (1973), pp. 234–59

M. Thévoz: *L'Art brut* (Geneva 1975; Eng. trans., 1976)

G. Presler: *L'Art brut: Kunst zwischen Genialität und Wahnsinn* (Cologne, 1981)

G. Schreiner, ed.: *European Outsiders* (New York, 1986)

C. Delacampagne: *Outsiders: Fous, naïfs et voyants dans la peinture moderne (1880–1960)* (Paris, 1989)

W. Morgenthaler: *Madness and Art: The Life and Works of Adolf Wölfli* (London, 1992)

A. S. Weiss: *Shattered Forms*, Art brut, *Phantasms, Modernism* (Albany, 1992)

N. Wacher: *Peinture à partir du matériel brut et le rôle de la technique dans la création d'art* (Paris, 1993)

<div align="right">ROGER CARDINAL</div>

Art Contemporain [Flem. Kunst van Heden]

Belgian exhibiting society of artists founded on 1 March 1905 in Antwerp and active from 1905 to 1955. Its founder, the dealer François Franck (1872–1932), was motivated by the many short-lived attempts by Antwerp artists to set up an artistic forum alongside or in opposition to the Société pour l'Encouragement des Beaux-Arts (founded in 1788) and the Cercle Artistique (founded in 1852). The society organized annual exhibitions in which the work of one or several late 19th century or contemporary artists was featured on a spectacular scale (e.g. Alfred Stevens in 1907), with artist-members often showing alongside representative groups of foreigners. Between 1918 and 1939 Art Contemporain gained a dominant position in the artistic life of Antwerp through its membership structure. The enterprise was financially supported by enthusiasts: dealers such as Henri Fester (1849–1939) and politically committed intellectuals such as G. Serigiers (1858–1930), Louis Franck (1869–1937), Pol De Mont (1857–1931) and Emmanuel De Bom (1868–1953). This group regarded the promotion of 'sincere and remarkable works of art, to whichever movement they might belong' as a prestigious mission to society. The multifarious, sometimes precarious composition of the society made it wary of particularly innovative art, and after exhibiting work by the Ecole de Paris there was open internal conflict, which brought further criticism from Antwerp's avant-garde artists. Nevertheless the work of members such as Jakob Smits, Albert Servaes, Georg Minne, Léon Spilliaert, Rik Wouters, Auguste Oleffe, Gustave Van de Woestyne, Edgard Tytgat, Gustave De Smet, Constant Permeke, Jean Brusselmans and others received ample attention. James Ensor was particularly fortunate to be promoted by Art Contemporain both at home and abroad. The close collaboration between the society and the Koninklijk Museum voor Schone Kunsten in Antwerp has a continuing significance as a result of the museum's purchases at the time, the gifts given by Friends of Modern Art (after 1925) and those of individuals, of which Charles Franck (1870–1935) and François Franck were the most prominent.

Bibliography

Art Contemporain produced catalogues for its annual exhibitions at the Koninklijk Museum voor Schone Kunsten, Antwerp, in 1905–14, 1920–44, 1947–54.

W. Koninckx and M. Gevers: *Trente années au service de l'art* (Antwerp, 1935)

L'Art contemporain/Kunst van Heden (exh. cat., Antwerp, Kon. Mus. S. Kst., 1955)

R. Avermaete: *Een eeuw Antwerps mecenaat* [A century of patronage in Antwerp] (Brussels, 1974), pp. 93–119, 150–64

In dienst van de kunst: Antwerps mecenaat rond 'Kunst van Heden' (1905–1955) [In the service of art: Antwerp's patronage of *Kunst van Heden* (1905–1955)] (exh. cat. by M. Browaeys and others, Antwerp, Kon. Mus. S. Kst., 1991)

<div align="right">HERWIG TODTS</div>

Art Deco

Descriptive term applied to a style of decorative arts that was widely disseminated in Europe and the USA during the 1920s and 1930s. Derived from the style made popular by the Exposition Internationale des Arts Décoratifs et Industriels Modernes held in Paris in 1925, the term has been used only since the late 1960s, when there was a revival of interest in the decorative arts of the early 20th century. Since then the term 'Art Deco' has been applied to a wide variety of works produced during the inter-war years, and even to those of the German Bauhaus. But Art Deco was essentially of French origin, and the term should, therefore, be applied only to French works and those from countries directly influenced by France.

1. France

The development of the Art Deco style, or the *Style moderne* as it was called at the time, closely

paralleled the initiation of the 1925 exhibition, and in many ways it was the product of it. The exhibition was originally conceived in 1907, and, unlike the Expositions Universelles that had preceded it in Paris, it was a government-sponsored project aimed specifically at developing export markets for French decorative and applied arts. It was also an attempt to find solutions to a broad range of problems experienced by French art industries since the mid-19th century, when the machine and the division of labour had been introduced into the artistic process. The issues that the exhibition was to address included: cooperation between artists, craftsmen and commercial manufacturers; increasing international competition in the luxury goods trade (of which France traditionally had been a leader); professional training for artisans; and apprenticeship legislation. These concerns were extremely important for Paris, which then had the highest concentration of artisans of any European city. The issues at stake, however, were not only artistic and economic but also cultural and nationalistic: the luxury crafts were considered one of the nation's traditional sources of prestige. Although its programme stipulated that everything included had to be 'modern', the exhibition in fact had conflicting goals: encouraging a union between art and industry, while at the same time finding modern applications for traditional handicrafts that would otherwise be destined to disappear.

Preparations for an international decorative arts exhibition, first scheduled for 1915 but later postponed until 1925, led to a concerted effort on the part of French designers to define and develop a modern, specifically French style of decorative arts. Thus, many of the constituent elements of the Art Deco style were in place before 1914. Even though they sought a style that was outwardly modern, the artists of the Art Deco movement generally paid more attention to maintaining high-art traditions of luxury and quality than to exploring the functional aspects of domestic design. Formally, the Art Deco style was both a reaction to, and an emanation of, the French Art nouveau style. Like Art Nouveau, the decorative repertory of Art Deco was based on nature, but,

whereas the former often derived its formal language from exotic flowers and plants whose twisting and climbing stems were usually integrated into the structure of an object, the latter was much more restrained, rejecting running motifs and climbing stems for stylized and geometricized flower blossoms, often roses, gathered up and tied into bouquets or in baskets.

The Art Deco style was also influenced by the elegance and refinement of Viennese decorative arts and by the exoticism and strong vibrant colours of the Ballets russes, which had made its début in Paris in 1909. The couturier Paul Poiret and the architect and decorator Louis Süe visited the WIENER WERKSTÄTTE and were impressed by its strikingly original and cosmopolitan style of design, as well as by its emphasis on making the environment, from domestic furnishings to clothing and jewellery, a total work of art. Poiret returned from Vienna and founded the Ecole d'Art Décoratif Martine and Atelier Martine in 1911. The furnishings he produced combined the Orientalism and warm colours of the Ballets Russes with the French Empire style. Poiret's clothing and decorative designs were widely diffused in magazines and luxurious reviews such as the *Gazette du bon ton* (1912–25), most notably through the illustrations of Paul Iribe (1883–1935) and Georges Lepape (1887–1971).

Louis Süe founded the Atelier Français in Paris in 1912 and tried to create a modern style that made explicit references to the French tradition. Many of the characteristics of what was to become the Art Deco style were presented in a manifesto written by one of Süe's associates, the landscape artist and garden theorist André Vera (1881–1971). Entitled 'Le Nouveau Style', this was published in *L'Art décoratif* in January 1912: in it Vera contended that a modern style of decorative arts should reject internationalism and also pastiche but nevertheless continue French traditions, especially the rationalism of the Louis XVI period and the more comfortable and bourgeois Louis-Philippe style. For decoration, contrasts of rich, bold colours should supplant the pale tones typical of Art Nouveau, and baskets and garlands of flowers should replace the 18th-century repertory

of torches, bows and arrows. The decorator Paul Follot created one of the earliest designs with these characteristics, which is deemed one of the first Art Deco works: a dining-room ensemble in sycamore, ebony and amaranth, which was exhibited at the Salon d'Automne of 1912 (Paris, Mus. A. Déc.). The chair backs were sculpted in an openwork design representing a basket of fruit and flowers.

This decorative and rather traditional current continued after 1918, reinforced by notions of a *retour à l'ordre*, which was the leitmotif of much post-war art in France. References to French classical art could be seen especially in decorative painting, sculpture and ceramics. The Art Deco movement was then led by Süe and the decorator André Mare (1885–1932), through their Compagnie des Arts Français (founded in 1919), together with André Groult (1884–1967), Clément Mère (*b* 1870), Paul Follot and the master cabinetmaker Jacques-Emile Ruhlmann. Their work continued the traditions of French *ébénisterie* and featured unusual combinations of luxurious and exotic materials, especially those from French colonies in Africa and Asia, such as ebony, palm-wood, rose-wood and shagreen (e.g. the armoire by Ruhlmann). They based their aesthetic on contrasts of textures, colours and materials and on complicated techniques such as lacquerwork, marquetry and inlaid work using such materials as ivory and mother-of-pearl. Other references to the *ébénistes* of the Louis XVI period can be seen in the ingenious devices incorporated into furnishings, such as swivelling or inclinable desktops, drawers and flaps (e.g. the desk by Mère, *c.* 1923; Paris, Mus. A. Déc.). Influenced by Japanese art, these decorators tended to give a pictorial treatment to such large pieces of furniture as armoires and buffets, applying the decoration all over the surface rather than restricting it to joints or mouldings (e.g. Ruhlmann, cabinet, 1925; Paris, Mus. A. Déc.; and Süe and Mare, cabinet, 1927; Richmond, VA Mus. F.A.).

The Art Deco movement encompassed a wide variety of decorative arts that were characterized by a certain sensuousness of curving forms, a lavish employment of luxurious materials and bold combinations of colours and floral patterns. The lacquered screens and furniture by Jean Dunand (1877–1942), who was also a master of *dinanderie*, were often engraved or sculpted and decorated with incrustations of mother-of-pearl or eggshell. In the work of the most important silversmith of the period, Jean Puiforcat, the clean lines and smooth surfaces, occasionally decorated with semi-precious stones, testify to a new architectural approach that departs from the exaltation of surface decoration typical of traditional silverwork. The painter Charles Dufresne brought the Art Deco style to tapestry; many of his designs were produced by the Beauvais factory. Georges Fouquet (1862–1957), Jean Fouquet (1899–1984), Louis Cartier (1875–1942), Raymond Templier (1891–1968) and Gérard Sandoz (*b* 1902) were the master jewellers of Art Deco. They replaced traditional precious stones and naturalistic floral settings with hardstones such as onyx, coral and jade in compositions of stylized motifs with strong colour contrasts (e.g. the pendant by Georges Fouquet). Decorative forged ironwork, with lively motifs of stylized roses and arabesques, was popular in domestic and public interiors of the period. Raymond Henri Subes (1893–1970) and Edgar Brandt (1880–1960) were two of the major exponents of this medium.

The Art Deco style reached its apogee at the Exposition Internationale des Arts Décoratifs et Industriels Modernes of 1925. In the climate of a post-war return to normality the exhibition lost much of its original emphasis on a union between art and industry and became instead a showcase for the finest products of the French luxury-goods industries. The most popular French pavilions were those devoted to a specific theme that demanded the collaborative effort of a group of artists. Among them was the sumptuous Hôtel d'un Collectionneur presented by Ruhlmann, its architecture by Pierre Patout. It featured furniture by Ruhlmann, lacquerwork by Dunand, forged ironwork by Brandt, sculpture by Joseph-Antoine Bernard, François Pompon and Emile-Antoine Bourdelle, and the large decorative painting *The Parrots* (New York, priv. col.) by Jean Dupas (1882–1964), one of the few painters to whom the

appellation Art Deco can justly be applied. The Société des Artistes Décorateurs presented decorative ensembles destined for a French embassy. Paul Poiret presented his collections in three *péniches* (barges) entitled *Amours*, *Délices* and *Orgues* decorated by Raoul Dufy. In the pavilion entitled Musée d'Art Contemporain, Süe and Mare presented a grandiose music-room furnished with a desk in ebony and bronze and a grand piano with curved legs in a modernized Louis XV style. The interior decoration studios of the major department stores in Paris—Au Printemps (Primavera), Galeries Lafayette (La Maîtrise), Au Bon Marché (La Pomone) and the Grands Magasins du Louvre (Studium)—each had their own pavilions and were important in diffusing the Art Deco style.

Art Deco began to decline in France after the exhibition of 1925, as a more functionalist and internationalist group of designers emerged who were opposed to the decorative extravagance, nationalism and traditionalism of Art Deco. They formed the Union des Artistes Modernes in 1929. It could be argued that the influence of Art Deco continued in France during the 1930s in such ensembles as the liner *Normandie* (1935), but by 1930 proportions were becoming more monumental and forms heavier and fuller, without the ornamental exuberance so characteristic of Art Deco.

2. USA

Because of the popularity of the 1925 exhibition, and through the diffusion of luxurious government-sponsored publications featuring the works displayed in the French section, the Art Deco style had a widespread international influence, especially in the USA. The Metropolitan Museum of Art in New York made numerous purchases from the exhibition and a display of 400 objects travelled to major American cities in 1926. The New York department store Lord & Taylor held yet another exhibition of the *Style moderne* in 1928. In spite of this, little that was produced in the USA during the late 1920s and early 1930s truly corresponds to the French works dating from 1920 to 1925, so the term 'Art Deco' should be used with caution.

The USA simply did not have the luxury craft tradition that lay at the heart of Art Deco. Most of the best designers working in the USA from 1926 to 1930, and whose work has been labelled 'Art Deco' in popular publications, were industrial designers born and trained in Europe. Joseph Urban, Paul Frankl and Kem Weber (1889–1963), for example, were from Vienna, and the rationalism and geometry of the furnishings produced by the Wiener Werkstätte, rather than the French *Style moderne*, are clearly the source of their design. Frankl integrated the Viennese style with a specifically American skyscraper aesthetic (e.g. the 'Skyscraper' bookcase, *c.* 1928; Cincinnati, OH, A. Mus.). Other designers in America incorporated the rich colours and decorative geometries of the French *Style moderne* with a machine aesthetic. The interiors designed by Donald Deskey (1894–1989) for Radio City Music Hall (1931) testify to the pervasive influence of French Art Deco, especially in their refinement and polychrome decoration, but they were infused with a rationalism, urban sophistication and modern use of materials that were not prevalent in France until the 1930s. Art Deco, in addition, should not be used to describe a style of architecture, but rather its surface ornament (see col. pl. IV). If the Chrysler Building (William Van Alen, 1929) in New York displays certain Art Deco influences in the decorative stainless-steel sunburst of the upper floors, its mechanistic iconography referring to automobiles was not part of the Art Deco repertory. The lobby, however, with its expensive marbles and richly decorated elevator doors with an intarsia design in the form of a papyrus flower, is a masterpiece of the Art Deco style. One can find the decorative motifs of the French *Style moderne* applied to the entrance of the Goelet Building (E. H. Faile, 1930) at 608 Fifth Avenue, New York, and to the top floors of the Kansas City Power and Light Company Building (Hoit, Price & Barnes, 1932).

A highly exaggerated and commercialized version of Art Deco was popular in cinemas and theatres during the late 1920s, notably in the Pantages Theatre (Marcus B. Priteca, 1929–30) in Los Angeles. By the mid-1930s the Art Deco

influence on American design gave way to the horizontal, flowing, streamlined style that was evocative of speed and a technological Utopia.

Bibliography

Encyclopédie des arts décoratifs et industriels modernes au XXe siècle, 12 vols (Paris, 1932/R New York and London, 1977) [official edition for the Paris *Exposition internationale des arts décoratifs et industriels modernes*, 1925]

B. Hillier: *Art Deco of the 20s and 30s* (London, 1968)

G. Veronesi: *Style 1925: Triomphe et chute des 'Arts-Déco'* (Lausanne and Paris, 1968)

Y. Brunhammer: *The Nineteen-twenties Style* (London, 1969)

Art Deco: Schmuck und Bücher aus Frankreich (exh. cat., foreword by F. Falk; Pforzheim, Schmuckmus.; Munich, Villa Stuck; Hamburg, Mus. Kst & Gew.; 1975–6)

C. Bizot and M. Béranger: *Bibliographie 1925* (Paris, 1976)

Cinquantenaire de l'Exposition de 1925 (exh. cat. by Y. Brunhammer and others, Paris, Mus. A. Déc., 1976–7)

V. Arwas: *Art Deco* (London, 1980, rev. 1992)

A. Duncan: *Art Deco Furniture: The French Designers* (London, 1984)

W. Uecker: *Art Deco: Die Kunst der zwanziger Jahre* (Munich, 1984)

P. Cabanne: *Encyclopédie Art Déco* (Paris, 1986)

A. Duncan: *American Art Deco* (London, 1986)

P. Frantz Kery: *Art Deco Graphics* (London, 1986)

Y. Brunhammer and S. Tise: *French Decorative Art, 1900–1942* (Paris, 1990)

M. Dufrene, ed: *Authentic Art Deco Interiors* (Woodbridge, Suffolk, 1990) [illustrates the 96 interiors in the 1925 *Exposition internationale des arts décoratifs et industriels modernes*]

SUZANNE TISE

Arte generativo

Style of Argentine painting named in 1959 by Eduardo Macentyre and Miguel Angel Vidal to describe their work, with its power to generate optical sequences by circular, vertical and horizontal displacement, and based on their studies of Georges Vantongerloo. Developing the tradition of geometric abstraction that had emerged in Argentina in the 1940s with groups such as Arte Concreto Invención, Movimiento Madí and Perceptismo, the aim of these artists was to extol the beauty and perfection of geometry through line and colour. They and the collector Ignacio Pirovano (1919–80), who acted as their theorist, were soon joined by the engineer and painter Baudes Gorlero (1912–59), who as well as creating his own work also analysed its development mathematically. All three artists were awarded prizes in 1959 in the Argentine competition *Plástica con plásticos* by a jury that consisted of the French critic Michel Ragon, the American museum director Thomas Messer (*b* 1920), the French painter Germaine Derbecq (1899–1973) and the Argentine critic Aldo Pellegrini (1903–75), shortly after which Gorlero died. MacEntyre and Vidal produced the *Arte generativo* manifesto in 1960, not as a theoretical statement but as a 'clarification of ideas'. They distinguished the adjective 'generative' ('able to produce or engender') from the verb 'to engender' ('to procreate, to propagate the same species, to cause, occasion, form') and from the noun 'generatrix' ('a point, line or surface whose motion generates a line, surface or solid'). After exploring these ideas more fully they suggested that shapes 'produce *power* through the sensation of breaking free from and wishing to penetrate the basic plane and *energy* from the displacements and vibrations that they produce'. Both MacEntyre and Vidal relied on an analytical process, organizing basic units (curved lines for MacEntyre, straight lines in Vidal's case) in accordance with constant laws and subjecting them to inventive variations characterized by an impeccable technique, splendid colour and surprising power.

Writings

E. MacEntyre and M. A. Vidal: *El arte generativo* (Buenos Aires, 1960)

I. Pirovano: 'Arte generativo: Eduardo MacEntyre, Miguel Angel Vidal', *Arte argentino contemporáneo* (Madrid, 1979)

NELLY PERAZZO

Arte Madí

Argentine movement of the 1940s based in Buenos Aires and led by Gyula Košice and the Uruguayan

artists Carmelo Arden Quin (*b* 1913) and Rhod Rothfuss (*b* 1920). Together with Joaquín Torres García and the Argentine poet Edgar Bayley (*b* 1919), they were responsible for the publication in early 1944 of a single issue of a magazine, *Arturo*, which heralded the development of the Constructivist movement in Argentina, stressing the importance of pure invention and of interdisciplinary links. Tomás Maldonado, who designed the cover, and Lidy Prati (*b* 1921), who was responsible for most of the vignettes, soon dissociated themselves from their colleagues to help set up the ASOCIACIÓN ARTE CONCRETO INVENCIÓN; the editorial content of the magazine, however, suggested a coherent aesthetic that was also promoted in booklets published by Košice and Bayley in 1945 and in two exhibitions, *Art Concret Invention* (which opened on 8 Oct 1945 in the house of the doctor and patron Enrique Pichon Rivière) and *Movimiento de Arte Concreto Invención* (from 2 Dec 1945 in the house of the photographer Grete Stern). Articles by Arden Quin and Košice stressed the pure quality of plastic images free of naturalistic or symbolic connotations, whose radical character was distinguished by Bayley from what he termed the falsity of such movements as Expressionism, Realism and Romanticism. Rothfuss's exposition of his ideas about shaped canvases, prefiguring by more than a decade devices taken up by American abstract painters, proved particularly influential.

An exhibition of manifestos, paintings, sculptures, poems and architectural maquettes, together with recitals of music and dance performances, titled simply *Madí*, was held in August 1946 (Buenos Aires, Inst. Fr. Estud. Sup.). It was followed by further group exhibitions entitled *Arte Madí* in October 1946 (Buenos Aires, Salón Altamira, and Buenos Aires, Bohemien Club, Gal. Pacífico) and 1948 (Paris, Salon Realités Nouv.) and by Košice's *Manifiesto Madí* of February–March 1947, which refers to drawing, painting, sculpture, architecture, music, poetry, theatre, novels, stories and dance. A journal, *Arte Madí Universal*, was also published from 1947 until June 1954. Košice's work, particularly his use of shaped canvases, light and movement, typified Arte Madí's

emphasis on spectator participation and on new technologies and materials.

Writings

E. Bayley: *Invención 2* (Buenos Aires, 1945)
G. Košice: *Invención 1* (Buenos Aires, 1945)
——: *Arte Madí* (Buenos Aires, 1982)

Bibliography
Vanguardias de la década del 40, Arte Concreto–Invención, Arte Madí, Perceptismo (exh. cat., intro. N. Perazzo, Buenos Aires, Mus. Mun. A. Plást. Sívori, 1980)
G. Pérez-Barreiro: 'The Negation of All Melancholy: Arte Madí/Concreto-Invención, 1944–1950', *Art from Argentina, 1920–1994* (exh. cat. by D. Elliot and others, Oxford, MOMA, 1994)
——: *The Argentine Avante-Garde, 1944–1950* (diss., Colchester, U. Essex, 1996)
Arte Madí (exh. cat., Madrid, Mus. N. Cent. A. Reina Sofía, 1997)

NELLY PERAZZO

Arte nucleare [It.: 'nuclear art']

Term applied to a style of Italian painting prevalent in the 1950s. The Movimento Nucleare was founded in 1951 by Enrico Baj and Sergio Dangelo (*b* 1931), with Gianni Bertini (*b* 1922), to promote a gestural, fantastical style of avant-garde art. In their first manifesto (1952) the artists introduced the idea of 'nuclear painting' and made it clear that they were striving for a relevant representation of post-War man and his precarious environment. *Arte nucleare* stood in opposition to the powers unleashed in the atomic age and expressed the general fear of imminent and uncontrollable damage from nuclear physics. The artists also reacted against the pictorial disciplines of De Stijl and all forms of geometric abstraction, pursuing instead the unpredictable effects of Surrealist automatism. This included gestural experiments similar to action painting and Tachism. Various *Arte nucleare* artists, including Gianni Dova, helped produce the magazine *Phases* in the mid-1950s. In 1955 Baj and other *Arte nucleare* artists joined the Mouvement International pour une Bauhaus Imaginiste (MIBI), founded by Asger Jorn.

A further manifesto was released by the *Arte nucleare* artists in January 1959. This warned against the negative application of new technology and also found possibilities of a positive, aesthetic development from some aspects of atomic fission. Although a few *Arte nucleare* exhibitions were held, the movement did not gain the currency enjoyed by its rival, *Art informel*, and by the early 1960s had faded from the international arena.

Bibliography

E. Baj and S. Dangelo: *Manifeste de la peinture nucleare* (Brussels, 1952)

T. Sauvage: *Arte nucleare* (Milan, 1962)

□

Arte Povera [It.: 'impoverished art']

Term coined by the Genoese critic Germano Celant in 1967 for a group of Italian artists who, from the late 1960s, attempted to break down the 'dichotomy between art and life' (Celant: *Flash Art*, 1967), mainly through the creation of happenings and sculptures made from everyday materials. Such an attitude was opposed to the conventional role of art merely to reflect reality. The first Arte Povera exhibition was held at the Galleria La Bertesca, Genoa, in 1967. Subsequent shows included those at the Galleria De'Foscherari in Bologna and the Arsenale in Amalfi (both 1968), the latter containing examples of performance art by such figures as Michelangelo Pistoletto. In general the work is characterized by startling juxtapositions of apparently unconnected objects: for example, in *Venus of the Rags* (1967; Naples, Di Bennardo col., see 1989 exh. cat., p. 365), Pistoletto created a vivid contrast between the cast of an antique sculpture (used as if it were a ready-made) and a brightly coloured pile of rags. Such combination of Classical and contemporary imagery had been characteristic of Giorgio de Chirico's work from *c.* 1912 onwards. Furthermore, Arte Povera's choice of unglamorous materials had been anticipated by more recent work, such as that of Emilio Vedova and Alberto Burri in the 1950s and 1960s, while Piero Manzoni had subverted traditional notions of the artist's functions (e.g. *Artist's Shit*, 1961, see 1989 exh. cat., p. 298). Like Manzoni's innovations, Arte Povera was also linked to contemporary political radicalism, which culminated in the student protests of 1968. This is evident in such works as the ironic *Golden Italy* (1971; artist's col., see 1993 exh. cat., p. 63) by Luciano Fabro, a gilded bronze relief of the map of Italy, hung upside down in a gesture that was literally revolutionary.

As well as expressing their interest in social issues, the Italians were preoccupied with creating various forms of physical interaction between the work of art and its viewer. From the early 1960s Pistoletto had been making life-size images of people that were attached to mirrored surfaces so that the reflections of the spectator became part of the work, for example *Vietnam* (1965; Houston, TX, Menil Col.; see 1989 exh. cat., no. 198), which represented demonstrators holding a banner. Gilberto Zorio began in the late 1960s to create installations that registered the actions of visitors or other changes in the work's immediate environment by such means as flashing lights. Other artists pursued more esoteric conceptual interests. Giulio Paolini created replicas of historic sculptures or paintings, which are given the status of original works of art by the ideas behind them, if not by their form. In *Mimesis* (1976; artist's col., see 1989 exh. cat., p. 364), Paolini placed two plaster casts of the same Classical statue opposite each other as if they were in conversation. This transforms the viewer's perception of the original sculpture by depicting the figures in silent dialogue with each other, rather than with the onlooker, and by shattering the concept of a work of art as being a unique creative act. *Mimesis* presents the duplicates as if they were ready-mades rather than the products of an individual artist. Fragments of plaster casts were also used by the Greek exile Jannis Kounellis, who was particularly concerned with expressing the disintegration of culture in the modern world (e.g. a performance held 1973; Rome, Gal. Salita; see 1986 exh. cat., p. 139).

The Arte Povera artists did not restrict themselves to allusions to Western civilization; from

1968, for example, Mario Merz made igloos (e.g. *Double Igloo*), referring to nomadic societies, which he admired particularly for being flexible and well adapted to their environments. He himself emulated these qualities in the ease with which he built the igloos from a wide range of both technological and 'natural' materials, including metal, glass, neon, slate, wax, earth and wood (see also col. pl. VI). This eclecticism in fact emphasized the essential difference between homogeneous traditional cultures and pluralistic modern ones. Around 1970 Merz also became preoccupied with the Fibonacci series of numbers, which he presented as the mathematical structure underlying a wide range of natural and manmade objects. A more active interference with nature was achieved by Giuseppe Penone: in *The Tree Will Continue to Grow Except at This Point* (1968; see 1978 exh. cat., p. 33), an iron impression of Penone's fist was fitted around the trunk of a sapling so as to affect but not prevent the tree's growth. The involvement of natural processes is also a feature of the work of Giovanni Anselmo. In *Structure that Eats* (1968; New York, Sonnabend Gal., see 1989 exh. cat., p. 368) vegetables were put between two stone blocks with the expectation that one would fall when the organic material rotted. This emphasis on the sculpture's impermanence shattered conventional notions of how art can transcend the normal processes of mortality. Anselmo pursued his interest in such phenomena as gravity into the 1980s, often using blocks of granite. In general, his colleagues also showed remarkable consistency in both their themes and imagery, although from the late 1970s the prevailing trend towards figurative art was reflected in some of the artists' work: for example, while still producing igloos, Merz painted animal forms, often combined with neon lights (e.g. *Crocodile in the Night*, 1979, Toronto, A.G. Ont.). Other artists created highly complex installations, which, in the case of Kounellis, often combined earlier pieces with new motifs (e.g. *Metamorphosis*, 1984; Schaffhausen, Hallen Neue Kst). Despite competition from the figurative Transavanguardia artists in Italy, Arte Povera remained a vigorous movement, responsible for

some of the most innovative and sophisticated Italian art of the period.

Bibliography

G. Celant: 'Arte Povera: Appunti per una guerriglia', *Flash A.*, 5 (Nov–Dec 1967), p. 3

Arte Povera (exh. cat., ed. G. Celant; Genoa, Gal. La Bertesca, 1967)

G. Celant: *Arte Povera* (Milan, 1969)

Conceptual Art, Arte Povera, Land Art (exh. cat., ed. G. Celant; Turin, Gal. Civ. A. Mod., 1970)

Fabro, Kounellis, Merz, Paolini (exh. cat., Berne, Ksthalle, 1980)

Identité italienne: L'Art en Italie depuis 1959 (exh. cat., ed. G. Celant; Paris, Pompidou, 1981)

The Knot: Arte Povera (exh. cat. by G. Celant, New York, Inst. A. & Urb. Resources, P.S.1, 1985)

Jannis Kounellis (exh. cat., intro. M. J. Jacob; Chicago, IL, Mus. Contemp. A., 1986), p. 139

Italian Art in the 20th Century: Painting and Sculpture, 1900–1988 (exh. cat., ed. E. Braun; London, RA, 1989)

Gravity and Grace: The Changing Condition of Sculpture, 1965–1975 (exh. cat., London, Hayward Gal., 1993)

CHRISTOPHER MASTERS

Arte programmata [It.: 'programmed art']

Term given to the work of various Italian artists active during the early 1960s who were primarily interested in KINETIC ART and OP ART. The phrase was used by Umberto Eco in 1962 for an exhibition that he presented at the Olivetti Showroom in Milan. This show included works by Bruno Munari, Enzo Mari and members of GRUPPO N and GRUPPO T (both founded 1959). The artists produced objects by a procedure analogous to the methods of technological research, creating a prototype that was then developed through a series of closely related artefacts. This practice was exemplified by Munari, whose mass-produced 'multiples' took the form either of hand-operated objects or simple machines (e.g. *X Hour*, 1963; see Tanchis, pp. 72–3). The 'multiples' required the participation of members of the public in order to function and were intended to explore optical and physical phenomena, concerns that also dominated the work of other *Arte programmata* artists. Giovanni Anceschi (*b* 1939) created remarkable dynamic

images with coloured liquids, while Gianni Colombo (*b* 1937) made reliefs constructed out of blocks that moved mechanically. *Arte programmata* gained an international reputation and in 1964 was the subject of exhibitions at the Royal College of Art, London, and at various venues in the USA. In the late 1960s, however, the artists became less closely associated, even though most continued to pursue their interests in kinetic and optical effects.

Bibliography

Arte programmata: Kinetic Art (exh. cat. by B. Munari, New York, Loeb Student Cent., 1964)

Arte italiana, 1960–1982 (exh. cat. by C. Tisdall and others, London, Hayward Gal. and ICA, 1982–3)

Arte programmata e cinetica, 1953–1963: L'ultima avanguardia (exh. cat. by L. Vergine, Milan, Pal. Reale, 1983–4)

A. Tanchis: *Bruno Munari* (Milan, 1986; Eng. trans., London, 1987)

<div align="right">CHRISTOPHER MASTERS</div>

Artes

Group of Polish avant-garde artists active in Lwów (now Lviv, Ukraine) between 1929 and 1935, from 1933 known as 'Neoartes'. Among its members were painters who studied in Lwów, Kraków and Paris: Otto Hahn (1904–42), Jerzy Janisch (1901–62), Henryk Streng (who after 1939 used the pseudonym Marek Włodarski), Margit Sielski (*b* 1903), Roman Sielski (*b* 1903), Mieczysław Wysocki (1899–1930), the self-taught painter Ludwik Lille (1897–1957) and the architect Aleksander Krzywobłocki (1901–79). Between 1930 and 1932 they held 11 exhibitions in Lwów, Warsaw and other cities. They searched for new, modern art, but they never defined it or formed any programme. Their art was heterogenous and covered various disciplines: painting, drawing, graphic art, collage and photomontage. Some of them were students of Léger and followed his style, but most of them moved towards Surrealism, for example Wysocki in his *Fantasy of a Fight* (1930) and Hahn in his lithograph *Composition with Leaves* (1930; both Wrocław, N. Mus.). They explored subjects popular among Surrealists, such as the journey, sea and dreams, as in Roman Sielski's *Seascape* (1931; Warsaw, N. Mus.). But they also made use of everyday subjects and depicted simple objects. Finally they broke with the timelessness and unreality of Surrealist visions and called for involvement in socio-political art. In 1933 Streng organized an opinion poll on new realism in art, and in 1936 he published in the monthly magazine *Sygnały* an article entitled 'Fighting for Live Art'. The move to realism was characteristic of the majority of Artes members. After the break-up of the group only Jerzy Janisch remained faithful to Surrealism; the others, for example Roman Sielski and Tadeusz Wojciechowski (1902–82), turned to Polish Colourism or, in the case of Streng, to abstraction.

Bibliography

P. Łukaszewicz: *Zrzeszenie artystów plastyków Artes, 1929–35* [The 'Artes' association of mixed-media artists, 1929–35] (Wrocław, 1975)

<div align="right">ANNA BENTKOWSKA</div>

Art informel [Informalism; Lyrical Abstraction]

Term coined in 1950 by the French critic Michel Tapié, primarily in relation to the work of Wols, and subsequently applied more generally to a movement in European painting that began in the mid-1940s and flourished in the 1950s as a parallel development to Abstract Expressionism (especially action painting) in the USA. Sometimes referred to as TACHISM, ART AUTRE or Lyrical Abstraction, it was a type of abstraction in which form became subservient to the expressive impulses of the artist, and it was thus diametrically opposed to the cool rationalism of geometric abstraction. Antecedents can be found in the work of Vasily Kandinsky (see col. pl. XVIII), Paul Klee (see col. pl. VIII) and Jean Dubuffet and particularly in the Surrealist current of Automatism, such as that practised by André Masson. In its more precise historical sense its pioneers were artists based in Paris, such as Jean Fautrier, Wols (e.g. *Composition*, 1947; Hamburg, Ksthalle, or

Yellow Composition, 1946–7; Berlin, Neue N.G) and Hans Hartung (e.g. *T. 1949-9*, 1949; Düsseldorf, Kstsamml. Nordrhein–Westfalen); Hartung in particular was producing paintings with many of the features of *Art informel* by the mid-1930s, as in *T. 1935-1* (1935; Paris, Pompidou; for a later example, see fig. 4). The movement came to include Jean-Michel Atlan, Jean Bazaine, Roger Bissière, Camille Bryen, Alberto Burri, Charles Lapicque, Alfred Manessier, Georges Mathieu, Henri Michaux, Serge Poliakoff, Pierre Soulages, Nicolas de Staël, Antoni Tàpies and others. Following the lead of Surrealist automatism, current in Surrealism, *Art informel* pictures were executed spontaneously and often at speed so as to give vent to the subconscious of the artist. Though embodying a wide range of approaches to abstraction, the brushwork in such works is generally gestural or calligraphic, as in Michaux's *Untitled Chinese Ink Drawing* (1961; London, Tate; see fig. 5) or Mathieu's *Capetians Everywhere* (1954; Paris, Pompidou). Sometimes there is an emphasis on the texture or tactile quality of the paint, leading to a variant of *Art informel* referred to as MATTER PAINTING. Certain artists, such as Bazaine, Manessier and Poliakoff, produced paintings that appeared less spontaneous and more controlled, with a more consciously mediated composition and use of colour, as in Manessier's *Barrabas* (1952; Eindhoven, Stedel. Van Abbemus.; see col. pl. V).

The roots of *Art informel* lay in the climate of 'art politics' that pervaded the period just after World War II in France. In seeking a dominant role within the avant-garde, its exponents were primarily in competition with the champions of geometric abstraction, who in 1946 attempted to reassert their earlier dominance by founding an exhibiting society, the Salon des Réalités Nouvelles. Although at this stage there was little cohesion among the practitioners of *Art informel*, some of whom even took part in the initial exhibitions of the Salon des Réalités Nouvelles, they soon came together in a series of exhibitions organized by Mathieu, who also coined the alternative term 'Lyrical Abstraction'. The first of these was an exhibition entitled *L'Imaginaire* (Paris, Gal. Luxembourg, 1947), which united the

work of Atlan, Bryen, Hartung, Mathieu, Jean-Paul Riopelle and Wols with that of Picasso, Hans Arp, Victor Brauner and others, a fairly heterogeneous mixture; the catalogue preface by Jean-José Marchand adopted the oppositional tone that marked *Art informel* in its early years, calling for a battle against Constructivism and Neoplasticism so as to free art from 'all enslavement and pseudo problems'. A second exhibition organized by Mathieu, *H.W.P.S.M.T.B.* (Paris, Gal. Colette Allendy, 1948), took its title from the names of its participants: Hartung, Wols, Francis Picabia, François Stahly, Mathieu, Tapié and Bryen. Tapié himself later organized several *Art informel* exhibitions, including three at Studio Facchetti in Paris: *Signifiants de l'informel* (1951 and 1952) and *Un Art autre* (1952). The Galerie Drouin in Paris also presented important group exhibitions, having shown Fautrier's *Hostages* series as far back as 1945 and Wols's first *Art informel* oils in 1947. A one-man show of Hartung's works was held at the Galerie Lydia Conti in Paris in 1947. Very quickly, therefore, *Art informel* achieved a high profile in

4. Hans Hartung: *T*, 1963–6 (London, Tate Gallery)

5. Henri Michaux: *Untitled Chinese Ink Drawing*, 1961
(London, Tate Gallery)

The cohesive identity of *Art informel* as a fully formed movement was marked by the publication in the early 1950s of two books espousing its aims and charting its development. These were Ragon's *Expression et non-figuration* (1951) and Tapié's *Un Art autre* (1952), the latter emphasizing the radical break from tradition achieved by *Art informel*. The critic Charles Estienne, formerly a supporter of geometric abstraction, insistently attacked its inflexibility in *L'Art abstrait est-il un académisme* (1950). Having established their dominance within the avant-garde by the 1950s, the proponents of *Art informel* became involved in internal wrangles as soon as external struggles became superfluous; in 1954, for instance, Estienne introduced the term Tachism to refer to the work of those second-generation French painters whom he had gathered together at the Salon d'Octobre in Paris from 1950, including Marcelle Loubchansky (*b* 1917), Jean Degottex, Simon Hantaî and others. Further fragmentation followed as each of the leading critics— Tapié, Ragon, Estienne and Julian Alvard—formed his own faction.

Once established in France, *Art informel* spread to many other countries. The most notable exponents abroad included Tàpies, Modest Cuixart, Antonio Saura and Manolo Millares in Spain and Alberto Burri, Emilio Vedova and Antonio Corpora in Italy, though the work of Tàpies and Burri had a gravity and severity at odds with most *Art informel* painting. Related work was produced in West Germany by members of Quadriga, the Zen 49 group and Gruppe 53, and in particular by painters such as Willi Baumeister, Julius Bissier, Karl-Otto Götz, Karl Fred Dahmen (*b* 1917), Emil Schumacher and Theodor Werner; in Britain by Alan Davie, Patrick Heron, Roger Hilton and William Scott; in the Netherlands by Ger Lataster; in Belgium by Louis Van Lint (*b* 1909), René Guiette (*b* 1893) and Jean Milo (*b* 1906); and in Greece by Yannis Spyropoulos. Sam Francis, one of the most European of American painters, was also associated with these developments, and there were exponents of *Art informel* as far afield as Japan, Poland, Yugoslavia, Czechoslovakia and Latin America. In his book *L'Art informel* (1962) Jean Paulhan argued that this movement broke with all

the cultural life of Paris. The momentum of *Art informel* was further bolstered by exhibitions illustrating the links between contemporary French art and that of other countries, beginning in 1948 (Paris, Gal. Montparnasse) with an incompletely realized attempt by Mathieu to point out the similarities. *Véhémences confrontées* (1951; Paris, Gal. Nina Dausset), organized by Tapié, linked works by Hartung, Wols, Bryen and Mathieu with the work of North American painters such as Jackson Pollock (then little known in Paris), Willem de Kooning and Jean-Paul Riopelle. The first group show in Paris of the Northern Europeans known as Cobra also took place in 1951, organized by the French writer Michel Ragon; their style was similar to *Art informel* in its spontaneous handling, but more violent in tone and with a greater emphasis on figurative content.

previous techniques and philosophies of art. Linking it to the work of philosophers and poets who had questioned the foundations of reality and the relation between the self and the world, he suggested that *Art informel* afforded insights into a half-world inaccessible to rational thought and beyond all experience. Nevertheless, he pointed to the similarities between certain microscopic images and *Art informel* works, making a connection, for example, between a picture by Wols and a photograph of nerve cells.

The popularity of *Art informel* immediately after World War II owed much to the fact that it was perceived as an attempt to shake off tradition and (in that it was an expression of artistic freedom) as a break from the atmosphere of political authoritarianism that had led to the war. For those artists still oppressed by political tyranny, as in Franco's Spain and Eastern Europe, it remained a permissible symbol of liberation. As an aesthetic, however, it represented a form of inward retreat in which reality was allowed only a concealed appearance. Thus by the early 1960s it was forcefully challenged by movements such as Nouveau Réalisme and Pop art, which sought a more direct engagement with everyday life and rejected the idea of art as the subjective expression of personality.

Bibliography

C. Estienne: *L'Art abstrait est-il un académisme* (Paris, 1950)
M. Ragon: *Expression et non-figuration* (Paris, 1951)
J. Alvard and R. van Gindertael: *Témoignages pour l'art abstrait* (Paris, 1952)
M. Tapié: *Un Art autre* (Paris, 1952)
J. Paulhan: *L'Art informel* (Paris, 1962)
G. Mathieu: *Au-delà du tachisme* (Paris, 1963)
M. Ragon: 'Lyrical Abstraction from Explosion to Inflation', *Abstract Art since 1945*, by W. Haftmann and others (London, 1971), pp. 72–102
M. Seuphor and M. Ragon: *L'Art abstrait*, iii (Paris, 1973)
A. Pohribny: *Abstract Painting* (Oxford, 1979)
Paris-Paris: Créations en France 1937–1957 (exh. cat., ed. G. Viatte; Paris, Pompidou, 1981), pp. 216–41, 252–69
W. Schmalenbach: *Der expressive Elan in der Malerei nach 1945* (Duisburg, 1987) [parallel German/English text]

PHILIP COOPER

Artistas Modernos de la Argentina

Argentine group of artists formed in 1952 and active until 1954. It was founded on the initiative of the art critic Aldo Pellegrini (1903–75) as a union of Constructivist painters belonging to the ASOCIACIÓN ARTE CONCRETO INVENCIÓN—Tomás Maldonado, Alfredo Hlito, Lidy Prati (*b* 1921), Ennio Iommi and Claudio Girola (*b* 1923)—and four independent semi-abstract artists: José Antonio Fernández Muro, Sarah Grilo, Miguel Ocampo and Hans Aebi (*b* 1923). Pellegrini's main concern was with the quality of the artists' work rather than with a shared programme. They were the first abstract artists in Argentina to exhibit together as a group abroad: in 1953 they showed both at the Museu de Arte Moderna in Rio de Janeiro and at the Stedelijk Museum in Amsterdam.

Pelligrini was pleased with the genuine interaction within the group. The work of the independent artists became more rigorous and economical, inclining progressively towards geometric abstraction, and their lack of dogmatism in turn led the Constructivists to adopt a more flexible approach. The group disbanded on Maldonado's move to Germany in 1954, but the former associates continued to work separately with great success.

Bibliography

A. Pellegrini: *Panorama de la pintura argentina contemporánea* (Buenos Aires, 1967), pp. 60–61
N. Perazzo: *El arte concreto en la Argentina* (Buenos Aires, 1983), p. 106

NELLY PERAZZO

Artistic Forum [Czech. Umělecká Beseda]

Czech society of artists, literary figures and musicians, active from 1863 to 1973. Founded in 1863 with the objective of establishing a unified national programme with which artists in different fields would be associated, its most active section became the Artists Group (Výtvarný), which brought together the outstanding contemporary figures in Czech art. Its first president was Josef Mánes, and its early members included Karel Purkyně and the sculptor Václav Levý (1820–70).

The group's original participation in the National Reawakening reached its climax in the early 1880s, when it was involved in the building and the decoration of the National Theatre in Prague. In the 1890s Artistic Forum became conservative and lost its earlier significance: while younger Czech artists joined the MÁNES UNION OF ARTISTS, older ones seceded in 1898 and founded the Union of Artists (Jednota Umělcu Výtvarných). In 1909 Artistic Forum was revivified by the new membership of Václav Rabas and Karel Boháček, graduates of the Academy of Fine Arts, who were preoccupied with landscape painting and with social themes. They subsequently persuaded members of the so-called 'Mayer Club', whose leader was J. Jareš, to join as well, the Club's special interest being Slovakia's history and traditions. From this time until the 1920s Artistic Forum underwent its period of greatest activity, organizing exhibitions, lectures and commemorative occasions. In 1914 Jareš and B. Malthesius published the periodical *Život a mythus* ('Life and myth'). After World War I Artistic Forum offered an alternative to the modernist and cosmopolitan hegemony of the Mánes Union of Artists. Various authors who espoused the national tradition joined the Forum, as did Jan Zrzavý and Josef Čapek, both of whom had been members of the Mánes Union for a short time. In 1921 the Forum began to publish the annual journal *Život* ('Life'); from 1933 it was published monthly and acquired great prestige in the 1930s. From 1930 the Forum organized exhibitions of the work of such artists as Zrzavý, Josef Šíma and De Chirico; *Ecole de Paris*, a show of contemporary Parisian art, was held in 1931. In the early 1940s, František Hudeček, František Gross and Václav Boštík, young members of the 42 Group, became members of the Forum. It survived the Communist putsch of 1948 in Czechoslovakia, but its activity was henceforth considerably limited. The Artistic Forum's demise was officially announced at its centenary celebrations in 1963, but it was not until 1973 that it finally ceased to exist.

Writings

Život & Mythus (1914)
Život (1921–48)

Bibliography

H. Jelínek: *50 let Umělecké besedy, 1863–1913* [50 years of the Artistic Forum] (Prague, 1913)

F. Skácelík, ed.: *Sedmdesát let Umělecké besedy 1863–1933* [70 years of the Artistic Forum] (Prague, 1933)

K. Krejčí: *Sto let Umělecké besedy* [100 years of the Artistic Forum] (exh. cat., Prague, N.G., Valdštejn Riding Sch., 1963)

LENKA BYDŽOVSKÁ

Artists International Association [AIA]

English group founded in London in 1933 as the Artists International to promote united action among artists and designers on social and political issues, and active from 1953 to 1971. In its original formulation it pursued an identifiably Marxist programme, with its members producing satirical illustrations for *Left Review* (e.g. see exh. cat., pp. 20–21) and propaganda material for various left-wing organizations. Reconstituted as the AIA in 1935, it avoided identification with any particular style, attracting broad support from artists working in both a traditional and modernist vein in a series of large group exhibitions on political and social themes, beginning with *1935 Exhibition (Artists Against Fascism & War)* in 1935 (London, 28 Soho Square). Support was given to the Republican cause in the Spanish Civil War (1936–9) and to the Artists' Refugee Committee through exhibitions and other fund-raising activities, and efforts were made to increase popular access to art through travelling exhibitions, public murals and a series of mass-produced offset lithographs entitled *Everyman Prints*, published by the AIA in 1940 (see exh. cat., p. 57).

The AIA published a journal sporadically and in different formats from 1934, beginning with *Artists International Bulletin* (1934–5) and continuing with *Artists International Association Bulletin* (1935–6 and 1939–47), *Artists News-sheet* (1936–8) and *Artists International Association Newsletter* (1947–64). Its early political stance was also affirmed in a book of essays, *5 on Revolutionary Art* (London, 1936), edited by the

sculptor Betty Rea (1904–64), an AIA member, with contributions by Herbert Read, Francis Klingender, Eric Gill, A. L. Lloyd and Alick West.

During World War II the AIA mounted a number of exhibitions to promote the ideological objectives of the war, notably *For Liberty* (1943), which was held in a basement canteen of the John Lewis department store in London; this included a number of specially commissioned works, for example *What We Are Fighting For* (1943; Zurich, Ksthaus) by Oskar Kokoschka. After the war exhibitions were held at the AIA Gallery, established in Lisle Street, London, in 1947, and there were further important theme exhibitions, such as the *Mirror and the Square* (1952; London, New Burlington Gals), which reviewed the range of current British art from forms of realism to abstract art.

The designer Misha Black (1910–77) and the painters James Boswell (1906–71) and Richard Carline (1896–1980) were successive chairmen of the AIA. Others prominent in the AIA's administration included the art historian Francis Klingender (the most influential of the Marxist intellectuals in the AIA) and the artists James Fitton (1899–1982), Paul Hogarth (*b* 1917), James Holland (*b* 1905), Victor Pasmore, Laszlo Peri, Cliff Rowe (1904–88) and Carel Weight (*b* 1908). Picasso, who had visited England to address the Sheffield Peace Congress in November 1950, was among the major artists, including Fernand Léger and Henry Moore, who participated in AIA exhibitions. The AIA officially abandoned its political objectives in 1953, but it continued as an exhibiting society until 1971, when it was dissolved.

Bibliography
D. D. Egbert: *Social Radicalism and the Arts: The West* (New York, 1970)
T. Rickaby: 'The Artists International', *Block*, 1 (1979), pp. 5–14
The Story of the Artists International Association, 1933–1953 (exh. cat. by L. Morris and R. Radford, Oxford, MOMA, 1983)
R. Radford: *Art for a Purpose: The Artists International Association, 1933–1953* (Winchester, 1987)

ROBERT RADFORD

Arturo

Argentine art magazine published as a single issue in Buenos Aires in early 1944. Its avant-garde stance proved influential on the development of Constructivism in Argentina, leading directly to ARTE MADÍ and to ASOCIACIÓN ARTE CONCRETO INVENCIÓN.

□

Ashcan school

Term first used by Holger Cahill and Alfred Barr in *Art in America* (New York, 1934) and loosely applied to American urban realist painters. In particular it referred to those members of THE EIGHT (ii) who shortly after 1900 began to portray ordinary aspects of city life in their paintings, for example George Luks's painting *Closing the Café* (1904; Utica, NY, Munson-Williams-Proctor Inst.). Robert Henri, John Sloan, William J. Glackens, Everett Shinn and George Luks were the core of an informal association of painters who, in reaction against the prevailing restrictive academic exhibition procedures, mounted a controversial independent exhibition at the Macbeth Galleries, New York (1908).

Sloan, Glackens, Shinn and Luks had all worked for the *Philadelphia Press*. It was in Philadelphia, where Henri had trained at the Academy of Fine Arts, that he convinced them to leave their careers as newspaper illustrators to take up painting as a serious profession. In an explicit challenge to the 'art for art's sake' aesthetic of the late 19th century, Henri proposed an 'art for life', one that would abandon the polished techniques and polite subject-matter of the academicians; it would celebrate instead the vitality that the painter saw around him in everyday situations (see col. pl. VII).

In 1904 Henri set up his own school in New York in a Latin quarter on Upper Broadway. He was joined there by Sloan, Glackens, Luks and Shinn; George Bellows, Glenn O. Coleman (1887–1932) and Jerome Myers (1867–1940) also associated themselves with Henri's new urban realism. Henri and his followers were initially referred to as the 'revolutionary black gang', a term that alluded to the dark subdued palette that characterized much of the group's early paintings. They drew

subject-matter from life in the Bowery, Lower Sixth Avenue and West 14th Street. Among the typical works of the Ashcan school were images of street urchins, prostitutes, athletes, immigrants and boxers, as in Bellows's *Stag at Sharkey's* (1909; Cleveland, OH, Mus. A.) and *Dempsey and Firpo* (1924; New York, Whitney. Such figure studies, together with street scenes such as *Hairdresser's Window* by Sloan, convey a vivid impression of life in New York in the early years of the century.

Their choice of such picturesque contemporary motifs was generally considered bold, but as William B. McCormick, writing in the *New York Press* in 1908, observed, there were clear precedents in European art:

'Surely it is not "revolutionary" to follow in the footsteps of the men who were the rage in artistic Paris twenty years ago. Nor is it "a new departure in American art" to paint after the manner of Manet, Degas, and Monet.'

Bibliography

I. Forrester: 'New York Art Anarchists', *N Y World Mag.* (10 June 1906), p. 6

B. B. Perlman: *The Immortal Eight, American Painting from Eakins to the Armory Show, 1870–1913* (New York, 1962)

W. I. Homer: 'The Exhibition of "The Eight": Its History and Significance', *Amer. A. J.*, i/1 (1969), pp. 53–64

—: *Robert Henri and his Circle* (Ithaca, 1969)

M. S. Young: *The Eight* (New York, 1973)

B. B. Perlman: 'Rebels with a Cause – The Eight', *ARTnews*, lxxxi/18 (1982), pp. 62–7

J. Zilczer: 'The Eight on Tour, 1908–1909', *Amer. A. J.*, xvi/64 (1984), pp. 20–48

B. B. Perlman: Painters of the Ashcan School: The Immortal Eight *(New York, 1988)*

E. H. Turner: Men of the Rebellion: The Eight and their Associates at the Phillips Collection *(Washington, DC, c.1990)*

Painters of a New Century: The Eight and American Art *(exh. cat. by E. Milroy, Milwaukee, WI, A. Mus.; Denver, CO, A. Mus.; New York, Brooklyn Mus. and elsewhere; 1991–2)*

V. M. Mecklenburg: 'New York City and the Ashcan School', Antiques, cxlviii (Nov 1995), pp. 684–93

Metropolitan Lives: The Ashcan Artists and their New York *(exh. cat. by R. Zurier, R. W. Snyder and V. M. Mecklenburg, Washington, DC, N. Mus. Amer. A., 1995–6)*

B. Fahlman: 'Realism: Tradition and Innovation', American Images: The SBC Collection of Twentieth-century American Art, *ed. E. Whitacre, L. C. Martin and W. Hopps (New York, 1996)*

V. A. Leeds: The Independents: The Ashcan School and their Circle from Florida Collections *(Winter Park, FL, 1996)*

M. SUE KENDALL

Asnova [Assotsiatsiya Novykh Arkhitektorov; Rus.: Association of New Architects]

Russian architectural group active in Moscow from 1923 to 1932. It was founded by Nikolay Ladovsky, Vladimir Krinsky and Nikolay Dokuchayev and was the USSR's first avant-garde architectural association. Asnova intended to serve the new Soviet regime by establishing an architectural language based on economic and psychological efficiency. This Rationalist approach also attempted to secure an irrefutable, scientific foundation for the aesthetics of modern architecture.

Ladovsky, Dokuchayev and Krinsky had already associated in Zhivskulptarkh (Paintsculptarch; 1919–20), Obmas (United studios; 1920–23) and the 'First Working Group of Architects' in Inkhuk (Institute of Artistic Culture; 1921–3). Vasily Kandinsky, Kazimir Malevich and El Lissitzky, among others, contributed to these multi-disciplinary groups, and their insights clarified the theoretical enquiries subsequently investigated by Asnova. From the early 1920s until its dissolution, Ladovsky, Dokuchayev and Krinsky taught at the Vkhutemas (Higher (state) artistic and technical workshops), Moscow. This academic context helped the trio to focus their ideas, create a coherent agenda and outline a methodological approach to architectural design. They restructured the curriculum of the 'Basic Division' (foundation course) to reflect Ladovsky's 'psychoanalytical' method and applied it in the studios

and workshops devoted to three-dimensional arts. By setting the tone and the rationale of the obligatory introductory courses, the members of Asnova helped to catalyse the Vkhutemas's creative energies. There was also an attempt in 1926 to found a journal, *Izvestiya ASNOVA*, but only one issue was produced.

Asnova polemically opposed the Constructivist position of Osa, the competing wing of the Soviet architectural avant-garde during the 1920s. While the Constructivists argued that a building's programme, function and technical considerations sufficed to determine its architectural design, the members of Asnova encouraged designers to clarify architectural form for the public's mental, perceptual and psychological comfort, which was held to depend on the merging of a building's visual and conceptual realities. The architect was thus obliged to maximize optical stimuli, through the use of volume and structure, in order to minimize the discrepancies between perceived form and actual form. These ideas were reflected in such buildings as Krinsky's Vesenkha skyscraper (1922–3), Lubyanka Square, Moscow, and in such projects as Ladovsky's competition entry (1929) for the monument to *Christopher Columbus* in Santo Domingo, Dominican Republic. Functioning as a loose association of broadly like-minded architects, Asnova's fluid membership also included Konstantin Mel'nikov and El Lissitzky, some of whose designs reveal clear debts to Asnova precepts, for example the projects for the Lenin Podium (1924) and the Wolkenbügel (1924), Moscow, by El Lissitzky, and the Soviet pavilion at the Exposition Internationale des Arts Décoratifs et Industriels Modernes, Paris (1925), and Rusakov Club (1927), Moscow, by Mel'nikov.

Writings

Izvestiya ASNOVA, i (1926)

Arkhitektura VKHUTEMAS: Raboty arkhitekturnogo fakulteta VKHUTEMASa, 1920–1927 [Architecture in the Vkhutemas: the work of the Architecture Department in the Vkhutemas, 1920–1927] (Moscow, 1927)

El Lissitzky: *Russland: Die Rekonstruktion der Architektur in der Sowjetunion* (Vienna, 1930; Eng. trans., 1970)

V. Krinsky: 'Voznikoveniye i zhizn' Assotsiatsii Novykh Arkhitektorov—ASNOVA [Emergence and life of the Association of New Architects—ASNOVA], *Sov. Arkhit.*, 18 (1969), pp. 20–28

V. Ye. Khazanova: *Iz istorii sovetskoy arkhitektury, 1926–1932: Dokumenty i materialy* [From the history of Soviet architecture, 1926–1932: documents and materials] (Moscow, 1970)

Bibliography

A. Kopp: *Town and Revolution: Soviet Architecture and City Planning, 1917–1935* (New York, 1970)

M. Bliznakov: 'The Rationalist Movement in Soviet Architecture of the 1920s', *Russian Formalism*, ed. S. Bann and J. E. Bowlt (Edinburgh, 1973), pp. 147–61

S. O. Chan-Magomedov: 'Nikolaj Ladovskij—An Ideology of Rationalism', *Lotus Int.*, xx (1978), pp. 104–26

A. Senkevitch: 'Aspects of Spatial Form and Perceptual Psychology in the Doctrine of the Rationalist Movement in Soviet Architecture in the 1920s', *VIA*, vi (1983), pp. 78–115

S. O. Chan-Magomedov: *Pioniere der sowjetischen Architektur* (Dresden, 1983); Eng. trans. as S. O. Khan-Magomedov: *Pioneers of Soviet Architecture* (London, 1987)

K. PAUL ZYGAS

Asociación Arte Concreto Invención

Argentine group formed in November 1945 by Tomás Maldonado and other Constructivist artists and active until c. 1964. Its other original members were Lidy Prati (b 1921), Alfredo Hlito, Manuel Espinosa, Raúl Lozza (b 1911), Alberto Molenberg (b 1921), Ennio Iommi, Claudio Girola (b 1923), Jorge Souza (b 1919), Primaldo Mónaco (b 1921), Oscar Núñez (b 1919), Antonio Caraduje (b 1920) and the poet Edgar Bayley (b 1919). Maldonado and Prati were prominent among the artists involved in the publication of the single issue of the magazine *Arturo* in early 1944, in which the image–invention was proposed as an alternative to representational, naturalistic or symbolic imagery, but they did not take part in two exhibitions of associated artists in 1945 that led to the establishment of ARTE MADÍ. In fact, their central role in setting up the

Asociación Arte Concreto Invención was a way of declaring their independence from the other group.

The first exhibition of the Asociación opened on 18 March 1946. It was accompanied by the publication of the *Manifiesto invencionista*, which affirmed the values of concrete art over figurative art and stressed the importance of a social role for art. Works exhibited by group members later that year, together with the theories espoused by them in two issues of their magazine (the first, *Revista Arte concreto invención*, published in August 1946 and the second, *Boletín de la Asociación arte concreto invención*, following in December 1946), were concerned largely with investigating the shaped canvas in a variety of ways that anticipated the work of American painters in the 1960s. After exploring with great inventiveness the relationship between the painted surface and its shape or supporting wall, they concluded that these formal concerns were too limiting and returned to more conventional rectangular formats, leaving it to painters associated with Arte Madí and PERCEPTISMO to continue with these experiments. While the painters concerned themselves with clear and harmonious structures of form and colour, the group's sculptors used new materials in constructions that replaced solid mass with transparencies and intersecting planes. From 1952 to 1954 Maldonado and other members of the group banded together with four independent painters working in a semi-abstract style as ARTISTAS MODERNOS DE LA ARGENTINA. Although group members gradually went their own way, their common aesthetic remained influential not only on painting and sculpture but also on theories of architecture and design.

Bibliography

N. Perazzo: *El arte concreto en la Argentina* (Buenos Aires, 1983), pp. 87–108

M. H. Gradowczyk: Argentina: Arte Concreto-Invención 1945/Grupo Madí 1946*(exh. cat., New York, Rachel Adler Gal., 1990)*

G. Pérez-Barreiro: 'The Negation of All Melancholy: Arte Madí/Concreto-Invención, 1944–1950', Art from Argentina, 1920–1994 *(exh. cat. by D. Elliott and others, Oxford, MOMA, 1994), pp. 54–65*

—: *The Argentine Avante-Garde, 1944–1950* (diss., Colchester, U. Essex, 1996)

NELLY PERAZZO

Association of American Painters and Sculptors

Group of artists founded in New York in 1911 with the aim of finding suitable exhibition space for young American artists. After preliminary meetings between the painters Jerome Myers (1867–1940), Elmer MacRae (1875–1955), Walt Kuhn (1877–1949) and others, a meeting was held at the Madison Gallery on 16 December 1911 for the purpose of founding a new artists' organization. At a subsequent meeting on 2 January 1912 they elected officers and began to discuss exhibition plans. The president, Julian Alden Weir, who had been elected *in absentia*, resigned, however, and the leadership passed to Arthur B. Davies.

Davies, Walt Kuhn and Walter Pach soon took the lead and developed the plan for a major international exhibition, much to the disapproval of the American Realists associated with Robert Henri; the latter group was interested in gaining broader exposure to a public that knew only of the major figures associated with the National Academy of Design and saw no reason to include foreign modernists. Davies and his allies, contemptuous of their provincialism, ignored their wishes. The result of the Association of American Painters and Sculptors' plans was the International Exhibition of Modern Art, known as the Armory show (1913), which introduced European modernism to the art-viewing public, and which in the eyes of both the public and the artists stripped the National Academy of Design of its importance. The Association disbanded shortly afterwards.

Bibliography

M. Brown: *American Painting from the Armory Show to the Depression* (Princeton, 1955)

—: *The Story of the Armory Show* (New York, 1963, rev. 1988)

DAVID M. SOKOL

Association of Artists of Revolutionary Russia [AKhRR; Rus. Assotsiatsiya Khudozhnikov Revolyutsionnoy Rossii]

Soviet group of artists active in Moscow and Leningrad (now St Petersburg) in 1922–32. It was established in January 1922 by a group of artists, including Aleksandr Grigor'yev (1891–1961), Yevgeny Katsman (1890–1976), Sergey Malyutin and Pavel Radimov (1887–1967), who were inspired by the 47th exhibition of the Peredvizhniki (the Wanderers). It was first called the Association of Artists Studying Revolutionary Life (Assotsiatsiya Khudozhnikov Izuchayushchikh Revolyutsionnyy Byt), then the Society of Artists of Revolutionary Russia (Obshchestvo Khudozhnikov Revolyutsionnoy Rossii) and finally, after the first group exhibition in Moscow in May 1922, the Association of Artists of Revolutionary Russia.

The primary goal of the artists of the Association, outlined in the first manifesto in 1922, was to depict post-revolutionary Russia—the everyday life of the proletariat, the peasantry and the Red Army—in a direct, accessible manner. Believing artists were 'the spokesmen of the people's spiritual life', they turned to the traditions of Russian 19th-century Critical Realism, concentrated on the didactic mission of art and voiced their opposition to the avant-garde. In addition to older Realists such as Abram Arkhipov, Nikolay Kasatkin and Konstantin Yuon, the Association immediately attracted many younger artists such as Isaak Brodsky, Aleksandr Gerasimov and Boris Ioganson, and, in order to acquaint themselves with the new Socialist reality, the members visited factories, railway workshops, shipyards etc, often using their experiences as the subject-matter of their paintings. The results of the desire expressed in the manifesto, 'to set down artistically and documentarily, the revolutionary impulse of this great moment of history' and to 'provide a true picture of events and not abstract concoctions discrediting our Revolution in the face of the international proletariat', showed a range of styles and treatments, including Boris Kustodiyev's dramatic *Bolshevik* (1920; Moscow, Tret'yakov Gal.), Aleksandr Gerasimov's *The Attack*

on the People (Moscow, Cent. Lenin Mus.; see fig. 43), Malyutin's restrained portrait of *Dmitry Furmanov* (1922; Moscow, Tret'yakov Gal.) and Mitrofan Grekov's battle paintings (e.g. *Gun Carriage*, 1925; Moscow, Tret'yakov Gal.). Brodsky's almost photographic compositions (e.g. *V. I. Lenin in the Smolny*, 1930; Moscow, Tret'yakov Gal.) were offset by Gerasimov's rhetorical depictions of Lenin, such as *V. I. Lenin on the Tribune* (1929–30; Moscow, Cent. Lenin Mus.), and Yevgeny Katsman's use of Neue Sachlichkeit (e.g. *Kaliazin Lacemakers*, 1928; Moscow, Tret'yakov Gal.).

By the mid-1920s the Association was the most influential single body of artists in Soviet Russia, with affiliates throughout the country. It opened a special young artists' section, the Association of AKhRR Youth (OMAKhRR; Obedineniye Molodyozhi AKhRR), established its own publishing house and enjoyed direct governmental support. In 1928 the name was again changed, to the Association of Artists of the Revolution (AKhR; Assotsiatsiya Khudozhnikov Revolyutsii), and in 1929 it founded its own periodical *Iskusstvo v massy* ('Art to the masses'). In other words, the Association became a powerful and vociferous arbiter of official taste and took every opportunity to condemn 'formalist experimentation', not only among the radical members of the old avant-garde, such as Malevich, but also among the younger generation of artists belonging to the Society of Easel Painters (OST), such as Yury Pimenov and David Shterenberg. The Association was abolished along with all other formal art and literary groups by the state decree in 1932, *On the Reconstruction of Literary and Artistic Organizations*, but its legacy was enduring, for its emphasis on the simple and didactic illustration of contemporary reality contributed much to the development of Socialist Realism in the 1930s and 1940s.

Bibliography
V. Kniazeva: *AKhRR* (Leningrad, 1967)

I. Gronsky and V. Perelman, eds: *AKhRR: Sbornik vospominaniy, statey dokumentov* [AKhRR: a collection of memoirs, articles and documents] (Moscow, 1973)

JOHN E. BOWLT

Association of Ottoman Painters
[Association of Turkish Painters;
Turkish Fine Arts Society;
Turk. Osmanli ressamlar cemiyeti;
Türk ressamlar cemiyeti; Türk sanayi-i
nefise birliği; Güzel sanatlar birliği]

Turkish group of painters founded in 1908 by students from the Fine Arts Academy in Istanbul. They had their first exhibition in Istanbul in 1910 and also published the monthly journal *Naşir-i efkâr* ('Promoter of ideas'), which was supported financially by Crown Prince Abdülmecid (1868–1944), himself a painter and calligrapher and honorary president of the Association. The members included Ibrahim Çallı, who was recognized as the most prominent in the group, Ruhi Arel (1880–1931), Feyhaman Duran (1886–1970), Nazmi Ziya Güran, Namık Ismail (1890–1935), Avni Lifij (1889–1927), Hikmet Onat (1886–1977) and Sami Yetik (1876–1945). It was not very active from 1910, when some of its painters left Istanbul to study art in Europe, but their return at the outbreak of World War I brought renewed activity. Some members were responsible for bringing Impressionism and other European movements to Turkey, and they acquainted the Turkish public with figurative and narrative compositions, as well as portraiture. The Association organized annual exhibitions at the Galatasaray High School in Istanbul, and some of the artists were given workshops and taken to the Front during World War I. Many of the painters also became influential teachers at the Fine Arts Academy: Çallı from 1914, Onat from 1915, Güran from 1918, Duran from 1919, Ismail from 1927.

In 1921 the Association of Ottoman Painters was renamed the Association of Turkish Painters, and when the Turkish Republic was proclaimed in 1923 its members were responsible for the first painting exhibition in Ankara. Although challenged in the late 1920s by new ideas brought from Europe by younger Turkish artists, the members of the Association remained influential figures in Turkish art. The Association of Turkish Painters was renamed the Turkish Fine Arts Society in 1926, and was known as the Fine Arts Society from 1929.

Bibliography
S. Tansuğ: *Çağdaş Türk sanatı* [Contemporary Turkish art] (Istanbul, 1986)
G. Renda and others: *A History of Turkish Painting* (Geneva, Seattle and London, 1988)

☐

Association of Revolutionary Art of Ukraine [ARMU; Ukrain. Asotsiiatsiya Revolyutsiynoho Mystetstva Ukraïny]

Ukrainian group of artists active from 1925 to 1930. The association was founded by statute on 25 August 1925 in Kiev, with branches formed subsequently in other Ukrainian cities such as Kharokov (Kharkiv), Odessa, Dnepropetrovs'k (Dnipropetrivs'k) and Uman'. Members also lived in Moscow, Leningrad (now St Petersburg) and Paris. Artists of various artistic backgrounds and different training belonged to the association, but it was best represented by the avant-garde artists Oleksandr Bohomazov, Nina Genke-Meller (1893–1954), Vasyl' Yermilov (1894–1967), Oleksandr Khvostov (1895–1968), Vadym Meller (1884–1962), Viktor Pal'mov (1888–1929) and Vladimir Tatlin. Its theoretical platform, formulated by Ivan Vrona (1887–1970), rector of the progressive Kiev State Art Institute, was based on Marxist principles, recognizing the era as a transitional stage towards a more cohesive national proletarian reality. The association's objective was to develop the strengths of Ukrainian artists and to be flexible enough to be able to consolidate a variety of formalist leanings without sacrificing high technical quality. Together with the Association of Artists of Red Ukraine (AKhChU; Asotsiiatsiya Khudozhnykiv Chervonoî Ukraîny), it succeeded in organizing one of the first exhibitions devoted to Ukrainian art of the 1920s. By 1927 ARMU was the single most influential body of artists in the country. It came to be dominated by painters who were attracted to the monumental art of Mykhaylo Boychuk, which was inspired by the Byzantine period. Among those who followed Boychuk's style were Sofiya A. Nalepins'ka-Boychuk (1884–1939), Ivan I. Padalka (1897–1938), Oksana Pavlenko (1895–1991), Mykola Rokyts'ky

(1901–44), and Vasyl' F. Sedlyar (1889–1937). In debating the means whereby ARMU's aim to revitalize the artistic culture of Ukraine could be realized, Sedlyar (1926) laid equal emphasis on the importance of concepts such as artistic industry and material culture, as well as on the visual arts. He defended the association against its rival, the ASSOCIATION OF ARTISTS OF REVOLUTIONARY RUSSIA (AKhRR), a group that turned to 19th-century Realism and by doing so stood in opposition to the left wing and to Productivist art as a whole. By June 1930, internal differences with ARMU had caused its leaders to dissolve it and to organize the group October (Ukrain. Zhovten') in its place.

Bibliography

V. Sedlyar: *AKhRR ta ARMU* [AKhRR and ARMU] (Kiev, 1926)
I. Vrona: *Mystetstvo Revoliutsiĩ i ARMU* [Art of the Revolution and ARMU] (Kiev, 1926)

MYROSLAVA M. MUDRAK

Auto-destructive art

Term applied to works of art in a variety of media, with the capacity to destroy themselves after a finite existence, ranging from a few moments to 20 years. This self-destruction may result from natural processes such as collisions, decomposition and dematerialization, or from mechanisms requiring collaboration between artists, scientists and engineers, and may be either random and unpredictable or strictly controlled. The term, which is also sometimes used more loosely to describe any works with the capacity to transform themselves, was first used by Gustav Metzger in a manifesto (November 1959). Metzger elaborated on what he saw as an inherently political art theory and practice in five manifestos, in public lectures and demonstrations and in his own innovative techniques, including 'painting' in acid on nylon (1960–62).

No formal, international movement grew out of Metzger's experiments, but various isolated and independent artists used destruction as a central element in their works in the early 1960s, including Jean Tinguely, whose *Homage to New York* burst into flames in March 1960. In 1961 Kenneth Kemble and the Arte Destructivo group organized the exhibition *Arte destructivo* in Buenos Aires, and in 1962 Rafael (Ralph) Montanez Ortiz (*b* 1934) wrote *Destruction Art*, a manifesto describing his destruction sculptures. These developments, and the performances of the Viennese AKTIONISMUS group *c.* 1962–70, often involving self-mutilation and ritual, were seen by some as manifestations of a common tendency. Recognizing this, Metzger organized the international Destruction in Art Symposium (DIAS) in London in 1966, in which artists, poets, musicians and psychologists met to create and discuss the social implications of Auto-destructive art.

Writings

G. Metzger: *Auto-destructive Art* (London, 1959)
—: *Manifesto Auto-destructive Art* (London, 1960)
—: *Auto-destructive Art, Machine Art, Auto-creative Art* (London, 1961)
—: *Manifesto World* (London, 1962)
—: *On Random Activity in Material/Transforming Works of Art* (London, 1964)
—: *Auto-destructive Art* (London, 1965)

Bibliography

Destruction to Art: Destroy to Create (exh. cat., intro. E. H. Varian; New York, Finch Coll. Mus. A., 1968)
K. Stiles: 'Synopsis of the Destruction in Art Symposium (DIAS)', *The Act* (1987), no. 1
—: *The Destruction in Art Symposium: The Radical Cultural Project of Event-structured Art* (diss., Berkeley, U. CA, 1987)

KRISTINE STILES

Automatistes, Les

Canadian group of artists active during the 1940s and the early 1950s, led by Paul-emile Borduas. They were named by Tancrède Marcil jr in a review of their second Montreal exhibition, published in February 1947 in *Le Quartier latin*, the student journal for the University of Montreal, Quebec. The earliest characteristic example of the group's work was Borduas's *Green Abstraction* (1941; Montreal, Mus. F.A.), a small oil painting intended as an equivalent to the automatic writing of the Surrealist poet André Breton; it was succeeded by

a series of 45 gouaches exhibited by Borduas in the foyer of the Théâtre Ermitage in Montreal from 25 April to 2 May 1942 and by other works painted before he moved to New York in 1953.

The group began to form around Borduas in the 1940s when students came to his studio to discuss Marxism, Surrealism and psychoanalysis, virtually forbidden subjects in Quebec at this time. Among these younger artists were Marcel Barbeau (b 1925), Jean-Paul Riopelle and Roger Fauteux, who studied under Borduas at the Ecole du Meuble, two students from the Ecole des Beaux-Arts, Pierre Gauvreau (b 1922) and Fernand Leduc, and Jean-Paul Mousseau (b 1927) from the Collège Notre-Dame. Although inspired by Surrealism and particularly by the concept of automatism, Les Automatistes extricated themselves from the illusionistic bias of the mainstream of that movement and applied its principles to an abstract idiom. Among the others associated with the group were Pierre Gauvreau's brother, the writer Claude Gauvreau (1925–71), the photographer and editor Maurice Perron, the ballet dancer Françoise Sullivan (b 1927), the future psychiatrist Bruno Cormier and the painter Marcelle Ferron (b 1924). The group exhibited in the studio of Franziska Boas in New York in January 1946 and twice in Montreal, in April 1946 and in February 1947, in improvised locations. In Paris Les Automatistes held an exhibition from June to July 1947 at the tiny Galerie du Luxembourg, where they were noticed by the French painter Georges Mathieu.

On 9 August 1948 Les Automatistes published their manifesto REFUS GLOBAL, which was regarded as anarchic and controversial, resulting in the ostracization of Borduas and the demoralization of the group. To help keep the group alive Claude Gauvreau organized two further exhibitions—Les Etapes du vivant in rue Ontario, Montreal, in May 1951 and La Matière chante at Galerie Antoine, Montreal, in April–May 1954—but by then two of the main exponents of Automatisme, Riopelle and Leduc, were living in Europe and other members of the group were keen to exhibit independently.

Bibliography

G. Mathieu: Au-delà du tachisme (Paris, 1963)

Borduas et les Automatistes, 1942–1955 (exh. cat., ed. B. Teyssèdre; Paris, Grand Pal.; Montreal, Mus. A. Contemp., 1971)

FRANÇOIS-MARC GAGNON

Bansko school

Art school in Bansko, south-east Bulgaria, that flourished from the late 18th century to the end of the 19th. The Bansko school artists worked on the decorative painting of houses and churches, and produced architectural designs, frescoes and icons. The first well-known artist in Bansko, and the founder of the school, was Toma Vishanov (b c. 1750), called Molera, who studied painting in Vienna in the second half of the 18th century. There are strong Baroque and Rococo elements in his icons and church frescoes, which also show traditional orthodox scenery and the influence of Western Catholic art. Vishanov's successors—his son, Dimitar Vishanov Molerov (d 1868), his grandson, Simeon Dimitrov Molerov (1816–1903), and his great-grandson, Georgi Simeonov Molerov (1844–78)—did not adopt his artistic views. Instead, as masters of line and colour, they followed the Creto-Athonite style of 18th- and 19th-century Bulgaria, working in the south-east of the country, in Rila monastery and at Mt Athos. The Bansko artists of the 19th century worked mainly for small village churches in a rustic folk style. A group of Bansko artists specialized in the decoration of churches and rich town houses, and they produced murals with landscapes and genre compositions in some houses. Domestic architecture in Bansko is different from the architecture in other regions of the country. The houses are made entirely of stone and are fortified, as in the Middle Ages. Some of the work of the Bansko painters survives, for example works by Toma Vishanov include murals (1811), church of the Virgin of Mercy, Rila Monastery; icons, church of the Holy Virgin, Bansko; and painted altar gates (1803; Sofia, N. Gal. Dec. & Applied A.). Surviving works by Dimitar Vishanov Molerov include murals and icons (1840–41) in the catholicon at Rila Monastery and murals (1835) in the church of Pchelino.

Bibliography

D. Molerov: 'Ikonopis v Bansko' [Icon painting in Bansko], *Izvestiya Etnog. Muz.*, iii (1923), pp. 43ff

N. Mavrodinov: *Izkustvoto na bălgarskoto văzrazhdane* [The art of the Bulgarian renaissance] (Sofia, 1955), pp. 41, 71–84, 198–9

A. Vasiliev: *Toma Vishanov Molera* (Sofia, 1969)

<div align="right">IVANKA GERGOVA</div>

Bauhaus [Bauhaus Berlin; Bauhaus Dessau, Hochschule für Gestaltung; Staatliches Bauhaus in Weimar]

German school of art, design and architecture, founded by Walter Gropius. It was active in Weimar from 1919 to 1925, in Dessau from 1925 to 1932 and in Berlin from 1932 to 1933, when it was closed down by the Nazi authorities. The Bauhaus's name referred to the medieval Bauhütten or masons' lodges. The school re-established workshop training, as opposed to impractical academic studio education. Its contribution to the development of FUNCTIONALISM in architecture was widely influential. It exemplified the contemporary desire to form unified academies incorporating art colleges, colleges of arts and crafts and schools of architecture, thus promoting a closer cooperation between the practice of 'fine' and 'applied' art and architecture. The origins of the school lay in attempts in the 19th and early 20th centuries to re-establish the bond between artistic creativity and manufacturing that had been broken by the Industrial Revolution. According to Walter Gropius in 1923, the main influences included John Ruskin and William Morris, and various individuals and groups with whom he had been directly involved: for example Henry Van de Velde; such members of the Darmstadt artists' colony as Peter Behrens; the Deutscher Werkbund; and the Arbeitsrat für Kunst.

1. Weimar period, 1919–c. 1925

In April 1919 Gropius founded the Staatliches Bauhaus in Weimar, incorporating the former Kunstschule and the Kunstgewerbeschule, which had been directed by Van de Velde. Although Van de Velde had originally proposed Gropius as a possible successor in 1915, the issue was not settled until four years later, after the end of World War I. The allusion in the Bauhaus's name to medieval masons' lodges was emphasized by Lyonel Feininger's Expressionist and Cubist-inspired woodcut of a Gothic cathedral, which was used for the title page of the founding manifesto of the Bauhaus in 1919. Gropius's manifesto ran (Gropius, 1919):

> The ultimate aim of all artistic activity is building! . . . Architects, sculptors, painters, we must all get back to craft! . . . The artist is a heightened manifestation of the craftsman. . . . Let us form . . . a new guild of craftsmen without the class divisions that set out to raise an arrogant barrier between craftsmen and artists! . . . Let us together create the new building of the future which will be all in one: architecture and sculpture and painting.

The reversion to the ideal of the medieval craftsman contrasted with the cooperation between art, industry and commerce that Gropius had advocated before World War I, and which was to dominate the Bauhaus after 1922. This change of direction can easily be explained against the background of the specific circumstances of the period. The devastation of the war and the immediate postwar period caused Gropius to have grave doubts about the machine and the expectations of progress associated with it. Like many of his contemporaries, he was borne along by the romantic utopian hope that by turning back to the Middle Ages with its deep spirituality and communal ideals, meaning and direction could be given to one's actions. Similar ideas were also circulating at that time in the Berlin Arbeitsrat für Kunst, to which Gropius belonged, and which had a significant influence on the early days of the Bauhaus.

Gropius began to gather an unrivalled array of avant-garde artists. In 1919 he first appointed the painters Lyonel Feininger and Johannes Itten and the sculptor Gerhard Marcks as teachers at the Bauhaus. In the period up to 1922 they were

followed by Georg Muche and Lothar Schreyer (1886–1966), both of whom, like Itten, emanated from the circle centred on the Expressionist Sturm-Galerie in Berlin, run by Herwarth Walden. They were also joined by Oskar Schlemmer, Paul Klee (see col. pl. VIII) and Vasily Kandinsky (see col. pl. XVIII). The structure of the Bauhaus curriculum was represented by Gropius in a wheel-like diagram, in which the outer edge of the wheel signifies the six-month preliminary course (the *Vorkurs*), while the two middle rings stand for the three-year courses (the *Formlehre* and *Werklehre*), including the materials that were used. The hub of the wheel refers to the building construction and engineering with which the Bauhaus was also concerned.

One of the most influential personalities on early Bauhaus was undoubtedly Johannes Itten, who established the celebrated preliminary course, derived from his experiences as a student at Adolf Hölzel's academy in Stuttgart. This compulsory course was designed to purge novices of residual academic tendencies and to activate their individual artistic potential. It was also intended to impart basic qualifications in creativity to serve as a foundation for the subsequent workshop training. The basis of the course was Itten's general precept about the artistic value of contrasting effects, whether of light and dark, materials and textures, forms, colours and rhythms. A prominent place was reserved in Itten's teaching for 'analyses of Old Masters'. These had the objectives of establishing either the rationally perceptible picture-structures based on geometry and construction, or the essential meaning expressed in the work, which should be identified through empathy. Feeling and thinking, intuition and intellect, expression and construction belonged inextricably together in Itten's holistically conceived educational and teaching programme.

The educational and teaching structure enabled those studying to qualify doubly as artists and craftsmen. The 'dual system' involved, on the one hand, artistic instruction known as *Formlehre*, in which the artist–teachers invested their full powers of innovation. Klee's lectures on basic problems of form, and Kandinsky's 'Colour Seminar', his 'Introduction to the Abstract Elements of Form' and his course on 'Analytical Drawing' were particularly noteworthy.

The other component of the syllabus was 'practical instruction' (*Werklehre*), in which the students attended regular classes in the Bauhaus workshops. The strong emphasis on craft was expressed in the fact that in the early days of the Bauhaus people spoke not of professors and students but of masters and apprentices. Each workshop was run by two masters, an artist and a craftsman or technician, or in the terminology of the Bauhaus a *Meister der Form* and a *Meister des Handwerks*. Each master specialized in one or more forms of art, although in the early phase people's spheres of activity were not always definitely established, and they altered frequently as a result of staffing changes. The form masters included Gropius, whose carpentry workshop made furniture characterized by strictly cubic tectonics and to some extent influenced by followers of De Stijl, in particular Gerrit Rietveld. Modernist styles also influenced the abstract work of Kandinsky in his mural painting workshop, while folklore inspired the individual craft textiles from Muche's weaving room.

The workshop training was aimed at the acquisition of specific technical and craft skills as well as artistic and design skills, based on the fundamental principle of learning through doing, of practical work on concrete tasks. Here the private aesthetic languages of the form masters were transformed into 'a public institutional language' resulting from the 'technically orientated attempts at problem-solving'. This attempt to achieve communication between art and craft was extremely progressive, at that time matched only in revolutionary Russia at Vkhutemas in Moscow. The Bauhaus's integration of different art and craft forms was exemplified by the avant-garde theatre workshop run first by Schreyer and then by Schlemmer. As well as producing paintings, Schlemmer designed costumes for his ballets that resembled coloured metallic sculpture (e.g. *The Abstract*, 1922; Stuttgart, Staatsgal.).

Despite such attempts to combine different arts in one piece of work, the Bauhaus in its early

phase was in general far from realizing the idea of the *Gesamtkunstwerk* under the 'wings of architecture'. In the first years there was no department of architecture, even though, according to the original concept, it should have been the cornerstone of the Bauhaus. Moreover, there was no effective coordination between the individual workshops, although there were exceptions, for example the collaboration of several workshops in furnishing and decorating the Expressionist Haus Sommerfeld (1920–21) in Dahlem, Berlin, designed by Gropius. The various workshop products from this Expressionist phase of the Bauhaus show the influence of Johannes Itten: with all their formal strictness they are in fact single pieces made by a craft process, some with ornamental surfaces. They show a sharp contrast with the principles of the pre-war Werkbund directed towards industrial mass production. Another interesting contradiction relates to the role of women in the Bauhaus. Although at the outset the school took women as students on the same basis as men, by 1920 Gropius was attempting to force women from the *Vorkurs* to the weaving, pottery or bookbinding workshops, and he prevented their admission to study architecture.

In its first years the Bauhaus was severely tested by the conflict between Gropius and Itten. Apart from personal differences, this was a conflict of principles that arose from the incompatibility between Itten's emphasis on autonomous artistic creation and Gropius's interest in socially committed design. Itten's primary orientation towards fine art was accompanied by Bohemian attitudes and quasi-religious activities in the Mazdaznan movement. In contrast, Gropius's basic inclination was directed towards finding a new place in society for the artist who had lost his roots in the 19th century, to enable him to collaborate in a socially constructive way on the shaping of reality. As a result, from *c.* 1922 Gropius supported a move in the Bauhaus towards industrial design, based on the following now famous formula: 'Art and technology, a new unity: technology does not need art, but art does need technology.' This tendency was strengthened as

the widespread pathos of the immediate post-war period soon gave way to a general disenchantment that led people to seek what was socially necessary and practicable. The move away from craft towards industry also coincided in time with the decline of Expressionist influences and the penetration of Russian Constructivist ideas into the Bauhaus through the appointment of Kandinsky and the participation of El Lissitzky at the Dadaist–Constructivist conference in Weimar, both in 1922. In 1921–2 Theo van Doesburg took up residence in Weimar, giving his private seminars based on Constructivism in opposition to the Expressionist Bauhaus: these met with an enthusiastic response, particularly from opponents of Itten. As Itten was not prepared to associate himself with the Bauhaus's new direction he left the school in the spring of 1923.

With the appointment in 1923 of László Moholy-Nagy as Itten's replacement, Functionalism started to become the determining factor in the development of the school. In contrast to Itten, Moholy-Nagy had a quite untroubled relationship with machines and industry, claiming that technology was a reality of the 20th century. Moholy-Nagy ran the preliminary course from 1923 to 1928. His teaching was pervaded with scientific content, concentrating on constructive problem-solving far more than had been the case in Itten's day. Technical reproducibility became the guiding principle governing Bauhaus activity, and Moholy-Nagy's repertory of formally extremely reduced images had a crucial impact on design work in the workshops as well. In particular he worked as a form master in the metal workshop, training such designers as Marianne Brandt.

These new trends were presented publicly for the first time in the context of a large Bauhaus exhibition in 1923. It included a review of international architecture including designs by J. J. P. Oud, Le Corbusier and Gropius, and a show house by Georg Muche, on which several Bauhaus workshops had collaborated in the furnishing and interior decoration. Murals by Joost Schmidt (1893–1948), Herbert Bayer and Oskar Schlemmer were also exhibited in areas throughout the school's premises. There was also a display of

items produced in the workshops, which demonstrated the development from craft-produced individual works to industrial assembly-line products. From the beginning the Bauhaus had been exposed to persistent criticism from politically conservative forces. In spite of the positive reception accorded to the exhibition in the German and international press, the funds allocated by the state of Thüringen were so sharply reduced after the victory of right-wing parties in 1924 that on 31 March 1925 the Bauhaus at Weimar decided to close.

2. First years in Dessau, c. 1925–c. 1928

In 1925 the Bauhaus transferred from Weimar to Dessau, an up-and-coming industrial town. A series of far-reaching changes were associated with this move. The preliminary course was lengthened from six months to a year, the workshop area was thoroughly overhauled and pottery, previously taught by Marcks, ceased to be part of the curriculum. There were also changes to the system by which an artist and a craftsman were in joint charge of each workshop: this had in fact latterly given rise to conflict, and so the running of the workshops was now partly entrusted to teachers known as *Jungmeister*. Having themselves trained at the Bauhaus, they now had the double qualification in art and craft that had been one of the declared objectives of Bauhaus teaching from the outset. It is interesting to note that some workshops not only had new people in charge but also were renamed in order to indicate an awareness of modern industrial demands: for example the former printing department under Feininger became the advertising department led by Herbert Bayer. Moreover, in Dessau the whole school was given the secondary title of Hochschule für Gestaltung.

The general conditions governing the continued work of the Bauhaus clearly improved. With substantial financial resources at its disposal, from 1926 the Bauhaus was housed in a new glass and reinforced concrete building designed by Gropius (see fig. 6). This was a milestone of Functionalism. The building contained the school, workshops and students' dormitory in three wings, which created a dynamic asymmetric shape. The designs of the outside walls corresponded to the different interior spaces, the workshops, for example, having huge spectacular sheets of glass. The building's design exemplified the Functionalist desire to develop freely an architectural order derived from science and technology.

In Dessau the metal workshop and the furniture workshop were among the most successful. In the furniture workshop Marcel Breuer, who had been at the Bauhaus as a student since 1920, succeeded in developing armchairs and chairs made of tubular steel, a breakthrough in designing furniture appropriate to its function and adapted to the potential of industrial mass production. The most outstanding characteristics of this metal furniture were its small mass, its transparency, lightness and ease of movement (the base of the frame acting as a skid).

Under Moholy-Nagy the metal workshop continued to set the standards for the gradual transformation of the Bauhaus into a modern laboratory of prototypes for industrial mass production. This applies particularly to the classic, innovative designs of light fittings by such designers as Marianne Brandt, Karl J. Jucker (1902), Wilhelm Wagenfeld or Gyula Pap (1899–1983).

A similar emphasis on industrial design was apparent in the textile department run by Gunta Stölzl from 1927 to 1931. Interest was concentrated completely on the design and manufacture of such utilitarian materials as furnishing textiles, and experiments were also begun on the use and aesthetic effects of new types of materials, for example synthetic fibres.

The workshop for mural painting in Dessau was taken over by Hinnerk Scheper (1897–1957). In contrast to Kandinsky's interest in abstract monumental painting, for which there was no longer any appropriate setting in modern architecture, Scheper placed emphasis on the problems of using colour in creating buildings and interiors, as shown for example by his colour masterplan for the Bauhaus building in Dessau (1926; N. B. Scheper priv. col., see 1988 Budapest exh. cat., p. 179). However, Kandinsky continued to

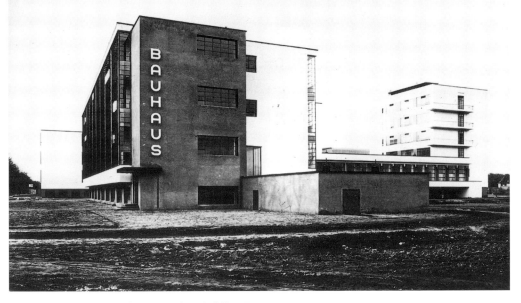

6. Walter Gropius (with Adolf Meyer): Bauhaus building, Dessau, 1925–6

develop on a smaller scale a sophisticated abstract vocabulary (e.g. *Several Circles*, 1926; New York, Guggenheim).

The same processes of modernization can also be recognized in the work of the advertising department. Bayer designed such severe typefaces as the universal, contour-free shadow type, which made a decisive contribution to the rationalization and categorization of script and typography, purging everyday graphic design of traces of historicism or Expressionism.

While a strictly utilitarian approach was generally dominant at Dessau, the sculptural workshop under Schmidt was the exception. The sculptural workshop had the character of a foundation department for the systematic study of such basic forms as the cube, sphere, cone and cylinder, and the complex interpenetrations of such forms. It also produced props for the Bauhaus stage (directed by Schlemmer) and

fulfilled commissions for trade fairs and exhibition stands.

This phase of reorganization and consolidation culminated in 1927 with the setting up of the long overdue department of architecture with the Swiss architect Hannes Meyer as head. It was thanks to Meyer that the systematic teaching of architecture was instituted on a scientific footing, discarding all aesthetic considerations since they were at variance with his socialist-inspired Functionalism. Gropius's leadership came to an end in spring 1928. Worn down by administrative duties and having been the butt of conservative criticism both in Weimar and in Dessau, he elected to work as an independent architect in Berlin; Meyer took over as Director. At the same time Moholy-Nagy (who was succeeded as head of the preliminary course by Josef Albers), Bayer and Breuer left the Bauhaus; Muche had already left Dessau in 1927.

3. Final period and later influences, from c. 1928

As the new Director, Meyer, socially committed and a strong adherent of Marxist ideology, fully spelt out his concepts regarding the Bauhaus and society (Meyer, 1929): 'Building and creating are indivisible and they are a social occurrence The Bauhaus at Dessau is not an artistic phenomenon, but a social one. As creative designers our work is conditioned by society, and society makes its mark on the whole range of our tasks.' Under Meyer's direction the Bauhaus's programme moved decisively away from the original concept of a unified art school towards that of a centre of production to satisfy social needs. The department of architecture now became the central focus of the Bauhaus, not, however, in the integral way announced in its founding manifesto but largely as an autonomous specialized department dissociated from other departments.

Meyer promoted a rigorous Functionalism in architecture, asserting that buildings should be organized according to economic, technical, social and psychological factors, although it is arguable whether his buildings met these 'functional criteria'. However, his Marxist commitment was expressed in such buildings as the workers' housing estate in Törten, Dessau (begun 1926), in which the houses were entered from communal balconies, and the Allgemeiner Deutscher Gewerkschaftsbund school at Bernau near Berlin, the architect's major work from that period, for which he won a competition in 1926. Within the Bauhaus the influence declined of those artists with innovative ideas in solving problems of applied creative design. The independent painting classes set up by Klee and Kandinsky had no institutional connection with the rest of the work at the Bauhaus and can be seen only as a relapse from Gropius's original master-plan for a new unity of art and technology. In these circumstances it was inevitable that the Bauhaus should start to disintegrate: Schlemmer, who had attempted to provide an anthropological basis for the Bauhaus system of teaching with his course *Der Mensch*, resigned from the school in 1929. In 1931 Klee went to the Kunstakademie at Düsseldorf, and Kandinsky became Meyer's main opponent within the Bauhaus.

At the same time it cannot be denied that between 1928 and 1930 the Bauhaus worked with unsurpassed efficiency as regards performance and economics. This was partly due to Meyer's transformation of teaching workshops into places of productive design in order to underline the social justification of the Bauhaus. In 1929 a department of photography was set up under the professional photographer Walter Peterhans (1897–1960). It concentrated not on experimental photography (as had been typical of Moholy-Nagy) but on commercial work, through its strict attachment to the advertising department led, after Bayer's departure, by the extremely versatile but now almost forgotten Schmidt.

In 1930 Meyer was dismissed from his post as Director of the Bauhaus because of his Marxist commitment. The new Director, recommended by Gropius, was Ludwig Mies van der Rohe, another exponent of Functionalism. However, he was anxious to bring the school back on to a non-political course. He combined the demand for social efficiency with a high aesthetic standard. Nonetheless, he remained loyal to Meyer's course in that the Bauhaus under his leadership retained the characteristics of a school of architecture with a few courses in design, two in fine-art painting and one in photography. In contrast to Meyer, however, Mies van der Rohe favoured teaching over the Bauhaus's programme of production.

After the victory of the National Socialists in the local elections in 1932, the Bauhaus in Dessau was closed down. The school moved to Steglitz, Berlin, where it continued to operate as a private institution under more difficult conditions in a former factory building. However, after Adolf Hitler seized power in 1933 the National Socialists put a final end to the continued existence of the Bauhaus, which had been vilified as culturally Bolshevist. After unsuccessful attempts by Mies van der Rohe to save it, with repression from the police, the Sturm-Abteilung (SA) and the Gestapo it was forced to close down.

After the closure of the Bauhaus, its members were dispersed across Europe and the USA. Some

became highly influential teachers: for example Gropius took up a professorship at the Graduate School of Design at Harvard University, Cambridge, MA, in 1937, while in 1938 Mies van der Rohe settled in Chicago, becoming Director of the College of Architecture, Planning and Design at the Illinois Institute of Technology. However, most important was the involvement of Albers in the BLACK MOUNTAIN COLLEGE, NC. Through the workshops and courses they disseminated Bauhaus design and teaching methods in the USA. Internationally numerous establishments came to model themselves on the Bauhaus, for example the New Bauhaus or the School of Design in Chicago, both founded by Moholy-Nagy, and after World War II the Hochschule für Gestaltung in Ulm. As well as setting standards for the development of modern design and the International Style, the Bauhaus established concepts for the teaching of art and design that remained relevant more than half a century later.

Unpublished Sources

Berlin, Bauhaus-Archv

Writings

W. Gropius: *Manifest des Staatlichen Bauhauses in Weimar* (Weimar, 1919)

W. Gropius, ed.: *Staatliches Bauhaus Weimar, 1919–1923* (Weimar and Munich, 1923)

H. Meyer: 'Bauhaus und Gesellschaft', *Bauhaus*, i (1929), p. 2

Bibliography

general

G. C. Argan: *Gropius und das Bauhaus* (Reinbek, 1962)

H. M. Wingler: *Das Bauhaus, 1919–1933: Weimar, Dessau, Berlin und die Nachfolge in Chicago seit 1937* (Bramsche, 1962, 3/1975)

J. Itten: *Mein Vorkurs am Bauhaus: Gestaltungs- und Formenlehre* (Ravensburg, 1963)

E. Roters: *Maler am Bauhaus* (Berlin, 1965; Eng. trans., 1969)

L. Lang: *Das Bauhaus, 1919–1933: Idee und Wirklichkeit* (Berlin, 1966)

W. Scheidig: *Bauhaus Weimar, 1919–1925: Werkstattarbeiten* (Munich, 1966)

D. Schmidt: *Bauhaus Weimar, 1919 bis 1925; Dessau, 1925 bis 1932; Berlin, 1932 bis 1933* (Dresden, 1966)

G. Naylor: *The Bauhaus* (London, 1968)

M. Franciscono: *Walter Gropius and the Creation of the Bauhaus in Weimar: The Ideals and Artistic Theories of its Founding Years* (Urbana and London, 1971, 2/Cologne, 1985)

E. Neumann, ed.: *Bauhaus und Bauhäusler: Bekenntnisse und Erinnerungen* (Berne and Stuttgart, 1971, rev. Cologne, 1985)

F. Kröll: *Bauhaus, 1919–1933: Künstler zwischen Isolation und kollektiver Praxis* (Düsseldorf, 1974)

K.-H. Hüter: *Das Bauhaus in Weimar: Studie zur gesellschaftspolitischen Geschichte einer deutschen Kunstschule* (Berlin, 1976, 3/1982)

C. Humblet: *Le Bauhaus* (Lausanne, 1980)

P. Hahn and C. Wolsdorff, eds: *Bauhaus-Archiv—Museum für Gestaltung, Architektur, Design, Malerei, Grafik, Kunstpädagogik* (Berlin, 1981)

R. Wick: *Bauhaus-Pädagogik* (Cologne, 1982, 4/1994)

F. Whitford: *Bauhaus* (London, 1984; Fr. trans., 1989)

P. Hahn, ed.: *Bauhaus Berlin; Auflösung Dessau, 1932; Schliessung Berlin, 1933; Bauhäusler und Drittes Reich* (Weingarten, 1985)

G. Naylor: *The Bauhaus Reassessed: Sources and Design Theory* (New York, 1985)

H. Dearstyne: *Inside the Bauhaus* (New York and London, 1986)

C. Schädlich: 'Bauhaus Dessau: Hochschule für Gestaltung', *Bild. Kst*, 11 (1986), pp. 482–6

E. Vitale: *Le Bauhaus de Weimar, 1919–1925* (Brussels, 1989)

A. Rowland: *The Bauhaus Source Book* (Oxford, 1990)

U. Westphal: *The Bauhaus* (London, 1991).

exhibition catalogues

Bauhaus, 1919–1928 (exh. cat. by H. Bayer, W. Gropius and I. Gropius, New York, MOMA, 1938; Ger. trans., Stuttgart, 1985)

50 Jahre Bauhaus (exh. cat., ed. W. Herzogenrath; Stuttgart, Württemberg. Kstver.; London, RA; 1968)

Bauhausfotografie (exh. cat., Stuttgart, Inst. Auslandsbeziehungen, 1983)

La tessitura del Bauhaus, 1919/1933 nelle collezioni della Repubblica Democratica Tedesca (exh. cat., essays E. Wolf and others; Pesaro, Pal. Ducale, 1985)

Photographie und Bauhaus (exh. cat., ed. C. Haenlein; Hannover, Kestner-Ges., 1986)

50 Jahre New Bauhaus: Bauhaus-Nachfolge in Chicago (exh. cat., ed. P. Hahn; W. Berlin, Bauhaus-Archv, Mus. Gestalt, 1987)

Bauhaus, 1919–1933: Meister- und Schülerarbeiten: Weimar, Dessau, Berlin (exh. cat., ed. J. Aron; Zurich, Mus. Gestalt., 1988)

Bauhaus Utopien: Arbeiten auf Papier (exh. cat., ed. W. Herzogenrath; Budapest, N.G.; Madrid, Cent. Reina Sofia; Cologne, Kstver.; 1988)

Experiment Bauhaus: Das Bauhaus-Archiv Berlin (West) zu Gast im Bauhaus Dessau (exh. cat. by U. Brüning and others, W. Berlin, Mus. Gestalt., 1988)

Bauhaus Weimar, 1919–1925: Werkstattarbeiten (exh. cat., essay J. Hörnig; Weimar, Kstsamml., 1989)

Keramik am Bauhaus (exh. cat., ed. K. Weber; W. Berlin, Bauhaus-Archv, 1989)

Fotografie am Bauhaus, 1919–1933 (exh. cat., ed. J. Fiedler; Berlin, Bauhaus-Archv, 1990)

Die Metallwerkstatt am Bauhaus (exh. cat., ed. K. Weber; Berlin, Bauhaus–Archv, Mus., Gestalt, 1992)

Das frühe Bauhaus und Johannes Itten (exh. cat., Weimar, Kstsammlungen; Berlin, Bauhaus-Archv, Mus. Gestalt; Berne, Kstmus.; 1994)

RAINER K. WICK

Biomorphism

Term derived from the Classical concept of forms created by the power of natural life, applied to the use of organic shapes in 20th-century art, particularly within SURREALISM. It was first used in this sense by Alfred H. Barr jr in 1936. The tendency to favour ambiguous and organic shapes in apparent movement, with hints of the shapeless and vaguely spherical forms of germs, amoebas and embryos, can be traced to the plant morphology of Art Nouveau at the end of the 19th century; the works of Henry Van de Velde, Victor Horta and Hector Guimard are particularly important in this respect.

From 1915 biomorphic forms appeared in wood reliefs, ink drawings and woodcuts by Hans Arp. By representing ovoid forms shifting into one another, he indicated the unity of nature in conscious opposition to the mechanization and dislocation of modern life. Biomorphic forms were also featured in the *Improvisations* painted around the beginning of World War I by Vasily Kandinsky, who had met Arp while living in Munich. At the end of the 1920s, apparently stimulated by the work of Yves Tanguy, Arp began to use more rounded and modelled shapes. He remained committed to biomorphism throughout his life, using it to express metaphors of cyclical transformation (*see* METAMORPHISM), cosmic harmony and the mystical union of human beings with the form-giving powers of nature.

Joan Miró was also influential in promoting the concept of biomorphism in his work, particularly from the mid-1920s, when he came into contact with Surrealism (see fig. 46). He developed arabesque contours and a flux of coloured spaces, from which the shapes seem to surface, to convey a sense of creation and evolution and a range of human archetypes, by turns humorous and aggressive. Similar strategies of deformation were developed in the mid-1920s by Picasso, for instance in his *Three Dancers* (1925; London, Tate) and in his series of bathers of the late 1920s. In these and related works he explored ideas of perpetual movement, and through human and animal associations he used the formal language of biomorphism to suggest psychological truths. The application of biomorphism to the human figure in the sculpture of Henry Moore from the early 1930s was, in principle, also rooted in formal concerns linked to Surrealism. In his case abstract rhythms and an organic interdependence of form and space were used to express the relationship between human and landscape forms.

The example of these artists, and especially the impersonal, pantheistic biomorphism of Miró and Moore, had a liberating effect on many others in the 1930s and 1940s. In particular Miró's use of biomorphism stimulated Alexander Calder (see col. pl. XXIV), Isamu Noguchi, Willi Baumeister and painters associated with Abstract Expressionism, notably Willem de Kooning (see fig. 1), Arshile Gorky, Jackson Pollock (see fig. 2) and Robert Motherwell. While biomorphism never resulted in a style as such, it remained an important tendency through the 1940s in unifying otherwise diverse stylistic innovations.

Bibliography

L. Glózer: *Picasso und der Surrealismus* (Cologne, 1974)

S. Poley: *Hans Arp: Die Formensprache im plastischen Werk* (Stuttgart, 1978)

C. Lichtenstern: *Picasso 'Tête de Femme': Zwischen Klassik und Surrealismus* (Frankfurt am Main, 1980)

——: 'Henry Moore and Surrealism', *Burl. Mag.*, cxxiii/944 (1981), pp. 645–58

B. Rose: 'Miró aus amerikanischer Sicht', *Joan Miró* (exh. cat. by R. S. Lubar and others, Zurich, Ksthaus; Düsseldorf, Städt. Ksthalle; New York, Guggenheim; 1986)

J. Mundy: *Biomorphism* (diss., U. London, Courtauld Inst., 1987)

CHRISTA LICHTENSTERN

Black Mountain College

Experimental liberal arts college at Black Mountain, NC, open from 1933 to 1957. In the 1940s and early 1950s it was a centre for a group of painters, architects, musicians and poets associated particularly with the development of performance and multimedia work, crossing many disciplines. It was founded by John Andrew Rice (1888–1968) and a group of students and staff from Rollins College, Winter Park, FL. It was located in the Blue Ridge Assembly Buildings, *c.* 29 km east of Asheville, NC, until 1941, when it moved to nearby Lake Eden until its closure. The progressive ideas of John Dewey influenced the interaction of formal education with community life, the absence of conventional grades and credits and the central importance accorded to the arts. The college was owned and administered by the staff. The setting was modest, and fewer than 1200 students attended in 24 years.

In the founding year Josef Albers, the first of many European refugees to teach at Black Mountain, came from Germany to teach art; through his activities the college disseminated Bauhaus teaching methods and ideas into American culture. The visual arts curriculum included courses in design and colour that later became a standard part of art education, as well as workshops in weaving, wood-working, printing, photography and bookbinding. Anni Albers, a former Bauhaus student, developed a weaving course that emphasized designing for industrial production. Xanti Schawinsky (1904–79), who studied with Oskar Schlemmer at the Bauhaus, taught art and stage studies from 1936 to 1938 and directed *Spectodrama: Play, Life, Illusion*, one of the earliest performances of abstract theatre in the USA.

In 1944 Black Mountain College sponsored its first summer arts programme, which attracted many major artists for intense periods of teaching and participation in concerts, exhibitions, lectures and drama and dance performances. Among the European artists who taught were Lyonel Feininger, Walter Gropius, Leo Lionni (*b* 1910), Amédée Ozenfant, Bernard Rudofsky (1905–88) and Ossip Zadkine. Other summer staff included Leo Amino (*b* 1911), John Cage, Mary Callery (1903–77), Merce Cunningham, Willem de Kooning, Buckminster Fuller, Jacob Lawrence (*b* 1917), Barbara Morgan (*b* 1900) and Robert Motherwell. Ilya Bolotowsky taught from 1946 to 1948.

After Josef Albers left in 1949, the central figure in the community was the poet and critic Charles Olson (1910–70), who taught at the college in 1948–9 and returned in 1951. Under his direction the college became a centre for the formulation of a new poetics based on open form and 'projective verse'. The *Black Mountain Review*, edited by Robert Creeley (*b* 1926), was one of the most influential small-press journals of the period, and the college played a formative role in the revival of the small-press movement in the USA. Creeley, Joseph Fiore (*b* 1925), M. C. Richards (*b* 1916) and Robert Duncan (1919–88) were among the members of the young American staff. A ceramics course was added to the curriculum and the faculty included Robert Turner (*b* 1913), Karen Karnes (*b* 1925) and David Weinrib (*b* 1924). The summer sessions in the arts brought many artists to the campus, including Harry Callahan, Shōji Hamada, Franz Kline, Bernard Leach, Ben Shahn, Aaron Siskind, Jack Tworkov and Peter Voulkos (*b* 1924).

Albers and the other European artists brought the spirit of modernism to the progressive, experimental spirit of the founders, and the fusion of these two movements culminated in a creative atmosphere and an intense, intellectual community, receptive to experimental ventures in the arts. It was at Black Mountain College that Buckminster Fuller attempted to raise his first dome in 1948, that John Cage staged his first work of performance art in 1952, and that the Cunningham Dance Company was founded in

1953. Through the work of its students, among them Ruth Asawa (*b* 1926), John Chamberlain, Ray Johnson, Kenneth Noland, Robert Rauschenberg, Dorothea Rockburne (*b* 1929), Kenneth Snelson, Cy Twombly, Stanley Vanderbeek (1927–84) and Jonathan Williams (*b* 1929), the college played a formative role in the definition of an American aesthetic and identity in the arts during the 1950s and 1960s.

Unpublished Sources

Raleigh, NC State Archvs [Black Mountain College papers]

Bibliography

F. Dawson: *The Black Mountain Book* (New York, 1970)
M. Duberman: *Black Mountain College: An Exploration in Community* (New York, 1972)
M. E. Harris: *The Arts at Black Mountain College* (Cambridge, MA, 1987)

MARY EMMA HARRIS

Blaue Reiter [Ger.: 'Blue Rider']

German group of artists active in Munich from 1911 to 1914. The principal members were Vasily Kandinsky, Franz Marc, Gabriele Münter, Alfred Kubin, Paul Klee and August Macke. The group's aim was to express the inner desires of the different artists in a variety of forms, rather than to strive for a unified style or theme. It was the successor to the NEUE KÜNSTLERVEREINIGUNG MÜNCHEN (NKVM), founded in Munich in 1909.

1. Foundation and exhibitions, 1911–c. 1912

The conservatism of certain members of the NKVM led to the resignation of Kandinsky, Münter, Marc and Kubin in 1911. At the instigation of Kandinsky and Marc, the four organized the first exhibition of the editorial board of *Blaue Reiter* (see below), held from 8 December 1911 to 1 January 1912 in the Galerie Thannhauser in Munich. According to Kandinsky in 1930 ('Der blaue Reiter Rückblick', *Das Kunstblatt*, 14), the name of the Blaue Reiter had come up spontaneously in coffee-table talk with Franz and Maria Marc: 'We both liked blue, Marc liked horse and I liked rider'. However, this explanation seems too trivial to be exhaustive.

From all Kandinsky's written statements it can be seen with hindsight that the claims attached to the name were considerable. It was linked to diverse traditions rooted in German history, and associated the masculine virtues of medieval knights and Christian warrior saints, including those of Russian Orthodox Christianity, with the group's romantic idea that the essence of things can be revealed to mankind through works of art. The horse was used as a subject by Franz Marc in many works, for example *Blue Horse* (1912; Saarbrücken, Saarland Mus.; see col. pl. IX), and in Kandinsky's cover of the almanac *Blaue Reiter* of 1912 (see fig. 7).

Kandinsky prefaced the catalogue list of the group's first show with the following text: 'In this small exhibition we do not seek to propagate a precise or special form, but aim to show in the diversity of the forms represented how the inner desire of artists shapes itself in manifold ways'. In keeping with this stance, the exhibition presented a heterogeneous picture. It contained 43 works by 14 artists, including Marc, Kandinsky, David Burlyuk, Vladimir Burlyuk, Robert Delaunay and the recently dead Henri Rousseau. At Marc's request August Macke, Heinrich Campendonk and Jean Bloé Niestlé (1884–1942) took part, while at Kandinsky's instigation his companion Gabriele Münter and his former pupil Elisabeth Epstein (1879–1956) showed works. Albert Bloch (1882–1961) was also invited by Kandinsky, while two works by his dead friend Eugen von Kahler (1882–1911) and, finally, pictorial visions by the composer Arnold Schoenberg were displayed.

The pluralism proclaimed at this exhibition attracted unexpectedly strong support from artists. Some, such as Hans Arp, who visited Munich in 1912, and Paul Klee, developed strong personal contacts with the group. Many others contributed to a second exhibition, devoted exclusively to graphic works. This show of 315 works by 31 artists was held from February to April 1912 in the art showroom of Hans Goltz (1873–1927). The best-known names included Klee, Kubin, Georges Braque and Pablo Picasso, as well as Emil Nolde, Max Pechstein, Ernst Ludwig Kirchner and Erich Heckel of Die Brücke. Klee, in particular, shared

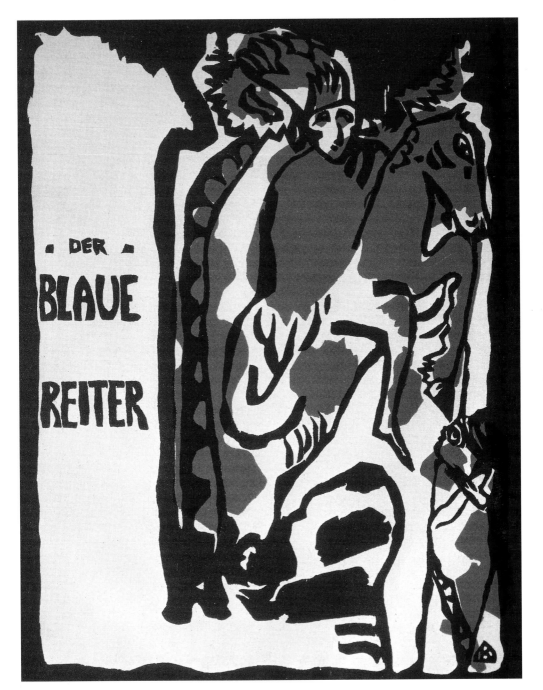

7. Vasily Kandinsky: Cover of the almanac *Der Blaue Reiter*, Berlin, 1912 (Berlin, Staatliche Museen, Gemäldegalerie)

the concern of his Blaue Reiter colleagues for the spiritual in art, emphasizing the qualities of popular and primitive art, as well as that produced by the mentally ill and children.

Among the public and critics the two exhibitions produced an almost entirely negative response. As with the earlier exhibitions of the NKVM, people felt they were being mocked and confused. Where new forms of expression appropriate to new subject-matter were being revealed, the public and critics saw only incompetence and the scurrilous outpourings of sick minds. Despite this opposition, the exhibition went on tour, first to the Gereonsclub in Cologne, and in March 1912 Herwarth Walden opened his Sturm-Galerie in Berlin with this collection. Exhibitions in Bremen, Hagen and Frankfurt am Main followed. Somewhat later a different selection of the works was to be seen at the exhibition of the Sonderbund in Cologne in 1912, and the following year, again in Berlin, they appeared in Herwarth Walden's Ersten Deutschen Herbstsalon, and even, on his initiative, in Sweden in 1914.

2. The 'Blaue Reiter' almanac and later developments, c. 1912–14

In order to explain to the public the difference between the intentions and practice of 19th-century painting and the entirely different expressive means of the new generation of artists, an almanac was produced in May 1912 by Piper-Verlag of Munich. Entitled *Der Blaue Reiter* and edited by Kandinsky and Marc, it was originally intended to be a periodical, but went through only one edition, which was reprinted in 1914. The almanac contained essays written exclusively by artists on subjects related to the fine arts. The carefully produced volume proved in retrospect to be the most significant programmatic writing on art of the 20th century. Kandinsky and Marc set out in individual essays their conceptions of the subject-matter of art and its formal expression. They reproduced works of art of very diverse styles, epochs and cultures, such as medieval book illustrations, religious paintings on glass, child art, and carvings and other objects from non-European cultures, juxtaposed with illustrations of their

own works (e.g. Marc's *The Steer*, 1911; New York, Guggenheim). In this way they reminded the reader that the endeavour to achieve a particular means of expression had always determined artistic form, not only for the artists of the Blaue Reiter. Their principal aim, however, was to explain the new subject-matters and means of expression used by the artists of their own group. On this point Kandinsky wrote: 'None of us seeks to reproduce nature directly . . . We are seeking to give artistic form to inner nature, i.e. spiritual experience'. He then went on to stress that as the artists' souls were different, so their motifs varied. However, they had in common the quality of bringing into their pictures only those details of nature that served 'the inner purpose of the particular work'. In 1912 Kandinsky also expounded his ideas in *Über das Geistige in der Kunst*.

Meanwhile, Alexei Jawlensky and Marianne Werefkin left the NKVM in 1912 and began contributing works to Blaue Reiter exhibitions. They had initially remained loyal to the circle in the NKVM headed by Adolph Erbslöh (1881–1947). However, after the publication of the group's *Das neue Bild*, which also came out in 1912 as a kind of counterblast to the almanac, disagreements within the NKVM sealed its fate. Its proposed fourth exhibition failed to materialize, and with Werefkin and Jawlensky, Wladimir von Bechtejeff (1878–1971) also announced his resignation. Jawlensky's work, in particular, exemplified the Blaue Reiter's use of form and colour to represent the artist's inner state as well as the subject depicted (e.g. *Head of a Woman*, 1912; Berlin, Alte N.G.).

As compared to other associations of artists at the beginning of the 20th century, the Blaue Reiter was marked by a sense of a spiritual mission. However, the painters of the Blaue Reiter were indebted to such other avant-garde movements as Futurism, Fauvism and Cubism; for example, the Futurist depiction of sequences of movement influenced Macke and Marc. Contemporary French developments, in particular the Orphism of Delaunay, had a decisive influence on Klee, Marc and Macke, who visited him in Paris in 1912. The French art that Klee saw was reflected

in his graphic art (e.g. *Garden of Passion*, etching, 1913; e.g. New York, MOMA). Delaunay's depiction of interpenetration of forms influenced such works as Marc's *The Tiger* (1912; Munich, Lenbachhaus). Such influences were not merely stylistic but helped to express in their art the deep convictions of Kandinsky's analytical spirituality and Marc's pantheistic philosophy.

The desire to represent inner experience was exemplified by Kandinsky's gradual advance towards abstraction. He first studied the laws inherent in forms and colours through contemplation of nature before the Blaue Reiter period. Finally he produced painted compositions without any link to objective reality that consisted of a pure play of colours and forms analogous to music. This was Kandinsky's highest goal, achieved in such works as *Composition VII* (1913; Moscow, Tret'yakov Gal.). Marc represented animals, whom he saw as beings less distorted by culture than man: he depicted them as embedded in surrounding nature, even producing compositions in which the subject was broken up almost entirely into prismatic structures. He thus attempted to create images whereby man too might again feel his unity with the cosmos. His thesis in the almanac, 'that art is concerned with the deepest things, that renewal cannot be a formal matter but a rebirth of thought', clearly expresses his concerns. With this conception Marc took his place in the tradition of mysticism, pursuing no lesser goal than to produce through his work 'symbols which belong on the altars of the coming intellectual religion, behind which the technical producer vanishes'. His final work before the outbreak of World War I consisted of almost entirely abstract paintings such as *Playing Forms* (1914; Essen, Mus. Flkwang).

It goes without saying that such aims and works made heavy demands on the beholder. However, the strength of the Blaue Reiter artists remained their openness to different forms of communication. They realized that the widespread need for spiritual renewal in a materialistic age sought expression in the most diverse ways. The group saw themselves as developing a spiritual principle that would draw together these various forces to give them the greatest possible impact on the outer world. Admittedly the reaction of the public did not meet the hopes and expectations of Kandinsky and Marc. In the preface to the second edition of the almanac a hint of resignation can be discerned. Kandinsky wrote: 'One of our aims—in my eyes one of the main ones—has hardly been attained at all. It was to show, by examples, by practical juxtaposition and by theoretical demonstration, that the question of form in art is secondary, that the question in art is predominantly one of content . . . Perhaps the time is not yet ripe for 'hearing' and 'seeing' in this sense'. Moreover, Marc quoted a dictum of Theodor Däubler: 'Everything in this world can only be a beginning'.

The outbreak of World War I put an end to the common endeavours of the Blaue Reiter. Kandinsky had to leave Germany and returned to Russia via Switzerland. Macke was killed in the Champagne region in the first weeks of the war. Marc, whose search for 'pure form' in his sketchbook from the battlefield had also led to abstraction, died at Verdun in 1916. Klee served in the rear of the Front, Münter lived in Sweden, and only Kubin stayed above the mêlée in his refuge at Zwickledt near Wernstein am Inn. Although the Blaue Reiter did not survive World War I, the BLUE FOUR group was formed in 1924 as its successor by Kandinsky, Jawlensky, Klee and Lyonel Feininger.

Writings

V. Kandinsky: *Über das Geistige in der Kunst: Insbesondere in der Malerei* (Munich, 1912)

V. Kandinsky and F. Marc, eds: *Der Blaue Reiter Almanach* (Munich, 1912, rev. 1965)

Bibliography

L. G. Buchheim: *Der Blaue Reiter und die Neue Künstlervereinigung München* (Feldafing, 1959)

O. Neigemont: *Der Blaue Reiter* (Munich and Milan, 1966)

Il Cavaliere Azzurro/Der Blaue Reiter (exh. cat. by L. Carluccio and L. Mallé, Turin, Gal. Civ. A. Mod., 1971)

R. Gollek: *Der Blaue Reiter im Lenbachhaus München: Katalog der Sammlung in der Städtischen Galerie* (Munich, 1974, rev. 3/1985)

A. Cavallaro: *Il Cavaliere Azzurro e l'orfismo* (Milan, 1976)

P. Vogt: *Der Blaue Reiter* (Cologne, 1977)

A. Hüneke, ed.: *Der Blaue Reiter: Dokumente einer geistigen Bewegung* (Leipzig, 1986)

Der Blaue Reiter (exh. cat., ed. H. C. von Tavel; Berne, Kstmus., 1986–7)

M. M. Moeller: *Der Blaue Reiter* (Cologne, 1987)

R. Gollek: *Brennpunkt der Moderne: Der Blaue Reiter in München* (Munich, 1989)

A. Zweite, ed.: *The Blue Rider in the Lenbachhaus, Munich* (Munich, 1989, Ger. trans., 1991) [with commentaries by A. Hoberg]

ROSEL GOLLEK

Block, Der

German association of architects formed in Saaleck early in 1928, in reaction to the avant-garde group Der Ring and to the emerging Modern Movement in general. The most prominent members were Paul Schultze-Naumburg, Paul Schmitthenner, German Bestelmeyer and Paul Bonatz. Bonatz and Schmitthenner were both supposed to take part in the exhibition of the Deutscher Werkbund in Stuttgart in 1927, and even prepared a layout plan for the Weissenhofsiedlung, the showpiece of the exhibition. Their design was, however, rejected in favour of the modernist design by Mies van der Rohe. Schultze-Naumburg from the early years of the century had propagated a return to organic and traditional forms of architecture, for example in his series of books *Kulturarbeiten* (1902–17). He was the leading theorist of the Heimatschutz movement, which advocated the preservation and continuation of German traditions and values. Bestelmeyer, Schmitthenner and Bonatz were among the most prominent architects of southern Germany, all holding influential teaching posts in Munich and Stuttgart. Der Block wanted to retain traditional skills and lifestyles and rejected functional, modern architecture with its emphasis on internationalism. Their 'Manifesto' appeared in *Baukunst 4* (v (1928), pp. 128–9; repr. in Teut, p. 29); its polemic, enriched with an emphasis on 'German-ness', was eventually to evolve into the fierce opposition and persecution by the Third Reich of the 'cultural bolshevism' of the architecture and architects of the Modern Movement. As a group, however, Der Block was shortlived, active only into 1929.

Bibliography

A. Teut, ed.: *Architektur im Dritten Reich, 1933–1945* (Berlin, 1967) [incl. repr. of manifesto]

K. Kirsch: *Die Weissenhofsiedlung: Werkbundausstellung 'Die Wohnung'* (Stuttgart, 1987)

CLAUDIA BÖLLING

Block group [Pol. Blok]

Polish avant-garde group active in Warsaw between 1924 and 1926. Group members included Henryk Berlewi, J. Golus, W. Kajruksztis, Katarzyna Kobro, K. Kryński, Maria Nicz-Borowiak (1896–1944), Aleksander Rafałowski (1894–1981), Henryk Stażewski, Władysław Strzemiński, Mieczysław Szczuka, M. Szulc, Teresa Zarnower (*d* after 1945). Most members of the group had already exhibited together in some of the numerous exhibitions of the avant-garde in Poland in the early 1920s. They shared an enthusiasm for Soviet Constructivism, but there were already significant divisions within the group when it was formally founded in early 1924, holding its first official exhibition in the showroom of the car manufacturer Laurent-Clément in Warsaw in March of that year. The first issue of the group's own magazine, *Blok*, appeared at the same time.

The members of Block proclaimed their adherence to the ideas of 'absolute constructivism', the rigour of the composition, the concept of collective work as opposed to the individual creative effort and 'the maximum economy of the means of artistic expression'. However, their lack of a unified artistic programme resulted in a marked division within the group in 1925. Kobro and Strzemiński, Nicz-Borowiak and Stażewski followed pure 'laboratory' Constructivism, while Szczuka and Zarnower adhered to the principle of the artist as a creator, engineer and manufacturer, thus unifying the artistic, social and political aspects of art. The 11 issues of *Blok* contained members' reviews of artistic events and articles by foreign contributors with reproductions of European works of art, and the group participated

in a number of exhibitions, including the first Warsaw International Exhibition of Architecture. The Block group ceased its artistic activity in March 1926, and many members subsequently joined the PRAESENS GROUP.

Bibliography
Constructivism in Poland, 1923–1936 (exh. cat., ed. R. Stanisławski and others; Essen, Mus. Flkwang, 1973)
Z. Baranowicz: *Polska avangarda artystyczna, 1918–1939* [The Polish artistic avant-garde, 1918–1939] (Warsaw, 1975), pp. 87–130
A. Turowski: *Konstruktywizm polski: Próba rekonstrukcji nurtu, 1921–1934* [Polish Constructivism: an attempt to reconstruct its development, 1921–1934] (Wrocław, 1981)

EWA MIKINA

Bloomsbury Group

Name applied to a group of friends, mainly writers and artists, who lived in or near the central London district of Bloomsbury from 1904 to the late 1930s. They were united by family ties and marriage rather than by any doctrine or philosophy, though several male members of the group had been affected by G. E. Moore's *Principia Ethica* (Cambridge, 1903) when they had attended the University of Cambridge. Moore emphasized the value of personal relationships and the contemplation of beautiful objects, promoting reason above social morality as an instrument of good within society. This anti-utilitarian position coloured the group's early history. It influenced the thinking of, for example, the biographer and critic Lytton Strachey (1880–1932) and the economist John Maynard Keynes (1883–1946) and confirmed the position of conscientious objection maintained by some members of the group in World War I. Before 1910, literature and philosophy dominated Bloomsbury; thereafter it also came to be associated with painting, the decorative arts and the promotion of Post-Impressionism in England. This was mainly effected by the introduction into Bloomsbury of Roger Fry in 1910 and his close friendship with Vanessa Bell and Duncan Grant, with Clive Bell and with the writers

Leonard Woolf (1880–1969) and Virginia Woolf (1882–1941). Fry, helped by the literary editor Desmond MacCarthy (1877–1952), Clive Bell and the Russian artist Boris Anrep (1883–1969), was chiefly responsible for the two large Post-Impressionist exhibitions held in London at the Grafton Galleries in 1910 and 1912. Bloomsbury's swift identification with radical tendencies in the arts was realized by Vanessa Bell's Friday Club (founded 1905) and the Grafton Group exhibiting society (1913–14); by Fry and Clive Bell's association with the newly founded Contemporary Art Society (1910); and by the publication of Bell's *Art* (London, 1914). This pre-eminence as apologists for new movements in art was soon challenged by Wyndham Lewis, T. E. Hulme and others, and by *c.* 1920 Bloomsbury painting and art criticism can be characterized as increasingly conservative.

While Fry's greatest admiration was reserved for Cézanne, whose work profoundly influenced his own painting from 1910 onwards, Vanessa Bell and Duncan Grant gained greatly from Matisse and, to a lesser extent, Picasso. From *c.* 1912 to 1920 they were among the most innovative artists in England in both their easel painting (espousing abstraction in 1914–15) and their decorative work and applied design. The latter was chiefly carried out for Fry's Omega Workshops, of which they were both co-directors. Professional and personal links with the Paris art world were curtailed by the restrictions of World War I and from then on England was the centre of their activities and influence. They were variously involved in the London Group, the London Artists' Association and in fostering a closer association between art and commercial design. Other figures in Bloomsbury maintained an interest in the arts: Keynes, for example, as a patron and collector, and Virginia Woolf as a financial backer in 1938 of the Euston Road School. Keynes's later ideas on the public funding of the arts led to the foundation of the Arts Council of Great Britain in 1946.

Between the two World Wars, Grant and Vanessa Bell developed a rich, mainly figurative style of decoration, which had some influence in England and which may be described as a Bloomsbury style. In their (and Fry's) easel paintings are found

consistent qualities of unemphatic realism and a pacific contemplation of their immediate surroundings, for example in Grant's *Vanessa Bell* (1942; London, Tate; see col. pl. X). Characteristic subjects include still-lifes, English, French and Italian landscapes, and portraits of their family and friends, usually informal in pose and setting. The classic Mediterranean tradition was preferred to Northern European art, with fluency preferred to laborious detail and formal values to illustrative content.

Bibliography

J. K. Johnstone: *The Bloomsbury Group* (London, 1954)

Q. Bell: *Bloomsbury* (London, 1968, rev. 3/1986)

R. Shone: *Bloomsbury Portraits: Vanessa Bell, Duncan Grant and their Circle* (Oxford and New York, 1976, rev. London, 1993)

D. A. Laing: *Roger Fry: An Annotated Bibliography of the Published Writings* (New York and London, 1979)

—: *Clive Bell: An Annotated Bibliography of the Published Writings* (New York and London, 1983)

RICHARD SHONE

Blue Four [Ger. Blauen Vier]

Name applied to a group of German painters, founded at the Bauhaus in Weimar, Germany, on 31 March 1924. The group consisted of Vasily Kandinsky, Paul Klee, Alexei Jawlensky and Lyonel Feininger, who were formerly associated with the BLAUE REITER group (see col. pls VIII and XVIII). The idea for founding the Blue Four came from Galka Scheyer, a former pupil of Jawlensky, who sought to make the work and ideas of these artists better known in the USA through exhibitions, lectures and sales. While the Blue Four was not an official association, its name was chosen to give American audiences an idea about the type of artists involved and also to allude to the artists' previous association with the Blaue Reiter group. In May 1924 Scheyer travelled to New York, where the first Blue Four exhibition took place at the Charles Daniel Gallery (Feb–March 1925). Scheyer then moved to California, where the first of many Blue Four exhibitions in the San Francisco and Los Angeles areas took place at the Oakland Museum

in autumn 1925. Further exhibitions, often with lectures by Scheyer, were held in Portland, OR (1927), Seattle, WA (1926, 1936), Spokane, WA (1927), Mexico City (1931) and in Chicago, IL (1932), as well as at the Ferdinand Möller Gallery in Berlin (1929).

Bibliography

The Blue Four (exh. cat. by R. Haas, Pasadena, CA, Norton Simon Mus., 1975)

S. Campbell, ed.: *The Blue Four Galka Scheyer Collection* (Pasadena, 1976)

P. Weiss: 'The Blue Four', *The Blue Four—Feininger, Jawlensky, Kandinsky, Paul Klee* (exh. cat., New York, Leonard Hutton Gals, 1984), pp. 7–12

Theme and Improvisation: Kandinsky and the American Avant-Garde, 1912–1950 (exh. cat. by G. Levin and M. Lorenz, Dayton, OH, A. Inst., 1992), pp. 156–9

P. Weiss: *The Blue Four: A Dialogue with America. The Correspondence of Lyonel Feininger, Alexei Jawlensky, Wassily Kandinsky and Paul Klee with Galka Scheyer* (in preparation)

MARIANNE LORENZ

Blue Rose [Rus. Golubaya Roza]

Group of second-generation Russian Symbolist artists active in Moscow between 1904 and 1908. The term derives from the title of an exhibition that they organized at premises in Myasnitsky Street, Moscow, in 1907. The group originated in Saratov, when in 1904 Pavel Kuznetsov and Pyotr Utkin (1877–1934) organized the exhibition *Crimson Rose* (Rus. *Alaya Roza*), which included the work of the two major Symbolist painters Mikhail Vrubel' and their teacher Viktor Borisov-Musatov. Later that year, at the Moscow School of Painting, Sculpture and Architecture, they attracted artists of a similar persuasion such as Anatoly Arapov (1876–1949), Nikolay Krymov, Nikolay Milioti, Vasily Milioti, Nikolay Sapunov, Martiros Saryan and Sergey Sudeykin. An important member of the group was the wealthy banker, patron and artist Nikolay Ryabushinsky, who publicized Blue Rose in his magazine GOLDEN FLEECE (Rus.: *Zolotoye Runo*). By 1907 most of the group had become co-editors, but a group statement or manifesto was never published. Ryabushinsky also

contributed to the stability of the group by purchasing works from Kuznetsov, Sapunov, Saryan and Sudeykin.

During the years of their collaboration, the group shared a common philosophy and approach to painting. Inspired principally by the Symbolist poets Andrey Bely and Aleksandr Blok, Blue Rose artists believed that it was the function of art to transcend reality and communicate with the beyond. To this end the group adopted a common symbolism and a common stylistic approach. Pregnancy, foetal life and flowing water were familiar themes, as in Kuznetsov's *Blue Fountain* (1905; Moscow, Tret'yakov Gal.), where the cool blue, grey and green tones convey a feeling of melancholy, and the indistinct outlines of the distorted human forms overlap in transparent veils to create a psychologically disturbing effect.

The unusual title of the exhibition was chosen for its evocative otherworldly qualities and recalled the imaginary flowers in the paintings of Odilon Redon. Flower symbolism was important for the Blue Rose group, and the exhibition was decorated with hyacinths, lilies and daffodils. It contained over a hundred works and attracted varied reviews. Igor' Grabar', for instance, assumed a mocking tone, calling on Blue Rose artists to surrender their symbols to the playwright Maurice Maeterlinck and to come out into the sunlight. However, Sergey Makovsky was entranced: 'The pictures are like prayers . . . a spring flower of mystical love.'

A few months after their exhibition, Blue Rose disintegrated. There was a feeling that Symbolism had come to the end of its useful life and the artists developed in different directions. Saryan journeyed to Armenia and Kuznetsov to Kyrgyzstan, where both began to use brighter and more vivid colours. Krymov and Sudeykin developed greater solidity of form in their work, while Arapov and Sapunov moved into stage design.

Bibliography

I. Grabar': 'Golubaya Roza', *Vesy*, 5 (1907), pp. 93–6
S. Makovsky: 'Golubaya Roza', *Zolotoye Runo*, 5 (1907), p. 25
Golubaya Roza (exh. cat., Moscow, 1907)
J. E. Bowlt: 'Russian Symbolism and the Blue Rose Movement', *Slav. & E. Eur. Rev.*, li/123 (1973), pp. 161–81
D. Sarabyanov: *Pavel Kuznetsov* (Moscow, 1975)
J. E. Bowlt: 'The Blue Rose: Russian Symbolism in Art', *Burl Mag.*, cxviii (1976), pp. 566–74
P. Stupples: *Pavel Kuznetsov: His Life and Work* (Cambridge, 1990)

ANTHONY PARTON

Boom style

Term apparently coined by Robin Boyd in *Australia's Home* (1952) and loosely applied to highly ornate architecture in a classical idiom that was fashionable in the eastern states of Australia between the late 1870s and early 1890s. The style was made possible by, and is to some extent an expression of, the financial boom that followed the discovery of gold in 1851. The climax of the boom was in the 1880s in Victoria, where the richest goldfields were located. The buildings most commonly associated with the Boom style are the richly decorated Italianate villas and speculative terrace houses of Melbourne. The English picturesque Italianate fashion had been introduced to Australia by the early 1840s but only reached its sumptuous apogee in Victoria in the late 1880s. The architecture is characterized by asymmetrical towers, balustraded parapets, polygonal bay windows and round-arched openings and arcades, though the terrace houses often lack the more elaborate features. The buildings were usually stuccoed and enriched with mass-produced Renaissance-style elements in cast cement. They frequently incorporate cast-iron filigree verandahs, prefabricated in sections. A typical stuccoed villa is Wardlow (1888), Carlton, Melbourne, by John Boyes. Other Italianate Boom style work was carried out in rich polychromatic brickwork, which was characteristic of Melbourne. The other fashionable idiom commonly included in the Boom style category is French Second Empire, employed for example at Labassa (1890), a lavish house in Caulfield, Melbourne, by John A. B. Koch, and the town hall (1883–5) at Bendigo by W. C. Vahland. The Boom style rapidly declined during the depression of the 1890s.

Bibliography

R. Boyd: *Australia's Home* (Melbourne, 1952, rev. Harmondsworth, 2/1978), pp. 52–65

M. Lewis: 'The Victorian House', *The History and Design of the Australian House*, ed. R. Irving (Melbourne, 1985), pp. 65–85

RORY SPENCE

Brabant Fauvism

Term first used in 1941 by the Belgian critic Paul Fierens to describe the style of painting of an informal group of artists active in and around Brussels (Brabant province), c. 1910–23. Its founder-members included Fernand Schirren, Louis Thévenet, Willem Paerels (1878–1962), Charles Dehoy and Auguste Oleffe, who had already been grouped together in Le Labeur art society, founded in 1898. When, in 1906, Oleffe moved to Auderghem, his house became an established meeting-place, and Edgard Tytgat, Jean Brusselmans, Anne-Pierre de Kat (1881–1968) and the most prominent member of the group Rik Wouters became associated. The first exhibition of the work of those who were later called the Brabant Fauvists was held at the Galerie Giroux in Brussels in 1912. Inspired by a variety of directions within Impressionism, the group rejected Symbolism and was heavily influenced by James Ensor. They sought to express themselves through a clear visual language, with pure glowing colours and precise composition. They chose simple subjects, such as still-lifes, harmonious landscapes and scenes from everyday life executed in a painterly manner with spontaneous, expressive brushstrokes, for example Wouters's *Woman Ironing* (1912; Antwerp, Kon. Mus. S. Kst.) and Schirren's *Woman at the Piano* (1915–17; Brussels, Mus. A. Mod.).

Bibliography

P. Fierns: 'A.-P. de Kat', *Rev. Apollo*, 6 (Nov 1941)

Le Fauvisme brabançon (exh. cat. by S. G. de Heusch, Brussels, Crédit Com. Belg., 1979)

S. G. de Heusch: *L'Impressionnisme et le fauvisme en Belgique* (Antwerp, 1988)

ELS MARÉCHAL

Brücke, Die [Ger.: 'the bridge']

German group of painters and printmakers active from 1905 to 1913 and closely associated with the development of Expressionism (*see* EXPRESSIONISM, §1).

1. Founding of the group

The Künstlergruppe Brücke was founded on 7 June 1905 in Dresden by four architecture students: Fritz Bleyl (1880–1966), Erich Heckel, Ernst Ludwig Kirchner and Karl Schmidt (later Schmidt-Rottluff) (see fig. 8). They were joined by other German and European artists, including Max Pechstein, Cuno Amiet and Lambertus Zijl in 1906, Akseli Gallen-Kallela in 1907, Kees van Dongen and Franz Nölken in 1908, Bohumil Kubišta and Otto Mueller in 1910; Emil Nolde was a temporary member (1906–7). Kirchner and Bleyl had become friends in 1901 as architecture students at the Technische Hochschule in Dresden. Heckel and

8. Ernst Ludwig Kirchner: *An Artists' Group (Otto Mueller, Ernst Ludwig Kirchner, Erich Heckel and Karl Schmidt-Rottluff)*, 1926–7 (Cologne, Museum Ludwig)

Schmidt-Rottluff had met while at school in Chemnitz. Through Heckel's brother Manfred they met Kirchner while studying architecture in Dresden c. 1904. They were united by a common aim to break new boundaries in art.

The four founder-members were self-taught as artists, their only training from private drawing lessons. They nevertheless acted as a group immediately, seeing themselves as pioneers who would change the world from its very basis and revive art. In their first manifesto, which they called a *Programm* (1906), they named the impulses behind their work: faith in the future, the strength of youth, the value of directness and authenticity, and the rejection of the older forces of the establishment. Although the use of pure colour and a more two-dimensional treatment of subject-matter had obvious similarities with Fauvist art, and in particular that of Henri Matisse, whose work the group saw at an exhibition in Berlin in 1908, the artists of Die Brücke aimed to encompass all life, rather than just the field of art, with their radical stance.

The art of Die Brücke was accompanied by a philosophical demand for totality. The writings of Friedrich Nietzsche were important, and both their name and the stylized imagery of the bridge motif were linked to the writer's *Also sprach Zarathustra*. The idea for the name was later attributed to Schmidt-Rottluff, who considered it appropriate as signifying leading from one shore to another; the group as a whole felt that it stood for the image of the bridge leading to new worlds, a representation that appeared in vignettes, on invitation cards or other printed matter produced by the group in 1905 and 1906.

2. History and development

In the early years of the group's existence much discussion took place on the various positions of international art, based on the influences that the young artists had come under in Germany, particularly the graphic art of *Jugendstil* and the work of various Post-Impressionist artists including Paul Gauguin, Vincent van Gogh and the Pointillists Georges Seurat and Paul Signac, as well as Edvard Munch and Matisse. Another influence was African and Oceanic sculpture, which they saw in the Völkerkundemuseum in Dresden. In 1905 some of the artists exhibited woodcuts and watercolours in Leipzig, and in 1906 Die Brücke held their first group exhibition in the showrooms of a lamp factory in Dresden. They quickly won access to the leading modern art galleries of Dresden and were able to exhibit their works annually: from 1907 until 1909 in Emil Richter's Kunstsalon; and in 1910 in the Galerie Ernst Arnold. They were soon able to exhibit throughout Germany.

The formation of Die Brücke can be seen from two angles: they not only associated for reasons of principle, to create a new sort of art within the group, but also for practical reasons such as better organization, particularly in exhibitions. Collaboration, which sometimes led to very close stylistic similarities, occurred through communal drawing and painting and the exchange of technical processes in their graphic works. They did not, however, live together in a commune, nor did they all always work together. On the contrary, they often worked in pairs on communal projects. The actual interrelation of their lives was small. They met in their studios with girlfriends and models, whom they painted as they moved about freely. In summer they went into the countryside to paint models in natural surroundings. Among their most famous outings were the periods spent by Heckel, Kirchner and Pechstein at the Moritzburger lakes near Dresden (see Heckel's *Bathers by a Pond (Moritzburg)*, 1910; Cambridge, MA, Busch-Reisinger Mus.), individual periods spent by Kirchner and Heckel on the Baltic island of Fehmarn and Heckel's and Schmidt-Rottluff's and Kirchner's time spent in Dangast on the North Sea (see fig. 9). Heckel had an especially key role as a communicator within the group and was also in charge of the group's business activities.

The connection that Die Brücke sought to make between art and life was expressed in a number of ways, including the organization of their own studio apartments. Kirchner and Heckel decorated their studios, which were shops in a working-class district of Dresden, with furniture and sculpture they had carved themselves and painted wall decorations. These studios are documented in many

9. Erich Heckel: *House at Dangast (The White House)*, 1908 (Madrid, Museo Thyssen-Bornemisza)

paintings and drawings. The peak of their association, both in terms of communal development and group exhibitions, occurred between 1909 and 1911, when their characteristic style of painting became very two-dimensional and employed luminous colours, as in Schmidt-Rottluff's *Estate in Dangast* (1910; Berlin, Neue N.G.). After this the members began to develop very individual styles. After Pechstein moved to Berlin in 1908, over the course of 1911 Heckel, Kirchner and Schmidt-Rottluff followed him. The association became looser; Pechstein was excluded from the group in 1912, after contravening an agreement between the members by showing at an exhibition of the Berlin Secession, which had become highly conservative. In Berlin in 1913 the group was formally dissolved as a result of Kirchner's account of the history of the group in the *Chronik der Künstlergemeinschaft Brücke* (Berlin, 1913), in which he portrayed himself as leader. The style associated with Die Brücke, however, was sustained by its originators for many years to come.

3. Group membership, portfolios and graphic work

Die Brücke was organized along the lines of a German artists' association. As well as the 'active

members' or artists, there were 'passive members' or friends and supporters, including important figures such as the collector Gustav Schiefler (1857–1935) and the art historian Rosa Schapiro (1874–1954). Between 1906 and 1912 the artists annually made a gift of a portfolio of graphic work for these passive members. The first three contained a single work by each of the artists, and from 1909 each was devoted to a single artist. After the *Programm* of 1906, the group published annual reports from 1907 until 1912, as well as various woodcut membership cards.

Although painting was central to the work of all the members of the group, they also devoted themselves with great vigour to graphic work as an important step on the way to the discovery of form and the composition of surfaces. On the other hand, they gave the print an independence from other artistic forms that it had not previously enjoyed. They saw themselves as reviving a specifically German late medieval tradition to which they referred in woodcuts, engravings and lithographs of elemental force, such as Heckel's *Two Seated Women* (colour woodcut, 1912; Berlin, Brücke-Mus.). They transformed the very foundations of these media and set new standards for them.

4. Final years and historical importance

The group Die Brücke came to epitomize what is understood by the term Expressionism, sowing the seeds of the movement in Germany. It was not until 1909 that the NEUE KÜNSTLERVEREINIGUNG MÜNCHEN, later BLAUE REITER, was formed as the second cornerstone of German Expressionism. Through Die Brücke, artists completed the step towards overcoming Impressionism and Post-Impressionism that had begun in France under Matisse and the Fauves, a step towards two-dimensionality in painting, pure colour and unrestrained independence of style. Die Brücke exemplified the striving among modern artists for a rebirth of artistic activity, communal ways of working and the unity of art with life. The group became synonymous with the call of youth for a revolution and a complete overhaul of the foundations of artistic thought.

5. The Brücke-Museum

The Brücke-Museum originated in 1964 with the donation by Schmidt-Rottluff of his art collection, later supplemented by the bequest of his entire fortune. It was also supported by extensive contributions from Erich Heckel. Based in Berlin from 1967, its principal concerns have been collecting and documenting the art of Die Brücke, so that it contains the most extensive collection of paintings, drawings and prints by all the members of the group.

Bibliography

U. Appollonio: *'Die Brücke' e la cultura dell'Espressionismo* (Venice, 1952)

L.-G. Buchheim: *Die Künstlergemeinschaft Brücke: Gemälde, Zeichnungen, Graphik, Plastik, Dokumente* (Feldafing, 1956)

P. Selz: *German Expressionist Painting* (Berkeley and Los Angeles, 1957)

Ausstellung Künstlergruppe Brücke: Jahresmappen, 1906–1912 (exh. cat. by H. Bolliger and E. W. Kornfeld, Berne, Klipstein & Kornfeld, 1958) [incl. complete cat. of membership cards, annual reports, exh. cats and posters]

L.-G. Buchheim: *Die Künstlergruppe 'Brücke' und der deutsche Expressionismus*, 2 vols (Feldafing, 1973)

L. Reidemeister: *Künstlergruppe Brücke* (Berlin, 1975)

Unmittelbar und unverfälscht: Frühe Graphik des Expressionismus (exh. cat., ed. H. Robels and D. Ronte; Cologne, Wallraf-Richartz-Mus., 1976)

G. Reinhardt: 'Die frühe Brücke: Beiträge zur Geschichte und zum Werk der Dresdner Künstlergruppe Brücke der Jahre 1905 bis 1908', *Brücke-Archv*, ix/10 (1977–8)

W.-D. Dube: 'The Artists' Group Die Brücke', *Expressionism: A German Intuition* (exh. cat., ed. P. Vogt; New York, Guggenheim; San Francisco, CA, MOMA; 1980), pp. 90–102

B. Martensen-Larsen: 'Primitive Kunst als Inspirationsquelle der Brücke', *Hafnia*, vii (1980), pp. 90–118

Künstler der Brücke: Heckel, Kirchner, Müller, Pechstein, Schmidt-Rottluff: Gemälde, Aquarelle, Zeichnungen, Druckgraphik, 1909–1930 (exh. cat. by G. W. Költzch, Saarbrücken, Saarland-Mus., 1980)

Die Künstlergruppe 'Brücke' (exh. cat., ed. B. Holeczek; Hannover, Sprengel Mus., 1983)

H. Jähner: *Künstlergruppe Brücke: Geschichte einer Gemeinschaft und das Lebenswerk ihrer*

Repräsentanten (Berlin, 1984) [incl. comprehensive bibliog.]
The Print in Germany, 1880–1933: The Age of Expressionism (exh. cat. by F. Carey and A. Griffiths, London, BM, 1984)

LUCIUS GRISEBACH

Brutalism

Term applied to the architectural style of exposed rough concrete and large modernist block forms, which flourished in the 1960s and 1970s and which derived from the architecture of Le Corbusier. The term originated from *béton brut* (Fr.: 'raw concrete') and was given overtones of cultural significance not only by Le Corbusier's dictum 'L'architecture, c'est avec des matières brutes établir des rapports émouvants' ('Architecture is the establishing of moving relationships with raw materials'), but also by the *art brut* of Jean Dubuffet and others, which emphasized the material and heavily impastoed surfaces. The epitome of Brutalism in this original sense is seen in the forms and surface treatment of its first major monument, Le Corbusier's Unité d'Habitation de Grandeur Conforme (1948–54; see fig. 10) in Marseille. The ultimate disgrace of Brutalism in this same sense is to be seen in the innumerable blocks of flats built throughout the world that use the prestige of Le Corbusier's *béton brut* as an excuse for low-cost surface treatments. In Le Corbusier's own buildings exposed concrete is usually very carefully detailed, with particular attention to the surface patterns created by the timber shuttering, and this can be seen in the work of more conscientious followers of the mode such as Lasdun or Atelier 5.

The definition of the compound term New Brutalism is more contentious and was part of the disputes and polemics of British architecture in

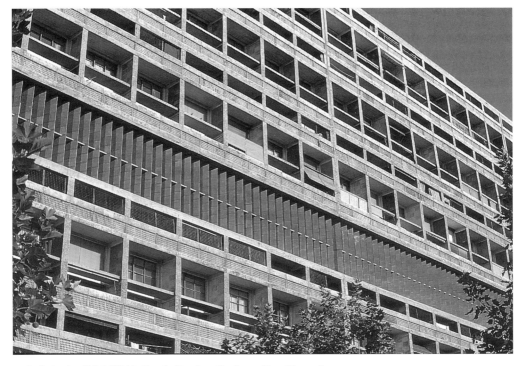

10. Le Corbusier: Unité d'Habitation de Grandeur Conforme, Marseille, 1948–54

the 1950s and 1960s. The debate began with Alison and Peter Smithson, who came to prominence in 1949 by winning a competition for the design of a new school at Hunstanton in Norfolk. On completion in 1954 this 'uncompromising' design was clearly seen to be inspired by works of Ludwig Mies van der Rohe, and as such its relatively refined detailing seems far from the usual connotations of the term Brutalism. However Hunstanton came to be seen as the first step for the more forceful and more obviously Brutalist architecture of Stirling & Gowan and others. During the school's construction period, however, the Smithsons engaged in a variety of architectural polemics, in the course of which Peter Smithson claimed of one of their own unexecuted designs that it would have been the first exponent of New Brutalism in England if it had been built. The project in question was for a small house of simple brick and timber construction, but the term New Brutalism already had overtones beyond meaning unpretentious or unaffected.

Wherever the phrase came from it was clearly intended as a counter to such coinages as 'New Humanism' or 'New Empiricism'. The former was a short-lived term coined by Marxist architects, and the latter was a label invented by the editors of the influential monthly the *Architectural Review* to describe the compromise between traditional and modern domestic architecture that had been developed in Sweden during World War II for large-scale social housing. This style, with its flush wall-surfaces, large windows, projecting balconies, wooden detailing and pitched roofs, was much imitated in post-war England but was also much despised by radical younger architects, for whom the Smithsons became a mouthpiece. The apparent disparity between the elegant steel and glass of the school and the plain blunt brick and timber of the house design underlines the essential aspect of New Brutalism as a polemic: it was not ostensibly concerned with style and was, in the Smithsons' phrase, 'an ethic, not an aesthetic'.

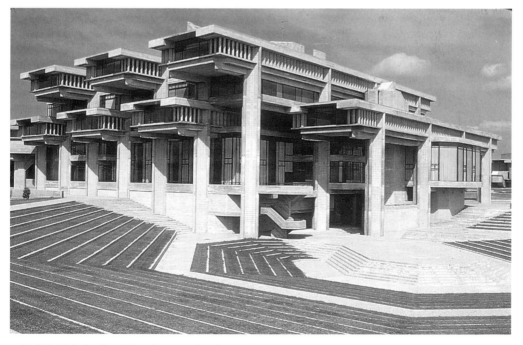

11. Paul Rudolph: Southern Massachusetts University, South Dartmouth, MA

Philip Johnson compared this attitude to that of Adolf Loos, which was perceptive and fair insofar as New Brutalism was not concerned with style but with the making of significant spaces and the honest expression of construction. Its increasing contempt for composition in the traditional sense and its insistence on image were not, however, related to Loos's work. Unlike the rather formal plan of Hunstanton, or the studied axiality of their entry for the Coventry Cathedral competition (1951), later Smithson designs such as the Sugden house (1956) often display a deliberately un-composed quality; the architects were attacked for this, although the designs show a similarity to Le Corbusier's un-composed works of the same period, such as the Maisons Jaoul (1955), which were considered beyond attack. In the Smithsons' view the strength of Le Corbusier was that, over and above the urbanistic and social vision, like Mies van der Rohe he produced works that delivered very powerful visual images. As their work became more preoccupied with visual image, it began to exhibit the qualities of the more generic Brutalism; there is little doubt that their polemics, their teaching and the example of their executed works such as the Economist Building (1964; see col. pl. XI) in London, probably the most urbane as well as the most programmatically New Brutalist work, did a great deal to establish the usage of the term Brutalism in good currency. As such it proved a useful way of labelling building as diverse as Louis Kahn's University Art Gallery (1953) at Yale, New Haven, CT, which comes very close to the Smithsons' ideas in some ways, Paul Rudolph's Southern Massachusetts University at South Dartmouth, MA (see fig. 11), the early housing of Stirling & Gowan (who rejected the term as being bad for client relations) and the 'Brick Brutalist' works of Sigurd Lewerentz or Oswald Mathias Ungers.

It is doubtful if any of the architects mentioned above ever set out deliberately to design Brutalist or New Brutalist buildings. The case of the Italian architect Vittoriano Viganó (*b* 1919) is different; his buildings (1959) for the Istituto Marchiondi Spagliardi, Baggio, were hailed by Italian writers as being specifically New Brutalist and were probably intended so by Viganó, with full acceptance of the Smithsons' stance of ethic not aesthetic.

Bibliography

Le Corbusier: *L'Unité d'habitation de Marseille* (Paris, 1950); Eng. trans. as *The Marseille Block* (London, 1950)

R. Banham: 'New Brutalism', *Archit. Rev.* [London], cxviii (1955), pp. 355–8

M. Webb: *Architecture in Britain Today* (London, 1964)

A. Smithson and P. Smithson, eds: *Team 10 Primer* (London, 1965)

R. Banham: *The New Brutalism: Ethic or Aesthetic?* (London, 1966)

'Banham's Bumper Book on Brutalism Discussed by Alison and Peter Smithson', *Architects' J.*, cxliv (1966), pp. 1590–91

REYNER BANHAM

Camden Town Group

Exhibiting society of 16 British painters that flourished between 1911 and 1914. It was created from the inner core of artists who regularly attended the informal Saturday afternoon gatherings first established by Walter Sickert in 1907 in a rented studio at 19 Fitzroy Street, London. Sickert, Lucien Pissarro, Spencer Gore, Harold Gilman and Robert Bevan, together with disciples, pupils and sympathetic colleagues, met weekly to display their work to each other and to a small band of patrons while discussing the politics of art in London. Although Fitzroy Street was never intended to represent a movement or school, between 1907 and 1911 it did nurture a distinct episode in the history of British art, which is most suggestively described as Camden Town painting. The pictures tended to be small: 'little pictures for little patrons', to quote one of the latter, Louis Fergusson. A Sickert-inspired vocabulary of favourite themes was established: nudes on a bed or at their toilet, informal portraits of friends and coster models in shabby bed-sitter interiors, mantelpiece still-lifes of cluttered bric-à-brac, and views of commonplace London streets, squares and gardens. Every theme was treated with objective perceptual honesty. The

handling developed by many of these painters, influenced above all by Lucien Pissaro, represents a late and temperate flowering in England of French Impressionism. With qualifications, interest in colour analysis and the development of a broken touch were characteristics common to the inner core of 'Camden Town' painters.

By the end of 1910 the Fitzroy Street gatherings were patronized by a large circle of painters representing a complex jigsaw of friendships and professional relationships. Recruits were discovered at exhibitions, notably those of the Allied Artists' Association (AAA). In 1909 and 1910 the establishment of the New English Art Club (NEAC) admitted work by several Fitzroy Street artists for exhibition. During the winter of 1910–11 Roger Fry staged the exhibition *Manet and the Post-Impressionists* at the Grafton Gallery. The public, most of the critics and the figureheads of the art world united to condemn the exhibition as an outrage. The old guard of the NEAC were among the most hostile, and it became obvious that the grudging tolerance recently displayed towards Fitzroy Street and its allies would be abruptly withdrawn. This revived antagonism was the main impetus behind the creation of the Camden Town Group.

Disaffection with the NEAC was the chief topic of discussion among members and satellites of Fitzroy Street early in 1911. The relative merits of capturing control of its jury or setting up a rival exhibiting society were hotly debated. Dining at Gatti's (probably in April), Sickert, Charles Ginner, Bevan, Gore and Gilman decided to create a new society. Discussion continued at Fitzroy Street, over dinner at the Criterion (when it was decided whom to invite as members) and in a restaurant in Golden Square when, according to Walter Bayes (1869–1956), Sickert is said to have invented the name Camden Town Group because 'that district had been so watered with his tears that something important must sooner or later spring from its soil'. Bayes, who had been recruited to Fitzroy Street in 1908 when Sickert admired his work in the AAA exhibition, had evidently joined the original Gatti's set to become a founder-member of the new society, as had James Bolivar Manson,

more recently introduced to Fitzroy Street by Pissarro. Manson was elected Secretary and Gore President of the new society. Ginner recorded that the founder-members of the Group wished to create a limited circle of those painters whom they considered to be the best and most promising of the day. This ideal explains the recruitment of Percy Wyndham Lewis (proposed by Gilman) and Maxwell Gordon Lightfoot, both outside the Fitzroy Street circle, and perhaps Augustus John and J. D. Innes, who sometimes attended the Saturday gatherings but were not within its inner core. Lesser credentials were demanded when the founders wished to invite friends, pupils and disciples. Sickert and Ginner proposed Malcolm Drummond (1880–1945), who had been a pupil at Rowlandson House, the private school where Sickert taught etching, drawing and painting from 1910 to 1914. Drummond's painting of *Brompton Oratory* (c. 1910; AC Eng) had been exhibited at the AAA in 1910. His *19 Fitzroy Street* (c. 1913–14; Newcastle upon Tyne, Laing A.G.) documents one of the Group's meetings and probably depicts Manson, Gore and Ginner examining pictures taken from the stack in the studio. Gilman proposed William Ratcliffe; Gore proposed his deaf pupil Doman Turner (c. 1873–1938). Henry Lamb, a neighbour with a studio in Fitzroy Street, was invited. Lastly, Gilman, strongly supported by Sickert, insisted that the Group should exclude women. Thus a finite membership of 16 was achieved: founder-members were Bayes, Bevan, Gilman, Ginner, Gore, Pissarro, Sickert and probably Manson; invited members were Drummond, Innes, John, Lamb, Lewis, Lightfoot, Ratcliffe and Doman Turner. Sickert persuaded Arthur Clifton of the Carfax Gallery in Bury Street, St James's, to lend his basement premises in June 1911 for their first exhibition.

Each of the members was entitled to show four works, which were to be hung together rather than mixed on the walls. In fact at the first exhibition only 55 instead of 64 pictures were shown; Innes did not exhibit, while Lamb with three and Lewis and John with two pictures each did not take up their full quota. Sickert's four contributions included two related figure subjects, now titled

What Shall We Do for the Rent? (*c.* 1909; Kirkcaldy, Fife, Mus. & A.G.) and *Summer Afternoon* (*c.* 1909; priv. col., see L. Browse: *Sickert*, London, 1943, pl. 61), but then both called *Camden Town Murder*, probably for publicity reasons. Lewis contributed two angular pen-and-ink drawings of a man's head, one now titled *The Architect* (1909; priv. col., see Baron, 1979, p. 259). These excited much derision, but otherwise there was little to offend the critics: fresh urban and rural landscapes, Camden Town figures in interiors, two cab-yard scenes by Bevan, and two music-halls by Gore. John's presence was reassuring, and every critic could recognize the qualities of design, draughtsmanship and the technical fluency of Lightfoot and Lamb.

The second exhibition of the Group was held at the Carfax Gallery in December 1911, when 53 pictures were included. Duncan Grant, elected to replace Lightfoot, who had resigned, contributed one picture; John did not exhibit; Bayes and Lewis with three pictures each and Lamb with two explain the shortfall. At a meeting attended by all members except Grant, Innes and John, the idea of expanding the Group was first debated but finally voted down. However, a motion that new and larger premises be sought for their exhibitions was carried unanimously and effectively delayed active consideration of their next exhibition, which did not take place until December 1912.

At the third and last Camden Town Group exhibition, again held at the Carfax Gallery because larger premises had not been found, 13 of the 16 members showed 45 pictures. Grant, John and Innes abstained; each, having closer artistic and commercial allegiances to rival societies and galleries, had exhibited only once with the Group. Their absence meant that the overall character of the paintings on view was more cohesive than in 1911. Only Bayes, Lamb and Lewis remained to represent styles developed outside the influence of the original nucleus of Fitzroy Street painters. The year between shows had allowed time for the talents of less experienced exhibitors to mature and this third exhibition included Drummond's *St James's Park* (1912; Southampton, C.A.G.) and Ratcliffe's *Clarence Gardens* (*c.* 1912; London,

Tate). Ginner also showed *Piccadilly Circus* (1912; London, Tate; see col. pl. XII), one of his earliest brilliantly coloured and tautly constructed cityscapes. Bevan showed his first London horse-sale paintings. Three artists exhibiting with the Camden Town Group, Lewis, Lamb and Gore, were also invited by Fry to contribute to his *Second Post-Impressionist Exhibition* at the Grafton Gallery, which opened in October 1912, and which was extended in December, thus overlapping the Carfax Gallery offering. The coincidence of these two exhibitions tended to polarize their respective characters in the eyes of critics and public. The viability of the Camden Town Group was threatened when it was relegated to a neutral position between the radicalism of Fry's selection and the conservatism of the NEAC.

During 1913 Clifton continued to sponsor the work of individual members of the Camden Town Group, as he had done in 1912, by offering them separate exhibitions. As in previous years, 19 Fitzroy Street (still chaired by Sickert) remained a central meeting-point where members of the finite Camden Town Group were joined by an ever-expanding number of visitors, many of whom became members of the parent society. Thus Jacob Epstein was admitted to membership in April 1913. Radical art politics were in a state of constant flux during this year as rival factions formed, overlapped and re-formed. Things came to a head in the autumn when the Fitzroy Street group reassembled after a summer recess to face decisions about the expansion of the Camden Town Group. It was decided to form a new society, the London Group, through the amalgamation of the two. Thus the Camden Town Group, after less than three years independence, was reabsorbed into the parental fold.

The Camden Town Group gradually petered out. Its last gesture was to respond to the invitation to select an exhibition of English Post-Impressionists, Cubists and others to be held at the Brighton Art Gallery from December 1913 until January 1914. However, this exhibition was also the first gesture as a corporate body of the London Group. Not only did all 11 active members of the Camden Town Group exhibit (those absent

being Doman Turner, Grant, Innes, John and Lamb), so too did all the Fitzroy Street founder-members of the London Group and eight of the nine artists elected before the first exhibition in March 1914.

Writings

Work by English Post-Impressionists, Cubists and Others (exh. cat., ed. W. Lewis and J. B. Manson; Brighton, A.G. & Mus., 1913), pp. 5–12

C. Ginner: 'Neo-Realism', *New Age* (1 Jan 1914)

W. Bayes: 'The Camden Town Group', *Sat. Rev.* (25 Jan 1930)

C. Ginner: 'The Camden Town Group', *Studio*, cxxx/632 (1945), pp. 129–36

W. R. Sickert: *A Free House: Or the Artist as Craftsman*, ed. O. Sitwell (London, 1947) [anthol. of Sickert's writings]

Bibliography

F. Rutter: *Some Contemporary Artists* (London, 1922)

—: *Since I was Twenty-five* (London, 1927)

—: *Art in my Time* (London, 1933)

A. Rutherston: 'From Orpen and Gore to the Camden Town Group', *Burl. Mag.*, lxxxii (1943), pp. 201–5

M. de Saumarez: 'Camden Town Group Pictures in the Leeds Collection', *Leeds A. Cal.*, iii/12 (1950), pp. 10–22, 28

J. Rothenstein: *Modern English Painters*, 2 vols (London, 1952–6, rev. 1976)

D. Sutton: 'The Camden Town Group', *Country Life Annu.* (1955), pp. 97–100

Q. Bell: 'The Camden Town Group I: Sickert and the Post-Impressionists', *Motif*, 10 (1962–3), pp. 36–51

—: 'The Camden Town Group II: Opposition and Composition', *Motif*, 11 (1963–4), pp. 68–85

—: 'Sickert and the Post-Impressionists', *Victorian Artists* (London, 1967), pp. 85–94

M. Easton: '"Camden Town" into "London": Some Intimate Glimpses of the Transition and its Artists, 1911–1914', *Art in Britain, 1890–1940* (exh. cat., U. Hull, A. Col., 1967), pp. 60–75

Camden Town Recalled (exh. cat. by W. Baron, London, F.A. Soc., 1976)

W. Baron: *Miss Ethel Sands and her Circle* (London, 1977)

R. Shone: *The Century of Change: British Painting since 1900* (London, 1977)

W. Baron: *The Camden Town Group* (London, 1979) [bibliog. and list of exhs]

S. Watney: *English Post-Impressionism* (London, 1980)

The Camden Town Group (exh. cat. by W. Baron and M. Cormack, New Haven, CT, Yale Cent. Brit. A., 1980)

C. Harrison: *English Art and Modernism, 1900–1939* (London, 1981)

For further bibliography *see* individual biographies of Camden Town Group artists.

<div align="right">WENDY BARON</div>

Canadian Art Club

Society of artists active in Toronto from 1907 to 1915. Among its 20 members were William Brymner, Maurice Cullen, Clarence Gagnon, James Wilson Morrice, Edmund Morris (1871–1913), A. Phimister Proctor (1860–1950), Horatio Walker, Homer Watson and Curtis Williamson (1867–1944). The Club was formed in reaction to the low standards and 'truth to nature' aesthetics of the Ontario Society of Artists and was modelled on Whistler's International Society of Sculptors, Painters and Gravers. Its eight exhibitions concentrated on small, carefully hung groups of works by leading Canadian artists and attempted to establish a high standard for other artists. The Club applauded individual achievement and was nationalistic in persuading expatriates to exhibit at home but, unlike the Group of Seven, defined nationality in only the broadest terms. The artists who exhibited at the Club were influenced by the Barbizon school, the Hague school and British *plein-air* painting, by Whistler and the Impressionists. Their works were well received by critics, and the Club's activities were an important catalyst for artistic and institutional change. Its major influence was that of its Quebec Impressionist members on the emerging Group of Seven. After the death of Morris in 1913, however, and with the distractions of World War I, the Club disbanded; personalities clashed, finances were shaky and the membership was too dispersed to sustain the enthusiasm to keep it alive.

Bibliography

The Canadian Art Club, 1907–1915 (exh. cat. by R. J. Lamb, Edmonton, Alta, A.G., 1988)

<div align="right">ROBERT J. LAMB</div>

Cercle et Carré

Movement founded in Paris in late 1929 during a meeting between the writer Michel Seuphor (born 1901) and the Uruguayan painter Joaquín Torres García, which became public in 1930. Though having no official manifesto, it is best characterized as broadly Constructivist in outlook. It comprised mainly abstract artists from Constructivism, Futurism, Purism, Neo-plasticism, Dada and Bauhaus, whose common motivation was to create an artistic opposition to the dominant Surrealists. The movement comprised both a periodical, which ran for three issues in 1930, and a single exhibition held at Galerie 23, Rue la Boëtie, Paris, from 18 to 30 April 1930. There were 130 exhibits, covering painting, sculpture, architecture and stage design, by 46 artists, including Hans Arp, Vasily Kandinsky, Le Corbusier, Fernand Léger, Piet Mondrian, Amédée Ozenfant, Antoine Pevsner, Luigi Russolo and Georges Vantongerloo. Notably, Theo van Doesburg refused to join, instead forming a rival group, Art concret. The exhibition closed with a lecture by Seuphor on 'Art poétique', with musical accompaniment from Russolo, but it was a commercial and critical failure.

Through his editorship of the periodical and wide support within the movement Seuphor moulded Cercle et Carré into a forum for abstract art. While nominally agreeing with Torres García over the importance of structure in art, his attitudes were basically Neo-plasticist. This stance alienated Torres García, for whom abstraction had never been the central issue, and he left the group in July 1930. While preparing the fourth issue of the periodical, in autumn 1930, Seuphor fell gravely ill, bringing the movement to an end. Abstraction-Création, founded by Auguste Herbin and Vantongerloo in 1931, regrouped many of the same artists.

Writings

M. Seuphor: 'Pour la défense d'une architecture', *Cerc. & Carré*, 1 (1930), pp. 1–3 [regarded as a manifesto]
J. Torres García: 'Vouloir construire', *Cerc. & Carré*, 1 (1930), pp. 3–4

Bibliography

M. Seuphor: *Le Style et le cri* (Paris, 1965), chap. 6
——: *Cercle et Carré* (Paris, 1971) [incl. a reprint of the original articles]
M.-A. Prat: *Cercle et Carré: Peinture et avant-garde au seuil des années 30* (Lausanne, 1984)

PHILIP COOPER

CIAM [Congrès Internationaux d'Architecture Moderne]

International organization of modern architects founded in June 1928 at the château of La Sarraz, Switzerland. It was instigated by Hélène de Mandrot (who had offered her château as a venue for a meeting of architects interested in discussing developments in modern architecture), Le Corbusier and Sigfried Giedion. Its foundation was stimulated by the campaign in defence of Le Corbusier's unexecuted competition entry (1927) for the League of Nations Building, Geneva, as well as the success of the Weissenhofsiedlung (1927) in Stuttgart—a permanent, model exhibition of social housing in which several noted European Modernists had participated (for further discussion *see* DEUTSCHER WERKBUND). The creation of CIAM established the MODERN MOVEMENT in architecture as an organized body, with a manifesto, statutes, a committee (*see* CIRPAC) and an address in Zurich: that of Giedion, who became its first secretary-general. Karl Moser was its first president, followed by Cornelis van Eesteren (1930–47) and Josep Lluís Sert (1947–56).

CIAM brought together proponents of several important modern architectural theories of the 1920s, including members of the Bauhaus (Walter Gropius, Hannes Meyer), Der Ring (Hugo Häring, Mies van der Rohe) and the avant-garde journal *ABC: Beiträge zum Bauen* (Mart Stam, Emil Roth) from Germany; of *L'Esprit nouveau* (Le Corbusier) from France; of De Stijl (Gerrit Rietveld, van Eesteren) from the Netherlands; of Devětsil and Stavba (Karel Teige) from Czechoslovakia; and the Praesens group (Szymon and Helena Syrkus) from Poland, as well as a number of individuals whose ideas linked them with one or other of these groups. Through CIAM these ideas were classified under the general approach of 'functionalism', which many critics (in particular Reyner Banham)

believed to be the reason for the subsequent simplification of the hitherto wide variety of formal characteristics of the avant-garde (*see also* INTERNATIONAL STYLE). At the height of its activity, in the 1930s and early 1950s, CIAM was the dominant international forum for discussion and dissemination of ideas on modern architecture and urban planning. In the context of altered conditions in the 1950s, however, many of its ideas and the didactic approach of its older members were challenged by the younger generation of architects who organized CIAM X in 1956 (*see* TEAM TEN), and this resulted in the formal dissolution of the organization in 1959.

1. 1928–46

The first meeting at La Sarraz, afterwards known as CIAM I, produced a declaration of principles on which future discussions would be based. These were concerned with the establishment of an autonomous architecture rooted in the social and economic needs of the times (including the adoption of industrialized production techniques) and freed from domination by tradition and the academies. A functional approach to urban planning based on dwelling, work and recreation was also specified, to be achieved through land organization, traffic regulation and legislation. At CIAM II (Frankfurt am Main, 1929) the organization's statutes were adopted, establishing a system of membership through national groups and stating its aims: to 'establish and represent the demands of modern architecture, to introduce the ideas of modern architecture into technical, economic and social circles, and to resolve contemporary building problems'. Discussions were centred on low-cost housing, an important preoccupation of the period, with visits to notable housing developments of this type by Ernst May, city architect of Frankfurt. The resulting publication, *Die Wohnung für das Existenzminimum* (1930), included plans of low-cost dwellings that were also exhibited by the group. CIAM III was held in 1930 in Brussels, where several new housing estates had been completed (e.g. the Cité Moderne by Victor Bourgeois). It discussed the efficiency of low-, medium- and high-rise housing, and the

rational organization of land for housing. National groups again prepared plans and reports; these were exhibited and published as *Rationelle Bebauungsweisen* (1931).

At the next meeting, intended as the first in a series on 'The Functional City', the 'existing chaos' of 33 large cities was to be analysed. In view of the lack of concrete achievements or proposals from the previous meetings, a considerable amount of preparatory work was planned under van Eesteren, who was then engaged on the General Extension Plan for Amsterdam. An extraordinary congress in Berlin (1931) and two further meetings of CIRPAC were devoted to these preparations, which included the standardization of presentation techniques. In the context of increasing political tensions, CIAM IV—originally scheduled for Moscow—was finally held in 1933 on board *SS Patris II*, a cruise ship sailing from Marseille to Athens and back. The study of the 33 cities was carried out in accordance with the four principal functions of the city: dwelling, work, transportation and recreation. Reviews of existing conditions were followed by 'requirements' within each function: for example, housing should be sited in the most favourable parts of the city; high-rise buildings could free space for recreation areas; green open spaces should be distributed over and around the city; work-places should be sited at the shortest possible distance from residential areas, the latter containing only local services; industry should be isolated by a green belt; and different kinds of traffic should have separate routes, with crossings at different levels.

CIAM IV was the most successful congress to date in terms of its collective discussions, but its results, summed up at the end of the congress as 'Statements', were very generalized. Although the official publications proposed did not appear, the results of CIAM IV formed the basis of two books published much later: Sert's *Can Our Cities Survive?* (1942) and Le Corbusier's *La Charte d'Athènes* (1943). In the latter Le Corbusier revised the Statements, presenting them in far stronger and more definitive terms than the original, thus depriving them of their suggestive nature. This particularly applied to his 'point de doctrine' on

urban planning: it was *La Charte d'Athènes* that embodied the concept of 'autonomous sectors' for the four major functions of the city, thus enshrining the notion of rigid zoning in modern urban planning that was adopted in much urban reconstruction after World War II and later heavily criticized.

CIAM V (Paris, 1937) followed three further preparatory CIRPAC meetings and was intended to consider proposals that could contribute to a concrete plan for 'The Functional City' at the level of regional, urban and suburban planning. Instead, the theme of 'Dwelling and Recreation' was nominated by Le Corbusier, an indication of his increasing influence in the organization, due partly to the break-up of the German group after the advent of Nazism. The results, including Le Corbusier's renewed call for high-rise blocks of flats in green open spaces, were published in *Logis et Loisirs* (1938). A related group, CIAM-Ost, was founded in 1937 to provide a forum for the discussion of special architectural problems faced by the states of eastern Europe. CIAM-Ost held two congresses in 1937, at Budapest and Brunn (now Brno), but its activities were halted by World War II. During the war the work of CIAM was continued in the USA by Gropius, László Moholy-Nagy, Giedion, Sert and others as the Chapter for Relief and Post-War Planning, which concentrated primarily on accumulating information about American industrialized building techniques.

2. 1947–59

The first congress after the war, CIAM VI (Bridgewater, CT, 1947), was a reunion meeting, intended to review work carried out and to consider the future function of CIAM in the context of post-war politics and urban reconstruction. Giedion was commissioned to publish a survey of the work of CIAM members during the period 1939–47; published as *A Decade of New Architecture* (1951). Through Giedion CIAM VI called for a 'new monumentality' and aesthetic expression in architecture. Changes were made to the statutes to allow CIAM to expand as a federation of independent groups, and leadership was vested in a council appointed by the congress. At Bridgewater the influence began to be felt of the younger generation, including Aldo van Eyck, Jacob Bakema and members of the English MARS Group, many of whom were unhappy with a perceived lack of humanism in the European avant-garde. The Declaration of Bridgewater reformulated the aims of CIAM as the creation of a physical environment that 'will satisfy man's emotional and material needs and stimulate his spiritual growth'; its task included ensuring that 'technical developments are controlled by a sense of human values' (see exh. cat., p. 84).

At CIAM VII (Bergamo, 1949) Le Corbusier's Grid ('Grille-CIAM') was introduced. This had been developed with the research group ASCORAL as a tool for depicting and comparing urban planning proposals, and there was a presentation of plans entitled 'The Applications of the Athens Charter by means of the CIAM Grid'. Discussions on the synthesis between architecture and the fine arts, and on education in architecture and urban planning, were also held, but the lack of resolutions reflected an increased academicism at the meeting. At this congress the influence of the Italian members was more apparent, as was the growing student body. Important reference points for the international organization were also being provided by such countries as Brazil and Venezuela, which in the 1940s and 1950s had begun to overtake Europe in their virtuosity in the new architecture; indeed, it was at Brasília that the planning concepts of the Athens Charter were subsequently realized for the first and only time.

CIAM VIII (Hoddesdon, 1951) was entitled 'The Heart of the City'. Its subject, 'the core', was suggested by the English group and reflected increasing concern with social and individual issues, together with a recognition of inadequacies in the Athens Charter. The subject was particularly relevant to contemporary reconstruction work and design of new towns, both in Europe and in the developing countries. Because of its connotations of community centre and city centre, 'the core' became the key term in bringing together separate architectural functions in a composite environment. The conclusions, following several short

talks and an exhibition of plans, included various generalizations about the nature of 'the core', including the demand that all motorized traffic should be banned.

Discussion of 'the core' continued at CIAM IX (Aix-en-Provence, 1953) under the wider theme of 'Habitat', the environment for human society, with the aim of producing a 'Charte de l'Habitat'. CIAM IX is renowned for the student party held on the roof of Le Corbusier's Unité d'Habitation, Marseille. In a sense this symbolized the end of unanimity in the interpretation and expectations of CIAM's theories and marked the split between the 'old guard' and the younger generation, who were concerned with ideas of individual architectural identity, scale and meaning. Cluster housing by Alison and Peter Smithson and Moroccan housing projects by ATBAT-Afrique presented by Georges Candilis and Shadrach Woods were influential in developing such ideas, which were in marked contrast to the original aims of CIAM to formulate an autonomous, universally applicable system of architecture and planning.

In 1954, following CIAM IX, a number of younger members from England and the Netherlands, including the Smithsons, Bakema and van Eyck, met at Doorn and produced the Doorn Manifesto, which rejected the mechanized functionalism of the Athens Charter and emphasized instead the primacy of human association in urban planning. The younger group, slightly enlarged, was subsequently established as the CIAM X Committee (see TEAM TEN) and adopted the Doorn Manifesto in its draft proposals, approved by Le Corbusier in 1955. At CIAM X (Dubrovnik, 1956), entitled 'Habitat: The Problem of Relationships', 39 projects were exhibited and studied by four working groups under the headings of Cluster, Mobility, Growth and Change, and Urbanism and Habitat. However, the challenge presented by the new approach of the younger generation, who were supported by Le Corbusier, confirmed the split in the organization and led to an extended discussion on the future of CIAM, which by then had grown to unwieldy proportions with groups in more than 30 countries and about 3000 members. At the end of the meeting it was decided to abolish the federation of groups and to reorganize the statutes and congresses.

Following a meeting at La Sarraz in 1957 the name of CIAM was changed to CIAM: Research Group for Social and Visual Relationships, reflecting its new concerns: 'to establish the interrelationships of the social structure and contemporary means of expression' (see exh. cat., p. 103). A committee composed of Bakema, Alfred Roth, Ernesto Nathan Rogers, John Voelcker and André Wogensky (b 1916) organized a working congress to see whether the new CIAM was viable. CIAM XI (Otterlo, 1959) was attended by 43 individual participants; most of the leaders of the 'old guard', including Le Corbusier, Giedion, Gropius, Sert and J. Tyrwhitt, were conspicuous by their absence, and it was made plain that the work of the old CIAM was no longer considered relevant. The meeting at Otterlo, coordinated by Bakema, had no formal structure; participants had been requested to 'avoid chatter, arguments and philosophical discussion', and the projects presented by each were examined and later published as *CIAM '59 in Otterlo* (1959). Clear differences in approach were apparent, however, and the meeting terminated with the decision to discontinue the name of CIAM. Nevertheless, informal contacts remained among a number of groups, and Team Ten in particular grew into a loose-knit 'family' of like-minded individuals who continued to meet irregularly until 1981.

Writings

Die Wohnung für das Existenzminimum (Stuttgart, 1930)
Rationelle Bebauungsweisen (Stuttgart, 1931)
Logis et loisirs (Paris, 1938)
J. L. Sert, ed.: *Can Our Cities Survive?* (Cambridge, MA, and London, 1942)
Le Corbusier, ed.: *Urbanisme de CIAM: La Charte d'Athènes* (Paris, 1943; Eng. trans., New York, 1973)
J. Tyrwhitt, J. L. Sert and E. N. Rogers, eds: *The Heart of the City: Towards the Humanisation of Urban Life* (London, 1952)
O. Newmann, ed.: *CIAM '59 in Otterlo* (Stuttgart, 1961)

Bibliography

S. Giedion, ed.: *A Decade of New Architecture* (Zurich, 1951)

S. Giedion: 'Les CIAM', *Archit. Aujourd'hui*, 113–14 (1964), pp. 36–7

M. Steinmann, ed.: *CIAM: Dokumente, 1928–1939* (Basle, 1979)

CIAM: Internationale Kongresse für Neues Bauen (Nendeln, 1979)

A. Smithson, ed.: *The Emergence of Team 10 out of CIAM* (London, 1982) [facsimiles of contemp. doc. incl. Doorn Manifesto]

Het nieuwe bouwen internationaal: CIAM: Volkshuisvesting, Stedebouw [CIAM: Housing, Town Planning] (exh. cat., ed. A. van der Woud; Otterlo, Rijksmus. Kröller-Müller, 1983) [incl. Declaration of La Sarraz, Statutes, Statements of the Athens congress, 1933]

<div align="right">JOS BOSMAN</div>

Circle of Artists [Rus. Krug Khudozhnikov]

Russian group of painters and sculptors, active from 1926 to 1932. It was founded in 1926 by graduates in painting from the Higher (State) Artistic and Technical Institute (Vkhutein) in Leningrad (now St Petersburg); most of them had been students of Aleksey Karev (1879–1942), Kuz'ma Petrov-Vodkin and Aleksandr Savinov (1881–1942). The group's goal, similar to that of the SOCIETY OF EASEL PAINTERS and the FOUR ARTS SOCIETY OF ARTISTS, was to promote the professional role of painters and sculptors and to play an intermediary role between conservative artists and those who were avant-garde extremists. Seeking a modern art that actively drew on the painterly achievements of the past and yet was an expression of contemporary life, the group declared its rejection of literary content and 'agitprop' intention. Instead, it concentrated on easel painting and sculpture in the round while at the same time encouraging formal experimentation.

The group was initiated by Vyacheslav Pakulin (1900–51), its chairman, and Aleksey Pakhomov (1900–73), and it included among its other leading members Aleksandr Rusakov (1898–1952), Vladimir Malagis (1902–74), Aleksandr Vedernikov (1898–1975) and Aleksandr Samokhvalov. Between 1927 and 1930 the Circle of Artists organized six exhibitions (in Leningrad and Kiev) and participated in several others. These were accompanied by lectures and debates on modern art, contributors to which included Nikolay Punin, Nikolay Tarabukin and Vsevolod Voinov (1880–1945). Typically, the group promoted the collective nature of their work and perceived their role in terms integral to the process of cultural construction in the USSR. Led by Pakulin in the desire for an elevated expression of the theme of labour, the group tended to create paintings of working figures in which the formal approach was given prominence. It was felt that with this combination of modern subject-matter and style the artist could best establish his professional identity without sacrificing his art to non-artistic demands. The Circle's members thus drew on the formal experiments of the French and Russian avant-garde of the early 20th century and created figurative works that had clear references to Fauvism, proto-Cubism and Neo-primitivism. Their art also showed the particular imprint of such Russian forerunners as Petrov-Vodkin, Karev and Vladimir Lebedev. Typical works, characterized by broad brushstrokes, distorted perspective and artificial colour, include Pakulin's *Woman with Buckets* (?1928), Pakhomov's *Reaper* (1928), Rusakov's *Electrician* (?1928) and Samokhvalov's *Conductress* (1928; all St Petersburg, Rus. Mus.). In 1930, however, split by differing opinions about which direction to follow and feeling pressure from both left and right, the group effectively ceased to function, and in 1932 it was officially disbanded.

Bibliography

O. Shikhireva: 'K istorii obshchestva "Krug khudozhnikov"' [On the history of the 'Circle of Artists' society], *Sov. Isk.* (1983), no. 1, pp. 296–326

A. Borovsky: 'Obshchestvo "Krug" i V. Malagis' [The society 'Circle' and V. Malagis], *Sov. Zhivopis'*, 9 (1987), pp. 261–75

M. Guerman and others: *Russian Art, 1920–1930* (New York, 1988), pp. 166–83

D. Severyukhin and O. Leikind: *Zolotoy vek: Khudozhestvennykh obedinenii v Rossii i SSSR, 1820–1932* [The golden age: art groups in Russia and the USSR, 1820–1932] (St Petersburg, 1992), pp. 91–3

<div align="right">JEREMY HOWARD</div>

CIRPAC [Comité International pour la Résolution des Problèmes de l'Architecture Contemporaine]

Elected executive organ of CIAM (Congrès Internationaux d'Architecture Moderne), which was founded in 1928 at La Sarraz, Switzerland, on the initiative and leadership of Le Corbusier and Sigfried Giedion to coordinate the international forces of modern architecture. CIRPAC was formally constituted as the executive organ by statutes adopted at CIAM II (1929), held in Frankfurt am Main. The congress of CIAM members elected their delegates and their deputies by a two-thirds majority; these delegates then became members of CIRPAC. The election was held with a view to providing representation for each national CIAM group on the executive board. The President and Deputy President of CIAM (and concurrently of CIRPAC) were also elected by the congress with a two-thirds majority. The President could select a Secretary. The mandate was carried over from one congress to another, and the officers could be re-elected. CIRPAC was involved in the organization of congresses; its President determined the time and place of the next convention, and it operated an office during congresses and executed the resolutions passed at them. Every national group could delegate a further member with an advisory status only to meetings of CIRPAC, and more members could be drafted into work in progress on the suggestion of the President. In practice it fell to the members of CIRPAC to organize and administer the CIAM group of their country while keeping in contact with the leaders of CIAM. It was the task of CIRPAC members to publicize the aims of CIAM in their own countries by organizing exhibitions and drawing on the press; they were also required to recruit new supporters, to carry through the resolutions passed by previous congresses and to prepare subsequent ones. CIRPAC organized ten congresses between 1929 and 1959, when CIAM was formally disbanded.

Bibliography

M. Steinmann, ed.: *CIAM: Dokumente, 1928–1939* (Basle, 1979)

CIAM: Internationale Kongresse für neues Bauen (Nendeln, 1979)

ÁKOS MORAVÁNSZKY,
KATALIN MORAVÁNSZKY-GYÖNGY

City Beautiful Movement

American urban planning movement directed towards achieving a cultural parity with the cities of Europe, led by architects, landscape architects and reformers. The movement began in the 1850s with the founding of improvement societies in New England towns, but it gathered momentum and secured a national identity in the 1890s under the stimulus of the World's Columbian Exposition, Chicago (1893), the development of metropolitan park systems and the founding of municipal art societies in major cities. National interest in the movement intensified with the publication of the comprehensive McMillan Plan for Washington, DC (1901–2), designed by the Exposition participants Daniel H. Burnham, Charles F. McKim, Augustus Saint-Gaudens and Frederick Law Olmsted jr.

Charles Mulford Robinson (1869–1917), journalist and author, emerged as the movement's chief spokesperson and advised municipalities to enlist experts. Politicians, art commissions and businessmen's clubs nationwide called on consulting architects, landscape architects and designers. Their objective was not social reform, but municipal reform and beautification, believed to elevate the prestige of cities and thus to attract wealth. The City Beautiful projects, many unrealized, ranged in scale from Cass Gilbert's design for the surroundings of the Minnesota State Capitol in St Paul (1903–6) to the ambitious plan of Daniel H. Burnham and Edward H. Bennett (1874–1954) for San Francisco, CA (1904–5). The movement culminated in Burnham and Bennett's plan for Chicago (1906–9), IL, which encompassed a 95-km radius and proposed a crowning civic centre, radial avenues and ring roads, a rearranged rail network and an extensive system of parks and parkways. By the end of World War I most of the movement's major personalities had completed

their careers, but their goals remained an animating force in American urban planning.

Writings
C. M. Robinson: *Modern Civic Art or the City Made Beautiful* (New York, 1903)
D. H. Burnham and E. H. Bennett: *Plan of Chicago* (Chicago, 1909/R New York, 1970)

Bibliography
J. Reps: *Monumental Washington: The Planning and Development of the Capital Center* (Princeton, 1967)
M. Scott: *American City Planning since 1890* (Berkeley, 1969)
T. S. Hines: *Burnham of Chicago: Architect and Planner of Cities* (New York, 1974)
J. A. Peterson: 'The City Beautiful Movement: Forgotten Origins and Lost Meanings', *J. Urban Hist.*, ii (1976), pp. 415–34
J. Kahn: *Imperial San Francisco: Politics and Planning in an American City, 1897–1906* (Lincoln, 1979)
A. Sutcliffe: *Towards the Planned City: Germany, Britain, the United States, and France 1870–1914* (New York, 1981)
R. H. Tracy: John Parkinson and the Beaux-Arts City Beautiful Movement in Downtown Los Angeles, 1894–1935 *(diss., Los Angeles, UCLA, 1982)*
W. H. Wilson: *The City Beautiful Movement* (Baltimore, 1989)
T. S. Hines: 'The Imperial Mall: The City Beautiful Movement and the Washington Plan of 1901–1902' Stud. Hist. A. *[Washington, DC]*, xxx (1991), pp. 78–99
J. A. Peterson: 'The Mall, the McMillan Plan and the Origins of American City Planning', Stud. Hist. A. *[Washington, DC]*, xxx (1991), pp. 100–15
K. C. Schlichting: 'Grand Central Terminal and the City Beautiful in New York', *J. Urban Hist.*, xxii/3 (March 1996), pp. 332–49

GAIL FENSKE

Cobra

International group of artists founded in the Café Notre-Dame, Paris, on 8 November 1948 and active until 1951. The name was a conflation of the initial letters of the names of the capital cities of the countries of origin of the first members of the group: Copenhagen, Brussels and Amsterdam. The initiators and spokesmen of the group were Asger Jorn, Christian Dotremont and Constant. All were searching, by way of experimental methods, for new paths of creative expression, and all shared similar expectations of the years following World War II: a new society and a new art. Inspired by Marxism, they saw themselves as a 'red Internationale of artists' that would lead to a new people's art. They rejected Western culture and its aesthetics. They also emphatically repudiated Surrealism, as defined by André Breton, although they had found useful points of departure within the movement. Their working method was based on spontaneity and experiment, and they drew their inspiration in particular from children's drawings, from primitive art forms and from the work of Paul Klee and Joan Miró.

The groundwork for Cobra was laid by a group of artists in Denmark who shared an interest in ancient or surviving forms of folk art. A deep love for the mythical characterized the work of Jorn, Carl-Henning Pedersen, Egill Jacobsen and Henry Heerup, for example *The Gramophoneman* (painted wood and iron; Ålborg, Nordjyllands Kstmus.) by Heerup; they evoked beings in paint or stone that seemed to belong to a world of folklore. This archetypal figuration is generally missing in the more abstract work of other members of the group such as Ejler Bille, the painters Else Alfelt (1910–74) and Erik Ortvad (b 1917), Svavar Guðnason, Sonja Ferlov Mancoba and the sculptor Erik Thommesen (b 1916), for example in the painting *The Dream of St John* (1941; Ålborg, Nordjyllands Kstmus.) by Guðnason. The group showed their work in the exhibition society Høst (Harvest) and grouped themselves around the periodical *Helhesten*.

The Belgian wing of Cobra originated from the Belgian/French movement Le Surréalisme Révolutionnaire, founded in 1947 in opposition to Breton and consisting mostly of somewhat older Surrealist writers. The leader of the movement in Belgium was Christian Dotremont, who later became the organizational axis of the Cobra movement. The only Belgian painter to be actively involved with Cobra was Pierre Alechinsky. The Belgian members were particularly interested in writing as a pictorial method of expression.

The Dutch contribution to Cobra was formed from De Experimentele Groep in Holland, founded in 1948 by Constant, Karel Appel, Corneille, Theo Wolvecamp (*b* 1925), Anton Rooskens and Jan Nieuwenhuys (1922–86). Shortly afterwards they were joined by Eugène Brands and the poets Gerrit Kouwenaar (*b* 1923), Jan G. Elburg (*b* 1919) and Lucebert.

The brief but intense alliance created by Cobra allowed many collaborative projects to be realized, including a series of publications and exhibitions. Among these were the periodical *Cobra* and the first *Exposition Internationale d'Art Expérimental*, held in the Stedelijk Museum, Amsterdam, in November 1949; the show was received with hostility by both press and public. In the same month the group was officially renamed the Internationale des Artistes Expérimentaux because of the increasing number of members of widely differing nationalities. Among them were the French painters Jean-Michel Atlan and Jacques Doucet; the German painter Karl-Otto Götz; the English painters Stephen Gilbert (*b* 1910) and William Gear (*b* 1915); the Swedish painter Anders Österlin (*b* 1926); and the American sculptor Shinkichi Tajiri. Members also collaborated on murals, for example those by Constant, Corneille and Appel at the house of Erik Nyholm, Funder, near Silkeborg, Denmark (see 1982 Paris exh. cat., pp. 72–3), signed and dated 30 November 1949, and on single works on canvas or paper. If a painter and writer were involved in such a collaboration, the result was called a *peinture-mot*. Dotremont in particular enjoyed these collaborations, which he continued long after 1951 with many former members of Cobra.

Although the group emphasized versatility and diversity rather than any kind of formalism, their common influences and interests led to an almost recognizable Cobra 'language', characterized by their world of fantastic beings (e.g. Constant's *Fantastic Animals*, 1947; Ålborg, Nordjyllands Kstmus.) and Appel's *Hip, Hip, Hoorah* (1949; London, Tate; see fig. 12), the use of vivid colours

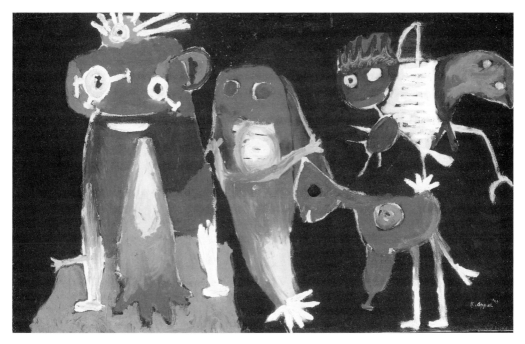

12. Karel Appel: *Hip, Hip, Hoorah*, 1949 (London, Tate Gallery)

and a spontaneous interplay of line and colour (e.g. Corneille's *Birds*, gouache on paper, 1948; Amsterdam, Stedel Mus.). These traits, in the work of the painters who continued after 1951 to build on the foundations laid by Cobra, gradually developed into a single, violently agitated mass of paint, seen primarily in the work of Appel and Jorn, as in *Wounded Beast II* (oil on masonite, 1951; Silkeborg, Kstmus.) by Jorn. From 1958 this also applied to the work of Alechinsky, who was particularly inspired by Japanese calligraphy. These three artists were significant because of their contributions to the formulation of the Cobra language, which shared many of the visual qualities of Abstract Expressionism. The idealism of the group was also echoed in subsequent international movements. When members began to receive individual acclaim the group lost its initial impetus and dissolved.

Bibliography

B. Schierbeek: *De Experimentelen* (Amsterdam, 1963)
Cobra, 1948–1951 (exh. cat. by W. de Haas-Stokvis, Rotterdam, Boymans-van Beuningen; Humlebæk, Louisiana Mus.; 1966)
M. Ragon: *Vingt-cinq ans d'art vivant: Chronique vécue de l'art contemporain: De l'abstraction au popart* (Tournai, 1969)
G. Jespersen: *Cobra* (Copenhagen, 1974)
W. Stokvis: *Cobra: Geschiedenis, voorspel en betekenis van een beweging in de kunst van na de tweede wereldoorlog* [Cobra: history, antecedents and significance of a movement in post-World War II art] (Amsterdam, 1974, rev. 3/1985)
M. Bandini: *L'estetico/il politico: Da Cobra all'internazionale situazionista, 1949–1957* (Rome, 1977)
Cobra, 1948–1951 (exh. cat., Hamburg, Kstver., 1982)
Cobra, 1948–1951 (exh. cat. by S. Lecombre, C. Besson and G. Béraud, Paris, Mus. A. Mod. Ville Paris, 1982)
J.-C. Lambert: *Cobra: Un Art libre* (Paris, 1983)
El moviminto Cobra en la colleción Karen van Stuijvenberg (exh. cat., Caracas, Mus. A. Contemp., 1984)
Cobra: Aventures collectives (exh. cat., Amersfoort, Zonnehof Mus.; Haarlem, Frans Halsmus.; Copenhagen, Kstindustmus.; and elsewhere; 1984–5)
E. Flomenhaft: *The Roots and Development of Cobra Art* (New York, 1985)
W. Stokvis: *Cobra: An International Movement in Art after the Second World War* (Barcelona, 1987) [in Eng. and Sp.]
—: *Cobra: Il contributo olandese e i rapporti con l'Italia* (Florence, 1987)
Cobra 40 Years After (exh. cat., Amsterdam, Nieuwe Kerk, 1988) [K. P. van Stuijvenberg col.]

WILLEMIJN STOKVIS

Cold art [Ger. *Kalte Kunst*]

Term used primarily in reference to a branch of Constructivism based on geometric forms of unmodulated colour, organized by simple mathematical formulae in such a way that the end result clearly bears this mathematical imprint, especially as found in the work of Swiss artists such as the painter Karl Gerstner (*b* 1930) and Richard Paul Lohse.

Although the label is sometimes applied to other types of art structured on mathematical principles, such as Op art and Kinetic art, in its stricter sense it relates more closely to the ideas propounded by Max Bill within the context of CONCRETE ART. In his essay 'The Mathematical Approach in Contemporary Art', he wrote of mathematical problems as 'the projection of latent forces . . . which we are unconsciously at grips with every day of our lives; in fact that music of the spheres which underlies each man-made system and every law of nature it is within our power to discern. Hence all such visionary elements help to furnish art with a fresh content.' As early as his series of lithographs, *15 Variations on a Single Theme* (Paris, 1938; see 1974–5 exh. cat., pp. 54–63), Bill subjected basic geometric shapes to variations through the application of simple rules.

Although mathematical principles were used in abstract works by other artists, for example in the constructions of Naum Gabo, they became most apparent in serial paintings produced by Gerstner and Lohse, in which both the size and colour of the forms were governed by simple mathematical laws. Many of Gerstner's works were variable, allowing the creation of different works from a single object, as in the *Tangential Excentrum* (painted aluminium, 1956–7; see Stierlin, p. 72),

which consists of painted strips that undergo a progressive alteration of tone and size when changes are made to the lateral position of the flat concentric circles to which they are attached. Gerstner's *Carro 64* (1959–61; see Stierlin, pp. 99–101) and other works with that title consist of eight rows of coloured cubes, each row having its own eight cubes, all of which can be removed from the frame and rearranged in numerous permutations. In these objects Gerstner claimed the 'original' to be the system of possible combinations embodied by the object, rather than seeing the work as a series of variations on a theme. Lohse also used serial principles but in more traditional media and non-variable formats, as in *15 Systematic Colour Scales Merging Vertically* (1950–67; Zurich, Ksthaus), in which a vertical 'fault-line' is produced where the rectangular forms of the colour scales are most compressed, the progressive compression being governed mathematically.

Gerstner wrote of his work in 1977 that 'The picture is a reality in its own right—what I have in mind is this: just as the mathematician creates conceptual models which are logically self-contained, the artist must be able to create sensuous models which are logically self-contained' (quoted in Stierlin, pp. 24–8). Cold art was thus seen by its exponents as a way of relating art to other areas normally beyond its domain, especially to the realm of science. The resulting works are intended as clear expressions of sensations communicated through the manipulation of precise colours and forms, although this rigorous approach tends to produce unemotional paintings, a feature reflected in the label itself. While the practitioners of Cold art felt there was no opposition between art and science, their exploitation of mathematics inevitably led to a dispute among critics over the status of their works. Whether or not they represent an expansion or transgression of the concept of art remains an open question, however; indeed it is one that rages at the heart of most modern art.

Writings
K. Gerstner: *Kalte Kunst?* (Teufen, 1957)

Bibliography
Max Bill (exh. cat. by L. Alloway and J. N. Wood, Buffalo, NY, Albright–Knox A.G.; Los Angeles, CA, Co. Mus. A.; San Francisco, CA, Mus. A.; 1974–5) [includes reprint of 'The Mathematical Approach in Contemporary Art']
H. Stierlin, ed.: *The Spirit of Colours: The Art of Karl Gerstner* (Cambridge, MA, 1981)
H. J. Albrecht and others: *Richard Paul Lohse: Modulare und serielle Ordnungen, 1943–84/Modular and Serial Orders, 1943–84* (Zurich, 1984)

□

Colour field painting

Term referring to the work of such Abstract Expressionists as Barnett Newman, Mark Rothko and Clyfford Still and to various subsequent American painters, including Morris Louis, Kenneth Noland, Frank Stella, Jules Olitski and Helen Frankenthaler. The popularity of the concept stemmed largely from Clement Greenberg's formalist art criticism, especially his essay 'American-type Painting', written in 1955 for *Partisan Review*, which implied that Still, Newman and Rothko had consummated a tendency in modernist painting to apply colour in large areas or 'fields' (see col. pl. III). This notion became increasingly widespread and doctrinaire in later interpretations of ABSTRACT EXPRESSIONISM, until the movement was effectively divided into 'gesturalist' and 'colour field' styles despite the narrow and somewhat misleading overtones of each category.

Among the main characteristics of Abstract Expressionist colour field painting are its use of colours close in tonal value and intensity, its radically simplified compositions and the choice of very large formats. From the later 1950s these tendencies were developed by Louis, Stella, Noland and others, although their art avoided the symbolic or metaphysical drama of the Abstract Expressionists. American colour field painting of the 1960s and 1970s often employed geometric motifs such as Louis's stripes and Noland's chevrons to emphasize the chromatic intensity between areas. Moreover synthetic media such as acrylics and Magna paint were allied to techniques such as spraying and soaking paint on to

unprimed canvas without a brush. These procedures produced extraordinary refinements of texture, luminosity and colouristic inflection, whose visual complexity was matched by the conceptual intricacies of formalist criticism of the period. Through the work of Ellsworth Kelly, Ad Reinhardt and Larry Poons, colour field painting also established links with other contemporary departures, including hard-edge painting, Minimalism and Op art.

Bibliography

C. Greenberg: 'American-type Painting', *Partisan Rev.*, xxii/2 (1955), pp. 179–96; also in *Art and Culture* (Boston, 1961), pp. 208–29

——: 'After Abstract Expressionism', *A. Int.*, vi/8 (1962), pp. 24–32

Three American Painters (exh. cat. by M. Fried, Cambridge, MA, Fogg, 1965)

I. Sandler: *The Triumph of American Painting: A History of Abstract Expressionism* (New York, 1970), pp. 148–57

——: *The New York School* (New York, 1978), pp. 214–55

DAVID ANFAM

Computer art

Term formerly used to describe any work of art in which a computer was used to make either the work itself or the decisions that determined its form. Computers became so widely used, however, that in the late 20th century the term was applied mainly to work that emphasized the computer's role. Such calculating tools as the abacus have existed for millennia, and artists have frequently invented mathematical systems to help them to make pictures. The golden section and Alberti's formulae for rendering perspective were devices that aspired to fuse realism with idealism in art, while Leonardo da Vinci devoted much time to applying mathematical principles to image-making. After centuries of speculations by writers, and following experiments in the 19th century, computers began their exponential development in the aftermath of World War II, when new weapon-guidance systems were adapted for peaceful applications, and the term 'cybernetics' was given currency by Norbert Wiener. Artists exploited computers' ability to execute mathematical formulations or 'algorithms' from 1950, when Ben F. Laposky (*b* 1930) used an analogue computer to generate electronic images on an oscilloscope. Once it was possible to link computers to printers, programmers often made 'doodles' between their official tasks. From the early 1960s artists began to take this activity more seriously and quickly discovered that many formal decisions could be left to the computer, with results that were particularly valued for their unpredictability. From the mid-1970s the painter Harold Cohen (*b* 1928) developed a sophisticated programme, AARON, which generated drawings that the artist then completed as coloured paintings. Although the computer became capable of that task as well, Cohen continued to hand-colour computer-generated images (e.g. *Socrates' Garden*, 1984; Pittsburgh, PA, Buhl Sci. Cent.).

Until *c.* 1980 graphic output was relatively slow: the artist entered instructions, and a line plotter would eventually register the computer's calculations as a visual depiction of mathematical formulae. Alternatively, drawings, photographs or video pictures could be 'digitized': tones broken down into patterns of individual units or 'pixels', and lines rendered as sine-curves. These elements could then be manipulated by the computer as sets of digits. Using complex algorithms known as 'fractals', artist-programmers have since evolved spectacular depictions of realistic and fantastic objects and scenes. It eventually became possible for artists to work interactively in real time with a display screen, using a 'light pen' or stylus. In the USA in the mid-1970s David Em (*b* 1952) made contact with computer programmers developing this technology. He developed both geometric patterns and illusionistic images. In Europe related developments included the patterns of forms and colours produced by such artists as the German Jürgen Lit Fischer (*b* 1940). The Quantel Paintbox was an early example of a sophisticated interactive graphic computer, designed to generate captions for television, as video images or as colour prints. Such artists as Richard Hamilton and David Hockney, both keenly interested in technical innovations, worked with

it, and the painter Howard Hodgkin used it to produce stage designs. Artists also used computer programmes to control complex movements in kinetic sculpture, to compose and perform music and to choreograph dance works. For makers of film and video, the computer offers unlimited possibilities in generating and transforming images and movement. From 1986 the artist Tom Phillips and the film director Peter Greenaway collaborated on a television version of Dante's *Inferno* in which the elaborate visual effects were achieved using a computer. By the 1990s personal computers could perform tasks that once required large, expensive items of hardware, while computer skills became a standard element in art and design education. As the capacity of computers increases continuously, it would be unwise to predict the kinds of computer art that may evolve. However, it is clear that in the culture that computers help to create, many things will become commonplace that were previously assumed to be impossible.

Bibliography

J. Reichardt, ed.: *Cybernetics, Art and Ideas* (London, 1971)

M. L. Prueitt: *Art and the Computer* (1984)

Digital Visions: Computers and Art (exh. cat. by C. Goodman, Syracuse, Everson Mus. A., 1987)

Art and Computers: A National Exhibition (exh. cat., intro. J. Lansdown; Middlesbrough, Cleveland Gal., 1988)

The Second Emerging Expression Biennial: The Artist and the Computer (exh. cat., intro. L. R. Cancel; New York, Bronx Mus. A., 1988)

P. Hayward, ed.: *Culture, Technology & Creativity in the Late Twentieth Century* (London, 1990)

F. Popper: *Art of the Electronic Age* (London, 1993)

MICK HARTNEY

Conceptual art [idea art; information art]

Term applied to work produced from the mid-1960s that either markedly de-emphasized or entirely eliminated a perceptual encounter with unique objects in favour of an engagement with ideas. Although Henry Flynt of the Fluxus group had designated his performance pieces 'concept art' as early as 1961, and Edward Kienholz had begun to devise 'concept tableaux' in 1963, the term first achieved public prominence in defining a distinct art form in an article published by Sol LeWitt in 1967. Only loosely definable as a movement, it emerged more or less simultaneously in North America, Europe and Latin America and had repercussions on more conventional spheres of artistic production spawning artists' books as a separate category and contributing substantially to the acceptance of photographs, musical scores, architectural drawings and performance art on an equal footing with painting and sculpture.

1. Precedents

In the mid-17th century, Poussin defined classicizing painting as 'nothing but an idea of incorporeal things' (see Holt). Only in the early 20th century, however, did artists question the traditional emphasis on perception and on finished objects. The Dadaists, particularly Marcel Duchamp with his invention of the Ready-made in 1913 (see col. pl. XVI), countered the 'retinal' qualities of beautifully made, unique objects whose status was linked to a monetary value with an art consciously placed 'at the service of the mind'. Duchamp's ready-mades, intellectually rather than manually conceived by ascribing a new use to old objects, demonstrated how art was defined by means of ideological mediation and institutional presentation within a determined historical context. He stressed the role of the spectator in constituting the meaning of these works, and by placing them in conventional exhibition spaces sought to destroy their atmosphere of cultural sanctification. Moreover, by rejecting the assumed link between aesthetic and monetary worth Duchamp emphasized in 1961 that his choice had been based on 'visual indifference with, at the same time, a total absence of good or bad taste' (Sanouillet and Peterson, p. 141).

The position formulated by the Dadaists in response to the mood of crisis that emerged in Europe after World War I was resuscitated in the 1950s and 1960s, another time of social upheaval, particularly by American artists sometimes referred to as Neo-Dadaists. Robert Rauschenberg, for example, literally effaced the Western view of the heroic individual creating precious objects

when in 1953 he acquired a drawing from Willem de Kooning, erased it and then exhibited the result as *Erased de Kooning Drawing*; when invited in 1960 to participate in a show featuring 40 portraits of dealer Iris Clert he sent a telegram to the gallery stating that 'This is a portrait of Iris Clert if I say so'. Robert Morris also anticipated notions central to conceptual art in works such as *Document* (1963; New York, MOMA), a relief construction from which he had removed 'all aesthetic quality and content' in a notarized 'Statement of Esthetic Withdrawal'; its acquisition by an esteemed cultural institution further highlighted its ironic stance.

2. The late 1960s

Conceptual art emerged in the mid-1960s as a probing critique of Western art and of the political and economic systems that sustain it. As defined by its most important practitioners, for example by Joseph Kosuth in two influential articles published in 1969 as 'Art after Philosophy' (see Meyer, pp. 155–70), it examined the role of artistic intention in relation to the meanings ascribed to the resulting objects; the communicative limits and internal coherence of existing visual languages; and the degree to which the impact of art is visual rather than intellectual. In ascribing more importance to communicating an idea than to producing a permanent object (see col. pl. XIII), conceptual artists questioned labour itself as a potentially alienating process. They also drew attention to the institutional framing of art, especially the avenues whereby it reaches and comes to have meaning in the public domain; the extent to which art production is a manifestation of commodity fetishism; the role of the market as a mediating agent for art in the public sphere; the hierarchical social structures that regulate who becomes an artist; the function of the culture industry in 'producing' spectators; and the institutionalized rules by which a particular medium is given its value.

As a definable and international movement, conceptual art made a sudden appearance *c.* 1966 with works such as Joseph Kosuth's series *Titled (Art as Idea as Idea)* (1966–7), dictionary definitions of words presented as photographic enlargements; *Air Show/Air Conditioning* (1966–7), a proposal for the exhibition of an unspecified 'column' of air by two English artists, Terry Atkinson and Michael Baldwin, who in 1969 became founder-members of the group Art and Language; and an exhibition in 1968 (Los Angeles, CA, Molly Barnes Gal.) of word paintings by John Baldessari, such as a canvas bearing the sentence 'Everything is purged from the painting but art'. A group exhibition devoted exclusively to the work of conceptual artists, *January 1–31: 0 Objects, 0 Painters, 0 Sculptors*, mounted by the New York dealer Seth Siegelaub in 1969, featured Kosuth, Robert Barry (*b* 1936), Douglas Huebler (1924–97) and Lawrence Weiner (*b* 1940); later that year Siegelaub followed this with *March 1–31*, an exhibition that existed only in catalogue form, in which he included 31 conceptual artists, among them LeWitt, Atkinson, Baldwin and Kosuth. Other group exhibitions soon followed, helping to define the terms of the movement. These included *When Attitudes Become Form* (Berne, Ksthalle; Krefeld, Kaiser Wilhelm Mus.; London, ICA; 1969); *Conceptual Art, Arte Povera, Land Art* (Turin, Gal. Civ. A. Mod., 1970), which presented conceptual art in relation to two movements emerging at the same time (*see* ARTE POVERA and LAND ART); and *Information* (New York, MOMA, 1970).

A prime concern of certain conceptual artists was with the context in which the work was exhibited. From the time of his first exhibition at the Galerie Fournier in Paris (March 1966), for example, Daniel Buren showed only striped paintings to focus the viewer's attention on their specific location rather than on their physical attributes. One phase of the *Street Work* made in New York in 1969 by Marjorie Strider (*b* 1934) consisted of 30 empty picture frames presented as 'instant paintings' and installed to make passers-by aware of their environment. In late 1969 Jan Dibbets invited recipients to return one page of his *Art and Project Bulletin* to him by post; he then used their addresses to construct a world map on which he noted their locations in relation to his own studio in Amsterdam. On a much smaller but equally exact scale Mel Bochner in his

Measurement Series (Munich, Gal. Heiner Friedrich, 1969) displayed the precise measurements of the exhibition space on its walls. Other artists were more concerned with the political, rather than purely physical, ramifications of the context, as in the case of the Rosario group's extended street 'exhibition' throughout northwest Argentina in November 1968, which consisted solely of the name Tucumán, an allusion to public protests over work conditions by workers from that province. In New York in May 1970, during the insurrectional period surrounding the Vietnam War and the Civil Rights movement, Adrian Piper (*b* 1948) presented a work that stated simply that it had been withdrawn 'as evidence of the inability of art expression to have meaningful existence under conditions other than those of peace, equality, truth, trust, and freedom'.

Elevating the conception of the work of art above its execution, conceptual artists were keen to demystify the creative act and to democratize the role of the artist and public alike by decentralizing control away from institutions such as commercial galleries. For many this could be achieved simply by not producing works as saleable commodities, hence the preference for temporary installations, performances or written texts over finite objects (see fig. 13). Part of the *Experimental Art Cycle* presented by the Rosario group in 1968 consisted of an empty room with a square drawn on the floor, accompanied by a page of instructions exhorting the spectator to construct a similar work elsewhere. Wiener, who stated that it was enough to know about his works to possess them, felt that any conditions imposed on the spectator constituted 'aesthetic fascism' (see Meyer, p. 218). As a corollary to this attack on the monopoly control of the artist, Huebler advocated the supercession of art as object-making or commodity production, since 'the world is more or less full of objects, more or less interesting; I do not wish to add any more' (Meyer, p. 137). Another, sometimes countervailing

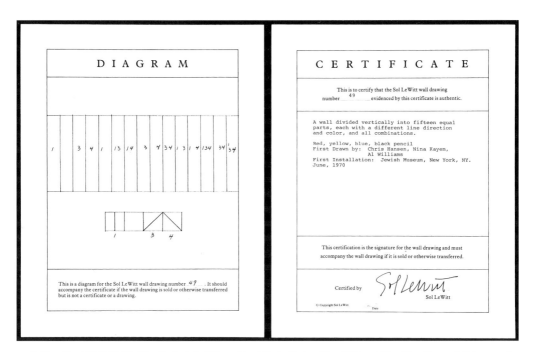

13. Sol Lewitt: *A Wall Divided Vertically into Fifteen Equal Parts, Each with a Different Line Direction and Colour, and All Combinations*, 1970 (London, Tate Gallery)

tendency of conceptual art concentrated on the self-referentiality of art, in order to address it as a language or as a form of logic. This position was represented in its most single-minded form by Kosuth, who assumed that art was a self-validating tautology, and in its most wide-ranging sense by Art and Language.

3. Evolution in the 1970s and 1980s

The theoretical impasse brought about in particular by Kosuth's insistence on the primacy of an artist's intentions was broken only by the ascendancy in the early 1970s of conceptual artists such as Buren and Hans Haacke, who recognized that the formative idea was only one aspect of the systemic process whereby the work of art acquired signification or 'completion' in society. Haacke in particular created works that deftly disclosed the conceptual role of institutions in framing all art, so that its meaning went far beyond the artist's original conception. Such works can be referred to as 'meta-conceptual', since they address the conditions preceding the production of all works of art and later influencing their public reception. Haacke neither privileged his own concepts as art nor resorted to an anti-art assault on the aura in which high art is institutionally encased. He instead presented works as so formally cool and so reticent with regard to his intention that their most obvious characteristic became their aura as art, as evoked by corporate patrons in remarks photo-engraved on the six plates of the series *On Social Grease* (e.g. *On Social Grease, No. 2*, 1975; Detroit, MI, Mr and Mrs Gilbert Silverman priv. col.). Haacke's self-conscious removal from the opinions he quoted enabled him to force cultural institutions to face the fallacy of their own modes of appropriating art, since they were shown saluting art's 'purity' and purported detachment within the 'impure' context of social manipulation. Ironically, then, art was shown to be useful to corporate patrons precisely because of the myth of art's 'uselessness'. Haacke and other conceptual artists such as Victor Burgin demonstrated that the context of art was ideologically evasive in that it could be identified only to the extent that the institutions framing it allowed it to be.

In the 1980s there emerged a new generation of artists who were indebted to conceptual art, particularly to the critical mode formulated by artists such as Haacke and Buren. These artists, along with the Americans Sherrie Levine (*b* 1947), Barbara Kruger (*b* 1945), Jenny Holzer (*b* 1950) and Rudolf Baranik (*b* 1920), extended the critical focus to include the intersection between the institutional concerns of the art world and other social and political matters such as those pertaining to gender or race. The subtitle of a photograph of two classical statues by the American artist Louise Lawler, *Sappho and Patriarch* (1984; see Foster, p. 98), consists of a question that in many ways encapsulates a major concern of this particular generation of conceptual artists: 'Is it the work, the location or the stereotype that is the institution?'

Writings

U. Meyer, ed.: *Conceptual Art* (New York, 1972)
D. Buren: 'Function of the Museum', *Artforum*, xii/1 (1973), p. 68
M. Sanouillet and E. Peterson, eds: *Salt Seller: The Writings of Marcel Duchamp* (New York, 1973)
H. Haacke: *Framing and Being Framed: Seven Works* (Halifax, NS, 1975)
D. Buren: *Reboundings* (Brussels, 1977)
General Idea (exh. cat., New York, 49th Parallel Gal., 1981)
H. Haacke: 'Museums, Managers of Consciousness', *A. America*, lxxii/2 (1984), pp. 9–16

Bibliography

E. Holt, ed.: *Documentary History of Art*, ii (New York, 1947), p. 145
G. Celant: *Arte Povera* (New York, 1969)
A. Schwarz: *The Complete Works of Marcel Duchamp* (New York, 1969)
Conceptual Art and Conceptual Aspects (exh. cat., New York, Cult. Cent., 1970)
K. Honnef: *Concept Art: Versuch einer Concept Art Theorie* (Cologne, 1971)
P. Maenz and G. de Vries, eds: *Art and Language* (Cologne, 1972)
E. Migliorini: *Conceptual Art* (Florence, 1972)
H. Rosenberg: *The De-definition of Art* (New York, 1972)
G. Battock, ed.: *Idea Art: A Critical Anthology* (New York, 1973)
L. Lippard: *Six Years: The Dematerialization of the Art Object from 1966–1972* (New York, 1973)

R. Wollheim: *On Art and the Mind* (Cambridge, MA, 1974)
Art and Language: 1966–1975 (exh. cat., Oxford, MOMA, 1975)
C. Russell: 'Towards Tautology: The Nouveau Roman and Conceptual Art', *Mod. Lang. Notes*, xci/5 (1976), pp. 1044–60
W. Fowkes: 'An Hegelian Critique of Conceptual Art', *J. Aesth. & A. Crit.*, xxxviii/2 (1978), pp. 157–67
D. Kuspit: 'Sol LeWitt the Wit', *A. Mag.*, lii/8 (1978), pp. 118–25
R. Morgan: 'Conceptual Art and the Continuing Quest for a New Social Context', *J.: S. CA A. Mag.*, 23 (1979), pp. 30–36
H. Osborne: 'Aesthetic Implications of Conceptual Art, Happenings, etc.', *Brit. J. Aesth.*, xx/1 (1980), pp. 6–20
R. Smith: 'Conceptual Art', *Concepts of Modern Art*, ed. N. Stangos (London, 1981), pp. 256–72
D. Craven: 'Hans Haecke's *Cunning Involvement*', *The Unnecessary Image*, eds P. D'Agostino and A. Muntadas (New York, 1982), pp. 21–5
C. Harrison and F. Orton: *A Provisional History of Art and Language* (Paris, 1982)
C. Robins: *The Pluralist Era: American Art, 1968–1981* (New York, 1984)
H. Foster: *Recordings* (Port Townsend, WA, 1985)
D. Craven: 'Hans Haacke and the Aesthetics of Dependency Theory', *A. Mag.*, lxi/7 (1987), pp. 56–8
I. Sandler: *American Art of the 1960s* (New York, 1988), pp. 343–58
Art conceptuel formes conceptuelles/Conceptual Art Conceptual Forms (exh. cat., Paris, Gal. 1900–2000, 1990)
L'Art conceptuel, une perspective (exh. cat., Paris, Mus. A. Mod. Ville Paris, 1990)

DAVID CRAVEN

Concrete art

Term coined by Theo van Doesburg in 1930 to refer to a specific type of non-figurative painting and sculpture. Van Doesburg defined the term in the first and only issue of *Art Concret*, which appeared in April 1930 with a manifesto, *The Basis of Concrete Art*, signed by van Doesburg, Otto G. Carlsund, Jean Hélion and the Armenian painter Leon Tutundjian (1905–68). In the manifesto it was stated that 'The painting should be constructed entirely from purely plastic elements, that is to say planes and colours. A pictorial element has no other significance than itself and consequently the painting possesses no other significance than itself.' Natural forms, lyricism and sentiment were strictly forbidden. Taking a narrow sense of the word 'abstract' as implying a starting-point in the visible world, it distinguishes Concrete art from ABSTRACT ART as emanating directly from the mind rather than from an abstraction of forms in nature. For this reason the term is sometimes applied retrospectively to the more cerebral abstract works by such other artists as Mondrian, Kandinsky, Malevich and František Kupka.

On van Doesburg's death in 1931 Concrete art was taken up and elaborated by Max Bill, beginning with a definition of the term in the catalogue for the exhibition *Zeitprobleme in der Schweizer Malerei und Plastik* (Zurich, Ksthaus, 1936). In Bill's case the concept remained essentially the same, referring to a clear, anti-naturalist style as 'the pure expression of harmonious measure and law'. In 1944 he organized the first international exhibition of Concrete art at the Kunsthalle in Basle and founded the review *Abstrakt/Konkret*, which ran for 12 issues until 1945. In 1960 he organized the comprehensive exhibition *Konkrete Kunst: 50 Jahre Entwicklung* at the Helmhaus in Zurich; this established Concrete art as an international movement. Much, although not all, of this work took geometric form. Bill's painting *Rhythm in Four Squares* (1943; Zurich, Ksthaus) and his sculpture *Endless Ribbon* (1935–53; Paris, Pompidou) are characteristic examples. The appearance and theories of Concrete art proved influential on later manifestations of abstract art, including Op art and hard-edge painting.

Bibliography

J. Baljeu: *Theo van Doesburg* (New York, 1974)
Max Bill (exh. cat. by L. Alloway and J. N. Wood, Buffalo, Albright-Knox A.G., 1974)

☐

Concretists, the [Swed. Konkretisterna]

Swedish group of artists active in the early 1950s. The members were the painters (Olof) Lennart Rodhe (*b* 1916), Olle Bonnier (*b* 1925), Pierre Olofsson (*b* 1921), Karl-Axel Ingemar Pehrson

(b 1921) and Lage Johannes Lindell (1920–80) and the sculptor Arne Jones (1914–76). With a number of other artists they had exhibited in *Ung konst* (Young art) in Stockholm in 1947 and came to be called *'1947 års män'* ('Men of the Year 1947'). In an article in *Konstrevy* in 1947, Sven Alfons (b 1918; painter and writer on art history) saw a common element in their work and described these artists as 'young Goth[ic]s'. The 'gothic' aspect is especially clear in several of Jones's sculptures (e.g. *The Cathedral*, 1948; Stockholm, Västertorp).

In 1948 Bonnier wrote an article in *Prisma* in which he attempted an explanation of his art as 'Depiction of Nature-Abstraction-Concretion'. Around 1950 a number of the artists from the 'Men of the Year 1947' formed a circle that produced works of Concrete art and exhibited collectively, mostly in Stockholm. Many of their Concrete works are characterized by upwardly-striving forms and shapes (hence 'gothic'), producing an intangible sense of space: movement, in the sense of optical rather than kinetic, is also significant both in their paintings and in Jones's sculptures. Several of the artists took nature as their inspiration (e.g. Pehrson's *Dolphin Movement*, 1952; Stockholm, Mod. Mus.). The Concretists were interested in executing monumental projects, such as Rodhe's mural *Lots of Packets* (glazed brick, 1952; 1948 sketch, Västerås, Kstmus.) in Östersund Post Office. The group gradually disbanded.

Bibliography

R. Söderbergh: *Den svenska konsten under 1900-talet* [Swedish art in the 20th century] (Lund, 1970)

B. Sydhoff: *Vår egen tid* [Our own time] (1973), v of *Bildkonsten i Norden* [Fine art in the North] (Lund, 1972–4)

Rodhe (exh. cat., ed. N. Öhman; Stockholm, Mod. Mus.; Göteborg, Kstmus.; 1988)

JACQUELINE STARE

Constructivism

Avant-garde tendency in 20th-century painting, sculpture, photography, design and architecture, with associated developments in literature, theatre and film. The term was first coined by artists in Russia in early 1921 and achieved wide international currency in the 1920s. Russian Constructivism refers specifically to a group of artists who sought to move beyond the autonomous art object, extending the formal language of abstract art into practical design work. This development was prompted by the Utopian climate following the October Revolution of 1917, which led artists to seek to create a new visual environment, embodying the social needs and values of the new Communist order. The concept of International Constructivism defines a broader current in Western art, most vital from around 1922 until the end of the 1920s, that was centred primarily in Germany. International Constructivists were inspired by the Russian example, both artistically and politically. They continued, however, to work in the traditional artistic media of painting and sculpture, while also experimenting with film and photography and recognizing the potential of the new formal language for utilitarian design. The term Constructivism has frequently been used since the 1920s, in a looser fashion, to evoke a continuing tradition of geometric abstract art that is 'constructed' from autonomous visual elements such as lines and planes, and characterized by such qualities as precision, impersonality, a clear formal order, simplicity and economy of organization and the use of contemporary materials such as plastic and metal.

1. Russian

(i) Formation, 1914–21. The technique of constructing sculpture from separate elements, as opposed to modelling or carving, was developed by Pablo Picasso in 1912, extending the planar language of Cubism into three dimensions. This method was elaborated in Russia, initially by Vladimir Tatlin from 1914 onwards and then by his many followers, who, like him, made abstract sculptures that explored the textural and spatial qualities of combinations of contemporary materials such as metal, glass, wood and cardboard, as in Tatlin's *Selection of Materials* (1914; untraced) and *Corner Counter-Relief* (1914–15; untraced; see Lodder, figs 1.12–13).

Russian artists did not begin to call their work 'constructions' and themselves 'constructivists' until after the Revolution of 1917. Coining the latter term, the First Working Group of Constructivists, also known as the Working Group of Constructivists, was set up in March 1921 within Inkhuk (Institute of Artistic Culture) in Moscow. The group comprised Aleksey Gan (1893–1942), Aleksandr Rodchenko, Varvara Stepanova, Konstantin Medunetsky, Karl Ioganson (Karel Johansen; c. 1890–1929) and the brothers Georgy Stenberg and Vladimir Stenberg. These artists had come together during theoretical discussions concerning the distinction between composition and construction as principles of artistic organization, which were conducted within the Working Group of Objective Analysis at Inkhuk between January and April 1921. 'Construction' was seen to have connotations of technology and engineering and therefore to be characterized by economy of materials, precision, clarity of organization and the absence of decorative or superfluous elements.

In order to give their work the quality of 'construction', the artists increasingly renounced abstract painting in favour of working with industrial materials in space. This was epitomized by the Constructivists' contributions to the Second Spring Exhibition of Obmokhu (Society of Young Artists), also known as the Third Exhibition of Obmokhu, which opened on 22 May 1921 (see Lodder, figs 2.15–16). The sculptures they showed displayed a strong commitment to the materials and forms of contemporary technology. The Stenbergs, for instance, created skeletal forms from materials such as glass, metal and wood, evoking engineering structures such as bridges and cranes, as in Georgy Stenberg's *Spatial Construction/KPS 51 NXI* (1921; untraced; reconstruction, 1973; Cologne, Gal. Gmurzynska). Rodchenko showed a series of hanging constructions based on mathematical forms; they consisted of concentric shapes cut from a single plane of plywood, rotated to create a three-dimensional geometric form that is completely permeated by space, for example *Oval Hanging Construction* (1920–21; New York, MOMA).

In their programme of 1 April 1921, written by Gan, the Constructivists emphasized that they no longer saw an autonomous function for art and that they wished to participate in the creation of a visual environment appropriate to the needs and values of the new Socialist society: 'Taking a scientific and hypothetical approach to its task, the group asserts the necessity to fuse the ideological component with the formal component in order to achieve a real transition from laboratory experiments to practical activity' (1990 exh. cat., p. 67). They envisaged their work as 'intellectual production', proclaiming that their ideological foundation was 'scientific communism, based on the theory of historical materialism'. They intended to attain what they termed 'the communistic expression of material structures' by organizing their work according to the three principles of *tektonika* (or tectonics, which derives from the principles of Communism and the functional use of industrial material, i.e. the politically and socially appropriate use of industrial materials with regard to a given purpose), *konstruktsiya* (or construction, the process of organizing this material), and *faktura* (the choice of material and its appropriate treatment). They also proposed to establish links with committees in charge of manufacturing and to conduct an intensive propaganda campaign of exhibitions and publications.

This artistic attitude was a product of the Utopian atmosphere generated by the Revolution and the specific conditions of the Civil War period (1918–21). After 1917, industry and the machine came to be seen as the essential characteristics of the working class and hence of the new Communist order. In practical terms, industrial development was also regarded by the state authorities as the key to political and social progress. Hence, the machine was both metaphor for the new culture under construction and the practical means to rebuild the economy as a prelude to establishing Communism. Moreover, the government fostered the debate concerning the role of art in industry, i.e. Production art (Rus. *proizvodstvennoye iskusstvo*; also known as Productivism), to which critics such as Osip Brik and Nikolay Punin contributed, arguing that the

bourgeois distinction between art and industry should be abolished and that art should be considered as merely another aspect of manufacturing activity. The artists themselves had been encouraged to believe they had a wider public role to play by their participation in the many official commissions to execute such propaganda tasks as decorating Russian cities for the Revolutionary festivals and designing agitational and educational posters. During the chaotic Civil War period, the avant-garde had also helped to run artistic affairs on behalf of the government and seemed to have become a vehicle for expressing the Communist Party's political objectives. The utilitarian ethos of Constructivism was a logical extension of this close identification between avant-garde art and social and political progress.

The Constructivists' experiments were more directly stimulated by Tatlin's extraordinary model for a *Monument to the Third International*, exhibited in Petrograd (now St Petersburg) in November 1920 and in Moscow in December 1920 (destr.). The monument was conceived as a working building, an enormous skeletal apparatus a third higher than the Eiffel Tower, enclosing three rotating volumes intended to house the executive, administrative and propaganda offices of the Comintern. Resembling a huge functioning machine made of iron beams and glass, the tower demonstrated the power of the machine aesthetic as a symbol of revolutionary objectives. Tatlin declared that he was restoring the essential unity of painting, sculpture and architecture, 'combining purely artistic forms with utilitarian intentions . . . The fruits of this are models which give rise to discoveries serving the creation of a new world and which call upon producers to control the forms of the new everyday life' (Bann, p. 14).

(ii) Achievements, 1922 onwards. In 1922 Constructivism was consolidated, with the first practical realizations of the Constructivists' impulse to extend the formal vocabulary of earlier artistic experiments into concrete design projects. Other artists embraced the group's ideas, including Lyubov' Popova, Gustav Klucis, Anton Lavinsky (1893–1968), the painter and architect Aleksandr Vesnin and the architect Moisey Ginzburg. Moreover, Gan elaborated and disseminated the Constructivist programme in his book *Konstruktivizm* (Tver', 1922) and in various articles. Initially, the theatre served as a crucible for developing an appropriate visual environment to express the new way of life. The first Constructivist stage set was Popova's design for Vsevolod Meyerhold's production of Fernand Crommelynck's farce *The Magnanimous Cuckold*, which opened on 25 April 1922 (see Lodder, figs 5.30, 31, 33). The mill in which the action is set became a multi-levelled skeletal apparatus of platforms, revolving doors, ladders, scaffolding and wheels that rotated at differing speeds at particularly intense moments during the play. The traditional costumes were replaced by overalls or production clothing (*prozodezhda*) devised to facilitate the actors' movements, which were based on biomechanics (a combination of acrobatics and stylized gestures inspired by robots and the *commedia dell'arte*). This event was followed by Stepanova's set for Meyerhold's production of Sukhovo-Kobylin's *Smert' Tarelkina* ('The death of Tarelkin'; 24 Nov 1922), comprising a series of separate apparatuses constructed from standard-sized wooden planks, painted white, and by Vesnin's set for the Kamerny Theatre's production of G. K. Chesterton's *The Man who Was Thursday* on 6 December 1923, which was a far more complex and architectural skeletal construction, evoking the modern city through its incorporation of specific urban elements such as scaffolding, conveyor belts, lift-shafts, steps, posters and neon signs.

The urge to create three-dimensional objects of direct social utility resulted in a number of designs for temporary agitational structures, such as portable and sometimes collapsible kiosks (e.g. Klucis's propaganda stands of 1922, Gan's folding street sales stand of *c.* 1922–3 and Lavinsky's sales kiosk for the State Publishing House, 1924). The use of bold colours and simple geometric forms in such projects foreshadowed Rodchenko's Workers' Club, made for the Exposition Internationale des Arts Décoratifs et Industriels Modernes held in Paris in 1925 and perhaps the most complete expression of the Constructivists' design methodology. Workers' clubs were seen as important new

institutions, on political grounds (for inculcating the new values of Communism) as well as educationally, culturally and socially (replacing the traditional role of the Church). Rodchenko standardized the component elements of the furniture and observed strict economy in terms of space, material and production methods. The chairs, for example, comprised three uprights (two rods in front and a wider plank behind) attached at the top by an open semicircular band to provide arms, in the middle by a solid semicircular seat and at the base by three rods. Made of wood, a cheap and plentiful material in Russia, the furniture answered the problems of contemporary cramped living conditions, so that certain items were space-saving and collapsible for easy storage (e.g. folding tribune, screen, display board and bench).

The Constructivists produced some of their most innovative work in graphic design. Rodchenko, for example, conceived striking layouts and covers for avant-garde magazines such as *Kino-fot* (1922), *Lef* (1923–5) and *Novy Lef* (1927–8), for cinema posters and magazines and for advertising images of wider circulation, such as his poster *Advertisement for Beer* (1925; Moscow, Rodchenko Archv; see col. pl. XIV). These were often photomontages, combining bold typography and abstract design with cut-out photographic elements. As the product of a mechanical process, the photograph complemented the Constructivists' commitment to technology, while conforming to the Communist Party's stated preference for realistic and legible images accessible to the masses.

Generally, however, practical implementation of Constructivist ideas was very slow and sporadic. Industry had been decimated following almost seven years of conflict, and those factories that had survived were not sufficiently progressive to accommodate the new type of designer. In addition, the small-scale private enterprises set up under the provisions of NEP (New Economic Policy), implemented in 1921, were run by entrepreneurs known as Nepmen, who tended to be hostile to the geometric austerity of Constructivist designs. The government was keen to harness art to improve the quality of industrial production, but it encouraged the more traditional approach

of applied art while sponsoring a return to realism in painting and sculpture. Constructivism was thus spurned by the Party, the working class and the new Soviet bourgeoisie (the Nepmen), who alone had the financial potential to become art patrons. The only area in which the Constructivists did establish a productive working relationship with any specific industrial enterprise was in the field of textile design. Popova and Stepanova produced many designs that were mass-produced by the First State Textile Printing Factory between late 1923 and 1924. They rejected traditional floral patterns in favour of economical combinations of one or more colours and simple geometric forms, as in Popova's *Textile Design* (1924; priv. col., see Lodder, plate X).

The extension of Constructivist ideas into the area of architecture was primarily the work of the Vesnin brothers (Aleksandr, Leonid, and Viktor) and of Moisey Ginzburg, who in order ot promote their ideas set up OsA (Association of Contemporary Architects; 1925–30) in December 1925 and the journal *Sovremennaya arkhitektura*. The Vesnins' Palace of Labour project (1922–23) for Moscow and their design for the *Leningrad Pravda* building (1924) established a distinct architectural vocabulary that had become subsumed within that of the International Style by the time its first buildings, such as Ginzburg's Gosstrakh appartment block for Moscow (1926), were erected.

Alongside these practical activities, the Constructivists formulated and elaborated their design methodology within VkhUTEMAS (Higher Artistic and Technical Workshops), set up at the end of 1920 to train highly qualified master artists for industry. Of particular importance for developing Constructivist ideas were the basic course and the woodworking and metalworking faculty, the latter directed by Rodchenko. The teaching staff also included Stepanova, Vesnin, Klucis, Tatlin and el Lissitzky, whose work took on a more Constructivist character following his return from the West in 1925. At the school, a new generation of artists were being trained to be engineer-constructors or artist-constructors, who would fuse artistic skills with a specialized knowledge of technology.

In the late 1920s and 1930s, the period of Stalin's five-year plans, the Constructivists suffered from the increasingly centralized control of art in Russia that led to the eventual imposition of Socialist Realism. They continued, however, to be particularly active in typographical, poster and exhibition design, areas in which photomontage was seen as an effective propaganda weapon (e.g. Klucis's *We Will Repay the Coal Debt to the Country*, 1930; and Lissitzky's design for the *Pressa* exhibition in Cologne, 1928; see Lodder, plate XV and figs 6.13a–b and 6.14). In 1931 Klucis stated, 'One must not think that photomontage is merely the expressive composition of photographs. It always includes a political slogan, colour and purely graphic elements. The ideologically and artistically expressive organization of these elements can be achieved only by a completely new kind of artist—the constructor' (1990 exh. cat., p. 116). Nevertheless, in an increasingly repressive political climate, official requirements for potent propaganda imagery tended to take priority over compositional invention, as is evident from issues of the internationally disseminated *USSR in Construction* that Rodchenko and Lissitzky designed in the later 1930s (e.g. by Lissitzky: *USSR im Bau*, No. 9, 1933). Constructivism may have been inspired by the early idealism of the Revolution, but it subsequently fell victim to the actual political system that emerged.

Bibliography

S. Bann, ed.: *The Tradition of Constructivism* (London, 1974/R 1991)

J. Bowlt: *Russian Art of the Avant-garde: Theory and Criticism, 1920–1934* (London and New York, 1976/R 1988)

C. Lodder: *Russian Constructivism* (London and New Haven, 1983)

C. Leclanche-Boulé: *Le Constructivisme russe: Typographies & photomontages* (Paris, 1984/R 1991)

L. Zsadova, ed.: *Tatlin* (Budapest, 1984); Eng. trans. (London, 1988)

S. O. Khan-Magomedov: *Alexandr Vesnin and Russian Constructivism* (London, 1986)

—: *Rodchenko: The Complete Work* (London, 1986) [important selection of translated documents]

A. Lavrentiev: *Varvara Stepanova: A Constructivist Life* (London, 1988)

D. Sarabianov and N. L. Adaskina: *Popova* (London, 1990)

Art into Life: Russian Constructivism, 1914–1932 (exh. cat., Seattle, U. WA, Henry A.G., 1990) [important selection of documents]

S. O. Khan-Magomedov: *Le Vkhutemas*, 2 vols (Paris, 1991)

Gustav Klucis (exh. cat., ed. H. Gassner and R. Nachtigaller; Kassel, Mus. Fridericianum, 1991)

Die grosse Utopie: Die russische Avantgarde, 1914–32 (exh. cat., Frankfurt am Main, Schirn Ksthalle, 1992)

2. International

As a selfconscious movement, International Constructivism was initiated in May 1922 at the Düsseldorf Congress of International Progressive Artists, when the International Faction of Constructivists was organized by Theo van Doesburg (representing the journal *De Stijl*), Hans Richter (representing 'the Constructivist groups of Romania, Switzerland, Scandinavia and Germany') and El Lissitzky (representing the editorial board of *Veshch'-Gegenstand-Objet*). The faction's declaration, later published in *De Stijl* (no. 4, 1922), emphasized their opposition to subjectivity, 'the tyranny of the individual', their dedication to the 'systematization of the means of expression', and their view of 'art as a method of organization that applies to the whole of life' and as 'a tool of universal progress'. In September 1922 the group issued the Manifesto of International Constructivism, which was also signed by the Belgian Karel Maes (1900–50) and the German Max Burchartz (1887–1961).

During the 1920s the principal focus of activity was Germany, and knowledge of both De Stijl and recent Russian developments proved catalysts. Theo van Doesburg had been active in Berlin and at the BAUHAUS since 1920 in promoting De Stijl aesthetic and Utopian ideals. The input from De Stijl was reinforced by the dissemination of information about Russian art through such émigrés as El Lissitzky, who arrived in Germany in late 1921, and through exhibitions, notably the *Erste russische Kunstaustellung*, which opened in Berlin in October 1922. Although the Russian Constructivists had already begun to implement their rejection of art in favour of utility, there was

little to distinguish their works from the constructions of Naum Gabo, who settled in Germany in 1922 (e.g. *Construction in Relief*, *c.* 1921; untraced, see Lodder, above, pl. 1.52), or from the approach inspiring Lissitzky's paintings, such as *Proun G 7* (1923; Düsseldorf, Kstsamml. Nordrhein-Westfalen). Both Gabo and Lissitzky opposed the Russian Constructivists' denial of an independent role for art but aspired, through pure abstract form, to express progressive social values and the scientific and technological possibilities for transforming the inner and outer world. Constructivism in the West was influenced by the example of such artists because of their presence there, and because their approach corresponded closely to the ideas of De Stijl.

Among the leading protagonists of Constructivism in Germany were Hungarian artists and theorists such as László Moholy-nagy, László Peri, Ernő (Ernst) Kállai, Lajos Kassák and Alfréd Kemény (1895–1945). Inspired by Utopian ideals, they had fostered contacts with Moscow after the short-lived Hungarian Revolution of 1919; Kemény, for instance, had participated in the Constructivists' debates in Moscow in 1921. Exploring the potential of the new materials, Peri produced his first Constructivist coloured cement reliefs in 1921. In contrast, Moholy-Nagy's abstract paintings, with their bold colours, interpenetrating geometric planes and interest in transparency, were close to Lissitzky's *Prouns*. Moholy-Nagy also vividly demonstrated the new repudiation of subjectivity when in 1922 he dictated to a professional sign painter, by telephone, the colours and composition of two paintings, using a colour chart and a piece of squared paper (e.g. *Em 2*, 1922; New York, MOMA). Moreover, his *Light Prop*, designed in 1929 (Cambridge, MA, Busch-Reisinger Mus.), epitomized the Constructivists' interest in exploring new technological possibilities for the arts.

Given its Utopian dimension, the new style provided an affirmative alternative to the nihilism of Dada and influenced the work of former Dadaists such as Hans Richter, who edited the journal *G* (1923–6), advertised in *De Stijl* as 'the organ of the Constructivists in Europe'. Kurt Schwitters, too, converted to a more Constructivist idiom, working alongside such figures as Friedrich Vordemberge-gildewart, César Domela and Carl Buchheister to establish 'die abstrakten Hannover'. The confluence of Constructivist and De Stijl influences became apparent at the Bauhaus, the principal centre in the West for Constructivism. The proselytizing of van Doesburg in Weimar and in his courses (1920–22), the subsequent formation of the KURI (Konstruktiv, Utilitär, Rational und International) student group in late 1921 under the stimulus of van Doesburg and of Hungarians such as Farkas Molnár, and the appointment of Moholy-Nagy in 1923 to run the Foundation Course signalled a decisive aesthetic shift away from Expressionism in favour of a more positive attitude towards the machine and industry. The change was epitomized by Gropius's slogan of 1923: 'Art and Technology—A New Unity'. The practical results were such classics of modern design as Marcel Breuer's tubular steel furniture and Wilhelm Wagenfeld's lamps.

By the mid-1920s Constructivist views had become the common currency of groups in Holland, Germany, Czechoslovakia and Poland. In Czechoslovakia, Constructivism was first expounded in December 1922 in the second issue of the magazine *Život* (Life) published under the banner 'New Art—Construction—Intellectual Activity' and illustrating the work of Jaromír Krejcar, Josef Šíma and Karel Teige. Subsequently the movement was embraced by Devětsil (1920–31), which aimed to destroy the boundaries between art and life and embraced practitioners of all the arts, including photographers, architects, writers and musicians.

In Poland, Mieczysław Szczuka, Władysław Strzemiński, Teresa Żarnower, Katarzyna Kobro and Henryk Stażewski were the key figures in the Block Group, a Constructivist movement centred on the magazine *Blok* (1924–6). Their programme emphasized 'the inseparability of the problems of art and the problems of society' but recognized the need for 'disinterested creation in art'. Within these general principles there was considerable diversity. At one extreme, Szczuka and Żarnower expounded a utilitarianism based on Russian Constructivism and called on artists to dedicate

themselves exclusively to industrial production in the service of the social and political revolution. Szczuka, allied with the Polish Communist Party, devoted himself to architecture, typography and photomontage. More in line with International Constructivism, Strzemiński and Kobro emphasized the autonomy of the work of art and the need to systematize artistic elements. Kobro's sculptures focused on the movement of form in space, as in *Hanging Construction 1* (1921–2; Łódź, Mus A.). Strzemiński, who had experimented with making reliefs, subsequently produced paintings influenced by Suprematism that emphasized the unity of ground and image in accordance with his formalist doctrine of Unism enunciated in 1927.

After the 1920s it becomes even more difficult to disentangle Constructivism from the wider history of non-objective art. As the totalitarian governments of Russia and Germany became increasingly intolerant of modernism, Paris became the refuge for experimental artists such as Gabo and Domela and the dominant centre of activity for abstract painters and sculptors. New organizations were formed there, such as CERCLE ET CARRÉ, Art Concret (1930) and the more significant ABSTRACTION-CRÉATION, a notably international and comprehensive grouping. Art Concret, organized by van Doesburg, was limited in its aim to unite those committed to a scientifically based art, and it included Jean Hélion, Otto Carlsund and Leon Tutundjian (1906–68).

In the 1930s London became the refuge for Constructivist émigrés such as Gropius, Breuer and Moholy-Nagy from the Bauhaus, followed by Gabo in 1936 and Piet Mondrian in 1938. Their presence reinforced British avant-garde experiments such as Ben Nicholson's *White Reliefs* (e.g. 1935; London, Tate), Barbara Hepworth's simplified carvings and the 'Constructivist Fabrics' project of 1937 by Alastair Morton (1910–63), which represented a continuation of the ideal of applying the new artistic language to everyday design. A more lasting monument to what is sometimes termed English Constructivism was *Circle: International Survey of Constructive Art* (1937), edited by Gabo, Nicholson and the architect Leslie

Martin. The book contained work and writings by virtually all the leading architects and artists of the international 'constructive trend'. Nevertheless, for all its optimism, *Circle* was in a sense the swansong of the earlier Utopianism, and the outbreak of hostilities in 1939 marked the end of International Constructivism as a movement.

After World War II Constructivism was rediscovered by another generation that was less ideologically and aesthetically radical than its forebears but which, nevertheless, was involved with developing an artistic language based on science and mathematics. Charles Biederman's *Art as the Evolution of Visual Knowledge* (1948) played a vital role in the re-awakening of interest in the earlier movement and in the promotion of the constructed relief as a prime art form among such American and British artists as George Rickey and Anthony Hill. In Europe, artists such as Max Bill, who developed the concepts of Concrete Art and Cold Art, Joost Baljeu and Victor Vasarely, as well as the Salon des Réalités Nouvelles in Paris, kept the notion of Constructivism alive, although in a far more aesthetically confined form.

Bibliography

G. Rickey: *Constructivism: Origins and Evolution* (New York, 1968)
Abstraction-Création (exh. cat., Paris, Mus. A. Mod. Ville Paris, 1978)
Constructivism in Poland, 1923 to 1936 (exh. cat., ed. H. Gresty and J. Lewinson; Cambridge, Kettle's Yard; Łódź, Mus. A.; 1984)
Wechsel Wirkungen: Ungarische Avantgarde in der Weimarer Republik (Marburg, 1986)
Arte Abstracto, Arte Concreto: Cercle et Carré, Paris, 1930 (exh. cat., Valencia, Valenc. A. Mod. Cent. Julio González, 1990)
Konstruktivistische Internationale schöpferische Arbeitsgemeinschaft, 1922–1927: Utopien für eine europäische Kultur (exh. cat., Düsseldorf, Kstsamml. Nordrhein–Westfalen; Halle, Staatl. Gal. Mortizburg; 1992)

CHRISTINA LODDER

Continuità

Italian group of painters and sculptors formed in 1961. With the critic Carlo Argan (*b* 1909) as

spokesman, it included Carla Accardi, Pietro Consagra, Piero Dorazio, Gastone Novelli (1925–68), Achille Perilli (*b* 1927) and Giulio Turcato among its founder-members. They were soon joined by Lucio Fontana, Arnaldo Pomodoro and Giò Pomodoro. Some of these artists had previously been members of FORMA, founded in 1947 to promote abstract art. The notion of continuity was inherent not only in the group's general aim—to regenerate the traditional greatness of Italian art—but equally as an ideal for specific works of art, each painting or sculpture reflecting the order and continuity of its creation. This was in opposition not only to the social realists, such as Renato Guttuso and Armando Pizzinato (*b* 1910), but also (to a lesser extent) to the Informalist trends among artists of the Fronte Nuovo delle Arti and the Gruppo degli Otto Pittori Italiani. However, some members, notably Turcato, went through all phases from Expressionism in the 1930s to geometrical abstraction in the 1960s. Accardi, Perilli and Novelli incorporated geometrical writing or 'signs' in their work. Fontana, the most influential and avowedly abstract artist to be associated with the group, added a further aspect to Continuità, the idea of continuity of a work within its surroundings, for example his *Spatial Environment* (1949; Milan, Gal. Naviglio), which was a precursor of environmental art. From the late 1950s onwards he also suggested continuity with the space behind the canvas in his slit canvases known as *Tagli* ('slashes', e.g. *Spatial Concept–Expectations*, 1959; Paris, Mus. A. Mod. Ville Paris). Among the sculptors, Giò Pomodoro created cast bronze reliefs with irregular surfaces, creating a sense of integration with the surrounding wall or floor. Continuità, like Forma before it, represented a convergence of artists with similar aims rather than a definitive movement.

Bibliography

L. Venturi: *Post-war Italian Painting* (New York, 1967)

New Italian Art 1953-71 (exh. cat., intro. G. Carandente; Liverpool, Walker A.G., 1971)

Corrente

Italian journal that gave its name to an artistic movement in Milan from 1938 to 1943. *Corrente* grew out of *Vita giovanile*, a Fascist youth journal founded in Milan in January 1938 that originally sought to combat the cultural chauvinism of official art. The fortnightly publication soon developed an anti-Fascist stance; in October 1938 it was retitled *Corrente di vita giovanile* and the Fascist party symbols were removed from its masthead. From February 1939 it was entitled simply *Corrente*.

As a movement, Corrente was never defined by a manifesto nor was its membership fixed. As its name implied, it was a confluence of various artistic currents in revolt against both the neo-classicism of the Novecento Italiano and the geometric abstraction of the Como school. In the late 1930s a core group of Corrente artists formed around the painter Renato Birolli. They were Arnaldo Badodi (*b* 1913), Bruno Cassinari, Sandro Cherchi (*b* 1911), Giuseppe Migneco (*b* 1908) and Italo Valenti (*b* 1912). Lucio Fontana, Giacomo Manzù and the Rome-based Renato Guttuso also participated in various activities of Corrente. The movement was not characterized by a single tendency, but generally advocated expressionism as a polemical, inherently humanistic style. Articles in the journal by Birolli, Guttuso and the art critic Raffaele De Grada (*b* 1916) reinforced the movement's cultural politics.

Corrente held two exhibitions in Milan in 1939, in March at the Palazzo Permanente and in December at the Galleria Grande. The exhibitions were documented by corresponding issues of the journal (nos 6 and 22). On 10 June 1940 *Corrente* was suppressed on Mussolini's orders. The artists continued their activity through the Bottega di Corrente (1940–41) and the Galleria della Spiga e Corrente (1942–3). Corrente artists also dominated the annual Premio Bergamo (1939–42), a state-sponsored but liberal exhibition. Towards the end of World War II the movement dissolved as the artists divided into two camps, represented on the one hand by the lyrical expressionism of Birolli and on the other by the realism of Guttuso.

Bibliography

R. De Grada: *Il movimento di 'Corrente'* (Milan, 1952, rev. 2/1975)

A. Luzi, ed.: *Corrente di vita giovanile (1938–1940)* (Rome, 1975)

B. Talvacchia: 'Politics Considered as a Category of Culture: The Anti-Fascist Corrente Group', *A. Hist.*, viii (1985), pp. 336–53

Corrente: Il movimento di arte e cultura di opposizione, 1930–45 (exh. cat., ed. M. De Micheli; Milan, Pal. Reale, 1985)

R. Ben-Ghiati: 'The Politics of Realism: *Corrente di vita giovanile* and the Youth Culture of the 1930s', *Stanford It. Rev.*, viii/1–2 (1990), pp. 139–65

EMILY BRAUN

Correspondence art [Mail art]

Term applied to art sent through the post rather than displayed or sold through conventional commercial channels, encompassing a variety of media including postcards, books, images made on photocopying machines or with rubber stamps, postage stamps designed by artists, concrete poetry and other art forms generally considered marginal. Although Marcel Duchamp, Kurt Schwitters and the Italian Futurists have been cited as its precursors, as a definable international movement it can be traced to practices introduced in the early 1960s by artists associated with Fluxus, Nouveau Réalisme and the Gutai group and most specifically to the work of Ray Johnson. From the mid-1950s Johnson posted poetic mimeographed letters to a select list of people from the art world and figures from popular culture, which by 1962 he had developed into a network that became known as the New York Correspondence School of Art.

Correspondence artists sought, among other things, to circumvent the commercial exploitation of their work, and in this respect their work can be linked to conceptual art, performance art and other developments of the 1960s and 1970s that elevated ideas over the production of finished objects. As for these other art forms, however, exhibitions played an important role in making public the results of an otherwise essentially private and intimate activity. Among the exhibitions that helped set the standards for subsequent shows, following the first *Correspondence Art* exhibition at the Whitney Museum in New York in 1970, were a special section curated by Jean-Marc Poinsot of the seventh Paris Biennale in 1971 and *Omaha Flow Systems* (1972; Omaha, NE, Joslyn A. Mus.), organized by Fluxus artist Ken Friedman (*b* 1949). These were conducted without entry fees or juries, and participants were provided with documentation.

In addition to organizing exhibitions, correspondence artists published magazines, established archives and conducted research, in each of these ways stimulating international interaction among contemporary artists. Their role was especially important in establishing links between North America and Western Europe on the one hand and Eastern Europe and the Soviet Union on the other. The Decentralized Worldwide Mail Art Congress held in 1986, which attracted over 500 artists, consisted of more than 80 meetings in 25 countries.

Bibliography

J.-M. Poinsot: *Mail Art: Communication a Distance Concept* (Paris, 1971)

H. Fischer: *Art et communication marginale: Tampons d'artistes* (Paris, 1974)

R. H. Cohen: 'Art and Letters: Please Mr. Postman Look and See . . . Is There a Work of Art in your Bag for Me?', *ARTnews*, lxxx/10 (1981), pp. 80–87

M. Crane and M. Stofflet: *Correspondence Art: Source Book for the Network of International Postal Art Activity* (San Francisco, 1984)

S. Home: *Assault on Culture: Utopian Currents from Lettrisme to Class War* (London, 1988)

JOHN HELD JR

Cubism

Term derived from a reference made to 'geometric schemas and cubes' by the critic Louis Vauxcelles in describing paintings exhibited in Paris by Georges Braque in November 1908; it is more generally applied not only to work of this period by Braque and Pablo Picasso but also to a range of art produced in France during the later 1900s, the 1910s and the early 1920s and to

variants developed in other countries. Although the term is not specifically applied to a style of architecture except in former Czechoslovakia (*see* Czech cubism), architects did share painters' formal concerns regarding the conventions of representation and the dissolution of three-dimensional form. Cubism cannot definitively be called either a style, the art of a specific group or even a movement. It embraces widely disparate work; it applies to artists in different milieux; and it produced no agreed manifesto. Yet, despite the difficulties of definition, it has been called the first and the most influential of all movements in 20th-century art.

I. Painting, sculpture and collage

1. Origins and application of the term

The question of when Cubism began and who led the way in its development is inextricably tied up with the question of what distinguishes Cubist art, how it can be defined and who can be called Cubist. The beginnings of Cubism have variously been dated 1907, 1908, 1909 and 1911. In 1907 Picasso painted *Les Demoiselles d'Avignon* (New York, MOMA), which has often been considered a proto-Cubist work. In 1908 Braque produced *Houses at L'Estaque* (Berne, Kstmus.) and related landscapes, which prompted the reference by Vauxcelles to 'cubes'. The landscapes made by Picasso at Horta de Ebro in 1909, such as *Reservoir at Horta de Ebro* (New York, priv. col., see 1983 exh. cat., p. 245), were regarded by Gertrude Stein as the first Cubist pictures. The first organized group showing by Cubists took place in a separate room, 'Salle 41', at the Salon des Indépendants in Paris in 1911; it included work by Fernand Léger, Robert Delaunay, Henri Le Fauconnier, Jean Metzinger and Albert Gleizes, but nothing by Picasso or Braque.

By 1911 Picasso was accepted as the inventor of Cubism, a view that began to be challenged only with the publication of John Golding's influential history of Cubism in 1959; here Braque's importance and possible precedence was recognized for the first time. A later interpretation of Cubism associated especially with William Aubin, the impact of which has been considerable, identifies Braque categorically as the first. According to this view, the major breakthrough represented by Cubism centres on the depiction of space, volume and mass, especially as it occurred in Braque's L'Estaque landscapes. This view of Cubism is associated with a distinctly restrictive definition of which artists are properly to be called Cubists. Marginalizing the contribution of the artists who exhibited at the Salon des Indépendants in 1911, it focuses attention strictly on those who took a leading part in the development of this new mode of depiction, usually identified as Braque, Picasso, Juan Gris (from 1911) and, to a lesser extent, Fernand Léger (especially in 1911–12). Douglas Cooper coined the terms 'true' Cubism and 'essential' Cubism to distinguish the work of these Cubists; the implied value judgement was intentional.

This restricted view of Cubism is linked to a formalist interpretation of its significance in 20th-century art. The assertion that the Cubist depiction of space, mass and volume supports rather than contradicts the actual flatness of the picture surface or the material qualities of the medium was made as early as 1920 by Daniel-Henry Kahnweiler, but it is also closely attuned to the art criticism of the 1950s and 1960s, especially that of Clement Greenberg. Contemporary views of Cubism were, in fact, complex and heteroclite; they were formed to some degree in response to the more publicized 'Salle 41' Cubists, whose methods were too distinct from those of the 'true' Cubists to be considered merely secondary to them. Alternative interpretations of Cubism have therefore developed. Such wider views of Cubism take in others who were later associated with the 'Salle 41' artists, most conspicuously Francis Picabia; the brothers Jacques Villon, Raymond Duchamp-Villon and Marcel Duchamp, who from late 1911 formed the core of the Puteaux group; the sculptors Alexander Archipenko, Ossip Zadkine and Joseph Csaky as well as the two regarded as 'essential' Cubist sculptors, Jacques Lipchitz and Henri Laurens; and painters such as Louis Marcoussis, Roger de La Fresnaye, František Kupka, Marc Chagall, Diego Rivera, Léopold Survage, Auguste Herbin, André Lhote, Gino Severini

(after 1916), María Blanchard (after 1916) and Georges Valmier (after 1918). More fundamentally, the notion of 'essential' Cubism was later undermined by interpretations of the work of Picasso, Braque, Gris and Léger that stress iconographic and ideological questions rather than methods of representation.

Before 1914 the image of Cubism both in France and internationally was based on an extremely broad definition. A more heterogeneous view of Cubism is certainly encouraged by the earliest promotional writings by its practitioners and associates. Picasso, Braque and Gris made almost no published statements on the subject before 1914. The first major text, *Du cubisme*, was produced by two 'Salle 41' Cubists, Gleizes and Metzinger, in 1912; this was followed in 1913 by a far from systematic collection of reflections and commentaries by the poet and critic Guillaume Apollinaire, who had been closely involved with Picasso (from 1905) and Braque (from 1907), but who gave as much attention to artists such as Delaunay, Picabia and Duchamp. Along with Léger he identified these three with a new tendency, which he labelled Orphic Cubism or ORPHISM and which he considered of special significance for the future. Painters such as Gleizes, Metzinger, Delaunay and Duchamp were powerful influences alongside Picasso, Braque, Gris and Léger in the development of art related to Cubism in Russia, Czechoslovakia, Italy, the Netherlands, Britain, Spain and the USA.

2. Cubist milieux: Kahnweiler's Cubists and the Salon Cubists

Picasso, Braque and Gris (and to a lesser extent Léger) were nevertheless distinct in important ways from the other Cubists. Braque and Gris were based in Montmartre until after World War I, while Picasso remained there until 1912. Most of the others, including Léger, were based on the Left Bank, in Montparnasse and in the Parisian suburbs of Puteaux and Courbevoie, and they moved in different, if overlapping, milieux. Before 1914 Picasso, Braque, Gris and Léger further distinguished themselves from the other Cubists by gaining the backing of a single committed dealer

in Paris, the German Daniel-Henry Kahnweiler, who paid each of them a guaranteed annual income for the exclusive right to buy their work and who sold only to a small circle of well-informed clients. Kahnweiler's support gave his artists the freedom to experiment in relative privacy.

The other Cubists, by contrast, concentrated before World War I on building their reputations by showing regularly at the major non-academic Salons in Paris, the Salon des Indépendants and the Salon d'Automne, and for this reason they are sometimes referred to as 'Salon' Cubists. Inevitably they were more aware of public response and the need to communicate. The first public controversies generated by Cubism resulted from Salon showings, not only at the Indépendants of 1911 but also at the Salon d'Automne of 1912; the latter occasion led to Cubism being debated in the Chambre des Députés, since the Salon d'Automne was held in the State's Grand Palais and the State could, therefore, be said to have subsidized the scandal. It was against this background of public anger that Gleizes and Metzinger wrote *Du cubisme* (1912), not necessarily to explain Cubism but to persuade a general audience that their intentions were serious.

3. Technical and stylistic innovations

Technical and stylistic innovations in Cubist painting and sculpture are easier to grasp than Cubism as a concept or art-historical category, particularly as a clear sequence can be outlined. The fact that almost all of these were introduced by Braque or Picasso reinforces the notion of an 'essential' Cubism, but the methods they devised were widely influential precisely because they were so open to different and often contradictory adaptations. The geometric simplifications of form that led to Vauxcelles's references to 'cubes' in 1908 were not in themselves innovative. The two basic methods favoured in early Cubism—the rendering of three dimensions by shifting viewpoints and of volume or mass in terms of flat planes—led to the complication, not the simplification, of the problem of depiction. Early Cubism, with its stress on multiple viewpoints and planar faceting, and its

retention of model, landscape or objects as starting-points, has misleadingly been referred to as Analytical Cubism (see below), although the artists themselves did not use this term.

The role assigned to Picasso's *Les Demoiselles d'Avignon* (1907) as the painting that opened the way to Cubism is based above all on the exaggerated changes of viewpoint applied to the figures, especially the crouching nude on the right, whose head appears almost to have swivelled free from the shoulders so that it can be confronted in three-quarter view. The use of contrasting vantage-points for different features became a central factor in the practice of all Cubists, leading to the assertion that Cubist art was essentially conceptual rather than perceptual. The critic Maurice Raynal, a supporter of Cubism, was most responsible for the emphasis given to this claim from 1912. Raynal argued that the rejection of consistent perspective represented a break with the insistence on instantaneity that characterized Impressionism. The mind now directed the optical exploration of the world as never before. Art was no longer merely a record of the sensations bombarding the retina; it was the result of intelligent, mobile investigation.

Arguments for Braque's L'Estaque landscapes of 1908 as the first Cubist paintings rest, by contrast, on their depiction of space, mass and volume. In works such as *Houses at L'Estaque*, a restrained use of shifting viewpoints is combined with a rendering of forms in space in terms of a continuous pattern of flat surfaces, subdued in colour, that tilt in and out across the picture plane. Such methods, which were taken further in pictures such as *The Port* (spring 1909; Chicago, IL, A. Inst.), clearly provided a stimulus for Picasso's faceting of buildings and sky in his Horta de Ebro landscapes of summer 1909, for example *Factory at Horta de Ebro* (St Petersburg, Hermitage). A crucial technique here, later referred to as 'passage', involves the breaking of the contours defining both the things depicted and the overall faceting so that surfaces appear to flow together, blurring above all the distinctions between solid form and space, foreground and background. The emphasis later placed on the planar depiction of space, mass

and volume arose from its usefulness in asserting the flatness of the support. The painting is seen both to capture the palpable three-dimensionality of the world revealed to the eyes and to draw attention to itself as a two-dimensional thing, so that it is both a depiction and an object in itself. From 1911 this emphasis on the status of the picture as an object was sometimes reinforced by Picasso and Braque by means of the admixture of sand and gesso in their paint to accentuate unevenness and tactility of surface. Picasso was the quickest, if not the first, to realize the implications of the planar depiction of space, volume and mass at their most extreme. In summer 1910, at Cadaqués in Catalonia, he produced pictures that so comprehensively broke down the distinctions between figures and spatial settings that the very identity of the subject was obscured; a major instance is *Female Nude* (Washington, DC, N.G.A.). From 1910 to 1912 the work produced by both Picasso and Braque was characterized by difficulties in the legibility of images that arose partly from the decision to open form fully out into space. Kahnweiler later referred to this kind of Cubist painting as Hermetic Cubism.

Early Cubism has been related to very different kinds of model or source. Picasso's work, for instance, has been linked above all to primitivism, that is to say to non-Western sources; the stylizations and distortions of *Les Demoiselles d'Avignon* seem to have come about in response to African sculpture, examples of which he knew in the collections of friends such as André Derain and in the Musée d'Ethnographie du Trocadéro in Paris, and to 'primitive' Iberian stone-carvings. The relation to African art has also been associated with the conceptual view of Cubism, since such sculptures were held to represent the figure emblematically rather than naturalistically, in terms of simple signs for facial features, limbs and other parts of the body. By contrast, Picasso's use of distortion from 1910 has also been related to the liberties taken by Ingres in idealizing human form. Yet, by general consent the major source for both the distortions created by the use of multiple perspective and for the depiction of forms in terms of planes is the late work of Paul Cézanne, who

was the subject of a major retrospective at the Salon d'Automne in 1907. There is little doubt that the concentration by Braque and Picasso between 1909 and 1912 on Cézanne's range of subjects—the posed model, still-life and landscape—was intended as a deliberate homage. Yet the extreme to which they exaggerated these formal strategies led to a fundamental change in the relationship between artist and subject not anticipated by Cézanne. They used these techniques not merely in response to things seen but positively to manipulate and even reconstruct their subjects, hence their temporary willingness to dispense with representational clarity in their Hermetic Cubist phase.

Later inventions in Cubism arose from a desire to emphasize further the material identity of the art object and to convey the subject-matter more lucidly. Probably in spring 1912 Picasso glued a factory-made piece of oilcloth printed with a realistic chair-caning pattern on to a small still-life, *Still-life with Chair-caning* (Paris, Mus. Picasso; see col. pl. XV). This is generally regarded as the first Cubist Collage. Later in 1912 Braque stuck a piece of cut-out wallpaper printed with wood-grain patterns on to a still-life drawing, *Fruit-dish with Glass* (Sept 1912; priv. col., see 1983 exh. cat., p. 85). This was the first Cubist papier collé. Papier collé differed from collage in that there was a more arbitrary relationship between the cut-out and stuck-on shapes and the things depicted: newspaper could stand for itself, but it could also depict anything from a glass to a soda-syphon; wood-grained wallpaper could depict the surface of a guitar or violin without being cut to the shape of either. Moreover, the broad areas of cut-out paper used in papier collé led to simpler compositions in which the flatness of the constituent planes was taken for granted, leading to more schematic signs for the representation of things. Linear configurations could denote figures and still-life objects in easily legible ways, as in Picasso's *Man with a Hat* (autumn–winter 1912; New York, MOMA), while remaining both obviously two-dimensional and capable of combining different viewpoints. At the same time, the use of cut-out shapes led to a novel development in the

Cubist depiction of space: effects of depth could be achieved by contrived overlappings of one flat shape by another, and indeed it became possible to suggest the illusion of space in front of the picture surface by, as it were, piling planes up one over another, apparently outwards, as in Braque's *The Clarinet* (1913; New York, MOMA). Complications of another kind were created by the insertion of words, a development that preceded collage and papier collé but that was fully elaborated only with their invention.

Between 1912 and 1914 Picasso, Braque and Gris were stimulated by the possibilities opened up by these new techniques to produce a kind of Cubism different in many ways from that of the preceding four years. The subject-matter and the question of representation are not obscured, but the range of spatial effects made possible and the range of reference allowed by the insertion of words and of fragments from the 'real world' led to paradoxical, highly subtle and complex results. Later these developments stimulated other artists to investigate very different, even contradictory, directions. The simple compositions and overlapping planes of Cubist papiers collés were important for the geometric abstraction of both De Stijl and the Suprematism of Kazimir Malevich in Russia. The Cubist use of schematic signs and word play was equally significant for the Dada and early Surrealist work of artists such as Picabia, Max Ernst and Joan Miró.

The changes effected in 1912 in the Cubism of Picasso, Braque and Gris have tempted historians to make a clear distinction between Cubism executed before and after that date. Because of the technical basis of the change in collage and papier collé, the tendency has been to make the distinction in terms of procedural differences. It has been suggested that up to 1912 Cubist method was 'analytical', entailing the part-by-part, viewpoint-by-viewpoint dissection of the subject, while after 1912 it was 'synthetic', based on the construction or invention of representational signs using elementary and sometimes geometric shapes. Explained in these terms, the earlier work was based empirically on the study of things, while the later work was more purely inventive and free of

such primary study. This distinction, from which the terms Analytic Cubism and Synthetic Cubism originated, was first developed by Gris and Kahnweiler from 1915 to 1921, and broadly speaking Picasso, Braque and Gris did tend more to 'synthetic' procedures after 1912. Their work prior to 1912, however, was not exclusively 'analytical', and synthesis or invention was a key factor in their Cubism from the beginning.

Invention and a conceptual rather than perceptual view of art are related preoccupations in Cubism (see fig. 14). Moreover, since Cubist art consistently stressed the directing role of the artist's will, the assertion of the independent status of the work was accompanied by a corresponding emphasis on the degree of control exerted by the person making it. The practice of

metamorphosis, introduced and developed above all by Picasso between 1912 and 1914, further underlined the importance of this subjectivity. The simpler the signs used in the process of depiction, the more similar and therefore the more interchangeable they became. As early as 1909 Picasso developed a major still-life from sketches for a figure composition. *Table with Loaves and Bowl of Fruit* (early 1901; Basle, Kstmus.) has its origins in a series of studies for a painting, *Carnival at the Bistro*, which Picasso never executed. The inanimate items laid here upon the table are transformations of the *commedia dell'arte* figures ranged behind the table. After 1912 Picasso consistently exploited and made clear the interchangeability of figures and objects in his work. The determining role of the artist's

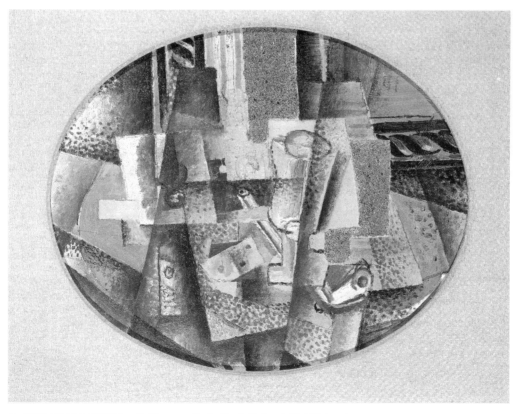

14. Georges Braque: *Still-life with Pipe*, 1914 (Paris, Musée National d'Art Moderne)

imagination was made still more explicit. The use of metamorphosis by Picasso and to some extent by Gris was to influence the Surrealists in the 1920s, especially Joan Miró and André Masson.

In sculpture, two Cubist pictorial innovations were of particular significance: first, the fusion of solid and space, and second, collage and papier collé. From the first followed the positive treatment of space in sculpture and the development of positive/negative reversals (positive features depicted by negative spaces and vice versa). Picasso anticipated this with a *Head of a Woman (Fernande)* (bronze, autumn 1909; Paris, Mus. Picasso), but the earliest to exploit it ambitiously in sculpture was Alexander Archipenko in 1910–11 and especially in 1912–13, for example in *Medrano II* (1913; New York, Guggenheim). From collage and papier collé came Cubist construction and Assemblage. Archipenko was again important in this respect, but Picasso's role was more central and influential. His first substantial construction was a metal *Guitar* (1912; New York, MOMA), but for the most part his early Cubist constructions, starting late in 1912, were made from varied materials and came directly out of collage and papier collé. The additive nature of collage, coupled with the suggestion of space in front of the picture surface achieved by overlapping planes in papier collé, led to the actual building of elements out from the support to form reliefs such as *Mandolin and Clarinet* (painted wood and pencil, 1913; Paris, Mus. Picasso).

The additive and improvisational insouciance of these three-dimensional compositions, which were often left deliberately untidy in appearance, contrasts strikingly with sculpture produced by traditional modelling and carving techniques that entailed either moulding or cutting away from a homogeneous, usually dense material such as clay, plaster, stone or wood. By contrast with such traditional methods, which required an elaborate craft training and often the collaboration of others for carving or casting, these Cubist constructions could be easily assembled using basic non-specialized skills. They were, moreover, characteristically flimsy and open, as in the case of two *Guitars* made of paper and string in late 1912

(Paris, Mus. Picasso), not heavy, durable and monolithic. Of the Cubist sculptors working in France it was Laurens who responded most inventively to Picasso's constructions, especially between 1915 and 1919 with works such as *Bottle and Glass* (1918; Paris, Pompidou) and *Guitar* (1917–18; Cologne, Mus. Ludwig); but as they could be seen by visitors in the studio or as illustrations in the periodical *Soirées de Paris* in 1914, their impact was also felt outside France. Indeed, Cubist construction was as influential as any pictorial Cubist innovation. It was the stimulus behind the proto-Constructivist work of both Naum Gabo and Vladimir Tatlin and thus the starting-point for the entire constructive tendency in 20th-century modernist sculpture.

4. Meanings and interpretations

The Cubism of Picasso, Braque and Gris had more than a purely technical or formal significance, and the often distinct attitudes and intentions of the other Cubists produced not so much a derivative of their work as different kinds of Cubism. It is by no means clear, in any case, to what extent these other Cubists depended on Picasso and Braque for their development of such techniques as faceting, 'passage' and multiple perspective; they could well have arrived at such practices with little knowledge of 'true' Cubism in its early stages, guided above all by their own understanding of Cézanne. The works shown at the Salons of 1911 and 1912 by these other Cubists extended beyond the conventional Cézanne-like range of subjects favoured by Picasso and Braque to include large-scale modern-life subjects and even allegory. Aimed at a large Salon public, these works made clear use of Cubist techniques of faceting and multiple perspective for expressive effect in order to preserve the eloquence of subjects that were richly endowed with literary and philosophical connotations.

At the Indépendants of 1911, Le Fauconnier's *Abundance* (1910–11; The Hague, Gemeentemus.) gave allegorical expression to a theme that concerned not only the 'Salle 41' Cubists but also the ABBAYE DE CRÉTEIL, a group of writers and artists that included Alexandre Mercereau, Jules Romains,

Henri-Martin Barzun, René Arcos, Charles Vildrac and Georges Duhamel (1884–1966). Le Fauconnier here used the allegory of fruitfulness to represent life as a process of incessant birth and rebirth, giving symbolic expression to the key notion of 'duration' proposed by the philosopher Henri Bergson according to which life is subjectively experienced as a continuous forward movement in time, with the past flowing into the present and the present merging into the future. The other Salon Cubists were also attuned to this concept—in *Du cubisme* Gleizes and Metzinger explicitly related this sense of time to multiple perspective—and to Bergson's insistence on the elasticity of our consciousness of both time and space. They gave physical expression to this blurring of distinctions by means of 'passage', using the faceted treatment of solid and space, and effects of planar interpretation to convey a physical and psychological sense of the fluidity of consciousness in Bergson's terms. These concerns are related to Jules Romains's theory of Unanimism, which stressed the power of collective feelings to break down the barriers between people. The one major innovation that one can be sure was made independently by the Salon Cubists, that of 'simultaneity', came of a conviction also rooted in their understanding of Bergson that the divisions of space and time should be comprehensively challenged.

Delaunay's *City of Paris* (1910–12; Paris, Pompidou) and Léger's *The Wedding* (c. 1911; Paris, Pompidou; see fig 15), both shown at the Salon des Indépendants in 1912, give form to this concept of simultaneity by presenting different motifs as occurring within a single time frame: Delaunay brings together the quais on the Seine, the three Graces, a view across the roofs and the Eiffel Tower, while Léger unites a wedding group with fragmentary views of a village setting. The subjects themselves again carry strong overtones of ideas derived from Bergson and Unanimism: for Romains the city was a Unanimist entity, a psychological as well as a physical fact, where responses to the past and the present interpenetrate; an event like a wedding was seen as a powerful emotional occasion through which the past

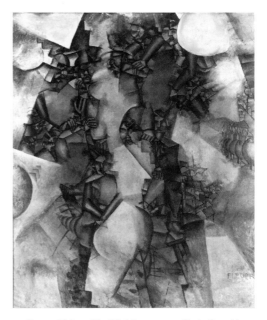

15. Fernand Léger: *The Wedding*, c. 1911 (Paris, Pompidou, Musée National d'Art Moderne)

is precipitated into the future with collective force. The conjunction of such subject-matter with simultaneity aligns Salon Cubism with early Futurist paintings by Umberto Boccioni, Gino Severini and Carlo Carrà; these Italian works, though themselves made in response to early Cubism, led the way in the application of techniques of simultaneity in 1911–12.

The Cubist work produced before 1912 by Picasso, Braque and Gris had little to do with Bergson, but wide cultural, literary, philosophical and even scientific and mathematical connotations have also been attributed to it. The scientific and mathematical connection was something made very generally in relation to Cubism. In the case of Picasso, Braque and Gris it followed from their known involvement with an amateur mathematician, Maurice Princet, around 1910–11. Princet introduced them to new mathematical developments popularized by Jules Henri Poincaré (1854–1912) and to currently fashionable theories of the Fourth dimension and the 'hypercube',

although they were unaware of the theories of Albert Einstein. Ancient and Renaissance theories of proportion were also considered relevant, especially to the Duchamp brothers and others involved in the *Salon de la Section d'Or* in late 1912 (*see* SECTION D'OR), though of the Montmartre Cubists only Gris was drawn to them.

These quasi-scientific and mathematical interests were linked with the 'hermetic sciences', the occult and alchemy. Of the writers sympathetic to Cubism, Mercereau and Gleizes's brother-in-law Jacques Nayral were actively engaged in Occultism, while Apollinaire and Jacob are known to have dabbled in the cabbala, alchemy and the writings of hermeticists such as Eliphas Lévi. Apollinaire's concept of Orphism had a clear mystical aspect, which followed from its roots in Greek myth, and alchemical themes seem to have been touched on in Duchamp's subject-matter from 1912 and in works by Marc Chagall such as *Homage to Apollinaire* (1913; Eindhoven, Stedel. Van Abbemus.). Picasso is also thought to have shared the enthusiasm of Apollinaire and Jacob for magic and the occult; indeed, it is possible that, like them, he thought of his Cubist works as magical mediators between himself and a hostile world.

Just as the Salon Cubists were linked with the Abbaye de Créteil group, so the early Cubist work of Picasso, Braque and Gris was associated with the post-Symbolist and sometimes proto-Surrealist poetry of Apollinaire and Jacob, and also with 19th-century Symbolist poetry, especially that of Stéphane Mallarmé. Their interest in Mallarmé has often been corroborated, and the obscurity of their 'hermetic' Cubism of 1910–12 has been related to Mallarmé's late poetic practice, by which things are not named but evoked through the images or sensations stimulated by their presence. Apollinaire's lyrical variant on these methods, arising from his ability to take ordinary things as a starting-point for series of images possessing 'supernatural' qualities, clearly relates to the use of banal subjects by Picasso and Braque as the springboard for arcane yet suggestive clusters of lines and planes. Indeed the poet Pierre Reverdy, who was also close to Picasso, Braque and Gris,

could claim that the importance of Cubism lay essentially in the fact that it had consolidated changes wrought first in poetry by Mallarmé and Arthur Rimbaud. It is also clear that the emphasis placed by these painters on the autonomy of the elements of their art (colours, lines, forms) and their belief in the directing role of the subjective imagination were extensions of Symbolist attitudes. This association between Cubism and Symbolism relates closely to the association often made between Cubism and the aesthetic theories of Immanuel Kant, particularly his theory of form as the key to beauty as elaborated in *Kritik der Urteilskraft* (Berlin, 1790).

The most extreme directions suggested by Cubism were not those followed by Picasso and Braque, who resisted the invitation to abstraction inherent in their most obscure Hermetic work. For them, the assertion of the autonomy of the work as an object was no more important than the task of representing things as informatively, suggestively and from as many different aspects as possible. Collage and papier collé resulted in part from a desire to shift the balance back towards 'real' things. The other Cubists, by contrast, especially Jacques Villon's Czech neighbour, František Kupka, and those grouped together as Orphists by Apollinaire (Delaunay, Léger, Picabia and Duchamp), accepted the invitation to abstraction with some enthusiasm (see col. pl. XXVIII).

Kupka's painting from 1912, rooted in his formative years in Prague and Vienna, was metaphysical in orientation. Duchamp in 1912 and Picabia from 1912 to 1914 developed an expressive and allusive abstraction dedicated to complex emotional and sexual themes, and in Duchamp's case to theories of the fourth dimension. From 1912 Delaunay painted a series of paintings entitled *Simultaneous Windows* (e.g. 1912; London, Tate; see col. pl. I), in which he combined planar structures derived from Hermetic Cubism with bright prismatic hues based on Michel-Eugène Chevreul's theories of simultaneous colour contrasts; the colour in early Cubist paintings had been distinctly subdued. In 1913–14 Léger produced a series entitled *Contrasts of Forms* (e.g. 1913; Philadelphia, PA, Mus. A.), which were also

based on a theory of contrasts but which gave equal stress to colour, line and form. His Cubism, even in this abstract guise, was explicitly associated with themes of mechanization and the celebration of modern life. Apollinaire supported all these developments in *Les Peintres cubistes* (1913), writing of a new 'pure' painting in which the subject no longer counted, but in spite of his use of the term Orphism these kinds of abstract Cubism were so varied that they defy attempts to treat them as a single category.

Although the importance of the subject was played down in the 'pure' painting practised in 1912–14, such art in its several forms was considered to carry meanings beyond the simply aesthetic. Picabia and Duchamp were dedicated to an expressive project with psychological and arcane overtones. Léger declared that he wanted to convey the dissonant energy of the modern by means of pictorial contrasts, and in his essay 'La Lumière' (first published in German translation in *Der Sturm* in 1913) Delaunay wrote in terms reminiscent of Bergson of his simultaneous contrasts as conveying 'the movement of the world'. It is understandable, therefore, that Delaunay's Orphism accompanied the ambitious further development of simultaneity in its broader Cubist and Futurist sense, and that it did so as the pictorial complement to developments in the poetry of Apollinaire and the Swiss adventurer-poet, Blaise Cendrars. In 1912–14 Delaunay produced a series of pictures that combined simultaneous contrasts of colour with fragmentary clusters of images of modern life such as aeroplanes, posters, rugby players and the Eiffel Tower, for example in the *Cardiff Team* (1912–13; Eindhoven, Stedel. Van Abbemus) and *Homage to Blériot* (c. 1914; Basle, Kstmus.). Bergson's attack on the divisions of space and time was all-important here still; the Eiffel Tower owed its central role to its function as the radio-mast of Paris, the point at which global distances were nullified. It was the prime symbol of simultaneity.

Duchamp, also labelled an Orphist by Apollinaire, was responsible for a further extreme development based on Cubism: the ready-made. The ready-made arose from a consideration of the linked notions of the painting as object and of 'pure' painting alongside the implications of collage and Cubist construction. On the one hand, the work is considered an object in its own right, pure and self-contained; on the other, it takes into itself the material detritus of the world. It was a short step to the decision that an ordinary object could be presented, with irony, as a self-sufficient work of art representing nothing but itself, as Duchamp did in 1913 by attaching a bicycle wheel to a kitchen stool (untraced; for replica, 1963, see col. pl. XVI) and in 1914 by selecting a bottle-drying rack as a sculpture in its own right.

While stopping short of such extreme conclusions, the works made after 1912 by Picasso, Braque and Gris were wide-ranging in their form and meaning. Braque pursued musical analogies by his use of words, for example in collages such as *Glass, Newspaper, Packet of Tobacco and Sheet Music* (spring 1914; Chicago, IL, A. Inst.) and in his concentration on subjects such as *The Musician* (1917–18; Basle, Kstmus.). Gris produced subtle word plays and introduced references to such disparate interests as Apollinaire's poetry and the popular *Fantomas* novels. Picasso, however, most effectively widened the range of meaning in Cubism, playing on the ambiguous metamorphic relationships between inanimate objects and figures, using bulbous organic shapes and extreme distortion to create comic and even grotesque sexual suggestions, and also using words in a witty manner, sometimes injecting a sexual or scatological humour reminiscent of the *Ubu* plays by Alfred Jarry, as in the highly suggestive placing of the words 'trou ici' (hole here) in relation to department-store lingerie advertisements in the collage *Au Bon Marché* (winter 1912–13; Aachen, Neue Gal.). Early in 1913 Picasso used press-cuttings concerning the Balkan War as a way of alluding to the climate of rising nationalism and international tension that would culminate in World War I. The very heterogeneity of Cubist art by Picasso, Braque and Gris after the invention of collage and papier collé can be thought of as a representation of the disparateness and intensity of early 20th-century urban experience.

5. Late Cubism

The most eventful and innovative period of Cubism was before 1914, but after 1918 Cubism returned as a central issue for artists in France. It continued as such until the mid-1920s, when its avant-garde status was rendered questionable by the advent of geometric abstraction and by the rebarbative presence of the Surrealists in Paris. Many Cubists, including Picasso, Braque, Gris, Léger, Gleizes and Metzinger, while developing other styles, continued on occasion to produce work that was clearly Cubist and that was attacked and defended as such. It is impossible, indeed, to date the end of Cubism, since such artists as Braque, Picasso and Gleizes returned to Cubist modes long after 1925, and since forms of avant-garde art directly responsive to Cubism emerged as late as the end of the 1920s and the 1930s in, for instance, the work of the American Stuart Davis and the Englishman Ben Nicholson. In France, however, a sharp decline in its significance is clear from about 1925.

Cubism was changed, moreover, by World War I. In 1914–15 the Cubists were dispersed either to the Front or abroad; those that continued with their art, including Picasso, Gris, Lipchitz, Laurens and a recent convert to Cubism, the Mexican Diego Rivera, were left relatively isolated. Cubism re-emerged as a significant force in 1917 with the première in Paris of the ballet *Parade*, produced by the Ballets Russes with a scenario by Jean Cocteau, music by Erik Satie and sets and costumes by Picasso, and especially with the support given by the dealer Léonce Rosenberg, who took up not only the artists stranded by Kahnweiler's exile in Switzerland but also many others, including Laurens, Lipchitz, Metzinger, Herbin and Severini. Soon after the Armistice on 11 November 1918 Rosenberg mounted a series of Cubist exhibitions at his Galerie de l'Effort Moderne in Paris, culminating in an exhibition by Picasso, all showing wartime work. Cubism was featured in exhibitions devised by organizations such as Lyre et Palette and in new periodicals such as *S.I.C.* (from 1915), *L'Elan* (1915–16) and *Nord-Sud* (from 1917). There were attempts, led by Louis Vauxcelles, to claim that Cubism was finished, but

these exhibitions, along with a well-organized Cubist showing at the Salon des Indépendants in 1920 and a revival of the Salon de la Section d'Or in the same year, demonstrated its survival.

By 1920 Cubism had become almost exclusively associated with the question of the autonomy of art. The changes that had occurred in Cubism were remarked by a number of commentators, including the artist and critic André Lhote, who himself was often called a Cubist. By this time Picasso was working in a variety of styles, but he continued occasionally to produce expressive Cubist work, while Léger, after his recovery from war wounds in 1917–18, produced Cubist pictures with references to modern life that were even more explicit than before, as in *The Typographer* (1919; Philadelphia, PA, Mus. A.). Most of those associated with Rosenberg's gallery, however— including Gris, Metzinger, Lipchitz, Laurens, Herbin and Severini—made direct reference to observed reality but were at pains to stress the self-sufficiency of their pictures and sculptures as objects in their own right. Lipchitz, for example, came close to complete abstraction in carvings such as *Standing Personage* (1916; New York, Guggenheim). There was also a tendency to give priority to the orderly qualities of Cubist composition, so that Cubism became part of a widely noted phenomenon in French culture at the end of the war, a return to classical traditions referred to by Jean Cocteau as a 'rappel à l'ordre'. Gris played a leading role in these developments; the clarity and sense of order of the work he produced between 1917 and 1920 led to its being referred to by the critic Maurice Raynal as 'crystal' Cubism. This narrowing of the frame of reference to a more purely formal one that excluded reference to the types of concerns manifested in Cubism before 1914—for example to Bergson's concept of duration, psychological interpenetration, the occult, the fourth dimension and the dynamism of modern life—coincided with the appearance from 1917 to 1924 of a coherent body of theoretical writing about Cubism; influential texts were published by Pierre Reverdy, Maurice Raynal and Daniel-Henry Kahnweiler and, among the artists, by Gris and Léger. Their theories, supported in the

writings of Reverdy and Raynal by reference to Kant and Plato, strengthened the insistence on the autonomous purity of art. The distillation of Cubism and its part in the 'rappel à l'ordre' have been linked to the tendency, shown by many of those left on the home front, to evade the realities of the war and also to the cultural dominance of a classical or Latin image of France during and immediately after the war. Cubism after 1914 can be seen as part of a far wider ideological shift towards a more conservative stance in French society and culture alike.

In the early 1920s confusion was caused by the decision of several Cubists to produce overtly classical figurative work either exclusively or alongside Cubist work; Picasso was the model, having developed parallel classicizing styles from 1914. There was, however, a consistency in the common Cubist and figurative themes of Classicism and order, and in the common accent on formal priorities. The Cubists considered classical styles above all to be structured formal idioms under the control of the artist. Cubist art itself remained extremely varied and changeable both within the oeuvre of a single artist such as Gris and across the work of artists as different from each other as Braque and Léger. Yet, Cubism as a publicly debated concept or movement became relatively unified and open to definition. Its apparent theoretical purity made it a gauge against which not only traditional academic art but such contrasting tendencies as Naturalism, Dada, Surrealism and various forms of abstraction could be measured, even though many of the more radical artists who attacked Cubism were specifically indebted to it. While late Cubism produced no major innovations, its self-imposed limitations and its greater coherence, both as a public phenomenon and in terms of theory and practice, prepared the way for a more general acceptance of Cubism as a whole and particularly of the 'essential' Cubism of the years prior to 1914.

See also ABSTRACT ART.

Bibliography

early sources
Cubistas (exh. cat., preface J. Nayral; Barcelona, Gal. Dalmau, 1912)

G. Apollinaire: *Les Peintres cubistes: Méditations esthétiques* (Paris, 1913)
P. Reverdy: 'Sur le cubisme', *Nord-Sud*, i (1917); repr. in *Oeuvres complètes, 'Nord-Sud', 'Self-defence' et autres écrits sur l'art et la poésie, 1917–1926*, ed. E.-A. Hubert (Paris, 1975)
M. Raynal: *Quelques intentions du cubisme* (Paris, 1919)
D.-H. Kahnweiler: *Der Weg zum Kubismus* (Munich, 1920; Eng. trans., New York, 1949)

artists' writings and statements
A. Gleizes and J. Metzinger: *Du cubisme* (Paris, 1912; Eng. trans., London, 1913)
F. Léger: 'Les Origines de la peinture et sa valeur représentative', *Montjoie!* (29 May 1913), p. 7; (14–29 June 1913), pp. 9–10; repr. in *Fonctions de la peinture* (Paris, 1965; Eng. trans., New York and London, 1973)
——: 'Les Réalisations picturales actuelles', *Soirées Paris*, 25 (1914), pp. 349–56; repr. in *Fonctions de la peinture* (Paris, 1965; Eng. trans., New York and London, 1973)
J. Gris: 'Des possibilités de la peinture', *Transatlantic Rev.* (1924), i/6, pp. 482–8; ii/1, pp. 75–9; repr. in D.-H. Kahnweiler: *Juan Gris: Sa Vie, son oeuvre, ses écrits* (Paris, 1946); Eng. trans. and rev. D. Cooper as *Juan Gris: His Life and Work* (London, 1968–9), pp. 195–200
R. Delaunay: *Du cubisme à l'art abstrait*, ed. P. Francastel (Paris, 1957)
A. Gleizes: *Souvenirs: Le Cubisme, 1908–1911* (Audin, 1957)
J. Lipchitz and H. H. Arnason: *My Life in Sculpture* (London, 1972)

exhibition catalogues
Le Cubisme (1907–1914) (exh. cat., Paris, Mus. N. A. Mod., 1953)
Les Cubistes (exh. cat., Bordeaux, Gal. B.-A.; Paris, Mus. N. A. Mod.; 1973)
W. Rubin: 'Cézannism and the Beginnings of Cubism', *Cézanne: The Late Work* (exh. cat., ed. W. Rubin; New York, MOMA, 1977)
The Planar Dimension (exh. cat. by M. Rowell, New York, Guggenheim, 1979)
Zeichnungen und Collagen des Kubismus: Picasso, Braque, Gris (exh. cat., Bielefeld, Städt. Ksthalle, 1979)
Kubismus: Künstler–Themen–Werke, 1907–1920 (exh. cat., Cologne, Josef-Haubrich-Ksthalle, 1982)
The Essential Cubism, 1907–1920: Braque, Picasso and their Friends (exh. cat. by D. Cooper and G. Tinterow, London, Tate, 1983)
Picasso and Braque: Pioneering Cubism (exh. cat., intro. W. Rubin, ed. J. Leggio; New York, MOMA, 1989) [with doc. chronology by J. Cousins]

general

A. H. Barr: *Cubism and Abstract Art* (New York, 1936)

C. Greenberg: 'The Pasted-paper Revolution', *ARTnews*, 57 (1958), pp. 46–9, 60–61; repr. as 'Collage' in *Art and Culture* (Boston, 1961), pp. 70–83

J. Golding: *Cubism: A History and an Analysis, 1907–1914* (London, 1959, rev. 1968, 3/1988)

R. Rosenblum: *Cubism and Twentieth-century Art* (New York and London, 1960, rev. 1977)

E. F. Fry: *Cubism* (London and New York, 1966)

D. Cooper: *The Cubist Epoch* (London and New York, 1970)

L. D. Henderson: 'A New Facet of Cubism: "The Fourth Dimension" and "Non-Euclidean Geometry" Reinterpreted', *A. Q.* [Detroit], xxxiv/4 (1971)

R. Rosenblum: 'Picasso and the Typography of Cubism', *Picasso in Retrospect*, ed. J. Golding and R. Penrose (New York, 1973), pp. 49–76

Le Cubisme, Université de Saint-Etienne, Centre Interdisciplinaire d'Etudes et de Recherche sur l'Expression Contemporaine, Travaux iv (Paris, 1973)

L. Steinberg: 'Resisting Cézanne: Picasso's *Three Women*', *A. America*, lxvi/6 (1978), pp. 114–33

V. Spate: *Orphism: The Evolution of Non-figurative Painting in Paris, 1910–1914* (Oxford, 1979)

L. Steinberg: 'The Polemical Part', *A. America*, lxvii/2 (1979), pp. 114–27

L. W. Gamwell: *Cubist Criticism, 1907–1925* (Ann Arbor, 1980)

J. M. Nash: 'The Nature of Cubism: A Study of Conflicting Explanations', *A. Hist.*, iii/4 (1980), pp. 435–47

D. Cottington: *Cubism and the Politics of Culture* (diss., U. London, Courtauld Inst., 1985)

C. Green: *Cubism and its Enemies: Modern Movements and Reaction in French Art, 1916–1928* (London and New Haven, 1987)

M. Roskill: *The Interpretation of Cubism* (Philadelphia, Toronto and London, 1987)

P. Assouline: *L'Homme de l'art: D.-H. Kahnweiler, 1884–1979* (Paris, 1988)

C. Poggi: *In Defiance of Painting: Cubism, Futurism and the Invention of Collage* (New Haven, 1992)

CHRISTOPHER GREEN

II. Architecture

Architectural interest in Cubism centred on the dissolution and reconstitution of the individual characteristics of three-dimensional form, using simplified geometrical shapes, juxtaposed without resort to the illusions of perspective. To the architect, Cubist paintings suggested that elements of form could be superimposed, made transparent or penetrate each other, while retaining the essence of their unique spatial relationships and context. By 1912 Cubism had become a predisposing factor in the development of the Modern Movement in architecture. While the nature of this influence may be in dispute, Cubism developed in parallel with the work of architects of the early Modern Movement such as Peter Behrens (AEG Turbine Factory, Berlin, 1908–9) and Walter Gropius (Fagus factory at Alfeld, Germany, 1911–13; see col. pl. XXXI), and thus with the simplification of building forms, the use of components appropriate to industrial production, and the increased use of glass (*see* MODERN MOVEMENT, §2).

Cubist conventions were found relevant to an architecture seeking a non-rhetorical manner appropriate to an increasingly industrialized society, and promised an architectural style that need not refer to the past. Attempts at the direct application of Cubism to architecture and interior design by members of the Puteaux group were superficial, however, and Banham (1960, p. 203) suggested that '. . . it is only in conjunction with Futurist ideas that Cubism was able to make any significant contribution to the mainstream . . .'. Although the ideology and subject-matter of the Italian Futurist painters and sculptors predated their visit in 1911 to Paris, their representational techniques were effectively transformed by it and are reflected in the dynamic brilliance of Antonio Sant'Elia (*see* FUTURISM, §2). Thus, what had become a revolution in painting was applied, as Banham puts it, as part of 'a profound reorientation towards a changed world'. The Cubo-Futurist ideas, widely propagated by Filippo Tommaso Marinetti, coloured aesthetic attitudes in the architectural avant-garde. For example, the influential DE STIJL movement (formed 1917) espoused the formal rigours of Neo-plasticism developed by Piet Mondrian under Cubist influence in Paris, and De Stijl was also linked by the classicizing tendencies of Gino Severini to Cubist theory through the writings of, for example, Albert Gleizes. The linking of elementary geometrical forms with inherent beauty as well as with ease of industrial

production, however, which had been foreshadowed from 1914 by the art-objects of Marcel Duchamp and pragmatically codified by Hermann Muthesius, was left to the founders of PURISM (1918), Amédée Ozenfant and Charles Edouard Jeanneret who in the same year exhibited paintings together in Paris and published *Après le cubisme* (1918).

Bibliography

G. Severini: *Du Cubisme au classicisme* (Paris, 1921)
P. R. Banham: *Theory and Design in the First Machine Age* (London, 1960), pp. 202–13
H. Sting: *Der Kubismus und seine Einwirkung auf die Wegbereiter der modernen Architektur* (Aachen, 1965)

JOHN MUSGROVE

Cubo-Expressionism

Term used to describe a style of Czech avant-garde art, literature, film, dance and cabaret of the period 1909–21. It was introduced by art historians and critics, notably Jiří Padrta and Morislav Lamač, in the early 1970s. The term has two meanings: a general one applicable to the tendency of the age and a specialized one referring to the synthesis of two styles that influenced the development of modern Czech art: French Cubism and German Expressionism.

Expressionism had been in vogue in Bohemia from the 1890s. In 1907 the group known as the Eight, influenced by the Edvard Munch exhibition of 1905, laid down the basic principles for the development of Czech modern art. They were dissatisfied with the prevailing naturalism and sought the reintroduction of colour as the dominant element in art, together with freer brushwork (*see* EIGHT, THE (i)). Most members of the Eight subsequently became joint founders of the Group of Plastic Artists, which was concerned primarily with Cubo-Expressionism. By 1911 the Expressionistic tendencies of Czech art at the beginning of the century had acquired formal direction under the influence of Cubism. The clean morphology of Cubism had impacted on contemporary central European themes: primarily an existential anxiety accompanied by feelings of absurdity and isolation. Cubo-Expressionism is thus an authentic cross-fertilization between foreign influences and the central European intellectual climate, with its conflicting currents of thought.

The influence of Cubism penetrated architecture, sculpture, painting and design. Some artists, such as Emil Filla and Vincenc Beneš, followed the one-sided response to stimuli shown in the work of Picasso and Braque. Others, such as the painters Bohumil Kubišta, Josef Čapek, Jan Zrzavý and the architects Vlastislav Hofman (1884–1964) and Josef Gočár, developed their own variant of Cubism.

A typical example of early Cubo-Expressionism is the sculpture *Anguish* (1911) by Otto Gutfreund. The anguish in the face of the figure cowering in a Cubistic cloak, as though it had sprung forth from unexplained existentialist horrors, was a frequent theme at the turn of the century. The sculpture drew on some of the emotional sources of the Eight, but its manner of execution was new. In his subsequent work Gutfreund moved from existential subjects to purely Cubistic, athematic sculpture, while Cubo-Expressionism was further developed in the work of Kubišta and Čapek. As early as 1912 Kubišta had shown his opposition to the Cubist aesthetic. His painting *Hanged Man* (1915; Brno, Morav. Mus.) is often cited as demonstrating the way in which Czech Cubo-Expressionism differs from French Cubism and German Expressionism. Kubišta's themes are suffused in the atmosphere of the time, pointing to the dark side of the human psyche, as in *Nervous Lady* (1912; Ostrava, A.G.) and *St Sebastian* (1912; Prague, N.G., Mun. Lib.), which was ignored by those artists who, like the pro-French Emil Filla, were purely Cubistic in their orientation. The *doppelgänger* was a frequent theme in Cubo-Expressionist art and literature, which concerned itself with the minutiae of the split personality. Inspiration, according to Kubišta and Zrzavý, is to be found in the hidden, split-off depths of the human psyche. Zrzavý, who was Kubišta's friend and private pupil, began as a Symbolist but turned to Cubo-Expressionism in *Obsession* (1915), *Suffering* (1916) and *Madman* (1918; all Prague, N.G., Mun. Lib.).

The diagonal was a typical motif in Cubo-Expressionism and acquired an important role, especially in architecture and design. Its possibilities were deduced from the theoretical literature of the time. The German theory of art and aesthetics and Viennese ideas on the history of art, especially the lectures of Alois Riegl, had a hold on many Czech architects; some of the principles of Cubo-Expressionist architecture were analogous to those of the German architects in the Gläserne Kette ('glass chain') group. Cubo-Expressionism had a greater following in Germany than in France. Many of its adherents exhibited at the Sturm-Galerie in Berlin and published articles in such leading German Expressionist journals as *Die Aktion* and *Der Sturm*. German critics especially valued Kubišta and Čapek (the latter both as artist and as writer) and Vlastislav Hofman. Cubo-Expressionism also had a powerful effect on literature, and many important writers were associated with the Group of Plastic Artists, including Karel Čapek, brother of Čapek, František Langer and Richard Weiner. Their collections of stories vividly caught the predicament of the individual tossed about by personal uncertainty regarding his true identity.

Bibliography

B. Kubišta: *Korespondence a úvahy* [Correspondence and considerations] (Prague, 1960)

J. Opelík: *Josef Čapek* (Prague, 1980)

F. Burkhardt and M. B. Lamerová: *Cubismo cecoslovacco: Architekture e interni* (Milan, 1982)

P. Wittlich: *Česká secese* [The Czech Secession] (Prague, 1982)

M. Nešlhová: *Bohumil Kubišta* (Prague, 1984)

M. Lamač: *Osma a Skupina výtvarných umělců* [The Eight and the Group of Plastic Artists] (Prague, 1988)

1909–1925, Kubismus in Prag (exh. cat., ed. J. Švestka and T. Vlček; Düsseldorf, Kstver., 1991)

KAREL SRP

Cubo-Futurism

Term first used in 1913 in a lecture, later published, by the Russian art critic Korney Chukovsky (1882–1969) in reference to a group of Russian avant-garde poets whose work was seen to relate to French Cubism and Italian Futurism; it was subsequently adopted by painters and is now used by art historians to refer to Russian art works of the period 1912–15 that combine aspects of both styles. Initially the term was applied to the work of the poets Vladimir Mayakovsky, Aleksey Kruchonykh, Velimir Khlebnikov, Benedikt Livshits (1886–1939) and Vasily Kamensky (1864–1961), who were grouped around the painter David Burlyuk. Their raucous poetry recitals, public clowning, painted faces and ridiculous clothes emulated the activities of the Italians and earned them the name of Russian Futurists. In poetic output, however, only Mayakovsky could be compared with the Italians; his poem 'Along the Echoes of the City', for example, which describes various street noises, is reminiscent of Luigi Russolo's manifesto *L'arte dei rumori* (Milan, 1913).

Burlyuk was particularly interested in the stylistic devices of Cubist painting and frequently wrote and lectured on the subject. As a result, several of the poets tried to discover analogies between Cubism and their own poetry. Particularly important in this respect was the work of Khlebnikov and Kruchonykh. Their poems of 1913–14 ignored the rules of grammar and syntax, metre and rhyme; they omitted prepositions and punctuation, used half-words, neologisms, irregular word formations and unexpected images. For some, such as Livshits, who attempted merely 'a cubist shaping of the verbal mass', this approach was too radical. Others preferred to introduce more visual qualities. Kamensky, for instance, divided his sheet of paper with diagonal lines and filled the triangular sections with single words, part words, individual letters, numbers and signs, in a variety of typefaces, imitating the geometrical planes and letters of Analytical Cubism.

The term Cubo-Futurism was subsequently used by artists such as Lyubov' Popova, whose stylistic development was indebted to both Cubism and Futurism. Her *Portrait* (1914–15; Athens, George Costakis priv. col.) includes the words 'Cubo Futurismo' as a conscious homage. Later art historians have used the term to categorize paintings and constructions by the Russian avant-garde in general, in which the influences of both

Cubism and Futurism are synthesized. Popova's most important work in this respect is *Seated Figure* (1914–15; Cologne, Wallraf-Richartz-Mus.), in which the treatment of the body recalls the work of Léger and Metzinger. However, her use of cones and spirals and the dynamism of line and plane betray the influence of Futurism.

Notable Cubo-Futurist paintings by other artists include Malevich's the *Knife Grinder* (1913; New Haven, CT, Yale U. A.G.) and Burlyuk's the *Siberian Fleet Sailor* (1912; London, Grosvenor Gal.). The mosaic of planes in the former recalls Analytical Cubism, and the cylindrical treatment of the body suggests the work of Léger, but clear trajectories of movement and the subject of man and machine indicate the influence of Futurism. In the latter the head is depicted from different points of view and is integrated with the background by means of echoed arcs, a technique borrowed from Braque, while the dynamism of the diagonals that fracture the image is clearly Futurist.

Cubo-Futurism was a passing but important phase in Russian avant-garde painting and poetry. Mikhail Larionov, Natal'ya Goncharova, Alexandra Exter, Ol'ga Rozanova and Ivan Klyun also painted in this manner. It acted as a springboard for non-objectivity, with Popova and Malevich progressing to SUPREMATISM and the poets Khlebnikov and Kruchonykh to an 'abstract' poetical language in which meaning was negated and only sounds were important.

Bibliography

K. Chukovsky: 'Ego-futuristy i Cubo-futuristy' [Ego-Futurists and Cubo-Futurists], *Shipovnik*, xxii (1914), pp. 95–154

Il Futurismo russo (Milan, 1967), v/44 of *L'arte moderna* [good pls]

V. Markov: *Russian Futurism: A History* (London, 1969)

S. Compton: *The World Backwards: Russian Futurist Books, 1912–1916* (London, 1978)

A. Z. Rudenstine: 'Cubo-Futurism', *Art of the Avant-garde in Russia: Selections from the George Costakis Collection* (exh. cat., ed. A. Z. Rudenstine and M. Rowell; New York, Guggenheim, 1981), pp. 46–74

C. Gray: *The Russian Experiment in Art, 1863–1922* (rev. and enlarged edn. London, 1990)

M. Yablonska: *Women Artists of Russia's New Age* (London, 1990)

ANTHONY PARTON

Cumberland Market Group

British group of painters. They took their subject-matter from everyday life, particularly that of north-west London, where Robert Bevan had his studio and held 'At Homes' for artist-friends. These formalized in late 1914 when Bevan, Charles Ginner and Harold Gilman established the group, joined in 1915 by John Nash. Christopher Nevinson and E. McKnight Kauffer attended meetings and compared works, although they did not exhibit with the group. Members consciously embraced the style called 'Neo-Realism', exploring the spirit of their age through the shapes and colours of daily life. Their intentions were proclaimed in Ginner's manifesto in *New Age* (1 Jan 1914), which was also used as the preface to Gilman and Ginner's two-man exhibition that year: it attacked the academic and warned against the 'decorative' aspect of imitators of Post-Impressionism.

Although the Cumberland Market Group developed from Walter Sickert's CAMDEN TOWN GROUP, its members sought more rigorous attention to natural facts, though not neglecting compositional selection and design and insisting on a love of the medium as essential to expressive painting. Characteristic paintings are Ginner's *Leeds Canal* (1914; Leeds, C.A.G.) and Gilman's *The Eating House* (c. 1914; Sheffield, Graves A.G.), which achieve equal weighting of form and content through strict control of colour and composition and through sensitivity to atmosphere and location. Their practices were briefly the basis of their School of Painting in Soho, London (1916–17). The group's only public exhibition took place in April 1915 at the Goupil Galleries in London, the location of their later meetings. Commitment to the group was not exclusive: Gilman was a founder-member of the LONDON GROUP; Ginner joined the avant-garde GROUP X. In 1921 Bevan and Ginner organized an exhibition of *Peintres modernes anglais* at the Galerie Druet, Paris, which included work by members of the group, as well as by

William Roberts and Edward Wadsworth. However, after Gilman's death in 1919 the group lapsed, although it never officially disbanded.

Bibliography

An Exhibition of Paintings by Harold Gilman and Charles Ginner (exh. cat., London, Goupil Gals, 1914)
Paintings by the Cumberland Market Group (exh. cat., London, Goupil Gals, 1915)

JUSTINE HOPKINS

Czech Cubism

Term used to describe a style in architecture and the applied arts, directly inspired by Cubist painting and sculpture, which was developed by architects and designers active in Prague shortly before World War I; the term itself was not used until the 1960s. The leaders of the style were the members of the Group of Plastic Artists (1911–14), which broke away from the Mánes Union of Artists in 1911 and for two years published its own journal, Umělecký měsíčník ('Art monthly'). The architects in the group were Josef Gočár, Josef Chochol, Vlastislav Hofman (1884–1964) and Pavel Janák; other members included Emil Filla, Václav Špála, Antonín Procházka and Otto Gutfreund. The group was reacting against the austere rationalism of such architects as Jan Kotěra, seeking instead to sustain architecture and the applied arts as branches of art rich in content. Their approach was expounded in various articles, particularly by Janák, who developed the principles of architectural Cubism; based on the thesis of Cubism in painting and sculpture, that art should create a distinctive, parallel picture of reality, it attempted to dematerialize a building's mass by the three-dimensional surface sculpturing of the façade with abstract, prismatic forms.

The principal buildings to embody these ideas include Gočár's sanatorium (1911–12) at Bohdaneč, and Black Madonna House (1911–12), Prague; three houses by Chochol (1911–13) beneath Vyšehrad in Prague; and Janák's rebuilding (1913) of an existing Baroque house in Pelhřimov with Cubist details. Later works include three teachers' houses (1917–19), Prague, by Otakar Novotný. Jiří

Kroha also acknowledged Cubism in some of his studies but soon moved away to develop an expression of his own. Architectural Cubism, unmatched in any other country, was a significant step in the evolution of Czech architecture, contributing to the demise of 19th-century academicism and historicism. At the same time it amounted to a break with other developments of the early 20th century, including the Viennese Secession as well as rationalism. However, while it brought architectural form to artistic abstraction, dynamizing mass and elaborating the spatial plasticity of façades and their detail, it had no profound effect on the interior planning of buildings or on their structure.

The principles of Czech Cubism found more prolific expression in the applied arts and in furniture design. In 1912 Gočár and Janák set up the Prague Art Workshops (PUD) for the design of arts, crafts and furniture; it was intended to concentrate on the furnishing of the complete house, with the contention that furniture should not only meet the demands of utility and good taste but also be serious art of substantial content. Distinctive Cubist furniture designs were produced by several architects including Janák. They also designed lighting, tableware, vases and other products. The style gained international recognition with the dining-room interior presented by Gočár and František Kysela (1881–1941) at the Deutsche Werkbundausstellung (1914) in Cologne.

After World War I and the formation of the Czechoslovak Republic (1918), the Cubist style underwent a major change. The pyramid was replaced by the cylinder and sphere in the rich plastic decorativeness of Rondocubism, which laid claim to become a national style in architecture. It is associated with the same group of names: Gočár, for example, used the circle as a generating motif for the Legiobanka (1921), Prague, with façade sculpture by Otto Gutfreund; Janák employed the style for the crematorium (1921) in Pardubice and the building of the Riunione Adriatica di Sicurtà (1922–4), Prague; and Novotný built a block of flats (1921) in Prague. This attempt to create a national style, together with the concept of architecture as primarily an art

form, culminated in 1925 with the interiors of the Czechoslovak Pavilion at the Exposition Internationale des Arts Décoratifs et Industriels Modernes (1925), Paris, designed by Janák and Kysela; the Pavilion was designed by Gočár. It then yielded to the more vigorously evolving Functionalism of avant-garde Czechoslovak architecture in the 1920s and 1930s, supported by Devětsil, the group centred on the figure of Karel Teige that was formed in 1920.

Bibliography

P. Janák: 'Hranol a pyramida' [The prism and the pyramid], *Umělecký Měsíčník*, 1 (1911)

I. Margolius: *Cubism in Architecture and the Applied Arts: Bohemia and France, 1910–1914* (London, 1979)

Filla, Gutfreund, Kupka och tjeckisk kubism, 1907–1927 (exh. cat., Malmö, Ksthall, 1982)

V. Šlapeta: 'Cubismo Bohemio', *Quad. Arquit. & Urb.*, 169–70 (1986), pp. 48–55

Český kubismus, 1909–1925 (exh. cat., eds J. Švestka and T. Vlček; Brno, Morav. Gal.; Düsseldorf, Kstver.; Prague, N.G.; 1991–2)

A. von Vegesack, ed.: *Czech Cubism: Architecture, Furniture and Decorative Arts, 1910–1925* (London, 1992)

Prague, 1891–1941: Architecture and Design (exh. cat., Edinburgh, City A. Cent., 1994)

RADOMÍRA SEDLÁKOVÁ

Dachau colony

Colony of German artists formed *c.* 1807 and active until 1946. It was based in the Bavarian city situated on the River Amper, 17 km north-west of Munich. Dachau is an ancient market town that dates back to *c.* AD 800 and that was awarded its charter in 1391. Its historic buildings include a ruined 16th-century castle, built for Albert V, Duke of Bavaria, by Heinrich Schöttl and Wilhelm Egckl (completed 1570–73), and a 17th-century town hall and parish church (1624–5) designed by Hans Krumpper. The artists' colony flourished there particularly from 1890 to 1914. Over the years *c.* 1000 artists, German and international, used the colony, which did not represent any particular school, although most of the artists were Romantic, Naturalist or Impressionist landscape

painters. The best-known participants were Max Liebermann and Lovis Corinth. Characteristic landscape works of the colony were *View from the Schlossberg towards the Munich Road* (*c.* 1860) by Eduard Schleich (1812–74), *Theresienwiese* (1882) by Adolf Lier (1826–86) and Corinth's *Wood near Dachau* (1893; all Dachau, Gemäldegal.). The Künstlervereinigung of Dachau was founded in 1927, but Hitler's rise to power in 1933 brought pressure on it to conform with state dictates on art. From 1933 to 1945 the town contained the notorious Nazi concentration camp, whose inmates are commemorated by a memorial and museum. After Germany's defeat in 1945 the Künstlervereinigung was dismantled, but it was re-established in 1947. In 1985 the Dachauer Gemäldegalerie reopened in celebration of the city's art-historical heritage.

Bibliography

C. Thiemann: *Erinnerungen eines Dachauer Malers* (Dachau, 1966)

G. Wietek: *Deutsche Künstlerkolonien und Künstlerorte* (Munich, 1976)

H. G. Richardi: *Dachau: Führer durch die Altstadt, die Künstlerkolonie und die KZ-Gedenkstätte* (Passau, 1979)

O. Thiemann-Stoedtner: *Dachauer Maler: Der Künstlerort Dachau von 1801–1946* (Dachau, 1981)

Kunst und Künstler in Dachau und im Amperland, 1890–1930 (exh. cat., Haimhausen, near Dachau, Schloss Haimhausen, 1981)

L. J. Reitmeier, ed.: *Dachau Ansichten und Zeugnisse aus zwölf Jahrhunderten* (Dachau, 1982)

H. Heres: *Dachauer Gemäldegalerie* (Dachau, 1985)

JAMES G. TODD JR

Dada

Artistic and literary movement launched in Zurich in 1916 but shared by independent groups in New York, Berlin, Paris and elsewhere. The Dadaists channelled their revulsion at World War I into an indictment of the nationalist and materialist values that had brought it about. They were united not by a common style but by a rejection of conventions in art and thought, seeking through their

unorthodox techniques, performances and provocations to shock society into self-awareness. The name Dada itself was typical of the movement's anti-rationalism. Various members of the Zurich group are credited with the invention of the name; according to one account it was selected by the insertion of a knife into a dictionary, and was retained for its multilingual, childish and nonsensical connotations. The Zurich group was formed around the poets Hugo Ball, Emmy Hennings, Tristan Tzara and Richard Huelsenbeck, and the painters Hans Arp, Marcel Janco and Hans Richter. The term was subsequently adopted in New York by the group that had formed around Marcel Duchamp, Francis Picabia, Marius de Zayas (1880–1961) and Man Ray. The largest of several German groups was formed in Berlin by Huelsenbeck with John Heartfield, Raoul Hausmann, Hannah Höch and George Grosz. As well as important centres elsewhere (Barcelona, Cologne and Hannover), a prominent post-war Parisian group was promoted by Tzara, Picabia and André Breton. This disintegrated acrimoniously in 1922–3, although further Dada activities continued among those unwilling to join Surrealism in 1924.

1. Early History: Zurich, 1914–18

Zurich Dada's roots lay in the pre-war international avant-garde. Kandinsky's abstraction and theoretical writings, together with Cubism and the development of collage, liberated Dada from the dual constrictions of reality and convention. Similarly the writings of such German Expressionists as Christian Morgenstern combined with the influence of French poets, thereby allowing the Dadaists to break the direct link between words and meaning. Disgust at the war's outbreak was immediately voiced in Zurich at Walter Serner and Konrad Milo's Cabaret Pantagruel (from August 1914), and was reinforced by the arrival of intellectual refugees during 1915. Serner collaborated with the painter Christian Schad on the periodical Sirius (1915–16), but the latter's move to Geneva restricted their participation in the group developing around Ball and Hennings, who founded the Cabaret Voltaire (5 February 1916),

establishing performance as a central Dada medium. Inviting participants, they met Arp and the Dutch painters Otto van Rees and Adya van Rees-Dutilh (1876–1959), and the painter, sculptor and dancer Sophie Taeuber-Arp. They were joined by the Romanians Janco and Tzara and the Germans Huelsenbeck and Richter. Other painters contributed, including Walter Helbig (1878–1968) and Oskar Lüthy (1885–1945), as well as the Austrian Max Oppenheimer (MOPP), the Romanian Arthur Segal and the Ukrainian Marcel Slodki (1892–1943). This internationalism was reflected in the cabaret's French and Russian evenings, at which the artists exhibited. Following the example of Futurist provocations Tzara, Huelsenbeck and Janco performed L'Amiral cherche une maison à louer, simultaneously reading texts in three different languages. 'African' music and poetry were also performed at soirées nègres, emphasizing a spontaneity of expression absent from Western art. This attracted Rudolph Laban (1879–1958), who initiated African performances for which Janco made Cubist cardboard masks (e.g. 1919; Paris, Mus. A. Mod. Ville Paris).

The term 'Dada' first appeared in the periodical Cabaret Voltaire (June 1916), where Ball defined their activities as proving 'that there are people of independent minds—beyond war and nationalism—who live for different ideals'. The new name signalled the more combative spirit of the first Dada Soirée (Zunfthaus zur Waag, 14 July), where Ball performed astonishing Lautegedichte (sound poems) composed from invented words, which exposed an emotive power distinct from everyday language. Tzara read his irreverent Manifeste de M. Antipyrine, which acknowledged that 'Dada remains within the framework of European weaknesses, it's still shit, but from now on we want to shit in different colours'. Such shock tactics increasingly came to characterize their public position. During the summer sound poems by Huelsenbeck were published (Phantastische Gebete, Zurich, 1916). They were illustrated with abstract woodcuts by Arp, which showed a spontaneity centred upon chance as a governing principle. Rejecting a determining role, Arp experimented with abstract collages

'made according to the laws of chance', in which papers were glued where they fell, reflecting a reverence for forces outside rationalism (see also AUTOMATISM).

Despite Huelsenbeck's return to Berlin, the group's activities developed in March 1917 when the Galerie Corray became the Galerie Dada, and the cabaret was replaced by the launching of a movement. Work by Campendonk, Klee, Kandinsky and others from the Sturm-Galerie in Berlin was exhibited in the gallery and accompanied by lectures. The soirées continued, including Ball's recital of *Gadji beri bimba* while dressed in cardboard cylinders designed by Janco. Music by Hans Heusser, Stravinsky and Arnold Schoenberg accompanied a later exhibition (May) combining de Chirico, August Macke, Enrico Prampolini, Fritz Baumann (1886–1942) and the Dadaists' works in unusual materials: Janco made plaster reliefs (e.g. *The Lock*, 1918; Tel Aviv, Mus. A.); Taeuber-Arp and Arp collaborated on geometric tapestries, for example *Pathetic Symmetry* (1916–17; Paris, Pompidou); and Arp made painted wooden reliefs, such as *Entombment of the Birds and Butterflies (Head of Tzara)* (1916–17; Zurich, Ksthaus), which introduced BIOMORPHISM into his work. At the same time Ball's withdrawal confirmed Tzara's leadership. He launched the periodical *Dada*, the first two numbers of which (July and December) reflected links with DER STURM in Berlin, Guillaume Apollinaire in Paris, Marinetti in Milan (see FUTURISM) and the PITTURA METAFISICA group in Ferrara. Through the latter he contributed to the Bolognese periodical *La Brigata*, inviting the editor, Francesco Meriano, to launch Italian Dada in summer 1917. However, Futurism's dominance and wider nationalism in Italy caused Tzara to break these links.

During 1917 and 1918 Serner and Schad collaborated more closely, the latter revealing a parallel concern with chance in his 'schadographs', unforeseen compositions achieved, like photograms, by laying objects on photographic paper and exposing them to light (e.g. 1918; Zurich, Ksthaus). By contrast, Richter's *Visionary Portraits* were superseded by an ordered abstraction close to that of Swedish artist Viking Eggeling (e.g.

Composition, c. 1916; Basle, Kstmus.) and resulted in a lengthy collaboration. Janco established an association of abstract artists, the NEUE LEBEN (April 1918), with Arp, Taeuber, Lüthy, Fritz Baumann, Augusto Giacometti, Otto Morach (1887–1973) and other Basle painters, while Tzara's explosive *Manifeste dada 1918* proclaimed Dada as 'the roar of contorted pains, the interweaving of contraries and of all contradictions, freaks and irrelevancies: LIFE.' By the time this appeared in *Dada 3* (December 1918), Zurich Dada was entering a more nihilistic stage resulting from contact with Picabia, who had arrived from New York, via Barcelona and Paris, earlier in the year.

2. New York, 1915–21

The works made by Picabia and Duchamp in New York, which would later be acknowledged as Dada, differed from Zurich Dada by being less concerned with the war but more aggressive towards the art establishment. Picabia frequented the circle around Alfred Stieglitz's periodical *Camera Work*, including Edward J. Steichen, Marsden Hartley, Arthur Dove, Charles Sheeler and others, and exhibited at Stieglitz's Photo-Secession gallery (see 291). There he met the Mexican Marius de Zayas, who, after contributing to Apollinaire's *Les Soirées de Paris*, returned to New York to help launch the innovative periodical *291* (March 1915), named after the gallery. While Picabia collaborated on *291*, Duchamp, who had also arrived in New York in June 1915, was introduced by the collector Walter Arensberg into a literary circle including William Carlos Williams, Margaret Anderson, Wallace Stevens, Alfred Kreymborg and Elsa Freytag-Loringhoven, the painters Joseph Stella, Morton Livingston Schamberg and Man Ray. Other exiles followed, notably Jean Crotti, Albert Gleizes and the composer Edgar Varèse; they gravitated around the Modern Gallery, which de Zayas opened in October. News of their work reached Tzara, but, although he contacted de Zayas in 1916, the parallels between them and the term Dada remained unnoticed.

In Picabia's mechanomorphic works, such as *Very Rare Picture on the Earth* (1915; Venice, Guggenheim), and in Duchamp's studies on glass,

images were adapted from technical diagrams. These commented upon the human condition and even assumed erotic overtones, sometimes implied in their titles, analogies taken up by Crotti, Man Ray and Schamberg (e.g. Man Ray's *Rope Dancer Accompanies Herself with her Shadows*, 1916; New York, MOMA). However, Duchamp went further in renouncing originality when he exhibited ready-mades at the Bourgeois Gallery (April 1916). These industrially produced objects constituted a deliberately anti-art gesture, raising serious questions about the accepted precepts of art (see col. pl. XVI). Ready-mades had been conceived in Paris, but Duchamp coined the term in New York and perfected the predetermined process of choice that removed all aesthetic judgement. While this encouraged such ironically titled objects as Schamberg and Freytag-Loringhoven's *God* (plumbing trap and mitre box, *c.* 1917; Philadelphia, PA, Mus. A.) and Man Ray's photograph of a mechanical egg-beater, *Man* (1918; Paris, Pompidou), the ready-made provoked the group's major controversy. Duchamp tested the juryless system of the Society of Independent Artists' exhibition held at Grand Central Palace, New York, in April 1917 (*see* SOCIETY OF INDEPENDENT ARTISTS) by submitting a ready-made: an upturned urinal, entitled *Fountain* and signed 'R. Mutt' (1917, untraced; editioned replica 1964; Ottawa, N.G.). He then publicly unmasked the fact of its concealment by the Society and defended 'Mr Mutt's' freedom of choice with a photograph of the work in *Blind Man* (no. 2, May 1917) supported by editorials written in its defence. In an additional provocation, he and Picabia (newly returned from Barcelona) invited Arthur Cravan (1887–1918), editor and sole author of the wittily insulting Parisian periodical *Maintenant* (1912–14), to lecture at the exhibition, resulting in a drunken strip-tease.

These events, and such periodicals as the single issue *Rongwrong* and Picabia's *391* (launched in 1916 with obvious reference to *291*, on which he had worked before), mocked establishment and avant-garde alike. They also coincided with the USA's entry into the war, which encouraged Picabia's embarkation for Europe in September

1917 and, a year later, Duchamp's move to Buenos Aires. Man Ray continued the provocation with *T. N. T.* (March 1919, edited with the anarchists Adolf Wolff and Adon Lacroix) and a replacement of artistic styles with mechanical techniques in his photographs and 'aerographs'. Meanwhile the Modern Gallery assumed de Zayas's name in 1919, and his promotion of radical art may have influenced the Estridentismo movement, launched in Mexico City in 1921. Duchamp's return to New York in 1920 brought renewed collaboration with Man Ray; they acted as advisers (and president and secretary respectively) to Katherine S. Dreier's Société Anonyme collection of international modern art founded in the same year. Man Ray and Duchamp's single issue of *New York Dada* (April 1921), which included articles by Tzara and Freytag-Loringhoven, confirmed a similarity of purpose, and both set off to participate in Paris Dada.

3. Barcelona and developments in Zurich, 1916–20

Avant-garde circles in Barcelona were aware of pre-war Parisian developments. In 1912 they had seen the first Cubist exhibition held outside France (Galería Dalmau), and after 1914 Futurism had found echoes in the work of various artists. Parisians escaping to Barcelona from the war combined these approaches in work subsequently associated with Dada. They included Marie Laurencin, Otto van Watjen, Serge Charchoune and Hélène Grunhof; Albert Gleizes and the Delaunays also visited the city, and Cravan was there before moving to New York. Although he was also a boxer, Cravan's bout against the World Champion, Jack Johnson, in Madrid (April 1916) was widely interpreted as a Dadaist gesture. The focus of activity was the gallery of Josep Dalmau (1867–1937), where notable shows of Charchoune, Grunhof and Gleizes were held in 1916. The group was galvanized by Picabia, who arrived in August. The gallery launched his periodical *391* in 1917, carrying contributions from others but dominated by Picabia's drawings and obscure references. It recalled activities in New York, giving them wider currency in Europe, and it went with him when he re-crossed the Atlantic in March 1917. In

October his poems *Cinquante-deux miroirs* were published, and the impact of these sudden activities was extended through such periodicals as Josep Junoy's *Troços* (1916-18) and Salvat Papasseit's *Un enemic del poble* (1917-19) and *Arc-Voltaic* (1918).

Picabia established contact with Tzara while in Lucerne during 1918. He exhibited works alongside those of Arp and Janco in January 1919 (*Neue Leben*; Zurich, Ksthaus) before visiting Zurich in February. There his nihilism and inventiveness won immediate acclaim; he and Tzara wrote an 'automatic' text for *391* (no. 8, February 1919), and they collaborated on *Dada 4-5* (*Anthologie Dada*) (May 1919), which linked Zurich Dada to the New York and Barcelona groups, and orientated Tzara towards Paris. An eighth Dada Soirée (Saal zur Kaufleuten, April 1919), following Picabia's departure, included Tzara's simultanist poem for 20 voices (*Le Fièvre du mâle*) and Arp's poem *Wolkenpumpe*. At the same time the imminent post-war dispersal was counterbalanced by the formation of the Groupe des Artistes Radicaux, including Arp, Baumann, Eggeling, Janco and Richter. Arp then left for Cologne, and Janco for Bucharest. Tzara shared the editorship of *Der Zeltweg* with Serner and Otto Flake in November, but his departure in January 1920 signalled the end of Zurich Dada. The short-lived Geneva Dada, launched in December 1919 by Serner and Schad, held a final Grand Dada Ball in March 1920.

A postscript to Zurich Dada was added in summer 1920. Tzara returned to Bucharest where he was reunited with the poet Ion Vinea and with Janco, who had established the periodical *Contimporanul* (1920-30) supporting non-objective art. In Italy, Tzara also visited the Mantuan Dadaists Gino Cantarelli (1899-1950) and Aldo Fiozzi, editors of *Procellaria* (1917 and 1919) and *Bleu* (1920). They introduced him to the writer and abstract painter Julius Evola (1898-1974), who immediately became Dada's most provocative Italian agent. With encouragement from Schad, who had moved to Rome, and from Serner, Evola launched a Rome Dada season in April 1921, with an exhibition (including Cantarelli and Fiozzi) at the Galleria d'Arte Bragaglia and performances at the Grotte dell'Augusteo cabaret. His readings of his own writings and of Tzara's *Manifeste dada 1918*, and his declaration of the death of Futurism, caused uproar. However, sustained Futurist hostility and his isolation following Schad's move to realism provoked a personal crisis, and Evola suddenly abandoned Dada for philosophy.

4. Berlin Dada, 1917–22

More so than in other cities, Berlin Dada was circumscribed by political events, as was already evident in Huelsenbeck's 'Der neue Mensch' (*Neue Jugend*, 23 May 1917), which marked his return to the collapsing city. At the artistic Alte Café des Westerns, he met political writers and artists for whom Berlin Dada constituted an extension of their opposition to the status quo; they included Franz Jung (1888-1963), Gerhard Preiss, Heartfield and his brother Wieland Hertzfelde (1896-1988), and Grosz. They were joined by Walter Mehring, Raoul Hausmann, Hannah Höch and the self-publicist Johannes Baader (1875-1955). Their disgust with the contemporary cultural situation was exposed in February 1918 in Huelsenbeck's lecture on Dada at the Galerie I. B. Neumann, which initiated the Club Dada (12 April). There he called for an art 'which in its conscious content presents the thousandfold problems of the day, the art which has been visibly shattered by the explosions of the last week, which is forever trying to collect its limbs after yesterday's crash' (*Dada Manifesto*, Berlin, 1918). While reiterating his moral concerns, he rejected the ideals of abstraction and of Expressionism, which was rapidly passing into the establishment. Hausmann, who became his close collaborator, responded with experiments across different media. Most notable were his phonetic poems (e.g. 'Selenautomobile', Dada matinée, 6 June), which, by the pronunciation of single letters, extended the Zurich sound poems. The form's abstraction was most evident in the printed 'scores', dubbed 'optophonetic poems', in which the force of each letter was indicated by its size. This was closely related to the mixed typography and overprinting of slogans that characterized Berlin Dada publications, such as *Club Dada* (1918).

The military defeat and the abdication of Emperor William II in 1918 brought the political crisis to a head and was followed by the brutal suppression of the communist-inspired Spartakist uprising (January 1919) by the Socialist Weimar government. The Dadaists responded in two publications in February: Baader's manifesto *Dadaisten gegen Weimar*, and *Jedermann sein eigner Fussball*, published by Hertzfelde's Malik Verlag. The former was simply anarchic, proclaiming Baader as President of the Earth, while the latter urged the renewal of the revolution and was immediately confiscated. Heartfield's cover of *Jedermann* ... was one of the earliest uses of the quintessential Berlin Dada medium of Photomontage. The collaging of photographs from the mass media allowed the artists to dissect reality through unexpected combinations with other images or with words, without retreating into realism. Heartfield and Grosz made photomontage a satirical weapon, throwing back the images issued by the establishment media, while Höch and Hausmann added comments on everyday culture (for example Hausmann's *Art Critic*, 1920; London, Tate; see fig. 16). Assemblages of found objects, notably Hausmann's *Mechanical Head: Spirit of our Age* (wooden hatmaker's dummy with objects, 1919; Paris, Pompidou), also employed this technique. In both works the use of immediate and ephemeral materials ensured against commercial value.

The critical nature of this work meant that few German Dada periodicals survived confiscation, the exception being Hausmann's *Der Dada* (1919–20), which included contributions from Picabia in its third number (April 1920, edited with Heartfield and Grosz). This reflected the heightened international activity of 1920. In February, Baader, Huelsenbeck and Hausmann undertook an increasingly riotous performance tour to Leipzig, Teplitz-Schönau, Prague and Karlsbad. In May, at the Erste Internationale Dada-Messe, paintings and drawings were combined with Dada posters, photomontages and assemblages, including a uniformed dummy with a pig's head, for which Grosz and Heartfield were fined for ridiculing the military. The show was

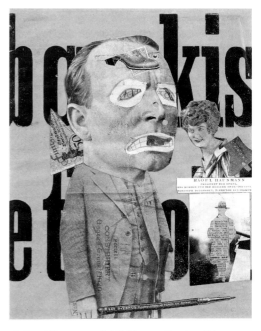

16. Raoul Hausmann: *Art Critic*, 1920 (London, Tate Gallery)

accompanied by the *Dada Almanach* (Berlin, 1920), edited by Huelsenbeck, which included contributions from Zurich, Barcelona and Paris Dada. That it included Tzara is remarkable, as Huelsenbeck bitterly attacked his ambitions in *En avant Dada: Eine Geschichte des Dadaismus* (Hannover, 1920). These events marked Berlin Dada's culmination, as personal conflicts led to its fragmentation shortly after.

The celebration of Vladimir Tatlin in such works as *Tatlin at Home* (photomontage, 1920; Stockholm, Mod. Mus.) by Hausmann indicated the Dadaists' continuing aspiration for a revolutionary art, which developed into an exchange with international Constructivism in the 1920s. Richter and Eggeling, who arrived in 1918 but did not participate in Berlin Dada, completed the abstract film *Rhythmus 21* in 1921, the title indicating musical structures. In October Hausmann and Arp wrote 'A Call for an Elementarist Art' (*De Stijl*, iv/10, 1922) with the Suprematists Jean Pougny and László Moholy-Nagy, identifying an international

art 'built up of its own elements alone'. These issues exercised the Kongress Internationaler Fortschrittlicher Künstler in Düsseldorf in May 1922, from which Richter, Theo van Doesburg and El Lissitzky split to form the International Faction of Constructivists (see CONSTRUCTIVISM, §2). They became the nucleus for the Konstructivisten und Dadaisten Kongress in Weimar (September), which was attended by Tzara, Arp and Kurt Schwitters, and which inspired Richter's periodical G (1923–4). In these exchanges the work of Arp, Richter, Hausmann and Schwitters maintained an unexpected balance between Dadaist chance and irony and Constructivist idealism.

5. Associated developments: Merz, Constructivism and MA, 1919–25

Huelsenbeck prevented Schwitters's admission to Berlin Dada because of his lack of political commitment, despite the considerable success of An Anna Blume, a chance poem published in Der Sturm in 1919. Schwitters had begun to produce such works and abstract collages (Merzbilder) soon after coming into contact with Hausmann and Höch in 1918. His response to Huelsenbeck's snub was to found his one-man 'movement', Merz, later in 1919, with its eponymous periodical (1923–32). His works relied upon chance finds of everyday materials, especially waste paper, with which he established a formal harmony, for example the Kots Picture (1920). Schwitters remained close to several Dadaists, performing with Höch and Hausmann in Prague in 1921, where the latter's phonetic poem fmsbw inspired his own Ursonate (1924–5; published in Merz, 24, 1932). He invited Arp to collaborate on Merz and arranged Tzara's lecture tour on Dada (Hannover, Jena and Weimar) after the Weimar Congress (1922). He also collaborated with Van Doesburg, who, as 'I. K. Bonset', spread a mechanistic Dada through Holland via his periodical Mécano (1922–3) and a tour undertaken with Schwitters. This coincided with the creation of Schwitters's Merzbau (begun 1923; reconstructed 1980–83; Hannover, Sprengel Mus.), a haphazard construction of ephemeral material which would grow to fill his house.

The cross-fertilization between Dada and Constructivism was also evident in the former Austria-Hungary. Schwitters lectured in Prague throughout the 1920s, although knowledge of Cubism and Russian art meant that local interest was muted, with the exception of Hugo Dux and Artus Černik (a member of Karel Teige's Devětsil group). However, the first tours did inspire the visiting Yugoslav writers Virgil Poljanski and Dragan Aleksić, who were associated with the Zagreb periodical Zenit (1921–6), edited by Poljanski's brother Ljubomir Micić. Aleksić established contact with Tzara and Schwitters, organizing Dada soirées in Osijek and Subotica (1922), and Poljanski published a number of single-issue periodicals, such as Dada-Jok (Zagreb, 1922). Although reluctant to sacrifice Zenit's independence, Micić blended Dada provocations with his admiration for Russian revolutionary culture and published the remarkable collage-paintings (known as pafamas, from Papierfarbenmalerei) of Jo Klek (pseudonym of Joseph Seissel).

A more important disseminator of Dada in Eastern Europe was the periodical MA (see MA GROUP) edited by Lajos Kassák, which carried articles by Dadaists. Kassák's collages and those of Moholy-Nagy (e.g. F dans les champs, 1920; Bremen, Ksthandel Wolfgang Werner) reflected this sympathy, and Kassák arranged for the translation into Hungarian of such texts as Tzara's Coeur à gaz (1922). There were more distant echoes of Dada. In Moscow the Nichegoki ('nothingist') group formed in 1919–21 around the writers Sergey Sadikov and Suzanna Mar, Yelena Nikolayeva and the artist Boris Zemenkov; and in Tiflis (now Tbilisi, Georgia) Il'ya Zdanevich and Simon Chikovani formed the 41° and H2SO4 groups in the early 1920s. Although claiming some allegiance to Dada, they derived essentially from Russian Futurism.

6. Cologne Dada, 1919–22

Cologne Dada secured an autonomous and pivotal position between activities in Zurich, Berlin and Paris. Max Ernst and Johannes Theodor Baargeld responded to the artificial calm maintained by the British occupying forces in a series of

anti-authoritarian publications, beginning with *Der Ventilator* (1918), which attracted more politically motivated artists, including Franz Seiwert (1894–1933), Anton Räderscheidt, Marta Hegemann (1894–1970), Heinrich Hoerle (1895–1935) and Angelika Hoerle (1884–1923). Rejecting Rhineland Expressionism, they were influenced by Klee's graphic style and de Chirico's sense of alienation. Ernst, Baargeld and Otto Freundlich were invited to participate in the Gesellschaft der Künst at the Kunstverein in November 1919, but the insubstantial collages and prints in their exhibition, accompanied by *Bulletin D*, provoked controversy. Arp arrived shortly after the exhibition, and with Ernst and Baargeld formed the Dada Weststupidia 3 or W/3 (named after their address), making *Fatagaga* (from 'Fabrication de tableaux garantis gazométriques'), collaborative collages whose images and titles mocked rational expectations (e.g. Ernst and Arp's photomontage *Switzerland, Birth-place of Dada or Physiomythological Flood-Picture*, 1920; Hannover, Sprengel Mus.). The Hoerles and Seiwert withdrew at the last moment, claiming that Dada was 'bourgeois art marketing', and moved towards forming the STUPID GROUP.

In April 1920 their periodical *Die Schammade* featured Arp, Huelsenbeck, Breton and Louis Aragon from Paris and was followed by the audacious exhibition *Dada Vorfrühling* (April); expelled from the Arbeitsgemeinschaft Bildender Künstler, Baargeld and Ernst rented space in the Winter brewery, access to which passed through its lavatories! An astonishing collection of exhibits, including a sculpture by Ernst that the public were invited to destroy (axe provided), brought uproar and police closure, as well as invitations to exhibit at the Berlin Dada Fair. However, Arp's departure for Berlin and Paris and the proletarian orientation of the Stupid group drained Cologne Dada of further group activity. Ernst continued to experiment with photomontages and with painting over engravings (e.g. *Perturbation, My Sister*, 1921; Berne, Kstmus.), the transformatory power of which proved astonishing when exhibited by the Paris Dadaists in May 1921. In the autumn his holiday with Arp and Tzara in

the Tyrol produced the joint publication *Dada Intirol, Augrandair*. There he met Breton and subsequently began a close collaboration with Paul Eluard, supplying collages for the poet's *Répétitions* and collaborating on *Les Malheurs des immortels* (both Paris, 1922). Before moving to Paris in late 1922, Ernst also began converting his imagery of unexpected juxtapositions into oil paintings (e.g. the *Elephant Celebes*, c. 1921), which would be identified by Breton as one of the first Surrealist paintings.

7. Final phase: Paris, 1919–24

Picabia was the initial focus of activity as Dada arrived in Paris by different routes. Its controversial début was marked by his blistering attack in *391* on the first post-war Salon d'Automne (1919) for concealing his mechanomorphic *Child Carburettor* (1919; New York, Guggenheim) and related works by Georges Ribemont-Dessaignes. Among his allies were the composer Erik Satie and Duchamp (who was visiting in late 1919), as well as the latter's sister Suzanne Duchamp and her husband Jean Crotti, who joined him in submitting related works to the Salon des Indépendants in January 1920. At the same time, a group of poets had formed separately around Breton, Aragon and Philippe Soupault's periodical *Littérature* (1919–24), including Eluard, editor of *Proverbe*, Théodore Fraenkel, Benjamin Péret, Jacques Rigaut, Céline Arnauld and Paul Dermée, editor of *Z*. They drew upon the French tradition, from Rimbaud to Alfred Jarry, of a poetic revolt against all norms of contemporary art and life. This was combined with their experience of the war to form a disdainful independence, embodied by Jacques Vaché, whose ultimate gesture was to commit suicide (January 1919). They were aware of *Dada* through Tzara's contacts with Apollinaire and Pierre Albert-Birot's *SIC* and, in 1919, exchanged contributions to periodicals with him. However, *Littérature* remained predominantly literary, notable for Breton and Soupault's experiments with automatic writing, *Les Champs magnétiques* (1919).

Tzara was the catalyst for cooperation between Picabia and Breton, as they marked his arrival

with the first Parisian soirée, the Premier Vendredi de Littérature (23 January 1920, Palais des Fêtes). The accompanying exhibition of works by de Chirico, Jacques Lipchitz, Léger and Gris reflected the avant-garde's confused acceptance of Dada, until their disruption brought expulsion from the Salon de la Section d'Or. Further Zurich-style soirées were publicized through *Dada 6 (Bulletin Dada)* (February), with its list of the movement's 76 presidents, *Dada 7 (Dadaphone)* (March) and *391*, no. 12, which carried Duchamp's scandalously moustachioed Mona Lisa, *L.H.O.O.Q.* (Paris, priv. col.) on the cover. The season culminated with Picabia's exhibition at Au Sans Pareil (April) and the Festival Dada (Salle Gaveau, 26 May). These events encouraged the participation of Charchoune and Vicente Huidobro, who had encountered Dada in Spain, Il'ya Zdanevich (Iliazd; 1894–1975) and the Belgian Dadaist Clement Pansaers, as well as the fashionable figures around Jean Cocteau, including Raymond Radigaet and the composers Darius Milhaud and Georges Auric.

In 1921 the group published the anti-nationalist manifesto *Dada soulève tout* (January), but their provocations no longer surprised the public. The Grande Saison Dada therefore introduced anti-cultural excursions and mock trials beginning with that of the nationalist writer Maurice Barrès (13 May) at the Salle des Sociétés Savantes. This event exposed divisions between the major participants, as Breton attempted to instil a greater sense of purpose into Dada in the face of Tzara's mockery of such authoritarianism. Ernst's exhibition of collages (Au Sans Pareil, May) provided a focus of unity, with Breton's preface praising the power of his juxtapositions, but Tzara's ambitious Salon Dada Exposition Internationale (Galerie Montaigne, June) was attacked by Picabia in *Pilhaou-Thibaou* (special issue of *391*, July). At the Salon d'Automne, Crotti and Suzanne Duchamp launched Tabu, their mystical offshoot of Dada, while Picabia again caused controversy with the submission of *Cacodylic Eye* (1921; Paris, Pompidou), a canvas simply bearing a profusion of greetings and signatures from friends. This, together with Arp's move towards sculpture and

Duchamp's construction of optical machines, confirmed the divergence of all Dadaists from any uniting artistic style, an attitude that would pass into Surrealism to a certain degree. The most notable arrival was Man Ray, whose paintings and provocative objects were exhibited in December 1921 (Librairie Six), and whose photographic experiments led to camera-less rayographs, published as *Les Champs délicieux* (Paris, 1922), which were produced by the same chance technique as the schadographs. He took this further, by using the same technique for a film, *Retour à la raison* (1923), which was greeted with public consternation.

By the time of Ernst's arrival in 1922, Dada was disintegrating. Breton had been isolated by his project for a 'Congrès de Paris' to discuss the state of contemporary culture, as Tzara and others refused to participate. However, Picabia rallied to Breton's cause in *La Pomme de pins* (February), just as the new series of *Littérature* moved away from Dada. Although Tzara retaliated, it was evident that self-destruction would result, and his lecture in Weimar in May was called 'Conférence sur la fin de Dada'. In 1923 his *Soirée de la coeur à gaz* (Théâtre Michel, 6–7 July) included music by Satie and readings by Iliazd, René Crevel and Pierre de Massot in costumes designed by Sonia Delaunay; Breton, Aragon, Eluard and Péret stormed the stage, bringing Paris Dada to a destructive end. In launching SURREALISM in 1924 Breton claimed works made under Dada, such as *Les Champs magnétiques* and Ernst's collages; not everything passed into the new movement, however. Tzara published *Sept manifestes Dada* in 1924, while Picabia made the anarchic film *Entr'acte* (November) with Satie and René Clair. Of the major artists, Ernst, Man Ray and Arp were, at least nominally, committed to the new movement, but all continued an exploration independent of Breton's orthodoxy, while others, such as Duchamp, Picabia and Ribemont-Dessaignes, preferred to remain outside this structure. This embodied the determination to undermine established values that had characterized all contributions to Dada, both in Paris and elsewhere, and it was this that would be echoed in other art

movements of the mid- to late 20th century, in particular in international Neo-Dada, Pop art and Nouveau Réalisme in the 1950s and 1960s.

Writings

T. Tzara: *La Première Aventure céleste de M. Antipyrine* (Zurich, 1916)

R. Huelsenbeck: *Phantastische Gebete* (Zurich, 1916)

A. Breton and P. Soupault: *Les Champs magnétiques* (Paris, 1919; Eng. trans., London, 1985)

R. Huelsenbeck: *En avant Dada: Eine Geschichte des Dadaismus* (Hannover, 1920)

R. Huelsenbeck, ed.: *Dada Almanach* (Berlin, 1920/R New York, 1966; Fr. trans., Paris, 1980; Eng. trans., London, 1993)

P. Eluard: *Répétitions* (Paris, 1922)

—: *Les Malheurs des immortels* (Paris, 1922)

T. Tzara: *Sept manifestes Dada* (Paris, 1924); rev. as *Sept manifestes Dada, lampisteries* (Paris, 1963; Eng. trans., London, 1977)

H. Ball: *Die Flucht aus der Zeit* (Munich, 1927)

R. Hausmann: *Courier Dada* (Paris, 1958)

G. Ribemont-Dessaignes: *Déjà jadis: Ou du mouvement Dada à l'espace abstrait* (Paris, 1958)

W. Mehring: *Berlin Dada* (Zurich, 1959)

H. Richter: *Dada—Kunst und Antikunst: Der Beitrag Dadas zur Kunst des 20. Jahrhunderts* (Cologne, 1964; Eng. trans., London, 1965/R 1978)

J. Kleinschmidt, ed.: *Memoirs of a Dada Drummer* (New York, 1974/R Berkeley and Oxford, 1974, 2/1991)

Bibliography

periodicals

Facsimiles of Dada periodicals have been collected in *Doc. & Per. Dada*, ed. A. Schwarz (Milan, 1970) and *Dada, Zurich, Paris, 1916–22*, ed. M. Giroud (Paris, 1981)

Soirées Paris (Paris, 1912–14; facs., Geneva, 1971)

Maintenant (Paris, 1912–15; facs., Paris, 1977)

291 (New York, 1915–16; facs., New York, 1972)

Sirius (Zurich, 1915–16)

Cabaret Voltaire (Zurich, 1916) [facs. in *Dada, Zurich, Paris, 1916–22*]

Troços (Barcelona, 1916–18)

SIC (Paris, 1916–19; facs., Paris, 1980)

Blind Man (New York, 1917)

Rongwrong (New York, 1917)

Nord-Sud (Paris, 1917–18; facs., Paris, 1980)

Dada (Zurich and Paris, 1917–22)

391 (Barcelona, New York, Zurich and Paris, 1917–24; facs., Paris, 1960)

Arc-Voltaic (Barcelona, 1918)

Club Dada (Berlin, 1918)

Der Ventilator (Cologne, 1918)

Jedermann sein eigener Fussball (Berlin, 1919)

Der Dada (Berlin, 1919–20)

Littérature (Paris, 1919–24; facs., Paris, 1978)

Die Schammade (Cologne, 1920)

Contimporanul (Bucharest, 1920–30)

Proverbe (Paris, 1920–21)

New York Dada (New York, 1921)

Zenit (Zagreb, 1921–6)

Dada-Jok (Zagreb, 1922)

Mécano (Amsterdam, 1922–3)

Merz (Hannover, 1923–32)

general

R. Motherwell, ed.: *The Dada Painters and Poets: An Anthology* (Cambridge and New York, 1951/R 1981)

G. Hugnet: *L'Aventure Dada* (Paris, 1957)

W. Verkauf, ed.: *Dada: Monograph einer Bewegung* (Zurich, 1957, rev. St Gall, 2/1965; Eng. trans., London and New York, 1975)

W. Rubin: *Dada and Surrealist Art* (New York and London, 1969)

M. Sanouillet: *Dada* (Milan, 1969; Ger. trans., Munich, 1973)

L. Lippard, ed.: *Dadas on Art* (Englewood Cliffs, 1971)

D. Ades: *Dada and Surrealism* (London, 1974)

G. Hugnet: *Dictionnaire du Dadaïsme* (Paris, 1976)

A. Schwarz, ed.: *Almanacco Dada* (Milan, 1976)

L. Kundera: *Dada* (Prague, 1983)

S. Lemoine: *Dada* (Paris and London, 1987)

K. Passuth: *Les Avant-gardes de l'Europe centrale, 1907–27* (Paris, 1988)

exhibition catalogues

Fantastic Art, Dada, Surrealism (exh. cat. by A. Barr, New York, MOMA, 1936)

Dada, Surrealism and their Heritage (exh. cat. by W. Rubin, New York, MOMA; Los Angeles, CA, Co. Mus. A.; Chicago, IL, A. Inst.; 1968)

Vom Dadamax bis zum Grüngürtel: Köln in den zwanziger Jahren (exh. cat., ed. W. Herzogenrath; Cologne, Kstver., 1975)

Dada and Surrealism Reviewed (exh. cat. by D. Ades, London, ACGB, 1978)

Dada Photomontagen: Photographie und Photocollage (exh. cat., ed. C.-A. Haelein; Hannover, Kestner-Ges., 1979)

Dada—Constructivism: The Janus Face of the Twenties (exh. cat. by A. B. Nakov and others, London, Annely Juda F.A., 1984)

In the Mind's Eye: Dada and Surrealism (exh. cat., ed. T. A. Neff; Chicago, IL, Mus. Contemp. A., 1985)

André Breton: La Beauté convulsive (exh. cat., ed. A. Angliviel de la Beaumelle and I. Monod-Fontaine; Paris, Pompidou, 1991)

specialist studies

M. Sanouillet: Dada à Paris (Paris, 1965)

M. Prosenc: Die Dadaisten in Zürich (Bonn, 1967)

E. Peterson: Tristan Tzara: Dada and Surrealist Theorist (New Brunswick, 1971)

Y. Poupard-Lieussor and M. Sanouillet, eds: Documents Dada (Geneva, 1974)

D. Tashjian: Skyscraper Primitives: Dada and the American Avant-garde, 1910–1925 (Middletown, 1975)

S. C. Foster and R. Kuenzli, eds: Dada Spectrum: The Dialectics of Revolt (Iowa City, 1979)

K. Ritia, ed.: Dada Berlin: Texte, Manifeste, Aktionen (Stuttgart, 1979)

R. Sheppard, ed.: Dada: Studies of a Movement (Chalfont St Giles, 1979)

A. Melzer: The Latest Rage, the Big Drum: Dada and Surrealist Performance (Ann Arbor, 1980)

H. A. Watts: Chance: A Perspective on Dada (Ann Arbor, 1980)

R. Sheppard, ed.: New Studies in Dada: Essays and Documents (Driffield, 1981)

—: Zurich: Dadaco, Dadaglobe (Tayport, 1982)

J.-C. Gateau: Paul Eluard et la peinture surréaliste, 1910–1939 (Geneva, 1982)

I. B. Leavens: From 291 to Zurich: The Birth of Dada (Ann Arbor, 1983)

H. Bolliger, G. Magnaguagno and R. Meyer: Dada in Zürich (Zurich, 1985)

S. C. Foster, ed.: Dada/Dimensions (Ann Arbor, 1985)

R. Kuenzli, ed.: New York Dada (New York, 1986)

G. Smid, ed.: Dames in Dada (Amsterdam, 1989)

F. Naumann: New York Dada, 1915–23 (New York, 1994)

DAWN ADES, MATTHEW GALE

Dau al Set [Cat.: 'die at seven']

Artistic and literary group based in Barcelona and active from 1948 to 1956. It was founded in September 1948 by the poet Joan Brossa, who proposed the group's name, together with philosopher Arnau Puig and the painters Modest Cuixart, Joan Ponç (b 1927), Antoni Tàpies and Joan-Josep Tharrats. They based their stance largely on Dada and Surrealism and related developments, notably on Max Ernst's early work (see fig. 47) and on the art of Paul Klee and Joan Miró (see col. pl. VIII and fig. 46), and directed much of their attention to the sub-conscious by way of magic and the occult. Making clear their opposition to academic and official artistic circles, they were an important force in promoting contemporary art in Catalonia after the damage to their culture effected by the Spanish Civil War (1936–9).

The group's ideas, and the work of the artists associated with it, were transmitted largely through their magazine, also titled Dau al Set. Their internationalism and wide-ranging interests led them to publish the magazine in Catalan, Spanish and French, and to feature poetry, music, anthropology and ethnology alongside existentialism and art. They championed the turn-of-the-century origins of modernism in Catalonia, in particular the architecture of Gaudí, and alluded to Art Nouveau metalwork even in Ponç's title lettering for the magazine. Among the critics actively involved in writing for Dau al Set were influential figures such as Juan Eduardo Cirlot and Alexandre Cirici Pellicer, and they counted from the beginning on the support of Joan Prats, whose editorial work from 1934 for another Barcelona-based magazine, D'Icí i d'Allà (Cat.: 'from here to there'), had paved the way for their own publication. Among the artists whose work became more widely known through illustrations in the magazine were Angel Ferrant, Josep Guinovart, Jorge Oteiza, Ramón Rogent, Antonio Saura and Josep Maria Subirachs, as well as the founder-members.

Bibliography

Cuadernos Guadalimar, vii: Dau al Set (Madrid, 1978)

L. Cirlot: El grupo 'Dau al Set' (Madrid, 1986)

I. Julián: Les avantguardes pictoriques a Catalunya al segle XX (Barcelona, 1986)

INMACULADA JULIÁN

Delft school

Term applied to conservative Dutch architects associated with the Technische Hogeschool, Delft, in the 1920s and 1930s, and by extension to anti-progressive architecture in Holland in the 1940s

and 1950s. It was probably first used in 1946 in an article entitled 'De dictatuur van de Delftse school' by the critic J. J. Vriend (1896–1975) in the journal *De Groene Amsterdammer*. Vriend, an adherent of *Nieuwe Zakelijkheid* (*see* NEUE SACHLICHKEIT), opposed the traditionalist tendency that dominated post-war reconstruction in the Netherlands outside Rotterdam. He traced its origins to the group of architects led by the architect and urban planner Marinus jan Granpré molière and their followers. Granpré Molière, a charismatic personality and able teacher, became professor of architecture at the Technische Hogeschool, Delft, in 1924. Unhappy with the 'unprincipled' architecture of the time, he sought clear values and norms for the art of building. In contrast to the Functionalism that was increasingly prominent in the 1920s and which took its norms and values from industrial processes and forms, Granpré Molière found his convictions in medieval scholastic philosophy. He was strongly influenced by the ideas of Thomas Aquinas, as interpreted by the French neo-Thomist Jacques Maritain, and particularly the Thomist notions of 'perfection, proportion and radiance'. Architecture was conceived as a hierarchical entity, in which age-old values, symbolism and the building's location were important. In construction preference was given to natural materials and traditional techniques, but the past also had symbolic value in a visual sense, and consequently modern technology and the architecture associated with it were avoided.

The architecture actually created under the influence of these ideas is less elaborate than its theoretical basis might indicate. Use of the sloping roof and simplicity and sobriety in conception and details are notable characteristics, while in church construction the influences of Early Christian and Romanesque architecture are apparent. Examples of Delft school work include the Muzenhof housing block (1938) by Johannes F. Berghoef; the Raadhuis (1930), Naaldwijk, and the church of St Anthony (1935–6) at Groesbeek, both by Granpré Molière; competition designs for the Stadhuis (1937–9; unexecuted), Amsterdam, by Johannes F. Berghoef and J. J. Vegter (1906–82); the Provincial Registry (1948–60), Middelburg, by J. F. Berghoef and H. de Lussanet de la Sablonière (*b* 1907), and the church of Our Beloved Lady On the Hill (1953) in Breda by Granpré Molière.

Between the 1930s and 1950s the ideas of the Delft school and of *Nieuwe Zakelijkheid* were in sharp opposition. Although both groups rejected 19th-century eclecticism and emphasized architecture's social and moral role, their ideological foundations were incompatible. At a debate in Doorn in 1941, unsuccessful attempts were made to reconcile the two sides. During the 1940s Delft school plans were favoured, for example at Middelburg, but the enlarged scale of development in the early 1950s demanded industrialization of the building trades, making Delft school ideas impractical. Granpré Molière retired in 1953, and the newly appointed lecturers at Delft, including Cor van Eesteren, J. H. van den Broek and J. Bakema, were committed to modernist architecture. In the 1950s the adherents of the Delft school generally adopted the prevailing International Style.

Bibliography

Plan, 6 (1972) [complete issue devoted to Granpré Molière]
J. de Heer: 'De Delftsche school en de katholieke architectuur tussen 1945 en 1955', *Eltheto*, 64 (1981), p. 21
A. Kuyper: *Visueel en dynamisch: De stedebouw van Granpré Molière en verhagen* (Delft, 1991)

OTAKAR MÁČEL

Deutsche Gartenstadtgesellschaft

German association of architects, urban planners and writers. Founded in 1902 and active until the 1930s, it was modelled on the English Garden Cities Association. In contrast to the English precursor, however, which was grounded on Ebenezer Howard's practical theories of economic decentralization, the Deutsche Gartenstadtgesellschaft had literary roots. Its direct predecessors were the communes established by literati seeking to re-establish contact with the land, which flourished in the countryside around Berlin at the turn of the century. Among its founder-members were the

writers Heinrich Hart (1855–1906) and Julius Hart (1859–1930), Bruno Wille (1860–1928) and Wilhelm Bölsche (1861–1939), and the literary tendencies of the group were clearly stated in the founding manifesto: 'The Deutsche Gartenstadtgesellschaft is a propaganda society. It sees the winning over of the public to the garden city cause as its principal aim' (quoted from *Founding Statutes of Deutsche Gartenstadtgesellschaft*, article 1, in Hartmann, p. 161). Practical skills were brought to the group by the cousins Bernhard (*b* 1867) and Hans (*b* 1876) Kampffmeyer, who had both trained as landscape architects and were active in literary and socialist circles in both Berlin and Paris.

The Deutsche Gartenstadtgesellschaft's first practical venture, a garden suburb in Karlsruhe, was begun in 1906 but remained incomplete for many years. A more successful project was the Gartenstadt Hellerau, near Dresden, on which building began in June 1909. The overall plan and a series of standard house designs were by Richard Riemerschmid, with further housing designs by Hermann Muthesius and Heinrich Tessenow. Like the 19th-century developments of Port Sunlight and Bournville in England, and the Krupp estates in Essen, the Hellerau estate was linked to a manufacturing firm, the Deutsche Werkstätten, which used industrial techniques to produce well-designed, standardized furniture. Riemerschmid's factory complex (1909) was given low profiles and high-pitched roofs to create the impression of a large group of farm buildings. This attempt to create a rural idyll dedicated to machine fabrication reflected the ideals of Karl Schmidt (*b* 1873), the owner of the Deutsche Werkstätten, who founded Hellerau as a model community in which artistic production, labour, leisure and education were to be fused into a harmonious entity. His idealistic vision was symbolized by the Bildungsanstalt (1910–12), built to the design of Heinrich Tessenow, a school for music and eurhythmic dance directed by the music educationalist Emile Jaques-Dalcroze and intended as the social focus of the community.

In 1912 Bruno Taut was appointed advisory architect to the Deutsche Gartenstadtgesellschaft and provided designs for two successful garden suburbs, the Gartenstadt Falkenberg near Berlin (1913–14), notable for its coloured façades, and the Gartenstadt Reform near Magdeburg (1913–14 and 1921). At the same time Jakobus Göttel, Taut's assistant, produced schemes for garden suburbs at Bonn and Bergisch-Gladbach that were only partially realized. Further model suburbs were built in the period up to 1914 at Ratshof, outside Königsberg, at Wandsbeck near Hamburg, and at Strasbourg, Mannheim and Nuremberg. By 1914 some 5600 houses had been built in model estates and suburbs throughout Germany, none of which were on the scale of Letchworth, the first English garden city. After 1918 the initiative in housing reform was seized by the newly constituted city councils, and the great housing schemes built in Berlin and Frankfurt during the 1920s implemented many of the ideas put forward in the pre-war years by the Deutsche Gartenstadtgesellschaft. Under the guidance of the Kampffmeyers the society remained active throughout the 1920s as a forum for debate on housing policy; it is significant that both Ernst May and Bruno Taut, who were responsible for large estates in Frankfurt and Berlin respectively, were on the committee of the Deutsche Gartenstadtgesellschaft in 1931. By this time, however, the association was moribund, and the last issue of its journal *Gartenstadt* appeared in November 1931. The 1937 supplement to *Wasmuths Lexikon der Baukunst* confirmed that the Deutsche Gartenstadtgesellschaft was no longer active.

Bibliography

E. Howard: *Garden Cities of Tomorrow* (London, 1902); Ger. trans. as *Gartenstädte in Sicht*, intro. F. Oppenheimer (Jena, 1907)

H. Kampffmeyer: *Die Gartenstadtbewegung* (Leipzig, 1909)

—: *Die deutsche Gartenstadtbewegung* (Berlin, 1911)

K. Hartmann: *Deutsche Gartenstadtbewegung: Kulturpolitik und Gesellschaftsreform* (Munich, 1976)

F. Bollerey, G. Fehl, K. Hartmann, eds: *Im Grünen wohnen—im Blauen planen: Ein Lesebuch zur Gartenstadt mit Beiträgen und Zeitdokumenten* (Hamburg, 1990)

A. Schollmeier: *Gartenstädte in Deutschland: Ihre Geschichte, städtebauliche Entwicklung und Architektur zu Beginn des 20. Jahrhunderts* (Münster, 1990)

☐

Deutscher Werkbund

German association of architects, designers and industrialists. It was active from 1907 to 1934 and then from 1950. It was founded in Munich, prompted by the artistic success of the third Deutsche Kunstgewerbeausstellung, held in Dresden in 1906, and by the then current, very acrimonious debate about the goals of applied art in Germany. Its founder-members included Hermann Muthesius, Peter Behrens, Heinrich Tessenow, Fritz Schumacher and Theodor Fischer, who served as its first president.

1. History and growth, until 1919

In the spring of 1907 Muthesius gave a lecture at the Handelshochschule, Berlin, in which he condemned eclecticism and applauded the new directness and simplicity of design that had dominated at the Dresden exhibition. This was against current trends, for, as Muthesius noted, 'domestic furnishing and decoration in present-day Germany are based on social pretensions, and an industry working with imitations and surrogates provides the material for this'. Such sentiments predictably upset the various interest groups involved with industrial design and led to demands for Muthesius's resignation from his official positions in the Prussian Handelsministerium and in the Berliner Kunstgewerbeverein. A series of stormy meetings in the Interessenverband des Kunstgewerbes revealed that further collaboration between the established interest groups and the progressive designers would be impossible; this conviction, coupled with the desire to build on the success of the Dresden exhibition, led to the foundation of the new association.

As the founding statutes explained, the function of the Werkbund was 'the ennobling of commerce through the collaboration of art, industry and craftsmanship, through education, propaganda, and a united position on relevant questions'. The nationalistic basis of the group was also made clear from the outset, with the collaboration of the best artistic and commercial minds seen as the sole guarantee of German culture. This nationalistic stance was strongly influenced by the political theorist Friedrich Naumann (1860–1919), the mentor of the first three secretaries of the Werkbund: Wolf Dohrn (1878–1914), Alfons Paquet (1881–1944) and Ernst Jäckh (1875–1959).

Between 1908 and 1915 the Werkbund published the deliberations of its annual conference, originally in pamphlet form, later in handsomely illustrated and highly influential yearbooks. Among the important contributions published in these volumes were essays by Muthesius (1912; an account of the particularly German ability to achieve universally valid design solutions); Walter Gropius (1913; illustrated with the American grain silos that were to become canonical images of architectural Modernism in the 1920s); and Behrens (1914; on time, space and modern form).

Although the architects were influential in defining the early goals of the Werkbund, architecture and urban planning played a less important role in the pre-1914 Werkbund than they were to do later. The membership expanded rapidly, from 491 in 1908 to 1972 in 1915, and reflected a wide spectrum of artistic credos, embracing Modernism and traditionalism, luxury and austerity. The commercial interests were also diverse, and they extended from craft workshops such as the WIENER WERKSTÄTTE to industrial giants such as the Allgemeine ElektricitätsGesellschaft (AEG), Krupp, Mannesmann and Daimler. Thus there could be no single Werkbund style or design philosophy, and this diversity of interests provoked a bitter debate at the Werkbund conference of 1914 in Cologne. In the principal speech Muthesius proposed that standard designs should be developed for objects intended for industrial production. Although he admitted that universally acceptable archetypes had traditionally evolved over long periods, he felt that in the industrial age these might be arrived at more rapidly through a more conscious design process, *Typisierung*

(standardization). This suggestion, although entirely in accord with Behrens's practice as artistic adviser to AEG, was badly formulated, and in the ensuing discussion Behrens himself declared that he was unsure of the meaning of Muthesius's key term, *Typisierung*. Other members of the artists' group, which included Henry Van de Velde, August Endell, Hermann Obrist, Gropius and Bruno Taut, were equally unclear and condemned Muthesius's proposals as an attack on artistic freedom. This open conflict within the Werkbund between the Nietzsche-inspired élitism of the artists, who felt that they alone were the custodians of beauty, and the more pragmatic interests of the industrialists and exporters was, however, terminated by the outbreak of World War I.

Although the standardization arguments were rehearsed again at the conference of 1916, held in Bamberg, the Werkbund was preoccupied with other matters during the war years: propaganda exhibitions in Basle, Winterthur, Berne and Copenhagen; a competition for the design of a German House of Friendship in Constantinople (now Istanbul); and morbid deliberations on the design of military graves. The defeat in 1918 and the reduction of Germany's industrial base following the Treaty of Versailles swept away the conditions on which the nationalist and export-orientated premises of the pre-war years were based, and the Werkbund reassembled in Stuttgart in September 1919 to discuss the future. While the opening lecture by the President, Peter Bruckmann (*b* 1865), reiterated the pre-war views of the importance of the Werkbund for nationalist *Kulturpolitik*, the radicals struck back in a speech by the architect Hans Poelzig which, in accord with the anti-industrialist and anti-capitalist sentiment of the immediate post-war years, supported hand-craftsmanship and condemned industrial fabrication. Poelzig was elected President at this meeting and was joined on the executive committee by supporters of the radical, 'Expressionist' position—Gropius, César Klein, Karl Ernst Osthaus, Bernhard Pankok and Bruno Taut. At this time the Werkbund was lobbying successfully for a 'Reichskunstwart', and Edwin Redslob (1884–1973), formerly the Werkbund

representative in Thuringia, was appointed to the position in October 1919.

2. Functionalism and Neue Sachlichkeit, 1920–30

Between 1920 and 1923 escalating inflation precluded any meaningful activity, and the Werkbund publications became sporadic. The Stuttgart compromise also collapsed, and Poelzig gave way to the more conservative Richard Riemerschmid as President in May 1921. Following the demise of the Expressionist hopes of regeneration through craftsmanship, the Werkbund's identification with the *Handwerk* lobby appeared to commit it to a regressive ideology, quite inconsistent with the founding ambitions. This conflict was resolved in 1923, when the association regained a positive new direction. Three important factors in this process were the location of the annual conference at Weimar, coinciding with the first major exhibition there by the Bauhaus; Gropius's speech at this meeting, hailing the new unity of art and technology; and the Werkbund's withdrawal from the Arbeitsgemeinschaft für Handwerkskultur in November 1923, which signalled the group's formal dissociation from the handcraft lobby. The highpoint of the Werkbund's fortunes was from 1924 to 1929. For the only time in its history it was strongly linked to one style— to Functionalism and Neue Sachlichkeit—and concerned pre-eminently with architecture and urban design. This focusing of interest was reflected in the membership of the executive. In 1924 the architects Ludwig Mies van der Rohe and Hans Scharoun joined the committee, and Mies van der Rohe became First Vice-President in 1926, a position that gave him ultimate control, since Bruckmann, the President, exercised only a nominal authority at the time.

Mies van der Rohe's regime was marked by a virtual takeover of the executive by the progressive architects of Der Ring: Hugo Häring and Adolf Rading joined in 1926, Ludwig Hilberseimer in 1927. These disciples of architectural Modernism spread their gospel in the Werkbund journal, *Die Form*, which, after a short run in 1922, achieved great influence between 1925 and 1930 and survived until 1934. A second major propaganda

forum was the Weissenhofsiedlung in Stuttgart, built in 1927. Conceived as a direct rebuff to the traditionalism of Paul Bonatz, Paul Schmitthenner and the Stuttgart school, and as a model for future Functionalist housing, the estate was laid out following Mies van der Rohe's site-plan, with 60 housing units in 21 buildings, designed by 16 architects: Mies van der Rohe, Gropius, Scharoun, Richard Döcker, Behrens, Poelzig, Hilberseimer, Adolf Schneck (b 1883), Adolf Rading, Bruno Taut and Max Taut from Germany; J. J. P. Oud and Mart Stam from the Netherlands; Josef Frank from Austria; Le Corbusier from France (see col. pl. XVII); and Victor Bourgeois from Belgium. This foretaste of the brave new world of concrete, steel and glass attracted half a million visitors and the antagonism both of the local traditionalists and of the extreme left, who regarded the whole enterprise as an aesthetes' indulgence. In organizing the next building exhibition, *Wohnung und Werkraum*, held in Breslau in 1929, the Werkbund countered some of the Stuttgart critics by employing only Silesian architects and artists.

3. Dissolution and re-formation, after 1930

At this point the membership of the Werkbund reached its peak at just under 3000, and the association enjoyed pre-eminence not only in Germany but throughout Europe as the most important pressure group for Neues Bauen. Yet its achievements in architecture and industrial design were those of an élite for an élite and had little practical impact as models for mass housing or industrial mass production, the association being unable to reconcile its intellectual and artistic goals with the demands of a mass culture. Squeezed between Communist demands for a proletarian culture and Nazi exhortations to return to the *Volk* and the soil, the Werkbund in 1930 had little to offer but aesthetic precepts. The facile identification of technology and artistic Modernism was already being questioned from within, however, and at the conference of 1930 in Vienna, Frank posed the important question, 'Was ist modern?'. This crisis of Modernism was exacerbated by the world economic collapse and the Depression, widely seen as a failure of capitalism.

An ambitious exhibition planned for Cologne in 1932, entitled *Neue Zeit*, would have given the Werkbund an opportunity to answer its critics, with the construction of a new university, housing estates and schools, extensive coverage of the applied and performing arts, and a series of scientific and philosophical congresses. None of this came to fruition, however, due to the Depression, and by the end of 1932 the Werkbund was effectively dead. *Gleichschaltung*, the process of assimilation into the new Nazi power structure, followed in June 1933, and in December 1934 the Werkbund finally lost its identity when it was incorporated into the Reichskammer der Bildenden Künste.

In March 1947 a group of former members, including Otto Bartning, Willi Baumeister, Egon Eiermann, Gerhard Marcks, Max Pechstein, Lilly Reich, Schumacher, Rudolf Schwarz, Max Taut, Döcker and Tessenow, signed a manifesto calling for the regeneration of the war-damaged cities and towns of Germany through simple, modern design rather than historical reconstruction. The aim, they said, should be 'das Einfache und das Gültige'. Local and regional initiatives followed, such as the founding of the Werkkunstschule in Krefeld in 1947 and of the celebrated Hochschule für Gestaltung in Ulm in 1950. A national Werkbund was re-established in September 1950 with Hans Schwippert (b 1899) as Chairman. From 1951 to 1961 the Werkbund collaborated with the Rat für Formgebung in the publication of *Deutsche Warenkunde*, and a monthly Werkbund journal, *Werk und Zeit*, first appeared in March 1952.

Towards the end of the 1950s the reconstituted Werkbund developed ambitions that went beyond the promotion of good industrial design. More directly political positions were adopted, concerned with the future form of both city and country. In the urban context, the *Interbau* exhibition of 1957 in Berlin gave several Werkbund architects the opportunity to build modern mass housing in a park landscape, and at Marl in 1959 the Werkbund discussed the destruction of the West German landscape through ill-conceived housing, roads and water-regulation projects.

Anticipating the ecology lobby of the 1970s, the Werkbund incorporated countryside conservation into its programme in 1960. The optimistic belief in a rationally planned future found expression in the 1960s in a series of public discussions organized by the Werkbund, most notably the conference 'Bildung durch Gestalt' held in Berlin in 1965, with contributions from Ernst Bloch (1885–1987) and Theodor W. Adorno (1903–69). In common with most institutions in West Germany, the Werkbund was subjected to the critical scrutiny of the New Left in the late 1960s, particularly at the Berlin conference of 1968, held under the title 'Die Generationen und ihre Verantwortung für unsere Umwelt'. Although it survived the anti-authoritarian assault, the Werkbund in the 1970s and 1980s took on a resigned, introspective character, and its principal achievements were concerned with documenting its own history: the Werkbund-Archiv was established in Berlin in 1972, and an exhibition on the history of the Werkbund was held in Munich in 1975.

For further discussion, *see* MODERN MOVEMENT, §§2 and 4.

Writings

Die Durchgeistigung der deutschen Arbeit (Jena, 1912) [incl. 'Wo stehen wir?' by Muthesius]

Die Kunst in Industrie und Handel (Jena, 1913) [incl. 'Die Entwicklung moderner Industriebaukunst' by Gropius]

Der Verkehr (Jena, 1914) [incl. 'Einfluss von Zeit- und Raumausnutzung auf moderne Formentwicklung' by Behrens]

Deutsche Form im Kriegsjahr (Munich, 1915)

Kriegergräber im Felde und daheim (Munich, 1916–17)

Handwerkliche Kunst in alter und neuer Zeit (Berlin, 1920)

Bibliography

H. Eckstein: *50 Jahre Deutscher Werkbund* (Frankfurt, 1958)

J. Posener: *Anfänge des Funktionalismus: Vom Arts and Crafts zum Deutschen Werkbund* (Berlin, 1964)

U. Conrads and others, eds: *'Die Form': Stimme des Deutschen Werkbundes, 1925–1934* (Gütersloh, 1969)

S. Müller: *Kunst und Industrie: Ideologie und Organisation des Funktionalismus in der Architektur* (Munich, 1974)

J. Campbell: *The German Werkbund: The Politics of Reform in the Applied Arts* (Princeton, 1978) [extensive bibliog.]

K. Junghanns: *Der Deutscher Werkbund: Sein erstes Jahrzehnt* (Berlin, 1982)

'75 Jahre Deutscher Werkbund', *Werk & Zeit*, 3 (1982) [special issue]

K. Kirsch: *Die Weissenhofsiedlung* (Stuttgart, 1987)

<div align="right">IAIN BOYD WHYTE</div>

Devětsil

Czech avant-garde group of architects, painters, sculptors, collagists, photographers, film makers, designers and writers, active 1920–31. Its name is a composite of the words 'nine' and 'forces'. The group's leader, Karel Teige, advocated a reconciliation between utilitarianism and lyrical subjectivity: 'Constructivism and Poetism'. Devětsil's architects, including Jaromír Krejcar and Karel Honzík, invested the geometry of architecture with an element of poetry, while painters and photographers such as Toyen and Jindřich Štyrský moved towards Surrealism, and when the group dissolved many of its members, including Teige, joined the Czech Surrealist group.

Bibliography

Czech Art of the Twenties and Thirties, 2 vols (exh. cat. by J. Kotalík and Bernd Kimmel, Darmstadt, Ausstellhallen Mathildenhöhe, 1988)

Czech Modernism, 1900–1945 (exh. cat., Boston, MA, Mus. F.A., 1990)

Devětsil: Czech Avant-garde Art, Architecture and Design of the 1920s and 1930s (exh. cat., ed. R. Svacha; Oxford, MOMA; London, Des. Mus.; 1990)

<div align="right">NICHOLAS WEGNER</div>

Donkey's Tail [Rus. Oslinyy Khvost]

Russian group of painters active in 1911–15. It was led by Mikhail Larionov and Natal'ya Goncharova. The name was chosen by Larionov and recalled a famous artistic scandal in Paris, when a picture,

painted by tying a brush to a donkey's tail, was exhibited without comment at the Salon des Indépendants of 1905. The Donkey's Tail group was the result of a difference in aesthetic ideology within the JACK OF DIAMONDS group. While most of their colleagues in Jack of Diamonds preferred to rely on the example of contemporary French and German painting, Larionov and Goncharova adopted the view that their art should evolve from the stylistic traditions of popular Russian art forms, such as the icon and *lubok* (a type of wood-engraving). A few, such as Kazimir Malevich and Alexsey Morgunov (1884–1935), shared their views and resigned in order to help found Donkey's Tail in 1911. The official launch of the group took place in early 1912 at the Jack of Diamonds conference, when Goncharova and Larionov interrupted the proceedings and, 'in a halo of scandal' (Livshits), proclaimed the formation of Donkey's Tail and their secession from Jack of Diamonds.

In March 1912 the group held its first exhibition, inviting young artists such as Kirill Zdanevich (1892–1969), Mikhail Le Dantyu (1891–1917), Aleksandr Shevchenko, Tatlin and the émigré Chagall to participate. The exhibition received a great deal of critical attention in the press, its artists being considered the most radical of the avant-garde. The artists of Donkey's Tail shared a common aesthetic ideology. As Voloshin noted, they painted scenes of everyday Russian life, pictures of soldiers, hairdressers, chiropodists and prostitutes, all executed in the popular style of the *lubok*, using bright colours, flat shapes and crudely articulated forms. Religious subjects based on the style of Russian icons were also characteristic of Donkey's Tail, as were Oriental themes, since the group had rejected the West and now looked to Eastern art for inspiration.

In April 1913 Donkey's Tail altered its name to Mishen' ('Target') and held a second exhibition in Moscow. By this time Larionov's and Goncharova's aesthetic of a return to the subjects and styles of traditional Russian art forms had crystallized under the name of NEO-PRIMITIVISM, and masterpieces of the style, such as Larionov's *Spring* (1912; Paris, Pompidou), were exhibited. To emphasize the correlation between their own work and that of naive and popular Russian art forms, the group included in the exhibition works by children, house- and signboard-painters and naive artists such as the Georgian Niko Pirosmanashvili. Target also served as a platform for Larionov's and Goncharova's new abstract style of Rayist painting (*see* RAYISM), and so the somewhat motley aspect of the exhibition can well be imagined. Nonetheless, the works exhibited at both Donkey's Tail and Target were the most important and experimental in Russian art of the pre-war period.

In the summer of 1913 the group published an almanac entitled *Oslinyy Khvost i Mishen'* ('Donkey's Tail and Target'), in which the artists reproduced their works, and published two Rayist manifestos and two critical essays about their work. By March 1914 several members of the original group, including Malevich, Morgunov and Fonvizin, had left. The remainder held a third exhibition entitled *No. 4: Futurists, Rayists, Primitives*. Works of different tendencies were shown, including non-objective Rayist works, Neo-primitive paintings and poems by Vasily Kamensky (1864–1961). With Larionov's and Goncharova's move to the West in 1915 the group dissolved.

Writings

Oslinyy Khvost [Donkey's Tail] (exh. cat., Moscow, 1912)
Oslinyy Khvost i Mishen' [Donkey's Tail and Target] (Moscow, 1913)
Vystavka Kartin Gruppy Khudozhnikov 'Mishen'' [Exhibition of paintings by the 'Target' group of artists] (exh. cat., Moscow, 1913)
Vystavka Kartin No. 4: Futuristy, Luchisty, Primitivy [Exhibition of paintings no. 4: Futurists, Rayists, Primitives] (exh. cat., Moscow, 1914)

Bibliography

M. Voloshin: 'Moskva: Khudozhestvennaya Zhizn': Oslinyy Khvost' [Moscow: artistic life: Donkey's Tail], *Apollon*, 7 (1912), pp. 105–6
B. Livshits: *Polutoraglazyy strelets* [The one-and-a-half-eyed archer] (Leningrad, 1933; Eng. trans., 1977)
J. Howard: *The Union of Youth: An Artists' Society of the Russian Avant-Garde* (Manchester, 1992)
A. Parton: *Mikhail Larionov and the Russian Avant-Garde* (Princeton and London, 1993)

ANTHONY PARTON

Earth [Serbo-Croat Zemlja] group

Croatian group of artists, architects and intellectuals active in Zagreb from 1929 to 1935. The original group included the painters Krsto Hegedušić, Omer Mujadžić (1903–91), Kamilo Ružička (1898–1972), Ivan Tabaković (1898–1977) and Oton Postružnik (1900–78); the sculptors Antun Augustinčić (1900–79) and Frano Kršinić; and the architect Drago Ibler. They aimed to defend their artistic independence against foreign influences such as Impressionism or Neo-classicism and against dilettantism and Art for Art's Sake. They maintained that art should mirror the social milieu from which it springs and should meet contemporary needs, hence their emphasis on the popularization of art, both at home and abroad. In spite of its ideologically heterogeneous membership, the group was Marxist in orientation but never espoused Socialist Realism.

Two additional artists, Vinko Grdan (1900–80) and Leo Junek (*b* 1899), participated in the first Land group exhibition in November 1929 at Salon Ullrich in Zagreb. The group's manifesto, printed in the catalogue, emphasized the members' belief that the artist cannot evade social developments or remain outside the collective body, for art and life are one. Ideological conflicts arose the following year, however, and some artists left the group. The second exhibition, held in February–March 1931 at Galerie Billiet, Paris, included some guest artists. The exhibition was officially acknowledged, which prompted group members, as enemies of bourgeois art, to object that their revolutionary aims were being compromised.

For the group's third show, in September 1931 at the Art Pavilion in Zagreb, guest architects, designers and the naive painters from Hlebine were invited to exhibit, in the belief that various artistic approaches should be combined in a sort of synthesis. In 1932 more members left the group on ideological grounds while other artists joined: Đuro Tiljak (1895–1955), the architect Lavoslav Horvat (1901–89), Marijan Detoni (1905–81), Edo Kovačević (1906–93), the architect Mladen Kauzlarić, the architect Stjepan Planić, Vanja Radauš (1906–75), Kamilo Tompa (1903–89) and Željko Hegedušić (*b* 1906). The group came under strong criticism for its Marxist stance when the official political line favoured Fascism, and the eighth exhibition, which opened in 1935 at the Art Pavilion, was closed by the police on the first day.

Bibliography

J. Depolo: 'Zemlja, 1929–35', *Nadrealizam: Socialna utmetnost* [Surrealism: social art] (exh. cat., Belgrade, Mus. Contemp. A., 1969)

JURE MIKUŽ

Ecole de Paris

Term applied to the loose affiliation of artists working in Paris from the 1920s to the 1950s. It was first used by the critic André Warnod in *Comoedia* in the early 1920s as a way of referring to the non-French artists who had settled and worked in Paris for some years, many of whom lived either in Montmartre or Montparnasse, and who included a number of artists of Eastern European or Jewish origin.

From *c*. 1900 a number of major artists had been attracted to the capital because of its reputation as the most vital international centre for painting and sculpture; these included Picasso, Gris and Miró from Spain, Chagall, Soutine and Lipchitz from Russia or Lithuania, Brancusi from Romania and Modigliani from Italy. The prominence of Jewish artists in Paris and of foreign artistic influences in general began by *c*. 1925 to cause intense resentment and led to the foreigners being labelled as 'Ecole de Paris' in contrast to French-born artists such as André Derain and André Dunoyer de Segonzac, who were said to uphold the purity and continuity of the French tradition. After World War II, however, these nationalistic and anti-Semitic attitudes were discredited, and the term acquired a more general use to denote both foreign and French artists working in Paris.

Bibliography

Paris–Paris, 1937–1957: Créations en France (exh. cat., ed. K. G. P. Hultén; Paris, Pompidou, 1981)
The Circle of Montparnasse: Jewish Artists in Paris, 1905–1945 (exh. cat. by K. E. Silver and R. Golan, New York, Jew. Mus., 1986)

RONALD ALLEY

Eight, the (i) [Cz. Osma]

Group of Bohemian painters established in 1906 with the aim of making colour the dominant element in their art. The members, all graduates of the Academy of Fine Arts in Prague, were Emil Filla, Friedrich Feigl (1884–1965), Antonín Procházka, Willy Nowak (1886–1977), Otokar Kubín, Max Horb (1882–1907), Bohumil Kubišta and Emil Artur Pittermann-Longen (1885–1936). Filla, Feigl and Procházka had undertaken further study journeys in Europe, which had opened up their artistic horizons and convinced them of the need for innovation in Czech art. At their initial meetings, held at a Prague coffee-house, the Union, they planned to publish their own magazine and put on an exhibition in the prestigious Topič salon in Prague. Eventually they succeeded in renting a shop in Králodvorská Street, Prague, where a hastily organized exhibition was opened on 18 April 1907, with a catalogue consisting of a sheet of paper headed *Exhibition 8 Kunstausstellung*. The number 8 in the title of the exhibition was intended to represent the number of members in the group; in fact there were only seven, because Pittermann-Longen was only allowed at his own request to exhibit 'behind the curtain in the cubby-hole', since he was still a student at the Academy. The catalogue was in German as well as Czech, as Nowak, Horb and Feigl were of German birth. The majority of the paintings exhibited showed the artists' tendency towards an expressionism in the manner of Munch (who had an exhibition in Prague in 1905), van Gogh, Honoré Daumier and Max Liebermann. Only Max Brod gave the exhibition a positive review; otherwise the reaction of the public and critics was negative. A second exhibition of the Eight took place in the Topič salon in 1908, though it was without the participation of Horb (who had died) and Kubín (who was in Paris). The new exhibitors were Vincenc Beneš and Linka Scheithauerová (1884–1960), the future wife of Procházka. The catalogue of exhibitors does not include Pittermann-Longen, and they were therefore once again seven. Among the artists' aims on this occasion was the enhancement of expression (Filla) and the liberation of colour splashes (Procházka). The exhibition produced an even more negative reaction than the first. Although it was never officially disbanded, the members of the group maintained contact until 1911, when some of them were co-founders of the Cubist-orientated Group of Plastic Artists. Kubín and Filla turned to Neo-primitivism, and Nowak to Neo-classicism; Feigl remained in the Expressionist tradition.

Bibliography

M. Brod: 'Frühling in Prag', *Die Gegenwart* (Berlin, 1907), pp. 316–17
M. Lamač: *Osma a Skupina Výtvarných Umělců* [The Eight and the Group of Artists] (Prague, 1988)

VOJTĚCH LAHODA

Eight, the (ii)

Group of eight American painters who joined forces in 1907 to promote stylistic diversity and to liberalize the exclusive exhibition system in the USA. They first exhibited together at Robert Henri's instigation at the Macbeth Galleries, New York, in February 1908, following the rejection of works by George Luks, Everett Shinn, William J. Glackens and others at the National Academy of Design's spring show in 1907, of which Henri was a jury member before resigning in protest. Henri, the driving force behind the group, was joined not only by Luks, Shinn and Glackens but also by John Sloan, Ernest Lawson, Arthur B. Davies and Maurice Prendergast. Henri was a painter of cityscapes and portraits who worked in a dark and painterly, conservative style influenced by Frans Hals and Velázquez; a gifted teacher, he encouraged his students to depict the urban poor with vitality and sensitivity.

Sloan, Luks, Shinn and Glackens had met Henri in Philadelphia in the 1890s while employed as newspaper illustrators. Henri persuaded them to move to New York, where they painted urban realist scenes of prostitutes, street urchins and vaudeville performers, for which they were later called the ASHCAN SCHOOL. Ironically, while these painters were often deemed rebels, all worked in the coarsely brushed academic mode of Henri, and

none but Sloan, who espoused Socialism, imposed social criticism. They commonly treated their subjects not as oppressed victims but as colourful and bohemian characters.

Lawson, Davies and Prendergast had little in common with the other members of the Eight; these three were influenced by late 19th-century French painting. Lawson portrayed upper Manhattan and the lower Hudson River with thickly applied impressionist strokes. Davies painted idyllic, symbolist landscapes populated by female nudes. Prendergast used a pointillist technique to depict the middle classes at leisure.

Despite some criticism, the Macbeth exhibition was generally well received and well attended. As a result it travelled to nine major cities, and the National Academy of Design temporarily liberalized its exhibition policies. The historic exhibition of the Eight is considered a milestone in the development of artistic independence, inspiring other independent exhibitions, including the Armory Show (1913), which radically transformed American art in the early 20th century.

Bibliography

The Eight (exh. cat. by E. Shinn, New York, Brooklyn Mus., 1944)

B. B. Perlman: *The Immortal Eight: American Painting from Eakins to the Armory Show, 1870–1913* (New York, 1962); rev. as *The Immortal Eight and its Influence* (1983)

A. Goldin: 'The Eight's Laissez-faire Revolution', *A. America*, lxi/4 (1973), pp. 42–9

M. S. Young: *The Eight: The Realist Revolt in American Painting* (New York, 1973)

F. Goodyear: 'The Eight', *In this Academy: The Pennsylvania Academy of Fine Arts, 1805–1976* (exh. cat., Philadelphia, PA Acad. F.A., 1976)

M. Laisson: 'The Eight and 291: Radical Art in the First Two Decades of the Twentieth Century', *Amer. A. Rev.*, ii/4 (1979), pp. 91–106

The American Eight (exh. cat., intro. J. W. Kowelek; Tacoma, A. Mus., 1979)

B. B. Perlman: 'Rebels with a Cause: The Eight', *ARTnews*, lxxxi/18 (1982), pp. 62–7

The Shock of Modernism in America: The Eight and the Artists of the Armory Show (exh. cat. by C. H. Schwartz, Roslyn, Nassau Co. Mus. F.A., 1984)

JANET MARSTINE

Eight, the (iii) [Hung. Nyolcak]

Hungarian avant-garde group founded in early 1909 and consisting of the painters Róbert Berény, Béla Czóbel, Dezső Czigány, Károly Kernstok, Ödön Márffy, Dezső Orbán (1884–1986), Bertalan Pór and Lajos Tihanyi. Later the sculptors Márk Vedres (1870–1961) and Vilmos Fémes Beck and the industrial designer Anna Lesznai (*b* 1885) also became members. The group was originally called the Searchers (Keresők) and had formed the most radical section within MIENK (Hungarian Impressionists and Naturalists), a broad-based group of artists. They left MIENK in order to develop a more modern aesthetic. The name the Eight was adopted on the occasion of the second exhibition in 1911, and its leader and organizer was Kernstok. Unlike the earlier Nagybánya school or other contemporary Western movements, the Eight had no homogeneous style, individual artists being influenced by a variety of sources ranging from Cézanne to Cubism. Though unified by a sense of the social function of art, the details of this belief again varied with each artist.

Essentially, the Eight grew up in opposition to the predominant Impressionist style and aesthetic then current in Hungarian art. In particular they rejected the subjective aspect of Impressionism, which aimed at a depiction of nature as perceived through the mood of the artist. This approach was seen as inappropriate to modern society, and, in the context of the political unrest of the period, this desire for change acquired a strong sense of urgency. In contrast to the subjectivism of Impressionism and its concomitant lack of order and structure, the Eight proposed an art of order and harmony based on permanent values. This aesthetic was furthermore seen as an integral part of a new social order in which the artist would assume a central role. This view was most forcibly expressed in Kernstok's essay 'The Social Role of the Artist' (*Huszadik Század*, 1, 1912, pp. 377–80), in which he claimed that in the future the artist would 'stand on the highest rung of the social ladder where, even if he will not enter into discussion with gods, he will direct the spirit of the masses'.

Though lacking their own periodical, the Eight were supported by such critics as Lajos Fülep (1885–1970) and by the Marxist philosopher György Lukács, both of whom wrote appreciative articles in the radical journal *Nyugat* ('West'). In particular, Lukács's article 'The Ways Have Parted' (*Nyugat*, i, pp. 190–93) was an important exposition of the group's aims. Lukács closed the article with 'a declaration of war on all Impression, all sensation and mood, all disorder and denial of values, every *Weltanschauung* and art that writes "I" as its first and last word'. The group exhibited only three times: first in December 1909 at the publishers Könyves Kálmán Műkiadó, then at the Nemzeti Szalon (National Salon) in Budapest from April to May 1911 and finally at the Nemzeti Szalon again, from November to December 1912.

The social inclination of the Eight was evident through the number of monumental paintings and frescoes executed by the group. Pór, for example, produced a fresco for the People's Opera House in Budapest in 1911, the very nature of such projects revealing a desire to communicate with a wide audience. At the second exhibition, Kernstok's *Horsemen on the River Bank* (1910; Budapest, N.G.) was one of the central attractions, and this work highlights the peculiar mixture of tradition and modernity within the group. Its bright coloration shows the influence of Fauvism, though the brushwork is less expressive, yet the subject-matter is distinctly Neo-classical. The statuesque naked figures and horses gathered by the riverside do indeed form an image of a Golden Age, but it is one rooted in the past not the present.

Other artists reflected the variety of influences that converged within the group. Tihanyi's *Self-Portrait* (1912; Budapest, N.G.) exploits elements of Cubist fragmentation, while Czigány's *Still-life with Apples* (c. 1910; Budapest, N.G.) is reminiscent of Cézanne. Berény, who had earlier also been influenced by Cézanne, later turned to Expressionism, as shown by his *Portrait of Béla Bartók* (1913; New York, Bartók Archvs, see Németh, pl. 33). By the end of 1912 the Eight had disintegrated through internal pressures and external political events; nevertheless, during its

short life it revolutionized aesthetic attitudes in Hungary and paved the way for its successor, the ACTIVISTS.

Bibliography

K. Passuth: *A Nyolcak Művészete* [The art of the Group of Eight] (Budapest, 1967)

L. Németh: *Modern Art in Hungary* (Budapest, 1969), pp. 49–62

Z. D. Fehér and G. Ö. Pogány: *Twentieth Century Hungarian Painting* (Budapest, 1975)

The Hungarian Avant Garde: The Eight and the Activists (exh. cat. by J. Szabó and others, London, Hayward Gal., 1980)

S. A. Mansbach: 'Revolutionary Events, Revolutionary Artists: The Hungarian Avant-garde until 1920', *'Event' Arts and Art Events*, ed. S. C. Foster (Ann Arbor, 1988), pp. 31–60

G. Eri and others: *A Golden Age: Art and Society in Hungary 1896–1914* (London, 1990), pp. 41–4

☐

Elementarism

Term coined by Theo van Doesburg and applied to painting and architecture to describe the constructive use of line, plane, volume and colour not only as the primary means of art but as an end in itself. In his article, 'L'Elémentarisme et son origine', he stated that the movement had been born in Holland in 1924 via the DE STIJL group. He then listed Elementarist contributors to the arts: 'Georges Antheil in music, César Domela, Vordemberge-Gildewart and the author of this article (the founder of the movement) in painting, Constantin Brancusi in sculpture, Mies van der Rohe, van Eesteren, Rietveld and the author in architecture, I. K. Bonset [one of van Doesburg's pseudonyms] in literature, Friederich Kiesler in the rejuvenation of the theatre'. The term is intimately related to the notion of abstraction and has roots extending back as far as Plato's *Philebus*. In its broader definition it can provide an insight into the development of abstraction. As early as 1915, in his article on the development of modern art, van Doesburg wrote about the 'fundamental elements' of art and analysed how they had been treated during different historical periods.

The publication of Heinrich Wölfflin's *Kunstgeschichtliche Grundbegriffe* (1915) had a profound effect on van Doesburg's ideas, particularly concerning the primary elements of painting and their ability to set the whole canvas in motion. The development of van Doesburg's theory was further supported by the writings of the Dutch Hegelian philosopher Professor G. J. P. J. Bolland, who saw art as elements in relationship. The architect J. J. P. Oud was much impressed by the ideas of van Doesburg and Bolland, and wrote an article 'Over Cubisme, Futurisme, moderne Bouwkunst' (*Bouwkundig Weekblad*, Sept 1916, pp. 156–7) in which he set out to show the ramifications of such an approach for architecture. This second definition of Elementarism gave the initial impetus to the magazine *De Stijl*.

In 1921 Raoul Hausmann, Hans Arp, Jean Pougny and László Moholy-Nagy signed a manifesto which was published as 'Aufruf zur elementaren Kunst' in *De Stijl*. Although these artists had much in common with van Doesburg, they did not constitute a school but had connections with two different movements, Constructivism and Dada. Van Doesburg discussed how the 'profound pioneering work' with the simplest means 'or the elemental means of expression' had been achieved in strict Constructivist terms in his article 'Zur elementaren Gestaltung' published in *G*, the magazine edited by Hans Richter. The point was demonstrated architecturally in the designs and models made by van Doesburg and Cornelis van Eesteren in 1923 for the De Stijl exhibition in Léonce Rosenberg's Galerie de l'Effort Moderne. He later dismissed the identification of the colour plane, architectural plane, visual and literal structure as 'anatomical architecture'.

Van Doesburg described the design for Gerrit Rietveld's Schröder House (1924) in Utrecht as 'the application of our most recent principles' in a letter to César Domela (27 Aug 1925; see Doig, pp. 168–9). He expanded on these principles in 'Tot een beeldende architectur' and 'Vers une construction collective', both published in *De Stijl*. It was in 1924–5 that van Doesburg's experiments in painting produced the transition that was the basis for the narrowest definition of Elementarism, as formulated by the artist himself. In 1924 he painted *Counter-composition V* (Amsterdam, Stedel. Mus.) and *Counter-composition VIII* (Chicago, IL, A. Inst.). Originally these had lozenge formats with horizontal and vertical axes. In June or July 1925 their orientation was changed to a square format, and they became diagonal counter-compositions.

The reintroduction of the diagonal and implied movement, which occasioned Mondrian's disassociation from De Stijl, to some extent had its roots in El Lissitsky's *Proun* series. Just as Lissitsky had applied the geometrical elements of the series in a *Proun* room for the Berlin Kunstaustellung (1923), van Doesburg's counter-compositions had a corresponding architectural manifestation. Virtually simultaneous with the creation and transformation of *Counter-composition V* and *Counter-composition VIII* was his design of a Flower Room in a villa by Robert Mallet-Stevens for Charles, Vicomte de Noailles, at Hyères, France. There the walls and ceiling were completely covered in diagonal counter-compositions. In his article 'Schilderkunst: Van kompositie tot contra-kompositie', van Doesburg wrote of the need for contrast between the visual structure of painting and the literal horizontal/vertical structure of architecture. From the tension between the two would rise a new 'plastic expression'.

In 1926 van Doesburg was commissioned to rebuild the Aubette, an entertainment complex in Strasbourg, in collaboration with Hans Arp and Sophie Taeuber-Arp. In the complex he again applied the principles of contrast between compositional and counter-compositional methods. The Aubette was the culmination of Elementarism. In the issue of *De Stijl* dedicated to the Aubette, van Doesburg published 'L'Elémentarisme et son origine' and the movement was retrospectively invented.

Writings

R. Hausmann, H. Arp, I. Puni and L. Moholy-Nagy: 'Aufruf zur elementaren Kunst', *De Stijl*, iv/10 (1921), p. 156

T. van Doesburg: 'Zur elementaren Gestaltung', *G*, 1 (1923)

H. Richter: 'G', *G*, 3 (1924)

T. van Doesburg: 'Tot een beeldende architectur', *De Stijl*, vi/6–7 (1924), pp. 78–83

——: 'Vers une construction collective', *De Stijl*, vi/6–7 (1924), pp. 89–91

——: 'Schilderkunst: Van kompositie tot contra-kompositie', *De Stijl*, vii/73–4 (1926), pp. 17–28

——: 'Schilderkunst en plastiek: Over contra-compositie en contra-plastiek–Elementarisme (manifest-fragment)' [Painting and plasticism: concerning counter-composition and counter-plasticism–Elementarism (extract from manifesto)], *De Stijl*, vii/75–6 (1926), pp. 35–43; 78 (1926–7), pp. 82–7

——: 'Brancusi', *De Stijl*, vii/79–84 (1927), pp. 85–6

——: 'L'Elémentarisme et son origine', *De Stijl*, viii/87–9 (1928), pp. 20–25

——: 'Elementarisme', *De Stijl*, final issue (1932), pp. 15–16

——: 'Elémentarisme (les éléments de la nouvelle peinture)', *De Stijl*, final issue (1932), pp. 17–19

Bibliography

J. Baljeu: *Theo van Doesburg* (London, 1974)

S. Bann: *The Tradition of Constructivism*, DMA, ed. R. Motherwell (London, 1974)

A. Doig: *Theo van Doesburg: Painting into Architecture, Theory into Practice* (Cambridge, 1986)

E. van Straaten: *Theo van Doesburg: Painter and Architect* (The Hague, 1988) [good bibliog. and docs]

S. Lemoine, ed.: *Theo van Doesburg: Peinture, architecture, théorie* (Paris, 1990)

ALLAN DOIG

Entartete Kunst [Ger.: 'degenerate art']

Term used by the Nazis in Germany from the 1920s to refer to art that did not fall into line with the arts policies of National Socialism, chiefly avant-garde work. The term 'degenerate art' has been used generally to describe art perceived as signifying decay, and usually forms of art production in chronological proximity. It has been used in a polemical context to enhance the value of a specific aesthetic viewpoint. The first known example is the assessment made by the Italian bourgeoisie of the 14th century of medieval art as a barbaric relapse when compared with antiquity. The Italian writer and statesman Niccolò Machiavelli employed the term 'degeneration' (*corruzione*) in his *Discorso* of 1581. It was used by Giovanni Pietro Bellori in his polemic against

Giorgio Vasari and Michelangelo. It is also used generally to mean irregular or against the rules, in contrast with the dominant aesthetic trend, which is set up as the rule. In this sense the term 'Baroque' was also initially intended to be disparaging. At the end of the 19th century the term was used in association with Nietzsche's concept of decadence. It was later used in this sense by Thomas Mann, who regarded the artist as 'a social outsider prone to be tired of life' (1987–8 exh. cat.) and considered this predisposition to be the basis of the need for artistic creativity. Familiarity with crises and melancholy was viewed as the cause and driving force of artistic genius, which found its expression in a new artistic subjectivity. In contrast, in his book *Entartung* (1892–3), Max Nordau viewed Naturalism, Symbolism and Realism as decadent art movements that had originated in the 'degeneracy' of their founders, and he proposed that they be combated in the interest of health. This perception was essentially in line with Emperor William II's ideas on art and with the imperial criticism of art, which, on occasion, even stigmatized Impressionism as 'gutter painting' (*Gossenmalerei*). William II had attempted to regulate art, claiming, in his speech at the inauguration of Siegesallee in Berlin in 1901: 'Art that goes beyond the laws and limits imposed on it by me ceases to be art.' In 1913 a resolution 'Against degeneracy in art' was passed in the Prussian house of representatives. In Germany these defamations were always closely linked to nationalistic tendencies.

With the growth of German nationalism from the end of the 1920s, the term was increasingly present in the art propaganda of the National Socialist Party and applied to everything that did not conform to Nazi goals. It became the central concept of their art policy, being used in the battle against 'foreign infiltration' (*Überfremdung*) of art. Citing petit-bourgeois artistic taste as 'popular sentiment' (*gesundes Volksempfinden*), the Nazis had instigated a wide campaign of defamation within all the arts. It was directed against avant-garde tendencies, both national and international, which had developed from the late 19th century. By 1930 the Minister for Culture and Education,

von Thüringen Frick, had already proclaimed his programme 'Against Negro culture—for German national traditions', aimed particularly at the Expressionists, and he ordered the removal of 70 paintings from the permanent exhibition of the Schlossmuseum at Weimar. Also in 1930 Hildebrand Gurlitt, the museum director in Zwickau, was dismissed for promoting such artists as Emil Nolde, Heinrich Zille, Ernst Barlach, Otto Dix (see col. pl. XXVI) and others. In March 1933 Bettina Feistel-Rohmeder, the director of the Deutsche Kunstkorrespondenz, called for the removal from the museums of all works revealing 'cosmopolitan and Bolshevik aspects'. The purpose of this propaganda was the bringing-in-to-line (Gleichschaltung) of the arts within a Nazi state. Art's only task was to illustrate the ideas of National Socialism and the glorification of the State. Feistel-Rohmeder demanded the seizure of 'degenerate works of art'. Museum directors were either forced out of office or relieved of their duties following the first defamatory exhibitions of 1933: *Regierungskunst von 1918 bis 1933* in the Staatliche Kunsthalle, Karlsruhe; *Novembergeist im Dienste der Zersetzung* in Stuttgart; *Kulturbolschewismus* in Mannheim; *Schreckenskammer der Kunst* in Nuremberg; *Kunst, die nicht aus unserer Seele kam* in Chemnitz; and *Spiegelbilder des Verfalls in der Kunst* in Dresden. The latter was sent by the Mayor of Dresden, Zörner, as a touring exhibition in Germany. The Law for the Restoration of Civil Service with Tenure, passed on 7 April 1933, facilitated the dismissal of directors for 'the promotion of degenerate art'. In October 1936 the 'temporary' closure of the modern wing in the Kronprinzenpalais in Berlin was ordered, though intended to be final. All these actions were arranged and coordinated by the Reich Ministry of the Interior for Information and Propaganda under Goebbels, in conjunction with the Gestapo. In 1937, under the newly elected President of the Reichskammer für Bildende Künste, Professor Adolf Ziegler, a commission was set up to select works for a planned exhibition of *Entartete Kunst* upon orders from Goebbels. One day after Hitler opened the first Grosse Deutsche Kunstausstellung in the Haus der Deutschen Kunst (now the Haus der Kunst), in Munich, the *Entartete Kunst* exhibition in the Archeologisches Institut in Munich began (19 July 1937). The skilfully anti-aesthetic hanging and the defamatory commentary on the works did not fail to achieve propagandistic success. In a reduced form, this exhibition toured to Leipzig, Berlin and Düsseldorf (1938), and to Chemnitz, Frankfurt am Main and Vienna (1939).

By August 1937 the wide-scale confiscation of all works of art in museums designated 'degenerate' had already begun. According to records, a total of 15,997 works of fine art were confiscated from 101 German museums. This action was justified by the Law on the Confiscation of Products of Degenerate Art, passed belatedly on 31 May 1938. Works affected were those of classical modernity, works by artists of Jewish descent and works of social criticism. Only a few were retained and hidden through the brave manoeuvring of individual members of museum staff. The artists themselves, assuming they had not already left Germany, were forbidden to paint or exhibit. In addition to confiscation, destruction took place of murals and architectural monuments, among others. In May 1938 Goebbels instigated the establishment of the Kommission zur Verwertung der Beschlagnahmten Werke Entarteter Kunst. Confiscated works were stored in depots and from there sold to interested parties abroad (the Nazis hoped for a source of revenue for foreign currency, which was needed for the rearmament programme), and sometimes exchanged (Hermann Goering made exchanges with older works of art for his private collection). In 1939, 125 works were put up for auction in Lucerne, including works by van Gogh, Gauguin, Franz Marc, Macke, Klee, Kokoschka and Lehmbruck. The end of the *Aktion entartete Kunst* was signalled by the burning of 4829 art works in the courtyard of the Berlin Fire Brigade.

Bibliography

M. Nordau: *Entartung*, 2 vols (1892–3/R Berlin, 1992–3)

P. Renner: *Kulturbolschewismus* (Zurich, 1932)

Entartete Kunst: Führer durch die Ausstellung (Munich, 1937)

W. Willich: *Säuberung des Kunsttempels: Eine kunstpolitische Kampfschrift zur Gesundung deutscher Kunst im Geiste nordischer Art* (rev. Munich, 1938)

A. Behne: *Entartete Kunst* (Berlin, 1947)

P. O. Rave: *Kunstdiktatur im 3. Reich* (Hamburg, 1949, rev. Berlin, 1992)

F. Roh: *Entartete Kunst: Kunstbarbarei im 3. Reich* (Hannover, 1962)

H. Brenner: *Die Kunstpolitik des Nationalsozialismus* (Reinbeck bei Hamburg, 1963)

J. Wulf: *Die bildenden Künste im Dritten Reich: Eine Dokumentation* (Gütersloh, 1963)

G. Busch: *Entartete Kunst: Geschichte und Moral* (Frankfurt am Main, 1969)

A. Hentzen: *Die Berliner Nationalgalerie im Bildersturm* (Cologne, 1971)

Die Beschlagnahme-Aktion im Landesmuseum Hannover, 1937 (exh. cat., intro. K. Sello; Hannover, Kstver., 1983)

Verboten-Verfolgt: Kunstdiktatur im 3. Reich (exh. cat., intro. S. Salzmann; Duisburg, Lehmbruck-Mus.; Hannover, Kstver.; Wilhelmshaven, Ksthalle; 1983)

Das Schicksal einer Sammlung: Die neue Abteilung der Nationalgalerie im ehemaligen Kronprinzenpalais (exh. cat., W. Berlin, Staatl. Museen Preuss. Kultbes., 1986)

Künstlerschicksale im Dritten Reich in Württemberg und Baden (exh. cat., Stuttgart, 1987)

Nationalsozialismus und entartete Kunst, 2 vols (exh. cat., ed. P. K. Schuster; Munich, Haus Kst, 1987–8)

Angriff auf die Kunst: Faschistische Bildersturm von 50 Jahren (exh. cat., Weimar, Ksthalle, 1988)

Stationen der Moderne (exh. cat., foreword J. Merkert; W. Berlin, Berlin. Gal., 1988)

Degenerate Art: The Fate of the Avant-garde in Nazi Germany (exh. cat. by Stephanie Barron, Los Angeles, CA, Co. Mus. A., 1991)

ANITA KÜHNEL

Environmental art

Art form based on the premise that a work of art should invade the totality of the architecture around it and be conceived as a complete space rather than being reducible to a mere object hanging on a wall or placed within a space. This idea, which became widespread during the 1960s and 1970s in a number of different aesthetic formulations, can be traced back to earlier types of art not usually referred to as environments: the wall paintings of ancient tombs, the frescoes of Roman or of Renaissance art and the paintings of Baroque chapels, which surround the spectator and entirely cover the architectural structure that shelters them. Indeed, the whole of art history prior to the transportable easel picture is linked to architecture and hence to the environment. A number of artists in the 1960s conceived environmental art precisely in order to question the easel painting.

In the first half of the 20th century, numerous antecedents of modern environments were created. The Futurists, notably Giacomo Balla, studied spatial ambience. In 1917 in Moscow, Aleksandr Rodchenko, Vladimir Tatlin and Georgy Yakulov designed the Café Pittoresque where the constructions seemed to be projected into space. Another collaboration between several artists in a public place, the Aubette entertainment complex in Strasbourg (1926; destr.) designed by Hans Arp, Sophie Taeuber-Arp and Theo van Doesburg, showed a kind of explosion of geometric forms in space. Closer still to the idea of an environment was El Lissitzky's use of the exhibition space at the van Diemen Gallery in Berlin in 1922 at the Erste Russische Kunstausstellung, which resulted in his *Proun Space* (1923; reconstruction Eindhoven, Stedel. Van Abbemus.); reliefs in painted wood were scattered over the walls and in the corners of a room the dimensions of which were very precisely calculated. Painting had emerged from the frame of the picture to fill the entire space. Piet Mondrian similarly transformed his studio in Paris into a virtual environment in accordance with his theories of Neo-plasticism. From 1923 to 1937 Kurt Schwitters constructed his *Merzbau*, a type of three-dimensional collage that gradually filled his living area in Hannover (destr. 1943). In this way, the idea of the environment began with the application in space of theories expressed in painting but which could no longer be contained within a two-dimensional surface. This was still true of the participation by Lucio Fontana in the exhibition *Spatial Ambience* (Milan, Gal. Naviglio, 1949), in which he created luminous spaces with fluorescent or neon light.

When the concept of the environment proper appeared in the 1960s, it was generally in the

context of live PERFORMANCE ART and Happenings, and in this respect it had its roots also in the international Surrealist exhibitions held during the 1930s and 1940s. These had been conceived as theatrical events, which made use of new materials or unlikely objects, such as the kilometres of string strung about the *First Papers of Surrealism* exhibition at the Reid Mansion, New York, by Marcel Duchamp in 1942. When Yves Klein exhibited *The Void* at the Galerie Iris Clert in Paris (1958), and when Arman responded by designing *Fullness* (1960) in the same place, transforming the gallery into an enormous dustbin, they were inaugurating a kind of environmental work that could be neither transported nor transposed. These were ephemeral, provocative creations, noncommercial by definition although exhibited in a gallery. They are manifestos forming a basis for all the artists' other work. At the same time in New York, Allan Kaprow was creating environments: *Yard* (1961) filled the Martha Jackson Gallery with car tyres. Together with other artists such as Jim Dine, Robert Whitman (*b* 1935) and Claes Oldenburg, he transformed and adorned premises, creating spaces for Happenings. In 1961 Oldenburg exhibited *The Store*, an exhibition and sale of painted sculptural replicas of food and other consumer items. Pop artists, Nouveaux Réalistes and other sculptors of the period were thus major exponents of environmental art in the early 1960s: examples include Christo's *Windows*, Edward Kienholz's *Tableaux* and George Segal's life-size figures in architectural settings. An entire exhibition, *Dylaby* (Amsterdam, Stedel. Mus., 1962), was presented as a succession of ludic environments designed by Robert Rauschenberg, Martial Raysse, Jean Tinguely and others. With Niki de Saint Phalle and Per Olof Ultvedt, Tinguely also made *She* (1966; Stockholm, Mod. Mus.), a giant sculpture of a woman into which the visitor entered.

At almost the same time, another category of environmental art emphasized the optical or sonorous nature of the space created. Kinetic artists willingly abandoned the easel painting for the complete space: Jesús-Rafael Soto created *Penetrables*, cubes of plastic shafts among which observers could lose themselves. The Groupe de Recherche d'Art Visuel invented uncertain pathways, implying an invitation for spectator participation. Several Italian artists (Getulio Alviani, Gianni Colombo and Enrico Castellani) perfected pared-down spatial environments, while others, such as Takis, linked sculpture and sound.

During the 1970s environmental art developed further still. Joseph Beuys and such Arte Povera artists as Jannis Kounellis and Mario Merz filled their spaces with humble materials not normally associated with sculpture. Dan Flavin and Californian artists such as Robert Irwin, James Archie Turrell (*b* 1943) and Doug Wheeler (*b* 1939) created spaces of light where volume is barely perceptible. Others created large-scale paintings directly on walls (e.g. Sol LeWitt's *Wall Drawings*) or linked to the space around them. Daniel Buren developed the idea of the *in situ* work of art, conceived specifically in relation to the architecture around it. American artists of the same generation explored the concept of site-specificity, for example Richard Serra's large-scale sculptures, Walter De Maria's *New York Earth-room* (1977; New York, Dia A. Found.) and Bruce Nauman's corridors: narrow spaces through which spectators were led in order to find, for example, their own image reflected in a television set.

Environmental art thus covers a number of extremely diverse visual tendencies culminating in an extension of the object to incorporate the surrounding space. The idea that spectators could enter the painting or sculpture, and that in being surrounded by it they are in some way part of it, has emerged as a more significant and unifying factor in the art of the second half of the 20th century than any single aesthetic formula.

Bibliography

12 Environments (exh. cat., Berne, Ksthalle, 1968)

Räume und Environments (exh. cat., Cologne; Opladen; 1969)

G. Kepes: *Arts of the Environment* (New York, 1972)

G. Celant: 'Artspaces', *Studio Int.*, cxc/977 (1975), pp. 114–23

F. Popper: *Art: Action and Participation* (New York, 1975)

G. Celant: *Ambiente/Arte: Dal futurismo alla Body art* (Venice, 1977)

Le stanze (exh. cat., ed. A. Bonito Oliva; Genazzano, Castello Colonna, 1979) [It./Eng. text]

Pittura-Ambiente (exh. cat. by R. Barilli and F. Alinova, Milan, Pal. Reale, 1979)

Für Augen und Ohren (exh. cat., E. Berlin, Akad. Kst. DDR, 1980)

ALFRED PACQUEMENT

Equipo Crónica [Sp.: 'the chronicle team']

Spanish group of painters formed in 1964 and disbanded in 1981. Its original members were Rafael Solbes (1940–81), Manuel Valdés (*b* 1942) and Juan Antonio Toledo (*b* 1940), but Toledo left the group in 1965. They worked collaboratively and formed part of a larger movement known as Crónica de la Realidad, using strongly narrative figurative images that were formally indebted to Pop art and that had a pronounced social and political content directed primarily against Franco's regime.

Both Solbes and Valdés studied at the Escuela de Bellas Artes de San Carlos in Valencia, but they came into close contact only in summer 1964 when they were included by the Valencian critic Vicente Aguilera Cerni in an exhibition, *España libre*, staged in Italy. This and another exhibition at the Ateneo Mercantil in Valencia, in which they participated with other young Valencian artists, led them to formulate a new concept of painting, Valdés having previously practised a kind of *Art informel* and Solbes an expressionism with subject-matter related to socially-committed literature.

From 1964 to 1966 the Equipo Crónica was heavily influenced by the theorist Tomás Llorens and closely involved with another group, Estampa Popular, with whom they participated in several demonstrations and anti-Franco activities. They remained in Valencia and from 1967 until the dissolution of the group on the death of Solbes in 1981 explored the narrative implications of their earlier pictures by working in series. The generic titles and subject-matter of these groups of works, such as *Recovery* (1967–9; see 1974 exh. cat., pp. 12–22), *Guernica 69* (1969; see 1974 exh.

cat., pp. 23–7), *Police and Culture* (1971; see 1974 exh. cat., pp. 33–42) and *The Poster* (1973; see 1974 exh. cat., pp. 57–62), consciously reflected the political climate of the period and the evolution of Spanish society. Characteristically they recycled images that were already familiar from the history of European painting, freely and ironically making reference to styles as diverse as Impressionism, Expressionism and Cubism and to particular works by modern masters such as Paul Cézanne and Pablo Picasso, and appropriating from the mass media a formal language of flat colours, unusual perspectives and techniques derived from photographs. Their use of confrontational methods such as deconstruction, deliberate anachronisms and irrational collage, especially in their later pictures, owed much to the experimental work of Gilles Aillaud (*b* 1928), Antonio Racalcati and Eduardo Arroyo, not only in stylistic terms but in their political stance and questioning of the concept of the avant-garde.

Bibliography

T. Llorens: *Equipo Crónica* (Barcelona, 1972)

Equipo Crónica (exh. cat. by T. Llorens, Saint-Etienne, Maison Cult.; Rennes, Maison Cult.; Pau, Mus. B.-A.; 1974)

Equipo Crónica (exh. cat., Seville, Cent. A. M-11, 1975) [with text by the group]

Equipo Crónica (exh. cat., intro. G. Busmann; Frankfurt am Main, Kstver.; Karlsruhe, Bad. Kstver.; 1977)

Equipo Crónica (exh. cat. by V. Bozal, T. Llorens and J. F. Yvars, Madrid, Bib. N., 1981)

Equipo Crónica: Sèries 1979/81: Paisatge urbà; Els viatges; Crónica de transició (exh. cat. by V. Bozal, T. Llorens and J. F. Yvars, Barcelona, Gal. Maeght, 1981)

M. DOLORES JIMÉNEZ-BLANCO

Escuelas de Pintura al Aire Libre

Open-air painting schools developed in Mexico as artistic teaching projects for broad sections of the population during the period of the Revolution (1910–17). The first phase of their existence took place under Victoriano Huerta's government (1913–14), and their structure was established under the government of Alvaro

Obregón (1920–24). Alfredo Ramos Martínez was the project's main promoter, supported by civil servants, intellectuals and artists. The precepts by which art was to be taught were based on those of John Dewey's Action School in the USA; children and adolescents, farmers and factory workers were to meet and develop their own ideas with sincerity and simplicity, taking as their model the Barbizon school of landscape painting, with its devotion to contact with untamed nature. The first of the *escuelas*, situated at Santa Anita Ixtapalapa on the outskirts of Mexico City, was named Barbizon. Impressionism, a great deal of naive art and a certain involuntary expressionism were all blended together in the works of the students, who needed no formal qualifications to enter the schools. David Alfaro Siqueiros was among them. The project was extended to Chimalistac and moved on in 1921 to Coyoacán, where an attempt was made to involve native Mexicans and mestizos in order to encourage the production of a uniquely Mexican art. Under the government of Plutarco Elías Calles (1924–8), the open-air painting schools system was expanded to include branches in Xochimilco, Tlálpan and Guadalupe Hidalgo. This expansion, which reached the states of Michoacán and Puebla in the 1930s, was due to the enormous need for expression that arises in periods of transition and social upheaval, when a society's cultural traditions are under attack. In 1932 the schools' name was changed to Escuelas Libres de Pintura; entry requirements were also changed. In 1935 government subsidies, already reduced, finally ceased, and the schools went into decline. The Tasco school, under the Japanese director Tamiji Kitagawa (1894–1990), was the last to disappear in 1937, having survived for two years on local resources. Several thousand students attended the open-air painting schools, and their works were exhibited in Berlin, Paris and Madrid in 1926 with great success. During their rise to fame, the schools were enthusiastically supported by Diego Rivera, Alfonso Reyes (1889–1959), Pierre Janet (1859–1947), Eugenio d'Ors and Dewey; during their decline, they were criticized by Siqueiros and Rufino Tamayo.

Bibliography

R. Martínez and others: *Monografía de las Escuelas de Pintura al Aire Libre* (Mexico City, 1926)

Homenaje al movimiento de Escuelas de Pintura al Aire Libre (exh. cat. by S. Pandolfi and others, Mexico City, Inst. N. B.A., 1981)

Escuelas de Pintura al Aire Libre y Centros Populares de Pintura (exh. cat., Mexico City, Inst. N. B.A., 1987)

S. Pandolfi: 'The Mexican Open-Air Painting Schools Movement (1913–1935)', Images of Mexico: The Contribution of Mexico to 20th Century Art *(exh. cat., ed. E. Billeter, Frankfurt am Main, Schirn Ksthalle; and elsewhere, 1988), pp. 123–8*

RAQUEL TIBOL

Estonian Artists' Group [EKR; Est. Eesti Kunstnikkude Rühm]

Estonian group of painters and sculptors active from 1923 to *c.* 1930. The group continued the progressive internationalist orientation of their predecessors in the YOUNG ESTONIA movement and united a new generation of painters committed to Cubist experimentation. The group was founded in Tartu by Eduard Ole (*b* 1898) and Friedrich Hist (1900–41), joined by Felix Randel (1901–77, named Johansen until 1936). Their work, like that of much of their colleagues, was primarily distinguished by modest geometricized abstraction and decorative colourism suggested by Synthetic Cubism, rather than by explorations of simultaneity, collage etc. It also often displayed strong characteristics of NEUE SACHLICHKEIT and PURISM. The earliest Estonian practitioners of Cubism were among the group's members: Jaan Vahtra (1882–1947) and Hist, who from 1921 studied in Latvia, where he kept company with the modernists of the RIGA ARTISTS' GROUP. In 1924 EKR exhibited in Tartu and Tallinn with the Latvians, by which time membership had grown with the critical additions of Märt Laarmann (1896–1979), Arnold Akberg (1894–1984) and Henrik Olvi (1894–1972). Akberg and Olvi created some of EKR's most radical work, with Akberg investigating non-objectivity in a Cubo-Constructivist manner and Olvi executing rigorous architectonic compositions. Laarmann is credited as the group's

ideologue, having written their manifesto, *The New Arts Book*, published in 1928. Other members included the sculptor Juhan Raudsepp (1896–1984) and Edmond-Arnold Blumenfeldt (1903–46). While Blumenfeldt's art was more Expressionistic, Raudsepp worked in the group's distinctive abstract geometric style, which was revived in the 1970s by Estonian nonconformist artists such as Tõnis Vint and Leonhard Lapin.

Bibliography

Kunst in Tallinn und Estland, vom Mittelalter bis zur Gegenwart (exh. cat., Kiel, Christian-Albrechts U., Ksthalle; Schleswig-Holstein. Kstver.; 1976)

E. Komissarov: 'Estniska konstnärsgruppen' [The Estonian Artists' Group], *Oväntatmöte: Estnisk och lettisk modernism från mellankrigstiden* [Unexpected meeting: Estonian and Latvian modernism from the period between the wars] (exh. cat., Stockholm, Liljevalchs Ksthall, 1993), pp. 27–36

MARK ALLEN SVEDE

Estridentismo

Mexican group of writers and artists, active between 1921 and 1927. The group's members included Silvestre Revueltas (1899–1940), Fermín Revueltas, Leopoldo Méndez, Ramón Alva de la Canal and Germán Cueto, and the writers Arqeles Vela and Germán List Arzubide, with Diego Rivera and Jean Charlot as sympathizers. All were keen to stress the importance of cosmopolitanism. They followed Futurism in a complete rejection of academicism and Symbolism in the arts, although no limits were imposed on what should replace these, and their ideal of making art public and accessible corresponded with that of the mural movement in Mexico. This aim at a cultural revival was initially expressed through a manifesto published in the first issue of the periodical *Actual*, written by the poet Manuel Maples Arce, who initiated the trend. The manifesto included a directory of avant-garde artists and writers of all contemporary styles, probably compiled with the help of Rivera and Charlot, who had recently returned from Paris. It called on Mexican intellectuals to unite and form a society of artists, claiming 'the need

to bear witness to the vertiginous transformation of the world'. Maples Arce recommended rapid action and total subversion as an immediate strategy, and looked to the USSR for ideological inspiration. Taking an iconoclastic attitude, he condemned religiosity and patriotism. The generally incoherent and aggressive manifesto borrowed from Marinetti's Futurist manifestos and Spanish Ultraist ideas. The group's ideas were further propagated by the periodicals *Irradiador* (1924) and *Horizonte* (1926–7), the latter being published by their own publishing house, Ediciones Estridentistas. Public meetings and casual exhibitions at the Café de Nadie, Mexico City, were also held.

Writings

M. Maples Arce: 'Hoja de vanguardia comprimido estridentista', *Actual*, 1 (1921)

G. List Arzubide: *El movimiento estridentista* (Mexico City, 1926)

Bibliography

L. M. Schneider: *El Estridentismo: Una literatura de la estrategia* (Mexico City, 1970/R 1997)

S. Fauchereau: 'The Stridentists', *Artforum*, xxiv (Feb 1986), pp. 84–9

Art in Latin America: The Modern Era, 1820–1980 (exh. cat. by D. Ades and others, London, Hayward Gal., 1989), pp. 131–2, 306–9 [contains reprint of manifesto]

L. Schneider: *Estridentismo o una literatura de la estrategia* (Mexico City, 1997)

ELISA GARCÍA BARRAGÁN

European School [Hung. Európai Iskola]

Hungarian artistic group formed in 1945 and active in Budapest until 1948. It was modelled on the Ecole de Paris and founded on the belief that a new artistic vision could only be established from a synthesis of East and West. According to its programme, it represented Fauvism, Cubism, Expressionism, abstract art and Surrealism in Hungary. The aim of its members was to organize exhibitions, publish writings and encourage contact between artists. Members included the art historians and critics Ernő Kállai, A'rpád Mezei

and Imre Pán, and painters in the group included, among others, Margit Anna, Jenô Barcsay, Endre Bálint, Béla Czóbel, József Egry, Jenô Gadányi, Dezső Korniss, Tamás Lossonczy, Ferenc Martyn and Ernő Schubert. Among the sculptors were Dezső Bokros Birmann, Erzsébet Forgách Hahn, Etienne Hajdu (in Paris), József Jakovits and Tibor Vilt. Marcel Jean, the Surrealist theorist who lived for a while in Budapest, was an honorary member, while Imré Amos and Lajos Vajda were looked to as role models. The group did not adhere to a unified style; for example, while Jenő Gadányi's *Fantastical Landscape* (1948; Budapest, N.G.) was Expressionist, Jenő Barcsay's *Street* (1946; Budapest, N.G.) was influenced by Cubism. The members sought to use both organic and inorganic forms to balance rationalism and intuition in their work. The majority of them started from the Constructivist–Surrealist scheme introduced by Lajos Vajda. Some of them produced 'bioromantic' work after World War II. Others worked towards monumentality through Expressionist–Constructivist works. They organized 38 exhibitions of members' (and some foreign) work.

The group published a series of books on aesthetics under the titles *Index Röpirat* ('Index leaflet') and *Vitairat-könyvtár* ('Debate library') and the periodical *Európai Iskola Könyvtáta* ('European School library', 1946–7). Stalinist cultural policy denounced the European School as decadent for its relationship with 20th-century artistic trends, and in November 1948 all further exhibitions by the group were banned; the members either withdrew to the countryside or pursued their activities abroad.

Writings

Index Röpirat [Index leaflet] (Budapest, 1946)
Vitairat-könyvtár [Debate library] (Budapest, 1946)

Bibliography

B. Hamvas, K. Kemény: *Forradalom a müvészetben: Absztrakció és szurrealizmus Magyarországon* [Revolution in fine art: abstraction and surrealism in Hungary] (Budapest, 1947)
E. Kallai: *A természet rejtett arca* [The hidden face of nature] (Budapest, 1947)
P. Kiss: *Az ember felé* [Towards the man] (Budapest, 1948)
A. Mezei: 'Vajda Lajos és az Európai Iskola' [Lajos Vajda and the European School], *Müvészettörténeti Tanulmányok* (1960), pp. 215–19
S. Mándy: *Az Európai Iskola és előzményei* [The European School and its antecedents] (Budapest, 1962)
S. Láncz: 'L'Ecole européenne', *Acta Hist. A. Acad. Sci. Hung.*, xxi (1975), no. 1–2, pp. 167–94
P. György and G. Pataki: *Európai Iskola* [The European School] (Budapest, 1990)
Wille zur Form (exh. cat., Vienna, Hochsch. Angewandte Kst, 1993)

ÉVA BAJKAY

Euston Road School

Name given by Clive Bell in 1938 to a group of English painters associated with the School of Drawing and Painting established in October 1937 by William Coldstream, Claude Rogers (*b* 1907) and Victor Pasmore, in a review of the exhibition *15 Paintings of London* (Oct-Nov 1938; London, Storran Gal.). The school was initially in Fitzroy Street, but it moved soon after to premises at 314/316 Euston Road. The term was quickly broadened to describe a movement encompassing as many as 30 other painters, many of them former students of the Slade School of Fine Art, including Rodrigo Moynihan, Lawrence Gowing (*b* 1918), William Townsend (1909–73), Graham Bell, Anthony Devas (1911–58) and Geoffrey Tibble (1909–52).

The Euston Road painters worked essentially in a realist tradition, reacting in part against modernist tendencies (especially Surrealism and abstract art) but also responding to the conditions engendered by the Depression, which they felt called for a socially committed art. These political concerns led Coldstream and Bell to work briefly in Bolton in 1938 in association with the Mass observation investigative project, resulting in paintings such as Coldstream's *Bolton* (1938; Ottawa, N.G.). They spoke of being guided by an aesthetic of verification, rather than one of discrimination, using restrained colours and brushwork and applying strict procedures of measurement to their treatment not only of landscapes and cityscapes but also of interior scenes

with figures, such as Graham Bell's *The Café* (1937–8; Manchester, C.A.G.). The school closed shortly after the outbreak of World War II, and an exhibition at the Ashmolean Museum, Oxford, in 1941, marked the official end of the movement. Many of the painters, however, remained active after the war, teaching and (with the exception of Pasmore, who turned to abstract art) continuing to work in a similar manner. Their aesthetic had a long currency in England, particularly through Coldstream's role as Slade Professor from 1949 to 1975.

Bibliography

C. Harrison: *English Art and Modernism, 1900–1939* (London, 1981), pp. 333–43

B. Laughton: *The Euston Road School: A Study in Objective Painting* (Aldershot, 1986)

British Art in the 20th Century (exh. cat., ed. S. Compton; London, RA, 1987)

DAVID CAST

Exat-51 [Eksperimentalni atelje; Croat.: 'experimental atelier']

Croatian group of artists active in Zagreb from 1950 to 1956. Its members were the architects Bernardo Bernardi (1912–85), Zdravko Bregovac (*b* 1924), Zvonimir Radić (1921–83), Božidar Rašica (1912–92), Vjenceslav Richter (*b* 1917) and Vladimir Zarahovič, and the painters Vlado Kristl (*b* 1922), Ivan Picelj and Aleksandar Srnec (*b* 1924). On 7 December they united officially at the plenary meeting of the Association of Applied Artists of Croatia (Croat. Udruženje likovnih umjetnika primijenjenih umjetnosti Hrvatske (ULUPUH)), at which time they proclaimed their manifesto. The group was formed to protest against the dominance of officially sanctioned Socialist Realism and the condemnation of all forms of abstraction and motifs unacceptable in Communist doctrine as decadent and bourgeois. In its manifesto, Exat-51 emphasized that such an attitude contradicted the principles of Socialist development, that the differences between so-called 'pure' art and 'applied' art were non-existent and that abstract art could enrich the field of visual communication. The activity of the group was therefore to spring from the existing social situation and, as such, to contribute to the progress of society. The principal intention was to attain a synthesis of all branches of the fine arts and to encourage artistic experimentation. At the first Exat-51 exhibition in February 1953, held in Zagreb at the Hall of the Architects' Society of Croatia, works by Picelj, Kristl, Srnec and Rašica were featured; the exhibition was later shown in Belgrade. The group made an important contribution in helping to free Yugoslav artists from predominant Stalinist dogmas, and its members later continued to work in a more individual manner, still adhering, however, to the main ideas set out in the manifesto.

Bibliography

J. Denegri and Ž. Koščević: *Exat-51, 1951–56* (Zagreb, 1979)

JURE MIKUŽ

Expressionism

International movement in art and architecture, which flourished between *c.* 1905 and *c.* 1920, especially in Germany. It also extended to literature, music, dance and theatre. The term was originally applied more widely to various avant-garde movements: for example it was adopted as an alternative to the use of 'Post-Impressionism' by Roger Fry in exhibitions in London in 1910 and 1912. It was also used contemporaneously in Scandinavia and Germany, being gradually confined to the specific groups of artists and architects to which it is now applied.

1. Painting, graphic arts and sculpture

Expressionism in the fine arts developed from the Symbolist and expressive trends in European art at the end of the 19th century. The period of 'classical Expressionism' began in 1905, with the foundation of the group DIE BRÜCKE, and ended *c.* 1920. Although in part an artistic reaction both to academic art and to Impressionism, the movement should be understood as a form of 'new Humanism', which sought to communicate man's spiritual life. It reflected the deep intellectual

unrest *c.* 1900, reflected in contemporary literary sources, about the destruction of the traditional relationship of trust between man and the world. This was set against 19th-century notions of reality. Art took on a new and crucially different role, no longer being used, as previously, to reproduce that which was visible, but rather to 'make things visible' (Paul Klee). The motivating forces or 'inner communication' were considered to be the only concepts worth portraying. A young generation of artists believed that the traditional artistic medium was inadequate to enable them to do this. In order to communicate the human spiritual condition the Expressionists made use of new, strong, assertive forms, often violently distorted, symbolic colours and suggestive lines. Their work also showed an interest in Primitivism (*see* Primitivism, §2).

(i) Origins and developments in Germany

(a) Origins. The roots of Expressionism lay in international developments of the late 19th century, although the German Expressionists always emphasized their independence from every foreign influence. Crucial impulses came, for example, from Norway, the Netherlands and Belgium, countries that had, like Germany, an old tradition of expressive art. Gauguin and the Nabis as well as the Swiss artist Ferdinand Hodler, were also involved with its pioneering ideals. In Germany before 1900 such local schools as those at the artists' colonies of Dachau or Worpswede developed intensely expressive landscape painting, in which stylized depictions of nature represented overpowering emotional experiences, as in German Romantic painting. These lyrical images of nature, linked to similar ideas in *plein-air* painting and *Jugendstil*, significantly influenced Expressionism. Another important influence during the first phase of Expressionism was the use of pure colours developed in Neo-Impressionism and Fauvism.

The work of Vincent van Gogh, Edvard Munch and James Ensor was still more important. These artists inspired a feeling of spiritual kinship in others and promoted several ideas, which were as yet unclear, about an art that could express spiritual dimensions. This potential was exemplified by van Gogh, in both his tragic life and work, characterized by an intensely expressive use of pure colours, and dynamic brushstrokes and outlines. Munch's work transformed people and landscapes into images representing dramatic tensions arising from areas of the psyche that had hitherto been taboo. The expressive strength of the symbolic colours and lines developed traditional motifs into images of the artist's psychological world. The tormented, hallucinatory view of the world of masks and phantoms painted by Ensor was equally characteristic of the Expressionists' sense of alienation. Expressionism developed in Germany not as a 'style', but rather as an 'ideology' formed by a sense of spiritual unity, although with no theoretically defined goal. It arose simultaneously in many places in Germany and was not confined to one generation: even such an established artist as Lovis Corinth responded to its impulses.

(b) Artists' groups. One of the early Expressionist centres was in northern Germany, the home of such painters as Emil Nolde, Christian Rohlfs and Paula Modersohn-becker, and of the sculptor Ernst Barlach. Their intuitive, untrained art was inspired by an awareness of the close link between man and nature, and eschewed both literary and classical influences. A second, stronger impulse came from central Germany. Here the artistic revolution after 1900 was a conscious, more intellectual process. Its focal-point was Die Brücke, founded in Dresden with the aim of 'attracting all the elements of revolution and unrest'. The founder-members were Erich Heckel, Ernst Ludwig Kirchner, Karl Schmidt-rottluff and Fritz Bleyl (1880–1966), who were later joined by others, including Max Pechstein, Cuno Amiet, Kees van Dongen, Otto Mueller and (briefly) Nolde. They were interested in the work of such artists as the French Neo-Impressionists, van Gogh and Munch. Like other Expressionists, their rejection of traditional Western aesthetic values led to an interest in non-European art, in particular from Africa and the Pacific islands, where both Nolde and Pechstein travelled. They also turned to the literature of Scandinavia (e.g. Henrik Ibsen and August Strindberg) and Russia (e.g. Fyodor

Dostoyevsky) as sources of inspiration. They were passionate graphic artists, like the northern Germans.

Die Brücke was the essential catalyst for German Expressionism. It reached its artistic climax after its members moved between 1910 and 1914 to Berlin. There they drew on contemporary themes, depicting the bright and dark sides of city life: people living under psychological pressure or with an eroticism that often had morbid overtones, as well as scenes from the circus and music-halls. All their themes expressed the human condition under extreme stress prior to the out-break of World War I. Such psychologically intense subjects demanded a painting of extraordinary communicative force. The Berlin works document the mature Expressionism of Die Brücke at its most intense. Even after the group's dissolution in 1913, Kirchner continued to produce some of the most powerful Expressionist paintings, for example *Street Scene* (1914–25; Madrid, Mus. Thyssen-Bornemisza; see fig. 17).

The artists of Die Brücke exemplified certain qualities that came to characterize Expressionism as a whole. Henceforth, the extent of an artist's heightened emotional involvement was seen as an important element in determining the status and quality of the work of art. The role of the artist in society was also altered. Expressionist artists considered themselves to be both provocative and esoteric. They not only demanded publicity, asking others to join together under the revolu-tionary banner, but also espoused elitist princi-ples, as expressed in the quotation '*odi profanum vulgus*' used by Kirchner in *Chronik der Künstlergemeinschaft Brücke* (Berlin, 1913). This double role formed part of the Expressionist artist's image as a 'wild' person, a destroyer of traditional values. In future the public became used to seeing the artist no longer as a sacred guardian of traditions but rather as a prophet, who ruthlessly broke social conventions.

Although Die Brücke was widely influential, the Expressionism of southern Germany diverged from the exalted form of personal expression prevalent among the artists in northern and central Germany. For the BLAUE REITER group in

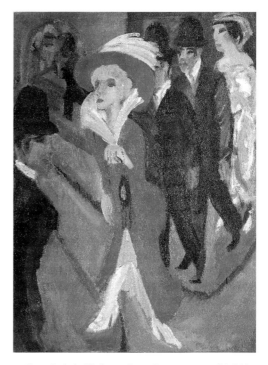

17. Ernst Ludwig Kirchner: *Street Scene*, 1914–25 (Madrid, Museo Thyssen-Bornemisza)

Munich, imagination was the source of inspiration in a pantheistic world-view: the group's members expressed a new poetry about nature and an urge towards mystical spiritualization, which included a strong eastern European element, as interpreted by the Russian artists, Vasily Kandinsky (see col. pl. XVIII) and Alexei Jawlensky. The painters in Munich aimed to create an image that would portray the 'mystic inner construction' of the world, a notion that Franz Marc developed. This spirituality became the basis for a move towards complete abstraction, completed by Kandinsky in 1910. There was also a strong French influence in Munich, particularly from Robert Delaunay and the Fauves, which brought with it an openness towards foreign influences. This was in contrast to north German Expressionism, which was intro-verted by nature and tended to concentrate on its own problems. Both tendencies were, however, linked by the sense of a need to find the point

where the outer and inner worlds met—their common inheritance from German Romanticism. This was, however, achieved pictorially in different ways. The northern artists concentrated on elementary, pictorial qualities that were expressive, rather than aesthetic, for example strong colours without much tonal subtlety. The Blaue Reiter painters developed a luminous, sensitive palette, rich in different tonal values, analogous to music, which was an aspect that greatly interested Kandinsky.

Western German Expressionism comprised the 'Rheinische Expressionisten' (August Macke, Walter Ophey (1882–1930), Heinrich Campendonk and others) and the 'Westfälische Expressionisten' (Eberhard Viegener (b 1890), Wilhelm Morgner, and Heinrich Nauen). Unlike the close association of Die Brücke, these were loose alliances of artists with fundamentally different characters and temperaments, who came together for various lengths of time. Expressionism was also promoted in Berlin by Herwarth Walden's periodical *Der Sturm* (founded 1910), and by his Sturm-Galerie (founded 1912). These played an important role in furthering the Expressionist cause, as well as the whole of the modern art movement in Berlin. The group Die Pathetiker (founded 1912 by Ludwig Meidner, Jacob Steinhardt and Richard Janthur (b 1883)) also worked there, as did Otto Dix, George Grosz and Max Beckmann periodically: the latter three artists all experimented with Expressionism, before developing more realistic styles. The Austrian artist Egon Schiele also exhibited in Berlin in 1916.

(c) *Printmaking.* The image of northern and central German Expressionism was determined not only by painting but also by graphic art, in particular woodcuts. This technique was used by such precursors of Expressionism as Munch and Gauguin, and culminated in the printed graphic work of the painters of Die Brücke, and Rohlfs and Nolde (e.g. *The Prophet*, 1912; Seebüll, Stift. Nolde). No other medium was as well suited as the woodcut to evoking strong emotional tensions by contrasting black-and-white planes or two basic colours, or to making such expressive use of its rudimentary roughness, without any pictorial illusion of bodies, shadows or space. Like Gothic woodcutters, they both designed and cut the blocks, even printing the copies themselves. Like Munch, they preferred the texture of blocks cut along the grain. The resistance of the brittle material was exploited for its expressive potential. Some of the best Expressionist woodcuts were produced during the Berlin years of Die Brücke. The urban themes of people, cityscapes, the circus and variety-hall, as well as the hectic and abnormal life-style of the city, are closely linked with the paintings of that era. Around 1910 their painting was influenced by the printmaking: the colours crowded on to the surface and were heavily outlined in black, as on woodcuts.

Despite the dominance of woodcuts, etching and lithography also played a vital role in Expressionism. Lithography could be quite graphic or painterly in its effect. It was made by applying brush, pen or chalk on to stone and printed in black-and-white or colour. This technique was already fully developed in the work of Die Brücke by 1907. Lithography was also important in the work of the sculptor Barlach, and in that of the Austrian Oskar Kokoschka, who became known in Berlin through his lithographs (see fig. 18). Some of the numerous colour prints of the period resemble watercolour, which was also one of the Expressionists' favourite techniques and exceptionally successful in the hands of Nolde and Rohlfs.

Nolde was one of the greatest Expressionist masters of etching. Other significant practitioners included Heckel and Kirchner, and later Beckmann, who were also particularly interested in drypoint. However, the paramount importance of Nolde started at the latest from the time of the famous *Hamburg Harbour* series (1910). His skilful pictorial compositions are among the most important achievements in 20th-century European graphic art.

(d) *Sculpture.* The success of Expressionist sculpture was achieved by a few important sculptors, above all Ernst Barlach, Wilhelm Lehmbruck and Bernhard Hoetger, who was also an architect. Their portraits penetrated, with striking depth, into the sitter's state of mind, as this was considered more

rot fischlein/ fischlein rot,
stech dich mit dem drei-
schneidigen messer tot
reiß dich mit meinen fingern
entzwei/
daß dem stummen kreisen
ein ende sei/

rot fischlein/ fischlein rot/
mein messerlein ist rot/
meine fingerlein sind rot/
in der schale sinkt ein
fischlein tot/

und ich fiel nieder und
träumte/ viele taschen hat
das schicksal/ ich warte bei
einem peruanischen steiner-
nen baum/ seine vielfingri-
gen blätterarme greifen wie
geängstigte arme und finger
dünner/ gelber figuren/ die
sich in dem sternblumigen
gebüsch unmerklich wie
blinde rühren/ ohne daß ein
heller/ verziehender streifen
in der dunklen luft von
fallenden sternblumen die
stummen tiere lockt/ blut-
raserinnen/ die zu vieren
und fünfen aus den grünen/
atmenden seewäldern/wo es
still regnet/ wegschleichen/
wellen schlagen über die
wälder hinweg und gehen
durch die wurzellosen/ rot-
blumigen/ unzähligen luft-
zweige/ die wie haare im
meerwasser saugend tau-
chen/ dort heraus winden
sich die grünen wogen/ und
das schreckliche meer der
untiefen und menschen-
fressenden fische/ faßt die
überfüllte galeere /oben an
den masten schwingen
käfige mit kleinen blauen
vögeln/ zieht an den eiser-
nen ketten und tanzt mit
ihr hinein in die teifune, wo
wassersäulen wie geister-
schlangen auf dem brüllen-
den meer gehen/ ich höre

18. Oskar Kokoschka: *The Dreaming Boys*, 1908 (Vienna, Historisches Museum)

important than any superficial similarity. They also took as themes extreme psychological states and human situations, including works inspired by experience of World War I (e.g. *The Avenger*, 1914). The artists' spirituality also led to religious imagery, which extended to represent general truths. The forms and expressive purpose of the sculpture are sometimes reminiscent of German Gothic art. Apart from the works of Barlach and Lehmbruck, Expressionist sculpture did not gain the international level of recognition of the painting and graphic work of this period.

Significant sculpture was also made by artists who otherwise practised painting and graphic arts, particularly the members of Die Brücke and their circle: for example, Kirchner was inspired to produce large sculptures after his meeting with Hermann Scherer in 1923. Such work was not known until relatively late and was seldom shown during their lifetimes. The favourite material was wood (also preferred by Barlach), since this was cheaper and easier to work than bronze. The Die Brücke artists' interest in sculptures from Africa and the Pacific islands, which they had seen in the collections of the Völkerkundemuseum in Dresden, clearly inspired their own sculpture in

its formal aspects. Their works, which were almost exclusively figurative, adapted, rather than copied the non-European art, in order to intensify the power of their own designs; they were later often painted. The sculptures can also often be found as motifs in the artists' paintings.

(ii) International developments and legacy of Expressionism
Although Expressionism particularly flourished in Germany, significant developments occurred in other European countries. The principal Austrian Expressionists were Schiele and Kokoschka, both of whom had been influenced by *Jugendstil* and especially Gustav Klimt. Kokoschka produced powerful Expressionist portraits, including some drawn for *Der Sturm*. Other important work was done before 1908 by Richard Gerstl, who was influenced by Arnold Schoenberg. Outside German-speaking countries, some Expressionist art was produced in Scandinavia (e.g. by Henrik Sørensen in Norway). However, the most important other group was based in the artists' colony of LAETHEM-SAINT-MARTIN in Belgium, which from 1905 developed an Expressionism dominated by rural and religious themes. Albert Servaes created a vigorous style characterized by schematic forms and sombre colours, which also informed the work of Constant Permeke, Gustave De smet and Frits Van den berghe. French art was dominated by other trends, although individual painters produced some work that showed Expressionist influences, for example that of André Dunoyer de Segonzac before World War I. Georges Rouault combined Expressionism with more traditional drawing techniques. Although such artists as Marcel Gromaire rejected the Expressionist label, their art betrayed an obvious debt: for example, work by Gromaire after World War I was heavily influenced by Flemish and (to a lesser extent) German Expressionism. The painting of Chaîm Soutine was also highly expressionistic, characterized by violent brushwork. Among sculptors active in Paris, the work of Alexander Archipenko and Ossip Zadkine also showed Expressionist influences.

The legacy of Expressionism was widespread. In Germany the period of 'Sturm und Drang' ended *c.* 1920, although a younger generation, formed by the disorders of the period of World War I, were vociferous for a long time in their support of certain Expressionist positions: in particular, the Expressionists' social criticism inspired NEUE SACHLICHKEIT. It can be argued that all later stylistic tendencies in German art have in some way been involved with Expressionism, even if only by clearly defining themselves in contrast to its formal and ideological arguments. Internationally the innovations of the Blaue Reiter undoubtedly influenced the development of later expressive abstraction. A more direct link between later movements and Expressionism was evident from *c.* 1980 in the figurative work of artists sometimes termed neo-Expressionists. These included the German Georg Baselitz and the so-called 'Neue Wilden', and the American Julian Schnabel and the *Nieuwe Beelding* movement.

Bibliography
H. Bahr: *Expressionismus* (Munich, 1920)
P. Fechter: *Der Expressionismus* (Munich, 1920)
G. Hartlaub: *Die Graphik des Expressionismus in Deutschland* (Stuttgart, 1947)
V. Apollonio: *'Die Brücke' e la cultura dell'Espressionismo* (Venice, 1952)
L.-G. Buchheim: *Die Künstlergemeinschaft Brücke* (Feldafing, 1956)
H. Neumayr: *Expressionismus* (Vienna, 1956)
B. S. Myers: *Die Malerei des Expressionismus* (Cologne, 1957)
P. Selz: *German Expressionist Painting* (Berkeley, CA, and Los Angeles, 1957)
L.-G. Buchheim: *Graphik des Expressionismus* (Feldafing, 1959)
J. Willet: *Expressionism* (London, 1970)
E. Langri: *Expressionism in Belgium* (Brussels, 1971)
E. Roters: *Europäischer Expressionismus* (Gütersloh, 1971)
W.-D. Dube: *Die Expressionisten* (Frankfurt am Main and Vienna, 1973)
P. Vogt: *Expressionismus* (Cologne, 1978; Eng. trans., New York, 1980)
R. Brinkmann: *Expressionismus* (Stuttgart, 1980)
L'Identité flamande dans la peinture moderne (exh. cat. by L. M. A. Schoonbaert and K. Peereboom, Tampa, FL, Mus.; Atlanta, GA, High Mus. A.; Lyon, Mus. B.-A.; 1980–81)
P. Kreiger and L. Reidemeister: *Meisterwerke des Expressionismus aus Berliner Museen* (W. Berlin, 1982)
S. E. Bronner and D. Kellner, eds: *Passion and Rebellion:*

The Expressionist Heritage (London and South Hadley, MA, 1983)

B. Herbert: *German Expressionism: Die Brücke and Der Blaue Reiter* (London, 1983)

German Expressionist Sculpture (exh. cat., ed. S. Barron; Los Angeles, CA, Co. Mus. A.; Washington, DC, Hirshhorn; Cologne, Josef-Haubrich-Ksthalle; 1983–4)

H. Jahner: *Künstlergruppe Brücke* (Berlin, 1984)

S. Sabarsky: *Graphics of the German Expressionists* (Milan and New York, 1984)

D. E. Gordon: *Expressionism: Art and Idea* (New Haven and London, 1987)

E. A. Powell III and B. Davis, eds: *German Expressionist Prints and Drawings: The Robert Gore Rifkind Center for German Expressionist Studies*, 2 vols (Los Angeles and Munich, 1989)

S. C. Trauger, ed.: *Bibliography of German Expressionism: Catalog of the Library of the Robert Gore Rifkind Center for German Expressionist Studies at the Los Angeles County Museum of Art* (Boston, MA, 1990)

J. Lloyd: *German Expressionism: Primitivism and Modernity* (New Haven and London, 1991)

PAUL VOGT

2. Architecture

Expressionist architecture, especially in the German-speaking area, developed during the years of political crisis preceding and following World War I. It was a protest movement in architecture with socio-political overtones and was fuelled by a solemn and euphoric belief in the future, which it strove to realize. Architecture was perceived as a substantial educational tool in refashioning human society. Pioneering developments in the fields of engineering and technology using such new building materials as steel, concrete and glass smoothed hitherto unexplored paths and seemed to open up new doors to the realization of Utopian ideas of society. The Expressionist generation of architects aimed to free form from the confines of the norm, replacing it with a direct, spontaneous communication between the idea and the product. The traditional building-unit principle was to be resolved in flowing or crystalline distortions of space. The mood of the period was reflected most radically in the Utopian phantasmagorias of Paul Scheerbart. In many written works from the turn of the century on he evoked an architecture made of glass, the light, crystalline, curving, floating images of which would transform the ways of living and thinking of the 'Old European'. However, the movement's dependence on clients who were willing to experiment, in addition to other external factors, meant that architectural practice was able to match the visionary start of Expressionism in only a restricted way. Many of its most creatively original contributions never went beyond sketches of ideas on paper. The inherently Utopian character of Expressionist architectural sketches systematically points forward to future possibilities in the development of architecture.

Significantly, the first examples of Expressionist architecture to be constructed were industrial buildings. In such commissions architects discovered what might be described as 'fallow land' which offered less resistance to experimentation. The transition to Expressionism was effected in Peter Behrens's buildings for AEG in Berlin (1903–13). They have a ceremonial character and developed as a new force from Romantic, national architecture, which was turning away from the eclecticism of the period of Emperor William II. The AEG turbine factory (1908–9) was the first German building to introduce the combination of steel and glass. Even though Behrens's buildings went far beyond pure functionalism in their expressive monumentality, they already indicated rationalist tendencies. In this they differed considerably from the contemporaneous buildings of Hans Poelzig. His water-tower (1911) in Posen (now Poznán, Poland) and his chemical factory at Luban (1911–12) were distinguished by a sculptural, dynamic, almost lyrical Expressionism, which culminated after World War I in his conversion of the Zirkus Schumann into the Grosses Schauspielhaus (1919) for Berlin. By the use of applied stalactite shapes he transformed the interior into a fan-tastic visionary cavern). The Jahrhunderthalle (1912–13) in Breslau (now Wrocław, Poland) by Max Berg can also be counted as one of the few projects realized before World War I that can be described as Expressionist. As a steel-and-concrete structure with a cupola with a bold 67 m span, it pointed in the direction of an

Expressionism that was completely in the grip of new technical achievements.

One of the important stylistic roots of Expressionism was *Jugendstil* or Art Nouveau architecture. Having begun with a formal language that was confined to surface decoration, *Jugendstil* evolved towards sculptural three-dimensionality. Such buildings as the Hochzeitsturm (1907) in Darmstadt by Joseph maria Olbrich, the Werkbund Theater (1914) in Cologne by Henry Van de Velde or the Casa Milà (1906–10) in Barcelona by Antoni Gaudí indicated a smooth transition from Art Nouveau to Expressionism. They were signposts on the way towards a new type of concrete architecture using cast sculptural shapes, though they themselves did not yet use concrete. At this point Erich Mendelsohn made his contribution; during his student years he had been closely connected with artists of the Blaue Reiter (*see* §1 (i)(b) above) and was decisively influenced by them. In numerous drawings before and during World War I he conjured up a new monolithic architecture using concrete, which aimed at overcoming the traditional structural laws relating to support and loading to achieve an organically flowing internal space. His first 'built sketch' was the Einstein Tower (1919–21) in Potsdam. It gave the impression of being a freely formed abstract sculpture. Even though it is renowned as a famous example of Expressionist architecture, at the same time it demonstrated the engineering and technical limitations of cast-concrete structures; large sections of the tower had to be made of rendered brick. Recognizing that his sketches were not (yet) able to be built, in his subsequent buildings Mendelsohn reverted at first tentatively and later more explicitly to the rectangular building unit, confining himself to 'Expressionist touches' in dynamic resolutions of corners, with a strong emphasis on a built mass that had been conceived three-dimensionally.

The political basis of the Expressionist avant-garde in Germany came to a head after World War I. The ARBEITSRAT FÜR KUNST was founded in Berlin in 1918 and shortly afterwards joined forces with the Novembergruppe, which had been set up along the same lines. Under the leadership of Walter Gropius, Bruno Taut and the architectural critic Adolf Behne, it became a political and artistic mouthpiece for architects such as Otto Bartning, Max Taut, Bernhard Hoetger, Erich Mendelsohn, Adolf Meyer and Hermann Finsterlin (1887–1973). In March 1919 the Arbeitsrat launched its manifesto under the heading: 'Art and the people must be united. Art should no longer be for the enjoyment of the few, but for the happiness and life of the masses. The objective is to bring the arts together under the wing of the great art of architecture.' The suppression of the Spartacist Revolution a few months later brought about a growing feeling of disillusionment, which ultimately smoothed the way for the advent of Neue Sachlichkeit and Functionalism. The Utopian visionary spirit of Expressionism lived on in reminiscences in the letter sequences emanating from the Gläserne Kette, a correspondence group that included the Taut brothers, Gropius and Finsterlin among its members. In Finsterlin's many sketches and in Taut's *Alpiner Architektur* (Hagen, 1919), Expressionism was shown at its most extreme, fully independent of any considerations as to whether it could actually be built.

The early Weimar Bauhaus, founded and directed by Walter Gropius, is also rooted in the climate of Expressionism. Its overall teaching concept was based on Expressionist ideas. Taut's concept of 'Die Stadtkrone', a Utopian secular cathedral of the people for every city, was echoed in the woodcut by Lyonel Feininger in the first Bauhaus manifesto (1919), which used the motif of the Gothic cathedral to idealize mediaeval craftsmanship and symbolize the Expressionist Utopia of the 'cathedral of the future'. Thus many of the later masters of 'Neues Bauen' (see below) went through a youthful 'Sturm und Drang' phase that had affinities with Expressionism. Ludwig Mies van der Rohe created his first design for the Friedrichstrasse office building (1919) in Berlin as a crystalline glass body, which seems to hark back in a refined form to Paul Scheerbart's visions. The same liking for acute angles and over-emphasis of verticals can be found in the Chilehaus (1921–3) in Hamburg by Fritz Höger, although here the idea

is conveyed in decorated bricks. The buildings of Rudolf Steiner in Dornach, near Basle, come into a special category (first Goetheanum, 1913–20; second Goetheanum, 1924–8). Flowing spatial distortion is an aspect they share with Expressionism, but in Steiner's buildings this derives directly from anthroposophical philosophy. Towards the mid-1920s a new trend and direction became apparent among the German architectural avant-garde under the designation 'Neues Bauen', moving away from Utopia towards reality, precise data and practical functionalism.

While the number of buildings constructed along uncompromisingly Expressionist lines in Germany remained small in the final analysis, there were countless examples in Dutch architecture, especially in Amsterdam. The AMSTERDAM SCHOOL with its publicity organ *Wendingen* (1918–31), directed by Hendrik Th. Wijdeveld, maintained close contact with the Expressionist avant-garde in Germany. Urban-planning development in Holland, however, was not subject to the drastic interruptions experienced in Germany, and the socio-political commitment of the Expressionist protest that was of prime importance in Germany was a subsidiary factor. Rather, a delight in experimenting in exotic forms was at the forefront. Among the most outstanding buildings by the Amsterdam school are the block of flats for the builder Klaas Hille (1911–12) and the Eigen Haard estate (1915–16; 1917–21), both in Amsterdam, by Michel de Klerk; the Minder Marinepersoneel (Minor marines) building (1911–13; destr.) in Den Helder by P. L. Kramer; and the Scheepvaarthuis (1912–16) in Amsterdam by J. M. van der Meij (with de Klerk and Kramer). The heyday of Dutch Expressionism was expressed in sometimes bizarre brick sculptures. In a certain respect it came to an end in 1923 with the early death of de Klerk, who had undoubtedly been the scintillating centre of the Amsterdam school. The group of architects associated with *De stijl*, who were at the opposite pole from the Amsterdam school, took over the artistic leadership of the Dutch avant-garde, influencing Functionalism, which was becoming established in Europe in the mid-1920s. Certain tendencies or aspects of Expressionism were revived in the 1950s in Brutalism and also in the poetic shell constructions of such architects as Jørn Utzon or Eero Saarinen.

Bibliography

P. H. Endt: 'Amsterdamse school', *Wendingen*, i (1918), no. 7, pp. 3–5

A. Behne: 'Wiedergeburt der Baukunst', *Die Stadtkrone*, ed. B. Taut (Jena, 1919), pp. 113–31

E. M. Hajos and L. Zahn: *Berliner Architektur der Nachkriegszeit* (Berlin, 1928)

W. Mueller-Wulckow: *Deutsche Baukunst der Gegenwart* (Leipzig, 1929)

A. Whittick: *European Architecture in the Twentieth Century*, 2 vols (London, 1950–53)

V. Gregotti: 'L'architettura dell'espressionismo', *Casabella Cont.*, 254 (1961), pp. 24–50

P. Scheerbart: *Dichterische Hauptwerke* (Stuttgart, 1962)

M. Taut and O. M. Ungers: *Die gläserne Kette: Visionäre Architektur aus dem Kreis um Bruno Taut, 1919–1920* (Berlin, 1963)

U. Conrads, ed.: *Programme und Manifeste zur Architektur des zwanzigsten Jahrhunderts* (Munich, 1964)

D. Sharp: *Modern Architecture and Expressionism* (London and New York, 1966)

W. Pehnt: *Expressionist Architecture* (London, 1973/R 1979)

Planen und Bauen in Europa, 1913–1933. Von der futuristischen zur funktionellen Stadt (exh. cat. by P. Pfaukuch, W. Berlin, Akad. Kst, 1977)

M. Tafuri and F. Dal Co: *Architektur der Gegenwart* (Stuttgart, 1977)

K. Frampton: *Modern Architecture. A Critical History* (London 1980; rev. and enlarged, 1985)

W. de Witt, ed.: *The Amsterdam School: Dutch Expressionist Architecture, 1915–1930* (New York and London, 1983)

W. Pehnt: *Expressionist Architecture in Drawings* (New York, Melbourne and Agincourt, 1985)

ITA HEINZE-GREENBERG

Färg och Form [Swed.: 'colour and form']

Swedish informal association of painters and sculptors, active from 1932. The two dominant artists were Bror Hjorth and Sven Erixson: the former created sculptures of forceful primitivism and some epic paintings in bold primary hues that echoed the decorative traditions of rustic art; the

latter painted works in a naive but spontaneous, earthy, colourful style. Other artists included Ivan Ivarson (1900–39), Ragnar Sandberg (*b* 1902), Albin Amelin (*b* 1902), Inge Schiöler (*b* 1908) and Åke Göransson (1902–42); the latter two declined into mental illness at early ages. Amelin's paintings often expressed a socio-political concern or represented sensual scenes of primitive violence.

Bibliography

R. Soderberg: *Introduction to Modern Swedish Art* (Stockholm, 1962)

O. Granath: *Another Light: Swedish Art since 1945* (Stockholm, 1982)

□

Fauvism

Movement in French painting from *c.* 1898 to 1906 characterized by a violence of colours, often applied unmixed from commercially produced tubes of paint in broad flat areas, by a spontaneity and even roughness of execution and by a bold sense of surface design. It was the first of a succession of avant-garde movements in 20th-century art and was influential on near-contemporary and later trends such as Expressionism, Orphism and the development of abstract art.

1. Definition and application of the term

The term derives from the word 'fauves', used in a review by the critic Louis Vauxcelles (*Gil Blas*, 17 Oct 1905) of the room at the 1905 Salon d'Automne where the incongruity of an Italianate bust by Albert Marquet, portrait of *Jean Baignères* (1905; France, priv. col.; see 1976 exh. cat., p. 44), surrounded by exuberantly coloured paintings by Henri Matisse, André Derain, Maurice de Vlaminck and others seemed to him like placing 'Donatello parmi les fauves'. As with other names of 20th-century movements, the label was thus pejorative in origin, in this case reflecting not only violently hostile critical reaction but also the incomprehension of the general public. Nevertheless, the painters to whom it was applied, not a consciously defined group but a loose association linked in certain cases by friendship, defiantly accepted the term as one appropriate to the violence with which they overturned academic conventions.

Gathered together under the banner of Fauvism were many different artists who had already shared the experience of working together, and whose interests and ideas about art were very similar. Scorching colours juxtaposed in full strength, used to create space and light and to express personal feelings, were essential elements of the new aesthetic. Although differently interpreted by each artist, such features could be found in their work well before 1905, as in Matisse's *Nude Study in Blue* (*c.* 1899–1900; London, Tate).

Fauvism was not a school with a precise theoretical programme, and its principles were set down only after the event, for example in Matisse's 'Notes d'un peintre' (*La Grande Revue*, 25 Dec 1908). It did, however, crystallize around Matisse, recognized as the leader of a new movement whose main protagonists were Charles Camoin, Henri-Charles Manguin, André Derain, Othon Friesz, Maurice de Vlaminck, Jean Puy, Louis Valtat, Georges Rouault and Kees van Dongen, and who were joined in 1906 by Georges Braque and Raoul Dufy. Initially they were divided into distinct groups, but the similarity of the influences on their work subsequently led to closer ties between them.

2. Historical influences and development from c. 1900

The sources of Fauvism include the work of Gustave Moreau, van Gogh and Gauguin as well as Neo-impressionism, all of which opened the way to a form of painting freed from the pictorial conventions accepted since the Renaissance. The response to these influences, however, varied according to the temperament of each artist.

Matisse, Rouault, Camoin, Marquet and Manguin had studied under Moreau, whose liberal teaching and far-sighted attitude enabled them to develop their own talents and to use colour subjectively as an expression of emotion. Conscious of his originality, Moreau told them that he was the bridge over which they would pass (P. L. Mathieu: *Gustave Moreau*, London, 1977, p. 240). On his death, his pupils dispersed.

In 1900–01 Derain and Vlaminck shared a studio at Chatou near Paris, where they investigated the possibilities of expressing space and states of mind by means of colour, as in Vlaminck's the *Bar Counter* (1900; Avignon, Mus. Calvet). Matisse was introduced by Derain to Vlaminck in 1901, thereby bringing the two Chatou artists into contact with Moreau's former pupils. Of all these artists, Vlaminck was the most indebted to van Gogh, whose work he first encountered at an exhibition at Bernheim-Jeune in Paris in 1901 and particularly at van Gogh's retrospective at the 1905 Salon des Indépendants. *Houses at Chatou* (1905–6; Chicago, IL, A. Inst.), a *Country Outing* (1905; Paris, Pompidou) and the *Red Trees* (1906–7; Paris, Pompidou; see fig. 19) are characterized by

an explosion of colour—intense, instinctive and arbitrary in its application, the impasto thick and heavily worked, and the handling violent, with dynamic brushwork—bearing the stamp of a temperament as passionate as van Gogh's.

Derain and Matisse, although influenced by van Gogh in their treatment of colour as an independent constructive element, particularly during their stay at Collioure near Perpignan in the summer of 1905, initially took their direction from Neo-Impressionism. They were less interested in scientific theories of the optical mixture of colour or in Seurat's pointillist technique than in the broader mosaic-like marks of Paul Signac and Henri-Edmond Cross. *Luxe, calme et volupté* (1904–5; Paris, Pompidou), executed in the

19. Maurice de Vlaminck: *Red Trees*, 1906–7 (Paris, Pompidou, Musée National d'Art Moderne)

company of Signac during the summer of 1904, is the most characteristic work from this phase of Matisse's career. It was this canvas, when exhibited at the Salon des Indépendants of 1905, that encouraged Dufy to adopt Fauvism, for in it he discerned 'the miracle of the imagination translated into line and colour' (A. Werner: *Raoul Dufy*, London, 1970, pp. 24–5).

Matisse and Derain freed themselves from Neo-Impressionism and carried the exaltation of saturated colour to its extreme at Collioure during the summer of 1905. In *Collioure* (1905; Troyes, P. Levy priv. col.; see 1976 exh. cat., p. 50) and *View of Collioure with the Church* (1905; New York, MOMA) Derain used Neo-Impressionist-derived dots or bars of colour but linked them to strips of pure colour which enriched each other in a carefully planned composition. These landscapes, along with his contemporary views of London and the Thames such as *Pool of London* (1906; London, Tate) or the *Houses of Parliament* (1905; St Tropez, Mus. Annonciade; see fig. 20), are as intense in colour as Vlaminck's work but less instinctive; the vibrations of separate brushstrokes against primed canvas sometimes appear to shatter the surface of the work.

Both Matisse's portrait of *André Derain* and Derain's portrait of *Henri Matisse* (both 1905; London, Tate) reveal a determined use of pure colour for expressive purposes. In Matisse's *View of Collioure* (1905; St Petersburg, Hermitage; see col. pl. XIX) colours appear to radiate from the picture with extraordinary power. The paint is applied in broad uninhibited strokes and

20. André Derain: *Houses of Parliament*, 1905 (St Tropez, Musée de l'Annonciade)

sometimes in large flat areas that play a key role in the spatial organization of the canvas and also mark Matisse's increasing distance from Neo-Impressionism.

Fauvism's debt to Gauguin was especially evident in the cases of Matisse and Derain, who saw a group of his late Tahitian pictures at the home of his executor, Daniel de Monfried, at Corneille-en-Conflans near Collioure. For Matisse, in works such as *Woman on a Terrace* (1906; St Petersburg, Hermitage), the influence of Gauguin can be seen in the anti-naturalistic and decorative use of colour arranged in flat planes and enclosed by a contour line. Gauguin's interest in symbolism and his search for a lost paradise away from civilization are also discernible influences in works by Matisse such as *Joy of Life*. The lessons of Gauguin's work for Derain were largely formal ones. Derain's *Charing Cross Bridge* (c. 1906; Paris, Mus. d'Orsay), for example, reveals his sensitivity to the formal and linear values of Gauguin's *Vision after the Sermon: Jacob Wrestling with the Angel* (1888; Edinburgh, N.G.), both in its organization of space by coloured masses in pure synthetic hues ringed with black and in the curving composition with rising perspective.

The impact of Gauguin's art on Fauvism was reinforced by that of French 15th-century painting, which was the subject of an acclaimed exhibition, *Primitifs français*, held in Paris in 1904 at the Pavillon de Marsan and the Bibliothèque Nationale. One of the most celebrated of such works, the Avignon *Pietà* (c. 1450), was acquired by the Louvre at that time. The Fauves found a sort of moral justification for their work in this French art, which was newly appreciated and officially condoned, yet which treated space without recourse to conventional perspective by using flat areas of saturated colour bounded by a linear style of drawing.

3. Associated developments

The appearance in 1905 of Fauvism in France was paralleled in Germany by the formation in that year of the group Die Brücke, whose art tended towards an exacerbated form of Expressionism deriving from the work of Munch, van Gogh and from much earlier sources such as Matthias Grünewald. Ernst Ludwig Kirchner, Emil Nolde, Max Pechstein, Karl Schmidt-Rotluff and Erich Heckel did have some dealings with the French Fauves, but their intense colours and expressive forms conveyed a dramatic inner anguish that was far removed from the painterly preoccupations of the French artists (see fig. 9).

Rouault, one of Matisse's fellow students in Moreau's studio, took part in the dazzling manifestation of 1905, but his preference for compassionate and religious subject-matter and for a restricted palette of blues and blacks distanced him from the mainstream of the movement. The Dutch painter Kees van Dongen also took part in the Salon d'Automne of 1905 with daring works in glowing colours that continued to characterize his art long after the demise of Fauvism. An Expressionist strain in his subject-matter and his treatment of the human figure identify him as an important link between the two movements.

4. Triumph and dissolution of Fauvism, 1905–8

On his return to Paris from Collioure, Matisse continued to use colour in what seemed a brutal way, for example in *Woman with a Hat* (1905; San Francisco, CA, W. A. Haas priv. col.; see Muller, p. 36), a portrait of his wife in which planes of shrill colour are matched for expressive and constructive purposes. It was this painting in particular that caused a scandal at the Salon d'Automne of 1905. The slightly later *Portrait with the Green Stripe* (1905; Copenhagen, Stat. Mus. Kst), in which the picture is subdivided into powerful zones of pure complementary colour, is even more concentrated in its formal organization and expressive effect.

The full flowering of Fauvism in 1906 was marked by its triumph at the Salon d'Automne, in which all the participants of the group exhibited, and by the work produced not only by the instigators of the style but by some of its more recent adherents. Manguin and Camoin painted dazzling light-filled works during the summer of 1905 at St Tropez, for example Manguin's *Fourteenth of July at Saint-Tropez, the Harbour—Left Side* (1905; Paris, Gal. Paris; see 1976 exh. cat., p. 78). Camoin

painted a lively, straightforward *Portrait of Marquet* (1904–5; Paris, Pompidou) at about this time. Marquet worked briefly in the company of the Fauves, recording their sense of common purpose in *Matisse Painting a Nude in Manguin's Studio* (1904–5; Paris, Pompidou) and then going on to work in Normandy with Dufy, a recent convert to Fauvism. Like Marquet, Dufy favoured subjects that had intrinsically brilliant colouring, as in *Street Decorated with Bunting, Posters at Trouville* and *Fourteenth of July at Le Havre* (all 1906; Paris, Pompidou). The Fourteenth of July, with its joyful fanfare of flags of red, white and blue, proved an irresistible Fauve subject; in 1906 Marquet also painted such a scene, *Fourteenth of July at Le Havre* (Bagnols-sur-Cèze, Mus. Bagnols-sur-Cèze). Marquet's friend Othon Friesz adopted Fauvism at Auvers-sur-Oise in 1906, and in *Landscape at La Ciotat* (1907; Troyes, Mus. A. Mod.) he employed a violent range of colours and a freedom of handling reminiscent of van Gogh in its twisting lines of trees and rocks. Braque's most typically Fauve works, such as *Little Bay at La Ciotat* (1907; New York, Sidney Janis Gal.), were painted in the south of France.

A memorial exhibition of the work of Cézanne held at the 1907 Salon d'Automne, which proved a major influence on the birth of Cubism, also caused the Fauves to question the continuing viability of a style based on saturated colour and expressive line. They were particularly sensitive to Cézanne's late works, such as *Mont Sainte-Victoire* (1902–6), *Large Bathers* (c. 1906; both Philadelphia, PA, Mus. A.) and *Château noir* (1904–6; Washington, DC, N.G.A.), in which a visionary element had been added to the search for order and harmony between man and nature.

From 1908, Fauvism ceased to exist both as a style and as a coherent group. Vlaminck abandoned his use of bright primary colours, as did Derain, who experimented briefly with Cubism before turning in the 1920s to classicizing elements. Braque's study of Cézanne and his meeting with Picasso led towards the foundation of Cubism. Matisse likewise developed his style with reference to Cézanne as early as 1899 and particularly after buying the *Three Bathers* (1905–6; Paris, Petit Pal.) from Vollard, adapting its rigorous compositional structure to his own concern for simplification. The increasing harmony of Matisse's work, however, particularly after his discovery of Persian miniatures and other examples of non-Western art, in no way diminished the expressive and constructive role of colour in his work.

Bibliography

G. Duthuit: *Les Fauves* (Geneva, 1949; Eng. trans. 1950)
Les Fauves (exh. cat. by J. Rewald, New York, MOMA, 1952)
M. Rayal: *Peinture moderne* (Geneva, 1953)
A. Salmon: *Le Fauvisme* (Paris, 1956)
B. Dorival: *Les Peintres du XXème siècle: Nabis, Fauves, Cubistes* (Paris, 1957)
L. Vauxcelles: *Le Fauvisme* (Geneva, 1958)
J. Leymarie: *Le Fauvisme* (Geneva, 1959)
J.-P. Crespelle: *The Fauves* (London, 1962)
Gustave Moreau et ses élèves (exh. cat. by J. Cassou, Marseille, Mus. Cantini & Gal. Faience, 1962)
C. Chassé: *Les Fauves et leur temps* (Lausanne, 1963)
Le Fauvisme français et les débuts de l'Expressionnisme allemand (exh. cat. by B. Dorival, M. Hoog and L. Reidemeister, Paris, Mus. N. A. Mod., 1966)
J. E. Muller: *Fauvism* (London, 1967)
J. Laude: *La Peinture française et 'l'art nègre': Contribution à l'étude des sources du Fauvisme et du Cubisme* (Paris, 1968)
G. Diehl: *Les Fauves* (Paris, 1971; Eng. trans. 1975)
Fauves et Cubistes (exh. cat., Paris, Grand Pal., 1972)
Les Fauves (exh. cat. by F. Daulte, Osaka, Seibu-Takatsuki Gal., 1974)
E. C. Oppler: *Fauvism Reexamined* (New York, 1976)
The 'Wild Beasts': Fauvism and its Affinities (exh. cat. by J. Elderfield, New York, MOMA; San Francisco, CA, MOMA; Fort Worth, TX, Kimbell A. Mus.; 1976)
Les Fauves (exh. cat., London, Lefevre Gal., 1978)
M. Giry: *Le Fauvisme: Ses origines, son évolution* (Neufchâtel, 1981)
Nabis und Fauves (exh. cat., ed. U. Perucchi; Zurich, Ksthaus; Bremen, Ksthalle; Bielefeld, Städt. Ksthalle; 1982–3)
James D. Herbert: *Fauve Painting: Making of Cultural Politics* (New Haven, 1992)

DORA PÉREZ-TIBI

Federation style

Term applied to domestic designs of Australian architecture from around the turn of the 20th

century, when the Commonwealth of Australia (1901) was created. It was first proposed by Professor Bernard Smith (1969) to replace the use of 'Queen Anne', which he argued was inappropriate and misleading in the Australian setting. The context of the original suggestion applies the name to a particular domestic picturesque idiom developed from the 1880s until *c.* 1914. These designs featured red bricks, turned wood ornament, half-timbering with rough-cast in the gables, shingled walls and striking terracotta tiles. Externally the designs derive from the English Domestic Revival pioneered by architects such as Richard Norman Shaw and from American sources such as the Shingle style, while internally there is an affinity with Arts and Crafts ideals. The designs developed within a ferment of discussion on the creation of an Australian style, partly as an off-shoot of the English Arts and Crafts movement's concern with the uniqueness of place, materials, climate and local culture, and partly as a response to the excitement caused by the recognition in Australia of an American style in the work of architects such as H. H. Richardson.

The rediscovery of this Australian work began in the 1960s, firstly by the architectural historian David Saunders (1928–86) in Melbourne, who later became Professor of Architecture at the University of Adelaide, South Australia. He prompted a resurgence of interest in architectural nationalism. The architectural aspect was quickly absorbed within a broader cultural nationalism that had been developing in all the arts since World War II and that reached its high point in the 1970s. A desire to create new descriptive terms, such as 'Federation style', independent of the British heritage of terms, was an enduring legacy. In the same spirit of creating an Australian nomenclature, Conrad Hamann used 'Federation villa' and 'Federation bungalow' to refer to picturesque hip-roof examples. Federation style was also adopted into usage by property agents as a substitution for Edwardian. Later the term was being applied broadly to any buildings using red bricks and expressing Arts and Crafts sympathies in decoration, even to previously ignored commercial and industrial work.

Bibliography

B. Smith: 'Architecture in Australia', *Hist. Stud.*, xiv (1969), pp. 85–92

C. Hamann: 'Nationalism and Reform in Australian Architecture, 1880–1920', *Hist. Stud.*, xviii (1979), pp. 393–411

G. Tibbits: 'The So-called Melbourne Domestic Queen Anne', *Hist. Envmt*, ii/2 (1982), pp. 4–44

R. Apperly: 'The Federation Period', *The History and Design of the Australian House*, ed. R. Irving (Melbourne, 1985), pp. 86–116

GEORGE TIBBITS

Fellowship of St Luke [Brotherhood of St Luke; Pol. Bractwo Swietego Łukasza]

Polish group of painters that flourished in 1925–39. It emerged from the studio of Tadeusz Pruszkowski (1888–1942) at the School of Fine Arts (Sekoła Sztuk Pięknych), Warsaw, and was the first post-war group in Warsaw's largest art school. The fellowship's 14 members, all pupils of Pruszkowski, included Bolesław Cybis (1895–1957), Jan Gotard (1898–1943), Antoni Michalak (1902–75) and Jan Zamojski (1901–85). The fellowship modelled itself on the medieval guilds, and the 'Master' Pruszkowski ceremoniously emancipated his pupils. The leadership of the group rested with the 'Chapter' (Kapituła). The members of the fellowship received special diplomas of emancipation. The group's artistic programme was also based on former models, primarily on 16th- and 17th-century Dutch painting, although the group was essentially held together by ties of friendship. The artistic character of the fellowship was largely influenced by the personality of Pruszkowski, an admirer of Frans Hals and Diego Velázquez and a colourful character in the Warsaw art world.

The fellowship's first exhibition in Warsaw's Zachęta Gallery in 1928 was enthusiastically received by the critics, but subsequent exhibitions, held more or less annually, met with increasing criticism. The members of the fellowship were attacked by the Polish colourists and the avant-garde. The cult of drawing and of the studio, which the fellowship espoused, was not approved of by the circles of innovative artists. On the other

hand this cult did meet with the approval of the State, the group's members receiving commissions to decorate the interiors of passenger ships and government buildings. In 1934 the artists of the Fellowship of St Luke jointly organized the Bloc of Professional Plastic Artists (Blok Zawodowych Artystów Plastyków), an association firmly in favour of the concept of national art. The Bloc also included artists from other groups of painters founded by Pruszkowski in his studio who shared similar attitudes, for example the 'Warsaw School' Association of Plastic Artists (Stowarzyszenie Plastyków 'Szkoła Warszawska'; 1929), the Free-painters' Lodge (Loża Wolnomalarska; 1932) and the Fourth Group (Grupa Czwarta; 1936).

Bibliography

W. Bartoszewicz: *Buda na Powiślu* [Cabin on the bank of the Vistula] (Warsaw, 1966)

Z. Baranowicz: 'Bractwo św. Łukasza', *Polskie życie artystyczne w latach 1915–39* [Polish artistic life in the years 1915–39], ed.A. Wojciechowski (Wrocław, 1974)

Malarze kręgu Pruszkowskiego [Painters of Pruszkowski's circle] (exh. cat., Warsaw, N. Mus., 1978)

WOJCIECH WŁODARCZYK

Fluxus

Informal international group of avant-garde artists working in a wide range of media and active from the early 1960s to the late 1970s. Their activities included public concerts or festivals and the dissemination of innovatively designed anthologies and publications, including scores for electronic music, theatrical performances, ephemeral events, gestures and actions constituted from the individual's everyday experience. Other types of work included the distribution of object editions, correspondence art and concrete poetry. According to the directions of the artist, Fluxus works often required the participation of a spectator in order to be completed (*see* PERFORMANCE ART).

The name Fluxus, taken from the Latin for 'flow', was originally conceived by the American writer, performance artist and composer George Maciunas (1931–78) in 1961 as the title for a

projected series of anthologies profiling the work of such artists as the composer La Monte Young, George Brecht, Yoko Ono (*b* 1933), Dick Higgins (*b* 1928), Ben, Nam June Paik and others engaged in experimental music, concrete poetry, performance events and 'anti-films' (e.g. Paik's imageless *Zen for Film*, 1962). In a manifesto of 1962 ('Neo-Dada in Music, Theater, Poetry, Art', in J. Becker and W. Vostell: *Happenings, Fluxus, Pop Art, Nouveau Réalisme*, Hamburg, 1965), Maciunas categorized this diversity under the broad heading of 'Neo-Dada' and stressed the interest shared by all the artists in manifesting time and space as concrete phenomena. Influences of Fluxus noted by Maciunas included John Cage's concrete music (1939) and intermedia event at Black Mountain College, NC (1952), with Merce Cunningham, Robert Rauschenberg and others; the Nouveaux Réalistes; the work of Ben; the concept art of Henry Flynt (*b* 1940); and Duchamp's notion of the ready-made.

The first of many Fluxus festivals, or Fluxconcerts, was organized by Maciunas in 1962 at the Museum Wiesbaden in Wiesbaden, Germany, to promote the anthology. The International Fluxus Festival of the Newest Music (festum fluxorum) consisted of 14 concerts, presenting musical and performance work by Joseph Beuys, Brecht, Cage, Alison Knowles (*b* 1933), Paik, Wim T. Schippers, Wolf Vostell, Robert Watts (1923–87), Young and others. Fluxconcerts—sometimes called *Aktionen*—also took place in Düsseldorf, Wuppertal, Paris, Copenhagen, Amsterdam, Nice, Stockholm and Oslo in 1962 and 1963. These events organized by Maciunas were influenced and paralleled by the independent activities of Young, Flynt, Robert Morris and others at Yoko Ono's studio in New York in 1961 and Brecht and Watts's Yam Festival in New York in 1963. All these artists were eventually associated with Maciunas and Fluxus, either through their collaboration on multiples, inclusion in anthologies, or participation in Fluxus concerts. The typical Fluxconcert consisted of a rapid series of performances of short events of scored actions and music. These events frequently consisted of physical performances representative of mundane activities, or music based on

non-musical sound sources. They were often humorous and concerned with involving the audience, specifically to disrupt the expected conventions of musical and theatrical performance and spectatorship; their 'event scores' were characterized by reduction, repetition, improvisation and chance.

About nine major compilations of activities of Fluxus artists were planned. The first, entitled *Fluxus 1* (Wiesbaden and New York, 1964), was termed a yearbox, because of its unique wooden packaging. The contents included texts and objects by dozens of artists associated with the first Fluxfestival, such as Ay-O, Brecht, Stanley Brown, Robert Filliou, Ken Friedman (*b* 1949), Geoff Hendricks (*b* 1931), Higgins, Takehisa Kosugi, Jackson MacLow (*b* 1932), Takako Saito, Tomas Schmit, Ben and Emmett Williams (*b* 1925). The publication of collections of object-based works by artists associated with Fluxus and the documentation of Fluxconcerts soon became the focus of Maciunas's activities. Examples of these publications include: broadsides, such as *Fluxmanifesto on Fluxamusement* (edited by Maciunas in New York, 1965); the 11 irregularly published editions of the *Fluxus Newspaper* (New York, 1964–79); *Fluxyearbox 2* (1966–8, 1976); the Duchamp-inspired attaché case of objects entitled *Fluxkit* (New York, 1965–6); the *Fluxfilms* anthology (New York, 1966) and the *Fluxus Cabinet* (New Marlborough, MA, 1975–7). Perhaps most important of all of Maciunas's publishing activities remain the object multiples, conceived as inexpensive, mass-produced unlimited editions. These were either works made by individual Fluxus artists, sometimes in collaboration with Maciunas, or, most controversially, Maciunas's own interpretations of an artist's concept or score. Their purpose was to erode the cultural status of art and to help to eliminate the artist's ego.

Fluxus embraced many of the concepts and practices associated with the post-war avant-garde of western Europe and North America, including those of Lettrism, concrete poetry, concrete and random music, Happenings and conceptual art, as first described by Flynt during the late 1950s and early 1960s. Under the organization and direction of Maciunas, a specific programme of ideological goals was formulated and disseminated through a series of manifestos. The manifesto of 1963 exhorted the artist to 'purge the world of bourgeois sickness, "intellectual", professional and commercialized culture … dead art, imitation, artificial art, abstract art, illusionistic art … promote a revolutionary flood and tide in art, promote living art, anti-art, … non art reality to be grasped by all peoples, not only critics, dilettantes and professionals'. The *Fluxmanifesto on Fluxamusement* used innovative typography and ready-made printed images to communicate the concept of the self-sufficiency of the audience, an art where anything can substitute for an art work and anyone can produce it.

Bibliography

Happening und Fluxus: Materialen (exh. cat., ed. H. Sohm and H. Szeeman; Cologne, Kstver., 1970)
H. Ruhe: *Fluxus, the Most Radical and Experimental Art Movement of the Sixties* (Amsterdam, 1979)
J. Hendricks, ed.: *Addenda I* (New York, 1983)
Addenda II: The Gilbert and Lila Silverman Collection (exh. cat., ed. J. Hendricks; Pasadena, Baxter A.G., 1983)
B. Moore: *Fluxus I: A History of the Edition* (New York, 1985)
Fluxus: Selections from the Gilbert and Lila Silverman Collection (exh. cat. by C. Phillpot and J. Hendricks, New York, MOMA, 1988)
J. Hendricks: *Fluxus Codex* (New York, 1989)
E. Milman, ed.: 'Fluxus: A Conceptual Country', *Visible Language*, xxvi/1–2 (1992) [special issue]

MICHAEL CORRIS

Forces Nouvelles

French group organized by the painter and critic Henri Héraut (*b* 1894), whose first exhibition, in April 1935 at the Galerie Billiet-Vorms in Paris, consisted of paintings by Héraut, Robert Humblot (1907–62), Henri Jannot (*b* 1909), Jean Lasne (1911–46), Alfred Pellan, Georges Rohner (*b* 1913) and Pierre Tal-Coat. Héraut, the eldest of the painters, hoped to establish a new aesthetic through the group and stated in his preface to the catalogue that since all modern movements, starting with Impressionism and Expressionism,

had endangered art there was a need to return to drawing, tradition and nature. The group's concentration on nature was often manifested in their preference for still-lifes, such as Lasne's *Still-life* (1939; Paris, Pompidou). Sensitive to the political situation in Europe, they rejected light-hearted subject-matter, often dwelling on disaster, as in Humblot's *Dead Child* (1936; priv. col., see exh. cat., pl. 11), and relied on a restricted dark palette, as in Héraut's *Othello* (1935; Rennes, Mus. B.-A. & Archéol.).

In January 1936 the first exhibition was held of the Salon de la Nouvelle Génération (Paris, Gal. Charpentier), founded by Héraut as an extension of Forces Nouvelles. The group's original members were joined by other painters such as Francis Gruber, Germaine Richier, Raymond-Jean Legueult (*b* 1898), André Fougeron and Jacques Despierre (*b* 1912). At the second Forces Nouvelles exhibition, held at the Galerie Billiet-Vorms in March 1936, Pellan and Tal-Coat were not present, although they still associated with the broader Salon de la Nouvelle Génération; the catalogue's preface was written by Eugenio d'Ors, who became one of the group's chief theorists, continuing Héraut's ideas. The last Salon de la Nouvelle Génération was held in 1938 at the Galerie Billiet-Vorms with 34 painters and sculptors, and the third Forces Nouvelles exhibition was held in 1939 at the Galerie de Berri in Paris, with only Héraut, Humblot, Jannot and Rohner. There were further Forces Nouvelles exhibitions until 1943, but its impetus was lost by 1939, and after World War II the artists pursued separate careers.

Bibliography

Forces Nouvelles, 1935–1939 (exh. cat. by P. Vorms and others, Paris, Mus. A. Mod. Ville Paris, 1980)

□

Forma

Italian group, founded in Rome in 1947. Its members included Pietro Consagra, Giulio Turcato, Piero Dorazio, Achille Perilli (*b* 1927), Antonio Sanfilippo (1923–80), Carla Accardi, Ugo Attardi (*b* 1923), Mino Guerrini and Concetto

Maugeri. These artists played an important part in the development of Italian abstract art during the late 1940s and the 1950s. While influenced by contemporary ART INFORMEL, the work of Forma cannot be confined to any neat stylistic definition. Both Turcato and Dorazio experimented at this time with geometric abstraction, influenced in particular by the work of the Futurist Giacomo Balla. Turcato's paintings had a strong narrative element, as can be seen from *Political Gathering* (1950; Rome, Gal. Anna d'Ascanio), in which the bright red triangles have an obvious political significance. While Dorazio's work consisted of disciplined rhythmic patterns of interlocking shapes, other artists, such as the painters Accardi and Sanfilippo and the sculptor Consagra, concentrated on creating freer, more expressive works. During the 1950s Turcato, too, moved towards a more lyrical form of abstraction. As well as staging its own exhibitions (e.g. at the Art Club in Rome in 1947), Forma was involved in important international events, including the Venice Biennale of 1948 and the exhibition *Arte astratta e concreta in Italia*, held at the Galleria d'Arte Moderna in Rome in 1951. The group also made an important contribution to debate on art through its eponymous magazine. Its successor was the group CONTINUITÀ (founded 1961), which included Accardi, Consagra, Dorazio, Perilli and Turcato.

Bibliography

Meister der Italienischen Moderne XIX: Forma 1, 1947–1987: Accardi, Attardi, Consagra, Dorazio, Guerrini, Maugeri, Perilli, Sanfilippo, Turcato (exh. cat. by B. Krimmel and others, Darmstadt, Inst. Mathildenhöhe, 1987–8)

CHRISTOPHER MASTERS

Formists [Pol. Formiści]

Polish group of painters and sculptors that flourished between 1917 and 1922, from 1917 to 1919 known as the Polish Expressionists (Ekspresjoniści Polscy). A foretaste of the Formists' work appeared in the three *Wystawy niezależnych* ('Exhibitions of the Independents'; 1911–13) in Kraków, organized by the artists later to become leading

Formists: the painter and stage designer Andrzej Pronaszko (1888–1961), his brother Zbigniew Pronaszko and Tytus Czyżewski, who all opposed Impressionism and favoured Cubism, Futurism and Expressionism. The Formists first exhibited in Kraków in 1917. Their aim was to find a new form and a new national style (they saw themselves as the Polish equivalent of the Italian Futurists and French Cubists) that was in part a continuation of the artistic ideology of the turn of the century (Polish modernism). A wide variety of artists took part in Formist exhibitions, including Stanisław Ignacy Witkiewicz, Leon Chwistek, the painter Tymon Niesołowski (1882–1965), August Zamoyski and the graphic artist Władysław Skoczylas (1883–1934), who later became the chief ideologist of national art.

The Formists published their own journal, *Formiści*, which appeared between 1919 and 1921 in Kraków. They collaborated with the circle of Polish Futurist poets and the Poznań-based group Revolt (Bunt). But the Formists lacked a clearly defined ideological and artistic programme. The theorists of Formism, firstly Zbigniew Pronaszko, then Chwistek and Czyżewski and finally Chwistek's rival Witkiewicz, held diametrically opposed views on art, which largely contributed to the break-up of the group: first the Kraków section, then the Warsaw and Lwów branches. Another key factor in the disintegration of the group was the shift of position by some Formists to colourism. An attempt in 1927 by Warsaw-based Formists to revive the group came to nothing. The Formists were the first innovative group in Poland. However, the diversity of their stylistic experimentation meant that any continuation of Formism should really be sought in Polish Art Deco rather than in the subsequent work of the avant-garde.

Bibliography

J. Pollakówna: *Formiści* [The Formists] (Wrocław, 1972)

H. Stępień: 'Formiści polscy' [The Polish Formists], *Polskie życie artystyczne w latach 1915–39* [Polish artistic life in the years 1915–39], ed. A. Wojciechowski (Wrocław, 1974)

WOJCIECH WŁODARCZYK

Four Arts Society of Artists
[Rus. Obshchestvo Khudozhnikov '4 Iskusstva']

Soviet exhibiting society, active in Moscow from 1924 to 1932. The society was planned to include representatives of all 'Four Arts', painting, sculpture, graphics and architecture. Among its members were the painters Martiros Saryan and Konstantin Istomin (1887–1942), the graphic artists Pyotr Miturich, Lev Bruni and Vladimir Favorsky, the sculptor Aleksandr Matveyev and painters such as Pavel Kuznetsov and Kuz'ma Petrov-Vodkin, who had previously exhibited with the Blue Rose group. At different times the group included such architects as Ivan Zholtovsky, Aleksey Shchusev, Vladimir Shchuko and El Lissitzky, together with artists such as Ivan Klyun, Vladimir Lebedev (1891–1967) and the sculptor Vera Mukhina contributing to one or more of the society's four Moscow exhibitions (1925, 1926, 1928 and 1929).

The group believed that the various visual arts should cooperate in the construction of the new environment and realized several projects, including a house at Sochi, on the Black Sea, on which Zholtovsky and Kuznetsov collaborated. The group's declaration of 1929 stressed its commitment to 'painterly realism' and the achievements of the 'French school . . . that has most fully and thoroughly developed the fundamental properties of the art of painting'. It emphasized that subject-matter was chosen in accordance with purely artistic problems and asserted, 'A new form is important not for its resemblance to a living form, but for its harmony with the material from which it is made, i.e. the surface plane of the painting, colour-pigment, canvas etc.' In 1931 the group petitioned to join AKhRR, the Association of Artists of Revolutionary Russia, but in 1932 it was dissolved by the Decree on the Reconstruction of Literary and Artistic Organizations.

Writings

'Four Arts Society of Artists: Declaration, 1929', *Russian Art of the Avant Garde: Theory and Criticism, 1902–1934*, ed. J. Bowlt (New York, 1976), pp. 281–4

Bibliography

V. Perel'man, ed.: *Bor'ba za realism v izobrazitel'nom iskusstve 20-kh godov: Materialy, dokumenty, vospominaniya* [The battle for realism in the fine arts of the 1920s: materials, documents, reminiscences] (Moscow, 1962), pp. 230–35

CHRISTINA LODDER

Friday Club

British group of painters, active 1905–22. Vanessa Bell conceived of and created the Friday Club in the summer of 1905. She was inspired by her experience of Parisian café life and the artists introduced to her in Paris by Clive Bell, and she hoped to create in London a similar milieu in which artists and friends could meet to exchange ideas. The Club met for lectures and held regular exhibitions in rented rooms, one taking place in Clifford's Inn Hall in 1907, another at the Baillie Gallery in 1908. Its members were oddly assorted: Vanessa Bell drew upon students from the Royal Academy Schools and the Slade School of Fine Art, as well as her own family and family friends. Lecturers included Clive Bell, Basil Creighton, Walter Lamb and Roger Fry. Virginia Woolf remarked that in its early stages the Club was split: 'one half of the committee shriek Whistler and French Impressionists, and the other are stalwart British'. In 1913 Essil Elmslie replaced Vanessa Bell as secretary to the Club, and meetings and discussions outside the annual exhibitions ceased. However, between 1910 and 1914 its exhibitions included young artists of talent, among them J. D. Innes, Derwent Lees (1885–1931), John Currie (*c*. 1890–1914) and Henry Lamb, and drew much comment from the press. Despite this, the history of the Club remains shadowy because no minutes of its meetings exist and not all its exhibition catalogues can be traced.

Bibliography

Catalogues of the Friday Club belonging to P. G. Konody are in the Victoria and Albert Museum, London
R. Shone: 'The Friday Club', *Burl. Mag.*, cxvii (1975), pp. 279–84

FRANCES SPALDING

Frie Udstilling [Dan.: 'Free Exhibition']

Danish association founded in 1891 in Copenhagen as an exhibiting society for progressive young Danish artists in revolt against official state institutions. Founder-members of the Frie Udstilling included its initiator, Theodor Philipsen, Johan Rohde, Jens Ferdinand Willumsen, Vilhelm Hammershøi, Harald Slott-Møller, Agnes Slott-Møller, Joakim Skovgaard, Niels Skovgaard, Kristian Zahrtmann, Peder Severin Krøyer and Julius Paulsen. Although they did not share a common aesthetic, these artists were united in their opposition to the conservative Kongelige Danske Akademi for de Skønne Kunster and its restrictive annual exhibition at the Charlottenborg, and in their promotion of international avant-garde painting.

The first exhibition organized by the association was held in March 1891 at Valdemar Kleis gallery at Vesterbro in Copenhagen. The critic Karl Madsen (1855–1938), a champion of the association, reported the exhibition's success in the radical cultural review *Tilskueren*. The organization moved into a temporary building designed by Thorvald Bindesbøll in the city's Hømarked in 1893, and among its achievements was the inclusion of major works by van Gogh and Gauguin in its exhibition of 1893. The association relocated to its permanent building, designed by Willumsen, in 1898 and moved again in 1914 to its current location, also designed by Willumsen, opposite Østerport station.

Bibliography

K. Madsen: 'Den frie udstilling', *Tilskueren* (April–May 1891), pp. 323–43
Fra den frie udstillings barndom: Festskrift til Franz Wendt (Copenhagen, 1975)
B. Lindwall: 'Artistic Revolution in Nordic Countries', *Northern Light: Realism and Symbolism in Scandinavian Painting, 1880–1910* (exh. cat., ed. K. Varnedoe; New York, Brooklyn Mus., 1982), pp. 35–42
J. F. Willumsen og den frie udstillings første år, 1891–1898 (exh. cat. by L. Krogh, Frederikssund, Willumsens Mus., 1982)
Gauguin og van Gogh i København i 1893 (exh. cat., essay by M. Bodelsen; Copenhagen, Ordrupgaardsaml., 1984)

B. Scavenius: *Den Frie Udstilling for Kunst* (Copenhagen,
1991)

PATRICIA G. BERMAN

Fronte Nuovo delle Arti

Italian group of artists. It was founded by Renato
Birolli in 1946 as the Nuova Secessione Artistica
Italiana and renamed in 1947. The manifesto of
1946 was signed by Giuseppe Santomaso, Bruno
Cassinari, Antonio Corpora, Renato Guttuso,
Ennio Morlotti, Armando Pizzinato (*b* 1910), Giulio
Turcato, Emilio Vedova and the sculptors Leonardo
Leoncillo (1915–68) and Alberto Viani. During the
first group exhibition, which was held at the
Galleria della Spiga in Milan in 1947, Cassinari
resigned, and the sculptors Pericle Fazzini and
Nino Franchina (*b* 1912) joined. This was the van-
guard of Italian painters and sculptors who, in the
wake of the fear and stagnation brought on by
World War II, endeavoured to revitalize Italian
20th-century art, which they felt had died with
Futurism and Pittura Metafisica. Although the
artists were stylistically very different, ranging
from abstraction to naturalism, they were united
by left-wing politics and by their wish, as stated
in their manifesto, to give their 'separate creations
in the world of the imagination a basis of moral
necessity'. While the group also shared an admi-
ration for Picasso, the polarization of the abstract
formalists and the realists became increasingly
evident during the Venice Biennale of 1948. That
year the Communist journal *Rinascita* published
an article highly critical of works exhibited in
Bologna by Fronte Nuovo members. The assump-
tion that the Communists had no artistic prefer-
ences was shattered and this helped to destroy the
group. Its stylistic diversity is indicated in a com-
parison of Guttuso's powerfully figurative *Mafia*
(1948; New York, MOMA) with Turcato's *Revolt*
(1948; Rome, G.N.A. Mod.); the latter evokes the
resistance to German repression in near abstract
forms derived from Picasso's *Guernica* (Madrid,
Prado). The group had disintegrated by 1952, when
Birolli, Corpora, Turcato and Vedova were among
the abstract painters gathered together in Lionello
Venturi's GRUPPO DEGLI OTTO PITTORI ITALIANI.

Bibliography

20th-century Italian Art (exh. cat., ed. J. T. Soby; New York,
MOMA, 1947)
Italian Art in the 20th century (exh. cat., ed. E. Braun;
London, RA, 1989)

☐

Functionalism

Term applied to architecture in which the form of
a building is derived from the function it is
intended to fulfil. As employed by such historians
as Nikolaus Pevsner and Siegfried Giedion, the
term became generally identified with early 20th-
century Modernism, for, like many of their archi-
tect contemporaries, they used it in justifying that
style. It would, however, be hard to substantiate
the claim that modern architecture is truly more
functional than that of many other periods, par-
ticularly as it was impregnated with aesthetic and
social concerns that sometimes conflicted directly
with the requirements of use.

Even in the realm of theory modernists cannot
claim any monopoly on functionalist ideas: A. W.
N. Pugin claimed in his *True Principles of Pointed
or Christian Architecture* (1841) that 'there should
be no features about a building which are not nec-
essary for construction, convenience or propriety',
defining propriety as the appropriate reflection of
the internal arrangements in the exterior. Even
though he applied them to Gothic examples, he
drew his ideas from the French Neo-classical
tradition, while the French reiterated theories
borrowed from the Italian Renaissance. Thus func-
tionalist ideas can be found in *De re aedificatoria*
(Florence, 1485) by Leon Battista Alberti if one
chooses so to read them, and these derive from
the theories of Vitruvius. Many studies of ver-
nacular architecture are also susceptible to a
functionalist interpretation.

If its superficial use as a stylistic tag is rejected,
Functionalism becomes a complex issue, for it con-
cerns the relationship between use and meaning,
disputed since the days of Aristotle. The predom-
inance of the term in architecture in the 20th
century reflects a broader cultural tendency, for
it was also used in other fields, notably social

anthropology, where its leading theorist was Bronislaw Malinowski (1884–1942). The decisive influence in both areas of knowledge was the rise of science and the associated ideology of Positivism, which gives primacy to the physical world, naively discounting all the philosophical difficulties of interpretation. Crucial, too, was Charles Darwin's theory of natural selection, which seemed to explain nature in terms of strict adaptation to purpose: Nature was demonstrated to be no longer static but in a state of flux, its great and hitherto inexplicable diversity reduced to a single process. Even if the mechanism was and still is in dispute, the evidence for the theory of evolution was overwhelming.

The importance of the Darwinian revolution cannot be overestimated. The natural world was put into a new perspective, and the same principles were applied to many aspects of human culture. Nature, the traditional yardstick for aesthetic criteria, took on a new interpretation: flowers were no longer beautiful for the sake of our enjoyment, but merely in order to attract pollinating insects; all was purposeful. The impact on architecture coincided with a crisis of meaning precipitated by the proliferation of 'styles' borrowed from buildings all over the world and thus rapidly devalued. Heroic attempts to create a new 'style' in the form of Art Nouveau also proved fruitless. The way was thus open for a return to what were seen to be fundamental principles: logical structure and construction, economic use of materials and a close attention to the requirements of use.

The formulation of an 'organic architecture' by the American architect Louis Sullivan was directly influenced by evolution theory. He was responsible for the much quoted phrase 'form follows function', advocating a renunciation of ornament as early as 1892 and producing a series of buildings notable for their expressed structure (see fig. 21). Sullivan reflected a tendency in American thinking that can be traced back to the Transcendentalism of Henry Thoreau (1817–62) and Walt Whitman (1819–91), and to the prophetic ideas of Horatio Greenough. Primarily a sculptor, Greenough is better known today for his writings:

21. Louis Sullivan: Bayard Condict Building, New York, 1897–9

as early as 1843 he advocated 'a scientific arrangement of spaces and forms to function and to site' (Greenough, 1947), and considered that 'character is the record of function', ascribing the beauty of a sailing frigate to its close response to the pressure of wind and wave. The concept of organic architecture was extended by Frank Lloyd Wright (see col. pl. XX), who worked in Sullivan's office (1888–93); he stressed the idea that a building should grow in response to site and circumstances. Wright's revolutionary architecture was published in Berlin in 1910, and proved influential.

European Modernists were greatly outnumbered by traditionalists even in the 1920s, and they soon discovered the value of solidarity, concealing their sometimes considerable differences of approach behind a common front. Functional or pseudo-functional arguments were their best

ammunition against their conservative rivals and were widely and uncritically accepted. The appearance of the new architecture, cubic and white, was read as functional because of its simplicity and a then unusual lack of ornament, even if its organization was often based on abstract geometric composition. Its authors often sincerely believed their functionalist arguments, but found in practice that the pressures of use were insufficient to dictate form. Moreover, when they turned to the question of construction, they found a craft industry geared to traditional designs. Thus, although they spoke of machine production, their works were often constructed by hand, and the 'machine aesthetic' was dictated not so much by machinery itself as by an anticipation of what it might bring. The desired simplicity of detail, however, and the compulsive use of crude flat-roof technologies resulted in technical failures and maintenance problems: 'Functionalist' architecture often functioned badly.

As well as these shortcomings there were some direct contradictions: Le Corbusier is widely remembered for his statement in *Vers une architecture* (Paris, 1923) that 'A house is a machine for living in', yet around the same time he also proclaimed that 'architecture is the masterly, correct and magnificent play of masses brought together in light'. He, more than any other individual architect, was responsible for the development of the 'white architecture', derived directly from Purism, a movement led by him. Perhaps the secret of Le Corbusier's success lay in his ability to justify the impressive forms resulting from his Purist aesthetic on the basis of a supposed Functionalist programme (see col. pl. XVII), but the contradiction was noted at the time by perceptive critics and still haunts architecture today.

The texts written in the 1920s by many supposedly Functionalist architects tend to be contradictory or inadequate. Johannes Duiker's apologia for his Open-air School (1929–30) in Amsterdam, for example, seems to present it as a machine for sunning children. Most other functions go unmentioned, including many preoccupations of the architect visible in the building. Although interesting as evidence of the architect's

attitude, such a document does not constitute an adequate description of work or theory. Perhaps architects are generally too close to their work to view it objectively, and too busy to undertake the difficult task of reflective analysis. Some architect-theorists, however, do struggle to define basic principles, and among those active in the 1920s two stand out in contrasting positions: Hannes Meyer, who represents a positivistic functionalism, and Hugo Häring, the father of organic functionalism (*see* ORGANIC ARCHITECTURE).

Meyer's manifesto 'Bauen', published in the Bauhaus magazine in 1928, the year he became director of the Bauhaus, was a statement of aims for the school and it remains a landmark in architectural theory. It opens with a denial of art, claiming that everything is a product of the formula 'function times economy'. He lists the 12 functions of a dwelling, claiming them as the only motives when building a house, and explains how the measurements—psychological as well as physical—that affect function are to be made; he asserts that 'building is nothing but organization: social, technical, economic, psychological organization'.

In spite of his functionalist polemic, Meyer's work fails to exemplify his theories. His description of his and Hans Wittwer's League of Nations project (1926–7) is almost self-contradictory, opening with a denial of symbolic connotations, then going on to discuss what the building represents. Even at the level of the 'functional criteria' the arguments do not hold. The oval hall, for example, is supposed to answer acoustic requirements, but no account is taken of the concentrated reflections that the curved surfaces would produce. His ideas nevertheless influenced the reorganization of architectural education after World War II, when departments of architecture were renamed departments of environmental design, history was dethroned and attempts were made to turn architecture into an objective science. This approach proved woefully inadequate, for it depended on the assumption that all aspects of building lent themselves to measurement, and it tried to turn qualities into quantities. Measurable aspects were taken into account

while unmeasurable ones, such as the value of a view from a window, were omitted. The reductiveness of such a programme resulted in cultural impoverishment that is widely felt, and remains a prime cause of the so-called crisis of Modernism in architecture.

A qualitative rather than a quantitative strand of functionalism was pursued by Hugo Häring, secretary of the Berlin organization Der Ring. He saw the Modernist revolution as a liberation from academic formalism, an opportunity to allow new forms to develop in response to the requirements of life, and he rejected the formal vocabulary of Le Corbusier in the 1920s as representing a return to geometry. If forms were evolved to fulfil performance requirements, he claimed, they would develop their own character in relation to the role they play: 'We should not express our own individuality, but rather the individuality of things, their expression should be identical with their being.' A well-known example of his organic functionalism is his farm at Garkau (1924–5) near Lübeck. The barn was given a lamella roof, an unusual construction that takes the structural shape of a pointed arch. Häring gave credible explanations for various planning decisions, but of special interest is the hierarchical relation of parts, culminating in the pear-shaped cowshed that relates the cows to the bull. Here he went beyond use itself towards the expression of use, thus linking the pragmatic with the symbolic. He foresaw the dangers of a purely technical approach and never allowed technique to dominate his own work. Although he built little, he provided the inspiration for a continuing tradition of German architecture that gained impetus in the 1950s and 1960s from his friend and colleague Hans Scharoun. Alvar Aalto held a similar theoretical position, and more recently Aldo van Eyck and Ralph Erskine have both claimed to pursue Functionalism at this more elevated level.

In the 1970s Functionalism came under attack—from Post-modernists, because it seemed to deny all symbolic content, and from Italian Rationalists, because they chose to emphasize architectural type and monumentality at the expense of response to immediate conditions. Both tendencies have since

run into difficulties through ignoring the relationship between use and meaning. A door handle is as much an invitation to open a door as the means of doing so, while space is still organized hierarchically in ways we take for granted; it is no accident, for example, that the judge sits on axis in a law court, and in the highest, most decorated seat. It was precisely in this relationship between the arrangement of space and the habits and conventions of society that the form–function question in architecture was pursued most fruitfully in the late 20th century.

See also RATIONALISM and MODERN MOVEMENT.

Bibliography

A. W. N. Pugin: *The True Principles of Pointed or Christian Architecture* (London, 1841)

H. Häring: 'Wege zur Form', *Die Form*, 1 (1925), pp. 3–5; Eng. trans. in *Form and Function*, ed. T. Benton and D. Sharp (Milton Keynes, 1975)

H. Meyer: 'Bauen' (1928), *Hannes Meyer: Bauen und Gesellschaft: Schriften, Briefe, Projekte*, ed. K.-J. Winkler (Dresden, 1980), pp. 47ff

H. Greenough: *Form and Function*, ed. H. A. Small (Berkeley, 1947)

E. R. De Zurko: *Origins of Functionalist Theory* (New York, 1957)

G. Baird: 'Karel Teige's Mundaneum, 1929, and Le Corbusier's In Defense of Architecture, 1933', *Oppositions* (1974), no. 4

J. Posener: 'Critique of the Criticism of Functionalism', *Lotus Int.*, 11 (1976), pp. 5–11

P. Steadman: *The Evolution of Designs: Biological Analogy in Architecture and the Applied Arts* (Cambridge, 1979)

P. B. Jones: 'Hugo Häring', *Archit. Rev.* [London] (April 1982), pp. 40–47

—: 'Implicit Meanings', *Archit. Rev.* [London] (June 1985), pp. 34–9

PETER BLUNDELL JONES

Futurism

Italian movement, literary in origin, that grew to embrace painting, sculpture, photography and architecture, which was launched by the publication on 20 February 1909 of 'Le Futurisme' by Filippo Tommaso Marinetti in the Paris newspaper *Le Figaro*. Marinetti's intention was to reject the

past, to revolutionize culture and make it more modern. The new ideology of Futurism set itself with violent enthusiasm against the weighty inheritance of an art tied to the Italian cultural tradition and exalted the idea of an aesthetic generated by the modern myth of the machine and of speed.

I. PAINTING, GRAPHIC ARTS AND SCULPTURE

1. Foundations and first manifestos of Futurism, 1909

Marinetti laid the foundations of the new literary poetics in his first manifesto, written in late 1908. Every new creation or action, he wrote, was now based on the 'beauty of speed'; museums, libraries, 'venerated' cities and academies had to be destroyed, as they belonged to traditional culture. An art born of progress was now to take the place of all the artistic forms of the past, even the most recent ones, because they were stale and static. These words were immediately taken up by a group of young painters based in Milan—Umberto Boccioni, Luigi Russolo and Carlo Carrà—who declared their enthusiastic support for Marinetti's ideas and offered to extend the same revolutionary polemic to figurative art. The *Manifesto dei pittori futuristi*, issued as a pamphlet dated 11 February 1910, was signed by Gino Severini and Giacomo Balla. This document, dashed off after their first meeting with Marinetti, expressed the new artistic ideals in violently aggressive words:

> We want to fight ferociously against the fanatical, unconscious and snobbish religion of the past, which is nourished by the evil influence of museums. We rebel against the supine admiration of old canvases, old statues and old objects, and against the enthusiasm for all that is worm-eaten, dirty and corroded by time; we believe that the common contempt for everything young, new and palpitating with life is unjust and criminal.

This first manifesto of Futurist painting was followed on 11 April 1910 by a more specific statement entitled *La pittura futurista: Manifesto tecnico*. The group declared their break with traditional and realistic painting and proclaimed the advent of a new awareness, which they labelled the 'dynamic sensation'. They claimed that the spatial conceptions of the past were smashed and that 'space no longer exists.' In their view, 'The construction of pictures is stupidly traditional. Painters have always depicted the things and persons placed before us. We shall place the spectator at the centre of the picture' (Drudi Gambillo and Fiori, i, 1958, pp. 65–6). A new theory of colour was proposed (ibid., p. 57):

> How can we still see a human face as pink, while our lives are undeniably doubled by night-time activity? The human face is yellow, it is red, it is green, it is blue, it is violet. The pallor of a woman looking into a jeweller's window is more iridescent than all the prisms of the jewels that fascinate her. Our pictorial sensations cannot be expressed in whispers. We make them sing and shout in our canvases, which ring out with deafening triumphal fanfares.

2. First Futurist works, 1910–11

Despite these strong affirmations, the young artists continued to work along the lines of divisionism and complementarity of colour; only from 1911 can one speak of real Futurist painting. Until the end of 1910 Boccioni was still oscillating between an exasperated Expressionism influenced by Munch and a divisionism reminiscent of Seurat; Carrà was torn between an 18th-century kind of academicism and the new theories of colour; Russolo remained tied to Symbolist ideas; and Severini, working in Paris, was strongly attracted by French Post-Impressionist painting. The first Futurist works, painted in 1910, were still closely derived from Marinetti's literary images; they included Russolo's *Perfume* (1910; sold London, Sotheby's, 1990, see Martin, fig. 45), Boccioni's *Controluce* (1910; priv. col., see M. Calvesi and E. Coen, *Boccioni*, Milan, 1983, p. 304) and Carrà's *Swimmers* (1910; Pittsburgh, PA, Carnegie Mus. A.) and *Funeral of the Anarchist Galli* (1910–11; New York, MOMA).

During the first year of Futurist activity the manifestos were frequently publicized by provocative declamations at evening performances; these irritated the public, which responded by throwing fruit and other objects. Turin, Naples and Milan were the first cities to be touched by the impetuous violence of Futurism. It was only in April 1911 that Futurist paintings were presented in Milan at the *Mostra d'arte libera* organized in the former workshops of the Ricordi record factory. In this large exposition—open, according to the invitation, to 'all those who want to assert *something new*, that is to say far from imitations, derivations and falsifications'—a small section was devoted to the Milanese Futurists Boccioni, Carrà and Russolo. Among the paintings shown by Boccioni was *Work*, retitled *The City Rises* (1910–11; New York, MOMA), a picture with a Symbolist flavour, representing human and animal tension in a vortex of colour fragmented in oblique threadlike brushstrokes. In *Mourning* (1909; priv. col.) the figures and gestures are multiplied and elongated in an Expressionist manner, producing a profoundly emotive sensation, while in *The Laugh* (1911; New York, MOMA), the tangle of figures is emphasized by intense bands of light. Carrà and Russolo presented works inspired by the new expression of form, adhering, as Carrà later wrote, 'to the symphonic concept of masses, weight and volume, of a general movement of forms determined by the modern sensibility'. The public and the critics reacted to the exhibition in very different ways. The most unexpected attack came from the young Florentine painter and writer Ardengo Soffici, who was close to French literary and artistic circles and very open to the avant-garde experiences of Cubism. Irritated by his violent review, the Futurists organized an expedition to Florence to punish Soffici. The quarrel was quickly settled, and the two groups were soon united under the banner of Futurism.

During this period Marinetti decided to spread propaganda abroad to make the Futurist movement known in other countries. An exhibition was planned in Paris at Bernheim-Jeune, and in autumn 1911 Boccioni and Carrà briefly joined Severini there, seeing Cubist works for the first time. The exhibition, which took place in February 1912, consisted of works by Boccioni, Carrà, Russolo and Severini. In the preface to their catalogue the artists emphasized their divergence from Cubism because of its static expression; they claimed to be searching for 'a style of movement', in opposition to the analytical view of the French painters. In this text their theoretical position was newly clarified: 'To make the spectator live at the centre of the picture, as our manifesto says, the painting must be the synthesis of what is remembered and what is seen.' They affirmed (Apollonio, 1970, p. 92):

If we paint the phases of an uprising, the crowd bristling with fists and noisy cavalry assaults will be translated on the canvas into bands of lines corresponding to all the forces in conflict, following the painting's laws of general violence. These lines of force must envelop the spectator and carry him away; he himself must be in some way obliged to grapple with the figures in the picture. All the objects, according to physical transcendentalism, tend towards the infinite through their force-lines, to bring the work of art back to true painting. We interpret nature by presenting these lines on the canvas as the origins or prolongations of the rhythms which the objects impress on our sensibilities.

A more aggressive and individual figurative programme now corresponded to the ideas expounded by the Futurists in their manifestos. In Boccioni's work, in fact, form and space were blended into a universal synthesis with colour, analysed in new combinations of complementary hues, tonal contrasts and Expressionistic deformations. The broken, fragmented and refracted representation was recomposed into a vortex of luminosity with a strong ascending tension. Impressionist and Post-Impressionist components were undoubtedly mixed with elements of Cubism. The decomposition of the subject, however, was not intended to create a new dimensionality. Nor did Boccioni seek to construct a

reality that would preserve only the memory of the object. Rather, the artist aimed to expand space through formal elements, which could emphasize the dynamic tension of the subject in relation to the surrounding environment.

In the second version of a set of three paintings entitled *States of Mind* (New York, MOMA and Civ. Mus. A. Contemp.), painted in autumn 1911 after his trip to France, Boccioni was searching for a style in which to translate sensations and emotions into images. The lines became a dynamic projection of the subject's state of mind, an objectivist transposition of a perception. In *The Farewells* the vision seems confused and chaotic; a locomotive is wedged into a tangled network of undulating and horizontal lines that suggest the chaos of departure and emotional embraces. In *Those who Go* the bullet-like speed of the rushing train is underlined by very rapid oblique brushstrokes, while in *Those who Remain* the vertical line of stasis prevails.

In works from this period by Carrà, space is defined by more accentuated linear rhythms, and the formal structure of the object is given more depth. The colours are quieter than those used by Boccioni, attenuated so as to make the painting cohere as a uniform whole. Carrà creates a magical equilibrium of forms and colours, giving special attention to the composition and thus creating a sensation of suspended movement. In the *Gallery of Milan* (1912; Milan, priv. col., see 1986 exh. cat., p. 159) the forms follow one another in a dynamic rhythm that tends to override the mere visual data; figuration is eliminated to bring out the vibrant energy of the material.

In Russolo's works of this time the Symbolist energy that pervaded his earlier paintings had lost none of its force. *Memory of a Night* (1911; priv. col., see 1986 exh. cat., p. 204) depicts an apparition, a dream in which spectral figures move in a deserted city. Among the Futurists Russolo was the artist who gave most space to imagination and fantasy, through his linear description of colours and lights, in a surreal play of movements. In *The Revolt* (1911; The Hague, Gemeentemus.) and *Dynamism of an Automobile* (1912–13; Paris, Pompidou) the composition is simplified into a succession of triangular forms that simulate the movement of a crowd or a motor-car.

Balla's early Futurist experiments are quite different. He represented movement with a more analytical approach, contemplating the spatial displacement of the object in time. In *Dynamism of a Dog on a Lead* (1912; Buffalo, NY, Albright-Knox A.G.) or the *Hand of the Violinist* (1912; London, priv. col., see 1961 exh. cat., p. 59) Balla captures the successive movements of the dog's lead, legs and wagging tail or the musician's left hand on his instrument, as in a sequence of superimposed and slightly off-register photographic images. The overpowering effect of physical sensations, particularly when exaggerated by modern machinery and inventions associated with speed such as the automobile, was taken as the subject for paintings such as *Speed of an Automobile+Lights+Noise* (1913; Zurich, Ksthaus). It was his long-standing interest in photography that suggested to him this episodic reading of the transformation of movement into a vision of reality that was still persuasive in naturalistic terms. Paintings such as *Swifts: Paths of Movement+Dynamic Sequences* (1913; New York, MOMA), with their calculated rendering of the stages of an action, suggest an awareness of the sequential photographic studies of Eadweard Muybridge and the chronophotography of Etienne-Jules Marey. Balla also encouraged the 'photodynamic' experiments of his friend Anton Giulio Bragaglia, which used long exposures to fix the fluidity of action. Bragaglia's attempts to establish these images as works of art, however, were scorned by the Milanese Futurists.

Of all the Futurists, Severini came closest to the experiments of the Neo-Impressionists. He constructed his images through the fragmentation of colour and form, unifying them through the harmony of the composition as a whole. Visual impressions appear to be broken down into many small coloured elements, as in a mosaic, and then regrouped to create a kaleidoscopic effect. In his early Futurist paintings, such as *Voices of my Room* (1911; Stuttgart, Staatsgal.), he proposed a simultaneity of plastic forms and sensations. As he declared in his manifesto of 1913, 'Le analogie

plastiche del dinamismo: Manifesto Futurista': 'Now in our age of dynamism and simultaneity, no reality can be separated from those memories, affinities and plastic aversions which its expansive action evokes simultaneously in us, and which are equally abstract realities, if one is to realize the total action of the reality in question.'

3. International manifestations of Futurism, 1912–13

Through the tireless propagandist activity of Marinetti, the Futurist movement spread abroad very rapidly in 1912. Exhibitions in Paris, Berlin, London, Brussels and other major European capitals propagated the new aesthetic of speed in different cultural environments. The aggressive character of the group gave rise to the most extreme reactions. In Germany and France in particular the intellectual and mercantile classes either closed ranks in defensive positions or gave the Futurists their enthusiastic support.

In Italy Marinetti tried to break through the general distrust by lining up with the Tuscan literary group of La voce and by transforming the magazine Lacerba into an organ for the diffusion of Futurist poetics. Every issue contained theoretical articles or polemical replies, as well as reproductions of drawings and paintings. The alliance with the Florentine group renewed the combative and aggressive spirit of Futurism. On the occasion of the first Futurist exhibition in Rome in 1913, at the Teatro Costanzi, Giovanni Papini and Ardengo Soffici also participated in the opening festivities. The latter, converted to the Futurist spirit, also exhibited various works with a strong formal accent, although they were based on the decomposition of planes.

Lacerba published a polemic between Boccioni and Guillaume Apollinaire on the idea of simultaneity, while in its pages new manifestos appeared. These included Marinetti's 'L'immaginazione senza fili e le parole in libertà' (i/12, 1913, pp. 121–4), Apollinaire's 'L'Antitradition futuriste' (i/18, 1913, pp. 202–3), Carrà's 'La pittura dei suoni, rumori e odori' (i/17, 1913, pp. 185–7), Marinetti's 'Il teatro di varietà' (i/19, 1913, pp. 209–11) and 'Il programma politico futurista' (i/20, 1913, pp. 221–2), signed by the group. On

1 August 1914 Lacerba also printed the contents of a pamphlet by Antonio Sant'Elia, 'Manifesto dell'architettura futurista' (repr. in Drudi Gambillo and Fiori, 1958, pp. 81–5), which had first appeared a month previously (see §II below). The alliance between the Futurists and Lacerba represented by these texts was soon destroyed by ideological differences, and at the end of 1914 their paths diverged.

As the number of followers of Futurism increased, so did the number of their exhibitions. At the end of 1913 an exhibition entitled Lacerba took place at the Libreria Gonnelli in Florence, and in Rome Giuseppe Sprovieri's new Galleria Permanente Futurista held a show of sculpture by Boccioni, previously exhibited in France. While Marinetti's activity reached out towards Russia and arrived in England with the support and encouragement of Christopher Nevinson, in Italy Futurism welcomed a number of new artists into its ranks: the poet Francesco Cangiullo (1888–1977), Fortunato Depero, Enrico Prampolini, Ottone Rosai, Giorgio Morandi, Mario Sironi and Arturo Martini.

Within the original group of painters, individual positions emerged more and more strongly from 1913. With the publication of his manifesto 'L'arte dei rumori' (Apollonio, 1970, pp. 126–33) Russolo abandoned his interest in painting to devote himself to music and the construction of new instruments, seeking to create harmonic modulations and chords that would give the 'sensation of the pulsating agitated life' of the metropolis. Carrà for his part elaborated theories about synaesthesia in 'La pittura dei suoni, rumori e odori', asserting that sounds, noises and smells must penetrate into the pictorial whole and give plastic expression to those sensations: 'To obtain this *total painting*, which demands the active cooperation of all the senses, *painting: plastic state of mind of the universal*, one must paint in the way that drunkards sing and vomit, sounds, noises and odours!' (Apollonio, 1970, p. 166). In his paintings these ideas were expressed by a more and more profound abstraction of forms in a dynamic sense. But Carrà did not deny the three-dimensional view of the

whole, accompanied by a search for more material solidity.

Around 1913 Severini's paintings, given an intense vitality of colour and light, were also tending towards a simplification of structure, as can be seen in his manifesto, written during the same period: 'It is *essentially important* to destroy the principle of light, local tones and shadows which painters before us have used to render the action of light on bodies, which belongs to the relativity of luminous, momentary and accidental phenomena' (Apollonio, 1970, p. 176). The study of movement and speed led Severini to emphasize intensity and luminous radiances in a sparkling colouristic abstraction. The subject of dance and of ballerinas already evident in works such as *Dynamic Hieroglyphic of the Bal Tabarin* (1912; New York, MOMA) brought out the decomposition of light and the fragmentation of lines, synthesized into joyous vortices of pure colours.

4. Futurism during World War I

At the outbreak of World War I the subject-matter of Futurist painting assumed more importance and became more overtly aggressive, with images of armoured trains, tunnels and cannons, as in Severini's *Plastic Synthesis of the Idea 'War'* (1915; Munich, Staatsgal. Mod. Kst). Their preferred colours also changed, becoming metallic. These images of war were the last studies of movement and formal composition within the Futurist movement; Severini, in fact, changed his painting in the direction of a formal purity of line and a classicism based on mathematical formulae.

Boccioni's use of complementary colours and dynamic intersecting planes created considerable spatial complexity in the image. His studies on dynamism led him, as early as 1912, to broaden his interests to sculpture, heralded by his publication in that year of his technical manifesto of Futurist sculpture, 'La scultura futurista' (Drudi Gambillo and Fiori, i, 1958, pp. 67–72). In his sculptures he sought to synthesize the impulses of a movement made by an object or by a figure, as in *Unique Forms of Continuity in Space* (1913; London, Tate; see col. pl. XXI), in terms of the absolute movement of the universe, extending the planes of the represented image in space. In his paintings Boccioni also developed his manner of figuration in the direction of abstraction, although this did not obliterate the subject, which remained recognizable thanks to the lines of its dynamic tension. Nevertheless, in the works of that period, such as *Dynamism of a Footballer* (1913; New York, MOMA) and *Dynamism of a Human Body* (1913–14; Milan, Civ. Mus. A. Contemp.), one can see the possibility of a return to a formal analysis.

The predominance of purely formal concerns in Boccioni's painting re-emerged at the end of 1914 through a meditation on volumes and masses inspired by the work of Cézanne. This was the basis on which, from 1916, his Futurist works went beyond the original poetics of the movement. In the new images, linked to a different spatial conception, the preoccupation with motion and speed was reabsorbed in a renewed interest in the subject itself. Divisionism now reappeared, amplified by more rapid brushstrokes to the point where they suggested a Cubist type of figuration, while colour was crystallized in violent chromatic juxtapositions.

Balla around 1913 moved from the veristic rendering of objects to a bold total abstraction of lines and colour. His series of *Iridescent Interpenetrations*, for example *Radial Iridescent Interpenetration: Prismatic Vibrations* (1913–14; Turin, Gal. Civ. A. Mod.), represent the extreme schematization of his studies of light and movement. In this work, coloured triangles, lined up in accord with optical affinities, create abstract and analytical visual textures. *Mercury Passing before the Sun, Seen through a Spyglass* (1914; Vienna, Mus. 20. Jhts) marks the artist's passage from the *Interpenetrations* to a true synthesis of forms. In Balla's paintings of 1915 simultaneity, which in Boccioni arose from the interpenetration of forms, was rendered through prismatic geometric schemes.

It was this particular conception of form and colour that influenced Depero, who joined the Futurist movement in 1914. Along with Balla he signed a manifesto on the *Ricostruzione futurista dell'universo* (Rome, 1915), in which they

proclaimed themselves Futurist abstract artists and sang the praises of a joyous universe, 'brightly coloured and full of light' (Apollonio, 1970, pp. 254–8). They created multimedia 'plastic complexes' from the most diverse elements, in accord with their abstract imaginative sensibilities. Balla's artistic experiments now extended to the theatre and to toys, chairs, benches, screens, divans and lampshades, mostly in green and yellow; huge Futurist flowers in scintillating colours rose from the floor, generated by an artificial nature.

Even in the preceding years Balla had amused himself by applying his theories on visual perception to realities outside painting itself. In his manifesto *Vestito antineutrale* (Apollonio, 1970, pp. 192–6), dated 11 September 1914, he described the style of an 'antineutral costume' to be worn in the demonstrations supporting Italy's entry into World War I: 'Since *neutrality is the synthesis of all that belongs to the past*, we Futurists today flaunt these antineutral, festively warlike clothes.' Balla himself enjoyed scandalizing the public with his eccentric dress.

5. Post-war developments

With the end of World War I and the deaths of Boccioni and Sant'Elia, Marinetti's movement lost its subversive character, and its centre moved from Milan to Rome. Balla, who emerged as the key artist of the movement, pursued his experiments with a new vein of spirituality, almost mysticism. Around him Prampolini bordered on Surrealism with his multimedia images, while Depero crystallized his figures in a mechanistic kind of schematization. With Marinetti's *Manifesto del tattilismo* (Drudi Gambillo and Fiori, i, 1958, pp. 56–61), dated 11 January 1921, a new and more playful phase of Futurism became official: 'The ends of Tactilism must be tactile harmonies, simply; and it must collaborate indirectly towards the perfecting of spiritual communications between human beings, through the epidermis.' These were years of great fervour in all fields, from dance to theatre, politics, cinematography and photography. In addition to the work made during this period by the movement's three senior artists—Balla, Prampolini and Depero—a new generation emerged, led by the mechanistic works of Gerardo Dottori and including also the geometric abstractions of Bruno Munari. This 'second Futurism', as it became known, was reinforced by the foundation of the Turin Futurist group by Fillia in 1923.

AEROPITTURA, a new phase of Futurism that attempted to revitalize the movement through a new cosmic idealism, was announced in 1929 by the publication of the *Manifesto dell'Aeropittura*, signed by Balla, Benedetta (Marinetti's wife, the painter and writer Benedetta Cappa, 1897–1977), Depero, Dottori, Fillia, Marinetti, Prampolini, the painter and sculptor Mino Somenzi (1899–1948) and the painter Tato (pseud. of Guglielmo Sansori, 1896–1974). In it they proposed a new theory of spiral dynamism. The heroic, dramatic transgressiveness of Futurism was thus transformed into a more imaginative and lyrical synthesis of the movement. Although in its strictest sense Futurism was confined to Italy, almost from its inception it had repercussions in other countries, leading notably to VORTICISM in England and to CUBO-FUTURISM and RAYISM in Russia.

Writings

F. T. Marinetti: *Le Futurisme* (Paris, 1911); rev. and ed. G. Lista (Milan, 1980)

M. Drudi Gambillo and T. Fiori, eds: *Archivi del futurismo*, 2 vols (Rome, 1958 and 1962/R Rome, 1986) [anthol. of pubd and unpubd lett. and doc. and illus. cat. of works by major artists]

F. T. Marinetti: *Teoria e invenzione futurista*, ed. L. De Maria (Milan, 1968)

L. Scrivo, ed.: *Sintesi del futurismo: Storia e documenti* (Rome, 1968)

U. Apollonio, ed.: *Futurismo* (Milan, 1970); Eng. trans. as *Futurist Manifestos* (London, 1973)

G. De Marchis and M. Carrà: *Lacerba* (Milan, 1970) [facs. of edns pubd 1913–15]

L. Caruso, ed.: *Manifesti, proclami, interventi e documenti teoretici del futurismo*, 4 vols (Florence, 1980)

C. Carrà: *La mia vita* (Milan, 1981)

Bibliography

G. Ballo: *Preistoria del futurismo* (Milan, 1960)

R. Carrieri: *Futurismo* (Milan, 1961)

R. T. Clough: *Futurism, the Story of a Modern Art Movement: A New Appraisal* (New York, 1961)

E. Crispolti: *Il secondo futurismo: 5 pittori e 1 scultore, Torino, 1923–1938* (Turin, 1961)

Futurism (exh. cat. by J. C. Taylor, New York, MOMA, 1961)

G. Acquaviva: *Futurismo* (Milan, 1962)

M. Calvesi: *Il futurismo*, 3 vols (Milan, 1967)

M. Martin: *Futurist Art and Theory* (Oxford, 1968)

M. Verdone: *Cinema e letteratura del futurismo* (Rome, 1968)

E. Crispolti: *Il mito della macchina e altri temi del futurismo* (Trapani, 1969; rev. 1971)

M. Kirby: *Futurist Performance* (New York, 1971; rev. 1986)

L. De Maria: *Marinetti e il futurismo* (Milan, 1973)

G. Lista: *Futurisme* (Lausanne, 1973)

Futurism: A Modern Focus (exh. cat., New York, Guggenheim, 1973)

J. P. Andreoli de Villers: *Futurism and the Arts: A Bibliography* (Toronto, 1975)

C. Tisdall and A. Bozzolla: *Futurism* (London, 1977)

P. Pacini, ed.: *26 Esposizioni futuriste, 1912–1918* (Florence, 1978) [repr. of Futurist exh. cats]

—: *Esposizioni futuriste, 1912–1931 (seconda serie)* (Florence, 1979) [repr. of Futurist exh. cats, with intro.]

G. Lista: *Arte e politica: Il Futurismo di sinistra in Italia* (Milan, 1980)

Futurism and the International Avant-garde (exh. cat. by A. d'Harnoncourt and G. Celant, Philadelphia, PA, Mus. A., 1980)

F. Roche-Pézard: *L'Aventure futuriste, 1909–1916* (Rome, 1983)

The Futurist Imagination: Word and Image in Italian Futurist Painting, Drawing, Collage and Free-word Painting (exh. cat., ed. A. C. Hanson; New Haven, CT, Yale U. A.G., 1983)

Futurismo a Firenze: 1910–1920 (exh. cat., Florence, Pal. Medici–Riccardi, 1984)

C. Salaris: *Storia del futurismo* (Rome, 1985)

I futuristi e la fotografia: Creazione fotografica e immagine quotidiana (exh. cat. by G. Lista, Modena, Musei Civ., 1985–6)

E. Crispolti: *Storia e critica del futurismo* (Rome, 1986)

M. Perloff: *The Futurist Moment* (Chicago, 1986)

Futurismo & futurismi (exh. cat., ed. P. Hultén; Venice, Pal. Grassi, 1986)

A. D'Elia: *L'Universo futurista, una mappa: Dal quadro alla cravatta* (Bari, 1988)

C. Salaris: *Bibliografia del futurismo, 1909–1944* (Rome, 1988)

ESTER COEN

II. ARCHITECTURE

In the first five years or so after the inception of Futurism by Filippo Tommaso Marinetti in 1909, architecture figured only by implication in the polemic of the manifesto writers of the Futurist movement, in the verses of its poets and in such Cubist-influenced paintings as Umberto Boccioni's the *Street Came into the House* (1911; Hannover, Kstmus). The Futurist's denunciation of historic precedent as a basis for design, their near-religious belief in science and technology and their emphasis on dynamism as an end in itself presented more intractable problems in architecture than in the other arts. Thus the earliest Futurist manifesto specifically to deal with architecture did not appear until 29 January 1914, in the Roman newspaper *Il piccolo giornale d'Italia* (Apollonio, ed., 1970, pp. 181–3). 'Aerostruttura, basi per un'architettura futurista', illustrated with drawings of two hypothetical projects, was by Enrico Prampolini, an associate of the Futurist group surrounding Giacomo Balla in Rome. It owes much to ideas on form and space already advocated by Boccioni, who also wrote, but did not publish, his views on architecture early in 1914 (first pubd 1972; repr. Godoli, pp. 185–7), attempting to relate the dynamic principles of Futurist painting and sculpture to architecture. This delay, followed by the outbreak of World War I, produced an architectural movement that operated solely through the medium of published and exhibited drawings and manifestos.

In 1912 the Milan-based architect Antonio Sant'elia, working in the popular northern Italian *Stile Liberty* and influenced by the review *Die Wagner Schule*, made the first of several hundred drawings of hypothetical buildings. These drawings constitute the main body of work on which the visual images associated with architectural Futurism are based. In examples executed in 1912 the *Stile Liberty* manner is still apparent, but by March 1914 it had virtually disappeared from the vivid perspective pencil and crayon sketches in the series *Città nuova* exhibited by Sant'Elia at the Prima Mostra dell'Assocazione degli Architetti Lombardi (Milan, Pal. Permanente). Among these, the earliest developed subjects of the Futurist

architectural canon, were designs for a hydro-electric power station with battered walls (Como, Mus. Civ. Stor. Garibaldi) and stepped-back buildings with curved lift-towers. Sant'Elia had recently become a member of the Nuove Tendenze, a moderate Milanese Futurist group, and showed his *Città nuova* series again in May–June 1914 at an exhibition of the group's work (Milan, Famiglia A.). He also contributed to the catalogue a 'Messagio' above his own signature, although he may have been helped in its composition by the art critic and journalist Ugo Nebbia (1880–1965). It contains no reference to Futurism *per se*, but the tenor of its contents and its format closely resemble earlier Futurist manifestos. Two months later, approached by Carlo Carrà, Sant'Elia joined the Futurist movement, and on 11 July 1914 some of the same drawings, now labelled *La Città futurista*, and a modified and extended version of the 'Messagio' were published as a pamphlet under the title *Manifesto dell'architettura futurista*, appearing in *Lacerba* a month later. The fully developed drawings depicted non-rhetorical, soaring forms—visionary scenographic representations of Utopian but feasible urban development, as in the high-speed transit system at several levels, served by an airstrip at roof level (1914; Como, Mus. Civ. Stor. Garibaldi). They express the apotheosis of new technologies and the dynamic energy of urban living, as advocated in the foundation manifesto. Moreover, as Banham pointed out, by affirming in the 'Messagio' that architecture remains an intuitive art, Sant'Elia ' . . . anticipates . . . the anti-Functionalist mood of Le Corbusier and Gropius in the Twenties . . . ' (1960, p. 130). Mario Chiattone, with whom Sant'Elia shared a studio, exhibited drawings in a similar though more earthbound style in the Nuove Tendenze exhibition. Futurist drawings and polemic were vigorously distributed by Marinetti to avant-garde groups in northern Europe, but the movement lost much of its vigour with the deaths in action of Boccioni and Sant'Elia in 1916.

After World War I Virgilio Marchi (1895–1960) acknowledged himself a follower of Sant'Elia in his own 'Manifesto dell'architettura futurista: Dinamico, stato d'animo drammatica', published in *Roma futurista* (29 Feb 1920), but added little to pre-war positions. His drawings range from the unadventurous towers and arched bridges of the proto-Rationalist *Metropoli futurista* to the incomprehensible contorted confections with titles such as *Visione architettonica* (both 1919–20), most of them published in his book *Architettura futurista* (Foligno, 1924). Mario Chiattone, who had not joined the Futurist movement, reverted to a nondescript Neo-classical manner, while Fortunato Depero and Prampolini, members of long standing, resorted to the device of using giant letters of the alphabet to form exhibition stands. In spite of Marinetti's efforts at revival (*Manifesto dell'architettura aerea*, 1934, with Angiolo Mazzioni and Mino Somenzi), in the 1920s and 1930s Futurist architecture merged with *Razionalismo* and European Expressionism.

Because of the association of Marinettian Futurism with Fascism, and as the *Città nuova* drawings were completed and exhibited before Sant'Elia joined the movement, attempts were made after World War II, especially by Bernasconi (1956) and Zevi (e.g. 1975, p. 177), to dissociate the work from the movement. Architectural influences other than Futurism have been adduced, such as the stepped-back apartments by Henri Sauvage, Rue Vavin, Paris (1912–14) and Harvey W. Corbett's vision of the future New York, reproduced in the *Illustrazione italiana* (Feb 1913). Etlin (1991) regarded Sant'Elian Futurism as one of several lines of development towards Italian Modernism between the wars, while Banham maintained that, as a turning-point in modern theories of design, its qualities were 'primarily ideological and concerned with attitudes of mind'. Whatever its origins, Sant'Elia's imagery retains its Futurist name and chimes with the popular conception of the architecture of the European modern movement in the inter-war years.

Bibliography

B. Zevi: *Storia dell'architettura moderna* (Turin, 1955, rev. 2/1975)

G. Bernasconi: 'Il messaggio di Antonio Sant'Elia del 20 maggio 1914', *Rev. Tec. Svizzera It.* (July 1956), pp. 145–52

P. R. Banham: *Theory and Design in the First Machine Age* (London, 1960), pp. 98–137 [contains a complete Eng. trans. of the 'Messagio']

Z. Birolli, ed.: *Umberto Boccioni: Altri inediti e apparati critici* (Milan, 1972)

Fillia [L.Colombo]: 'Futurismo e Fascismo', *L'architettura in Italia, 1919–1943: Le polemiche*, ed. L. Patteta (Milan, 1972), pp. 257–60

U. Apollonio, ed.: *Futurismo* (Milan, 1970); Eng. trans. as *Futurist Manifestos* (London and New York, 1973)

E. Godoli: *Guida all'architettura moderna: Il futurismo* (Bari, 1983)

E. Crispolti: *Attraverso l'architettura futurista* (Modena, 1984)

L. Caramel and A. Longatti: *Sant'Elia: L'opere completa* (Milan, 1987; Eng. trans., New York, 1988)

D. P. Doordan: *Building Modern Italy: Italian Architecture, 1914–1936* (New York, 1988), pp. 19–44

B. Zevi: 'Lines of Futurism', *A. & Des.*, v/11–12 (1989), pp. ix–xvi

R. A. Etlin: *Modernism in Italian Architecture, 1890–1940* (Cambridge, MA, and London, 1991), pp. 53–100

JOHN MUSGROVE

Gaceta del arte

An international monthly cultural review that was published in Tenerife, Canary Islands, from February 1932 to June 1936. Its editor-in-chief was Eduardo Westerdahl (1902–80), and its editors included the writer Domingo Pérez Mink. The proclamation of the Second Republic in Spain in 1931 created an atmosphere of liberalization, and national and international avant-garde periodicals of the previous decade such as *Esprit*, *Cahiers d'art*, *Die Brücke* and *Revista de Occidente* reappeared. The very character of the islands and the emphasis on international tourism favoured the *Gaceta del arte*'s publication. Its viewpoint was dependent on Westerdahl's European travels, which put him in contact with such contemporary avant-garde movements as Functionalism, Rationalism, Surrealism and many others. His programme was to disseminate the most progressive styles and ideas emerging in Europe, from aesthetics and ethics to fashion. From the outset, *Gaceta del arte* maintained connections with the Rationalist movement in architecture. Its contacts with Surrealism emerged later through Oscar Domínguez. The *Gaceta del arte* always maintained its independence, however, although there was a Surrealist faction among the magazine's editors, represented chiefly by Domingo López-Torres and Pedro Garcia Cabrera. Domínguez exhibited in Tenerife in 1933 and the review devoted a special issue to Surrealism. The *Exposición internacional del Surrealismo* was held in Tenerife in 1935 and included works by De Chirico, Duchamp, Dalí, Max Ernst, Domínguez and Giacometti among others; André Breton visited the island for the occasion. The *Gaceta* continued as a platform for the discussion of new ideas from Europe and from Spain. Its contributors included some of the most important artists of the day, such as Miró, Kandinsky and Angel Ferrant. It was always well received, particularly in liberal circles in Madrid and Barcelona. When the Spanish Civil War loomed in 1936, the review took a position against the war and against Fascism, but events caused its disappearance in June 1936.

Bibliography

D. Pérez Mink: *Facción española surrealista de Tenerife* (Barcelona, 1975)

E. Westerdahl: *Gaceta del arte: Revista internacional de cultura* (Madrid, 1981)

PILAR BENITO

GATEPAC [Grupo de Artistas y Técnicos Españoles para el Progreso de la Arquitectura Contemporánea]

Spanish group of architects. It developed from GATCPAC, a Catalan group formed in 1930 by Josep lluís Sert, Josep Torres i clavé, Sixto Illescas (1903–86) and Juan Baptista Subirana (1904–79). In 1930 GATEPAC was founded as a state body bringing the Catalan group together with a group of architects from central Spain, the most prominent of whom was Fernando García mercadal, and a group from the Basque country that included José María Aizpurua (1904–36) and Joaquín Labayen

(1904–74). It remained active until the outbreak of the Spanish Civil War in 1936. GATEPAC was the Spanish representative in CIRPAC and in CIAM, and the architecture designed and promoted by the group can be seen as exemplifying the orthodox Rationalism of the 1930s. Although the young architects who belonged to GATEPAC were all influenced to some extent by Le Corbusier, they also showed a particular preoccupation with the relation of architecture to technical considerations and to social and economic conditions. The group's theoretical concepts were thus closely related to the principles of Neue Sachlichkeit.

The most active of the constituent groups was GATCPAC, which was responsible for the publication of the magazine *A. C. Documentos de actividad contemporánea*. Through this they promoted Modernist architectural ideas within Spain and in other Spanish-speaking countries with articles and reports on the activities and works of the group and other modern architects. They were also closely involved in the process of social and political renewal that Spain was undergoing in the 1930s, drawing up practical proposals for such utopian projects as the 'Ciudad Cooperativa para el Reposo y las Vacaciones' (1933–4), a kind of 'green city' to be built on the coast near Barcelona; the Macià plan (1932–5), an urban project for Barcelona seen as a functional city and drawn up in collaboration with Le Corbusier; or the construction of the Casa Bloc (1932–6) in Sant Andreu, Barcelona, an experimental model housing unit planned for use throughout the city.

Writings

A.C./G.A.T.E.P.A.C., 1931–1937 (Barcelona, 1975) [facs. edn of the group's journal]

Bibliography

O. Bohigas: *Arquitectura española de la segunda república* (Barcelona, 1970)
F. Roca: 'El G.A.T.E.P.A.C y la crisis urbana de los años 30', *Quad. Arquit. & Urb.*, xc (1972)
J. C. Theilacker: 'La organización interna del G.A.T.C.P.A.C.', *Quad. Arquit. & Urb.*, xc (1972), pp. 6–10
E. Donato: 'Cronología del proyecto C.R.V.', *Quad. Arquit. & Urb.*, xciv (1973), pp. 20–22

JORDI OLIVERAS

General Idea

Canadian partnership of conceptual artists working as performance artists, video artists, photographers and sculptors. It was formed in 1968 by A. A. Bronson [pseud. of Michael Tims] (*b* Vancouver, 1946), Felix Partz [pseud. of Ron Gabe] (*b* Winnipeg, 1945) and Jorge Zontal [pseud. of Jorge Saia] (*b* Parma, Italy, 1944; *d* Feb 1994). Influenced by semiotics and working in various media, they sought to examine and subvert social structures, taking particular interest in the products of mass culture. Their existence as a group, each with an assumed name, itself undermined the traditional notion of the solitary artist of genius. In 1972 they began publishing a quarterly journal, *File*, to publicize their current interests and work. In the 1970s they concentrated on beauty parades, starting in 1970 with the *1970 Miss General Idea Pageant*, a performance at the Festival of Underground Theatre in Toronto that mocked the clichés surrounding the beauty parade, resulting in the nomination of Miss General Idea 1970. This was followed by the *1971 Miss General Idea Pageant*, which involved the submission by 13 artists of photographic entries that were exhibited and judged at The Space in Toronto.

From 1971 to 1977 General Idea presented a series of performances and exhibitions for the planned *1984 Miss General Idea Pageant and Pavilion*, such as *Going thru the Motions* (Toronto, A.G. Ont., 1975), which included designs for the architectural setting, and a rehearsal for the pageant. Undermining temporal structures, in 1977 they enacted the destruction of the 1984 pavilion by fire at a large site in Kingston, Ontario. This was followed, in the late 1970s and early 1980s, by a series of 'archaeological' exhibitions that documented the destruction and displayed 'retrieved' fragments from the pavilion. The first of these was the exhibition *Reconstructing Futures* in 1977. Later, in works such as *The Unveiling of Cornucopia* (1982; see 1984–5 exh. cat., p. 97) they exhibited such images in the guise of rescued mural fragments. In the late 1980s General Idea turned their attention to the AIDS epidemic through exhibitions and installations.

Bibliography

General Idea's Reconstructing Futures (exh. cat. by C.
　Robertson, Toronto, Carmen Lamanna Gal., 1977)
General Idea: 1968–1984 (exh. cat. by J.-C. Ammann, T.
　Guest and General Idea, Basle, Ksthalle; Eindhoven,
　Stedel. Van Abbemus.; Toronto, A.G. Ont.; Montreal,
　Mus. A. Contemp.; 1984–5)

　　　　　　　　□

Gödöllő colony

Hungarian artists' colony. It was formed in 1901
at Gödöllő, near Budapest, when the painter
Aladár Körösfői-Kriesch undertook to revive the
traditional art of weaving with looms donated by
the Ministry of Culture. Members included Sándor
Nagy and his wife, the painter and designer Laura
Kriesch (1879–1966), Ervin Raálo (1874–1959), Jenő
Remsey (1885–1980), Endre Frecskai (1875–1919),
Léo Belmonte (1870–1956), Árpád Juhász (1863–
1914), Rezső Mihály (1889–1972), István Zichy
(1879–1951), Mariska Undi (1887–1959), Carla
Undi (1881–1956) and the sculptor Ferenc Sidló
(1882–1953). Inspired by the ideals of John Ruskin
and William Morris and by the heroic vision
of peasant life celebrated by Tolstoy, the group
established workshops in ceramics, sculpture,
leatherwork, furniture-making, embroidery, book-
binding and illustration, fabric and wallpaper
design and, most importantly, in stained glass and
the weaving of carpets and tapestries coloured
with vegetable dyes. Their goals were social as well
as artistic: to enable the rural poor to stay on the
land, they taught traditional craft techniques to
local young people and exhibited their work to
international acclaim. They also sought to develop
a modern national style by adapting the rich
forms and colourful ornament of vernacular art
and architecture, which they recorded and pub-
lished between 1907 and 1922 in the five-volume
study, *A magyar nép müvészete* (The art of the
Hungarian people). In 1909 they had a collective
exhibition at the National Salon in Budapest. As
artists identified with a style of romantic nation-
alism, Gödöllő designers and craftsmen obtained
such important government commissions as the

decoration of the Hungarian pavilions at inter-
national exhibitions and, in 1913, the design
and decoration of the Palace of Culture of
Marosvásárhely (now Tîrgu Mureş, Romania),
where the stained-glass windows by Sándor Nagy
and Ede Thoroczkai Wigand rank as one of the
greatest achievements of 20th-century Hungarian
art. The colony existed until 1921. The textile work-
shop carried on for a few more years under the
management of Sándor Nagy and the weaver
Vilma Frey (1886–after 1921).

Bibliography

K. Gellér and K. Keserü: *Gödöllői müvésztelep, kiállitás
　katalógus angolnyelvü kivonattal* [Conceptions and
　ideals of the artists of Gödöllő] (Kecskemét, 1977)
K. Gellér: 'Hungarian Stained Glass of the Early 20th
　Century', *J. Stained Glass*, xvii/2 (1986–7), pp. 200–14
K. Gellér and K. Keserü: *A Gödöllői müvésztelep* [The
　Godollo artists' colony] (Budapest, 1987)
E. Cumming and W. Kaplan: *The Arts and Crafts
　Movement* (London, 1991), pp. 191–5

　　　　　　　　　　　　　　FERENC BATÁRI

Golden Fleece [Rus. *Zolotoye Runo*]

Russian artistic and literary magazine pub-
lished monthly in Moscow during 1906–9. It was
financed and edited by the millionaire Nikolay
Ryabushinsky, and it sponsored the first exhibi-
tions in Russia of modern and of contemporary
French art. In its first two years, this beautifully
produced, well-illustrated and lively magazine was
principally dedicated to Russian Symbolism. The
poets Aleksandr Blok, Konstantin Bal'mont
(1867–1943) and Andrey Bely were regular con-
tributors and co-editors, as were many painters
of the World of Art (Mir Iskusstva) generation
such as Alexandre Benois, Mikhail Vrubel',
Igor' Grabar', Mstislav Dobuzhinsky, Konstantin
Korovin, Nicholas Roerich, Konstantin Somov
and Valentin Serov. The Blue Rose group were also
represented.

　　By 1908, however, Ryabushinsky had become
friendly with younger artists such as Mikhail
Larionov, Natal'ya Goncharova and Georgy

Yakulov. Under their influence, and sensitive to the changing artistic climate, Ryabushinsky altered the bias of the magazine from its distinctly Symbolist position to one that embraced contemporary French and Russian art.

In its last two years *Golden Fleece* became preoccupied with publicizing the French art shown in its exhibitions. Special issues were devoted to Gauguin and Matisse, and particular attention was paid to publishing translations of artists' writings, such as selections from van Gogh's letters and Matisse's *Notes of a Painter*. Maurice Denis and Rodin were both, for a short time, co-editors of the magazine.

The three exhibitions organized by *Golden Fleece* during 1908–10 were particularly important. The first *Salon of the Golden Fleece* (1908) presented over two hundred works by van Gogh, Gauguin, Cézanne, the Neo-Impressionists, the Nabis and the Fauves as well as the work of younger Russian artists. The impact of this exhibition upon the latter was immense, and it substantially influenced the artistic development of Larionov and Goncharova among others. Painters who had exhibited Impressionist and mildly Symbolist canvases in the exhibition were forced to reconsider their views in the light of the French contribution. The impact on the Russians was consolidated in 1909 when the Fauves were again invited to show works at the second *Golden Fleece* exhibition. By this time, however, the Russians were already assimilating the influence of the French. Larionov's and Goncharova's latest exhibits showed a rapid development from the Impressionist paintings of the previous year to works that were Post-Impressionist and Fauvist in style. These two historic exhibitions brought into focus the latest achievements of French painting and played a fundamental role in the development of modern Russian art. But before the demise of *Golden Fleece* in 1910 due to financial problems, a third and final 'all Russian' exhibition brought together Larionov, Goncharova, Martiros Saryan, Pyotr Konchalovsky, Il'ya Mashkov and Robert Fal'k. This exhibition led to the founding of the Jack of Diamonds group later in the year.

Bibliography

Zolotoye Runo: Zhurnal khudozhestvennyy literaturnyy i kriticheskiy [Golden Fleece: artistic, literary and critical magazine] (Moscow, 1906–9)

Salon 'Zolotogo Runa' [Salon of 'Golden Fleece'] (exh. cat., Moscow, 1908)

Zolotoye Runo [Golden Fleece] (exh. cats, Moscow, 1909 and 1910)

J. E. Bowlt: 'Nikolai Ryabushinsky: Playboy of the Eastern World', *Apollo*, xcviii (1973), pp. 486–93

ANTHONY PARTON

Great Plains painting

Term applied to Hungarian late 19th- and 20th-century painting associated with the Great Plains, a large expanse of land in the Carpathian Basin, mainly in Hungary. The sparsely populated area contains numerous small farming communities loosely scattered around urban centres. Up to the end of World War II these communities probably represented the poorest stratum of Hungarian society; the unfavourable climate with its frequent droughts made their life especially difficult. The landscape and ethnic population of the area appeared occasionally in the work of certain Hungarian painters in the 19th century, but it was not until the Austrian painter August von Pettenkofen regularly visited the area that the depiction of the landscape and life style of the Great Plains became more widespread. From 1851 he returned annually to paint near Szolnok, bringing with him other Austrian, German and Hungarian painters from Paris (*see* SZOLNOK COLONY). The depiction of the Great Plains gradually became a romanticized image representing Hungary as a whole.

Apart from Szolnok, the most significant artistic centre in the area was Hódmezővásárhely, where artists created an artistic community under the leadership of János Tornyai (the museum there is named after him). Their association was free from institutional constraints, and they were united by their ideas and approach. They collected and inspired others to collect folk artefacts, set up scholarships, founded art and literary societies (1910), published the magazine *Jövendő* ('The

Future'; 1910–12) and built a cultural centre. Tornyai, Gyula Rudnay (1878–1957) and Béla Endre (1870–1928) were the most outstanding representatives of this community. Their work displays a characteristic naturalism, especially in the depiction of social detail. Folk art had no effect on their painting style, which was rather influenced by the peasant genres of Mihály von Munkácsy, to which they added the expression of nationalist sentiments. In Tornyai's work the romanticized image of Hungary assumed symbolic power (e.g. *Woeful Hungarian Fate*, c. 1910; Budapest, N.G.). Rudnay's work, which employs dramatic chiaroscuro, evokes the atmosphere of Hungarian history, while Endre's paintings are generally more peaceful in tone with brighter colours and a lyrical atmosphere. Hódmezővásárhely remained one of the most important cultural centres of the Great Plains between the Wars. The career of Menyhért Tóth (1904–80) can be linked with its art life from the end of the 1930s, even though his work is visionary and surrealist.

After World War II a number of artists decided to establish themselves in Hódmezővásárhely or in the southern region of the Great Plains, including György Kohán (1910–1966), István D. Kurucz (*b* 1914), Ferenc Szalay (*b* 1931) and József Németh (*b* 1928). Their work, with its striving for monumentality and decorative realism, represents a well-defined trend in 20th-century Hungarian art. Great Plains painting can also be associated with groups of artists in Szeged and Debrecen, where, in the absence of established artists' colonies, the painters generally relied upon municipal scholarships or individuals in organizing study-trips abroad. Notable among the painters who started their careers there were István Bosznay (1868–1944), Sándor Nyilasy (1873–1934), Lajos Károlyi (1877–1927), József Szöri (1878–1914) and László Holló (1887–1976). Their work generally developed towards a nostalgic evocation of the past and a detailed depiction of everyday provincial life. The two solitary painters of life on the Great Plains were József Koszta and István Nagy. Koszta worked alone on an isolated farm near Szentes. His style is individual and passionate but still continues Munkácsy's heritage. Nagy spent a

short but intensive period on the Great Plains during the 1920s; his work there idiosyncratically combined Expressionism and Constructivism. Another artistic centre in the area, the Kecskemét colony, was at the turn of the century more responsive to modernist tendencies and can be related to the Great Plains only geographically rather than stylistically.

Bibliography

P. Bánszky: 'Látomások az Alföldről' [Visions of the Great Plains], *Művészet* [Art], xix/12 (1978), pp. 4–7

G. Rideg: 'Kinek a szemlélete az alföldi szemlélet?' [Whose perspective is the Great Plains perspective?], *Művészet* [Art], xix/12 (1978), pp. 2–4

G. Theisler: 'Támpontok és kételyek: Az alföldi festészet klasszikusairól' [The classic figures of Great Plains painting: basic facts and unanswered questions], *Művészet* [Art], xix/12 (1978), pp. 7–10

M. Egri and N. Aradi: 'Az Alföld képzőművészeti centrumai' [Art centres of the Great Plains], *Magyar Művészet 1890–1919* [Hungarian art 1890–1919], ed. L. Németh (Budapest, 1981), pp. 228–50

P. Kovács: 'Az alföldi festészet' [Painting of the Great Plains], *Magyar Művészet 1919–1945* [Hungarian art 1919–1945], ed. S. Kontha (Budapest, 1985), pp. 282–97

MÁRIA SZOBOR-BERNÁTH

Gresham group

Association of Hungarian artists who met regularly at the Gresham Café in Budapest from the mid-1920s to 1944. A loose and friendly association free from institutional constraints, they were united merely by the approximate similarity of their aesthetic thinking, rather than any particular style. Such leading members of the Hungarian avant-garde as Róbert Berény and Aurél Bernáth were, especially in their youth, among the artists at the Gresham. In the 1920s the group contained such representatives of the nascent Hungarian Expressionist movement as József Egry, István Szőnyi, Béni Ferenczy and Pál Pátzay (1896–1979). They are also often referred to as the 'post-Nagybánya school', which refers to the principles of the Nagybánya colony, active in the 1910s, and to their desire to uphold the artistic tradition

and stance of the group represented primarily by Károly Ferenczy.

The avowed goal of the Gresham group was to align themselves with the internal development of Hungarian art, while emphasizing the importance of quality. They opposed the official art policy of the day and rejected the artistic establishment. They were generally against the avant-garde, but they equally repudiated the resurgence of Neo-classicism and distanced themselves from academic, nationalistic art. Their ideal was an art that drew on the resources embedded in tradition, while retaining qualities of abstraction and timelessness. Aurél Bernáth's *Self-portrait in a Yellow Coat* (1930; Budapest, N.G.) may be taken as a representative example of their work.

The Gresham group exerted a decisive influence on Hungarian art between the wars, and its influence was still felt after World War II. Several former members were among the most respected artists in the country between 1945 and 1949. The painters Géza Bornemisza (1884–1966), Béla Czóbel (*b* 1883), Jenő Elekfy (1895–1968), Imre Szobotka (1890–1961) and Elemér Vass (1887–1957) were also members, as was the tapestry designer Noémi Ferenczy. Others joined for various lengths of time and at different intervals. The group also contained critics such as Zoltán Farkas (1880–1969), István Genthon (1903–69), Simon Meller, Miklós Rózsa (1874–1945) and Arnold Schoen (1887–1973), and patrons, notably Lajos Fruchter (*d* 1953), Sándor Szilágyi and Béla Radnai. The economist and publisher Imre Oltványi Ártinger (1893–1963) was an outstanding promoter of the group, and he commissioned a number of monographs on members of the group for his series *Ars Hungarica*.

Bibliography

P. Pátzay: *Alkotás és szemlélet* [Creation and perspective] (Budapest, 1967)

L. Németh: 'A Gresham—múlt és jelen' [The Gresham—past and present], *Művészet*, xvii/12 (1976), pp. 6–10

J. Szabó: 'A rajz és az akvarell a Gresham-kör művészetében' [Drawings and watercolours in the art of the Gresham circle], *Művészet*, xvii/12 (1976), pp. 20–22

L. Végvári and S. Kontha: 'A Gresham csoport kialakulása és esztétikája' [The formation and aesthetics of the

Gresham group], *Magyar Művészet, 1919–1945* [Hungarian art, 1919–1945], ed. S. Kontha (Budapest, 1985), pp. 446–89

MÁRIA SZOBOR-BERNÁTH

Groupe de Recherche d'Art Visuel [GRAV]

Group of artists active in Paris from 1960 to 1968. Eleven artists signed the original manifesto, but only six of them formed the core of the group: Horacio García Rossi (*b* 1929), Francisco Sobrino, François Morellet, Julio Le Parc, Joël Stein (*b* 1926) and Jean-Pierre Vasarely, known as Yvaral (*b* 1934). The group took its name from the Centre de Recherche d'Art Visuel, founded in Paris in July 1960. Following the belief of Victor Vasarely (father of Yvaral) that the concept of the artist as a solitary genius was outdated, the artists' main aim was to merge the individual identities of the members into a collective activity that would be more than the sum of its parts. They also believed that 'workers collaborating with the aid of scientific and technical disciplines [would] be the only true creators of the future'. The group exhibited in Europe within the framework of the NOUVELLE TENDANCE movement, and it successfully developed the logic of group activity through the strategy of anonymity and the holding of collective events called *Labyrinths*. From the outset, members of GRAV adopted the principle of submitting individual work to the consideration of the group as a whole, which would determine its relevance to the overall programme. In 1961 they felt confident enough to assert that 'plastic reality' was inherent in 'the constant relationship between the plastic object and the human eye'. This conviction led them to experiment with a wide spectrum of kinetic and optical effects, employing various types of artificial light and mechanical movement as well as optical or 'virtual' movement. In *Assez de mystifications!*, the text that they published on the occasion of the Paris Biennale in 1961, they sought to forge a connection between their efforts to engage the 'human eye' and their forthright denunciation of the élitism of traditional art, which appealed to 'the cultivated eye . . . the intellectual eye'.

The first *Labyrinth*, presented at the Paris Biennale of 1963, was the culmination of three years of joint research into optical and kinetic devices. It also, however, demonstrated the difficulties inherent in the group's position. The emphasis on the 'human eye' had shifted to a more general concern with 'spectator participation', and the new slogan became: 'It is forbidden not to touch'. No special privilege could be attached from then on to the purely visual stimuli of the earlier works, and on 19 April 1966 GRAV held a *Day in the Street* in central Paris, inviting passers-by to walk on uneven wooden blocks, or experience the deformation of their vision through elaborate distorting spectacles. Close as these events were to the Happenings being pioneered in the USA at the same time, they sprang from the rationalistic premises of the European kinetic movement. When the group members presented *Labyrinth 3* in New York in March 1965, they realized that their work, based as it was on research into optical and kinetic effect, had little relevance to the American context.

The agreed dissolution of the group in November 1968 sprang from the recognition that it was impossible to maintain the rigour of a joint programme. Morellet commented at the time that he had argued from the start for a suppression of individual signatures, and that the members who had hesitated to take this step had condemned the group to eventual disappearance. Stein, however, laid more emphasis on the inability of both commercial and public galleries to tolerate the group strategy and singled out the decision of the committee of the Venice Biennale in 1966 to give their major prize to Le Parc as one of the crucial factors in the group's decline. In discussing and publicizing the reasons for their failure, rather than just dissolving tacitly, the surviving members remained consistent with the scientific claims of their original programme.

Published Writings

Assez de mystifications! (Paris, 1961)

'The Texts of the Groupe Recherche d'Art Visuel, Paris: 1960–1965', ed. and trans. R. Gadney and S. Bann, *Image* (Winter 1966), pp. 13–30

Bibliography

F. Popper: *Origins and Development of Kinetic Art* (London, 1968)

J. Stein: 'Dissolution du GRAV', Leonardo, ii (1969), pp. 295–7

STEPHEN BANN

Group f.64

American group of photographers, active 1932–5. It was a loose association of San Francisco Bay Area photographers who articulated and promoted a modern movement in photographic aesthetics. The group was formed in August 1932 by photographers who shared an interest in pure and unmanipulated photography as a means of creative expression. It derived its name from the smallest possible aperture setting on a camera, the use of which resulted in the greatest and sharpest depth of field, producing an image with foreground and background clearly focused. The original membership consisted of Ansel Adams, Imogen Cunningham, John Paul Edwards (1883–1958), Sonya Noskowiak (1900–75), Henry Swift (1891–1960), Willard Van Dyke (1906–86) and Edward Weston. The emphasis on clarity was partly a reaction against the lingering Pictorialism in West Coast photography, exemplified by the work of William Mortensen (1897–1965) and Anne Brigman (1869–1950), who achieved painterly effects through manipulation of the negative and print.

Group f.64's working technique demanded the use of a large-format view camera, and their pristine presentation of exhibition photographs required the dry-mounting of glossy contact prints to proportionally correct white boards. The collective imagery of the group incorporated a broad range of organic and industrial forms as well as occasional portraiture, but the common concern was for technical precision in rendering a formally well-defined image. This style of realism complemented contemporaneous American Precisionist painting (see Precisionism) and paralleled similar photographic developments in European Neue Sachlichkeit.

Group f.64 mounted only one exhibition, at San Francisco's M. H. de Young Memorial Museum in November 1932. Works shown included Cunningham's *Leaf Pattern* (*c.* 1929; Berkeley, CA, Imogen Cunningham Trust), Edwards's *Boats and Riggings* (*c.* 1930; Oakland, CA, Mus.), Adams's *Lakes and Cliffs, Sierra Nevada* (1927), Noskowiak's *Sand Pattern* (1932), Van Dyke's *Bone and Sky* (1932) and Weston's *Pepper No. 30* (1930; all San Francisco, CA, MOMA). The show also featured photographs by associate members Preston Holder (*b* 1907), Consuela Kanaga (1894–1978), Alma Lavenson (*b* 1897) and Brett Weston (*b* 1911). Although the group remained active for only a few years, its concept of 'straight' photography proved a viable photographic proposition for America in the 1930s and was influential as an approach for future generations of photographers.

Bibliography

J. P. Edwards: 'Group f.64', *Camera Craft*, xvii/3 (1935), pp. 107–13

G. M. Craven: *The Group f.64 Controversy: An Introduction to the Henry F. Swift Memorial Collection of the San Francisco Museum of Art* (San Francisco, 1963)

Group f.64 (exh. cat. by J. S. Tucker, St Louis, U. MO, 1978)

K. Tsujimoto: *Images of America: Precisionist Painting and Modern Photography* (Seattle, 1982)

<div style="text-align: right">RICHARD LORENZ</div>

Group of Plastic Artists [Czech: Skupina Výtvarných Umělců]

Bohemian avant-garde group, active 1911–17. In February 1911 a fundamental rift between the older and younger generations in the MÁNES UNION OF ARTISTS was occasioned by the fall in subscriptions to the union's journal *Volné směry* after its new editors, Emil Filla and Antonín Matějček, reproduced Picasso's work and published Filla's article on the virtues of the new primitivism. The majority of the young contributors to the journal pointedly withdrew from the Mánes Union. Towards the end of 1911 they established the Group of Plastic Artists, oriented towards Cubism; its members were Vincenc Beneš, V. H. Brunner, Josef Čapek, Emil Filla, Josef Gočár, Otto Gutfreund, Vlastislav Hofman (1884–1964), Josef Chochol, Pavel Janák, Zdeněk Kratochvíl, František Kysela, Antonín Procházka, Ladislav Šíma, Václav Špála, the writers Karel Čapek (1890–1938) and František Langer, and the art historian V. V. Štech. For personal reasons and differences of opinion, Bohumil Kubišta, Otokar Kubín and Matějček remained outside the group and soon returned to the Mánes Union. Gočár was elected the group's first president.

In the autumn the group began publishing its own journal, *Umělecký měsíčník*. The first editor was Josef Čapek and the editorial board consisted of Filla, Janák, Kysela, Langer, Štech and the composer Václav Štěpán (1889–1944); after April 1912 Čapek, Janák and Langer took turns as editor, and Hofman joined the editorial board. The group's first exhibition was organized as an independent part of the Exhibition of Art at the Community House (Obecný Dům) in Prague, in which the Mánes Union and the Union of Plastic Artists also took part. The architectonic arrangement of the room used for this purpose was designed by Janák; there were exhibits of furniture, ceramics, glass, architectonic models and photographs of buildings alongside Cubo-Expressionist pictures and sculptures (*see* CUBO-EXPRESSIONISM).

The group's second exhibition (Community House, Sept–Nov 1912) was considerably more representative and brought together almost 100 exhibits, including paintings by the guest artists Willy Nowak (1886–1977) and Friedrich Feigl (1884–1965) and 20 works by German Expressionists. Gočár was responsible for the general arrangement and Kysela for the poster, while Štech wrote the introduction to the catalogue. Within the group itself the tension between two camps gradually came to a head: one, led by Filla and Beneš, was in favour of orthodox Cubist methods, the other, led by the Čapek brothers, saw Cubism as an aesthetic system open to all but gave equal acceptance to Italian Futurist works. The dispute reached its climax in 1912 when the Čapek brothers, Brunner, Hofman, Chochol and Špála left the group (the last named artist had recently joined the Mánes Union).

The third exhibition took place in the Goltz Salon, Munich, in April 1913 and presented works by Beneš, Filla, Procházka, Gutfreund, Gočár and Janák. In May 1913 the group opened a fourth exhibition at the Community House, with eleven paintings by Braque, nine by Picasso, five by Derain and two by Gris. There were also works by Cézanne and Ardengo Soffici, as well as examples of folk art, exotic art and ancient art, to underline the group's relationship to these sources. In this respect the exhibition was reflecting ideas expressed in *Umělecký měsíčník*. In October 1913 the group's fifth exhibition took place at the Sturm-Galerie in Berlin. There were many works by Beneš and Filla from the years 1909–13, and exhibits by Gutfreund, Gočár, Janák and Procházka. The sixth and last exhibition was held in February 1914 at the Community House. Paintings and sculptures by members of the group were placed side by side with African statuettes; guest artists included Munch, Picasso, Max Pechstein, Braque and Derain. In 1914 *Umělecký měsíčník* ceased publication. During World War I the group disbanded, and in 1917 Beneš, Gočár, Janák, Kratochvíl and Kysela joined the Mánes Union. Filla followed them after his return from the Netherlands in 1920.

Bibliography

M. Lamač: *Osma a Skupina výtvarných umělců* [The Eight and the Group of Plastic Artists] (Prague, 1988; Fr. trans., 1992)

Český kubismus (exh. cat., ed. A. von Vegesack; Weil am Rhein, Vitra Des. Mus., 1991; Ger. trans., 1991)

Kubismus in Prag (exh. cat., ed. J. Švestka and T. Vlček; Düsseldorf, Kstver., 1991)

LENKA BYDŽOVSKÁ

Group of Seven

Canadian group of painters. It was named in May 1920 on the occasion of an exhibition held in Toronto and was initially composed of Frank Carmichael (1890–1945), Lawren S. Harris, A. Y. Jackson, Franz Johnston (1888–1949), Arthur Lismer, J. E. H. MacDonald and Fred Varley. On Johnston's resignation in 1926, A. J. Casson (1898–1992) was invited to join. The group later expanded to include two members from outside Toronto, Edwin H. Holgate from Montreal (in 1930) and Lionel LeMoine FitzGerald from Winnipeg (in 1932). The essential character of the group's style and approach to landscape painting was in evidence well before their official formation in 1920, and some of their most important pictures also pre-date that first exhibition. Although they continued to show together officially only until December 1931 and disbanded in 1933, when former members helped establish a successor organization with a much larger membership drawn from all over the country (the Canadian Group of Painters), the term continued to be applied to the later works of the group's original members.

The Group of Seven had its origins in Toronto from 1910 to 1913, when a number of its future members, together with like-minded painters such as Tom Thomson, met while working as commercial artists in the studios of the company Grip Limited. The Toronto Arts & Letters Club, founded in 1908, also became a vital meeting point for them and other interested artists. They were united in their frustration at the conservative and limited character of art in Canada and by a belief in their capacity to give expression to a national and independent artistic image through the painting of the northern Canadian landscape, as in Jackson's *Terre Sauvage* (1913; Ottawa, N.G.). There was early opposition to their style, not so much because of their debts to late 19th-century European art (Symbolism, with mystical overtones, and Post-Impressionism) but because of their simplification of form and boldness of colour, which seemed shocking in relation to more traditional approaches to landscape painting. There was also resentment towards their presumption of representing a national school. Nevertheless they received strong support from Eric Brown, Director of the National Gallery, and eventually broke down some of the resistance through their own aggressiveness in advocating their position. Controversy abounded after the official formation of the group, but the issue was forced by their successful participation in 1924 in the *British Empire Exhibition* in Wembley,

England, from which the Tate Gallery in London purchased Jackson's *Entrance to Halifax Harbour* (1919). Through the later 1920s the group's pre-eminent position in Canadian art was established.

Although projected as a national school, the Group of Seven was essentially based in Ontario, which created resentment among artists in other parts of the country. Moreover, the ties among former members of the group gradually weakened through the 1930s, but their approach to land-scape, increasingly resistant to change but secure in broad-based public support, became an oppressive restraint on succeeding generations of painters in Ontario. Their unassailable position was broken only in the 1950s with the emergence of Painters Eleven.

Bibliography

F. B. Housser: *A Canadian Art Movement: The Story of the Group of Seven* (Toronto, 1926)

T. MacDonald: *The Group of Seven* (Toronto, 1944)

P. Duval: *Group of Seven Drawings* (Toronto, 1965)

P. Mellen: *The Group of Seven* (Toronto, 1970)

The Group of Seven (exh. cat. by D. Reid, Ottawa, N.G., 1970)

D. Reid: *A Bibliography of the Group of Seven* (Ottawa, 1971)

H. Hunkin: *The Group of Seven: Canada's Great Landscape Painters* (Edinburgh, 1979)

M. Tooby, ed.: *The True North: Canadian Landscape Painting, 1896–1939* (London, 1991)

DAVID BURNETT

Group X

Group of British artists formed in 1920. It exhib-ited at the Mansard Gallery, Heal's, in London, between 26 March and 24 April of that year. The nucleus of the group, whose name had no precise significance, was a regrouping of the Vorticists, comprising Wyndham Lewis, Jessica Dismorr, Frederick Etchells, Cuthbert Hamilton, William Roberts and Edward Wadsworth; these artists were joined by Frank Dobson, Charles Ginner, McKnight Kauffer and John Turnbull. Although the artists were united in a belief that 'the experiments undertaken all over Europe during the last ten years should be utilized directly and developed,

and not be lightly abandoned or the effort allowed to relax' (Lewis, exh. cat., intro.), the works exhib-ited were characterized chiefly by a tendency to angular figuration; the critic Frank Rutter (1876–1937) wrote in the *Sunday Times* (28 March 1920) that 'the real tendency of the exhibition is towards a new sort of realism, evolved by artists who have passed through a phase of abstract experiment'.

Although the group had intended to exhibit together twice annually, the show of 1920 was their first and last. The short-lived and relatively conservative nature of Group X was indicative both of the disruption to British avant-garde activ-ity caused by World War I, and of the more wide-spread cultural retrenchment, referred to as a 'rappel à l'ordre' in the post-war period.

Bibliography

Group X (exh. cat. by W. Lewis, London, Mansard Gal., 1920)

MONICA BOHM-DUCHEN

Grupo CAYC

Argentine group of artists. It was founded in Buenos Aires in 1971 as the Grupo de los Trece by the critic Jorge Glusberg (*b* 1938) and renamed Grupo CAYC because of its close association with the Centro de Arte y Comunicación. The group held its first public show in 1972 in the exhibition *Hacia un perfil del arte latino americano* at the third Bienal Coltejer, Medellín, Colombia. The group's chief members were Jacques Bedel, Luis Benedit, Jorge Glusberg, Víctor Grippo, the sculp-tor Leopoldo Maler (*b* 1937), the sculptor Alfredo Portillos (*b* 1928) and Clorindo Testa. Treating the visual aspect of works of art as just one element in order to demonstrate the complexity and richness of the creative process, they took a wide view of Latin American culture that spanned the cosmogony of Pre-Columbian societies to the technological and scientific concepts of the late 20th century. In 1977 they won the Gran Premio Itamaraty at the 14th São Paulo Biennale with their collective work *Signs of Artificial Eco-systems*.

Bibliography

J. Glusberg: *El Grupo CAYC* (Buenos Aires, 1979)

H. Safons: *A Sense for History: CAYC Group* (Buenos Aires, 1980)

J. Glusberg: *Del Pop-art a la Nueva Imagen* (Buenos Aires, 1985), pp. 127–32, 483–8

HORACIO SAFONS

Grupo Hondo

Spanish group of painters. It was formed in Madrid in 1961 by Juan Genovés, José Paredes Jardiel (*b* 1928), Fernando Mignoni (*b* 1929) and Chilean Gastón Orellana (*b* 1933) and was active until 1964. They first exhibited together in 1961 at the Galería Nebli, Madrid, reacting against the total abstraction of *Art informel* but applying its free, automatic, rapid and uninhibited techniques to a socially committed and Expressionist 'neo-figurative' style. They acquired two new members, José Vento (*b* 1925) and Carlos Sansegundo (*b* 1930), for their second exhibition in 1963, at the Sociedad de Amigos de Arte in Madrid, but they went their separate ways a year later.

Bibliography

Grupo Hondo (exh. cat., intro. M. Conde; Madrid, Gal. Nebli, 1961)

Grupo Hondo (exh. cat., Madrid, Soc. Amigos A., 1963) [incl. group statement]

V. Sánchez Marín: 'Pop-art y Nueva Figuración: Las tendencias más recientes en el arte español', *Artes* (Dec 1964) [special issue], pp. 33–8

PILAR BENITO

Grupo R

Catalan group of architects. They were active in Barcelona from 1951 to 1959. Their aim was the renewal of Catalan architecture. The group, which included Oriol Bohigas, Joaquim Gili Moros (*b* 1916), Josep Martorell, Antoni de Moragas Gallissa (*b* 1913), José Pratmarsó Parera (*b* 1913), José María Sostres Maluquer and Manuel eq Valls Verges (*b* 1912), was formed through a competition organized by the Colegio de Arquitectos de Cataluña y Baleares in January 1949 to solve housing problems in Barcelona. They were later joined by Pau Montguró and Francesc Vayreda. For them the development of architecture and urban planning was based not only on technical, but also on economic and social considerations. Outstanding among their activities were the exhibitions held in the Galerias Layeyanas in Barcelona (1952, 1954 and 1958) and courses that they organized including 'Economics and Urban Development' and 'Sociology and Urban Development'.

Bibliography

A. Fernandez Alba: *La crisis de la arquitectura española, 1939–1972* (Madrid, 1972)

PILAR BENITO

Gruppe 5 [Nor.: 'Group 5']

Norwegian group of artists active from 1961. It has had a decisive influence on the recognition of abstract art in Norway. The group was founded in 1961 by the Spanish-born Ramon Isern (Solé) (*b* 1914; *d* 1989), together with Håkon Bleken (*b* 1929), Halvdan Ljøsne (*b* 1929), Lars Tiller (1924–94) and Roar Wold (*b* 1926). They were all teachers in the architectural department (Institutt for form og farge) of the Norges Tekniske Høgskole in Trondheim. They wished to define their shared opposition to the traditional and conventional Trondheim art world and to break Oslo's dominance of Norwegian art. Without any agreed ideological platform, they examined, in non-representational paintings, the relationship between plane, form, colour, space, the process of abstraction and the legacy of Constructivism, as they had in their teaching. In their abstract paintings the Constructivist stamp was rhythmically enlivened by the materiality of colours and such evocative spatially expansive subjects as that of Wold's *At the Edge of the Beach* (1963; Oslo, Mus. Samtidskst). Isern made geometrically defined and totem-like sculptures in different materials, as well as tapestries with similar forms. Most of the group's members also executed charcoal drawings, graphics and collages, such as Ljøsne's oil painting *Accumulation* (1965; Oslo, Mus. Samtidskst) with glued-on newspaper clippings and disturbing spatial effects, and wrote articles about art theory (see Bleken).

In general the group's exhibitions were well received in Norway and abroad; the response to their only show in Oslo, in 1966, emphasized their academic background. The twelfth Gruppe 5 exhibition, in Odense, Denmark, in 1970, made it clear that the original shared ethos had become channelled into quite different, personal expressions: Bleken drew socially critical and universal figurative visions with an advanced charcoal technique, for example *The Judges* (1970; Oslo, Norsk Kulturåd) from the series of 12 charcoal drawings entitled *Fragments of a Dictatorship*; Ljøsne painted expressive, relief-like, symbol-laden signs on the border of figuration; Wold's Abstract Expressionism also approached the figurative; Tiller alternated between irregular and strictly geo-metric forms with strong colour contrasts; while Isern created non-figurative collage variations, often with political titles. During the period of the group's activity its individual members executed such large decorative commissions as Isern's monumental concrete sculpture *Tetrahedon* (h. 12 m, 1969), placed in front of the Board of Health Building in Oslo. The group was never formally dissolved but held its farewell exhibition in 1980, only to arise again at the same place, Trondhjems Kunstforening (Trondheim Art Association), in 1994.

Writings

H. Bleken: 'Kunst-Kunstner', *Samtiden*, 10 (1964), pp. 620–29

Bibliography

Gruppe 5 (exh. cat., foreword A. Holm; Trondheim, Kstforen., 1961)

Gruppe 5 (exh. cat., foreword and commentary O. Thue; Odense, Fyns Stiftsmus., 1970)

J. Brockmann: 'Fem kunstnere tar felles avskjed med "Gruppe 5"' [Five artists take their leave of Gruppe 5], *Årsberetning, Trondhjems Kstforening: Trondhjem, 1980*

—: *Malerne på Gløshaugen* (Trondheim, 1985), pp. 4–6 [with Eng. trans.]

T. Nergaard: *Håkon Bleken* (Oslo, 1986), pp. 26–39

Gruppe 5 (exh. cat.; Trondheim, Kstforen.; Reykjavik, Hafnarfjørdur Cult. & A. Fund.; Tampere, Tammerfoshuset; 1994)

S. Aamold: *Ramon Isern* (diss., U. Oslo, in preparation)

SUSANNE RAJKA

Gruppe 33 [Künstlervereinigung Gruppe 1933]

Swiss group of artists. It was founded in Basle in 1933 by the painters Otto Abt (1903–82), Walter Bodmer, Paul Camenisch (1893–1970), Theo Eble (1899–1974), Max Haufler, Charles Hindenlang (1894–1960), Carlo König (1900–70), Rudolf Maeglin (1892–1971), Ernst Max Musfeld (1900–64), Otto Staiger (1894–1967), Max Sulzbachner (*b* 1904) and Walter Kurt Wiemken (1907–40), the sculptors Daniel Hummel and Louis Weber (*b* 1891) and the architect Paul Artaria. Camenisch was effectively leader of the group, which arose in opposition to the conservatism of the Gesellschaft Schweizerischer Maler, Bildhauer und Architekten (GSMBA) and also to the rising tide of hostility to modern art engendered by the Nazis in neighbouring Germany. Soon after its foundation a programme propagated by the members claimed their aim to be 'the active participation in the development of the plastic arts without ignoring the phenomena and expression of our time'. Left-wing and anti-fascist politically, the members of the group worked within various modern currents such as Surrealism, Constructivism and abstract art. With the expansion of its membership, however, it soon attracted artists from less modern tendencies as well as photographers, film makers, graphic designers and stage designers. There also arose a significant grouping of socially engaged architects.

The first Gruppe 33 exhibition took place on the ground floor of a scarcely finished building in Basle in December 1933. A larger and more significant show took place in Basle in October 1934, arousing fierce opposition in the press. Unable to obtain any official recognition and exhibiting space, in November 1934 Club 33 was opened in Basle as a place for the group to meet and exhibit. Gruppe 33 continued to organize exhibitions there into World War II, and a large show was held at the Kunsthalle in Basle in 1943 to celebrate their tenth anniversary; this also marked the beginning of their cultural integration. Another anniversary exhibition was held at the same location in 1953, but, with the change in political climate caused by the Cold War, Camenisch was excluded, as he was a member of the left-wing

political party, the Partei der Arbeit. This brought to a close the oppositional role that had previously characterized the group, although it continued to function in this tamer form.

Bibliography
50 Jahre 'Gruppe 33': Der Mitglieder der ersten Zehn Jahre (exh. cat. by Y. Höflinger, Basle, Ksthalle; Chur, Bündner Kstmus.; Lugano, Villa Malpensata; Lausanne, Pal. Rumine; 1983–4)

☐

Gruppe 53

German group of painters founded in Düsseldorf in 1953 and active until 1959. In 1953 some young Düsseldorf artists banded together to form an association known as the Künstlergruppe Niederrhein, with a shared interest in *art informel* and the intention of mounting exhibitions, in opposition to the established artists' association, the Rheinische Secession. From 1954 the group emerged as Gruppe 53, with joint exhibitions held primarily in buildings owned by the Kunstverein für die Rheinlande und Westfalen, and every second year at the Städtische Kunsthalle in Düsseldorf. The members included Peter Brüning, Winfried Gaul (*b* 1928), Gerhard Hoehme, Horst Egon Kalinowski, Herbert Kaufman (*b* 1924), Peter Royen (*b* 1923), Rolf Sackenheim (*b* 1921) and Friedrich Wertmann (*b* 1927). Abstract artists from outside Düsseldorf, such as Karl Fred Dahmen (1917–81), Bernard Schultze and Emil Schumacher, were also invited to exhibit with them, as were other Düsseldorf artists representing various developing trends in painting. Thus Konrad Klapheck, who worked figuratively, and members of the Zero group, including Heinz Mack, Otto Piene and Günther Uecker, exhibited with Gruppe 53. There was no common aesthetic programming policy, although representative works include Brüning's *Bild 2/63* (1963; Bonn, Städt. Kstmus.), Gaul's *Good-bye to Rembrandt* (1956–7; Saarbrücken, Saarland Mus.) and Hoehme's *Black Spring* (1956; priv. col.). Economic and organizational interests formed the basis of their joint action, along with the desire to establish abstract

art. All those involved painted in an abstract way and rejected geometrically inspired 'cold abstraction'. The group received considerable support from the collector, art historian and later gallery owner Jean-Pierre Wilhelm (1912–68). He made contacts with gallery owners, especially in Paris, and with artists from abroad. When the opportunities for exhibiting abstract work by young artists in Düsseldorf had improved as a result of Gruppe 53's commitment, and when other commercial galleries opened in addition to Wilhelm's Galerie 22, the reasons motivating the group disappeared, and it was consequently disbanded in 1959.

Bibliography
H. Schubert: 'Ausstellungen, S. 34/39', *Kstwk*, xi/10 (April 1958)

CLAUDIA BÜTTNER

Gruppe Progressiver Künstler [Gruppe der Progressiven]

German group of artists. It was founded in Cologne in 1925 by Franz Seiwert (1894–1933) and Heinrich Hoerle (1895–1936), with Otto Freundlich, Gerd Arntz (*b* 1900), Hans Schmitz (1896–1977), Augustin Tschinkel (*b* 1905) and the photographer August Sander. The group extended the programme of a 'proletarian' art that had characterized Seiwert and Hoerle's STUPID GROUP and their intervening work to include artists from other centres in the Rhineland and throughout Germany. They supported the revolutionary opposition to the ineffectual Weimar Republic, which they saw as a tool of repressive right-wing elements in the establishment. Following collaborations with the idealist and pacifist Berlin periodical *Die Aktion*, Seiwert and Hoerle started their own artistic publication, *A bis Z*, in October 1929, beginning the group's most fertile period. While the periodical attracted contributions from a broad cross-section of artists (including Raoul Haussmann, Jean Hélion and László Moholy-Nagy), the group favoured a stripped-down figurative style, whose schematized forms and abstract elements drew attention to the mechanization of contemporary existence. With echoes of Oskar Schlemmer's work

and of Parisian Purism, some compositions also tended towards the coldness of Neue Sachlichkeit. Their critical political stance made them an immediate target for Nazi opposition. The group and periodical were ended in 1933, Seiwert died the same year, and Hoerle and Freundlich's work was subsequently designated as *entartete Kunst*.

Bibliography

A bis Z: Organ der Gruppe Progressiver Künstler, Koln, 1929–33 (R Cologne, New York, Munich, 1969)

Vom Dadamax bis zum Grüngürtel: Köln in den zwanziger Jahren (exh. cat., ed. W. Herzogenrath; Cologne, Kstver., 1975), pp. 78–130

U. Bohnen: *Das Gesetz der Welt ist die Änderung der Welt: Die rheinische Gruppe Progressiver Künstler, 1918–1933* (Berlin, 1976)

Franz W. Seiwert (1894–1933); Leben und Werk (exh. cat. by U. Bohnen, Cologne, Kstver.; Münster, Westfäl. Kstver.; W. Berlin, Kstamt Kreuzberg; Ludwigshafen, Städt. Kstsamm., 1978), pp. 28–63

Heinrich Hoerle; Leben und Werk (1895–1936) (exh. cat. by D. Backes, Cologne, Kstver., 1981–2), pp. 30–52

MATTHEW GALE

Gruppo 7

Italian group of architects. It was formed in 1926 by seven students from the Scuola Superiore di Architettura del Politecnico, Milan: Giuseppe Terragni, Guido Frette, Ubaldo Castagnoli, Sebastiano Larco, Carlo Enrico Rava, Luigi Figini and Gino Pollini. Castagnoli was replaced in 1927 by Adalberto Libera.

The avant-garde group was the first to be formed in support of modern architecture in Italy, and its four-part manifesto, published in *Rassegna italiana* (Dec 1926 to May 1927), laid the foundations for Italian *Rationalismo* (*see* RATIONALISM). Seeking to distance itself equally from the Futurists and their 'destructive fury' as well as from the blandly classicizing work of contemporary *novecento* architects such as Giovanni Muzio, Gruppo 7 called for sincerity, logic and order in architecture. Echoing Le Corbusier, their manifesto announced the advent in Europe of the *esprit nouveau*, already manifest in literature, art and music as well as in architecture; it was distinguished by strict adherence to logic and rationality, a concern for rhythm and classical proportions and a sense of history as faith in the spirit of the age. The second and third parts of the manifesto discussed the architectural scene in Europe, particularly in Italy, deploring the poor quality of architectural education and the general public's lack of comprehension, while the last part characterized that period as 'a new archaic era' in which architects were confronted with the promising beginnings of a new style.

Central to the writings of Gruppo 7 was the belief that the 'universal' achievements of the Modern Movement were not incompatible with a national character. Indeed, the manifesto embraced a nationalist programme consistent with the cultural policies of the fascist regime. Equally significant was the insistence on the need to develop a few fundamental building types by concentrating on essential problems of architecture and by renouncing individualism. Immediately after the publication of its manifesto, Gruppo 7 mounted an exhibition at the 3rd Biennale in Monza (1927), showing renderings and models of unexecuted projects in which a concern for structural clarity and abstract rhythms combined with an impersonal, perhaps even metaphysical, style of presentation. Terragni's gas factory referred to a wide range of modernist sources, from Erich Mendelsohn to El Lissitzky, while Figini and Pollini's more restrained garage project anticipated the 'Mediterranean' purism of their later work. Some of the Monza material was included in the Italian section of the Weissenhofsiedlung exhibition organized by the Deutscher Werkbund in Stuttgart later that year (1927) and it was here that Gruppo 7 was able to witness at first hand the achievements of the European masters.

The critical success of the group's initiatives and encouragement from political circles led to a larger exhibition the following year in Rome: in the first Esposizione dell'Architettura Razionale (1928), organized by Adalberto Libera and the critic Gaetano Minnucci, Gruppo 7 found itself in the company of about 40 other Rationalists from various parts of Italy. Soon after this a larger organization was formed under the name of

Movimento Italiano per l'Architettura Razionale (*see* MIAR), with Libera as its secretary. MIAR itself was dissolved in 1931 following reactions to its second Esposizione dell'Architettura Razionale in Rome, which included a photomontage attacking respected members of the profession. By this time, however, Terragni, Figini and Pollini had produced some seminal works and the group had achieved its prime objective: that of provoking a wide-ranging public debate on many issues central to the development of modern architecture in Italy.

Writings

'Architettura', *Rass. It.*, xviii (Dec 1926), pp. 849–54
'Architettura (II): Gli stranieri', *Rass. It.*, xix (Feb 1927),
 pp. 129–37
'Architettura (III): Imprepazione, incomprensione,
 pregiudizi', *Rass. It.*, xix (March 1927), pp. 247–52
'Architettura (IV): Una nuova epoca arcaica', *Rass. It.*, xix
 (May 1927), pp. 467–72

Bibliography

C. Belli: 'Origini e sviluppi del Gruppo 7', *La Casa*, 6
 (1959), p. 177
E. Shapiro: 'Gruppo 7', *Oppositions*, 6 (1976), pp. 86–102
 [contains Eng. trans. of parts 1 and 2 of manifesto]
—: 'Gruppo 7', *Oppositions*, 12 (1978), pp. 88–104
 [contains Eng. trans. of parts 3 and 4 of manifesto]
D. P. Doordan: *Building Modern Italy: Italian Architecture,
 1914–1936* (New York, 1988)
R. Etlin: *Modernism in Italian Architecture, 1890–1940*
 (Cambridge, MA, 1991)

LIBERO ANDREOTTI

Gruppo degli Otto Pittori Italiani

Italian group of eight painters. It was formed in 1952 after the disintegration of FRONTE NUOVO DELLE ARTI. Six of them had belonged to the earlier group: Renato Birolli, Antonio Corpora, Ennio Morlotti, Emilio Vedova, Giuseppe Santomaso and Giulio Turcato; the other founder-members were Afro and Mattia Moreni (*b* 1920). The group, which exhibited at the Venice Biennale of 1952, was coordinated by Lionello Venturi, who described its style as 'abstract-concrete . . . born of a tradition that began around 1910 and that includes Cubism, Expressionism and Abstraction'. Geometric or post-Cubist forms dominate these artists' work; however, the naturalistic colour and atmospheric luminosity of such paintings as Vedova's *Cosmic Vision* (1952; New York, MOMA) and Birolli's *Brambles and Paths* (1953; Brescia, Cavellini priv. col., see Venturi, 1959, pl. 14, p. 47) typify this group's leanings towards expressive abstraction. During the 1950s Birolli, Corpora and Morlotti became more involved with Informalism and Tachism, and Santomaso and Vedova were significantly inspired by Hans Hartung and Wols respectively. Of the eight, Afro was the most outstanding exponent of lyrical expressionism, largely achieved through his use of vibrant and transparent colour in works such as *Underwater Fishing* (1955; Pittsburgh, PA, Carnegie).

Bibliography

L. Venturi: *Otto pittori italiani* (Milan, 1952)
—: *Italian Painters of Today* (Rome, 1959)

□

Gruppo N

Italian group of artists. It was formed in Padua in 1959. It included Alberto Biasi (*b* 1937), Ennio Chiggio (*b* 1937), Giovanni Antonio Costa (*b* 1935), Edoardo N. Landi (*b* 1937) and Manfredo Massironi (*b* 1937). The group gained notoriety in 1959 when Massironi competed unsuccessfully for the Premio San Fedele, for which he submitted a piece of cardboard that he had selected because of the interesting optical qualities of its surface. During the 1960s Gruppo N played an important part in the development of Op art in Italy. The work of Biasi, for example, included geometric abstract reliefs with striking optical effects, such as the *Optical-dynamic Relief (Drops)* (painted iron and card, 1962; Padua, priv. col., see exh. cat., p. 37); this attempted to create an effect analogous to the patterns caused by drops of water falling on a liquid surface. The group's gallery, Studio N, which opened in Padua in November 1960, rapidly became an important centre for experimental art, music and poetry. The group had its own room at the Venice Biennale of 1964 and also participated in various exhibitions of *Arte programmata* in

Italy, as well as showing work at Studio F in Ulm (1963) and the Museum Sztuki, Łódź (1967).

Bibliography
I. Mussa: *Il gruppo enne: La situazione dei gruppi in Europa negli anni 60* (Rome, 1976)
Antologia Alberto Biasi (exh. cat. by D. Banzato and others, Padua, Mus. Civ., 1988)

CHRISTOPHER MASTERS

Gruppo T

Italian group of artists. It was founded in Milan in 1959 and active until 1962. The founders were Giovanni Anceschi (*b* 1939), Davide Boriani (*b* 1936), Gianni Colombo (*b* 1937) and Gabriele de Vecchi (*b* 1938). These artists, who were primarily interested in kinetic art, first exhibited as a group in 1960 in the Galleria Pater in Milan, where they held six exhibitions entitled *Miriorama 1–6*, none lasting more than a few days. In the last of these shows the four founder-members were joined by Grazia Varisco (*b* 1937). Gruppo T's works frequently invited the participation of the exhibition visitor: for example, Boriani's *Magnetic Surfaces* contained patterns of iron dust that changed as the objects were handled. By contrast the exhibits of a show held at the Galleria Danese in December 1960 were powered by electric motors (e.g. *Rotoplastik* by Colombo). The group cooperated with other artists with similar aims, including Gruppo N, at whose gallery, Studio N, in Padua they exhibited in 1962. They also were supported by Lucio Fontana, who presented an exhibition of their work at the Galleria La Salita in Rome in 1961. Gruppo T's last exhibition was at the Galleria del Cavallino in 1962.

Bibliography
I. Mussa: *Il gruppo enne: La situazione dei gruppi in Europa negli anni 60* (Rome, 1976)

CHRISTOPHER MASTERS

Hagenbund [Künstlerbund Hagen; Hagengesellschaft]

Austrian group of artists formed in 1900 in Vienna and active until 1930. Its most prominent members included Heinrich Lefler and Joseph Urban. The group took its name from Herr Haagen, the landlord of an inn at which artists often met for informal discussion. Originally called the Hagengesellschaft, most of its members left the Künstlerhaus at the same time as the Secessionists in 1897. Three years later they left the Secession to form the Hagenbund. At first the group intended to remain within the Künstlerhaus, and they held their first two exhibitions on its premises. However, between 1902 and 1912, and again from 1920 until 1930, they exhibited independently in a market-hall (the Zedlitzhalle) converted by Urban. The group favoured a distinct Art Nouveau style based on folk art and British antecedents, such as the work of Aubrey Beardsley. Their manner was less extreme than that of the Secessionists, and this contributed to their official success; Lefler and Urban were the major contributors to a pageant held in 1908 in celebration of Francis Joseph's 60 years on the throne. The influence of the Hagenbund was felt largely through their illustrations, which were popular with a younger and less upper-class audience than the Secessionists had. Most notable was the series *Gerlachs Jugendbücherei*, illustrated with lithographs by Lefler, Urban and Karl Fahringer (1874–1952). Among Austrian artists who participated in Hagenbund exhibitions were Robin Christian Andersen, Anton Hanak, Oskar Laske (1874–1951) and, at times, Oskar Kokoschka and Egon Schiele. Although the group was not dissolved until 1930, its importance had faded by the outbreak of World War I.

Bibliography
H. Bisanz: 'The Visual Arts in Vienna from 1890 to 1920', *Vienna 1890–1920*, ed. R. Waissenberger (New York, 1984), pp. 148–50

□

Halmstad group [Swed. Halmstadgruppen]

Swedish group of six painters active from 1929. It disbanded only with the death of the various members. The artists were the brothers Axel Olson (1899–1986) and Erik (Arthur) Olson (1901–86),

their cousin (Anders) Waldemar Lorentzon (1899–1984), Sven Jonson (1902–83), (Carl) Stellan (Gabriel) Mörner (1896–1979) and Theodor Esaias Thorén (1901–81). All had connections with Halmstad, a town on the west coast of Sweden. In 1919 Egon Östlund, a mechanical engineer working in Halmstad, established contact with the Olsons and Lorentzon. Through Östlund, they became familiar with the work of Gösta Adrian-Nilsson, and over the years Östlund supported the Halmstad group. Adrian-Nilsson's paintings were important early mutual influences for the group, as were Cubism and Neo-plasticism. In the early 1930s the group began to paint in a Surrealist style, as in, for example, Erik Olson's the *Day through the Night* (1935; Stockholm, Mod. Mus.); they were influenced by such artists as Salvador Dalí and Yves Tanguy. Gradually the painters developed in different directions, but the group remained active, exhibiting together. They were the most significant exponents of Surrealism in Sweden and took part in various Surrealist exhibitions in Europe in the 1930s. Axel Olson became very involved in local art life, while Erik Olson had close contacts with Danish Surrealists and participated in the resistance to the German occupation of Denmark during World War II. In 1950 he converted to Catholicism and had connections with the *art sacré* movement in France. He also painted many religious works. In 1963 he was awarded the Order of Gregory the Great by Pope John XXIII (*reg* 1958–63). Lorentzon joined the Oxford Movement in 1938 and from that time executed mainly religious decorations. Mörner was very versatile, designing sets for various theatres, mostly in Stockholm and Göteborg. He wrote articles on art and several books, including his autobiography *Spegel mot mitt liv* ('Mirror to my life'; Stockholm, 1969) and *Det varma kvällsljuset* ('The warm evening light'; Stockholm, 1976).

Bibliography

P. Hultén and others: *Halmstadgruppen 50 år* [50 years of the Halmstad group] (Halmstad, 1979)
Halmstadgruppen 60 år: Halmstad-Berlin-Paris-Halmstad (exh. cat., ed. L. Robbert; Stockholm, Liljevalchs Ksthall, 1989)

JACQUELINE STARE

Hard-edge painting

Term applied to abstract paintings composed of simple geometric or organic forms executed in broad, flat colours and delineated by precise, sharp edges. The term was coined by the Californian art critic Jules Langsner in 1958 and intended by him merely as an alternative to the term 'geometric abstraction'. Generally, however, it is used in a more specific sense: whereas geometric abstraction can be used to describe works with large numbers of separate, possibly modelled, elements creating a spatial effect, hard-edge painting refers only to works comprised of a small number of large, flat forms, generally avoiding the use of pictorial depth. It is in relation to this type of painting, particularly as produced by artists such as Ellsworth Kelly, Kenneth Noland, Barnett Newman and Ad Reinhardt from the mid-1950s to the end of the 1960s, that the term acquired general currency. Characteristic of this style are Newman's *The Gate* (1954; Amsterdam, Stedel. Mus.) and Kelly's *White Black* (1961; Chicago, IL, A. Inst.).

Bibliography

Systemic Painting (exh. cat. by L. Alloway, New York, Guggenheim, 1966)
I. Sandler: *American Art of the 1960s* (New York, 1988)

☐

Heimatstil [Ger.: 'regional style']

Name of a 20th-century movement in architecture, interior decoration and the decorative arts, aimed at protecting and promoting regional and native characteristics. It developed in individual ways in a number of European countries, for example Germany, Switzerland, Poland and Finland, and flourished with varying intensity until the end of the 1940s. *Heimatkunst* (Ger.: 'regional art') was, similarly, linked to local and regional traditions without being folk art as such. *Heimatstil* was at its height in Switzerland in the years leading up to, and during, World War II, advocating a nationalist culture based on the traditional rural society, as opposed to the grandeur and modern functionalism of cosmopolitan urban culture. It was

believed that architecture and the decorative arts should reflect such typically Swiss values as modesty, honesty and being at one with nature. These national characteristics, turned into material form, should make an impact on a new, more natural way of life that was inherently tied to the notion of country. *Heimatstil* saw as beautiful only that which was in accordance with the essence of the inhabitants of a particular region.

Heimatstil was characterized by an emphasis on the fitness for purpose and durability of buildings and objects and the use of natural materials of Swiss origin, primarily wood: furniture was not generally painted or stained and was given a matt finish in order to bring out the simple graining of the native wood. The revival of traditional craft methods, for example frame construction in architecture and solid construction in furniture, was an important element in the movement. An emphasis on basic functional form and clear construction was also important: such visible methods of construction as dovetail joints, arrises or frame construction emphasized craft traditions while at the same time making it easier to dispense with superfluous decoration. A formal language was developed that was intended to express the relationship between form and function and to encompass and appeal to reason and to emotion. This language was linked to Biedermeier and craft traditions, but the idea was not merely to imitate historical traditions but to adapt them in a manner appropriate to the time. Such organizations as Heimatschutz (founded 1905), Heimatwerk (founded 1930) and the Verein zur Förderung des Kunsthandwerks in der Schweiz (founded 1936) all made a success of publicizing *Heimatstil*. This was achieved through such campaigns as 'Mehr Holz in unsere Bauten' (1937–42), influential journals, for example *Raum und Handwerk* and *Das ideale Heim*, and exhibitions aimed at educating taste, for example *Das massive Möbel aus einheimischem Holz* (1937), *Das Haus aus unserem Holz* (1938) and *Die Aussteuer* (1939), all held in the Kunstgewerbemuseum, Zurich. Advisory centres were established, as were further education institutions. There was also a perceptible influence on architecture from advocates of the Modern Movement, but it was mainly those circles hostile to modernism that were active in the promotion of traditional forms in architecture and objects for everyday use. To this end, they pursued political and ideological interests, for example the identification and regeneration of rural culture, or the legalization of economic and political measures that protected farmers and craftsmen or, as in the case of Heimatwerk, promoted job creation in the economically deprived mountain areas. In 1938 traditional rural values were adopted as official cultural policy in the programme of 'Geistige Landesverteidigung'. An eloquent expression of this was provided by examples of everyday objects used in rural societies and rural architecture in the Landesausstellung held in Zurich in 1939.

The Swiss *Heimatstil* of the 1930s and 1940s should be seen as a reaction to an internal political crisis and to the external political threats of the time. Switzerland was searching for a new national identity, which it discovered in a combination of an ideology of growth and a cultural conservatism. *Heimatstil*, advocating modernity modified by traditionalism, reflected this basic national consensus. From 1936 its influence led to a wide return to rural architecture and lifestyle in the urban environment. Refinement of craft was, nonetheless, still the prerogative of the upper middle classes. The majority of objects loosely classified as part of *Heimatstil* did not actually reflect the traditional crafts or skills. Goods with only an outward appearance of craft traditions were mass produced, while aspects of regional architectural traditions were used only as decoration and not in construction.

Bibliography

P. Artaria: *Schweizer Holzhäuser* (Basle, 1936)

E. Laur jr: 'Neue Schweizerstuben', *Heimatwerk*, ii/1 (1937), pp. 2–7

'Das massive Möbel aus einheimischem Holz: Ausstellung im Kunstgewerbemuseum Zürich', *Raum & Handwk*, ii/10 (1937), pp. 7–17

'Warum lieben wir Bauernmöbel?', *Raum & Handwk*, ii/1 (1937), p. 10

Das Haus aus unserem Holz (exh. cat., Zurich, Kstgwmus., 1938), Wegleitungen des Kunstgwmus. Zürich, cxxxvii

Die Aussteuer (exh. cat., Zurich, Kstgewmus., 1939),
　Wegleitungen des Kunstgewmus. Zürich, cxlii
'Unsere Wohnungen: Landesausstellung: Ein Bilderbuch
　schweizerischer Wohnkultur', *Ideale Heim*
　(Winterthur, 1939)
J. Leuthard: *Der Massivmöbelbau im schweizerischen
　Handwerksschaffen* (Chur, 1946)
A. Roth: 'Zum Problem des Wohnmöbels', *Das Werk*,
　xxxiii/12 (1946), pp. 407–20
R. Hamann and J. Hermand: *Stilkunst um 1900* (Berlin,
　1967)
C. Cattaneo: 'Der Bauernhof zwischen Funktionalismus
　und Heimatideologie', *Dreissiger Jahre Schweiz* (exh.
　cat., Zurich, Ksthaus, 1982), pp. 210–17
——: 'Wohnungsbau zwischen Neuem Bauen und
　Heimatstil', *Dreissiger Jahre Schweiz* (exh. cat., Zurich,
　Ksthaus, 1982), pp. 172–81
G. Frey: *Schweizer Möbeldesign 1927–1984* (Berne, 1986),
　pp. 39–40
J. Gisler: 'Tradition und Fortschritt im Schweizer Heim:
　Möbel und Design als Ausdruck des schweizerischen
　Selbstverständnisses vor und nach dem zweiten
　Weltkrieg', *Sonderfall?: Die Schweiz zwischen Réduit
　und Europa* (exh. cat., Zurich, Schweiz. Landesmus.,
　1992), pp. 197–206

JOHANNA GISLER

High Tech

Stylistic term applied to the expressive use of modern technology, industrial components, equipment or materials in the design of architecture, interiors and furnishings. It was first employed in print by Joan Kron and Susan Slesin in magazine articles of 1977. High Tech described the then-fashionable style of decoration using out-of-context, brightly coloured elements of industrial design (e.g. factory lamps, warehouse shelving, office chairs, work-benches, duct-work, glass bricks etc) in domestic interiors and shops. In their book *High-Tech: The Industrial Style and Source-book for the Home* (1978), however, Kron and Slesin cited a number of buildings, most notably the Centre Georges Pompidou (1971–7; see fig. 3), Paris, by Richard Rogers and Renzo Piano, to add weight to their argument that 'the industrial aesthetic in design . . . is one of the most important design trends today'. By 1980 this building had become the standard exemplar of High Tech architectural design and remained a monument of definition thereafter. The bright colours of its exposed ducts, its transparent escalator tubes hung on the exterior of its boldly exhibited structural system and its general air of technological optimism made it a convincing large-scale demonstration of the Kron and Slesin aesthetic.

In an architectural context, the words 'high technology' had already acquired a different and highly charged polemical meaning—as the opposite of 'low tech' or even of 'appropriate technology'. In the late 1960s and early 1970s so-called 'levels of technology' had become an issue, as environmental awareness, concern for the underdeveloped areas of the world, fuel crises and cultural pessimism had led many architectural thinkers to abandon the faith in technological progress that had sustained modern architecture since the 19th century and to foresee a more modest and less energy-intensive future. The *Architectural Review* (May 1977) declared a doubt that the world could afford any more buildings like the Centre Pompidou. Six years later, however, the *Architectural Review* devoted an entire issue (July 1983) to High Tech and appeared to have forgotten its doubts and concerns. High Tech had become a respected—if still controversial—tendency in contemporary architecture. Its established leaders were Richard Rogers and Norman Foster; they had been partners briefly (as Team 4) in the mid-1960s, and the outstanding product of that partnership, the prize-winning Reliance Controls Factory (1967) at Swindon, Wilts, was seen as the beginning of a supposed High Tech movement. A respectable ancestry of outstanding buildings was soon traced and included Pierre Chareau's and Bernard Bijvoet's Maison de Verre (1929–32), Paris, and the house that the Eames designed for themselves (1948–9) in Pacific Palisades, Los Angeles, as well as major works of engineering back to and including the Eiffel Tower, Paris, and the Crystal Palace (destr.), London. It could also be linked (especially by Foster) to the prestige of recent advanced engineering, as represented by space-vehicles for example.

The controversy surrounding High Tech had three main causes. The first was the jealousy caused by its egregious success, as it fell to Rogers and Foster to design two of the most notable financial buildings of the 1980s: the Hongkong & Shanghai Bank (1985), Hong Kong (Foster Associates), and the Lloyds of London headquarters (1987; Richard Rogers + Architects; see col. pl. XXII). The second cause of controversy was that, with this conspicuous success, High Tech seemed to prevail over other movements such as Postmodernism, which had been expected to be the dominant successors to an exhausted Modernism, and the wrath of anti-Modernists was extreme. The third cause of controversy—and one that provoked even those who still maintained faith in Modernism—was that in laying obvious claim to be the true heir to the former Modernist tradition, High Tech as practised seemed to discount the work of the revered masters of the Modern Movement, Gropius, Le Corbusier and Mies van der Rohe, and to establish a lineage that descended from the less celebrated visionaries of the Futurist, Expressionist and Constructivist movements. In its emphasis on precision engineering, transparency and light weight, in what the engineer Frank Newby called its 'structural exhibitionism', in its bright colours and high finishes, in its often intricate and elaborate 'machine' detailing, High Tech departs decisively from Gropius's aesthetic of 'large, compact forms' or Le Corbusier's 'play of volumes assembled in light'.

Although some of the buildings commonly described as High Tech may differ from the International Style in materials and finishes, they do adhere more or less to its compositional preferences for compact rectangular forms in simple abstract relationships, even if they range from the suave, brushed-metal and black-glass headquarters building for Porsche of Great Britain (1964) near Reading, Berks, by the Dewhurst Haslam Partnership, to the startling red-and-yellow, corrugated-metal Provincial Center (1986), Flin-Flon, Manitoba, by IKOY Partnership. Indeed, one of the problems of High Tech as a stylistic label is to identify some central and essential qualities within the wide range of extreme designs that it is currently made to embrace. Other examples of the diversity of High Tech include the remarkable tented structure for the Schlumberger Laboratories (1984), Cambridge, England, by Michael Hopkins and Partners (with the engineer Tony Hunt); the Sainsbury Centre for Visual Arts (1977) at the University of East Anglia, Norwich, a vast airy corrugated metal shed designed by Foster Associates (also with Tony Hunt); and the Renault Distribution Centre (1984), Swindon, Wilts, also by Foster (with Ove Arup & Partners), which has bright yellow steel supports. At yet another extreme are the galleries of the Menil Collection in Houston, TX, which are filled with natural light controlled by a system of overhead sunshades, fixed and non-mechanical but precisely calculated for the architect, Renzo Piano, by the engineers Peter Rice and Tom Barker, with whom he had worked following the Centre Pompidou.

If there is a theme that unites all these diverse works, it is the 'attitude that assumes that architecture has no further task than to perfect its own technologies', which Alan Colquhoun supposed to be the design philosophy behind the Centre Pompidou. A notable and striking feature of High Tech is the dominance within it of British talent, even outside the British Isles. Although the designer of what is regarded by many as the true successor to the Centre Pompidou, the Cité des Sciences et de l'Industrie (1986) in the Parc de la Villette, Paris, is the French architect Adrien Fainsilber, the coloured duct-work, which is the dominant feature of its interior, is the work of a largely British team, and the two gigantic skylights over its central lobby were designed by the London-based partnership of Peter Rice and Ian Ritchie. Examples of the High Tech aesthetic in furniture—also by British designers—include the Omkstack chair (1971) and Graffiti shelving (1983) by Rodney Kinsman (b 1943) and Foster's Nomos office furniture (1986) in chromium-plated steel, glass and plastic.

Bibliography

R. Banham: 'Centre Pompidou, Paris', *Archit. Rev.*
[London], clxi/693 (1977), pp. 270–94

J. Kron and S. Slesin: *High-Tech: The Industrial Style and Source-book for the Home* (New York, 1978)

Archit. Rev. [London], clxix/1037 (1983) [issue on High Tech]

G. Bylinsky: *High Tech: Window to the Future* (Hong Kong, 1985)

Space Des., 1 (1985) [issue on High Tech]

C. Davies: *High-Tech Architecture* (New York, 1988)

REYNER BANHAM

Hlebine school [Hlebinska slikarska škola; Hlebine Primitives]

Croatian group of painters who worked in Hlebine and the neighbouring village of Podravina, near Zagreb, from c. 1932. Its principal members included Krsto Hegedušić, Ivan Generalić, Franjo Mraz (1910–81) and Mirko Virius (1889–1943). The first mention of the group was in 1932, when Hegedušić began to encourage peasants from the area to paint. The Croatian authorities at that time favoured an art programme based on a folk style and aimed at an authentic national artistic expression, and Hegedušić's idea corresponded with prevailing populist support for ruralism and its manifestation in various artistic media. An art independent of western European ideas was also preferred. Hegedušić exerted a strong influence on his collaborators (among the first of whom were Generalić and Mraz) through his use of rural motifs and his technique of painting on glass. He also organized several exhibitions in which the work of the Hlebine school was shown with that of the EARTH GROUP (Zemlja). After World War II Generalić was the most important artist of the group to work in the region. The painters Franjo Filipović (b 1930), Dragan Gaži (1930–83), Mijo Kovačić (b 1935), Ivan Večenaj (b 1920), Martin Mehkek (b 1936), Ivan Lacković-Croata (b 1932) and Josip Generalić (b 1936) gathered round him and formed the 'second Hlebine school'. Unlike the first generation, who had been preoccupied with themes of social criticism, the second generation nostalgically evoked idyllic peasant life and labour and celebrated their beauty. The Hlebine Primitives became well known internationally, exhibiting at the Biennale in São Paulo in 1955 and at the Exposition Universelle et Internationale in Brussels in 1958. This frequent international exposure created the impression that their primitivist work was representative of modern Yugoslav art. Their most important works are in the Gallery of Primitive Art in Zagreb.

Bibliography

Hlebinski krug-petdeset godina naivnog slikarstva [The Hlebine school of painting: fifty years of naive painting] (exh. cat. by M. Špoljar and T. Šola, Zagreb, Gal. Primitive A., 1981)

JURE MIKUŽ

Homme–Témoin

French group of painters who held their first exhibition as a group at the Salon des Moins de Trente Ans in June 1948. Their manifesto, which affirmed their commitment to realism and to communism, was drawn up and published by the critic Jean Bouret. In the preface to the exhibition catalogue he stated that 'painting exists to bear witness, and nothing human can remain foreign to it'. The best-known artists associated with the group were Bernard Buffet and Bernard Lorjou (b 1908). Buffet's style, as represented by such series as *Flagellation*, *Resurrection* (both 1952) and *Horrors of War* (1954), illustrates the atmosphere of 'existential' *Angst* that characterized the work of many painters associated with Homme–Témoin. Lorjou's the *Atomic Age* (1950) is a tableau of post-war urban suffering, oppression and spiritual longing. The painters were obviously strongly influenced by the harsh and expressionistic styles of Francis Gruber and Chaïm Soutine. In content, their work developed almost into a pastiche of those contemporary artists who protested against war atrocities or political opposition to tyranny, such as Fautrier or Matisse.

Bibliography

J. Bouret: *L'Age atomique de Bernard Lorjou* (Paris, 1950)

Aftermath: France, 1945-54. New Images of Man (exh. cat., London, Barbican A.G., 1982)

Y. Le Pichon: *Bernard Buffet*, 2 vols (Paris, 1986)

Imaginistgruppen [Swed.: 'Imaginist group']

Swedish Surrealist group, founded *c.* 1945, which grew out of the short-lived MINOTAURGRUPPEN. Its founders were C. O. Hultén, Max Walter Svanberg and Anders Österlin (*b* 1926), and later its members included the artists Gösta Kriland (1917–89), Bertil Lundberg (*b* 1922), Bengt Orup (*b* 1916), Bertil Gadō (*b* 1916), Lennart Lindfors and Gudrun Ählberg-Kriland. The Imaginistgruppen followed the example of the Minotaurgruppen by using the styles and techniques characteristic of Surrealism, as in Hultén's *Beach Statue* (frottage, 1948; Malmö, Kstmus.). In 1947 the group founded its own publishing house in Malmö, and that year it produced a collection of frottages, *Drömmar ur bladens händer* ('Dreams from the hands of leaves'), by Hultén. *Första fasen* ('First phase'), a text on Imaginism written by Svanberg in 1948, was included in the catalogue of an exhibition of his work in Göteborg in 1949. In this 'manifesto', the first part of his *Deklarationer om imaginism i tre utvecklingsfaser* ('Declarations on Imaginism in three phases'), Svanberg discussed the crucial role played by imagination, stressing the free and revolutionary nature of Imaginist art. He claimed that the image, which contained disparate elements, was central and that its realization required the overthrow of traditional art forms, as these were based on reality. These were all familiar Surrealist ideas, and Svanberg developed them further in *Andra fasen* ('Second phase') (1950) and *Tredje fasen* ('Third phase') (1952), so becoming the group's chief theorist. The Imaginistgruppen participated in the Surrealist exhibition held at the Galerie Aleby in Stockholm in 1949, and Imaginistgruppen exhibitions were held in Stockholm in 1951, in Malmö and Göteborg in 1952, at the Galerie de Babylone in Paris in 1953 and at Lund University in 1954. In 1950 the publishing house issued an album of eight lithographs by Svanberg. Svanberg left the group in 1953, claiming to be the only true Imaginist, but the group continued in existence until 1956.

Prints

C. O. Hultén: *Drömmar ur bladens händer*, preface M. W. Svanberg (Malmö, 1947)

Bibliography

C. O. Hultén: Arbeten, 1938–1968 (exh. cat. by C. Dotremont and others, Lund, Ksthall, 1968)

J. Pierre: *Max Walter Svanberg et le règne féminin* (Paris, 1975)

Max Walter Svanberg (exh. cat., Malmö, Ksthall, 1979), pp. 7–12, 21–8 [incl. repr. of *Första fasen*]

□

Independent Group

British group of artists, architects and critics. It met as an informal discussion group at the Institute of Contemporary Arts, London, from 1952 to 1955. Its members, drawn from those of the ICA who were dissatisfied with the Institute's policy towards modernism, included the art critic Lawrence Alloway (1926–90), the design historian Peter Reyner Banham (1922–88), the art historian Toni del Renzio (*b* 1915), the artists Nigel Henderson, Richard Hamilton, Eduardo Paolozzi, William Turnbull and John McHale (1922–78), and the architects Alison and Peter Smithson, James Stirling and Colin St John Wilson.

Reyner Banham convened the first full session (1952–3), during which the Group analysed the philosophy of the Modern Movement. In particular, the theories of Amédée Ozenfant and Le Corbusier were called into question for their failure to deal with consumerism and new technology. Alloway and McHale convened the second term (1955), whose theme was American mass culture and its relationship to fine art. Advertising, car styling, Hollywood films and women's fashion were analysed with a degree of seriousness usually reserved by British art critics for paintings.

The Group's ideas reached a wider audience by means of magazine articles, ICA events and works of art. Hamilton's collage *Just What Is It That Makes Today's Homes So Different, So Appealing?* (1956; Tübingen, Ksthalle) captured the essence of the Group's thinking on mass culture. Several Royal College of Art students attending the ICA, particularly Roger Coleman, were influenced by the Group.

See also POP ART.

Bibliography

L. Alloway: 'The Development of British Pop', *Pop Art*, ed. L. R. Lippard (London, 1978), pp. 27–69

A. Massey and P. Sparke: 'The Myth of the Independent Group', *Block*, 10 (1985), pp. 48–56

A. Massey: 'The Independent Group: Towards a Redefinition', *Burl. Mag.*, cxxix (1987), pp. 232–42

——: *The Independent Group: Modernism and Mass Culture in Britain, 1945–1959* (Manchester, 1995)

ANNE MASSEY

Inkhuk [Institut Khudozhestvennoy Kultury; Rus.: 'Institute of Artistic Culture']

Soviet institute for research in the arts that flourished from 1920 to 1926. Inkhuk was a dominant force in the development of Soviet art, architecture and design in the 1920s. Founded in Moscow in May 1920, with affiliations in Petrograd (now St Petersburg) and Vitebsk, it attracted many members of the avant-garde, especially Lyubov' Popova and Aleksandr Rodchenko; its key administrative positions were occupied by Vasily Kandinsky (Moscow), Vladimir Tatlin (Petrograd) and Kazimir Malevich (Vitebsk). At one time Inkhuk maintained contact with Berlin (through El Lissitzky and the journal *Veshch'/Gegenstand/ Objet*), the Netherlands, Hungary and Japan, although it never really had the chance to develop these international connections. One of the principal aims of Inkhuk was to reduce the modern movements such as Suprematism and Tatlin's concept of the 'culture of materials' to a scientifically based programme that could be used for educational and research purposes—a development analogous to the initial endeavours of the Russian Formalist school of literary criticism, which attempted to analyse literature in terms of formal structures. In its aspiration to elaborate a rational basis for artistic practice, Inkhuk encouraged discussions on specific issues of artistic content and form, such as the debate on 'composition versus construction' in 1921.

The practical contribution of Inkhuk was twofold, for it investigated both the intrinsic, formal components of the artistic process ('laboratory art') and also its utilitarian application ('production art'). The former, advocated by Kandinsky, Inkhuk's first chairman, was soon rejected by the majority of the Inkhuk members as being too aesthetic and irrelevant to the needs of a technological society, especially when Kandinsky emphasized the need to take account of intuitive and occult responses as well as physical and material elements. Kandinsky soon left Inkhuk and in the summer of 1921 entered the commission for the establishment of the State Academy of Artistic Sciences (GaKhn), where he presented a version of the Inkhuk proposals.

Towards the end of 1920 Inkhuk was reorganized by Rodchenko, Varvara Stepanova, the sculptor Aleksey Babichev (1887–1963) and the musician Nadezhda Bryusova (1881–1951). Babichev and his Working Group of Objective Analysis compiled a new programme that gave primary consideration to scientific analysis and the material organization of the work of art. But even Babichev's call for an 'exact aesthetics' underwent serious criticism, since some artists felt that the very notion of the independent, 'beautiful' work of art was outmoded, and that the real justification of art lay in its functional applicability. This opinion, identifiable with the Productionists (or Productivists), was voiced by the most influential faction within Inkhuk and contributed directly to the rise and consolidation of Constructivism in 1921 (*see* CONSTRUCTIVISM, §2). The concern with concrete materials and the object (Rus. *veshch'*), shared by such artists as Georgy and Vladimir Stenberg and Rodchenko, and the ideological publications by its apologists Boris Arvatov, Osip Brik (who became head of Inkhuk in 1922), Aleksey Gan (1889–*c*. 1940), Boris Kushner and Nikolay Tarabukhin, left a deep imprint on the evolution of early Soviet culture.

The exhibition *5×5 = 25*, organized at Inkhuk by Rodchenko in September 1921, expressed the belief that studio art had to be replaced by a utilitarian creative process. Typical of the five works shown by each of the five participants (Alexandra

Exter, Popova, Rodchenko, Stepanova and Aleksandr Vesnin) was Rodchenko's painted series of three monochrome panels in red, yellow and blue (all untraced). The artists' statements in the catalogue, such as Stepanova's that 'technology and industry have confronted art with the problem of construction not as contemplative representation, but as an active function', also epitomized the new ideas. At a plenary session of Inkhuk in November 1921, the majority of the participants, together with their associates, condemned studio painting as outmoded and useless and promoted new artistic values in the 'absoluteness of industrial art and Constructivism as its only form of expression'. As a result, many artists entered the world of industrial design and production: for example, Popova and Stepanova turned to textile design, Rodchenko to graphic design and photography and Vesnin to architecture.

Inkhuk was attached to GaKhn at the beginning of 1922 and quickly lost its autonomy, but its Petrograd affiliation, Ginkhuk (Rus. Gosudarstvenny Institut Khudozhestvennoy Kultury: 'State Institute of Artistic Culture'), assumed its formal status only in October 1924. An extension of the Museum of Artistic Culture in Petrograd, Ginkhuk was divided into five sections: Formal and Theoretical Systems under Malevich, Material Culture under Tatlin, Organic Culture under Mikhail Matyushin, General Ideology under Nikolay Punin and the Experimental Department under Pavel Mansurov. Although Ginkhuk was smaller than its Moscow counterpart, it attracted a number of Malevich's and Matyushin's most promising students and, through its exhibitions and tabulations, made an especially valuable contribution to the elaboration of colour theory. Ginkhuk was closed by official decree at the end of 1926.

Bibliography

A. Z. Rudenstine, ed.: *Russian Avant-garde Art: The George Costakis Collection* (London, 1981)

C. Lodder: *Russian Constructivism* (New Haven, 1983)

S. O. Khan-Magomedov: *Rodchenko: The Complete Work* (London, 1986)

JOHN E. BOWLT

International Style

Term applied to architecture of the MODERN MOVEMENT after 1932. That year the first architectural exhibition at the Museum of Modern Art (MOMA), New York, was held following a visit to Europe by historian Henry-Russell Hitchcock and Philip Johnson, Director of Architecture at MOMA; the term was enshrined in the title of the accompanying book and catalogue *The International Style: Architecture since 1922*. Buildings selected for inclusion in the exhibition, with some notable exceptions (see below), had certain formal characteristics in common, being mostly rectilinear, undecorated, asymmetrical and white.

The idea of an international architecture, partly inspired by the symbolic socialist use of the word 'international', had been suggested by Walter Gropius in his title *Internationale Architektur* for the first *Bauhausbuch* (Munich, 1925). It was also used by Ludwig Hilberseimer in the title of his book *Internationale neue Baukunst* (Stuttgart, 1927), published a year or two before he was appointed to teach at the Bauhaus, and its validity was confirmed by successful international participation in the Siedlungaustellung (1927) at Weissenhof, Stuttgart (for further discussion *see* DEUTSCHER WERKBUND; *see also* MODERN MOVEMENT, §4). After the foundation of CIAM (Congrès Internationaux d'Architecture Moderne) in 1928, Hitchcock accepted this position when he used the phrase 'international style' in referring to the work of European avant-garde architects in his book *Modern Architecture: Romanticism and Reintegration* (New York, 1929) and again in the MOMA exhibition catalogue.

While the work of 48 architects, firms and official groups from 15 countries was shown at MOMA, the exhibition was dominated by that of European avant-garde architects of the Modern Movement. More than half of them were from Germany, including Marcel Breuer, Walter Gropius, Ernst May, Erich Mendelsohn, Mies van der Rohe and Hans Scharoun. The Netherlands was represented by the work of J. J. P. Oud, Mart Stam, Johannes Brinkman and L. C. van der Vlugt; Italy by Luigi Figini and Gino Pollini; France by Le Corbusier and André Lurçat; Spain by José Manuel

de Aizpúrua and Joaquín Labayen; Finland by Alvar Aalto and Erik Bryggman; Sweden by Gunnar Asplund and Sven Markelius; Switzerland by Werner Moser; Britain by Joseph Emberton; and Japan by Mamoru Yamada. The most notable of the six American architects whose work was shown were Raymond Hood and J. André Fouilhoux (1879–1945), George Howe with the Swiss emigré architect William Edmond Lescaze, and another recent immigrant, Richard Neutra.

In analysing the exhibited work in stylistic terms, Hitchcock and Johnson purged it of the ideological connotations implicit in the socio-cultural origins of the Modern Movement. They saw the International Style as a 'frame of potential growth rather than as a fixed and crushing mould', with only three controlling 'principles': the first, 'the conception of architecture as volume rather than mass', premised a gridded structure divided into volumes by non-load-bearing (lightweight) planes and wrapped in a smooth skin, producing an aesthetic of surface. The second, 'regularity rather than symmetry as the chief means of order-ing design', was related to the underlying disci-pline of arranging façades according to a regularly disposed structure, and it seemed to oppose the emerging Functionalist ethic in its assertion that the prime architectural problem is 'to adjust the irregular and unequal demands of function to reg-ular construction and the use of standard parts'. The third principle, 'proscribing arbitrary applied decoration', completed the description of a new architecture that claimed already to exist in a 'set of actual monuments, not a vague corpus of the-ory'. While by far the majority of buildings exhib-ited at MOMA—such as Le Corbusier's Villa Savoye (1929–31; see col. pl. XXIII), Poissy, and Mies van der Rohe's Tugendhat House (1928–30; see fig. 22),

22. Ludwig Mies van der Rohe: Tugendhat House, Brno, 1928–30

Brno—conformed to the then mainstream prismatic 'white architecture', however, the way to a major extension of the boundaries of the International Style was opened by the inclusion of such buildings as Mendelsohn's curved, glazed Schocken Store (1928) at Chemnitz and the skyscrapers by Hood and Fouilhoux for McGraw-Hill (1931), New York, and by Howe and Lescaze for the Philadelphia Savings Fund Society (PSFS; completed 1933; see fig. 23), Philadelphia.

Reversion to a formalized concept of style nevertheless ran counter to the anti-aestheticism of such radical European avant-garde architects as Hannes Meyer, and in the very year of the MOMA exhibition even Le Corbusier had successfully pleaded with Alberto Sartoris to change the name of a forthcoming book to *Gli elementi dell'architettura funzionale* (Milan, 1932; preface by Le

23. George Howe and William Lescaze: Philadelphia Savings Fund Society Building, Philadelphia, PA, 1933

Corbusier) instead of *razionale*. This was important in helping to make the term FUNCTIONALISM a convenient one for architects wishing to justify the new and unfamiliar forms without reference to style. Buildings in the International Style may also be characterized as having structures independent of the articulation of enclosed space, although in many of the buildings shown at MOMA this characteristic was formalized rather than real. The effect of independent structure results in adaptability to function rather than its overt expression, and, taken together with the economy and technological convenience of rectilinear geometry, this was one of the main causes of the anonymity and banal appearance often ascribed to buildings of the International Style.

It was, however, the simple, white cubic forms that first caught the international imagination in the 1930s and early 1940s, when several notable examples were built in Europe, including a tuberculosis sanatorium (1929–32), Paimio, Finland, by Aalto, medium-rise flats in Doldertal (1935–6), Zurich, by Alfred Roth and Emil Roth (with Marcel Breuer), and the two Highpoint blocks (1933–8) in north London by Tecton; and private houses in the Netherlands by Brinkman and van der Vlugt and in Hungary by Farkas Molnár and Jószef Fischer. In the same period buildings of this general character, often adapted to climate or tinged with regional features, can be found as far apart as Mexico City (e.g. Luis Barragán's duplex houses and Juan O'Gorman's standardized schools, both 1933–4); Rio de Janeiro (e.g. Oscar Niemeyer's Obra do Berço day nursery and maternity clinic, 1937); Tokyo (e.g. Yamada's Communications Ministry Hospital, 1937); Moscow (e.g. the Vesnin brothers' Zil Club, 1937); and Tel Aviv (e.g. Arieh Sharon's cooperative housing, 1939).

The buildings of the Italian *Razionalismo* movement (*see* RATIONALISM), notably Giuseppe Terragni's Casa del Fascio (now Casa del Popolo; completed 1936), Como, and Ignazio Gardella's Dispensario Antitubercolare (1936), Alessandria, strongly influenced developments elsewhere: an example is Jorge Hardoy's Virrey del Pino flats (1943), Buenos Aires, one of numerous rectilinear, multi-storey, reinforced-concrete buildings erected

around the world in which the appearance was determined by *brise-soleil* systems. On the other hand a more baroque approach to the 'white' style was taken by Oscar Niemeyer and Lúcio Costa in their Brazilian Pavilion (with Paul Lester Weiner) for the New York World's Fair of 1939 and in Niemeyer's lakeside buildings at Pampulha (1942–6), Belo Horizonte, Brazil.

After World War II the International Style moved into the more practically orientated mode foreshadowed in the MOMA exhibition. Absence of historical reference was *de rigueur* as a matter of economy in dealing concurrently with post-war reconstruction in Europe and Asia and with increasingly rapid urbanization and a growing demand worldwide for schools, housing and other social buildings of all kinds. The Athens Charter, which originated at CIAM IV (1933), was revised and published by Le Corbusier in 1943 and, although subsequently widely criticized for its emphasis on zoning and the use of widely spaced multi-storey blocks as vital ingredients of urbanization, it had significant implications for Latin American, South-east Asian and African countries with exploding urban populations or in their first years of post-colonial independence between 1945 and c. 1960. Multi-storey mass housing is found all over the world, from Hong Kong to Caracas, where Carlos Raúl Villanueva's elegant Banco Obrero housing climbs the hills behind the city. The principal monument to Corbusian urbanism, however, is Brasília, the capital city of Brazil, inaugurated in 1960 (urban plan 1957). Despite its functional failings, its open phalanx of identical ministry buildings and the formalism of the executive offices and Congresso Nacional (1960) constitute one of the most memorable images of 20th-century architecture.

In Europe and the USA developments in structural techniques using steel and concrete frames with prefabricated infill panels, which were designed to expedite the construction of housing and schools, added to the increasingly standardized appearance of many buildings; this can be seen in the more than 100 schools built in 1947–55 by C. H. Aslin (1893–1959) to a system developed for Herts County Council in England.

The mainstream of the International Style, however, reached its apogee in the work of Mies van der Rohe in the USA, for example his Lake Shore Drive Apartments (1948–51), Chicago. The development of the curtain wall as a practical method of construction changed the character of the International Style in the late 1940s and early 1950s to one of undecorated rectilinear formalism, with surface structure and materials (usually mainly glass) consistently articulated. Many of the gridded patterns of curtain walling systems nevertheless reflect the sophisticated detailing and refined proportions of Mies's exposed steel or bronze frames, which were mostly not curtain walls. Particularly characteristic of this corporate 'glass box' International Style is the work of Skidmore, Owings & Merrill in the 1950s, during which period office buildings of this genre changed the appearance of every major city in the world, from New York (e.g. United Nations Headquarters, 1947–53, by an international committee under the chairmanship of Wallace K. Harrison) to Melbourne (e.g. ICI Building, 1958, by Bates, Smart & McCutcheon) or Mexico City (e.g. Torre Latino Americano, 1957, by Augusto H. Alvarez and Adolfo Zeevaert).

Meanwhile Le Corbusier had begun to develop new, more sculptural forms of expression, particularly in reinforced concrete, in his buildings of the 1950s in France and India. Together with the contemporary reinforced-concrete work of Kenzo Tange in Japan, these buildings soon became associated with BRUTALISM and such related developments as New Brutalism and New Empiricism, which represented a new honesty of expression stemming from the work and precepts of members of TEAM TEN, who had thrown CIAM into disarray and led to its demise in 1959. The NEO-LIBERTY movement in Italy kindled the wrath of the orthodox Modernists in 1957, with the firm BBPR daring to revive historical reference overtly in a gesture of contextualism in their Torre Velasca (completed 1958), Milan. Although orthodox International Style buildings continued to be constructed in the 1960s, this was the beginning of a growing pluralism in Modernism—subsequently ranging from the more rhetorical buildings of late

Modernism to the mechanistic expressions of HIGH TECH—that defied collective characterization. By 1963, when early evidence of Post-modernism had already appeared in architecture (*see* POST-MODERNISM, §1), for example in the Guild House Retirement Home (1960–62), Philadelphia, by Venturi, Rauch & Scott Brown, Hitchcock had concluded that 'the International Style is over' (see Hitchcock, 1963, epilogue).

Bibliography

H.-R. Hitchcock and P. Johnson: *The International Style: Architecture since 1922* (New York, 1932, rev. 2/1966)

A. Roth: *La Nouvelle Architecture* (Zurich, 1940)

S. Giedion: *A Decade of New Architecture* (Zurich, 1951)

H.-R. Hitchcock: *Architecture, Nineteenth and Twentieth Centuries*, Pelican Hist. A. (Harmondsworth, 1958, rev. 2/1963)

P. R. Banham: *The New Brutalism: Ethic or Aesthetic?* (London, 1966)

J. Jacobus: *Twentieth-century Architecture, 1940–65* (London, 1966)

J. Joedicke: *Architecture since 1945* (London, 1969)

W. H. Jordy: *American Buildings and their Architects*, iii–iv (New York, 1970–73)

C. Jenks: *Modern Movements in Architecture* (London, 1973, rev. 2/1985)

A. Smithson and P. Smithson: *Without Rhetoric: An Architectural Aesthetic, 1955–1972* (London, 1973)

P. R. Banham: *The Age of the Masters* (London, 1975)

A. M. Vogt: *Arkitektur 1940–1980* (Frankfurt am Main, 1980)

W. J. R. Curtis: *Modern Architecture since 1900* (Oxford, 1982, rev. 2/1987) [esp. pt 2, chaps 13–18, and pt 3, chaps 19–22]

H. Searing, ed.: *In Search of Modern Architecture* (New York, 1982)

M. Tafuri: *Storia dell' architettura italiana, 1944–1985* (Turin, 1982; Eng. trans., 1989) [esp. pt 1, chaps 1–4]

B. Bognar: *Contemporary Japanese Architecture: Its Development and Challenge* (New York, 1985)

D. P. Handlin: *American Architecture* (London, 1985) [esp. chaps 6–9]

G. Monnier: *L'Architecture en France: Une Histoire critique, 1918–1950* (Paris, 1990) [esp. pts 2 and 3]

D. Sharp: *Twentieth Century Architecture: A Visual History* (London, 1991)

For further bibliography *see* MODERN MOVEMENT.

ANDREW BALLANTYNE

Jack of Diamonds [Rus. Bubnovy Valet]

Group of Russian avant-garde painters active in Moscow from 1910 to 1917. It was founded by Mikhail Larionov, Natal'ya Goncharova, Aristarkh Lentulov, Pyotr Konchalovsky, Robert Fal'k, Il'ya Mashkov and Aleksandr Kuprin, young artists who found membership of existing art societies no longer compatible with their experimental styles of painting. Regular participants included Alexandra Exter, David Burlyuk and Vladimir Burlyuk. The name 'Jack of Diamonds', chosen by Larionov, suggested not only the roguish behaviour of the avant-garde but also their love of popular graphic art forms such as old printed playing cards.

The group's first exhibition took place in Moscow in 1910, and, following the example of the exhibitions sponsored by the magazine GOLDEN FLEECE, they invited contributions from foreign artists such as Albert Gleizes, Albert Le Fauconnier and members of the 'Neue Künstlervereinigung München', including Kandinsky, Gabriele Münter and Alexei Jawlenski. In this first exhibition the influence of the Lubok (popular Russian print) was especially evident in the work of Larionov and Goncharova. Crude in style and content, Larionov's *Soldiers* (1910; Los Angeles, CA, Co. Mus. A.), with obscenities scribbled across the canvas, caused a scandal at the exhibition. Other leaders of the group were inspired more by Fauvism and contemporary German art. Mashkov's *Portrait of Vinogradova* (1909; Moscow, Tret'yakov Gal.), with its bold arabesques, daring colouring and simplified portraiture, recalls Henri Matisse, and Konchalovsky's magnificently ugly *Portrait of Antaro* (?1910; untraced) bears the stamp of Kees van Dongen.

During 1911 Larionov and Goncharova organized their own group called the DONKEY'S TAIL and seceded from the Jack of Diamonds group on ideological grounds. Their complaints about the group's reliance on Western models instead of on indigenous Russian sources were shared by seven other artists, including Kazimir Malevich, who also resigned from the group. Twice as many young artists who wished to be associated with the group filled the gap, however, and Lentulov,

Konchalovsky, Mashkov, Fal'k and Kuprin became the leaders.

In their second, third and fourth exhibitions of 1912–14 (all in Moscow; the exhibition of 1913 was a smaller version of one that opened in St Petersburg), the Jack of Diamonds group invited a wide range of French and German artists to participate. They included not only Fauves such as Matisse, Derain, Kees van Dongen and Vlaminck but also Cubists: Robert Delaunay, Gleizes, Le Fauconnier, Léger, Braque and Picasso. Works by artists of Die Brücke and Der Blaue Reiter, such as Ernst Kirchner, Erich Heckel, Franz Macke, Franz Marc and Kandinsky, were also shown. Moreover the Jack of Diamonds almanac of 1913 included translations of Le Fauconnier's 'La Sensibilité moderne et le tableau' and Apollinaire's essay 'Fernand Léger'. Such painters had a profound effect upon the Jack of Diamonds group, who began to synthesize these trends in their art from 1912 to 1914. Konchalovsky, Fal'k and Kuprin now concentrated more on still-lifes than portraits and painted brightly coloured works in which the subjects were faceted and rearranged in a mildly Cubist way. The work of new participants, such as Nadezhda Udal'tsova and Lyubov' Popova, who had both worked in Paris under Le Fauconnier and Jean Metzinger, was much more radical and in a thoroughly Cubist vein.

Jack of Diamonds failed to exhibit as a group in 1915, preferring to contribute works individually to *Vystavka zhivopisi: 1915 god* ('Exhibition of painting: The year 1915'), a large avant-garde exhibition in Moscow. Their penultimate exhibition was held during 1916, but without the participation of either Konchalovsky or Mashkov. Instead the exhibition was dominated by artists from Petrograd (St Petersburg): Natan Al'tman, Jean Pougny and Ol'ga Rozanova, who showed several works described as 'Non-objective compositions'. The exhibition also included nearly 70 Suprematist paintings by the prodigal Malevich and his friend Ivan Klyun. Jack of Diamonds dissolved following their final exhibition in Moscow in 1917.

Writings
Bubnovy Valet [Jack of Diamonds] (Moscow, 1913)

Bibliography
Bubnovy Valet (exh. cats, Moscow, 1910–14, 1916–17; St Petersburg, 1913) [illus. album of works shown at the first exh.]

A. Grishchenko: 'O gruppe khudozhnikov "Bubnovy Valet" ' [About the 'Jack of Diamonds' group of artists], *Apollon*, vi (1913), pp. 31–8

Vystavka proizvedeniy khudozhnikov gruppy 'Bubnovy Valet' [Exhibition of works by the 'Jack of Diamonds' group of artists] (exh. cat., ed. V. Midler; Moscow, 1927)

G. Pospelov: 'O "valetakh" bubnovykh i "valetakh" chervonnykh' [On the 'Jacks' of Diamonds and the 'Jacks' of Hearts], *Panorama Isk. '77* [Panorama of Arts '77] (1978), pp. 127–42

G. Pospelov: *Karo-Bube: Aus der Geschichte der Moskauer Malerei zu Beginn des 20. Jahrhunderts* (Dresden, 1984)

Sieben Moskauer Künstler/Seven Moscow Artists, 1910–1930 (exh. cat., Cologne, Gal. Gmurzynska, 1984)

ANTHONY PARTON

Jeune Peinture Belge

Belgian group of avant-garde artists active from 1945 to 1948. It was formed on the initiative of an art critic Robert L. Delevoy and a lawyer René Lust, with the intention of promoting the work of young contemporary painters and sculptors through exhibitions. It developed from the groups Route libre (1939) and L'Apport (1941–51). The main exhibitions took place in 1947 in Brussels at the Palais des Beaux-Arts. The 'first generation' of artists involved in the foundation of the group included the sculptor Willy Anthoons (b 1911) and the painters René Barbaix (1909–66), Gaston Bertrand (b 1910), Anne Bonnet (1908–60), Jan Cox (1919–80), Jack Godderis (b 1916), Emile Mahy (1903–79), Marc Mendelson (b 1915), Charles Pry (b 1915), Mig Quinet (b 1906), Rik Slabbinck (b 1914) and Louis Van Lint (1909–87).

The members of Jeune Peinture Belge were engaged in a constant searching for new means of representation and were responsible for introducing elements of *Art informel* to Belgian art, for example *Still-life* (1947; Brussels, Mus. A. Mod.) by Van Lint. Although they followed no particular style and were highly individualistic, they all devoted attention to plastic forms and pictorial means. Despite a common interest in Fauvism,

Cubism and Surrealism, the artists retained traces of Flemish Expressionism in their work. In later exhibitions additional and younger painters and sculptors joined the original members, including Pierre Alechinsky (*b* 1927), Pol Bury (*b* 1922), Jo Delahaut (*b* 1911), Jules Lismonde (*b* 1908), Jean Milo (*b* 1906), Antoine Mortier (*b* 1908), Luc Peire (*b* 1916), Roger Somville (*b* 1923) and Jan Vaerten (*b* 1909).

After the group's dissolution in 1948 a new organization was established in 1950 under the title Jeune Peinture Belge—Fondation René Lust, which initiated the annual Prix Jeune Peinture Belge, first won by Alechinsky. In 1952 ART ABSTRAIT was formed as a successor to Jeune Peinture Belge.

Bibliography

R.- L. Delevoy: *La Jeune Peinture Belge* (Brussels, 1946)

M. Seuphor: *Geschiedenis van de abstracte schilderkunst in Vlaanderen* (Brussels, 1963)

P. Mertens: *La Jeune Peinture Belge* (Brussels, 1975)

M. Huys and others: *40 ans Jeune Peinture Belge* (Antwerp, 1990)

JEAN-PIERRE DE BRUYN

Junk art

Term first used by the critic Lawrence Alloway in 1961 to describe an urban art in which found or ready-made objects and mechanical debris were transformed into paintings, sculptures and environments by welding, collaging, décollaging or otherwise assembling them into new and unusual forms. The name evolved from the phrase 'junk culture', which had been used in the late 1950s and early 1960s, particularly in Great Britain and the USA, by writers such as Hilton Kramer (*b* 1928) to describe the vulgar and kitsch qualities of objects with built-in obsolescence produced in industrial nations after World War II.

Precedents for Junk art prior to World War II include collages by Georges Braque and Pablo Picasso (see col. pl. XV), Marcel Duchamp's ready-mades (see col. pl. XVI), Dada assemblages, Kurt Schwitters's *Merzbau* constructions and Surrealist objects such as Meret Oppenheim's fur-lined teacup known as *Object* (1936). Urban junk featured in the sculptural form known as Assemblage, which often included discarded pieces of chipped, painted wood; rusted metal; partially destroyed or non-functional objects; torn, stained or burnt cloth or newspapers; ripped linoleum; and other found objects characterized by a worn appearance and urban associations. Notable among the artists working in this idiom in the late 1950s and early 1960s in both Europe and the USA were Americans such as Robert Rauschenberg, Lee Bontecou, Allan Kaprow, John Chamberlain, Carolee Schneemann (*b* 1939) and Richard Stankiewicz; the Argentinian Kenneth Kemble; British artists such as John Latham and Eduardo Paolozzi; Europeans associated with NOUVEAU RÉAL-ISME, such as César and Jean Tinguely; and other Europeans, such as Ettore Colla, Alberto Burri and Lucio Fontana. In California, and especially in the San Francisco Bay area, Junk art developed into a form identified by the critic Peter Selz (*b* 1919) as Funk art, which was characterized by an association with the sensual, earthy beat of Jazz and Blues music and with the work of the Beat poets; the idiosyncratic use of materials such as used stockings, black leather, vinyl, fur and torn and stained pictures of pin-up girls contributed to the sometimes erotic, humorous and scatological suggestions of the assemblages, paintings, sculptures and ceramics of artists such as Bruce Conner (*b* 1933), Robert Arneson (*b* 1930), Jay Defeo (*b* 1929), Joan Brown (*b* 1938), Harold Paris (*b* 1925), Wallace Berman (*b* 1926) and David Gilhooly (*b* 1943).

The presence of commercial and urban refuse in art not only emphasized the relative value of contemporary objects but commented ironically on the relativity of the history of value in a society that rapidly discards objects only to have them reappropriated and elevated to the status of art. Using this waste material to create a new hierarchy in the order of things, Junk art used common objects democratically in an artistic context while contradicting and confounding preciousness. In bringing mass-produced things from the urban environment into the context of fine art, it laid the foundations for further appropriation of popular imagery that was to follow in the early 1960s with the advent of Pop art.

Bibliography

L. Alloway: 'Junk Art', *Archit. Des.*, 31 (March 1961)

The Art of Assemblage (exh. cat. by W. C. Seitz, New York, MOMA, 1961)

A. Kaprow: *Environments, Assemblages and Happenings* (New York, 1966)

D. Zack: 'Funk Art', *A. & Artists*, ii (April 1967)

——: 'Funk Art: The Grotesque Show at Berkeley, California', *A. & Artists*, ii (Oct 1967)

J. Nuttall: *Bomb Culture* (London, 1970)

J. Pierre: 'Funk Art', *L'Oeil*, 190 (Oct 1970), pp. 18–27

KRISTINE STILES

Kapists [Capists; Pol. Kapiści, from 'Komitet Paryski': Parisian Committee]

Polish group of painters. In 1924 a number of students of Józef Pankiewicz at the Academy of Fine Arts in Kraków formed a committee, whose aim was to organize a study trip to Paris. Jan Cybis (1897–1972), Hanna Rudzka-Cybisowa (1897–1988), Zygmunt Waliszewski, Artur Nacht-Samborski, Piotr Potworowski and Józef Czapski were among the painters who therefore founded the Paris branch of the Kraków Academy from 1924 to 1930. They gained fame after two successful exhibitions at the Galerie Zak in Paris (1930) and the Galerie Moos in Geneva (1931). Most of the artists returned to Poland in 1931, where they were still known as the Kapists. They were a loose association, and, although they had no clearly defined programme, they were principally influenced by the work of Pierre Bonnard. The members were Post-Impressionist painters representing the trend known as Polish Colourism, and they stressed the importance of good craftsmanship in painting. Generally their work is associated with a particular sensitivity to colour, its harmony and contrasts. Forms were built with colour, and the use of perspective and chiaroscuro was limited, as in Rudzka-Cybisowa's *Still-life with Armchair* (c. 1956; Poznań, N. Mus.). They painted from nature but did not imitate it, and their compositions were sometimes close to abstraction (e.g. *Shells* by Jan Cybis, 1953–4; Poznań, N. Mus.). Zygmunt Waliszewski was the only member of the group who did not reject literary subject-matter (e.g. the *Toilet of Venus*, 1933; Warsaw, N. Mus.). Kapists were well-represented on the staff of the Academy of Fine Arts, Warsaw, opened in 1945. Along with Constructivism, the Polish Colourism introduced by the Kapists became one of the most popular trends in Polish painting in the first half of the 20th century.

Bibliography

M. Wallis: *Sztuka polska dwudziestolecia* [Polish art, 1918–39] (Warsaw, 1959)

J. Pollakówna: *Malarstwo polskie między wojnami, 1918–1939* [Polish painting between the wars, 1918–1939] (Warsaw, 1982)

T. Dobrowolski: *Malarstwo polskie ostatnich dwustu lat* [Polish painting of the last two hundred years] (Wrocław, 1989)

ANNA BENTKOWSKA

Kecskemét colony

Hungarian artists' colony established in 1911 at Kecskemét, c. 80 km south-east of Budapest. The town provided studios for artists and offered commissions. The studios were designed in Hungarian Secessionist style by the colony members Béla Jánszky (1884–1945) and Tibor Szivessy (1884–1963). In the Secessionist spirit of *Gesamtkunst* the colony's activities ranged from ceramics to tapestry. A weaving school was set up, and free courses in art and industrial design were held in the town. Members came in part from the Nagybánya colony: the initiator of the colony and its first leader was the painter Béla Iványi Grünwald, and Elek Falus (1884–1950) played a significant role in the foundation of the colony and went on to direct its textile workshop. From 1920 the colony was led by Imre Révész (1859–1945), a noted genre-painter. Artists also came from the SZOLNOK COLONY, and the sculptors Zsigmond Kisfaludi Strobl and Imre Csikász (1884–1914) also worked there.

Unlike the Nagybánya and the Gödöllő colonies, Kecskemét artists had no common programme or unified style. They held only two joint exhibitions, in 1913 and 1919. While some of the artists maintained the traditions of *plein-air*

painting acquired at Nagybánya, others continued under the influence of Szolnok, and of Secessionism. Iványi Grünwald's own Kecskemét paintings (e.g. *Summer*, 1912; Budapest, N.G.) are Secessionist in character, and he created large-scale decorative compositions (e.g. his design for the interior of the Kecskemét Casino). He also painted biblical subjects and, along with Vilmos Perlrott Csaba, used a number of well-known gypsy themes. Perlrott Csaba's paintings, influenced by Cubism, display many characteristic Kecskemét motifs, as in *Calvary* (1912; Kecskemét, Katona Mus.). Falus, a versatile Secessionist artist, was mainly preoccupied with tapestry, but he also worked in book design and illustration, the skills for which he had acquired in England. Another Secessionist artist, Géza Faragó (1877–1928), produced a number of accomplished poster designs. The number of artists working at the colony grew during World War I. Some came to prominence, in various styles and genres, such as the Cubist János Kmetty, the activist Béla Uitz and the important Hungarian avant-garde artist Lajos Kassák.

Bibliography

Z. Farkas: 'A kecskeméti művésztelep' [The artists' colony of Kecskemét], *Vasárnapi Újság* (1912), pp. 705–7

K. Sztrakoniczky: 'Kecskeméti művésztelep' [The artists' colony of Kecskemét], *Művészet* (1912), pp. 395–400

Kecskemét múltja a képzőművészetben [Kecskemét's past in the fine arts] (exh. cat., foreword K. Telepy; Kecskemét, Katona Mus., 1968)

G. Sümegi: 'A kecskeméti művésztelep ellentmondásai' [The contradictions of the Kecskemét artists' colony], *Forrás* (1980), no. 2

K. Telepy: 'A kecskeméti művésztelep' [The Kecskemét artists' colony], *Magyar művészet, 1890–1919* [Hungarian art, 1890–1919] (Budapest, 1981), pp. 318–22

KATALIN GELLÉR

Kinetic art

Term applied to works of art concerned with real and apparent movement. It may encompass machines, mobiles and light objects in actual motion; more broadly, it also includes works in virtual or apparent movement, which could be placed under the denomination of OP ART. Kinetic art originated between 1913 and 1920, when a few isolated figures such as Marcel Duchamp, Vladimir Tatlin and Naum Gabo conceived their first works and statements to lay stress on mechanical movement. At about the same time Tatlin, Aleksandr Rodchenko and Man Ray constructed their first mobiles, and Thomas Wilfred and Adrian Bernard Klein, with Ludwig Hirschfeld-Mack and Kurt Schwerdtfeger at the Bauhaus, began to develop their colour organs and projection techniques in the direction of an art medium consisting of light and movement (1921–3). Although László Moholy-Nagy and Alexander Calder pursued more or less continuous artistic research into actual motion in the 1920s and 1930s, it was only after 1950 that the breakthrough into kinetic art, and its subsequent expansion, finally took place. Such artists as Pol Bury, Jean Tinguely, Nicolas Schöffer and Harry Kramer played a leading part in this development as far as mechanical movement was concerned; Calder, Bruno Munari, Kenneth Martin and George Rickey in the domain of the Mobile; and Wilfred, Frank Joseph Malina (1912–81), Schöffer and Gyorgy Kepes (*b* 1906) in that of lumino-kinetic experiment.

The term 'kinetic art' followed a similar evolution. Gabo had spoken of 'kinetic rhythms' in his and Antoine Pevsner's *Realist Manifesto* (Moscow, 1920) at the time of his first moving sculpture, *Kinetic Construction* (or *Standing Wave*, 1919–20; London, Tate; see fig. 24); Moholy-Nagy had used the adjective 'kinetic' intermittently during the elaboration of his *Light Prop* (or *Lichtrequisit*, 1929–30; Cambridge, MA, Busch-Reisinger Mus.) from 1922 to 1930; and Victor Vasarely applied the term 'cinétisme' constantly from 1950 to his works in virtual movement. The word also appeared in the *Yellow Manifesto*, published on the occasion of the exhibition *Le Mouvement* at the Galerie Denise René in Paris (1955). In 1960 Wolfgang Ramsbott (with the aid of Harry Kramer) published the basic chronology of kinetic art, and in the following years the writings of Rickey, Frank Popper and others, as well as a number of important exhibitions in Europe and the USA, helped to establish kinetic art as a valid art trend.

24. Naum Gabo: *Kinetic Construction* or *Standing Wave*, 1919–20, replica 1988 (London, Tate Gallery)

The development of kinetic art from the 1960s can only be fully appreciated by taking into account the spirit in which the individual artists and groups of artists used motion in their works: whether they were within or outside the Constructivist and Dadaist traditions; whether their inspiration was of an artistic, technological or natural origin; and whether their works were conceived in connection with environmental schemes or with a view to the participation of the spectator and his autonomous and even creative behaviour. For a number of artists working in the Constructivist tradition, movement in its own right was the almost exclusive preoccupation, whether like Rickey or Martin they inclined towards touch-, air- or heat-operated mobiles, or

whether like Schöffer they preferred mechanical movement. By contrast Calder, both in his mobiles and in his occasional motorized works, attached himself to the Surrealist (and Dadaist) tradition (see col. pl. XXIV). This also predominated in Bury's almost imperceptibly moving constructions and in Tinguely's humorous meta-mechanical sculptures of the mid-1950s. American artists such as Fletcher Benton (*b* 1931), Charles Mattox (*b* 1910), Howard Jones (1922–91) and James Seawright (*b* 1936) were virtually untouched by these opposing Constructivist and Dadaist traditions and showed a more direct involvement with modern technology. However, for many artists, the use of kinetic devices was also a means for transcending technology. For Takis it served to render visible hidden magnetic forces in nature (e.g. *Magnetic Ballet*, 1961; priv. col., see Brett, pp. 30–31); for Piotr Kowalski (*b* 1927) to establish common principles for technology and art in an ironic vein; for Gerhard von Graevenitz, Enzo Mari (*b* 1932) and Bruno Munari to lay stress on the principle of creative programming. As regards artists who were using motion mainly in conjunction with light, a distinction could be made between those who continued the purely painterly tradition, such as Malina, Nino Calos and Katsuhiro Yamaguchi, and those who created three-dimensional Constructivist statements, for instance Julio Le Parc, François Morellet, Hugo Rodolfo Demarco (*b* 1932) and Gregorio Vardanega. Such artists as Liliane Lijn (*b* 1939) and Nam June Paik might be characterized by their direct approach to physics, whereas Wen-Ying Tsai combined a highly developed interest in electronics with a subtle way of implicating the spectator in the functioning of his cybernetic sculptures, begun in 1968.

In the late 1960s and throughout the 1970s kinetic research was not considered meaningful unless related to the notion of environment. The architectural and urbanistic aspects of this term, with Schöffer's spatiodynamic and cybernetic towers (built for exhibitions in France in 1954 and 1955) as their prototype (in 1961 a permanent tower was erected in the Parc de la Boverie in Liège), are distinguished from the more artistic

use of the term as a closed common space occupied both by the spectator and the plastic statements. This was exemplified by 'environments' or installations created by such groups of artists as Gruppo T in Milan, Gruppo N in Padua, the Groupe de Recherche d'Art Visuel in Paris and the group Dvizheniye (Rus.: 'Movement') active in Moscow during the 1960s.

By the 1980s, although kinetic art as such had decreased in importance, its influence made itself felt in works that reactivated the notion of audience participation through interaction and also in art forms that, while bordering on the field of science and technology, nevertheless tried to maintain a distinction between scientific invention and artistic imagination.

Bibliography

A. B. Klein: *Colour-music* (London, 1926, rev. as *The Art of Coloured Light*, 3/1937)

W. Ramsbott: 'Chronologie der kinetischen Kunst nach 1900', *Movens*, ed. F. Mon (Wiesbaden, 1960), pp. 179–83

Bewogen beweging (exh. cat. by K. G. Hulten, Amsterdam, Stedel. Mus., 1961)

G. Kepes, ed.: *The Nature and Art of Motion* (New York, 1965)

S. Bann and others: *Four Essays on Kinetic Art* (London, 1966)

Directions in Kinetic Sculpture (exh. cat. by P. Selz, Berkeley, U. CA, A. Mus., 1966)

Kunst-Licht-Kunst (exh. cat. by F. Popper, Eindhoven, Stedel. Van Abbemus., 1966)

M. Compton: *Optical and Kinetic Art* (London, 1967)

F. Popper: *Naissance de l'art cinétique* (Paris, 1967, rev. 2/1970)

G. Rickey: *Constructivism* (New York, 1967)

Lumière et mouvement (exh. cat. by F. Popper, Paris, Mus. A. Mod. Ville Paris, 1967)

G. Brett: *Kinetic Art* (London, 1968)

J. Burnham: *Beyond Modern Sculpture* (New York, 1968)

F. Popper: *Origins and Development of Kinetic Art* (London, 1968)

W. Sharp: 'Luminism and Kineticism', *Minimal Art*, ed. G. Battock (New York, 1968), pp. 317–58

The Machine as Seen at the End of the Mechanical Age (exh. cat. by K. G. Hulten, New York, MOMA, 1968)

Kinetics (exh. cat., intro. T. Crosby; London, Hayward Gal., 1970) [with essays by J. Benthall and F. Popper]

J. Tovey: *The Technique of Kinetic Art* (New York, 1971)

J. Benthall: *Science and Technology in Art Today* (London, 1972)

D. Davis: *Art and the Future* (New York, 1973)

F. Malina, ed.: *Kinetic Art: Theory and Practice* (New York, 1974)

F. Popper: *Art, Action and Participation* (London, 1975)

——: *Die kinetische Kunst: Licht und Bewegung, Unweltkunst und Aktion* (Cologne, 1975)

Arte programmata e cinetica, 1953–1963: L'ultima avanguardia (exh. cat., ed. L. Vergine; Milan, Civ. Mus. A. Contemp., 1983)

Electra: Electricity and Electronics in the Art of the 20th Century (exh. cat. by F. Popper, Paris, Mus. A. Mod. Ville Paris, 1983)

F. Popper: *Art of the Electronic Age* (London, 1993)

V. F. Koleychuk: *Kinetizm* [Kinetic art] (Moscow, 1994)

FRANK POPPER

Kitchen Sink school

English group of painters active in the 1950s. Its name was derived from an article of 1954 by the critic David Sylvester and is used to identify a brand of English realist painting whose main exponents were John Bratby (*b* 1928), Derrick Greaves (*b* 1927), Edward Middleditch (*b* 1923) and Jack Smith. These artists knew each other and exhibited together but did not share a common programme or ideology. Like the contemporary 'angry young men' of realist drama and literature, they rejected their label. Their work represents a distinctive but brief reaction against the élitism of abstraction and Neo-Romanticism in favour of figurative social realism, a reaction that found its most ardent voice in the writings of the Marxist critic John Berger (*b* 1926).

Greaves, Middleditch and Smith were closest in style and subject-matter. Smith's *After the Meal* (1952) is typical of the school's unheroic depictions of the domestic life and labour of the contemporary working-class. Such commitment was commended by Berger as responding to the austerity of post-war Britain during the Cold War. Bratby remained somewhat apart: his palette was brighter and his brushwork more vigorous; his subject-matter was drawn from his own domestic and middle-class experience as in *Still-life with Chip Fryer* (1954; London, Tate). Political

radicalism did not unite these paintings as much as Berger's claim would suggest; they also included subjects such as *Venice in the Rain* (1953; Sheffield, Graves A.G.) by Greaves or *Fig-tree and Beansticks* (1957; AC Eng) by Middleditch.

In 1956 the Kitchen Sink painters were honoured as Britain's representatives at the Venice Biennale. That year Berger temporarily withdrew from art criticism, having become increasingly disillusioned by a realism not directly related to working-class experience and with no specific social or political affinities. After 1956 the imposed identity of the school gradually subsided.

Bibliography

D. Sylvester: 'The Kitchen Sink', *Encounter*, iii/15 (1954), pp. 61–4

A. Clutton-Brock: *John Bratby*, Painters of Today (London, 1961) [20 colour pls]

J. Steyn and D. Cherry: 'The Moment of Realism, 1952–1956', *Artscribe*, 35 (1982), pp. 44–9

J. Steyn: 'Realism v. Realism in the Fifties', *A. Mthly*, 78 (1984), pp. 6–8

The Forgotten Fifties (exh. cat. by J. Willet, Sheffield, Graves A.G., 1984)

INGRID SWENSON

Kraków group [Pol. Grupa Krakowska]

Polish group of avant-garde artists, initially active in 1933–9 and later revived. Based in Kraków, the group included young painters and sculptors, students and graduates of the Academy of Fine Arts, Kraków: Sasza Blonder, B. Grünberg, Maria Jarema, L. Lewicki, S. Osostowicz, S. Piasecki, B. Stawiński, J. Stern, Henryk Wiciński, and A. Winnicki, as well as more loosely affiliated members: F. Jaźwiecki and Adam Marczyński. The group arose from a larger students' group, Żywi, with 30 members, founded in the academy in early 1932, which developed in reaction to the conservative teaching methods, as well as in response to the political atmosphere of the 1930s and its effect after the collapse of various Constructivist groupings. The Kraków group, whose membership was affiliated to the Academic Left and the already-banned Polish Communist Party, defined its activities as revolutionary, pro-proletarian and anti-nationalist. The young artists were related by a free, liberal artistic programme, and their activities came into conflict with the authorities of the academy, who had recourse to expulsions and permitted police interventions and arrests at academy exhibitions. The artists associated with the working-class movement and the trade union movement employed the slogan 'proletarian arts' but, unlike the Constructivist group, forbore to define their programme. Their main aim was the defence of their threatened freedoms, and thus, for example, they responded to the call directed to all artists on 1 May 1934 to form 'a common front in opposition to the Fascisization of life in Poland, and to threats against independent creativity'.

The Kraków group's chief theoretician was the young sculptor Henryk Wiciński. The work of the membership took in a wide stylistic range, from expressionism through colour field painting to abstraction deriving from the depiction of objects. Working together in 1931, the students first exhibited as a group at the exhibition organized by Leon Chwistek in Lwów in autumn 1933. The group was promoted by Władysław Strzemiński, who also took part in the exhibition in Kraków in February 1935, defending the group from 'the stabilizers of art', a phrase he used in the text he wrote for the catalogue of the exhibition, incorporated in the students' rules in Kraków in November 1932. The initial group remained together until 1939, although it was rather more diffuse in its last three years, when some of its members had left Kraków. The outbreak of war obviated preparations for the group's autumn exhibition, and most of the work of the membership was destroyed during the Occupation of Poland by the Nazis. The Kraków group was the last avant-garde group of the inter-war years, reacting to altered conditions in the 1930s, which not only in Poland but also abroad led to a crisis that served to ruin avant-garde artistic programmes. Its activities were necessarily defensive, aimed at direct threats, and, perhaps more truly than previous Constructivist programmes, the group was expressive of artistic and political conditions in Poland at that time.

The group was reactivated, nevertheless, some time after the war.

Bibliography

A. Wojciechowski, ed.: *Polskie życie artystyczne w latach 1915–1939* [Polish artistic life in the years 1915–1939] (Wrocław, 1974)

Z. Baranowicz: *Polska awangarda artystyczna, 1918–1939* [The Polish artistic avant-garde, 1918–1939] (Warsaw, 1975), pp. 213–30

J. Pollakówna: *Malarstwo polskie między wojnami, 1918–1939* [Polish painting between the wars, 1918–1939] (Warsaw, 1982)

EWA MIKINA

Kukryniksy

Collective pseudonym derived from the names of three Russian painters and illustrators, known particularly for their caricatures. The three were Mikhail (Vasil'yevich) Kupriyanov (KU) (*b* Tetyushi, 21 Oct 1903; *d* Moscow, 11 Oct 1991); Porfiry (Nikitich) Krylov (KRY) (*b* Shchelkunovo, 22 Aug 1902; *d* Moscow, 15 May 1990); and Nikolay (Aleksandrovich) Sokolov (NIKS) (*b* Moscow, 21 July 1903). All three studied at VKHUTEMAS/Vkhutein in Moscow: Kupriyanov and Sokolov in the faculty of graphic art in 1921–9 and 1923–9 respectively; Krylov in the faculty of painting (1921–7). They first worked together on the wall newspaper at Vkhutemas, but their first published caricature appeared in the magazine *Komsomoliya* ('A plenum of komsomol literature'). Thereafter, their work appeared frequently in at least a dozen magazines and newspapers during the late 1920s and 1930s. In 1931 the group met Maksim Gor'ky, whose interest in their work gave it an important stimulus. They became permanent contributors to *Krokodil* and *Pravda* from 1932. They also produced albums of cartoons such as *O . . .* ('About . . . '; Moscow, 1930). The early caricatures of the Kukryniksy were rather parochial, but the basic traits of their work were already apparent: an acute vision, a peculiarly grotesque three-dimensionality, a certain theatricality in the treatment of the subject, social awareness and, in their paintings, a sympathy with the traditions of 19th-century Russian critical realism, as in the *Old Bosses* (1936–7; Moscow, Tret'yakov Gal.). The Kukryniksy also produced theatre designs, for example for the 1932 production of *Gorod glupov* ('Town of fools'), based on a story by Mikhail Saltykov-Shchedrin (watercolour sketches in Moscow, Bakhrushin Cent. Theat. Mus.). They illustrated the satirical novel *12 stul'yev* ('12 chairs') by Il'f and Petrov (Moscow, 1933), Anton Chekhov's *Dama s sobachkoy* ('The lady with a little dog'; Moscow, 1948) and many other books, often in black watercolour. During World War II the Kukryniksy produced many posters (e.g. *We Shall Mercilessly Crush and Destroy the Enemy*, 1941; Moscow, Tret'yakov Gal.), and after the war they attended the Nuremberg Trials as reporters for *Pravda*. As well as working collectively, the members of the group worked independently: Kupriyanov producing watercolour sketches and landscapes; Krylov and Sokolov painting portraits and landscapes.

Writings and Reproductions

Knizhnyye illyustratsii [Book illustrations] (Leningrad, 1973) [facsimiles]

Vtroyom [We three] (Moscow, 1975)

Sobraniye proizvedeniy [Collected works], 4 vols (Moscow, 1982–8)

[N. A. Sokolov:] *Nabroski po pamyati* [Sketches from memory] (Moscow, 1987)

Bibliography

N. I. Sokolova: *Kukryniksy* (Moscow, 1975)

Kukryniksy: Zhivopis', satira, illyustratsiya, plakat, skul'ptura [Kukryniksy: painting, satire, illustration, posters, sculpture] (exh. cat., Moscow, 1977)

G. L. DEMOSFENOVA

Laethem-Saint-Martin [Flem. Sint-Martens-Latem]

Belgian artists' colony named after the village on the Leie River, near Ghent. Among the first artists to gather there, staying for short periods from 1898, were Symbolists such as Albert Servaes, George Minne, Albijn Van den Abeele (1835–1918), who had lived there from at least 1869, Valerius De Saedeleer and Gustave Van de Woestyne and

his brother, the poet Karel Van de Woestyne. Reacting against Impressionism, which they regarded as superficial, they sought to transmit the rural peace of the village and the simplicity and deeply religious nature of its inhabitants. A second group of artists, active from 1905, were the Flemish Expressionists led by Servaes and including Constant Permeke, Gustave De Smet and Frits Van den Berghe.

Bibliography

P. Haesaerts: *L'Ecole de Laethem-Saint-Martin* (Brussels, 1945)

A. De Ridder: *Laethem-Saint-Martin, colonie d'artistes* (Brussels and Paris, 1945)

A. Stubbe: *A. Servaes en de eerste en tweede Latemse kunstenaarsgroep* [A. Servaes and the first and second Laethem artists' group] (Leuven, 1956)

P. Haesaerts: *Laethem-Saint-Martin: Le Village élu de l'art flamand* (Brussels, 1963, 5/1970)

D. CARDYN-OOMEN

Land art

International art form that developed particularly from the late 1960s and early 1970s. It was part of a revolt against painting and sculpture and the anti-formalist current of the late 1960s that included CONCEPTUAL ART and Arte Povera. A number of mainly British and North American artists turned their attention to working directly with nature, notably Christo and Jeanne-Claude, Walter De Maria, Michael Heizer, Dennis Oppenheim, Robert Smithson and Richard Long. They created immense sculptures on the same scale as landscape itself, or exhibited written and photographic accounts of their excursions. With few exceptions, their works (also known as earthworks) are almost inaccessible, situated far from human settlements in deserts or abandoned areas. Their lifespan was brief: little by little they were destroyed by the elements and often by erosion, so that for posterity they exist only in the form of preparatory drawings, photographs or films. The works themselves were seen by only a small number of people and sometimes by only the artist.

In one sense Land art constituted a return to the landscape tradition, for many years a major category of painting. Instead of being represented, however, the landscape and the materials it contained served as raw materials for the construction of mainly sculptural works in nature. Land artists had a precedent in the prehistoric period. The tombs and megalithic monuments of Brittany and England (e.g. at Carnac and Stonehenge), the immense abstract diagrams composed of geometrical figures in Nazca, Peru, and the giant hill-figures drawn into the ground itself in England had a considerable impact on artists tired of modernist influences and seeking new stimuli in 'primitive' sources. Land art was one of the most spectacular manifestations of the artist's search for an escape from traditional painting and sculpture, and yet it was also a return to ancient practices whose significance is unknown. Land art was in this sense part of the pervasive 'primitivist' tendency of 20th-century art.

Land art is not, strictly speaking, an aesthetic category. None of the major artists associated with it saw the whole of their work as Land art, considering it as only one approach among many in their complex artistic explorations. Christo and Jeanne-Claude, for example, should be considered separately. Originally exponents of Nouveau Réalisme, wrapping all kinds of *objets trouvés* (see fig. 25), they soon went on to wrap a number of historical monuments from which they logically progressed to landscapes. After working on such works as *Wrapped Coast—One Million Square Feet, Little Bay, Sydney, Australia* (1969), they executed *Valley Curtain, Rifle, Colorado* (1970–72) and *Running Fence* in California (1976), multiplying spectacular actions on a monumental scale and mobilizing all the forces of the media.

The immense, unexploited territories of North America played a major role in the development of Land art in the USA. De Maria, Heizer, Oppenheim and Smithson are the principal American artists to have executed works using the deserts, mountains and prairies of the American landscape. In 1968 De Maria executed his *Mile-long Drawing*, two parallel lines in the Mojave Desert, CA, followed by his *Las Vegas Piece* (1969), near Las

25. Christo: *Empaquetage* (Marseille, Musée Cantini)

Heizer also abandoned painting for the desert, where he realized some giant works: *Isolated Mass/Circumflex* (1968); *Five Conic Displacements* and *Double Negative* (1969–70). He moved large masses of earth and dug enormous trenches to make up monumental designs, some of which could be seen only from the air. He also designed a permanent work built in hard materials in the desert in Nevada: *Complex One/City* (1972–6). Oppenheim created a number of plans for intervening in the landscape and modifying natural processes. In *Time-line* (1968), he traced a representation of the International Date Line in the snow, while *Directed Seeding–Cancelled Crop* (1969) consisted of interruptions in the growth of wheat in a field according to a geometrical design. Finally, Smithson created some of the most important works of Land art before his premature death (1973): *Spiral Jetty*, Great Salt Lake, UT (1970); *Broken Circle/Spiral Hill*, Netherlands (1971); *Amarillo Ramp*, TX (1973). He invented the idea of the 'Nonsite', transporting fragments of nature in the space of the museum. He emphasized the idea of entropy, of the destructive potential contained in nature. Other American artists produced some examples of Land art including for example Robert Morris and James Turrell with his Roden Crater project. To these may be added those artists who constructed their sculptures in nature, such as Alice Aycock, Nancy Holt and Mary Miss among others.

In Europe it was mainly British artists who involved themselves in Land art. Richard Long constructed works in nature using materials found on the spot and recorded them by means of photographs. Lengthy walks over the land form the basis for works by Hamish Fulton and David Tremlett. In the Netherlands, Jan Dibbets traced perspective drawings in the landscape. Other artists outside the USA who worked with Land art include the Dutch artist Marinus Boezem (*b* 1934), the English artist Peter Hutchinson (*b* 1930) and the Canadian artist George Trakas (*b* 1944).

Land art was also a return to nature, coming during a period of ecological debate on respect for the earth, the dangers of pollution and the excesses of consumerism. Immediately before

Vegas, where the lines are perpendicular and cut into the earth in depth. His *Lightning Field*, created in New Mexico in 1977, comprises 400 steel poles arranged geometrically. It is one of the few permanently maintained Land art works. In 1967

Land art, such trends as Pop art had exalted industrial objects and mass-production. In contrast Land art was an anti-industrial and anti-urban aesthetic current that isolated the work of art from the contamination of the great artistic centres, the capital cities. It was also a Utopian attempt to escape from the art system—the recuperation of art by the market—in that the work was immovable and far from galleries and museums. Yet none of the artists concerned could resist producing other works that conformed more closely to traditional exhibition spaces. The fact that it was distanced from the system contributed to Land art's brief lifespan, from the earliest examples in 1968–9 to its near disappearance in the mid-1970s. Only a few artists, such as Christo and Turrell, continued to practise Land art after that time.

Bibliography

Conceptual Art, Arte Povera and Land Art (exh. cat., Turin, Gal. Civ. A. Mod., 1970)

Land Art (exh. cat., Hannover, Fernsehgal. Gerry Schum, 1970)

L. Lippard: *Six Years: The Dematerialization of the Art Object* (New York, 1973)

L. Alloway: 'Site Inspection', *Artforum*, xv/2 (1976), pp. 49–55

E. C. Baker: 'Artworks on the Land', *A. America*, lxiv/1 (1976), pp. 92–6

A. Causey: 'Space and Time in British Land Art', *Studio Int.*, cxciii/986 (1977), pp. 122–30

N. Rosen: 'A Sense of Place: Five American Artists', *Studio Int.*, cxciii/986 (1977), pp. 115–21

Probing the Earth: Contemporary Land Projects (exh. cat. by J. Beardsley, Washington, DC, Hirshhorn; La Jolla, CA, Mus. Contemp. A.; Seattle, WA, A. Mus.; 1977–8)

N. Foote: 'Monument—Sculpture—Earthwork', *Artforum*, xviii/2 (1979), pp. 32–7

R. Morris: 'Notes on Art as/and Land Reclamation', *October*, 12 (1980), pp. 87–102

J. Beardsley: 'Traditional Aspects of New Land Art', *A. J.* [New York], xlii (1982), pp. 226–32

L. Lippard: *Contemporary Art and the Art of Prehistory* (New York, 1983)

A. Sonfist, ed.: *Art in the Land* (New York, 1983)

J. Beardsley: *Earthworks and Beyond: Contemporary Art in the Landscape* (New York, 1984)

ALFRED PACQUEMENT

Linked Ring, Brotherhood of the

Association of photographers that flourished in Britain between 1892 and 1909. The association was founded by a group of artistic photographers (mainly Pictorialist) who were disenchanted with the attitudes and activities of the council members of the Photographic Society of Great Britain, the majority of whom were photographic scientists and technologists (*see* PICTORIAL PHOTOGRAPHY). The lecture and exhibition programmes were directed to their interests. Alfred Maskell and George Davison were instrumental in bringing together on 27 May 1892 the 15 British photographers who were the founders of the Linked Ring: Bernard Alfieri, Tom Bright, Arthur Burchett (1875–1913), Henry Hay Cameron (1856–1911, son of Julia Margaret Cameron), Lyonel Clark, Francis Cobb, Henry E. Davis, Alfred Horsley Hinton (1863–1906), Henry Peach Robinson and his son Ralph W. Robinson (1862–1942), Francis Seyton Scott, Henry Van der Weyde and William Willis (1841–1923). All were either distinguished photographers or closely involved in the medium. The name was chosen to symbolize the unity of the members linked together in a spiritual and aesthetic band of brothers. The association was constituted 'as a means of bringing together those who are interested in the development of the highest form of Art of which Photography is capable' and those only were eligible who admitted the artistic capabilities in photography.

In order to carry out the principal aim of the Linked Ring (the promotion of the art of photography), the Links (members) added to their numbers many of the most distinguished photographers of the period at an international level, including Gertrude Käsebier, Clarence H. White, James Craig Annan, Edward J. Steichen, Heinrich Kuehn, Alvin Langdon Coburn, F. Holland Day, Hugo Henneberg and Hans Watzek. There was no differentiation between amateur and professional. Several worked in a range of media, although the dominating interest for most was photography. Those Links able to do so met once a month to discuss matters of mutual interest and make decisions on admission of new members. The major activity was the annual exhibition known as the

Photographic Salon, which set new standards in photographic art. Initially it was held in the Dudley Gallery in Piccadilly, London. Other exhibitions (usually loans of members' work) were also organized. Although the Links did not publish a magazine, the *Linked Ring Papers* were printed privately for circulation among members only. Copies of these are rarely seen.

In aesthetic matters considerable variety is to be found in the work of the Links, from what had become unfashionable realism, as in the work of Joseph Gale (*c.* 1835–1906), through naturalistic and impressionistic work to Pictorial photography (at which time it reached its peak of artistry and popular appeal). The latter explored mood and atmosphere, which were achieved by various means, such as *contre-jour* lighting, soft-focus lenses and special printing processes. The Pictorialists produced a wonderfully rich range of prints, employing such processes as platinum, carbon, gum and oil prints, and combinations such as gum platinum and bromoil.

Monochromatic colours ranged from etching black to red chalk. Workers who used carbon printing sometimes produced prints in blues and greens (for appropriate subjects). When the major objective had apparently been achieved (the promotion of photography as a visual art) internal dissensions occurred within the Linked Ring, and the association was disbanded, with considerable reluctance, on 24 November 1909.

Bibliography

M. F. Harker: *The Linked Ring: The Secession Movement in Photography in Britain, 1892–1910* (London, 1979)
For further bibliography *see* PICTORIAL PHOTOGRAPHY.

MARGARET HARKER

London Group

English exhibiting society founded in November 1913. On its foundation it absorbed many members of the CAMDEN TOWN GROUP and also incorporated the more avant-garde artists influenced by Cubism and Futurism, some of whom afterwards joined the Vorticist movement. Among the founder-members were David Bomberg, Henri Gaudier-Brzeska, Jacob Epstein, Harold Gilman (the group's first president until his death in 1919), Charles Ginner, Spencer Gore, Percy Wyndham Lewis, John Nash, Christopher Nevinson and Edward Wadsworth. The group was organized in opposition to the conservatism of the Royal Academy and the stagnation of the formerly radical New English Art Club. Though, as can be judged from the names of its founders, it had no homogeneous style or aesthetic, it acted as a focal point for the more progressive elements in British art at that time.

The first unofficial manifestation of the London Group was an exhibition held in Brighton (Dec 1913–Jan 1914) under the auspices of the Camden Town Group. Its subtitle, however, 'An Exhibition of the Work of English Post-Impressionists, Cubists and Others', revealed a greater breadth of style than that associated with the Camden Town Group. Sickert, though he did not exhibit with the London Group until 1916, made a speech at the opening arguing for the need to keep the group free from attachment to specific styles or factions. Despite this call for independence the London Group was most interesting and influential when under the sway of a particular, more homogeneous element of its membership. In 1914 it was officially named the London Group on the suggestion of Epstein and that year held its first exhibition under this name at the Goupil Galleries in London from March to April; the works were selected by a hanging committee elected from the membership. The following year two exhibitions were held, as was the practice until 1930 when they became annual. At an early stage non-members were also encouraged to exhibit and this remained the policy thereafter.

During World War I the Vorticists Wyndham Lewis and Wadsworth as well as Epstein were among those who left the group. Gore and Gaudier-Brzeska died during the war and Gilman soon afterwards. With the acceptance of Roger Fry into the group in 1917, followed in 1919 by Vanessa Bell and Duncan Grant (who was also listed as a founder-member), the Bloomsbury Group became the most influential circle within the group. Other artists, including Frank Dobson,

Mark Gertler and Matthew Smith, were also important figures in the 1920s. In 1928 a retrospective of the first 15 years of the group's existence was held at the New Burlington Galleries in London.

In 1930 Henry Moore, Barbara Hepworth, Maurice Lambert (1901–64) and John Skeaping (1901–80) became members of the group, so introducing a strong faction of progressive sculptors. The participation of Moore and Hepworth was short-lived, however, as they found the group too eclectic; other avant-garde artists of the time, notably Ben Nicholson, remained outside altogether. In the later 1930s the London Group was an important forum for the Euston Road School. The London Group was at its most vital from the 1910s to the 1930s, after which its position as a significant force in British art began to decline.

Bibliography

G. S. Whittet: 'Groups and Guerrillas: London Commentary', *The Studio*, clxviii (Sept 1964), no. 857, pp. 134–5

London Group: 1914–64 Jubilee Exhibition: Fifty Years of British Art at the Tate Gallery (exh. cat. by A. Forge, A. Bowness and D. Farr, London, Tate, 1964)

S. Watney: *English Post-Impressionism* (London, 1980), pp. 109–17

C. Harrison: *English Art and Modernism 1900–1939* (London and Bloomington, 1981)

☐

Luminism

Term applied generally to Belgian Neo-Impressionism and more specifically to the work produced after 1904 by the movement's exponents, in which they combined aspects of Realism, Impressionism and Neo-Impressionism; it was also applied from 1910 in the Netherlands to describe the late phase of Dutch Impressionism that is comparable stylistically with Fauvism. The term derives from Vie et Lumière, the name of a group formed by Emile Claus and others. After Georges Seurat's death in 1891 some Belgian Neo-Impressionists turned away from the painting movement in favour of decorative arts. When the avant-garde group Les XX was superseded in 1894

by the Libre Esthétique (1894–1914), Claus and other Belgian Impressionists sought a more national, often Flemish identity, enhanced by the nationalist tendency to pay homage to the century-old Dutch Flemish tradition of landscape painting, and by the Romantic–Realist style taught at Belgian academies and practised by the schools of Kalmthout, Tervuren and Dendermonde.

At the Salon of the Libre Esthétique in Brussels in 1904, Octave Maus exhibited a huge collection of Impressionists' works, all French except for those by the pointillist Théophile Van Rysselberghe, who had settled in Paris. Although the show inspired a second wave of Neo-Impressionist followers, critics found Maus's Salon too French. In this climate Claus founded the group Vie et Lumière with George Morren and Adrien Joseph Heymans, the leader of the Kalmthout school; it included Claus's pupils Jenny Montigny (1875–1937), Anna De Weert (1867–1950), Georges Buysse (1864–1916) and Modest Huys (1875–1932), as well as William Degouve de Nuncques, and some former members of Les XX: Georges Lemmen, James Ensor and Anna Boch (1848–1936), the last a disciple of Van Rysselberghe. In 1905, perhaps under pressure from the critics, Maus organized a second, but this time international, Impressionist exhibition, *L'Evolution externe de l'impressionnisme*, in which the members of Vie et Lumière exhibited for the first time under the group's name. The group's work was characterized by a preference for depicting the Flemish countryside (with or without figures), in particular the area where Claus lived, around the River Lys between Deinze and Ghent, bathed in sunlight. Claus's villa, Zonneschijn, at Astene became a magnet for numerous followers from Ghent, Paris and even the USA and Japan. The work also reflected academic training that most members had undertaken, and which remained visible in the importance given to accurate drawing and solidly constructed compositions. Colour or technique never overwhelmed the subject-matter. The work of the Belgian Luminists, however, has been criticized as 'Impressionist academicism'; this was perhaps why some artists moved towards a more

genuine, natural art that became known as Flemish Expressionism.

Luminism in the Netherlands developed after Belgian Neo-Impressionism had been imported by Jan Toorop and Henry Van de Velde. In 1901 Toorop and Johan Thorn Prikker organized the 'First International Exhibition' in The Hague with Claus, Van Rysselberghe and others, as well as Vincent van Gogh and the French artists Paul Signac, Odilon Redon, Edouard Vuillard, Camille Pissarro and Paul Cézanne. Dutch Impressionists, including Piet Mondrian, began to move from the expressive brushwork of the 1880s towards an emphasis on firmly defined forms in balanced compositions of horizontals and verticals; Jan Sjuijters began to use colour expressively, rather than naturalistically. Under his influence, and after meeting Toorop in 1908, Mondrian broke away from Impressionism. The following year they exhibited with Leo Gestel in the St Lucas exhibition. It was at this point that their work became 'Luminist'; it showed their interest in light and the autonomy of colour and emphasized order and structure. By contrast with the work of the Belgian Luminists, their style had characteristics similar to those of French Fauvism and to German Expressionism.

Bibliography

A. Santon: *Un Prince du luminisme, E. Claus* (n.p., 1946)
Les Jeux de la lumière dans la peinture belge (exh. cat., Brussels, Musées Royaux B.-A., 1965)
Peintres belges, lumière française (exh. cat., Brussels, Musées Royaux B.-A., 1969)
Licht door kleur: Nederlandse Luministen (exh. cat., The Hague, Gemeentemus., 1977)
M.-A. Stevens: 'Belgian Art: Les XX and the Libre Esthétique', *Post-Impressionism: Cross-currents in European Painting* (exh. cat., London, RA, 1979–80), pp. 252–9
C. Van Damme: 'De Vlaamse Impressionisten' [The Flemish Impressionists], *Openb. Kstbez.* (1982), 2, pp. 43–79
S. Polden: *A Clear View: The Belgian Luminist Tradition* (exh. cat., London, Whittford and Hughes, 1987)
S. Goyens de Heusch: 'Die belgischen Luministen und ihre Vorläufer', *Landschaft im Licht: Impressionistische Malerei in Europa und Nordamerika (1870–1910)* (exh. cat., ed. G. Crymmek; Cologne, Wallraf-Richartz Mus.; Zurich, Ksthaus; 1990), pp. 95–102
Néo et post-impressionnistes belges dans les collections privées de Belgique (exh. cat., Pontoise, Mus. Pissarro; Charleroi, Mus. Com. B.-A.; 1990)
S. Goyens de Heusch: 'Impressionism, Neo-Impressionism and Luminism', *Impressionism to Symbolism: The Belgian Avant-garde, 1880–1900* (exh. cat., London, RA, 1994), pp. 35–9

ROBBERT RUIGROK

Machine aesthetic

Term applied to the concept of the machine as a source of beauty, a concept particularly important in the development of art and design in Europe and North America in the 20th century. It can be argued, however, that the origins of the machine aesthetic lie in the 19th century, although few 19th-century architects, designers or writers were willing to think of machines as in themselves potential sources of beauty. Such writers as John Ruskin stressed instead the close affinity between organic forms, especially in decorative ornament, and aesthetic pleasure; a wide range of 'modern' machines from locomotives to kitchen implements continued therefore to be heavily ornamented. Moreover, the introduction of Mass production techniques, with industrial design replacing craftsmanship, was largely seen as incompatible with individual artistry and therefore aesthetic worth. In the 20th century, however, historians and polemicists of the Modern Movement, including Nikolaus Pevsner, Lewis Mumford, Sigfried Giedion and Herwin Schaefer claimed to find the origins of a new aesthetic in some of the great achievements of the 19th century in engineering and the applied arts, such as Joseph Paxton's Crystal Palace (1851), London, the chairs of Michael Thonet and machine shop lathes.

Numerous distinct artistic movements—all of them, however, sharing a commitment to modernism—contributed to the development of the machine aesthetic in the 20th century. In the years before World War I the Italian Futurists developed an aesthetic that celebrated the machine as the embodiment of energy and power, and this was translated visually into a kaleidoscope of different

colours and complicated geometry (*see* FUTURISM). In Great Britain, from *c.* 1914 Wyndham Lewis and other artists associated with VORTICISM also sought to celebrate the arrival of the 'machine age', while working in a harsher, less romantic style than the Futurists (see fig. 48). In France after World War I the French painter Amédée Ozenfant and the Swiss architect Le Corbusier developed a Purist aesthetic (*see* PURISM and col. pl. XXIII), characterized by an appreciation of the ideal purity of form of the machine. In the 1920s and 1930s this view came to be the predominant, canonical form of the machine aesthetic, and the essence of machine beauty was seen by many artists, designers and polemicists as a stark, unornamented, geometric simplicity and regularity of shape, and smooth, frequently shiny surfaces. Le Corbusier's dictum that 'the house is a machine for living in', for example, sought to establish an architectural aesthetic analogous to the beauty of some engineering works. This view was inextricably related to FUNCTIONALISM and was promoted by Walter Gropius at the BAUHAUS in Germany, by the DE STIJL group and by the Museum of Modern Art in New York as well as by Le Corbusier and the group associated with the journal *L'Esprit* in Paris.

Other versions of the machine aesthetic continued to evolve, however. In the 1920s, for example, the ART DECO style, characterized by a stylized and geometric approach to natural forms rather than an emphasis on functionalism, was widely popular, especially in France. PRECISIONISM celebrated modern technology in a specifically American context but continued to have affinities with Purism. In the 1930s a new approach emerged in which speed and efficiency were seen as the essential characteristics of the machine, and this was often expressed by an aerodynamic, streamlined or tear-drop shape. Such shapes, however, were applied not only where they had a real function, as with aeroplanes or automobiles, but also with stationary objects, including buildings. This approach became very popular with American industrial designers such as Norman Bel Geddes, Raymond Loewy and Walter Dorwin Teague, who favoured a streamlined approach in the design of everything from locomotives to cameras and pencil-sharpeners. A biomorphic approach also emerged in the 1930s and gained great force in the 1940s and 1950s, for example in the works of Charles Eames and Frederick Kiesler. These designers insisted that machines could conform to human bodily contours, rather than humans having to conform to the contours of the machine, and this led to the common adoption of amoeba shapes. In the 1960s the Japanese Metabolists (*see* METABOLISM) developed a mechanistic approach, based on the concept of interchangeable, renewable parts, and the English ARCHIGRAM group apotheosized the machine as raw technology. This led ultimately to the HIGH TECH approach to architecture and interior decoration and to such buildings as the Centre George Pompidou in Paris by Renzo Piano and Richard Rogers (1971–7; see fig. 3). The personal and ever-changing nature of any definition of beauty, evident in these diverse approaches, and the continuing development of the forms of machinery through advances in technology will doubtless continue to necessitate a constant reassessment of machine aesthetics.

Bibliography

Le Corbusier: *Vers une architecture* (Paris, 1923); Eng. trans. as *Towards a New Architecture* (London, 1927)

N. Bel Geddes: *Horizons* (New York, 1932)

L. Mumford: *Technics and Civilization* (New York, 1934)

Machine Art (exh. cat., New York, MOMA, 1934)

S. Cheney and M. Cheney: *Art and the Machine* (New York, 1936)

N. Pevsner: *Pioneers of Modern Design (from William Morris to Walter Gropius)* (London, 1937)

W. Teague: *Design this Day; the Technique of Order in the Machine Age* (New York, 1940)

S. Giedion: *Space, Time and Architecture* (Cambridge, MA, 1941)

R. Banham: *Theory and Design in the First Machine Age* (New York, 1967)

The Machine Age in America, 1918–1941 (exh. cat. by R. Wilson, D. Pilgrim and D. Tashjian; New York, Brooklyn Mus.; and elsewhere; 1968–9)

H. Schaefer: *Nineteenth Century Modern: The Functional Tradition in Victorian Design* (New York, 1970)

J. L. Meikle: *Twentieth Century Limited: Industrial Design in America, 1925–1939* (Philadelphia, 1979)

B. Constensou, ed.: *Léger et l'esprit moderne* (Paris, 1982)

RICHARD GUY WILSON

Magic Realism

Style of painting popular in Europe and the USA mainly from the 1920s to 1940s, with some followers in the 1950s. It occupies a position between Surrealism and Photorealism, whereby the subject is rendered with a photographic naturalism, but where the use of flat tones, ambiguous perspectives and strange juxtapositions suggest an imagined or dreamed reality. The term was introduced by art historian Frank Roh in his book *Nach-Expressionismus: Magischer Realismus* (1925) to describe a style deriving from Neue Sachlichkeit, but rooted in late 19th-century German Romantic fantasy. It had strong connections with the Italian Pittura Metafisica of which the work of Giorgio de Chirico was exemplary in its quest to express the mysterious. The work of Giuseppe Capogrossi and the Scuola Romana of the 1930s is also closely related to the visionary elements of Magic Realism. In Belgium its surreal strand was exemplified by René Magritte, with his 'fantasies of the commonplace', and in the USA by Peter Blume, as in *South of Scranton* (1930–31; New York, Met.). Later artists associated with Magic Realism include the American George Tooker (*b* 1920), whose best-known work *Subway* (1950; New York, Whitney) captures the alienation of strangers gathered in public, and the German Christian Schad, who also used the style in the 1950s. The later use of the term for types of non-Western, particularly Latin American fiction was not connected with the artistic application.

Bibliography

F. Roh: *Nach-Expressionismus: Magischer Realismus* (Leipzig, 1925)

Neue Sachlichkeit and German Realism of the Twenties (exh. cat., intro. W. Schmied; London, Hayward Gal., 1978–9)

Realismo Magico: Pittura e scultura in Italia, 1919–1925 (exh. cat. by M. Fagiolo dell'Arco, Milan, Pal. Reale, 1989)

☐

Magnum [Magnum Photos, Inc.]

International photographic agency, founded with offices in New York and Paris in April 1947 by the photographers Robert Capa, Henri Cartier-Bresson, Chim, George Rodger (*b* 1908) and William Vandivert (1912–*c*. 1992). In the period after World War II, when illustrated news magazines flourished, Magnum became the most famous of picture agencies. This was initally due to the reputation of its founder-members, who had photographed the Spanish Civil War (1936–9) and World War II (three of them as correspondents for *Life* magazine). Its celebrity was sustained by the success of its work, the quality of the photographers it continued to attract and by the deaths while on assignment of Capa (the driving force behind Magnum), Chim and Werner Bischof, the first new member to be admitted.

Magnum was founded as an independent cooperative agency whose members could for the first time retain copyright of their negatives. This ensures an increased income from resales and a high degree of control over how pictures are published, to prevent any distortion of their meaning. The members each hold an equal share in Magnum and make policy decisions collectively. Magnum finances photographers' projects and takes a percentage of their fees to cover administrative costs. This arrangement enables the photographers to travel and pursue their projects free from the usual constraints of agency work. Initially the company employed a number of freelance 'stringers' to supplement its income, but this practice declined as more members were admitted. Prospective members undergo a careful selection process. New offices opened in London in 1986 and in Tokyo in 1989. By the mid-1990s the membership had risen to forty and had included such photographers as Eve Arnold (*b* 1913), Bruce Davidson, Josef Koudelka, Marc Riboud (*b* 1923), Eugene Richards (*b* 1944) and Sebastião Salgado.

The freedom of Magnum's photographers to work on projects in which they were personally interested, in a supportive environment, contributed to a development in the expressive potential of photojournalism, particularly in its treatment of humanist themes. A corporate culture of social awareness, which had always been characteristic of documentary photography, became the hallmark of Magnum. Initially this

took the form of an idealism evident in the first group photoessays, such as 'People are People the World Over' (pubd. *Ladies Home J.*, 1947–8). By the 1960s, however, the series of uprisings, wars of independence and the protest movements in both East and West had redirected the course of what came to be termed 'concerned photography' by Cornell Capa (a former President of Magnum), and the work became more overtly critical. Thereafter, many of the photographers turned to more personal subjects, although in the 1980s Sebastião Salgado produced an impressive body of work in the developing nations, which furthered the agency's tradition of humanistic reportage.

From the 1960s changes occurred that influenced the agency's course in the following decades. Television superseded picture magazines, which had been the chief outlet for Magnum's work. As travel costs and office overheads rose sharply, the survival of the company came under threat, and increasingly the photographers had to take on commercial assignments in business and industry, advertising, exhibition-planning and film-making. Magnum remained a prestigious photographic agency, but its role was less pioneering than before.

Photographic Publications

Magnum's Global Photo Exhibition 1960 (exh. cat., Tokyo, Takashimaya Gal., 1960)
America in Crisis (New York, 1969)
After the War Was Over, intro. M. Blume (London, 1985)
A L'Est de Magnum (Paris, 1986)
In our Time, essay by F. Ritchin (London, 1989) [useful bibliog.]

Bibliography

J. Morris: 'Magnum Photos: An International Cooperative', *US Camera 1954* (New York, 1953), pp. 110–60
'Magnum', *Creative Camera*, 57 (March 1969), pp. 94–115
H. Tardy: 'Magnum', *Reporter-Objectif*, 10 (Dec 1972), pp. 32–78
H. V. Fondiller: 'Magnum: Image and Reality', *35 mm Photography* (Winter 1976), pp. 58–103, 114–18
'Magnum', *Phototechniques*, v/10 (Nov 1977), pp. 27–66

NICK CHURCHILL

MA group

Hungarian group of artists and writers, active *c.* 1916 to 1926. It was associated with the journal *MA*, whose name was derived from the Hungarian for 'today', but it also refers to the movement Hungarian Activism (Hung.: Magyar Aktivizmus; *see* ACTIVISTS). Founded by the writer and artist Lajos Kassák, *MA* first appeared in November 1916, and from then until it was banned on 14 July 1919 it was published in Budapest, at first edited solely by Kassák and by 1917 by Béla Uitz also. From 1 May 1920 until its demise in mid-1926 it was published in Vienna under Kassák's sole editorship. It was the most important forum for Hungarian Activism, and over the years its members included Sándor Bortnyik, Péter Dobrović (1890–1942), Lajos Gulácsy, János Kmetty, János Máttis Teutsch, László Moholy-Nagy, Jószef Nemes Lampérth, Béla Uitz among others. The first issue had a Cubist cover by the Czech artist Vincenc Beneš (see Kassák, p. 127) and an article by Kassák entitled 'A plakát es az uj festészet' ('The poster and the new painting', *MA*, i/1, pp. 2–4), which set the revolutionary tone of the group. The article suggested that painting should aspire to the same aggressive power as that achieved by posters: 'The new painter is a moral individual, full of faith and a desire for unity! And his pictures are weapons of war!.' Many members of the MA group did in fact produce posters during the short Communist regime under Béla Kun in 1919; Uitz, for example, designed *Red Soldiers, Forward!* (1919; Budapest, N.G.).

On 14 October 1917 the first exhibition organized by the MA group was held at 15 Visegrádi Street in Budapest with a one-man show of works by Máttis Teutsch. His paintings of this period were often near-abstract landscapes executed in bright colours and arabesque forms, as in *Bright Landscape* (1916; Pécs, Pannonius Mus.). From 1917 to 1918 another five exhibitions were organized by the group: the third in 1918 was a large group show with works by Bortnyik, Dobrović, Gulácsy, Kmetty, Máttis Teutsch, Nemes Lampérth, Uitz and others. One of the most radical artists at this time was Bortnyik, who produced works such as *Dynamic Composition* (1918; Budapest, N.G.), showing the influence of Futurism in its attempt

to depict energy and dynamism. The seventh MA show, of graphic work, and the ninth of work by Bortnyik were held in 1919. Bortnyik's show included works such as *Red Locomotive* (1918; Budapest, N. Mus., Dept Mod. Hist.), which applied the techniques of Synthetic Cubism to a political subject. In 1919 *MA* came under attack from the paper *Ember* and also from Béla Kun, the latter claiming it to be a product of bourgeois decadence. Kassák published a letter of defence in *MA*, but by July 1919 the periodical had been banned, ostensibly due to a paper shortage.

The reappearance of *MA* in Vienna on 1 May 1920 under Kassák's editorship marked a new phase of Hungarian Activism. Kassák himself began to produce visual art and advocated a form of two-dimensional abstraction close to Constructivism and Suprematism. In 1921 he published the pamphlet 'Bildarchitektur' (repr. as 'Képarchitektúra', *MA* vii/4, 1922, pp. 52–4), which set out the new artistic credo. This bombastic essay linked the new art form, *Bildarchitektur*, with a new way of life, and it was seen stylistically by Kassák as an extension of Cubism, Expressionism and the *Merz* compositions of Kurt Schwitters: '*Bildarchitektur* is building on the flat surface . . . For *Bildarchitektur* is art and art is creation and creation is everything.' Kassák began to produce works such as *Bildarchitektur* (1922; Budapest, N.G.), which use geometrical colour planes in a manner reminiscent of El Lissitsky's *Proun* projects. In the early 1920s Bortnyik also produced *Bildarchitektur* works, before turning to Surrealism with works such as the *Green Donkey* (1924; Budapest, N.G.). Moholy-Nagy's interest in Kassák's theories soon brought him into the international mainstream, and in 1923 he started to teach at the Bauhaus.

As well as Constructivism, the influence of Dada was also strong in this later phase of the MA group. Kassák for example produced collages and photomontages, such as *Hanged Man* (1920; Budapest, Lajos Kassák Mem. Mus.), that, like John Heartfield's photomontages, used aggressive social satire. Some of Moholy-Nagy's work, such as *H Relief* (1920; untraced, see J. Szabó: *A Magyar Aktivizmus története* [The history of Hungarian

Activism], Budapest, 1971, pl. 132), resembled that of Schwitters. In 1922 Kassák and Moholy-Nagy's book *Buch neuer Künstler* (Vienna, 1922) was published, and it included illustrations of Constructivist, Futurist and Purist works together with some of cars and machines, reflecting the breadth of the MA group's interests at this time. Though maintaining contacts with many other European avant-garde circles, the MA group remained fairly isolated in Vienna, and in 1926 *MA* ceased publication. Lajos Kassák then returned to Hungary, where he founded the short-lived journal *Dokumentum*, while the other members pursued separate careers.

Bibliography
L. Kassák: *MA* (Basle, 1968)
For further bibliography *see* Activists.

PHILIP COOPER

Makovets

Association of Russian painters and graphic artists active in Moscow from 1921 to 1926. The name is that of the hill at Sergiyev Posad, on which the monastery of the Trinity and St Sergius, a centre of Russian Orthodoxy, is located, although until 1924 the group was known as the 'Art is Life' Union of Artists and Poets (Rus. Soyuz khudozhnikov i poetov 'Iskusstvo-zhizn'). Sergey Gerasimov, Lev F. Zhegin (1892–1969), Konstantin K. Zefirov (1879–1960), Vera Ye. Pestel' (1896–1952), Sergei M. Romanovich (1894–1968), Artur Fonvizin, Vasily Chekrygin, Nikolai M. Chernyshov (1885–1973), Aleksandr Shevchenko and others joined the association. They were greatly influenced by the aesthetics of Pavel Florensky, who was the spiritual leader of the group.

In 1922 two editions of a magazine, *Makovets*, were published, although the third issue was censored and exists only in manuscript. The members of Makovets criticized the avant-garde because, in their opinion, it was engaged solely in 'producing individual elements of form', which excluded the 'spiritual essence of the artist'; instead they proclaimed 'the end of analytical art' in favour of a new development and advocated uniting separate

artistic elements 'in a powerful synthesis' (from 'Nash prolog' [Our prologue], *Makovets*, i). They believed that realism formed the basis of creative work, not narrow empirical realism but realism enriched with vivid religious experience. They based their ideas not on the medieval icon but rather on the art of the Renaissance, the Russian religious romanticism of the 19th century and the Symbolism of the early 20th. Most Makovets images contain an intimate, lyrical emotionality that borders on a mystical vision, as in Chekrygin's cosmic fantasies. The group's romantic idealism influenced a particular type of 'unofficial' realism distinguishable by its spiritual sincerity.

Bibliography

Makovets, i–ii (1922)

B. Berman: 'Obshchestvo "Makovets"' [The Makovets association], *Tvorchestvo* (1980), no. 3, pp. 16–18

A. Kovalev: 'Makovets', *Iskusstvo* (1987), no. 12, pp. 32–41

Makovets, 1922–6: Sbornik materialov po istorii ob'yedineniya [Makovets, 1922–6: a collection of materials on the group's history], ed. Y. A. Ilyukhina and others (Moscow, 1994)

M. N. SOKOLOV

Mánes Union of Artists [Czech: Spolek výtvarných umělců Mánes]

Czech association of painters, sculptors, architects, critics and art historians, active from 1887 to 1949. It was founded in 1887 by students at the Prague Academy of Fine Arts whose aim was to develop the Bohemian artistic traditions embodied in the work of Josef Mánes and of artists of the older generation such as Mikoláš Aleš, whom they elected as their first president. In the mid-1890s, when the union comprised almost the entire younger generation of artists, it specifically associated itself with the Secessionist movement in central Europe. In the autumn of 1896 it started publishing the first Czech art journal, *Volné směry*, and from 1898 onwards it organized exhibitions that expressed the new artistic values, both as regards the choice of works and the methods of presentation. Among the leading personalities

were the sculptor Stanislav Sucharda, the painter Jan Preisler and the architect Jan Kotěra. The union collaborated with the Hagenbund of Vienna, and established many contacts with Paris and other artistic centres. Members systematically brought modern European art to the notice of the Bohemian public, organized the Rodin retrospective exhibition of 1902, for which the society built a *fin-de-siècle* exhibition pavilion to Kotěra's design, and also mounted numerous other exhibitions. In 1911 the younger generation, led by Emil Filla, left the union and founded the GROUP OF PLASTIC ARTISTS. When the latter fell into decline during World War I, the majority of those who had left returned to the Mánes Union, occupying a decisive position in it during the inter-war period. In 1930 the union opened a functionalist exhibition building, designed by Otakar Novotný. In the 1930s it supported contemporary artistic trends and provided a venue for avant-garde architects and Surrealist artists. In 1936, when the photographic section was founded, the union brought together the avant-garde of the 1920s and 1930s at the International Exhibition of Photography. The last influx of strength into the union was linked with the generation that matured in the late 1930s, including Josef Istler, Václav Tikal, Zdeněk Sklenář and Karel Černý. Soon after the Communist putsch in Czechoslovakia in 1948 the union went into decline.

Bibliography

SVU

Mánes (exh. cat. by J. Kotalík, Prague, Mánes Exh. Hall, 1987)

L. Bydžovská: *Spolek výtvarných umělců Mánes v letech, 1887–1907* [Mánes Union of Artists, 1887–1907] (diss.)

LENKA BYDŽOVSKÁ

MARS Group [Modern Architectural Research Group]

Organization of British architects, designers, engineers and journalists that was started in 1933 and dissolved in 1957. The MARS Group formed the British section of the CIAM and was established by Wells Coates with the architects E. Maxwell Fry

and David Pleydell-Bouverie and the critics Philip Morton Shand, Hubert de Cronin Hastings and John Gloag. Its initial membership, mostly young architects with little experience of building, included the partners of Connell Ward and Lucas, and Tecton; the writers John Betjeman and James Richards; and Ove Arup. With *c.* 24 members by 1934, it grew to a peak of 120 by 1938, but the group was most significant in policy-making within the CIAM during the 1950s.

MARS worked as a pressure group within the struggle to improve public housing and amenities. Its first public statement appeared as an architectural and social investigation of Bethnal Green, London (1934), which demonstrated the severe deprivation in that area. Despite the success of this exposition, Berthold Lubetkin and Francis Skinner of Tecton became exasperated at the lack of positive action and left the group in 1935 to form the Architects and Technicians Organisation (a key group of mixed professions campaigning for better housing rights and, subsequently, in defiance of official policy on air raid precautions).

After 1935 the MARS Group's main strategy was to promote widespread acceptance of modern architecture, culminating in the exhibition *New Architecture* (1938) in London, a stylish presentation conceived by Godfrey Samuel, with separate sections by individual members under a general layout designed by László Moholy-Nagy (prior to his departure for the USA) and completed by Misha Black (1910–77). Although well attended—it was opened by Le Corbusier—it was criticized for not confronting the wider social implications of modern architecture. In 1942 the Group published a Plan of London, an ambitious redevelopment proposal for the capital. This was largely the work of the MARS Town Planning Committee under refugee members Arthur Korn and Arthur Ling (*b* 1913) with E. Maxwell Fry and Eileen Brown and William Tatton-Brown (*b* 1910). Referred to as a master plan, it envisaged a linear layout based on a rationalized traffic network, with London broken down into neighbourhood units, each of a fixed size. Its publication provoked much dissent from within the group and therefore cannot be seen as a collective statement. Younger architects who became members in the post-war years were critical of past policy and opposed to the CIAM Athens Charter evolved in 1933. This came to a head at CIAM IX held at Aix-en-Provence in 1953, when English and Dutch protesters, including Peter Smithson and Alison Smithson, William Howell, Jacob Bakema and Aldo Van Eyck, formed the breakaway Team Ten after the Congress. Both CIAM and MARS Group were dissolved in 1957.

Writings

New Architecture (exh. cat., London, 1938)

MARS Report (London, 1944–5) [only three issues appeared: nos 1 and 2 are on urban plan. and no. 3 is a record of proc. at the RIBA confer. in London in 1945, held to discuss mod. archit.]

Turn Again (exh. cat., London, 1955) [a presentation to improve new bldg in the City of London]

Bibliography

D. Lasdun: 'MARS Group, 1953–57', *Architect's Y-b.*, viii (1957), pp. 57–61

E. M. Fry: 'The MARS Plan of London', *Perspecta*, xiii (1971), pp. 162–73

L. Campbell: 'The MARS Group, 1933–1939', *Trans. RIBA*, viii (1986), pp. 72–86

M. Reading: *A History of the MARS Group, 1933–45* (diss., U. Bristol, 1986)

MALCOLM READING

Matter painting

Term applied to a style of painting that originated in Europe in the 1950s, often abstract in form, emphasizing the physical quality of thick impasto into which tactile materials such as metal, sand, shells and cement might be added. More specifically it refers to the work of Dutch painters such as Bram Bogart and Jaap Wagemaker and Belgian painters such as Bert de Leeuw (*b* 1926), René Guiette (*b* 1893) and Marc Mendelson (*b* 1915). This expressive style was not bound to any specific aesthetic and was used by each artist to different ends. In Wagemaker's *Cruel Desert* (1965; Bochum, Mus. Bochum, Kstsamml.), for example, the effect is violent and brutal through the incorporation of teeth into the composition. The works of Guiette, however, were more contemplative and abstract,

intended as meditations on the nature of painting and its materials, as in *Work in White* (1958; see exh. cat.). Among the other European painters in relation to whose work the term is often used are Jean Dubuffet, Jean Fautrier, René Burri and Antoni Tàpies.

Bibliography

Guiette (exh. cat. by A. Bosquet, Paris, Gal. Int. A. Contemp., 1958)

K. J. Geirlandt: *L'Art en Belgique depuis 45* (Antwerp, 1983)

☐

Mec art

Term coined in 1965 as an abbreviation of 'mechanical art' by Alain Jacquet and Mimmo Rotella and promoted by the French critic Pierre Restany (*b* 1930) to describe paintings using photographically transferred images that could be produced in theoretically unlimited numbers. The term was first publicly used of works by Serge Béguier (*b* 1934), Pol Bury, Gianni Bertini (*b* 1922), Nikos (*b* 1930), Jacquet and Rotella at an exhibition at the Galerie J in Paris entitled *Hommage à Nicéphore Niépce*. In contrast to the use of screenprinting by Americans such as Robert Rauschenberg and Andy Warhol to incorporate photographic images, the Mec artists projected images directly on to canvases coated with photosensitive emulsion, and they generally used the method to alter rather than merely reproduce the original photographic image. In his *Cinétizations*, for example, Bury cut and turned concentric rings in the original photograph before rephotographing the image and transferring it on to canvas, as in *La Joconde* (1964; see 1989 exh. cat., p. 61). Having earlier used the method of *décollage*, Rotella continued to rely on torn surfaces when he began in 1964 to produce works that he termed *reportages*, rephotographing his altered material before projecting it on to the sensitized canvas. Jacquet, for his part, broke down the photographic image in paintings such as his *Déjeuner sur l'herbe* series (1964; e.g. Paris, Fonds N. A. Contemp.) into a pattern of coloured spots to imitate the process of printing by four-colour separations used in the mass media.

Bibliography

Alain Jacquet (exh. cat. by O. Hahn, Zurich, City-Gal., 1965)

A. Bonito Oliva and others: *Mimmo Rotella: 'Lamière'* (Milan, 1989)

Pol Bury (exh. cat. by P. Cabanne, Paris, Gal. 1900-2000, 1989)

☐

Metamorphism

Term applied to the process by which one shape is transformed into another, especially in SURREALISM and other tendencies in 20th-century art. The concept of metamorphosis, encompassing literary sources from Ovid through Dante Alighieri to Johann Wolfgang von Goethe, was revived in the early 19th century. For the ancient Greeks, as outlined by Ovid, it concerned the miraculous process of the transformation from the world of nature to another sphere of existence; in Goethe's reformulation of metamorphosis in terms of the evolution of organic life (1790), however, it means a law of formation. Being based on the principles of 'polarity' and 'enhancement', it rules the transformation of nature and defines art as an enhanced 'second nature'.

Themes relating to such concepts of metamorphosis were dealt with by 19th-century artists in the guise of transformation myths, such as that of Apollo and Daphne, and of Narcissus and Pygmalion, all of which emphasized moments of self-discovery. By the late 19th century, in Symbolism and especially in the representation of organic formative processes in Art Nouveau, such ideas began to be expressed in a more purely visual form. In Cubism different types of objects, and even human figures and inanimate objects, were represented as interchangeable and in that sense as undergoing transformation from one state into another. A more purely psychological interpretation of such processes was proposed in Pittura Metafisica, especially in the use of mannequins as stand-ins for people.

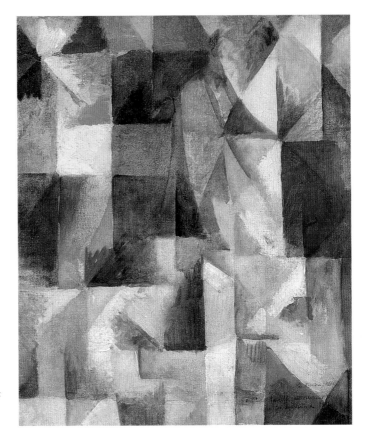

I. Robert Delaunay: *Windows Open Simultaneously*, 1912 (London, Tate Gallery)

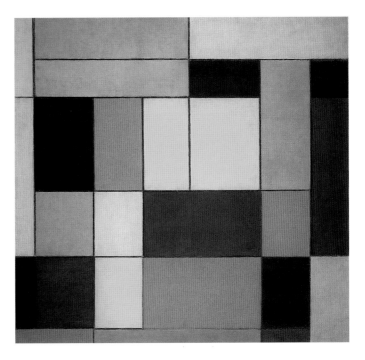

II. Piet Mondrian: *Composition with Grey, Red, Yellow and Blue*, 1920–26 (London, Tate Gallery)

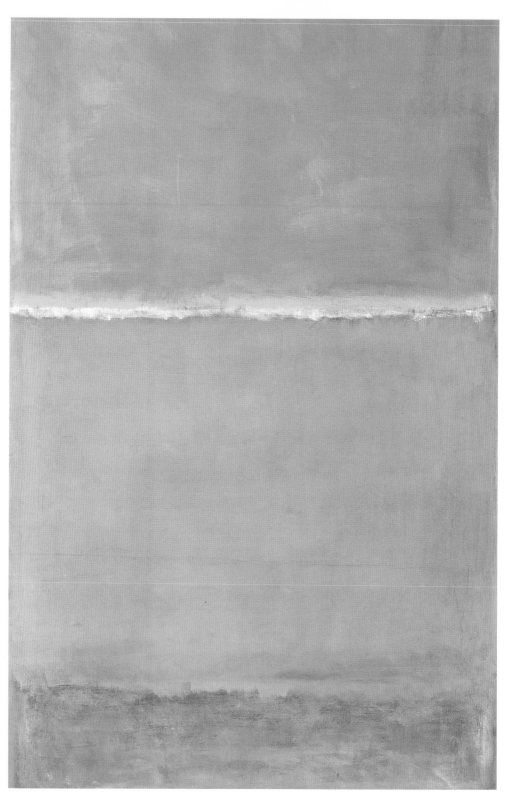

III. Mark Rothko: *Untitled*, *c.* 1951–2 (London, Tate Gallery)

IV. Elevator doors, Bullocks Wiltshire Department Store, Los Angeles, CA

V. Alfred Manessier: *Barrabas*, 1952 (Eindhoven, Stedelijk Van Abbemuseum)

VI. Mario Merz: *Cone, c.* 1967 (London, Tate Gallery)

VII. Robert Henri: *Portrait of Willie Gee*, 1904 (Newark, NJ, Newark Museum)

VIII. Paul Klee: *Senecio*, 1922 (Basle, Kunstmuseum)

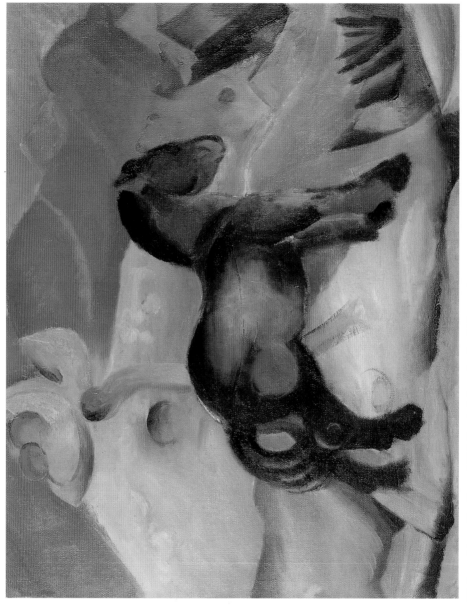

IX. Franz Marc: *Blue Horse*, 1912 (Saarbrücken, Saarland Museum)

X. Duncan Grant: *Vanessa Bell*, 1942 (London, Tate Gallery)

XI. Alison Smithson and Peter Smithson: *The Economist* Building, St James's Street, London, completed 1964

XII. Charles Ginner: *Piccadilly Circus*, 1912 (London, Tate Gallery)

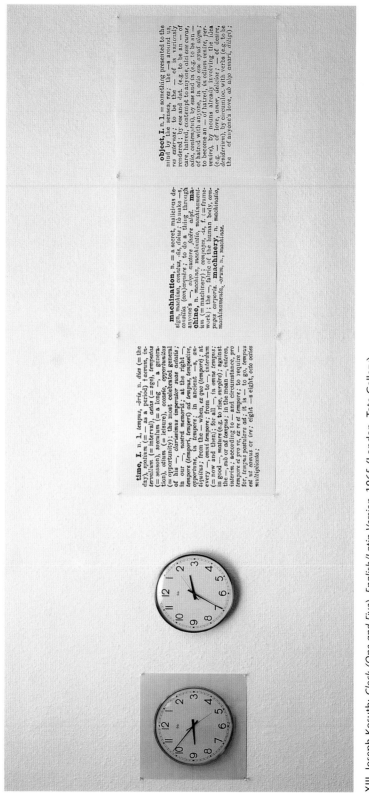

XIII. Joseph Kosuth: *Clock (One and Five), English/Latin Version*, 1965 (London, Tate Gallery)

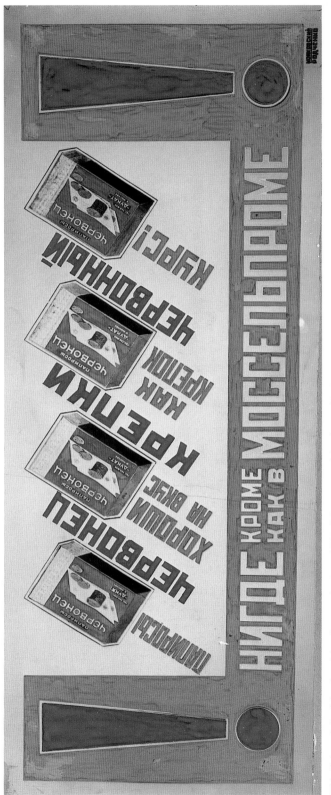

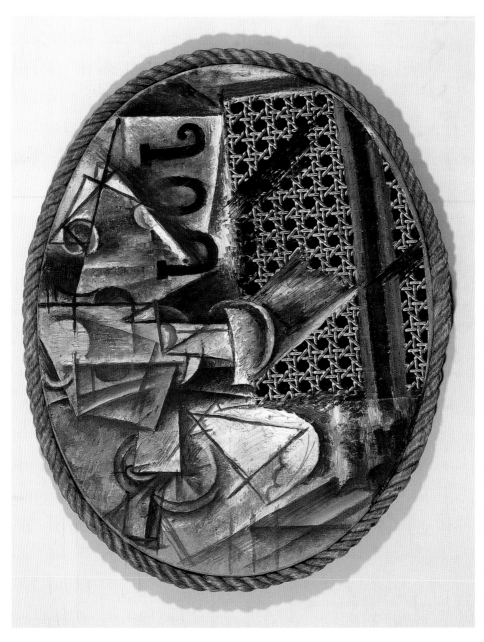

XV. Pablo Picasso: *Still Life with Chair-caning*, 1912 (Paris, Musée Picasso)

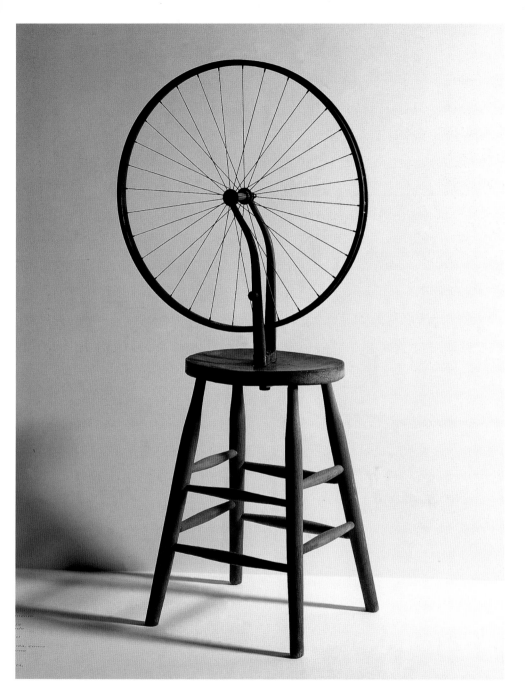

XVI. Marchel Duchamp: *Bicycle Wheel,* replica, 1963 (Coll. Richard Hamilton, Henley-on-Thames)

XVII. Le Corbusier: Private House, Weissenhofsiedlung, Stuttgart, 1927

XVIII. Vasily Kandinsky: *Cossacks*, 1910–11 (London, Tate Gallery)

XIX. Henri Matisse: *View of Collioure*, 1905 (St Petersburg, Hermitage Museum)

XX. Frank Lloyd Wright: Frank Thomas House, Oak Park, IL, 1901

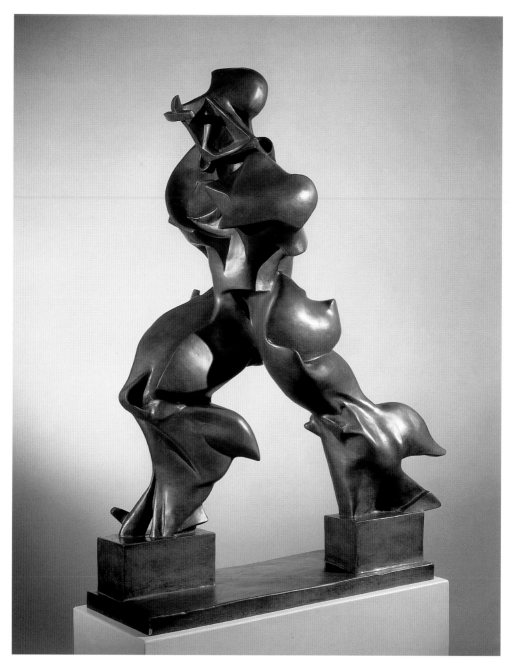

XXI. Umberto Boccioni: *Unique Forms of Continuity in Space*, 1913 (London, Tate Gallery)

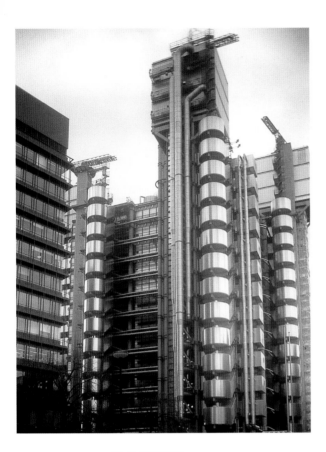

XXII. Richard Rogers: Lloyd's Building, London, 1979–87

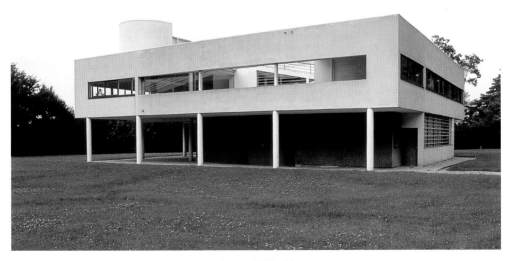

XXIII. Le Corbusier: Villa Savoye, Poissy-sur-Seine, 1929–31

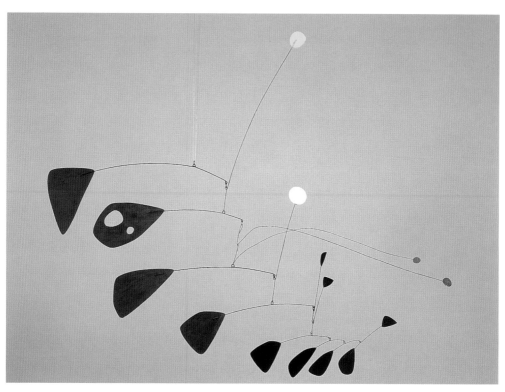

XXIV. Alexander Calder: *Antennae with Red and Blue Dots*, 1960 (London, Tate Gallery)

XXV. Dankmar Adler & Louis Sullivan: Auditorium Building, Chicago, IL, 1886–9

XXVI. Otto Dix: *Three Prostitutes on the Street*, 1925 (Hamburg, Private Collection)

XXVII. Yves Klein: *IKB 79*, 1959 (London, Tate Gallery)

XXVIII. František Kupka: *Fugue in Red and Blue* (Prague, National Gallery)

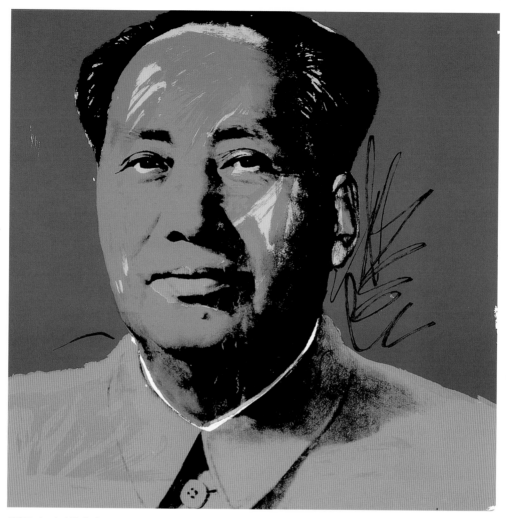

XXIX. Andy Warhol: *Mao*, 1972 (Private Collection)

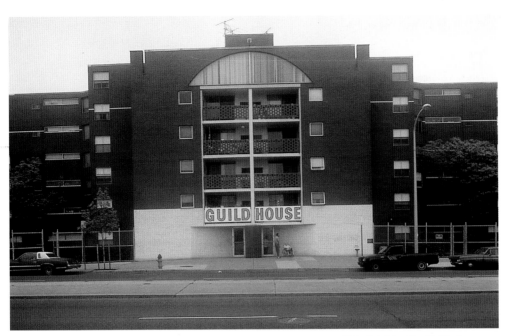

XXX. Venturi, Rauch & Scott Brown: Guild House Retirement Home, Philadelphia, PA, 1960–6

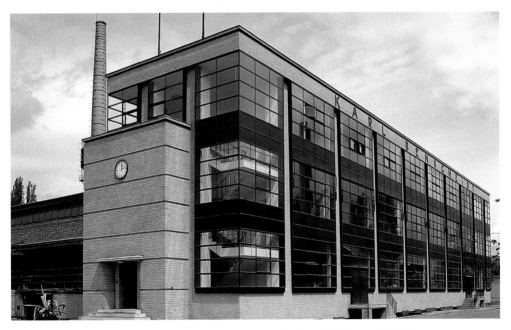

XXXI. Walter Gropius and Adolf Meyer: Fagus Factory, Alfeld on the Leine, 1911–13

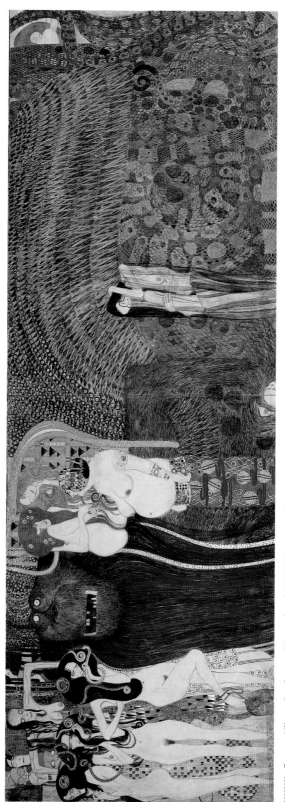

XXXII. Gustav Klimt: *Beethoven Frieze*, detail, 1902 (Vienna, Wiener Sezession)

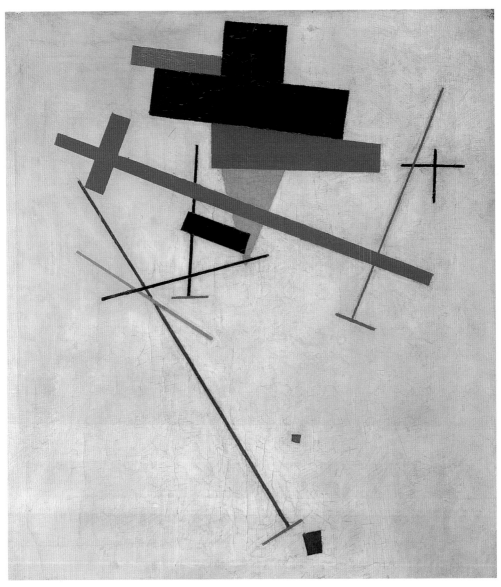

XXXIII. Kazimir Malevich: *Suprematist Composition*, 1915 (Ludwigshafen, Wilhelm Hack-Museum und Städtische Kunstsammlungen)

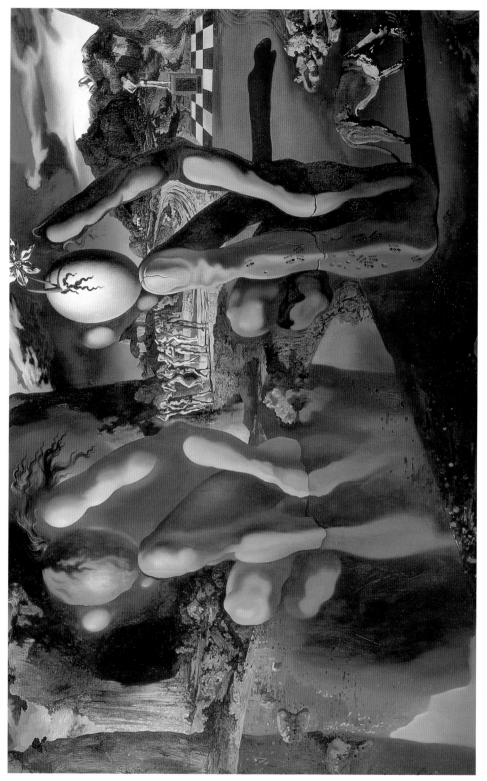

XXXIV. Salvador Dalí: *Metamorphosis of Narcissus*, 1937 (London, Tate Gallery)

XXXV. Jacob Epstein: *Doves*, 1913 (London, Tate Gallery)

XXXVI. Kolo Moser: Decorative coffer, 1905–6 (Vienna, Österreichisches Museum für Angewandte Kunst)

With Surrealism, metamorphism became both a subject and a creative principle allied to other processes and strategies such as biomorphism, automatism, *frottage* and decalcomania. Their understanding of metamorphosis, spurred by Sigmund Freud's theory of dreams, by Franz Kafka's short story *Die Verwandlung* (1915) and by André Breton's call for a modern mythology, seems also to have been based on models in the ancient Greek philosopher Heraclitus, the North African philosopher Apuleius, the hermetic tradition and Friedrich Nietzsche. It was applied both to the subject-matter and to the overt imagery of a painting such as the *Metamorphosis of Narcissus* (1937; London, Tate; see col. pl. XXXIV) by Salvador Dalí and to the more abstract concerns of artists such as André Masson and Joan Miró. Conceived by the Surrealists as a central aesthetic category, metamorphosis attested to the social power of the individual imagination and to the transcendence of the concept of the marvellous over reason. In the wake of Surrealism, metamorphism was also applied to abstract painting and sculpture, especially by artists working from the 1940s to the early 1960s, such as Fritz Winter, Karl-Otto Götz, Bernhard Schultze and Hann Trier, who created dynamic and even violent images of organic growth as a reaction against realism.

Bibliography

C. Heselhaus: 'Metamorphose-Dichtungen und Metamorphose-Anschauungen', *Euphorion*, xlvii/2 (1953), pp. 121–46

Metamorphosen: Surrealismus heute (exh. cat., Leverkusen, Schloss Morsbroich, 1965)

Métamorphose de l'objet: Art et anti-art, 1910–1970 (exh. cat., Brussels, Pal. B.-A., 1971)

U. M. Schneede: *Malerei des Surrealismus* (Cologne, 1973)

Natur-Gestalt in der Verwandlung: Baum–Fels–Figur (exh. cat., W. Berlin, N.G.; E. Berlin, Altes Mus.; 1978)

W. Chadwick: *Myth in Surrealist Painting, 1929–1939* (Ann Arbor, 1980)

C. Lichtenstern: *Metamorphose in der Kunst des 19. und 20. Jahrhunderts*, 2 vols (Weinheim, 1990–92)

CHRISTA LICHTENSTERN

MIAR [Movimento Italiano per l'Architettura Razionale]

Italian architectural movement founded in 1930. Dissolved in 1931, it was a short-lived coalition of the largest group of Italian Rationalist architects assembled between the two world wars. Succeeding two previous associations of Rationalist architects, GRUPPO 7 and the Movimento dell' Architettura Razionale (MAR), it was composed of a range of regional groups: Piero Bottoni (*b* 1903), Luigi Figini, Gino Pollini, Pietro Lingeri and Giuseppe Terragni in Milan, Bruno Lapadula (*b* 1902), Luigi Piccinato (*b* 1899) and Mario Ridolfi in Rome, Gino Levi Montalcini, Giuseppe Pagano and Ettore Sottsass sr (1892–1953) in Turin, as well as a mixed group composed of Alberto Sartoris, Mario Labò and Adalberto Libera, who was the national secretary.

On 30 March 1931 through the initiative of the MIAR, the second Esposizione dell'Architettura Razionale was opened at Pietro Maria Bardi's bookshop and gallery in Rome. It included *la tavola degli orrori*, where reproductions of works by academic architects, such as Marcello Piacentini and Gustavo Giovannoni, were displayed. As well as making joint declarations concerning their fields of research and their aspirations in the *Manifesto per l'Architettura Razionale*, some of the members of MIAR, including Giuseppe Pagano, intended that Rationalism should be recognized officially as an architectural expression of Fascism. Despite achieving some official recognition, however, MIAR was opposed by the academic front, including Piacentini, and by the Sindicato Fascista degli Architetti, who together formed the RAMI (Raggruppamento degli Architetti Moderni Italiani).

The coherence of MIAR began to break up in the face of this opposition and through internal differences, which were exacerbated by dissent over members' participation in important government projects, such as the building of the new Città Universitaria in Rome. Following the dissolution of the movement, some former members continued to hold their position as Rationalists, and their activity was chiefly focused on competitions and the organization of experimental works for the Triennale exhibitions in Milan.

Writings
Manifesto per l'Architettura Razionale (1931)

Bibliography
G. Veronesi: *Difficoltà politiche dell'architettura in Italia, 1920–1940* (Milan, 1953)
M. Cennamo, ed.: *Materiali per l'analisi dell'architettura moderna: Il MIAR* (Naples, 1976)
E. Mantero, ed.: *Il Razionalismo italiano* (Bologna, 1984)

MATILDE BAFFA RIVOLTA

Minimalism

Term used in the 20th century, in particular from the 1960s, to describe a style characterized by an impersonal austerity, plain geometric configurations and industrially processed materials. It was first used by David Burlyuk in the catalogue introduction for an exhibition of John Graham's paintings at the Dudensing Gallery in New York in 1929. Burlyuk wrote: 'Minimalism derives its name from the minimum of operating means. Minimalist painting is purely realistic—the subject being the painting itself.' The term gained currency in the 1960s. Accounts and explanations of Minimalism varied considerably, as did the range of work to which it was related. This included the monochrome paintings of Yves Klein (see col. pl. XXVII), Robert Rauschenberg, Ad Reinhardt, Frank Stella and Brice Marden, and even aspects of Pop art and Post-painterly Abstraction. Typically the precedents cited were Marcel Duchamp's ready-mades (see col. pl. XVI), the Suprematist compositions of Kazimir Malevich (see col. pl. XXXIII) and Barnett Newman's Abstract Expressionist paintings. The rational grid paintings of Agnes Martin were also mentioned in connection with such Minimalist artists as Sol LeWitt.

After the work of such critics as Clement Greenberg and Michael Fried, analyses of Minimalism tended to focus exclusively on the three-dimensional work of such American artists as Carl André, Dan Flavin, Donald Judd, LeWitt, Robert Morris and Tony Smith, although Smith himself never fully subscribed to Minimalism. These artists never worked or exhibited together as a self-defined group, yet their art shared certain features: geometric forms and use of industrial materials or such modern technology as the fluorescent electric lights that appeared in Flavin's works. Minimalists also often created simple modular and serial arrangements of forms that are examples of SYSTEMS ART. LeWitt's serial works included wall drawings as well as sculptures.

Judd and Morris were the principal artists to write about Minimalism. Judd's most significant contribution to this field was the article 'Specific Objects' (1965). Judd's article began by announcing the birth of a new type of three-dimensional work that could not be classified in terms of either painting or sculpture and, in effect, superseded both traditions. Judd's concept became retrospectively identified with his own boxes and stark geometric reliefs of the period (see fig. 26). Originally, however, he explained his idea with reference to the work of a heterogeneous selection of artists, including Lee Bontecou, John Chamberlain, Klein, Yayoi Kusama (*b* 1929), Claes Oldenburg, Richard Smith, Frank Stella and H. C. Westermann (1922–81). The article was also copiously illustrated with works by such artists as Richard Artschwager, Flavin, Jasper Johns, Phillip King, Morris, Rauschenberg, Stella, and with one of Judd's own pieces. Judd distinguished the new work by means of its compositional 'wholeness', which, unlike previous art, was not 'made part by part, by addition'. He was later to focus the critical implications of this distinction with a dismissive reference (1969) to the 'Cubist fragmentation' of Anthony Caro's work. For Judd, his own work achieved its formal integrity principally by adapting into a third dimension the 'singleness' that he observed in the compositions of such painters as Barnett Newman, Jackson Pollock, Mark Rothko and Clyfford Still.

Morris's influential 'Notes on Sculpture' appeared a year after Judd's article. In it he established the criteria by which his own recent work could be evaluated. Like Judd, he repudiated an aesthetic based on Cubist principles. 'The sensuous object, resplendent with compressed internal relations, has had to be rejected' (*Artforum*, v/2 (Oct 1966), p. 23). In its place Morris proposed a more compact, 'unitary' art form. He was

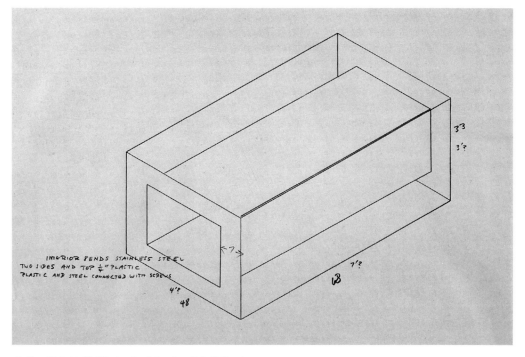

26. Donald Judd: *Untitled*, 1967–8 (London, Tate Gallery)

especially drawn to simple, regular and irregular polyhedrons. Influenced by theories in psychology and phenomenology, Morris argued that these configurations established in the mind of the beholder 'strong gestalt sensation', whereby form and shape could be grasped intuitively. Judd and Morris both attempted to reduce the importance of aesthetic judgement in modernist criticism by connecting the question of the specificity of the medium to generic value. Nevertheless, a distinction between the categories of art and non-art was maintained with Judd's claim that 'A work needs only to be interesting'.

For Greenberg and Fried, Minimalist work was united by the threat it posed to their modernist aesthetic. The modernist response to Minimalism was outlined in Greenberg's 'Recentness of Sculpture' and Fried's 'Art and Objecthood' (both 1967). Both critics were troubled by claims for Minimalism as a new art form, and were also concerned at the Minimalist elimination of complex compositional relations and subtle nuances of form, which they believed to be essential qualities of modernist sculpture. The critical resistance that Minimalism met in its initial stages persisted, and censure arose not only from modernist critics but also from the tabloid press. This was particularly evident in the abuse that was given to André's sculpture made from building bricks, *Equivalent VIII* (1966; London, Tate; see fig. 27), upon the occasion of its exhibition at the Tate Gallery in London in 1976.

From the 1960s the Minimalists' work remained remarkably consistent, continuing its geometric and serial forms (e.g. LeWitt's *Cube Structures Based on Five Modules*, 600×800×700 mm, 1971–4; Edinburgh, N.G. Mod. A.). Conceptual art inherited many of the concerns as well as the contradictions of Minimalist discourse. Attempts were made by Joseph Kosuth, among others, to resolve its complex views on the relationship between aesthetic judgement and the art object.

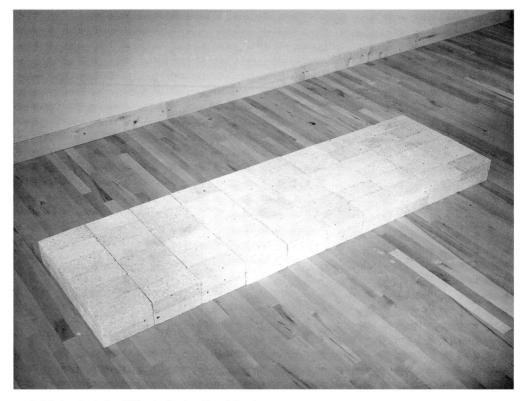

27. Carl Andre: *Equivalent VIII*, 1966 (London, Tate Gallery)

Minimalism's sense of 'theatricality' stimulated much subsequent work in the fields of installation and performance art, where it helped facilitate a critical engagement with the spectator's perception of space and time. The concept of 'theatricality' was first used in connection with Minimalism by Michael Fried to characterize the absence of 'presentness' in the spatial and temporal experience of the art work. While Fried was critical of this situation, his analysis led, by default, to a reassessment of Minimalism from an anti-humanist perspective.

Bibliography

D. Judd: 'Specific Objects', *A. Yb.*, 8 (1965), pp. 74–82

R. Morris: 'Notes on Sculpture', *Artforum*, iv/6 (Feb 1966), pp. 42–4; v/2 (Oct 1966), pp. 20–23; v/10 (June 1967), pp. 23–9

M. Fried: 'Art and Objecthood', *Artforum*, v/10 (June 1967), pp. 12–23

C. Greenberg: 'Recentness of Sculpture', *American Sculpture of the Sixties* (exh. cat., Los Angeles, CA, Co. Mus. A., 1967) [intro.]

G. Battcock, ed.: *Minimal Art: A Critical Anthology* (New York, 1968) [incl. ess. by Morris, Greenberg and Fried cited above]

C. Harrison: 'Expression and Exhaustion in the Sixties', *Artscribe*, 56 (Feb–March 1986), pp. 44–9; 57 (April–May 1986), pp. 32–5

T. de Duve: 'The Monochrome and the Blank Canvas', *Reconstructing Modernism: Art in New York, Paris and Montreal, 1945–1964*, ed. S. Guilbaut (Cambridge, MA, and London, 1990), pp. 244–310

C. Harrison: *Essays on Art and Language* (Oxford and Cambridge, 1991) [esp. pp. 37–47]

CHRISTOPHER WANT

Minotaurgruppen [Swed.: 'Minotaur group']

Swedish Surrealist group, founded in Malmö in 1943 and dissolved in the same year. Its members were C. O. Hultén, Endre Nemes, Max Walter Svanberg, Carl O. Svensson and the Latvian-born Adja Yunkers (b 1900). The name was probably inspired by that of the French Surrealist review *Minotaure* (1933–9) and also by the role that myth, particularly that of the minotaur, had assumed in Surrealist art. The group had one exhibition, at the Radhus in Malmö, showing work that was typically Surrealist, with grotesque metamorphoses of creatures and disconcerting juxtapositions of objects, as in Svanberg's *Melancholy Emotion* (gouache, 1943; priv. col., see Pierre, p. 27).

Bibliography

C. O. Hultén: *Arbeten, 1938–1968* (exh. cat. by C. Dotremont and others, Lund, Ksthall, 1968)

J. Pierre: *Max Walter Svanberg et le règne feminin* (Paris, 1975)

□

Moderne Kunstkring [Dut.: 'Modern art circle']

Group of Dutch artists founded in November 1910 on the initiative of Conrad Kikkert (1882–1965), a Dutch painter and critic, who had moved to Paris in the same year. The objective was to convey to the Netherlands the latest developments in painting in Paris. Its members included a large number of Dutch painters who either had connections with Paris or lived there. Kikkert financed the venture. The first exhibition was held between 6 October and 5 November 1911 at the Stedelijk Museum, Amsterdam. It was a great success, attracting 6000 visitors. Of the 166 works shown, half came from abroad. As 'father of Cubism', Paul Cézanne was well represented by 28 works from the Hoogendijk collection; also exhibited were 19 works by Auguste Herbin, 7 by Pablo Picasso and 6 by Georges Braque. The Paris-based painter Lodewijk Schelfhout (1881–1943), one of the first Dutch artists to paint in a Cubist style, submitted 12 works; other Dutch artists, such as Jan Sluyters,

Kees van Dongen and Piet Mondrian, were mainly influenced by Fauvism. Mondrian showed the triptych *Evolution* (1910–11) and *Red Mill* (1910), in which, in addition to a vivid use of colour, he first divided the surface in a schematic manner; after December 1911, when he went to Paris at Kikkert's insistence, he came under the influence of Cubism.

The second Moderne Kunstkring exhibition was held between 6 October and 7 November 1912 at the Stedelijk Museum, Amsterdam, and attracted 8000 visitors. It marked the beginning of abstract art in the Netherlands. Cubism still dominated, represented in the work of Alexander Archipenko, Braque, Albert Gleizes, Herbin, Fernand Léger, Jean Metzinger and Picasso. Mondrian's first Cubist work, the *Blossoming Apple Tree* (1912; The Hague, Gemeentemus.), was a notable exhibit; with Petrus Alma he was one of the few Dutch artists to emulate Picasso's Analytical Cubism. Kikkert, Henri Le Fauconnier and Schelfhout worked more according to the principles of Gleizes and Metzinger. Jacob Bendien's first abstract paintings were also shown at this exhibition.

After 1912 the Moderne Kunstkring was no longer the only place outside the French Salon des Indépendants where Paris-based Dutch artists, such as Alma, Mondrian, Otto van Rees and Schelfhout, exhibited. In 1912 they exhibited at the *Sonderbund* exhibition in Cologne. During that year the general interest moved towards developments in German painting. In 1913 the third Moderne Kunstkring exhibition was held, which included 18 works by Franz Marc and 14 by Vasily Kandinsky. Earlier that year Le Fauconnier and Kikkert had broken away from the Cubism of Picasso and Braque, finding it too theoretical. As a result, these painters were no longer represented: Le Fauconnier, on the other hand, exhibited 27 paintings and was honoured as leader of the Cubists; Schelfhout, who was represented with 16 paintings, displayed a moderate form of Cubism still based on recognizable forms of representation. Mondrian exhibited 6 paintings, *Tableaux I* to *VI*, a series of abstractions of trees and plants, which revealed Picasso's influence. Jacoba Heemskerck van Beest's work was similarly influenced by Picasso.

In 1913 Kikkert was instrumental in expelling Sluyters (who had already resigned from the governing committee at the end of 1912) and Leo Gestel from the society because they were also members of the Hollandse Kunstenaarskring, which promoted Impressionism. Chairman Jan Toorop was given the ineffectual, but impressive-sounding, role of Honorary President. As a result of these problems Mondrian withdrew from the committee. In 1914, at the outbreak of World War I, Alma, Kikkert, Mondrian and Schelfhout returned to the Netherlands and the Moderne Kunstkring lost its bridging function to artistic life in Paris.

Bibliography

A. Venema: 'De stormachtige beginjaren van de Moderne Kunstkring, 1910–1915' [The stormy early years of the Moderne Kunstkring, 1910–1915], *Tableau*, i/2 (1978–9), pp. 34–43, 48

G. Imanse: 'Het onstaan van de abstracte kunst in Nederland *c.* 1900–1918 en het artistieke klimaat in die periode' [The beginning of abstract art in the Netherlands *c.* 1900–1918 and the artistic climate of this period], *Van Gogh bis Cobra: Holländische Malerei, 1880–1950* (exh. cat. by G. Imanse and others, Stuttgart, Württemberg. Kstver.; Utrecht, Cent. Mus.; Bonn, Rhein. Landesmus.; 1980–81), pp. 93–135 [also pubd in Dut.]

JOHN STEEN

Modern Movement

Term applied to the architecture of simple geometrical forms and plain undecorated surfaces, free of historical styles, that developed mainly in Europe in the late 19th century and the early 20th prior to World War II. The origin of the term is especially associated with Nikolaus Pevsner, whose book *Pioneers of the Modern Movement* (1936) traced the sources of the movement from William Morris to Walter Gropius. Pevsner capitalized the words and asserted that the Modern Movement had resulted in 'the recognized accepted style of our age'. After 1932 the term INTERNATIONAL STYLE was widely used synonymously with Modern Movement to describe such work of this period,

which is also encompassed within the more popular global term Modernism.

See also RATIONALISM and FUNCTIONALISM.

1. Origins, 1860–c. 1907

The European Modern Movement embraced not only radical changes in the formal and stylistic characteristics of buildings but also a sense of social involvement. Both had their origins in Britain in the Arts and Crafts Movement, which itself had grown out of a reaction against the overblown forms and uncontrolled decoration of machine-made objects of the mid-19th century. William Morris, for example, sought to combine social amelioration with better design: the hand-crafted products of the company he set up were believed to convey socio-cultural as well as professional satisfaction to the craftsmen who made them, while their unpretentious, traditional forms also looked forward to the aesthetic values of the Modern Movement. Architects associated with the Arts and Crafts Movement, including Philip Webb and A. H. Mackmurdo, favoured extended plain surfaces in buildings: Mackmurdo designed Brooklyn (*c.* 1886) at Enfield, London, a remarkable, early flat-roofed house with unadorned walls and horizontal windows to the upper floor. Elegant, uncomplicated interiors and undecorated surfaces also characterize such houses as the Orchard (1899–1900), Chorleywood, Herts, by C. F. A. Voysey, a member of the Arts and Crafts Exhibition Society (founded 1888) and perhaps the most important figure of the English domestic revival; externally his houses were often simply and boldly modelled, with uninterrupted surfaces (e.g. Perrycroft, 1893, near Malvern, Worcs). These innovative British developments prompted the German Government to second the architect Hermann Muthesius to the German Embassy in London from 1896 to 1903 to study and report on British architecture and design.

New attitudes to volumetric form also began to appear in the 1890s, especially in the work of Victor Horta in Belgium (e.g. Maison Tassel, 1892–3) and that of Héctor Guimard in France. Their approach was inspired by the freedoms

implicit in the two-dimensional origins of Art Nouveau, a movement that began in opposition to *fin-de-siècle* eclecticism and accentuated the use of the curved line for decorative features. Art Nouveau detailing was combined with unadorned stone masses and extensive glazed areas in the Glasgow School of Art (begun 1896); the work of Mackintosh, who was influenced by Voysey, was rejected by the Arts and Crafts Movement in Britain but proved to be influential in Europe.

The new freedom of form also found expression in Vienna, for example in Josef Maria Olbrich's Secession Building (1897–8); in Turin, in Raimondo D'Aronco's exuberant *Stile Liberty* buildings for the Esposizione Internazionale d'Arte Decorativa Moderna (1902); and in Barcelona, where Gaudí set whole buildings on the move (e.g. Casa Milà, 1906–10). Other overt uses of uninhibited, non-historical forms included Olbrich's remarkable Hochzeitsturm (1905–8), Darmstadt, and the two white, marble-clad examples of Secession *Gesamtkunstwerk*: Wagner's Postsparkasse (1903), Vienna, its banking hall lit by a great glazed roof, and Hoffmann's Palais Stoclet (1905–11), Brussels. Also in the Viennese circle after his return from Chicago in 1896 was Adolf Loos, who published an influential diatribe in opposition to the *Gesamtkunstwerk* ethic in his 'Ornament und Verbrechen' (*Cah. Aujourd'hui*, June 1913). His Goldman & Salatsch Building (Looshaus; 1910; see fig. 28) and his early houses in Vienna, with openings set irregularly in plain rendered wall surfaces (e.g. Steiner House, 1910, and Scheu House, 1912–13), are among the important early images of the Modern Movement.

Structural rationalism, another fundamental component of Modernism, was newly evident in H. P. Berlage's Beursgebouw (1896–1903), Amsterdam, built on the strictest principles of Viollet-le-Duc and with an exposed steel roof structure. The first decisive move towards an overt structural rationalist expression, however, was seen in the work of the Perret brothers in France, whose exposed reinforced-concrete frame-and-panel construction produced some of the earliest astylar façades of the Modern Movement (e.g.

28. Adolf Loos: Goldman & Salatsch Building (Looshaus), Vienna, 1910

eight-storey block of flats at 25 Rue Franklin, Paris, 1903–5). Also designed for concrete construction, the buildings of Garnier's projected *Cité industrielle* (exhibited 1904) assumed elemental cubic forms. In the USA an uncompromising interpretation of framed structure was expressed in Sullivan's Auditorium Building (1886–9; see col. pl. XXV) in Chicago, IL. At the same time a unique planar horizontality was purveyed by Frank Lloyd Wright (who had studied with Sullivan) in his proposals for the Prairie House, for example in the Robie House (1909; see fig. 29; *see also* PRAIRIE SCHOOL). The planning, simple massing, unadorned surfaces and environmental control of Wright's Larkin Building (1903–6; destr. 1950), Buffalo, NY, in particular, were prophetic of burgeoning Modernism.

2. Deutscher Werkbund and the aesthetics of Functionalism, c. 1907–16

One of the most important events in the development of the Modern Movement was the foundation (1907) in Munich of the DEUTSCHER WERKBUND

29. Frank Lloyd Wright: Robie House, Chicago, IL, 1909

with the aim of bringing together industrialists, artists and craftsmen with a common interest in 'ennobling' German products. Its foundation was stimulated by Muthesius's return to Germany in 1903 and his appointment to the Handelsministerium with a brief to improve the country's system of education in the applied arts. The schools were then still largely dedicated to hand crafts, although the influential political theorist Friedrich Naumann put forward a German idealist case for a sophisticated machine aesthetic aimed at improving the quality as well as the economic accessibility of German goods. The Deutscher Werkbund had an initial membership of 13 artist-designers, including Hoffmann, Olbrich and Peter Behrens, and 10 industrial groups, including the Werkstätten für Handwerkskunst, as well as private firms. Its acceptance of industrialization and the machine led to such radical new industrial buildings as those designed between 1907 and 1919 for the Allgemeine Elektrizitäts-Gesellschaft (AEG) by Behrens and the Fagus Factory (1911–13; see col. pl. XXXI) on the Leine at Alfeld, by Walter Gropius and Adolf Meyer; these are among the best-known images of the early Modern Movement. Poelzig's Milch Chemical Factory at Luban and his five-storey shop and office building at Breslau (now Wrocław, Poland; both 1911–12) were equally uncompromising stylistically, although more dynamic in form: taken in combination with the undoubted symbolism of Behrens's Turbinenfabrik, they represent the beginnings of architectural Expressionism.

The few years immediately before World War I were critical in determining aesthetic trends, with formal developments in the Modern Movement influenced by both Cubism and Futurism from about 1912. Cubist painting from 1908 had shown that everyday objects could be dissolved and re-synthesized as geometric or transparent superimposed compositions, and this aesthetic was well suited to express the nascent forms arising from

the new building technology (*see* CUBISM, §II). More literal interpretations such as CZECH CUBISM, however, produced little more than the eccentric façades designed by such architects as Josef Chochol and Josef Gočár. A more dynamic urban utopia was depicted by the Italian Futurists, whose stylized, industrial monumentalism was in touch with faster transport systems and engineering virtuosity (*see* FUTURISM, §2). The architect-prophets of Futurism were Antonio Sant'Elia and Mario Chiattone, both of whom showed their work at the first Nuove Tendenze exhibition in Milan in 1914.

A rift between the supporters of machine aesthetics and those of hand crafts emerged at the Werkbund conference and exhibition (1914) at Cologne, at which Muthesius, who proposed a form of standardization related to machine production, confronted the Expressionist lobby headed by Henry Van de Velde, the Belgian head of the Kunstgewerbeschule at Weimar, who was supported by Gropius and Bruno Taut. The Expressionist group favoured artistic independence and freedom to create forms that would be realized through the building crafts. Among notable buildings erected for the exhibition, a model factory by Gropius and Meyer was a further development along the lines of the Fagus Factory, though showing additional influences from Frank Lloyd Wright; while Van de Velde's model theatre and Bruno Taut's Glashaus were important early precedents in the development of Expressionism (*see* EXPRESSIONISM, §2). The growing Werkbund controversy was set aside with the onset of war, and when Van de Velde left Germany he recommended that Gropius should succeed him as head of the Weimar Kunstgewerbeschule. Although few buildings of importance to the Modern Movement were built during World War I, in 1914–15 Le Corbusier proposed the elemental 'Dom-Ino' slab-and-column system (unexecuted) for building houses; around this time Jan Wils and Robert van't Hoff were producing a simplified architecture in the Netherlands (e.g. van't Hoff's buildings at Huis ter Heide, near Utrecht), and in the USA Irving Gill, who had worked for Sullivan, was building white, astylar houses in Los Angeles of which the Dodge House (1914–16), Hollywood, is the best-known example.

3. De Stijl to Der Ring, 1917–25

A major contribution to the forms of the emerging Modern Movement was made by the abstracted, rectilinear geometry espoused by the De Stijl group (founded Leiden, 1917), which was able to flourish during the war because of the neutrality of the Netherlands. Much influenced by Cubism and Neo-plasticism, De Stijl was formally antithetical to the contemporary Expressionist and sometimes eccentric AMSTERDAM SCHOOL, and it attracted such designers as El Lissitzky, who had worked with Kazimir Malevich, and Gerrit Rietveld, a furniture-designer turned architect. Rietveld's Schröder House (1924), Utrecht, has been held to demonstrate better than any other building the meaning of 20th-century architecture (see Sharp, p. 74). In Rotterdam a technologically orientated group DE OPBOUW was formed (1920); members included J. J. P. Oud, Mart Stam and J. A. Brinkman, and it had a notable impact on public housing in the city in the 1920s.

In Germany the radical ARBEITSRAT FÜR KUNST and the NOVEMBERGRUPPE were both founded towards the end of 1918, the former by Bruno Taut on socialist-idealist lines and the latter declaring for innovation and new forms. Most of the architectural avant-garde, including Gropius, Otto Bartning, Hugo Häring, Hans Scharoun, Bruno Taut and Max Taut, were members of both groups, and some of them also joined Bruno Taut's Gläserne Kette, a correspondence group formed in 1919 to keep radical design ideals alive during the ensuing period of economic instability. In Weimar, the seat of the new German government, Gropius was courted by both the Kunstgewerbeschule and the Hochschule für Bildende Kunst, and in 1919 he merged them to form the Staatliches Bauhaus (*see* BAUHAUS), which became highly influential in the development of the Modern Movement.

The radical lobby of the immediate post-war period championed the formal freedoms of Expressionism—seen especially in Mendelsohn's Einstein Tower (1920–24), Potsdam—and the handcraft ideal as opposed to the industrialization of the building process, which they associated with capitalism. Poelzig was elected president of the reassembled Werkbund at Stuttgart in 1919, and

for a brief period Expressionism gained ground even in the Bauhaus itself. This trend was, however, reversed, partly under the influence of De Stijl (Theo van Doesberg was a visiting lecturer at the Bauhaus in 1923) and Russian Constructivism. The Werkbund dissociated itself from the hand-craft organizations, and by 1923 Gropius stood at the head of a school ' . . . devoted to Machine-Age architecture' (see Banham, p. 12). This was also the year in which the Werkbund met at Weimar, in which Gropius spoke of the new technology as part and parcel of a functional architecture, and in which Le Corbusier exhibited his Citrohan designs of 1920–22 at the *Haus am Horn* exhibition (1923) at the Bauhaus. These were published in the *Bauhausbuch* under the prophetic general title *Internationale Architektur* (Munich, 1925).

Another radical group, DER RING, was founded in Berlin in 1923–4 to encourage the advancement of the international movement in architecture and to support *Neues Bauen*, a term widely used in Germany (*Nieuwe Bouwen* in the Netherlands) after 1920, initially to stress the role of technology in determining form but eventually applied generally to a rational modern architecture constructed with the new building techniques. Der Ring extended its membership in 1926 to include architects from all shades of the design spectrum, from the dynamism of Expressionism to the more rigorous rectilinear geometry inspired by Neue Sachlichkeit (a name first used in 1925 to categorize an anti-Expressionist movement in painting) and notions of Functionalism: Poelzig, Mendelsohn and Ludwig Mies van der Rohe, as well as most of the members of the Novembergruppe and the Gläserne Kette (disbanded in 1920), were then united in a single, more broadly based movement.

Notable supporters of the Modern Movement in France included, in addition to Le Corbusier, Henri Sauvage, who completed the Futurist-inspired eight-storey block of flats in the Rue des Amiraux, Paris, in 1927. In 1925 the Exposition Internationale des Arts Décoratifs et Industriels Modernes was held in Paris, which, although mainly associated with the origins of Art Deco,

also included important buildings associated with the Modern Movement, such as the Soviet Pavilion by Konstantin Mel'nikov and, in particular, Le Corbusier's influential Pavillon de l'Esprit Nouveau (both destr.). The latter was named after the journal *L'Esprit nouveau*, which in January 1921 published the principal manifesto of PURISM. The philosophy of the Purist movement, initiated originally in painting by Le Corbusier and Amédée Ozenfant as a reaction to Cubism, embraced an admiration for the beauty and purity of machine aesthetics; it characterized many of Le Corbusier's buildings of the late 1920s and early 1930s, among them some of the best-known works of the Modern Movement (*see* §4 below).

4. Towards an international style, 1926–32

In 1925 the Bauhaus was relocated at Dessau, at first in temporary accommodation. The concept of *Neues Bauen* seemed wholly appropriate to its new range of buildings there, designed by Gropius (with Meyer), which were completed the following year (see fig. 6). There were also signs of increasing international patronage for the Modern Movement in two renowned houses, one in the USA and one in Britain: the Lovell Beach House (1922–5), Newport Beach, CA, by the immigrant Austrian architect Rudolph Schindler, and the unpretentious house New Ways (1923–5), Northampton, designed by Behrens for the Bassett-Lowke family.

The highest point in the development of the Modern Movement to date was, however, represented in the Weissenhofsiedlung (1927), a collaborative permanent exhibition of mixed housing mounted by the Deutscher Werkbund at Weissenhof, a suburb of Stuttgart, to demonstrate the potential of *Neues Bauen*. The exhibition, held under the direction of Mies van der Rohe, who had been elected vice-president of the Werkbund in 1926, combined work of both the older and younger generations of the progressive Werkbund membership and other invited Europeans. Almost all the original 21 separate buildings survive, and the surprisingly consistent result—all the buildings have plain walls, asymmetrical openings and flat

roofs, and almost all are rectilinear in shape—more than justified the Werkbund's aim to produce a model for social housing using new technologies and free of historical refer-ences (for further discussion *see* DEUTSCHER WERKBUND). The influence of the Weissenhofsiedlung was imme-diate and worldwide. The socio-political impor-tance of housing in the late 1920s and early 1930s was vital to the development of the Modern Movement and, even in less élitist circumstances than the Werkbund exhibition, it continued to produce memorable results, for example the Grossiedlung (1931), Siemensstadt, near Berlin, designed for the German elec-trical firm Siemens by several members of Der Ring, including such architects of widely dissimilar approaches as Gropius, Scharoun and Häring.

The international status of the Modern Movement implicit in the participation at Weissenhof of such architects as Le Corbusier, Mart Stam, J. J. P. Oud and Victor Bourgeois, in addition to the German members of the Werkbund, seemed to be confirmed with the foundation of CIAM (Congrès Internationaux d'Architecture Moderne) in Switzerland in 1928 at the instigation of Hélène de Mandrot, Sigfried Giedion and Le Corbusier. In Germany the broad-ening aesthetic base of the movement ranged from the sweeping dynamism of Mendelsohn's Schocken department store (1928; destr. 1960) in Stuttgart and Chemnitz (1928) and Scharoun's block of flats at the second Werkbund exhibition, *Wohnung und Werkraum*, held at Breslau (now Wrocław, Poland) in 1929, to the interlocking rec-tilinear volumes and rich planar surfaces of the German Pavilion at the Exposición Internacional, Barcelona (1929), which has become one of the icons of the Modern Movement.

Important developments also took place elsewhere in Europe. In the Netherlands the ARCHITECTENGROEP DE 8 was founded (1927) in Amsterdam with aims similar to those of the earlier *De Opbouw*, expressed in such buildings as the Zonnestraal Sanatorium (1926–8), Hilversum, and the Van Nelle Tobacco Factory (1925–31), Rotterdam. In Italy the rationalist GRUPPO 7 was founded in 1926, ultimately leading to the formation of a country-wide movement (*see* RATIONALISM), the principles of which were expressed particularly in the Novocomum block of flats (1927–8), Como. In France, Le Corbusier's Villa Stein-de Monzie (1926–7), Garches, Paris and Villa Savoye (1929–31; see col. pl. XXIII), Poissy, near Versailles, were the ultimate achievements of his Purist phase that did much to establish the image of the Modern Movement.

In spite of the economic depression of the 1930s, the new forms also influenced such architects as Fernando García Mercadal and Rafael Bergamín (1891–1970) in Spain, Thomas Tait, Maxwell Fry, Amyas Connell and Joseph Emberton in Britain, Paul Artaria, Hans Schmidt and Rudolf Steiger in Switzerland, Josef Kranz, Jan Visek (1890–1966) and Bohuslav Fuchs in Czechoslovakia, Bohdan Lachert, Józef Szanajca and other members of the Praesens group in Poland, Gunnar Asplund in Sweden and Alvar Aalto in Finland. Even before 1930 the aes-thetics of the movement, as well as the populist principles of its early exponents, were carried further afield by immigrant architects or those returning home from training in Europe: Richard Neutra in the USA, Alberto Prebisch and Antonio Ubaldo Vilar in Argentina, Gregori Warchavchik, Lúcio Costa and Rino Levi in Brazil, and Jose Villagrán García and Luis Barragán in Mexico are a few well-known examples. The buildings of the European Modern Movement dominated the exhi-bition of architecture (1932) at MOMA, New York, described and illustrated in the accompanying book by Henry-Russell Hitchcock and Philip Johnson, *The International Style: Architecture since 1922* (New York, 1932), which led to the widespread adoption of the term International Style to describe the work of these architects as well as later developments.

Bibliography

H. Muthesius: *Stilarchitektur und Baukunst* (Berlin, 1902)
N. Pevsner: *Pioneers of the Modern Movement* (London, 1936, rev. New York, 2/1949); rev. as *Pioneers of Modern Design from William Morris to Walter Gropius* (London, 1960)
S. Giedion: *Space, Time and Architecture* (Cambridge, MA, 1941)

——: *A Decade of New Architecture* (Zurich, 1951)

B. Zevi: *Poetica dell'architettura neoplastica* (Milan, 1953)

H. Eckstein: *50 Jahre Deutscher Werkbund* (Frankfurt am Main, 1958)

H.–R. Hitchcock: *Architecture: Nineteenth and Twentieth Centuries*, Pelican Hist. A. (Harmondsworth, 1958, rev. 2/1963)

P. R. Banham: *Theory and Design in the First Machine Age* (London, 1960)

L. Benevolo: *Storia dell'architettura moderna*, 2 vols (Milan, 1960)

P. Collins: *Changing Ideals in Modern Architecture* (London, 1965)

H. Sting: *Der Kubismus und seine Einwirkung auf die Wegbereiter der modernen Architektur* (Aachen, 1965)

D. Sharp: *Modern Architecture and Expressionism* (London, 1966)

B. Miller Lane: *Architecture and Politics in Germany, 1918–1945* (Cambridge, MA, 1968)

H. Wingler: *The Bauhaus: Weimar, Dessau, Berlin and Chicago* (Cambridge, MA, 1969)

R. Macleod: *Style and Society: Architectural Ideology in Britain 1835–1914* (London, 1971)

N. Pevsner: 'Secession', *Archit. Rev.* [London], clix/887 (1971), pp. 73–4

C. Jencks: *Modern Movements in Architecture* (London, 1973, rev. 2/1985)

W. Pehnt: *Expressionist Architecture* (London, 1973)

N. Powell: *The Sacred Spring: The Arts in Vienna, 1898–1918* (New York, 1974)

C. Benton, ed.: *Documents: A Collection of Source Material on the Modern Movement* (Milton Keynes, 1975)

C. Benton and T. Benton, eds: *A Source Book on the History of Architecture and Design 1890–1939* (Milton Keynes, 1975)

T. Benton, S. Muthesius and B. Wilkins: *Europe, 1900–14* (Milton Keynes, 1975)

J. L. Marfany: *Aspectes del modernisme* (Barcelona, 1975)

M. Tafuri and F. Dal Co: *Architettura contemporanea*, 2 vols (Milan, 1976; Eng. trans., New York, 1979) [esp. vol. i]

J. Campbell: *The German Werkbund: The Politics of Reform in the Applied Arts* (Princeton, 1978) [with bibliog.]

G. Gresleri: *L'Esprit nouveau* (Milan, 1979)

K. Frampton: *Modern Architecture: A Critical History* (London, 1980) [esp. pt 2, chaps 1–19, and bibliog.]

W. J. R. Curtis: *Modern Architecture since 1900* (Oxford, 1982, rev. 2/1987) [esp. pt 1–2]

I. B. Whyte: *Bruno Taut and the Architecture of Activism* (Cambridge, 1982)

R. Pommer and C. F. Otto: *Weissenhof 1927 and the Modern Movement in Architecture* (Chicago, 1991)

D. Sharp: *Twentieth-century Architecture: A Visual History* (London, 1991)

JOHN MUSGROVE

Movimento arte concreta [MAC]

Italian art movement founded in Milan in December 1948 by the critic (and at that time painter) Gillo Dorfles (*b* 1910), the artist and architect Gianni Monnet (1912–58; the originator and leader of the group), Bruno Munari and Atanasio Soldati (1896–1953), a painter who had been working in an abstract idiom during the 1930s. They were inspired by the growth of CONCRETE ART in Switzerland and immediately attracted a large following with other Italian artists, among them Galliano Mazzon (*b* 1896), Luigi Veronesi, Mario Nigro (*b* 1917), Mauro Reggiani (*b* 1897), Ettore Sottsass and Amalia Garau. In Turin, Naples and Florence, other groups of Concrete artists formed that had links with the Milan group, which disbanded after Monnet's death in 1958. MAC had no rigid programme or manifesto: despite its name, its adherents did not discriminate rigorously between what they termed 'Concrete art' and more generic abstract or geometric art, which did not flourish in Italy. In Milan the group brought together those few artists who had rejected the tradition of Novecento Italiano and who did not accept the artistic and ideological attitudes of social realism. Similarly, some years after its foundation, when non-representational art became prominent, MAC defended the positions of rationalism and perceptive rigour and was in fact responsible for the diffusion in Italy of the theories of Gestalt psychology and rejected automatism, irrationalism and profusion of sentiment in non-figurative works. MAC's theoretical antagonism towards non-representational art was not, however, borne out coherently in the works produced by its members, which, particularly after 1954, reflected the influence of action painting. The most interesting of MAC's activities was the publication of their monthly and, from 1954, annual bulletins, the graphics, typography and

layout of which were truly innovative: they included such features as a square format, transparent paper and pages cut into shapes or sewn together (for which Munari was mainly responsible), and they contained articles on design, on visual perception, on the synthesis of the arts and on the reproducibility of art work.

Writings

Arte concreta (1948–53)
Documenti d'arte oggi (1954–8)
G. Monnet: *L'arte moderna dall'A alla Z* (Milan, 1955)

Bibliography

P. Fossati: *Il movimento arte concreta* (Turin, 1980)
M. Meneguzzo: *Il MAC, 1948/1958: Direzioni, contraddizioni e linee di sviluppo di una poetica aperta* (Ascoli Piceno, 1981)
L. Caramel: *MAC* (Milan, 1984)

<div align="right">MARCO MENEGUZZO</div>

Narkompros [Narodnyy Komissariat Prosveshcheniya; Rus.: People's Commissariat for Enlightenment]

Soviet government agency established in Russia in 1917. When the Bolshevik Party took power following the Revolution of October 1917, it inaugurated a new set of administrative bodies or People's Commissariats. Narkompros was set up under Anatoly Lunacharsky on 26 October 1917 to take responsibility for the administration of education and the arts, including the maintenance of museums and ancient monuments. It was divided into various departments: Music (MUZO), Photography and Film (FOTO-KINO), Literature (LITO), Theatre (TEO) and Fine Arts (IZO), which was set up in Petrograd (now St Petersburg) in early 1918.

IZO was run by an Arts Board or Collegium, which consisted of David Shterenberg (President), Natan Al'tman, Nikolay Punin, Sergey Chekhonin, Aleksandr Matveyev, Aleksey Karev and Grigory Yatmanov. Later members included Vladimir Baranoff-Rossiné, Iosif Shkol'nik (1883–1926), Vladimir Mayakovsky and Osip Brik, and five architects including Vladimir Shchuko. Another Arts Board was organized in Moscow, headed by Vladimir Tatlin, who acted as Shterenberg's assistant. The Moscow Board included such artists as Kazimir Malevich, Robert Fal'k, Il'ya Mashkov, Ol'ga Rozanova, Aleksandr Rodchenko and Vasily Kandinsky. In both cities the Collegium organized various subsections to administer different aspects of artistic life, including the teaching of art in schools, the publication of art books and journals such as the Petrograd IZO's journal *Iskusstvo kommuny* ('Art of the commune'), which ran from 1918 to 1919, the revitalization of architecture and the promotion of art in industrial production, craft and design.

In 1918–21, during the years of the Civil War, the All-Russian Central Exhibitions Bureau of Narkompros managed to arrange 28 jury-free exhibitions. The first of these, which opened in April 1919 in Petrograd, included almost 300 artists of all tendencies and a total of 1826 works. The Museums Bureau, set up in Moscow in early 1918 and run by Rodchenko with the assistance of Varvara Stepanova, bought 1926 works from 415 artists and organized 30 provincial museums, to which it sent 1211 works. The Subsection for Artistic Work registered artistic organizations that would undertake government propaganda projects. It organized competitions for various agitational projects including news kiosks and monuments to important political figures to be erected in all the major cities as part of Lenin's Plan for Monumental Propaganda inaugurated in April 1918 (*see* AGITPROP). It also commissioned stencil posters for different propaganda campaigns, including almost 2000 for the Abolition of Illiteracy Campaign, and it collaborated with the city soviets on arranging street decorations for the Revolutionary festivals of May Day and the anniversary of the Revolution. The Art and Production Subsection was directed by Rozanova, who, with Rodchenko, visited craft studios in and around Moscow and raised money to revitalize them.

IZO was also responsible for formulating a cultural policy for the new Socialist society. In 1919 it published a general statement of its aesthetic position and considered the nature and types of

artistic forums that should be established. Among other proposals it suggested the setting up of a Scientific and Theoretical Department in the Central Section of the Academy of Fine Arts (AKIZO) in order to maintain contact with the latest technological and scientific ideas, while acknowledging that INKHUK, the Institute of Artistic Culture, was to be responsible for 'questions relating to the science of art'. Although avant-garde artists provided the majority of workers in IZO between 1918 and 1921, their aesthetic values were not accepted by the Party, and criticisms of Futurism, along with warnings about its adoption as the official aesthetic doctrine, were printed in *Pravda*, the Party newspaper, as early as November 1918. Lenin was particularly opposed to avant-garde ideas, and in 1921, having won the Civil War, the Party was free to reorganize and to purge IZO of avant-garde elements. From then on, the control of the arts by Narkompros became less innovative and more bureaucratic. Lunacharsky left in 1929.

Bibliography
S. Fitzpatrick: *The Commissariat of Enlightenment: Soviet Organization of Education and the Arts under Lunacharsky, October 1917–1921* (Cambridge, 1970)
C. Lodder: *Russian Constructivism* (New Haven, 1983)
CHRISTINA LODDER

National Art Society of Bulgaria [Rodno Izkustwo; Society of Artists of Bulgaria]

Bulgarian group of artists active from 1893. Founded on 24 June 1893 as the Society of Artists of Bulgaria, it was the first arts society to be established in Bulgaria. Having in its ranks the best-known intellectuals and artists of the time, its aim was to organize and develop the nation's artistic life. One of its principal goals was to expand the artistic outlook and develop the aesthetic sense of Bulgarian artists and the public by making them aware of the works of western European Old Masters. It initiated group exhibitions in 1894, 1897, 1898 and 1900, and in 1895 founded *Izkustwo*, the first magazine in Bulgaria to devote itself to art criticism. In 1895 the Society prepared a draft bill dealing with the establishment of an academy of the arts in Sofia; this led to the formation of the National Academy of Arts (Nationalna Hudozhestvena Academia). After other artists' organizations were founded in the first three decades of the 20th century—among them Contemporary Art (1904), the Society of Artists of Southern Bulgaria (1912), the Society of Independent Artists (1919), National Art (1919), the Society of Artists of Northern Bulgaria (1921) and the NEW ARTISTS' SOCIETY (1931)—the National Art Society of Bulgaria continued its existence within the framework of the Union of the Societies of Artists of Bulgaria (founded in 1932), which in 1959 was renamed the Union of Bulgarian Artists. Until 1990 the Union of Bulgarian Artists was a very centralized arts organization, controlled by an executive council and its congress, and its members could only be professionally recognized artists who held a degree or had a specialized education in the arts and who actively participated in exhibitions. The Union was the sole sponsor of the arts and maintained complete control over all aspects of Bulgaria's art life, imposing its artistic criteria on what type of art was to be exhibited both in Bulgaria and abroad. It provided the funds for purchases of art by Bulgarian art galleries and also ensured the professional status of artists. The Union's function changed after 1990, when Bulgaria embraced democratic reforms: its structure became decentralized, and the conditions for its membership became more democratic. At the same time, however, it lost control over financial matters and sponsorship of artists and arts events.

Bibliography
Catalogue of Joint Exhibitions (exh. cat., Sofia, Society of Artists of Bulgaria, 1922)
Proceedings of the Congresses of the Union of Bulgarian Artists: Sofia, 1970, 1973, 1976, 1979, 1982, 1985 and 1988
JULIANA NEDEVA-WEGENER

Neofiguración

Paraguayan movement, active in the second half of the 1960s. It developed in Asunción as the

Paraguayan equivalent of the Nueva Figuración movement in Argentina. However, it formulated its own guidelines and aims, and had a considerable influence on later developments in the visual arts in Paraguay. It represented an approach to figurative art halfway between *Art informel* and Expressionism, between a preoccupation with the physical material of the painting and the intention of distorting the figure. It was used by a group of Paraguayan artists to loosen the rigid pictorial image that had become accepted in the 1950s and to assimilate aspects of historical experience that had not until then played a part in artistic development. Social criticism was approached from two different angles within Neofiguración. The first, represented primarily by Carlos Colombino and Olga Blinder, had a sense of drama and a strong political message; the second, represented by William Riquelme (*b* 1944) and Ricardo Migliorisi, had a more satirical perspective and a playful and irresponsible spirit that to some extent was characteristic of the time.

Bibliography

M. A. Fernández: *Art in Latin America Today: Paraguay* (Washington, DC, 1969)

O. Blinder and others: *Art actual en el Paraguay* (Asunción, 1983)

T. Escobar: *Una interpretación de las artes visuales en el Paraguay* (Asunción, 1984)

Deira, Macció, Noé, de la Vega: *1961 Neo Figuración 1991* (exh. cat., Buenos Aires, 1991)

J. Barnitz: 'New Figuration, Pop and Assemblage in the 1960s and 1970s', *Latin American Artists of the Twentieth Century (exh. cat., ed. W. Rasmussen; New York, MOMA, 1993), pp. 122–33*

TICIO ESCOBAR

Neo-Georgian

Stylistic term applied to the revival in the UK in the late 19th century and the 20th of the classical Georgian style of domestic architecture and interior and furniture design from the period 1714–1830. Similar, contemporary revivals of late 18th- and early 19th-century Georgian colonial styles also took place in such countries as the USA and Australia. Neo-Georgian was one of the most popular architectural styles in the UK between 1900 and 1930; it continued to be employed despite the advent of Modernism, and in the 1980s a new phase of popularity began, stimulated by the anti-modernist, eclectic and pluralist trends of POST-MODERNISM.

1. Architecture

The origins of the Neo-Georgian style can be found in the 1860s. The house (1860–62; destr.) at 2 Palace Green, Kensington, London, designed for William Makepeace Thackeray by Frederick Hering (1800–69), who drew on Thackeray's sketches, was an early, isolated example reflecting a literary interest in the 18th century. Another precursor is Crabbet Park (1872–3), E. Sussex, designed for their own use by the poet Wilfred Scawen Blunt and his wife Lady Anne Blunt; its bilateral symmetry and central emphasis distinguish it from contemporary work in the prevalent Queen Anne Revival style, for example by Richard Norman Shaw and W. E. Nesfield. For such architects, schooled in the Gothic Revival, this symmetry was uncomfortable and was generally avoided even in buildings that reproduced Georgian decorative details. Symmetry can be taken as a defining characteristic of Neo-Georgian, although plans were frequently asymmetrical behind regular façades, partly to accommodate the more complicated social requirements of the age.

Neo-Georgian themes were later developed by Shaw (e.g. 170 Queens Gate, Kensington, 1887–8) and his pupils, including Ernest Newton and Mervyn Macartney (1853–1932), as well as by his admirers, for example Reginald Blomfield. They were also used by architects involved with the Arts and Crafts Movement. Shaw's work subsequently influenced Edwin Lutyens, who became the most celebrated of the many Neo-Georgian architects active before 1914. Lutyens found compositional devices to extend Neo-Georgian designs for large country houses; he also introduced the style for large urban buildings, in which Neo-Georgian can be distinguished from the contemporaneous Baroque Revival by the use of red brick with stone dressings, pitched roofs and general avoidance of large-scale architectural orders (see fig. 30). Most

30. Edwin Lutyens: The Institute, Hampstead Garden Suburb

architects worked in both styles, selecting according to building type and tradition, but after the succession of King George V in 1910 the idea of a Georgian revival was considered highly appropriate. Neo-Georgian was thereafter preferred for public housing, and it achieved an almost universal popularity with the London County Council Architects' Department until 1930. A more severe aesthetic was developed, relying solely on proportion and materials and virtually without ornament. Neo-Georgian was also used in the design of new towns; Welwyn Garden City (begun 1924), for example, was designed almost entirely in the style, used for houses and public buildings alike.

Neo-Georgian thus preceded Modernism as an architecture of anonymous public service, but its use began to be challenged in the 1930s. At the same time, Neo-Georgian architects working in that decade began to prefer a more accurate reproduction of the later Georgian period, paralleled in the Regency revival in interior decoration. After 1945 the style was often discouraged and denigrated by influential critics, but it remained popular with institutions and individual clients, and some fine buildings by such architects as E. Vincent Harris and Albert E. Richardson employed the style with an individual character that had been lacking in the 1920s and 1930s. After 1950 younger architects, including Raymond Erith, Donald MacMorran (1904–65) and Francis Johnson (b 1910), developed personal styles based on classical precedent, although Erith, the most prominent, dissociated himself from pre-World War II Neo-Georgian. The resurgence of Neo-Georgian in the 1980s, led by Erith's partner Quinlan Terry, who preferred 17th-century sources and Baroque detail (e.g. Richmond riverside development, near London, 1983–8), achieved an unprecedented degree of critical and commercial acceptance, and many practices without a firm attachment to classicism were willing to adopt the style when required by clients.

Bibliography

L. Weaver: *Smaller Country Houses of Today*, 2 vols (London, 1910–19)

R. Gradidge: *Dream Houses: The Edwardian Ideal* (London, 1980)

D. Calabi: *Architettura domestica in Gran Bretagna, 1890–1939* (Milan, 1982)

J. M. Robinson: *The Latest Country Houses* (London, 1984)

A. Powers, ed.: *Real Architecture* (London, 1987)

A. Powers: 'Larkhall', *Architects' J.* (1989), Sept, pp. 50–56

G. Stamp: 'MacMorran and Whitby—A Progressive Classicism', *Mod. Painters*, iv/4 (1991), pp. 56–60

ALAN POWERS

2. Decorative arts and painting

The revival of 18th-century models in architecture was paralleled in the decorative arts. Crucially, however, what tended to be revived were elements of classical design rather than literal copies of original items of furniture, glass, silver or ceramics. Robert Adam was a much quarried source of design ideas, often reduced to a Neo-classical shorthand of paterae, swags and drops applied to unmistakably modern objects such as grand pianos, coffee tables and gas fires.

In furniture, the most popular sources of design were the pattern books published by Adam, Thomas Chippendale, George Hepplewhite and Thomas Sheraton, all of which were republished in facsimile several times during the 19th and early 20th centuries. Although the quality of workmanship was often excellent, the designs were adapted to allow for machine manufacture and a more economic use of materials. The result was invariably a dilution of the design, resulting in a spindly effect that instantly differentiated revival versions from period originals. Particularly popular between 1890 and 1910 was satinwood furniture with painted decoration in the manner of Sheraton, produced by firms such as Edwards & Roberts, Maples and Hampton & Sons, all of London. The domestic effect of this revivalism is best demonstrated by the interiors of Manderston, Borders Region, which was built in 1903–5 and furnished by the London firm of Mellier & Co. Manderston has a 'Chippendale' dining room and an 'Adam' morning room. Some of the finer interiors were designed by architects, such as the furniture, carpets and decoration of the White House (1907–10), Shiplake, Oxon, by George Walton. The popularity of this type of interior lasted a long time. Stanford Hall (remodelled 1928 by White Allom), Leics, had a 'Georgian' mahogany dining room and 'Adam' bedrooms. The style persisted into the 1930s for the first-class reception rooms of transatlantic liners.

In silver, ceramics and textiles, the muscularity and careful proportions of the Georgian models were similarly diluted to produce etiolated yet often fussier versions for a mass market. A number of pottery manufacturers founded in the 18th century, such as Adams & Co. and Wedgwood, turned to reproductions of their earlier wares or new designs in the old manner. One of the most successful examples of the latter was Wedgwood's 'Edme' pattern, designed by John Goodwin in 1908 for the French market and made in Queen's Ware (the body designed by the firm's founder Josiah Wedgwood). It was in continuous production from 1913. In art, the 18th century came to represent an ideal pre-industrial elysium, from which ideas were garnered by such artists as the illustrator Kate Greenaway. Genre pictures in vaguely Regency settings were particularly popular and both fed off and encouraged Georgian revivalism in interior decoration through the ready availability of engravings made from successful Royal Academy paintings by William Quiller Orchardson, Marcus Stone and others.

Bibliography

C. Aslet: *The Last Country Houses* (New Haven and London, 1982)

R. Reilly: *Wedgwood*, ii (London, 1989)

Neo-Liberty

Italian architectural movement that developed in the second half of the 1950s as a reaction to the widespread diffusion of the International Style, especially in relation to the sensitive historic environment of many Italian cities. Its name was originally coined by detractors of the movement to imply that it was simply a revival of the Italian

Stile Liberty or Art Nouveau. The initiators of the movement were the Turin architects Roberto Gabetti (*b* 1925) and Aimaro d'Isola (*b* 1928), who were both pupils of Carlo Mollino at the Politecnico, Turin. In 1957 the architectural journal *Casabella Continuità*, edited by Ernesto Nathan Rogers and Vittorio Gregotti, published a number of works by Gabetti and d'Isola, including the influential Borsa Valori (1953) and Bottega d'Erasmo residential block (1953–6), both in Turin. In presenting their work, the architects declared their rejection of the idealist and doctrinaire theories of the Modern Movement, preferring instead to immerse themselves in the continuation of a local building tradition in the interests of an educated and bourgeois clientele. This sparked off an international debate that polarized on the one hand the defenders of the orthodoxy of the Modern Movement, led by the British critic Reyner Banham (1922–88), and on the other a group of architects from Turin, Novara and Milan who supported the views expressed in *Casabella*. While having their own differences, Vittorio Gregotti from Novara, Aldo Rossi, Guido Canella and Gai Aulenti from Milan, together with Gabetti, d'Isola and Giorgio and Giuseppe Raineri from Turin, were united in their wish to heal the rupture they perceived in the history of architecture through a reappraisal of the sources of the Modern Movement. The ideas expressed by Gabetti and d'Isola were part of a general move away from the purist principles of the Modern Movement at that time, and, like many other architects, they continued to develop new approaches in their architecture in the 1960s and after.

Bibliography

R. Gabetti, A. d'Isola and V. Gregotti: 'L'impegno della tradizione', *Casabella*, 215 (1957), pp. 62–75

R. Banham: 'Neo-Liberty: The Italian Retreat from Modern Architecture', *Archit. Rev.* [London], cxxv/747 (1959), pp. 231–5

Controspazio, 4–5 (1977), pp. 84–93 [corr. on the debate repr. from *Casabella*]

F. Cellini and C. d'Amato: *Gabetti e Isola: Progetti e architettura, 1950–1985* (Milan, 1985)

ANDREA NULLI

Neo-plasticism

Term coined by Piet Mondrian and first used in 1919 as the title of a collection of his writings published by the dealer Léonce Rosenberg. It gained currency as a descriptive term applied to Mondrian's theories of art and to his style of painting, in which a grid, delineated by black lines, was filled with blocks of primary colour (see col. pl. II). The original term applied to some of his principles was *nieuwe beelding* (new imagery); he also used *abstract-reële schilderkunst* (abstract-real painting) and Neo-Cubism. Neo-plasticism applied to all aspects of design that were part of daily life. The evanescence of natural shapes was reduced to a few essential expressive means: horizontal and vertical lines, areas of primary colour and black and white. For Mondrian a composition had to present a dynamic balance, in which the internal was externalized and the external internalized. Mondrian published *Le Néo-plasticisme* while in Paris, having become convinced that his theories, published in DE STIJL, were almost unknown beyond his native country. A collection of his articles was translated into German and published in 1925 as *Neue Gestaltung* as the fifth in the series of Bauhausbücher. His theories were published in English for the first time in 1937 under the title of 'Plastic Art and Pure Plastic Art' in *Circle: An International Survey of Constructivism*.

No distinct school of Neo-plasticists ever existed, although some works by artists including Jean Gorin, César Domela, Jean Helion and Burgoyne Diller may be described as Neo-plasticist. Mondrian's theories were to a large extent disseminated by verbal communication through numerous discussions with other painters, sculptors, architects and writers. Neo-plasticism was promoted from 1929 by the movement CERCLE ET CARRÉ, founded by Michel Seuphor, and three issues of its eponymous journal (1930). Mondrian and other artists exhibited in an exhibition of Neo-plasticism in 1930 at the Galerie 23 in Paris. The style spread to the USA when Mondrian visited in 1940 and became a member of AMERICAN ABSTRACT ARTISTS, many of whom experimented with Neo-plasticism.

Writings

P. Mondrian: *Le Néo-plasticisme: Principe général de l'équivalence plastique* (Paris, 1919)

Bibliography

J. R. Lane and S. C. Larsen, eds: *Abstract Painting and Sculpture in America, 1927–1944* (Pittsburgh, 1983)

J. Holtzman: *The New Art, the New Life: The Collected Writings of Mondrian* (Boston, MA, and London, 1986)

P. Overy: *De Stijl* (London, 1991)

I. Rike: *Mondriaan's 'Nieuwe Beelding' in English* (Amsterdam, 1991)

H. HENKELS

Neo-primitivism

Russian movement that took its name from Aleksandr Shevchenko's *Neo-primitivizm* (1913). This book describes a crude style of painting practised by members of the DONKEY'S TAIL group. Mikhail Larionov, Natal'ya Goncharova, Kazimir Malevich and Shevchenko himself all adopted the style, which was based on the conventions of traditional Russian art forms such as the *lubok*, the icon and peasant arts and crafts. The term Neo-primitivism is now used to describe a general aspiration towards primitivism in the work of the wider Russian avant-garde during the period 1910–14. It embraces the work of such disparate painters as Chagall, David Burlyuk and Pavel Filonov, and poets such as Velimir Khlebnikov and Aleksey Kruchonykh.

Neo-primitivism was to a certain extent inspired by the impact of Expressionism; adherents of both movements shared an admiration for the expressive power of naive art forms and a desire to rediscover a national artistic style. However, in its most extreme form Neo-primitivism was more daring and flamboyant. The surprising colours and gross distortions of Malevich's painting *Floor Polishers* (1911; Amsterdam, Stedel. Mus.) and the simplistic bravado of Larionov's *Soldier on a Horse* (1912; London, Tate), for example, were decisive developments on Western examples and sprang from a more rigorously defined theoretical basis. Members of Donkey's Tail held that traditional Russian culture had lost its distinctive character and identity following the introduction of elegant European standards by Peter the Great. They wished to return to their national artistic origins and to express them anew in painterly form. Consequently they looked back to traditional art forms for inspiration and spurned European fine art traditions of representation.

The old Russian print or Lubok played a crucial role in the elaboration of Neo-primitivism. Larionov, Goncharova and Chagall were all to some extent influenced by its subject-matter and stylistic devices. In their own works, words and texts decorate brightly coloured compositions, people and objects float arbitrarily one above the other in the flattened and indeterminate picture space, and the same characters that animate the hilarious topsy-turvy world of the Russian *lubok* are delineated in a flat and distorted figurative style. The beauty of ancient icons inspired artists such as Goncharova, Malevich and Vladimir Tatlin to give way to subtle colouring, inverted perspective and bold simplicity. Goncharova's *Four Evangelists* (1911; St Petersburg, Rus. Mus.) are particularly notable in this respect. Signboards, painted trays, embroideries, the work of children and naive artists, prehistoric and Siberian tribal art also offered inspiration to the avant-garde, who built up magnificent collections of such artefacts and proudly showed them alongside their own Neo-primitive works in exhibitions such as *Target* (1913).

Neo-primitivism profoundly influenced the work of the Russian poets. Mayakovsky wrote a poem about shop signboards, Khlebnikov chose prehistoric and pagan themes in such poems as *Shaman and Venus*, *Vila and Wood Goblin* and *The Maiden's God*, while Kruchonykh based some of his poems on the example of the *lubok* and chose the coarser aspects of peasant life with which to offend the refined and cultured tastes of society. Moreover these poems are filled with deliberate archaisms, naiveties, lapses, incorrect spellings and wrong word transfers, which find their counterpart in the Neo-primitive style of Donkey's Tail. Neo-primitivism was not only a vibrant and instinctive style of painting. In its attempt to

re-evaluate in painterly terms the visual traditions of the Russian nation and to revitalize art by adopting a more spontaneous and expressive approach, it left its stamp on an entire generation of Russian artists.

Writings

A. Shevchenko: *Neo-Primitivizm: Yego teoriya, yego vozmozhnosti, yego dostizheniya* [Neo-primitivism: its theory, its potentials, its achievements] (Moscow, 1913); Eng. trans. in J. Bowlt: *Russian Art of the Avant-garde* (New York, 1976), pp. 41–54

V. Markov: *Russian Futurism* (London, 1969)

Bibliography

I. Davies: 'Primitivism in the First Wave of the Twentieth Century Avant-garde in Russia', *Studio Int.*, clxxxvi (1973), pp. 80–84

J. E. Bowlt: 'Neo-Primitivism and Russian Painting', *Burl. Mag.*, cxvi (1974), pp. 132–40

M. Betz: 'The Icon and Russian Modernism', *Artforum*, xv/10 (1977), pp. 3–45

A. Parton: *Mikhail Larionov and the Russian Avant-garde* (Princeton and London, 1993)

ANTHONY PARTON

Néo-Réalisme

Term used to describe a movement among certain French painters in the 1920s and 1930s, resulting in works of a poetic naturalist style. Among the main exponents were Maurice Asselin, Jean-Louis Boussingault, Maurice Brianchon, Charles Dufresne, André Dunoyer de Segonzac, Raymond-Jean Legueult (*b* 1898), Robert Lotiron (*b* 1886) and Luc-Albert Moreau; Dunoyer de Segonzac was the unofficial leader. Though there was no conscious grouping, various of these artists were associated in an informal way. *Néo-Réalisme* arose in reaction to modern movements such as Cubism and Surrealism, which were seen as breaking with the French tradition. Essentially it was a manifestation of the post-war 'rappel à l'ordre', and the artists concerned attempted to steer a path between modernism and academicism. It placed primary emphasis on the study of reality and nature as ordinarily perceived, and its aesthetic was well summed up by Dunoyer de Segonzac's statement (Jamot, p. 102):

The search for originality at any price has led only to a terrible monotony. The world of illegibility, the lecture-picture and the puzzle-picture, which are a result of a decadent symbolism, is going to become dated . . . In actual fact the French tradition has been carried on quietly by Vuillard, Bonnard, Matisse and many others . . . There has been no break with the magnificent school which stretches from Jean Fouquet to Cézanne.

Typical of the style is Dunoyer de Segonzac's *Church of Chaville (Winter)* (1934–7; Paris, Mus. A. Mod. Ville Paris). *Néo-Réalisme* is not connected with the later movement Nouveau Réalisme.

Bibliography

P. Jamot: *André Dunoyer de Segonzac* (Paris, 1929)

R. Nacenta: *School of Paris* (London, 1960), pp. 35–6

☐

Neo-Romanticism

British movement of the 1930s to early 1950s in painting, illustration, literature, film and theatre. Neo-Romantic artists focused on a personal, poetic vision of the landscape and on the vulnerable human body, in part as an insular response to the threat of invasion during World War II. Essentially Arcadian and with an emphasis on the individual, the Neo-Romantic vision fused the modernist idioms of Pablo Picasso, André Masson and Pavel Tchelitchew with Arthurian legend, the poetry of William Wordsworth (1770–1850) and the prints of William Blake and Samuel Palmer. Celebrated as modern yet essentially traditional, its linear, lyrical and poetic characteristics were thought to epitomize the northern spirit. Neo-Romanticism flourished in response to the wartime strictures, threat of aerial bombardment and post-war austerity of the 1940s, in an attempt to demonstrate the survival and freedom of expression of the nation's spiritual life.

Neo-Romanticism was first used as a term by Raymond Mortimer in the *New Statesman and Nation* (March 1942) and was widely applied dur-

ing the 1940s as a tentative, all-embracing category, notably to the work of Paul Nash, John Piper, Henry Moore, Ivon Hitchens and Graham Sutherland, who by 1946 was regarded as the leading Neo-Romantic; his Wordsworthian paraphrasing of the Pembrokeshire landscape, for example in *Entrance to a Lane* (1939; London, Tate), was a seminal work for the development of an emergent generation that included John Minton, Michael Ayrton, John Craxton, Keith Vaughan, Robert Colquhoun and Robert MacBryde. Sutherland's rendering of landscape for symbolic purposes was emulated by other artists, as in John Minton's *Recollections of Wales* (1944; Brit. Council Col.).

After the mid-1940s the Arts Council of Great Britain and the British Council promoted Neo-Romantic artists at home and abroad, but hopes of leading the European avant-garde were gradually eroded by an indigenous pop culture and the arrival of American Abstract Expressionism. The hothouse atmosphere of the blockade disappeared, and many artists migrated south, as can be seen in John Minton's *Road to Valencia* (1949; AC Eng). Kenneth Clark, Peter Watson, John Lehmann and Colin Anderson were major patrons and advocates of the movement, and Herbert Read, Geoffrey Grigson and Wyndham Lewis were among the writers influential in its promotion. Many of the artists were themselves active writers, with John Piper's *British Romantic Artists* (London, 1942) and Michael Ayrton's art criticism for *The Spectator* (1946–8), in particular, contributing to the acceptance of the movement. Between 1942 and 1946 young Neo-Romantic painters and writers gathered in London: in Bedford Gardens at the studio of Minton, Colquhoun and MacBryde and at Peter Watson's flat in Palace Gate; however, there was never an official group. What united most of these young men, apart from aesthetic interests and wartime hardship, was their outsider status as homosexuals. As the Neo-Romantic spirit declined in the 1950s, so did the reputations of this lost generation of artists.

The term is sometimes also applied, especially in the USA, to the dream-like landscapes and figures painted in the 1930s by a group of artists based in Paris, including Tchelitchew, Eugene Berman and his brother Leonid Berman (*b* 1896) and Christian Bérard.

Bibliography
R. Ironside: *Painting Since 1939* (London, 1947)
A Paradise Lost: The Neo-Romantic Imagination in Britain 1935–55 (exh. cat., ed. D. Mellor; London, Barbican A.G., 1987)
M. Yorke: *The Spirit of the Place: Nine Neo-Romantic Artists and their Times* (London, 1988)
V. Button: *British Neo-Romanticism* (diss., U. London, in preparation)

VIRGINIA BUTTON

Neo-Tudor

Architectural style originally associated with the English Domestic Revival and employed by architects of the Arts and crafts movement. As early as the 1860s Richard Norman Shaw and W. E. Nesfield produced designs in the Old english style after sketching tours in the south-eastern counties, inspired by such architects as George Devey. Characteristic building features were tile-hanging, hipped gables and applied half-timbering, for example in Shaw's design of Cragside (1869–85), near Rothbury, Northumb. At the same time the search for a national style identified the domestic architecture of the Elizabethan and Jacobean eras as the most appropriate models. The Royal Jubilee Exhibition (1887) in Manchester featured a reconstruction of 'Old Manchester and Salford', a model village in 16th-century style half-timbering. Used for houses and cottages at Port Sunlight (from 1888), as well as at Bedford Park (from 1875) and later Hampstead Garden Suburb (from 1905), both in London, the style's picturesque quality came to dominate modern house design. After World War I speculative builders adopted it wholeheartedly for the extensive suburban developments growing around British cities, as an antidote to the Neo-Georgian municipal estates. Semi-detached houses, with half-timbering and roughcast gables, leaded lights and decorative brickwork, embodied security and stability in the brand new suburbs and gave home owners a

feeling of continuity. A parallel style also influenced interior decoration, with vernacular-orientated furnishings being devised in a mass-produced format. Heavily criticized by contemporary architects and critics, Neo-Tudor nevertheless determined the appearance of most inter-war suburban developments.

Bibliography

A. Saint: *Richard Norman Shaw* (Yale, 1976)
P. Davey: *Arts and Crafts Architecture* (London, 1980)
A. M. Edwards: *The Design of Suburbia: A Critical Study in Environmental History* (London, 1981)
P. Oliver, I. Davis and I. Bentley: *Dunroamin: The Suburban Semi and its Enemies* (London, 1981)

☐

Neue Künstlervereinigung München
[NKVM; Ger.: 'New Artists Association of Munich']

Organization founded as an independent exhibiting group to counteract the inability of both official outlets and the Munich Secession to accommodate avant-garde practice. It was established at the home of Marianne Werefkin, and was subsequently entered in the Munich Association's Register on 22 March 1909. Vasily Kandinsky was elected president and Alexei Jawlenski vice-president; Alexander Kanoldt (1881–1939) was appointed secretary and Adolph Erbslöh (1881–1947) chairperson of the association's exhibition committee. Gabriele Münter and Alfred Kubin offered their allegiance; other dedicated supporters included Heinrich Schnabel, Oscar Wittenstein and the Russian dancer Aleksandr Sakharov.

Kandinsky designed the membership card and publicly proclaimed the aims of the association by means of a circular. He promoted the Symbolist idea of 'artistic synthesis', and his colour woodcut poster for the first NKVM exhibition accordingly reduced literary allusion and focused on simplified planes of colour. On the recommendation of Hugo von Tschudi, the NKVM was permitted to use the privately owned Moderne Galerie Thannhauser for this exhibition (1–15 December 1909). Other artists who exhibited included Paul Baum (1859–1932), Erma Bossi, Karl Hofer, Vladimir Bekhteyev

(1878–1971), Moisey Kogan and Pierre-Paul Girieud. Landscape predominated in the 128 works exhibited, with still-life, portraiture and figural compositions in evidence. The range of stylistic treatment was likewise varied and embraced the media of graphics and sculpture. Critical and public reception of this exhibition was hostile.

The second exhibition (1–14 September 1910) provoked further controversy owing to Kandinsky's decision to invite a large contingent of young artists from Paris and Russia. The exhibition catalogue, which included texts by Henri le Fauconnier, David Burlyuk and Vladimir Burlyuk, Kandinsky and Odilon Redon, emphasized universalist aims. G. J. Wolf railed in *Die Kunst für Alle*: 'The beautiful and culturally renowned name of Munich is being used as a roost for an artists' association of mixed Slavic and Latin elements There is not one Munich painter amongst them.' The vivid colouration and abstraction of Kandinsky's *Composition II* and *Improvization X* elicited much press criticism. Franz Marc felt the need to publish a defence of the NKVM. A controversy within the association arose between the more conservative group centred around Erbslöh and Kanoldt and the more radical painters under Kandinsky's leadership. A final break occurred on 2 December 1911 when the NKVM jury considered arrangements for its next exhibition, scheduled to open at Thannhauser's gallery on 18 December. Kandinsky was obliged to submit his large-scale painting *Composition V* for approval. Its rejection led to the resignation of Kandinsky, Münter, Marc and Kubin from the association, and to their planning of the exhibition Der Blaue Reiter.

The number of artists who participated in the third NKVM exhibition was drastically reduced. Otto Fischer (1870–1947), an art historian who joined the association in 1911, attempted to justify the motives of the conservative element in the group in his book *Das Neue Bild* (1912). Stressing the role of the object in the work of art, he declared: 'A painting is not solely expression, but also representation.' This publication caused the withdrawal of Bekhteyev, Jawlenski and Werefkin from the NKVM, and no further exhibitions were held.

Writings

F. Marc: *Zur Ausstellungen der Neuen Künstlervereinigung bei Thannhauser* (Munich, 1911)

Bibliography

H. Uhde-Bernays: 'Ausstellungen', *Der Cicerone*, ii/1 (1910), p. 30

G. J. Wolf: 'Von Ausstellungen', *Kst Alle: Mal., Plast., Graph., Archit.*, xxvi/3 (1910), pp. 68–70

O. Fischer: *Das Neue Bild* (Munich, 1912)

J. Eichner: *Kandinsky und Gabriele Münter: Von Ursprüngen moderner Kunst* (Munich, 1957)

P. Selz: *German Expressionist Painting* (Los Angeles, 1957)

L. Buchheim: *Der Blaue Reiter und die 'Neue Künstlervereinigung München'* (Feldafing, 1959)

Auguste Macke–Franz Marc: Briefwechsel (Cologne, 1964)

P. Vogt: *Geschichte der deutscher Malerei im 20. Jahrhundert* (Cologne, 1972)

R. Gollek: *Der Blaue Reiter im Lenbachhaus München* (Munich, 1974)

B. Herbert: *German Expressionism: Die Brücke and Der Blaue Reiter* (London, 1983)

S. Behr: *Women Expressionists* (Oxford, 1988)

SHULAMITH BEHR

Neue Leben [Ger.: 'new life']

Swiss group of artists active from 1918 to 1920. It was founded in Basle in 1918 and came to prominence primarily through four exhibitions of its members' work: at the Kunsthalle in Basle (1918 and 1920), the Kunsthaus in Zurich (1919) and the Kunsthalle in Berne (1920). The driving force behind it was Fritz Baumann (1886–1942), a painter and teacher from Basle who before World War I returned to his native city having studied in Munich, Karlsruhe, Paris and Berlin (where he was a member of the circle associated with the magazine *Der Sturm*). With Arnold Brügger (1888–1975), Otto Morach (1887–1973), Niklaus Stoecklin (1896–1982) and Alexander Zschokke (1894–1981), he initiated a loose association of 44 known artists, women and men, of whom a considerable number worked in the arts and crafts. Lively contacts were established between Neue Leben and avant-garde artists living in exile in Switzerland, particularly the Dada group in Zurich, and also artists in Geneva and Ticino.

Other prominent members were Hans Arp, Alice Bailly, Augusto Giacometti, Marcel Janco, Oscar Lüthi (1882–1945), Francis Picabia and Sophie Taeuber-Arp.

Neue Leben exposed the Swiss public to such international art movements as Cubism, Futurism and Expressionism, typical of the heterogeneity of the period. Baumann's manifesto, written in 1918, was consequently less concerned with formulating maxims relating to a current style than with the expectation of a radical shift and a 'really new comprehensive style'. Similar hopes with a greater political emphasis were voiced in the *Manifest radikaler Künstler* (Zurich, 1919). Its main themes were the uncompromising wish to remove the boundaries between 'applied' and 'fine' art, to be guided by the power of originality and to redefine the role of the artist both aesthetically and socially.

Bibliography

F. Baumann: *Das Neue Leben: Für die neue Bewegung in der Kunst* (Basle, 1918)

M. Heller and L. Windhöfel: 'Das Neue Leben', *Künstlergruppen in der Schweiz, 1910–1936* (exh. cat., ed. B. Stutzer; Aarau, Aargau. Ksthaus, 1980), pp. 60–93

C. Geelhaar and M. Stucky: *Expressionistische Malerei in Basel um den ersten Weltkrieg* (Basle, 1983)

MARTIN HELLER

Neue Sachlichkeit [Ger.: 'new objectivity']

Term applied to the representative art that was developed in Germany in the 1920s by artists including Max Beckmann, Otto Dix and George Grosz. The term MAGIC REALISM is associated but not directly related to it. The use of 'Neue Sachlichkeit' may derive from the Dutch word *zakelijkheid*, which was used from *c.* 1900 to describe the work of such Dutch architects as H. P. Berlage; this was followed by *nieuwe zakelijkheid* used from 1923 to indicate the reaction against Expressionism in architecture. The political events in Europe and the general mood to which they gave rise influenced painting, design and photography (e.g. the work of Albert Renger-patsch), as well as architecture. Despite the wide

significance of objectivity at this time, the term applies primarily to a movement in German painting, and it is this with which this article is primarily concerned.

Neue Sachlichkeit was 'new' in so far as it was in contradistinction to 19th-century Naturalism and the work of the Nazarenes, and it was frequently characterized by a satirical social realism. The general mood in Germany in the 1920s was conditioned by the experience of World War I. The war fever that artists had depicted, mainly in an Expressionist style, subsided after the first months in the battlefields: the cruelty and senselessness of war was to become a recurrent theme in the work of Neue Sachlichkeit artists. Moreover, the sobering effect of both the war and the failure of the revolutionary events in Germany in 1918–19 gave rise to an unsentimental, coolly factual view of reality. As an attitude and style, Neue Sachlichkeit was a reaction to the past, to patriotism and to grand gestures. As Wilhelm Michel wrote: 'We are dealing with a *new* objectivity . . . We are dealing with a discovery of *things* after the crisis of the *ego*' (*Dt. Kst & Dek.*, 1925). Neue Sachlichkeit in Germany was closely linked to wider European developments: throughout Europe the period following the war was characterized by a *rappel à l'ordre* and to more traditional figurative styles.

The principal centres of the movement in Germany were the cities of Berlin, Dresden, Karlsruhe, Cologne, Düsseldorf, Hannover and Munich. However, the various exponents of Neue Sachlichkeit never joined into groups or formed a school, and they were scattered throughout Germany. The term was first applied to these various artists by Gustav F. Hartlaub, Director of the Städtische Kunsthalle Mannheim, for an exhibition of paintings that he organized in Mannheim in 1925. The title of the exhibition, which was originally to be Post-Expressionism, became a synonym for diverse tendencies in figurative art. Hartlaub exhibited the artists whom he saw as the successors of the waning Expressionism, and who, in his opinion, pointed towards the future of German art in the 1920s. He exhibited 124 works by 32 artists, including

Beckmann, Grosz, Dix, Alexander Kanoldt (1881–1939) and Georg Schrimpf.

The original, historical meaning of Neue Sachlichkeit differs widely, however, from the present understanding of the term. The artists of this tendency came from very different social classes and thus pursued quite opposite ideas regarding both subject-matter and politics. Although Hartlaub distinguished between right and left, between 'verists' and 'classicists', over the decades totally contradictory definitions of Neue Sachlichkeit were made. It was not until the 1970s that art scholarship distinguished clearly between the different tendencies of Neue Sachlichkeit. Accordingly, the verists (Beckmann, Dix, Grosz, Christian Schad, Karl Hubbuch, Rudolf Schlichter and Georg Scholz) can be distinguished from more romantic artists (Kanoldt, Schrimpf, Franz Lenk, Carl Grossberg, Anton Räderscheidt), as well as from proletarian revolutionaries (Otto Griebel, Lea Grundig, Käthe Kollwitz, Otto Nagel and Curt Querner) and other highly politicized artists (Gerd Arntz, Heinrich Hoerle, Oskar Nerlinger and Franz W. Seiwert).

The verists had originally been involved with Dada: they saw themselves as moralists, whose starting-point was the idea that the existing order could be changed. Their social criticism led in their paintings and drawings to a mode of representation heightened to caricature, as can be seen in Dix's *Three Prostitutes on the Street* (1925; priv. col.; see col. pl. XXVI). Their attitude was described by Grosz in 1925: 'The verist holds up a mirror to his contemporaries' mugs. I drew and painted out of a spirit of contradiction, trying in my works to convince the world that it was ugly, sick and mendacious.' The critique offered by the proletarian revolutionary artists was aimed in the same direction, but it had a stronger party-political motivation. Most of them were affiliated to the Communist party and saw the human being as 'the revolutionary subject of history': their depictions of working-class life were exemplified by Nagel's *Early Shift* (*c.* 1929; Dresden, Gemäldegal. Neue Meister). In contrast were the exponents of an idyllic Neue Sachlichkeit, who opposed reality with romanticizing timeless

imagery of people and landscapes: in the case of Schrimpf this reflected the influence of Italian Pittura Metafisica.

Despite their differences of form and subject-matter, these artists were united by a rejection of the distortions of Expressionism, which they regarded as subjective and irrational. They also saw Futurism and Cubism as constituting a form of artistic revolt that exhausted itself over formal questions. Their attitude was expressed by Beckmann in 1918: 'Let us hope that, from a mind-less imitation of the visible, a feeble, backward-looking degeneration into empty decoration and a false, sentimental, inflated mysticism, we are now arriving at a transcendent objectivity arising from a deep love of nature and human beings.' They were also united, therefore, by a commit-ment to reproducing objective reality at a time when abstract art was making its breakthrough and the Bauhaus was designing a new world (see fig. 31). This preoccupation with reproducing reality was followed by a commitment to painting, in particular illusionistic panel painting. Despite their differences, stylistically the artists of Neue Sachlichkeit were in general influenced by the early Netherlandish, Italian and German artists, whose works they could study in art galleries. Moreover, Max Doerner's monograph *Malmaterial und seine Verwendung im Bilde* (1921) served as an important aid in acquiring the techniques of the Old Masters, which involved using a fine brush and several layers of glazes in order to create smooth-surfaced paintings characterized by a strong linear quality. This precise craft technique was practised by the Neue Sachlichkeit artists in opposition to the dawning machine age. The impression of a 'frozen reality' was given by the elimination of atmospheric elements and by an exact, almost photographic reproduction of particular objects. The paintings, however, recon-struct reality rather than simply copy it, fre-quently in order to emphasize its darker aspects, even when depicting a seemingly pleasant subject (e.g. Beckmann's *Viareggio*, 1925; St Louis, MO, A. Mus.).

As well as employing traditional techniques, Neue Sachlichkeit revived such 19th-century

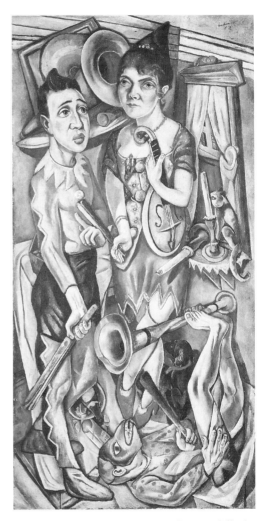

31. Max Beckmann: *Carnival*, 1920 (London, Tate Gallery)

painting genres as the still-life, landscape, town-scape and portrait. Portraits were particularly popular, because, on the one hand, they could be realistically heightened and, on the other, they could serve as an image of the human being exposed to a harsh fate. Grosz's work includes particularly subtle, expressive examples (e.g. por-trait of the poet *Max Hermann-Neisse*, 1925; Mannheim, Städt. Ksthalle): such paintings, how-ever, mark a retreat from the political radicalism

of his earlier career. Stylistic developments also occurred, for example in the work of Beckmann, whose use of colour became richer from 1925. A more significant change, however, happened towards the end of the 1920s, when most of the exponents of Neue Sachlichkeit gave up their cool, precise style in favour of softer forms. This should be regarded in the context of the rise of political mass-movements, nationalistic enthusiasm and technical progress, which disorientated the artists, causing them to abandon their detached objectivity. Such drastic social changes also affected the critical content of Neue Sachlichkeit, since it became no longer easy for individual artists to identify enemies in society to criticize and caricature. Artists began to realize that they were unable to change society through their art, and at the end of the decade Neue Sachlichkeit, always a heterogeneous movement, rapidly disintegrated.

Bibliography

Neue Sachlichkeit (exh. cat. by G. F. Hartlaub, Mannheim, Städt. Ksthalle, 1925)

F. Schmalenbach: 'The Term "Neue Sachlichkeit"', A. Bull., 22 (1940), pp. 161–5

W. Schmied: Neue Sachlichkeit und magischer Realismus in Deutschland, 1918–1933 (Hannover, 1969)

Tendenzen der zwanziger Jahre (exh. cat. by S. Waetzoldt and V. Haas, W. Berlin, 1977) [15th Council of Europe exh.]

J. Hermand: 'Einheit in der Vielfalt: Zur Geschichte des Begriffes "Neue Sachlichkeit" ', Stile, Ismen, Etikette: Zur Periodisierung der modernen Kunst (Wiesbaden, 1978), pp. 80–94

Revolution und Realismus: Revolutionäre Kunst in Deutschland, 1917–1933 (exh. cat., W. Berlin, Staatl. Museen, 1978)

Neue Sachlichkeit and German Realism of the Twenties (exh. cat., intro. and text W. Schmied; London, Hayward Gal., 1978–9)

U. M. Schneede: Neue Sachlichkeit, Verismus, figurativer Konstruktivismus, Propyläen-Kstgesch., xii (Berlin, 1984), pp. 255–63

E. Bertonati: Neue Sachlichkeit in Deutschland (Herrsching, 1988)

Neue Sachlichkeit: Magischer Realismus (exh. cat., ed. J. Hülsewig-Johnen; Bielefeld, Städt. Ksthalle, 1990)

URSULA ZELLER

Neukunstgruppe

Name given to a group of Austrian artists formed in Vienna in 1909. They exhibited together at the Gustav Pisko Galerie, Vienna, in December 1909 as the Neukünstler. The application of the term *Neukunst* may have been influenced by Ludwig Hevesi's book *Altkunst–Neukunst* (Vienna, 1909). Egon Schiele is credited with inventing the name 'Neukünstler'. He was not only one of the exhibitors but also author of an untitled manifesto (published in *Die Aktion*, 1914) that demanded the complete independence of the artist from tradition, and that preached subjective creativity as an absolute: 'The "Neukünstler" is and must be his unlimited self, he must be a creator, he must be able to build his foundations completely alone, directly, without all the past and the traditional Each one of us must be—himself'. The other artists who participated in the Neukünstler exhibition included Anton Faistauer (whose poster for the exhibition was derivative of Schiele), Franz Wiegele, Rudolf Kalvach, Albert Paris von Gütersloh and Hans Böhler (1884–1961). Like Schiele and Faistauer, Gütersloh was fascinated at that time by the gestural language of thin, young, male figures. Kalvach and Gütersloh, as far as can be seen from their few extant graphic works, shared a preference at the time of this exhibition for small-scale narratives similar to caricature.

The Neukünstler exhibition was the first public appearance of a group of artists of c. 20 years of age. Some of them had left the Akademie der bildenden Künste because of its rigid courses. Schiele and Gütersloh had already taken part in the *Internationale Kunstschau* exhibition of 1909. Unlike the Secession, however, the group lacked a concrete programme or an individual spokesperson.

Schiele's participation in the exhibition is significant as the occasion on which he first showed works that revealed his separation from Viennese *Jugendstil* aestheticism. His originality, which was soon to make him the principal exponent of Viennese Expressionism with Oskar Kokoschka, was at once recognized by the critic Arthur Roessler. In a long, enthusiastic review of

the exhibition, which led to their later friendship, he described Schiele as the foremost of the exhibitors and as 'unusually gifted'.

The term *Neukunst* was not applied again until 1912, when an exhibition of Austrian paintings and graphics was held at the House of Creative Artists in Budapest, organized by Gütersloh. This exhibition included works by Schiele, Gütersloh, Faistauer, Anton Kolig and Robin Andersen as well as works by Arnold Schoenberg and Kokoschka, important landmarks of early Austrian Expressionism. It is possible, however, that Kokoschka's works were presented separately from the rest. *Neukunst* remained a concept varying in meaning and used in specific cases, but undefinable in programmatic or structural terms. Roessler's volume of essays *Kritische Fragmente: Aufsätze über österreichische Neukünstler* (Vienna, 1918) covers artists of some heterogeneity, like the two exhibition groupings, with the emphasis, however, always on the work of Schiele.

Writings

A. P. von Gütersloh: 'Neukunst', *Pester Lloyd, Morgenblatt* (4 Jan 1912), pp. 1–3
A Neukunst Wien 1912 (exh. cat., preface A. P. von Gütersloh; Budapest, House Creative Artists, 1912)

Bibliography

C. M. Nebehay: *Egon Schiele, 1890–1918: Leben, Briefe, Gedichte* (Salzburg, 1979, rev. 2/1980/*R* Munich, 1983)
P. Werkner: *Physis und Psyche: Der österreichische Frühexpressionismus* (Vienna and Munich, 1986); Eng. trans. as *Austrian Expressionism: The Formative Years* (Palo Alto, 1993)

PATRICK WERKNER

New Artists' Society

Bulgarian association of artists active from 1931 to after 1944. Founded in 1931 in Sofia, its objective was to unite artists with similar aesthetic viewpoints who espoused new trends in art in keeping with movements in western Europe in the 1920s and 1930s. Its members enriched Bulgarian art by creating works with a sophisticated approach to style, a purity of form and a stable internal structure. From 1931 to 1937 the Society participated in all the exhibitions of the various artists' associations in Bulgaria. In 1934 it organized exhibitions in Sofia, Ruse and Zagreb, and in 1935 exhibitions of prints and drawings in Zagreb and Ljubljana and in Varna, Bulgaria. Although its first members worked primarily in a realistic manner, around 1936—when membership had grown to 55—other Bulgarian artists who had studied and worked in Paris, Munich and Vienna joined its ranks. Artists such as Alexandar Zhendov, Bencho Obreshkov, Boris Eliseev, Vera Nedkova, David Perets, Eliezer Alshekh, Ivan Nenov, Kiril Petrov and Kiril Tsonev contributed more modernist approaches, rejecting academic art, folkloric elements and especially the ideas of Socialist Realism put into practice by the founders of the Society. After 1944 the New Artists' Society was absorbed by the Union of Bulgarian Artists (*see* NATIONAL ART SOCIETY OF BULGARIA). Many of those who had been members of the Society were declared 'bourgeois artists' by the Communist regime and were no longer able to take part in exhibitions; several, including Alshekh, Eliseev and Perets, emigrated.

Bibliography

Exhibition of the New Artists' Society (exh. cat., Sofia, 1934)
Spring Exhibition of the New Artists' Society (exh. cat., Sofia, N. Acad. A., 1937)
S. Rusev: *Celebration of the 50th Anniversary of the New Artists' Society* (Sofia, 1981)

JULIANA NEDEVA-WEGENER

New Brutalism

Term coined by Peter Smithson in 1953 with reference to the design by Smithson and Alison Smithson for a school (completed 1954) at Hunstanton, Norfolk. It was intended as a counter to such terms as New Empiricism.

For fuller discussion *see* BRUTALISM.

☐

New Empiricism

Term coined in the 1950s by the editors of the *Architectural Review* to describe the compromise between traditional and modern domestic architecture developed in war-time Sweden for large-scale social housing. For fuller discussion *see* BRUTALISM.

☐

New English Art Club [NEAC]

English exhibiting society. The club was founded in 1886 by a generation of British artists who looked to France for their inspiration. They had originally intended to call themselves the 'Society of Anglo-French Painters'. They felt that their work was being neglected by the Royal Academy, and the club's constitution, based on the method of jury selection at the Paris Salon, ensured a more democratic selection procedure than at the Academy.

The club's first exhibitions were dominated by naturalist pictures inspired by Bastien-Lepage and other popular Salon painters who offered a diluted form of Impressionism; H. H. La Thangue and G. Clausen were among the exhibitors. However, in 1888 an Impressionist clique plotted a takeover. Led by Walter Sickert, a newcomer to the club, the members of this group modelled themselves on Degas and Monet and saw themselves as the truly 'progressive' artists. There was much in-fighting between this group and the more conservative faction headed by Stanhope Forbes and the Newlyn school. By 1890 the clique, now known as the 'London Impressionists', had a virtual monopoly of the NEAC committee. The Newlyn artists resigned *en masse* and several others, including the Glasgow Boys, followed suit.

Until the mid-1890s the most radical English painting was exhibited at the club. Théodore Roussel's *The Reading Girl* (1886–7; London, Tate) created a critical storm. This straightforwardly modern-day nude contrasted with the nudes at the Royal Academy which were permitted only by virtue of mythological or classical references. Philip Wilson Steer sent a number of pastel seascapes, distinguished by experimental handling

inspired by Monet and the Neo-Impressionists. The best of these works created a memorable image of naivety in their depiction of children playing by the seaside. Sickert preached an aesthetic based on the painting of modern life, and put it into practice in his depictions of London music-halls.

The 'London Impressionists' were supported by A. L. Baldry in the *Artist and Journal of Home Culture*, Dugald Sutherland MacColl in the *Spectator*, George Moore in the *Speaker*, Elizabeth Pennel in the *Star* and Frederick Wedmore in the *Academy*. By 1893 the first phase of English Impressionism was nearing an end and the club saw a certain diversification: a vogue for the 18th century and the English portrait painters Reynolds, Romney and Gainsborough; the popularity of Turner, Constable and English picturesque landscape; and a new enthusiasm for Spanish painting. The enthusiasm for the art of the past, affecting artists and critics alike, was seen in two new members, William Rothenstein and Charles Conder. As students in Paris they had moved in the *fin-de-siècle* circle of Louis Anquetin and Toulouse-Lautrec. However, by the turn of the century Conder was drawing on Watteau and the later minor masters of the 18th century, while Rothenstein experimented with Watteau-like pictures and was also attracted by 17th-century art. Roger Fry's faintly washed drawings also evoked the 18th century. A new sobriety replaced the feverishness of the 1890s. At the Slade School of Fine Art two stalwart NEAC members, Frederick Brown and Henry Tonks, urged their students, including Augustus John, Ambrose McEvoy and William Orpen, to pursue a classical tradition of craftsmanship. After 1900, however, the NEAC also served as a nursery for a number of secessionist groups, including the Fitzroy Street group centring on Sickert, the Bloomsbury painters, the Vorticists and the English Surrealists.

Among the NEAC's most distinguished recruits between the wars were Stanley Spencer (a member from 1919 to 1927), Edward Wadsworth (from 1921) and Paul Nash (from 1919). Gradually, however, the society lost its position as a forum for advanced art, attracting neither the later practitioners of Surrealism nor major figures associated with

forms of abstract art; instead, like the Royal Academy, it became a venue for the promotion of conservative traditions of British figurative painting.

Bibliography

C. Kains-Jackson: 'The New English Art Club', *Artist and J. Home Cult.*, xiv (1893), no. 161, pp. 99–111; no. 168, pp. 355–7

G. Moore: *Modern Painting* (London, 1893)

W. J. Laidlay: *The Origin and the First Two Years of the New English Art Club* (London, 1907)

F. Brown: 'Recollections', *A. Work*, vi (1930), pp. 269–78

A. Thornton: *Fifty Years of the New English Art Club* (London, 1935)

B. Laughton: *Philip Wilson Steer* (Oxford, 1971)

W. Baron: *Sickert* (London, 1973)

A. Gruetzner: 'Two Reactions to French Painting in Great Britain and Ireland', *Post-Impressionism: Cross-currents in European Painting* (exh. cat., London, RA, 1979), pp. 178–217

R. Billcliffe: *The Glasgow Boys* (London, 1985)

The New English Art Club Centenary Exhibition (exh. cat. by A. Robins, London, Christie's, 1986)

<div align="right">ANNA GRUETZNER ROBINS</div>

New Horizons [Heb. Ofakim Hadashim]

Israeli group of painters founded in 1948 around Yosseff Zaritsky after his dismissal from the chairmanship of the Israeli Association of Artists and Sculptors over his choice of artists for the Venice Biennale in that year. He and other founder-members such as Arie Aroch, Zvi Mairovich (1911–74), Yehezkel Streichman and Avigdor Stematsky, who first exhibited together in November 1948 at the Tel Aviv Museum, wished to free Israeli art from the Expressionist style and Jewish imagery and symbolism that it had inherited from the 1920s. Among the 30 painters contributing works to the first show were Marcel Janco, Yochanan Simon (1905–76) and Aharon Giladi (*b* 1907).

New Horizons aligned itself with the international modernist movement and espoused an abstract aesthetic in opposition to the figurative traditions prevailing in Israel. The group's first exhibition, however, included many figurative and even realist works, demonstrating the flexibility of its ideology. Heterogeneous though it was, the dominant and most important trend within the group was that represented by Zaritsky (e.g. *Yehiam*, 1951; Tel Aviv, Mus. A), Streichman, Stematsky and, to a lesser extent, by Aroch and Mairovich. These and other painters looked to the Ecole de Paris, especially to Picasso and Braque, for inspiration and developed a form of lyrical abstraction. Characterized by thickly applied paint on a broadly geometric armature, Stematsky's *Study* (1962; Jerusalem, Israel Mus.) is typical of this style. Though abstract in appearance by the 1960s, these paintings were invariably modelled on nature, often on landscape, as is clear from works of the 1950s such as Streichman's *Composition on a Maritime Theme* (1957; Jerusalem, Israel Mus.). The group exhibited annually from 1948 to 1963 with a constantly changing membership. Eventually divisions in the group became too great and a split developed between those looking to the Ecole de Paris and those more interested in other European and American developments. During and after its existence the New Horizons group proved most influential on Israeli art.

Bibliography

Yehezkel Streichman (exh. cat. by Y. Zalmona, Jerusalem, Israel Mus., 1987)

A. Barzel: *Art in Israel* (Milan, 1988)

New Topographics

Term first used by the American William Jenkins (1975 exh. cat.) to characterize the style of a number of young photographers he had chosen for the exhibition at the International Museum of Photography, Rochester, NY, in 1975. These photographers avoided the 'subjective' themes of beauty and emotion and shared an apparent disregard for traditional subject-matter. Instead they emphasized the 'objective' description of a location, showing a preference for landscape that included everyday features of industrial culture. This style, suggesting a tradition of documentary

rather than formalist photography, is related to the idea of 'social landscape', which explores how man affects his natural environment. Jenkins traced the style back to several photographic series by Edward Ruscha in the early 1960s of urban subjects such as petrol stations and Los Angeles apartments.

Followers of the style offered 'objective' descriptions of places such as motels, warehouses, suburban areas and parking lots. In their frank representation of commercial imagery, they demonstrated their links with Pop art and Photorealist painting, while in their use of every-day subject-matter and passive framing techniques they represented a photographic trend of the 1970s that employed as its preferred form snapshots rather than the more conventional artistic forms. Associated with the style were the photographers Robert Adams, Lewis Baltz, Joe Deal (*b* 1947), Frank Gohlke (*b* 1942), Nicholas Nixon (*b* 1947), Stephen Shore, John Schott (*b* 1944), Henry Wessel jr (*b* 1942) and the German photographers Bernd and Hilla Becher.

Bibliography
New Topographics: Photographs of a Man-altered Landscape (exh. cat., ed. W. Jenkins; Rochester, NY, Int. Mus. Phot., 1975)

MARY CHRISTIAN

New York Five

Term applied in the late 1960s and early 1970s to five architects practising in New York—Peter D. Eisenman, Michael Graves, Charles Gwathmey, John Hejduk and Richard Meier—whose work was the subject of an exhibition at MOMA, New York, in 1969 and subsequent publication *Five Architects* (1972). These architects were related at that time in their allegiance to the forms and theories developed by Le Corbusier in the 1920s and 1930s. This is most clearly seen in the work of Graves, Gwathmey and Meier (see fig. 32), while Hejduk was also strongly affiliated with Synthetic Cubism and Constructivism, and Eisenman was deeply influenced by the work of the Italian

32. Richard Meier: High Museum of Art, Atlanta, GA

Rationalist architect Giuseppe Terragni. Anticipating criticisms of this 'Twenties Revivalism', Colin Rowe challenged the idea of Modernism as the constant pursuit of originality by stating that the great revolutions in thought and form in the early 20th century were so 'enormous as to impose a directive that cannot be resolved in any individual life span' (Frampton and Rowe, 1972, p. 7). The most vehement critique of the work of the New York Five (referred to as the 'Whites') came in a group of essays, 'Five on Five' (1973), written by the architects Ronaldo Giurgola, Allan Greenberg (b 1938), Charles W. Moore, Jaquelin Robertson (b 1933) and Robert A. M. Stern (the 'Grays'), whose theoretical affiliation was with Robert Venturi and Vincent Scully. Denying the existence of a 'school' and very anxious to nullify the possibility of Corbusian Modernism as a major tendency in the 1970s, they attacked the Five's 'lack of concern with siting', the 'unusability' of their spaces and, particularly, their 'élitism and hermeticism'—their treatment of architecture as ' "high art", divorcing it from day to day life' (Robertson). The phenomenon of the New York Five is not to be seen as a school or movement but as a tendency signalling a deliberate reworking of early 20th-century Modernism in the face of a counter-tendency later defined as POST-MODERNISM. The work of the members of the New York Five subsequently developed in different directions.

Bibliography

K. Frampton and C. Rowe: *Five Architects: Eisenman, Graves, Gwathmey, Hejduk, Meier* (New York, 1972, rev. 1975)

R. Stern, J. Robertson, C. Moore, A. Greenberg and R. Giurgola: 'Five on Five', *Archit. Forum*, cxxxvii (1973), pp. 46–57

P. Goldberger: 'Should Anyone Care About the New York Five or their Critics, the Five on Five?', *Archit. Rec.*, clv/2 (1974), pp. 113–16

P. Eisenman and R. Stern, eds: 'White and Gray', *A & U*, 52 (1975), pp. 25–180 [special feature]

R. Haag Bletter: 'Contemporary Confrontations', *J. Soc. Archit. Hist.*, xxxviii/2 (1979), pp. 205–7

WALTER SMITH

Nieuwe beelding [Dut: 'new imagery']

Term used by Piet Mondrian and other artists associated with DE STIJL in the 1910s and 1920s. The search for the 'new imagery' was characterized by the use of the most basic elements of image-making: straight lines (horizontal and vertical), the primary colours and rectangular forms (see col. pl. II). The theosophist M. H. J. Schoenmaekers also used the term in writing about his central concepts in *Het nieuwe wereldbeeld* ('New world image'; 1915) and *Beeldende wiskunde* ('Visual mathematics'; 1916). The two uses of *nieuwe beelding* are not, however, related.

Bibliography

I. Rike: *Mondriaan's 'Nieuwe Beelding' in English* (Amsterdam, 1991)

N. H. M. Tummers, H. Jager and H. Matthes: *'Het beelden denken': Leven en werk van Mathieu Schoenmaekers* ['Plastic thinking': the life and work of Mathieu Schoenmaekers] (Baarn, 1992)

H. HENKELS

Noucentisme

Cultural movement that influenced all areas of artistic activity in Catalonia between 1908 and 1923. The term was coined by the philosopher Eugenio d'Ors, who used it to refer to a new '20th-century' spirit that he perceived in Catalan art at the beginning of the century. In a series of articles in periodicals d'Ors qualified as *Noucentistes* those artists and writers whose work in his opinion was characterized by a new sensibility, and the designation was established in 1911 with the publication of the *Almanac dels Noucentistes*, a collection of drawings and poems that had in common a reversion to classicism, a particular interest in urban life and a special concern for the determining aspects of private life. *Noucentisme* was influential in Catalan art for more than two decades and constituted a parallel movement to that of avant-garde art, towards which, however, it showed only a detached curiosity. *Noucentisme* encouraged a return to order and normality after the radicalism, bohemianism and individualism that had characterized some of the major figures

of modernism. Among painters, its leading exponents were Joaquím Sunyer, Jaume Mercadé (1887–1967), Francesc Galí (1880–1965) and (in their early work) Josep Torres García (1874–1949) and Joan Miró, while in sculpture the leading figures were Aristide Maillol, Manolo, Josep Clarà, Fidel Aguilar and, to some extent, Pablo Gargallo. In architecture, the classicizing aspects of the Vienna Secession (*see* SECESSION, §3) influenced Rafael Massó and Joseph Maria Pericas, while a stricter classicism marked the work of Adolf Florensa (1889–1968), Francesc Folquera (1891–1960), the brothers Ramón (1887–1935) and Josep (1886–1937) Puig Gairalt and Nicolau Maria Rubió i Tudurí (1891–1981). Other influences derived from *Modernisme*, the Catalan version of Art Nouveau, were introduced by such architects as J. Puig i Cadafalch and J. Torres Grau (1879–1945). *Noucentisme* also inspired the foundation of such cultural institutions as the Universitat Industrial, the Escola Nova, the Bernat Metge Foundation (for the translation into Catalan of Greek and Latin classics) and the Institut d'Estudis Catalans.

Bibliography

E. Jardí: *El Noucentisme* (Barcelona, 1980)
F. Fontbona and F. Miralles: *Del Modernisme al Noucentisme, 1888–1917* (Barcelona, 1985)
M. Peron, A. Suárez and M. Vidal: *Noucentisme i ciutat* (Madrid, 1994)

IGNASI DE SOLÀ-MORALES

Nouveau Réalisme

Movement of French and other European artists announced by the publication in Paris of a short manifesto of 27 October 1960, drawn up by the French critic Pierre Restany (*b* 1930) and signed by the original Nouveaux Réalistes. These were Arman, the French artist François Dufrêne (1930–82), Raymond Hains, Yves Klein, Martial Raysse, Daniel Spoerri, Jean Tinguely and the French artist Jacques de la Villeglé (*b* 1926).

The Nouveaux Réalistes were a loosely organized band of artists, working in a variety of media, but chiefly distinguished by their reaction against the prevailing aesthetic of Lyrical Abstraction or *Art informel*. In contrast to the abstract painters of the late 1940s and 1950s, the Nouveaux Réalistes favoured materials taken from everyday urban life. Their work can be seen as a response to the rise of an American-style, consumer society in post-war Europe, and as a reaction against abstraction it had much in common with that of Jasper Johns and Robert Rauschenberg, while their embrace of popular culture foreshadowed POP ART of the 1960s. But unlike Pop artists, Nouveau Réalisme showed little interest in painting; in fact Klein was its only painter (see col. pl. XXVII). In its concern with assemblage and ready-mades, Nouveau Réalisme owed something to Kurt Schwitters and Marcel Duchamp as well as to the Surrealists' taste for walking around Paris.

Perhaps the most characteristic works of Nouveau Réalisme were the *décollages* of Dufrêne, Hains, de la Villeglé and Mimmo Rotella. Termed *affichistes* (Fr. *affiche*, poster), they took as their material found street and subway posters that had been torn and spoilt by passers-by. The earliest *décollage*, *Ach Alma Manetro*, was 'created' by Hains and de la Villeglé in 1949, but they did not begin to exhibit *décollage* until 1957. Rotella had discovered *décollage* independently in Rome in the mid-1950s. In contrast to Hains and de la Villeglé, who left the lacerated posters untouched, Rotella and Dufrêne took the liberty of improving on their found material, scraping, tearing and gluing to create new compositions. Although *décollage* often stressed the formal properties of torn posters, it was a medium capable of surprising sociological resonance, as witnessed by Hains's exhibition *La France Déchirée* (Paris, Gal. J, 1961) which contained posters reflecting the French reaction to the war in Algeria.

The first official Nouveau Réalisme exhibition, for which the manifesto of October 1960 was drawn up, was at the Galerie Apollinaire in Milan in 1960. Other important exhibitions included *A 40° au-dessus de Dada* at the Galerie J in Paris in May 1961 and *The New Realists* (which included James Rosenquist, Roy Lichtenstein and Andy Warhol) at Sidney Janis Gallery in New York in October 1962. Noteworthy one-man exhibitions

included Klein's *Le Vide* (1958), in which he presented a completely empty space at the Galerie Iris Clert in Paris. A few years later Arman responded with *Le Plein*, filling the same gallery from floor to ceiling with detritus from the street. In 1961 Galerie J mounted *Feu à Volonté*, in which visitors were invited to fire rifles at the assemblages of Niki de Saint Phalle, the only woman in the group, later known for her large, brightly coloured sculptures of human figures.

Arman worked with various forms of accumulation, such as his *Dustbins* series, where he emptied the contents of wastebaskets into boxes of clear glass or plastic. He created a series of 'portraits' by enclosing various personal effects of his subjects in such boxes. Similar in spirit were the *tableaux pièges* (trap pictures) of Spoerri, who created his first sculptures by gluing down every item on his dinner table at the end of a frugal meal. These tabletops were then hung on the wall, as literal, gravity-defying still-lifes. The *tableaux pièges*, at first largely embodiments of the modest circumstances of Spoerri's life in a Left Bank hotel, gradually incorporated items bought at flea markets and left-overs from gallery banquets organized by him.

Tinguely followed a direction only obliquely allied to Nouveau Réalisme as he set about constructing a variety of machines using scrap metal and old motors. His most notorious work of the time was *Homage to New York*, a huge set of machines designed to self-destruct as sensationally as possible, which they did in the garden of the Museum of Modern Art in New York in 1960. Other less central members included César and Christo. César's *Compressions* were sculptures created at scrap metal yards by crushing car bodies and other industrial scrap into cubes. Christo came closest to Nouveau Réalisme with his magazines wrapped in transparent plastic, although *Iron Curtain—Wall of Oil Barrels, 1961–1962* (1962), a wall of oil drums blocking off the Rue Visconti in Paris, suggests the *affichistes*' fascination with the street as well as Tinguely's and César's taste for industrial materials. The French artist Gérard Deschamps (*b* 1937) made collages from swirls of cloth, women's scarves, curtains and old corsets. His promising early works, which were the only Nouveau Réaliste works to engage the history of French painting, were overshadowed by his subsequent decision to withdraw from the art world.

The work of Klein, the unofficial leader of the group, paradoxically had little to do with the Nouveau Réaliste aesthetic. His monochrome canvases, painted with a royal blue he called 'International Klein Blue', seemed more concerned with artistic metaphysics than with consumer society; however, his charismatic personality and flair for flamboyant public actions helped galvanize and popularize Nouveau Réalisme. In his brief career he sought out a number of unorthodox methods of creating paintings. His *Anthropométries* used naked female models as 'living paint brushes' while the *Feu* series was made with a powerful flame-thrower. Other works contained sponges saturated with 'International Klein Blue'. His non-painterly activities included publishing a doctored photograph of himself diving into a street from a high wall and selling invisible (non-existent) works of art that he called 'zones of pictorial immateriality'.

Raysse's work of the early 1960s consisted of new consumer items, usually of brightly coloured plastic, which he displayed with a minimum of intervention. Some of his works, such as *Raysse Beach* at the *Dylaby* exhibition at the Stedelijk Museum in Amsterdam (September 1962), resembled nothing so much as department stores. His work of the mid-1960s, wall pieces using colour photographs, neon and plastic, came closest of all the Nouveaux Réalistes' creations to American and British Pop art.

In the wake of Klein's untimely death in 1962, and also due to the international success of American Pop art, the Nouveaux Réalistes drifted apart, but despite its short collective life (1960–63), Nouveau Réalisme was perhaps the major European art movement between 1945 and 1980.

Bibliography

Zero, iii (July 1961) [contains texts by Klein, Spoerri and Tinguely]

D. Spoerri: *Topographie anecdotée du hasard* (Paris, 1962; Eng. trans., New York, 1966)

Christo, ed.: *KWY 11* (Spring 1963) [special issue on Nouveau Réalisme]

L. Lippard: *Pop Art* (London, 1966), pp. 174–7

P. Restany: *Les Nouveaux Réalistes* (Paris, 1968); rev. as *Le Nouveau Réalisme* (Paris, 1978)

Beautés Volées: Dufrêne, Hains, Rotella, Villeglé (exh. cat. by B. Cesson, Saint-Etienne, Mus. A. & Indust., 1976)

1960: Les Nouveaux Réalistes (exh. cat., ed. B. Contensou; Paris, Mus. A. Mod. Ville Paris, 1986)

M. R. Rubinstein: 'Europa Resurgent: Objects and Activities of the Nouveaux Réalistes', *A. Mag.*, lxiii (September 1988), pp. 68–75

J. de la Villeglé: *Jacques de la Villeglé: Catalogue thématique des affiches lacerées*, 14 vols (Paris, 1989)

M. Livingstone: *Pop Art: A Continuing History* (London, 1990), pp. 47–56

A. Pacquement: 'The Nouveaux Réalistes: The Renewal of Art in Paris around 1960', *Pop Art* (exh. cat., ed. M. Livingstone; London, RA; Cologne, Mus. Ludwig; Madrid, Cent. Reina Sofia; 1991–2), pp. 214–18

MEYER RAPHAEL RUBINSTEIN

Nouvelle Tendance

Title of a series of exhibitions held in Europe in the 1960s. The first of these, a result of the initiative of the Yugoslav critic Matko Meštrović, took place at the Galerija Suvremene Umjetnosti in Zagreb in 1961, under the title *Nove Tendencije*, and brought to light the common bond among young contemporary artists working broadly within the Constructivist tradition in Eastern and Western Europe. For the first time since the 1920s there was a widely based movement transcending national frontiers, which was working to counter romantic and individualistic notions of artistic practice, and place the scientific notion of 'research' in the foreground. Among the artists contributing to this first exhibition were the Groupe de Recherche d'Art Visuel of Paris, Gruppo N of Padua and Gruppo T, which comprised an international cross-section of artists including Gerhard von Graevenitz from the Netherlands and Richard Lippold from the USA.

Although no strict programme was initially implied in the launching of the exhibitions, most of the participants were in agreement over their general attitudes. Writing in the introduction to the catalogue to the *Nouvelle Tendance* exhibition in Paris in 1964, the Swiss artist Karl Gerstner (*b* 1930) mentioned several points in common: in particular, emphasis was laid upon the need to demystify the work of art and involve the spectator as a participant, and works were conceived in such a way as to lend themselves to multiple production on an industrial basis. In the later part of the decade, the emphasis turned increasingly to the use of computers in generating graphic imagery.

Bibliography

Nouvelle Tendance (exh. cat., intro. K. Gerstner; Paris, Mus. A. Déc., 1964)

F. Popper: *Origins and Development of Kinetic Art* (London, 1968)

STEPHEN BANN

Novecentismo

Term used to describe the work of a group of young architects in Milan after World War I who responded to the post-war 'call to order' (*see also* NOVECENTO ITALIANO). The four original collaborators were Giovanni Muzio, Mino Fiocchi (1893–1983), Emilio Lancia (1890–1973) and Gio Ponti, joined later by Aldo Andreani (1887–1971), Giuseppe De finetti, Gigiotto Zanini, Piero Portaluppi (1888–1976), Pino Pizzigoni (1901–67) and others. Inspired by Milanese Neo-classicism, they proposed an architecture that would be recognizably Italian, although more disciplined than *fin-de-siècle* Italian eclecticism. Their ideas were linked with the aims of metaphysical painters such as Giorgio de Chirico. Thus, unlike the Futurists, they favoured the symbolic use of historic elements, while admitting new concepts in spatial design and building technology at a practical level, although not as generators of form. Ideologically moderate, the protagonists of *Novecentismo* expressed themselves through buildings rather than the written or spoken word. Muzio was the most important and prolific of the *Novecentismo* architects, and his oeuvre characterizes the development of the movement.

There were two phases of *Novecentismo*. In the first, corresponding roughly with the 1920s, elements of classical origin, including framed windows, recessed arcuated panels and shallow niches, were used in conjunction with varied surface treatments often in non-repetitive or asymmetrical arrangements. The effect was to suggest what Etlin has called a 'flat, thinly layered ornamentation' that accentuated rather than destroyed the planar qualities of the external walls. The canonical example of this phase is Muzio's private apartment building in Milan's Quartiere Moscova, the Ca' Brutta (1919–22). Lancia and Ponti worked together in this genre, as did Portaluppi and Andreani, although the highly original work of the last-named is less easily categorized. By the mid-1920s, however, adherence to *Novecentismo* by such architects as Finetti and Pizzigoni, influenced by Adolf Loos and other Europeans, tinctured with Neue Sachlichkeit images, was already pointing the way to *Razionalismo* (*see* RATIONALISM).

Muzio (with the painter Mario Sironi) was responsible for the stylistic culmination of the decorative phase of *Novecentismo* in the spectacular interior conversion of Giuseppe Piermarini's Villa Reale (1780) for the Esposizione Internazionale di Arti Decorativa (1930), Monza, as well as for the most obviously transitional building leading to the second phase of the movement, the administration building (1928–9) of the Università Cattolica del Sacro Cuore, Milan. Etlin has called it geometrical Novecento: the surface layer of classical features was dropped in favour of shallow-panelled walls with piers and recesses marking structural bays and floor-levels—the hallmarks of a long series of buildings throughout the 1930s by Muzio, Ponti, Portaluppi, Lancia, Zanini and others. This tendency began to merge with *Razionalismo* as early as 1933 in such buildings as Ponti's Casa Marmont, Milan. Surface ornamentation continued in geometrical forms, for example receding chamfered window surrounds, often in combination with such features of classical origin as vestigial cornices and friezes where context demanded, as in Lancia's mixed-use buildings (1935) on the corner of Corso Mateotti and the Via Monte Napoleone.

Novecentismo, which ran parallel with *Razionalismo* from the mid-1920s, was under reassessment in the late 20th century for its proto-Post-modern, as well as its proto-modern characteristics, but, as Doordan suggested, it 'must be assessed in its own terms . . . [as a] specific tectonic expression . . . the articulation of mural surfaces' (p. 44).

Bibliography

G. Muzio: 'Alcuni architetti d'oggi in Lombardia', *Architettura in Italia 1914–1943: Le polemiche*, ed. L. Patetta (Milan, 1972), pp. 78–85

F. Zeri, ed.: *Il novecento* (1982), II/iii of *Storia dell'arte italiana* (Turin, 1979–82)

Precursors of Post Modernism: Milan, 1920–1930s (exh. cat. by F. Irace, New York, Architectural League of New York, 1982)

D. P. Doordan: *Building Modern Italy: Italian Architecture, 1914–1936* (New York, 1988), pp. 29–44

A. Burg: *Novecento Milanese: I novecentisti e il rennovamento dell'architettura a Milano fra il 1920 e il 1940* (Milan, 1991)

F. Dal Co and S. Polano, eds: '20th-Century Architecture and Urbanism: Milano', *A + U* (Dec 1991) [supernumerary issue], pp. 65–98

R. A. Etlin: *Modernism in Italian Architecture, 1890–1940* (Cambridge, MA, and London, 1991), pp. 165–224, 329–76

JOHN MUSGROVE

Novecento Italiano

Italian artistic movement. It grew out of an association of seven artists at the Galleria Pesaro in Milan in 1922, who were brought together by a post-war European tendency of a 'call to order': Anselmo Bucci (1887–1955), Leonardo Dudreville (1885–1975), Achille Funi, Gian Emilio Malerba (1880–1926), Piero Marussig, Ubaldo Oppi and Mario Sironi. Together with their leader, Margherita Sarfatti, writer and art critic for Mussolini's newspaper, the *Popolo d'Italia*, they aimed to promote a renewed yet traditional Italian art. Bucci suggested the name Novecento, which identified the group with a series of illustrious epochs (Quattrocento, Cinquecento) in Italian art history, each with specific stylistic connotations.

The choice was not entirely presumptuous, despite the fact that the 20th century had barely begun, for the group represented a vote of confidence in their times and linked the great art of the past to their own.

The group's first exhibition was held at the Galleria Pesaro in 1923; Mussolini gave the inaugural speech, in which he acknowledged the relation of culture to politics but declared 'far be it from me to encourage something which could be identified as State art'. After the group exhibited together at the Venice Biennale in 1924, it became apparent to Sarfatti that the generic formula of the Novecento could incorporate other Italian artists and possibly lead to the identification of a national art.

The promotion of nationalism by the Fascists during their steady consolidation of power in the 1920s was paralleled by the directive committee organized by Sarfatti to head the Novecento Italiano after the disbanding of the original group early in 1925. The committee's main function was to organize a series of major exhibitions both at home and abroad that would underline the 'eternal' qualities of Italian art (precision, rigorous tectonic structure, classical Mediterranean clarity) and to reclaim its natural hegemony. The members left from the original group (Sironi, Funi and Marussig) were joined by cultural and political figures such as Arturo Tosi (1871–1956) and the sculptor Adolfo Wildt, with Alberto Salietti (1892–1961) as secretary. *La prima mostra del Novecento italiano* was held in the Palazzo della Permanente, Milan, in 1926. Mussolini was again invited to open the exhibition that, in Sarfatti's words, sought to 'bring together for the unselfish purpose of promoting beauty and work, the best artists of the new generation, whose work carries the imprint of an industrious and noble spiritual *travail*'. Despite the success of many exhibitions held abroad and the second major exhibition at the same venue in Milan in 1929, by the late 1920s the Novecento Italiano had assembled so many varied artists under its umbrella that it lacked coherence and strength as an artistic movement. It was severely attacked by both critics and former members for different and contradictory reasons.

For a long time Novecento Italiano was simplistically equated with Fascist art. Though it failed as a visual art movement, its impact was felt on other artistic endeavours; the literary magazine *900* directed by Massimo Bontempelli (1878–1960), although of a very different nature, owed both its name and its genesis to the Novecento. The movement's influence was also felt in the architectural style prevalent in Italy in the 1920s and exemplified by Giovanni Muzio's Ca' Brutta, Milan (1919–23); it also led to *novecentismo* in the decorative arts, a style related to the French Art Deco.

Bibliography

La prima mostra del Novecento italiano (exh. cat., preface M. Sarfatti; Milan, Pal. Permanente, 1926)

La seconda mostra del Novecento italiano (exh. cat., Milan, Pal. Permanente, 1929)

F. Tempesti: *Arte dell'Italia fascista* (Milan, 1976)

R. Bossaglia: *Il 'Novecento italiano' storia, documenti, iconografia* (Milan, 1979)

La metafisica: Gli anni venti (exh. cat., Bologna, Gal. A. Mod., 1980)

Gli anni trenta: arte e cultura (exh. cat., Milan, Pal. Reale, 1982)

Il 'Novecento italiano' 1923–33 (exh. cat., ed. R. Bossaglia; Milan, Pal. Permanente, 1983)

SIMONETTA FRAQUELLI

November Group

Finnish group of painters who first exhibited in November 1917. Though the two groups co-existed for some time, the November Group was effectively the successor to the SEPTEM GROUP, representing a nationalist Expressionist art in contrast to the international Impressionist and Neo-Impressionist art of the latter. Its leader was Tyko Konstantin Sallinen, and other members included Marcus Collin (1882–1966), Alvar Cawén (1886–1935), Jalmari Ruokokoski (1886–1936) and William Lönnberg (1887–1949). The group exhibited between 1917 and 1924, though even before this, largely through the impact of Sallinen's work, Expressionism had become established in Finnish art.

As the group's leader, Sallinen was against propagating any specific aesthetic and there was consequently a fair diversity of styles, some members being influenced more by Cubism or the Septem style than Expressionism. Nevertheless, by the time the group was established, Sallinen had adopted an austere Expressionist style using dark colours and this became the dominant and most important style in the group. Most of the artists drew their subjects from specifically Finnish life and culture, characteristic works being Sallinen's *The Barn Dance* (1918; Helsinki, Athenaeum A. Mus.) and Ruokokoski's portrait of *T. K. Sallinen* (1921; Helsinki, Athenaeum A. Mus.).

Bibliography

J. B. Smith: *Modern Finnish Painting* (London, 1970)
M. Levanto: *Ateneum Guide* (Helsinki, 1987)

□

Novembergruppe

Group of German artists named after the German Revolution of November 1918, founded in Berlin on 3 December 1918 and active until 1932. In the wake of World War I and the German Revolution, a number of Expressionist artists including Max Pechstein and César Klein invited all the 'revolutionaries in spirit (Expressionists, Cubists, Futurists)' to form an association of 'radical creative artists'. Their intention was not to form an exhibition society but to influence and demand participation in all activities of importance to the arts and to artists: in architecture as a public affair; in the reorganization of art schools; in the restructuring of museums; in new exhibition spaces; and in new laws to protect the arts and artists. A hope for a new and better society, a tendency towards socialism and a belief that the arts would be able to change society formed the Expressionist basis for the association.

Chapters of the Novembergruppe were founded in many German cities, including Dresden, Halle, Magdeburg, Bielefeld and Karlsruhe. Writers, architects, composers and musicians joined, and in 1919 the group published an important pamphlet, *An alle Künstler*, with a cover by Max Pechstein, a drawing by César Klein of a symbolic Phoenix, a poem by Johannes R. Becher and contributions by Ludwig Meidner, Walter Hasenclever, Kurt Eisner and others. An anonymous call for socialism was echoed by Meidner's statement that to support socialism meant to stand 'for justice, freedom and love of mankind—for God's order in this world'. The group organized large exhibitions (e.g. in 1919 and 1920 at the Lehrter railway station in Berlin), parts of which toured to many cities and towns.

Although public reaction to the Novembergruppe's modern art forms was hostile at first, the continuous exhibition activities and their accompanying lectures gained adherents. In the years leading up to the group's dissolution the radicalism of both the art and the group's political stance diminished, and the Novembergruppe became merely an exhibiting society; the political left represented by Otto Dix, George Grosz and Raoul Hausmann attacked the group for the betrayal of its revolutionary goals. To promote all the arts and strengthen the coherence of the group, balls and other entertainment evenings were held. The group published *Der Kunsttopf* and *NG* and graphic portfolios. Performances of modern music were held and poets were invited to read from their works. Until its dissolution in 1932 the Novembergruppe was an important cultural factor in Berlin and partially responsible for the growing acceptance of modern art.

Bibliography

W. Grohmann: 'Zehn Jahre Novembergruppe', *Kst Zeit*,
 iii/1–3 (1928)
H. Kliemann: *Die Novembergruppe*, Bildende Kunst in
 Berlin, iii (Berlin, 1969)

PETER W. GUENTHER

Nul [Dut.: 'Zero']

Group of Dutch artists founded at the end of 1960 by Armando, Jan Henderikse (*b* 1937), Henk Peeters (*b* 1925) and Jan Schoonhoven as a continuation of the Informele Groep to which the same artists

had belonged with Kees van Bohemen (1928–85). It was named after its German counterpart, the ZERO group, whose members Peeters met in 1960 and with whom Nul exhibited frequently. The exhibition *Monochrome Malerei* (1960; Leverkusen, Schloss Morsbroich) played a part in the birth of Nul. The group was a reaction against the expressionism of the 1950s. The artists turned against the expression of emotion through painterly means. In place came an attempt to represent space by means of uniform monochrome fields of colour, as seen in the work of Yves Klein, whom Peeters had met in 1960, and to manifest rational arrangement by composing objects and materials in series. A work of art was not allowed to be an illusionistic representation of reality but should be a reality itself. This is evident from the actual works: Armando's nuts and bolts welded on to plates, inspired by the welding techniques in shipbuilding; the changing light and shadow play in the white reliefs of Jan Schoonhoven; the series of *objets trouvés* by Henderikse; the smoke-paintings of rain, snow and fog by Peeters.

In April 1961 the manifestos *Manifest tegen Niets* ('Manifesto against nothing') and *Einde* ('End') were published, in which the group declared: 'A painting is as much worth as no painting. An installation is as good as no installation'. Piero Manzoni also signed these manifestos. In November 1961 the magazine *Nul=o* was published. Nul exhibited together with Gruppo T and Gruppo N and the Groupe de Recherche d'Art Visuel at the exhibition *Nove Tedencije* in Zagreb in 1961 and 1963. In 1962 a *Nul* exhibition was organized at the Stedelijk Museum in Amsterdam. Work was also submitted by Gruppo T, the Gutai group, Yves Klein, Yayoi Kusama (*b* 1929) and Jesús Rafael Soto. The majority of Nul's members saw this exhibition as the end of the group.

Bibliography

Nul (exh. cat., Amsterdam, Stedel. Mus., 1962)
Nul en Zero (exh. cat., The Hague, Gemeentemus., 1964)
'60–'80 Attitudes/Concepts/Images (exh. cat., Amsterdam, Stedel. Mus., 1982)

JOHN STEEN

Objective Abstraction

Term applied to the work of a group of British artists in the 1930s. It was used after the exhibition *Objective Abstractions* was held at the Zwemmer Gallery, London, from March to April 1934. Seven painters participated: Rodrigo Moynihan, Geoffrey Tibble (1909–52), Graham Bell, Victor Pasmore, Ceri Richards, Thomas Carr and Ivon Hitchens; Edgar Hubert (*b* 1906) and William Coldstream were also members of the group (although they did not exhibit on this occasion), and with Moynihan, Tibble and Bell were the only truly abstract painters at the time. All, however, as indicated by their answers to a 'questionnaire' published in the catalogue, were united in their rejection of the geometric abstraction espoused by much of the European avant-garde in the 1930s and in their belief in an art, inspired initially by nature, that would develop according to an unpredictable internal logic of its own.

The late work of J. M. W. Turner and of Claude Monet was a major inspiration. *Objective Abstraction* (*c.* 1935–6; London, Tate) by Moynihan is a typical example of the style. By 1937, however, under the influence of the political climate, Moynihan, Tibble, Bell, Pasmore and Coldstream had reverted to figuration, primarily of a social realist nature, and they became part of the Euston Road School. Nevertheless, Objective Abstraction can be seen as a precursor of the gestural abstraction of much post-war British painting.

Writings

Objective Abstractions (exh. cat. by V. Pasmore, R. Moynihan, G. Tibble, G. Bell and others, London, Zwemmer Gal., 1934)

MONICA BOHM-DUCHEN

Omega Workshops

English applied arts company based in London. It was founded by Roger Fry in 1913 and lasted until 1919. The company produced ceramics, furniture, carpets and other textiles, designed and made by Fry, Duncan Grant, Vanessa Bell, Henri Doucet (1883–1915), Henri Gaudier-Brzeska, Winifred Gill (1891–1981) and Nina Hamnett. The name Omega

Workshops was first mentioned in Fry's circular letter of 11 December 1912 sent out as a financial appeal. Wyndham Lewis may also have been involved in the founding of the Workshops. Of the various explanations of the name the most common is that it implied the products to be the 'last word' in design (Ω being the last letter of the Greek alphabet).

Having raised sufficient capital, Fry leased 33 Fitzroy Square in London as the base for the Omega Workshops in March 1913. It was then registered as a limited company on 14 May 1913 with Fry, Bell and Grant as co-directors. Among the other artists associated with the Workshops at the beginning were Wyndham Lewis, Cuthbert Hamilton, Edward Wadsworth, Frederick Etchells and his sister Jessie Etchells (1892–1933). These artists left on 5 October 1913 after a dispute between Wyndham Lewis and Fry over the Omega Workshops' entry to the Ideal Home Exhibition, which opened in London later that month. The split led Wyndham Lewis to found the Rebel Art Centre and shortly afterwards the Vorticists. Other artists later joined the Omega Workshops, although association was largely informal.

While interested in the idea of communal artistic activity, Fry was more concerned with aesthetic, rather than social, reform and hoped that the Workshops might overcome philistinism in Britain. He also pragmatically viewed the Workshops as a means of income for avant-garde artists. One of his main aims was to apply the aesthetic of Post-Impressionism and Fauvism to the decorative arts. In contrast to the moral earnestness of the late 19th-century British design guilds, Fry also wished the products to exude a joyful lightheartedness derived from the artist's free expression. Fry's hostility to William Morris's idea of craft perfection was reflected in the largely amateur craft skills of the Omega Workshops' artists. Broadly, Fry was inspired by the work of the Wiener Werkstätte and Paul Poiret's Atelier Martine rather than that of 19th-century English designers.

Products from the Omega Workshops are stamped or painted with an Ω mark alone, although from style or medium the artist can often be determined. Objects could be either bought from stock or custom-made. Most were made at Fitzroy Square although complex objects, for example marquetry furniture, were made by outside firms. The influences of Post-Impressionism and Fauvism are evident in such works as Bell's four-part screen *Bathers in a Landscape* (1913; London, V&A), decorated with simplified figures in a landscape. Like most Omega Workshop artists, Grant alternated between the abstract and the figurative in his designs: the rug he produced for the Ideal Home Exhibition (1913; London, V&A), for example, has a geometric design; the swimmer and fish pattern on one of his pencil-boxes (1913; London, V&A) is equally characteristic. Bell also produced carpets with abstract motifs (e.g. 1914; London, V&A). Fry specialized in ceramics and produced, for example, a buff-coloured tureen with a lid (earthenware, white tin glaze, 1914–15; London, V&A). In 1914 the Workshops' artists were also commissioned to decorate the interior of the Cadena Café (destr.), 59 Westbourne Grove, London, with a scheme that incorporated a large abstract mural. The furniture frequently included marquetry designs, for example Fry's 'Giraffe' marquetry cupboard (c. 1915; untraced; see Collins, pl. VI). From May 1915, at Bell's suggestion, dresses were also made. Books were published in limited editions, for example 75 copies of the [15] *Original Woodcuts by Various Artists* (Dec 1918; copy in London, V&A), which includes work by Fry, Bell, Grant and E. McKnight Kauffer. The premises at Fitzroy Square also served as an exhibition space, and sketches by Mikhail Larionov were exhibited there in February 1919.

Throughout its existence the Omega Workshops struggled financially, despite a small band of devoted customers. By mid-1919 it was forced to close and, following a sale of stock in June and July 1919, the premises were cleared by September 1919. The company was not officially liquidated until 24 July 1920.

See also BLOOMSBURY GROUP.

Bibliography

I. Anscombe: *Omega and After: Bloomsbury and the Decorative Arts* (London, 1981)

J. Collins: *The Omega Workshops* (London, 1983)

The Omega Workshops: Alliance and Enmity in English Art, 1911–1920 (exh. cat. by P. Diamand and J. Collins, London, Anthony d'Offay Gal., 1984)

The Omega Workshops, 1913–19: Decorative Arts of Bloomsbury (exh. cat. by F. MacCarthy, London, Crafts Council Gal., 1984)

☐

Op art

Term used as an abbreviation of 'optical art' to refer to painting and sculpture that exploits the illusions or optical effects of perceptual processes. It was used for the first time by a writer in an unsigned article in *Time* magazine (23 Oct 1964) and entered common usage to designate, in particular, two-dimensional structures with strong psychophysiological effects. The exhibition, *The Responsive Eye*, held in 1965 at MOMA, New York, under the direction of William C. Seitz, showed side by side two types of visual solicitations already practised by artists for some time: perceptual ambiguity created by coloured surfaces, then at the fore in the USA, and the coercive suggestion of movement created by lines and patterns in black and white, used abundantly by European artists engaged in KINETIC ART. The outstanding Op artists included Victor Vasarely, Bridget Riley, Jesús Soto, Yaacov Agam, Carlos Cruz-Diez, Julio Le Parc and François Morellet.

The origins of Op art can be traced from both the art-historical tradition and from popular art, in particular from ornament, *trompe l'oeil* and anamorphosis. The antecedents of Op art in terms of graphic effects and coloured interaction may be found in the works of the Post-Impressionists, Futurists, Constructivists, Dadaists and above all in the artistic and didactic statements of the masters of the Bauhaus. Links with psychological research can also be established, in particular with Gestalt theory and with discoveries in psychophysiology. Op artists thus managed to exploit various phenomena: the after-image and consecutive movement; line interference; the effect of dazzle; ambiguous figures and reversible perspective; successive colour contrasts and chromatic vibration; and in three-dimensional works different viewpoints and the superimposition of elements in space.

Vasarely began working with graphic elements on the surface plane before superimposing them on transparent materials in order to obtain subtle visual effects. His binary structures (from 1952) were already at the centre of what was only later called 'Op art'. It was, however, only the introduction of colour to his 'plastic unities' that revealed their inner relationships: another geometrical form in a different colour or hue is added to the basic element, generally a square acting as a background, giving an infinite number of possible combinations. These works, as well as the large-scale 'algorithms' of the *Planetary Folklore* series, were in Vasarely's view not only to be considered as stepping-stones towards an application in architecture and town planning (discussed in *Victor Vasarely Farbstadt/Polychrome City*, Munich, 1977), but also as a structuralist programme for use in the area of cybernetics.

From 1961 Riley obtained strong black and white effects, for example in *Blaze* (1964; London, Tate; see fig. 33). Geometric units such as squares, triangles and circles were depicted in such ways that their distortions set up a definite rhythm. The optical spasms that result from this often allude to energy and to psychological phenomena, perhaps emanating from the unconscious. Later Riley moved away from the sharp contrasts of black and white, which created a fluctuating or 'active' space and strong light effects, towards tonal variation and eventually to colour contrast.

Soto's research into optical vibrancy began in 1952 when he experimented with various chromatic and luminous elements distributed over the surface before he arrived at the moiré effect, which he favoured as a means of making solid objects such as wire structures appear to dissolve. The effect was often enhanced by mobile wooden or metal rods, often of different colours, suspended by string before a striped background. This evolution towards space and towards a cosmological approach was developed further in the late 1960s in the series of *Penetrables*, where he appealed to both the tactile and optical senses of the spectator or participant. These works, comprising spaces filled with suspended metallic

strips or nylon strings through which the spectator walked, were intended to represent the totality of relations in the world.

Agam similarly constructed works that depended on the spectators' participation. He used musical terminology such as 'contrapuntal' and 'polyphonic' when naming his works. In this way he was trying to reach beyond the time-scale implicit in traditional music, regarding mere duration as infinitely less rich than the dynamic, irreversible and unforeseen quality of time that is involved in his transformable paintings. Agam's notion of time centred upon the concepts of irreversibility and the simultaneity of acts and events in nature in which he saw true 'unity', a word that testifies to his profound knowledge of Hebrew spirituality. With this principle in mind he set out to create an art that existed only in the realm of the possible—the virtual—which is one of the main characteristics of Op art.

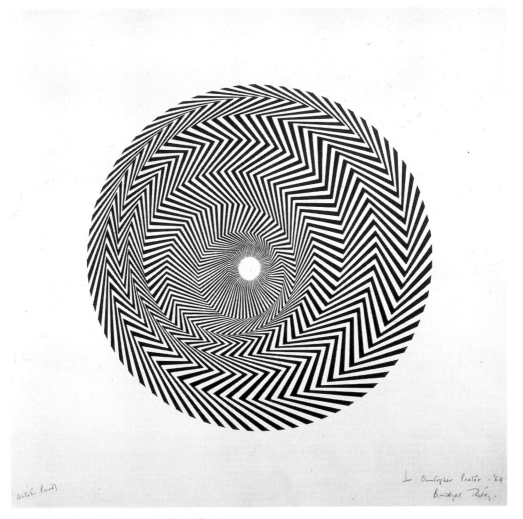

33. Bridget Riley: *Blaze*, 1964 (London, Tate Gallery)

In his *Physichromies* (from 1959) Cruz-Diez applied a theory of additive colours, combining a technique of regularly spaced card strips with earlier experiments with colour. He achieved a subtle interaction between the very intensereflections from the surfaces turned towards the spectator and the effects of expanding colour recorded upon the surfaces adjacent to the pigment. This allowed him in later environmental works to undertake an analysis of colour in confined spaces in order to induce successive situations that are themselves liable to give rise to chromatic events.

Through their roles in the Groupe de recherche d'art visuel, Le Parc and Morellet already had the development of a new visual situation as an ultimate objective; their interest lay exclusively in the object/eye relationship rather than in the object considered for its intrinsic plastic properties. Le Parc began his research in works that he called 'surface-sequences', in which he sought to obtain effects of progression and juxtaposition by decreasing the diameter of successive black and white circles, by using similar sequences with a range of 12 (later 14) colours, or by gradually inclining a line in a clockwise or anticlockwise direction. When traced by the spectator's eye, these surface-sequences gave rise to new and surprising structures. The *Grids* of Morellet also gave the impression of curves although they were built up from a rigorous pattern of straight lines. Both Le Parc and Morellet subsequently undertook an impressive number of experiments with mobiles, light and environmental structures, often aiming at a total implication of the spectator in the aesthetic process, yet never abandoning their initial preoccupation with optical relationships.

In the USA the beginnings of Op art, in particular the chromatic element, were dominated by the work of Josef Albers. Although the picture surface in his *Homage to the Square* series is not disrupted, some perceptible changes of colour do occur. American artists such as Frank Stella, Larry Poons and Richard Anuskiewicz developed this research for a time by means of periodic structures, surface modulation and chromatic vibrations before evolving towards reductionism and Minimal art.

Although Op art must be considered in its entirety as an ephemeral art trend, it has nevertheless had some permanent effects on the perceptual qualities of the spectator, on the relationship between artists, architects and town planners and on the systematic application of optical phenomena in technologically highly-developed art forms.

Bibliography

Le Mouvement (exh. cat. by R. Bordier, K. Hulten and V. Vasarely, Paris, Gal. Denise René, 1955) ['Yellow Manifesto']

Arte programmata (exh. cat. by B. Munari and U. Eco, Milan, Olivetti Italia, 1962)

31 Gestalter einer totalen visuellen Synthese (exh. cat. by C. Belloli, Basle, 1962)

Nouvelle tendance (exh. cat., Paris, Mus. A. Dec., 1964)

The Responsive Eye (exh. cat. by W. C. Seitz, New York, MOMA, 1965)

R. G. Carraher and J. Thurston: *Optical Illusions and the Visual Arts* (New York, 1966)

F. Popper: *Naissance de l'art cinétique* (Paris, 1967, rev. 2/1970)

——: *Origins and Development of Kinetic Art* (London, 1968)

U. Apollonio: 'La Ciné-visualité chromatique', *L'Art depuis 45*, by W. Haftmann and others, i (Brussels, 1969)

R. Parola: *Optical Art: Theory and Practice* (New York, 1969)

C. Barrett: *Op Art* (London, 1970)

——: *An Introduction to Optical Art* (London, 1971)

J. Lancaster: *Introducing Op Art* (London, 1973)

L'ultima avanguardia: Arte programmata e cinetica, 1953–1963 (exh. cat. by L. Vergine, Milan, Pal. Reale, 1983)

FRANK POPPER

Opbouw, De [Dut.: 'construction']

Dutch association of architects, based in Rotterdam between 1920 and 1940. It was founded on 31 January 1920 by the Rotterdam architect Willem Kromhout as an alternative to the existing group Bouwkunst en Vriendschap; precise details of the establishment of De Opbouw, however, were lost when its archives were destroyed by fire during the German bombing in 1940. Its initial members were Marinus Jan Granpré Molière, a leading figure of the Delft school, Josephus Klijnen (1887–1973), L.

Bolle, Alphonsus Siebers (1893–1978), Pieter Verhagen (1882–1950), Leendert Cornelis van der Vlugt, Jaap Gidding (1887–1955), Jacob Jongert, Willem Hendrik Gispen (1890–1981) and J. J. P. Oud. Later they were joined by Mart Stam and Johannes bernardus van Loghem, who became chairmen, Cornelis van Eesteren, Willem van Tijen, W. van Gelderen, Piet Zwart, Paul Schuitema (1897–1973) and Theodor Karel van Lohuizen (1890–1956). Binding the members initially was the search for a clearly distinctive position in contrast to that of Amsterdam, the cultural centre. The influence of De Stijl, *Nieuwe Bouwen* ('new building') and a general interest in new ideas about art and architecture played a part, but no manifesto was possible because differences in viewpoints—such as those between Granpré Molière and Oud—were too great. De Opbouw moved to the left politically from the second half of the 1920s, through the influence of Stam and van Loghem. This gradually resulted in some members leaving the group, including Oud and Klijnen. This political orientation became linked with support for functionalist architecture, thus making possible De Opbouw's merger with the Amsterdam-based ARCHITECTENGROEP DE 8 in 1932. Collective action with Amsterdam was achieved mainly through the periodical *De 8 en Opbouw* and through participation in CIAM activities, while De Opbouw continued to be active independently in Rotterdam. De Opbouw ceased in 1940, with the German occupation. It held a number of exhibitions of members' work and twice (1927 and 1935) issued statements about urban planning questions, but its importance was chiefly defined by the work of its members.

Bibliography

G. Fanelli: *Moderne architectuur in Nederland, 1900–1940* (The Hague, 1978) [English summary]

R. Dettingmeijer: 'The Fight for a Built City', *Het nieuwe bouwen in Rotterdam, 1920–1960* (exh. cat., Rotterdam, Mus. Boymans-van Beuningen, 1982), pp. 19–57 [Dut. and Eng. text]

B. Rebel: *Het nieuwe bouwen* (Assen, 1983), pp. 10–46, 130–32

De 8 en Opbouw, 1932–1943 (Amsterdam, 1985) [reprint with an essay by Manfred Bock]

OTAKAR MÁČEL

Organic architecture

Term that implies a connection of architecture with nature, adopted from the 19th century but later applied with different meanings by a number of architects. At the most naive level it has been used to describe buildings whose forms resemble or imitate plants and animals and which might more accurately be called biomorphic. This was not, however, the use of the term intended by such proponents as Frank Lloyd Wright and Hugo Häring. Their interest lay in the inner processes of nature and the relation between these processes and the forms produced. This interpretation derives essentially from the view of nature proposed in Charles Darwin's 19th-century theory of evolution; the adaptation of organs and organisms to specific purposes and circumstances, which was the root of functionalist ideas in many fields (*see* FUNCTIONALISM).

The term 'organic' was also used in the 19th century by William Morris to describe both Gothic architecture and the architecture that he hoped would grow out of it by throwing off 'the pedantic encumbrances' of applied style, evolving its forms 'in the spirit of strict truthfulness, following the conditions of use, material and construction' (Zevi, 1945). Morris reiterated the ideas of A. W. N. Pugin and John Ruskin, the principal theorists of the Gothic Revival. A line of descent can be traced between Morris and other later architects, beginning with the Arts and Crafts architecture of Philip Webb, C. F. A. Voysey and W. R. Lethaby—the so-called English Free Style. It was influential abroad, leading to the work of Wright and Louis Sullivan via the Shingle style; to Häring, Hans Scharoun and Erich Mendelsohn via the work of Henry Van de Velde and Hermann Muthesius; and to Alvar Aalto via the National Romanticism of Eliel Saarinen and Lars Sonck. This architecture was notable for its informality, functional and aggregative planning and adaptation to local conditions.

The ascendancy of the Gothic Revival over Neoclassicism at a time of British imperial expansion represented the casting off of the Latin yoke in favour of a style seen as indigenous; the vernacular sources used later by Arts and Crafts architects

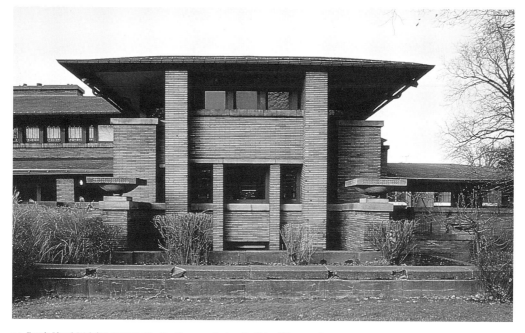

34. Frank Lloyd Wright: Darwin Martin House, exterior, Buffalo, NY, 1903–6

had the same implication. These arguments, still raging at the turn of the century in Europe and the USA, influenced pioneering Modernists at an impressionable age, who later reformulated them as the polarity between organic architecture and International Style Modernism. Some historians took up this debate in the period following World War II when attempting to broaden the narrow definition of Modernism, and, with the appearance of *Verso un'architettura organica* (1945) by Bruno Zevi (*b* 1918), which stressed parallels in the work of Wright and Aalto, an alternative Modernist tradition was posited, which retained its currency. This tended to stress content as opposed to form, substance as opposed to style, the specific as opposed to the universal and above all the integration of a building with its contents and context.

The main American theorist of organic architecture was Frank Lloyd Wright. He wrote an essay entitled 'Organic Architecture' (Kaufmann and Raeburn) in 1910 and thereafter called his work organic (see fig. 34). For him it encompassed a num-

ber of attitudes: the building should be integrated into its site, and materials should be used with respect for their inherent natures. In planning, separate elements should be articulated according to their uses but at the same time integrated into a coherent whole. This could be achieved with a geometric grid. Wright seems to have believed—on the evidence of crystallography—that such ordering systems reflected an underlying order in nature. Within the geometric discipline, spaces could be allowed to interpenetrate one another without loss of control, flowing from room to room and from inside to outside, breaking the box and encouraging continuity with earth and nature.

In Germany during the 1920s the word 'organic' was widely used in connection with functionalist ideas, but the most serious and consistent theorist of organic architecture or, as he preferred, 'building' was Hugo Häring. Like Wright he was concerned with the functional articulation of elements and the nature of materials, but he held a different view of the architect's role, which he saw as almost that of interpreter rather than

creator, the medium through which the task expresses itself. Thus Häring's essay 'Wege zur Form' (1925) ends with the words: 'We should not express our own individuality but rather the individuality of things: their expression should be identical with their being.'

A more fundamental difference between the ideas of Häring and Wright was the significance of geometry. Partly in reaction against the academic Neo-classical formalism that he had been taught as a student, Häring viewed geometry not as a means of universal order but as an impediment to functional planning, a strait-jacket constraining the building's legitimate development as an organ of life. This led him to interpret architectural history as a path of intellectual discovery, in which geometry as bearer of symbolic order served a transitional role that could later be dispensed with. Instead, Häring argued, architects should pursue the path of nature, discovering an organic ordering that arises from the requirements of life and construction. He put his argument into practice in his designs.

Although Häring built relatively little, his ideas exerted a profound influence on Hans Scharoun, whose architecture is notable for its extreme freeplanning and spatial fluidity. The work and ideas of Häring and Scharoun gave rise to a continuing German organic tradition whose foremost exponents were Günter Behnisch and Frei Otto. In Belgium Lucien Kroll, who called his work organic, gave the idea of a self-generating architecture a new meaning with his participative medical faculty buildings for the University of Leuven. In the later 20th century the biomorphic side of organic architecture was promoted by a number of architects in Austria and Hungary, such as Imre Makovecz and the partnership of Michael Szyszkowitz and Karla Kowalski.

Bibliography

H. Häring: 'Wege zur Form', *Die Form*, 1 (1925), pp. 3–5

F. L. Wright: *An Organic Architecture: The Architecture of Democracy* (London, 1939/R London and Cambridge, MA, 1970)

B. Zevi: *Verso un'architettura organica* (Turin, 1945; Eng. trans., London, 1950)

E. Kaufmann and B. Raeburn: *Frank Lloyd Wright: Writings and Buildings* (New York, 1960)

J. Joedicke and H. Lauterbach: *Hugo Häring: Schriften, Entwürfe, Bauten* (Stuttgart, 1964)

'Organic Response', *Archit. Rev.* [London], clxxvii/1060 (1985) [special issue]

PETER BLUNDELL JONES

Orphism

Term coined by Guillaume Apollinaire c. 1912 to refer to the work of several painters in Paris. He applied it to a new kind of joyously sensuous art, whose roots were in Cubism and which had a tendency towards abstraction. The word *orphique* had been used by the Symbolists and originated in the Greek myth of Orpheus, who was significant as the ideal artist for the Symbolists. In 1907 Apollinaire had written a collection of quatrains under the title *Bestiaire ou cortège d'Orphée* (Paris, 1911), with woodcuts by Raoul Dufy, into which he incorporated the figure of Orpheus as a symbol of the poet and the artist in general. For Apollinaire, however, as for the generation of Symbolists who preceded him, the myth of Orpheus meant the study of mystic, occult and astrological sources, which gave rise to artistic inspiration. 'The voice of light', which he described in his Orphic poems, was a metaphor, common in mystic texts, for 'inner experiences'. In a footnote to his volume of poetry he identified the 'voice of light' by means of a line drawing, although it was still not fully articulated; once it had totally expressed itself, it would take on colour and become painting. The metaphor of light, therefore, represented the artist's power to create entirely new forms and colours, and in the process referred to the creation myth of hermetic, Orphic texts. Accordingly, Orphism could signify a direct sensuous address by means of colour and light, as well as an innovative creative process.

However, Orphism also referred to the analogy, popular c. 1912, between colour and music: Orpheus was a singer, and with his music even tamed wild beasts. Apollinaire frequently spoke about correlations between the arts; for example

in *Les Peintres cubistes: Méditations esthétiques* (Paris, 1913) he stated: 'In this way, we move towards a completely new form of art, which will be to painting, as known up to now, what music is to literature.' Many Orphic painters, especially those who had taken steps towards abstract art, cited analogies like these in their theoretical statements or even in the titles of their pictures, as, for instance, František Kupka's *Fugal Pictures* such as *Fugue in Red and Blue* (Prague, N.G.; see col. pl. XXVIII) or Picabia's abstract pictures, for example *Udnie* (*Young American Girl* or *The Dance*) (1913; Paris, Pompidou, Mus. N. A. Mod.; see fig. 35). Conversations with Francis Picabia and his wife, Gabrielle Buffet-Picabia, a musician, probably did much to inspire these ideas in Apollinaire. Similarly Kandinsky's *Über das Geistige in der Kunst* (Munich, 1912), a theory of art that describes in great detail the correlations between colours and sounds, doubtless first stimulated this train of thought. Robert Delaunay also concerned himself with analogies between colour and music to

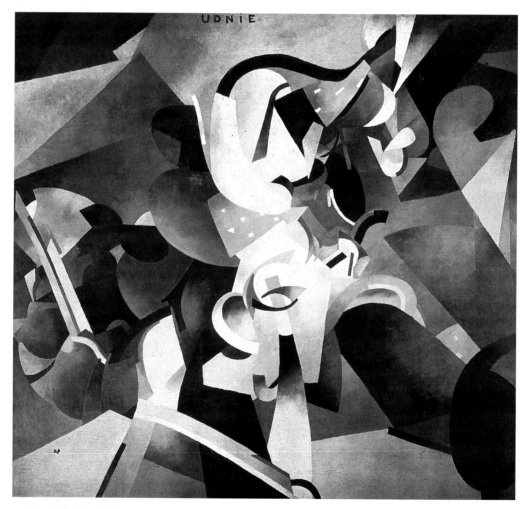

35. Francis Picabia: *Udnie (Young American Girl or The Dance)*, 1913 (Paris, Pompidou, Musée National d'Art Moderne)

emphasize the purity and independence of colour, and was able to achieve his first successes in exhibitions of the Blaue Reiter at the invitation of Kandinsky.

In *Les Peintres cubistes* Apollinaire defined 'Orphic Cubism' as:

> the art of painting new totalities with elements that the artist does not take from visual reality, but creates entirely by himself; he gives them a powerful reality. An Orphic painter's works should convey an untroubled aesthetic pleasure, but at the same time a meaningful structure and sublime significance. In other words, they must reflect the subject. This is pure art. The light in Picasso's work embodies this art, which Robert Delaunay invents, and toward which Fernand Léger, Francis Picabia and Marcel Duchamp are also striving.

In his apparently arbitrary grouping of different artists under the same heading, Apollinaire was showing not so much his insensitivity as his determination, in terms of cultural policy, to rally under a common flag all the artists who were important to him, as well as new avant-garde artists. In October 1912 Apollinaire gave the inaugural address at the *Section d'Or* exhibition, which consisted of works by such Cubist painters as Albert Gleizes, Jean Metzinger, Roger de La Fresnaye and Picabia, who had moved away from the Cubist style of Picasso and Braque, forming the Puteaux group, which met at the Duchamps' home to discuss new theories about the fourth dimension and simultaneous art. In his address Apollinaire announced the 'fragmentation of Cubism' in a new art invented by Robert Delaunay, who did not, however, take part in the exhibition.

In November and December 1912, some time after his imprisonment on suspicion of stealing the *Mona Lisa* from the Musée du Louvre and his subsequent release, Apollinaire stayed at the Delaunays' flat. During this period Robert Delaunay produced his first *Fenêtres*, for example *Window on the City* (1912; New York, Guggenheim; see also col. pl. I), which Apollinaire included under the stylistic heading of Orphism. Apollinaire's friendship with Robert Delaunay led to close collaboration. Apollinaire wrote and published a series of texts about Delaunay's art, in which he further promoted the concept of Orphism. In March 1913 Orphism was displayed to the public for the first time at the Salon des Indépendants; describing the Salon in *L'Intransigeant* (25 March 1913), Apollinaire wrote that 'it combines painters of totally different characters, all of whom have nonetheless achieved a more internalized, more popular and more poetic vision of the universe and of life'. In his review of this exhibition in the Orphic magazine *Montjoie!* (29 March 1913) Apollinaire even argued for the abolition of Cubism in favour of Orphism: 'If Cubism is dead, long live Cubism. The kingdom of Orpheus is at hand!' Apollinaire celebrated the Herbst salon of 1913, organized by *Der Sturm*, as 'Orphism's first Salon'; most of the exhibits were works by Robert Delaunay and Sonia Delaunay, supplemented by abstract works by Picabia, Metzinger's *Blue Bird* (c. 1913; Paris, Mus. A. Mod. Ville Paris), as well as pictures by Gleizes and Léger and a considerable number of Futurist paintings. This exhibition also marked the turning-point in Apollinaire's artistic strategy for Orphism. After he became involved through some incautious remarks in an argument between Delaunay and Umberto Boccioni about the ambiguous term 'simultaneity', his relationship with Delaunay cooled markedly. Apollinaire became increasingly interested in other artists, such as Picabia and Alexander Archipenko, but above all in the Futurists.

After 1913 Apollinaire did not use the term Orphism again in his art criticism. The artists whose works carried this label also shook off the description as quickly as possible and created totally individual stylistic trends of their own. Just as the content of the term Orphism was and remains vague in meaning, so its history is very short. It would have remained a footnote in the history of ideas were it not for art history's urge to classify, and for the very different types of pictures produced by the artists who at various times came under this heading. The works that

most closely matched Robert Delaunay's pictures and theories were by Kupka, one of the first artists to paint wholly abstract pictures on musical themes. All the other artists intermittently referred to by Apollinaire, including Léger, Picabia, Duchamp and especially Picasso, created independent new categories of art that could scarcely qualify as Orphic. If restricted to the implications of colour and light, the expression of abstract-rhythmic colour-compositions, the term Orphism would most obviously embrace pictures by Robert Delaunay and Sonia Delaunay. Robert Delaunay himself, however, thought this description too imprecise and too poetic to express his real wishes. His aim was to produce 'pure painting' based on the interplay of colours. His temporary classification as Orphic was for him a necessary marketing strategy, which was proved successful by his exhibitions in Germany. The only artists that can be considered as Delaunay's direct pupils were the American painters Patrick Henry Bruce and Arthur Burdett Frost jr, who c. 1912 strove to create a similar form of art under Robert Delaunay's aegis. Even the Synchromists Morgan Russell and Stanton Macdonald-Wright, sometimes classified as Orphists, were at great pains to distance themselves, particularly from Robert Delaunay, by writing their own manifestos, even if at the time their art could not fail to seem Orphic. Orphism was thus a stylistic heading created by Apollinaire, and one with an elusive nature from which painters included within it always tried to escape.

Bibliography

H. B. Chipp: 'Orphism and Color Theory', A. Bull., xl (1958), pp. 58–63
J. Golding: Cubism: A History and an Analysis, 1907–1914 (London, 1959, rev. 1968, 3/1988)
R. Rosenblum: Cubism and Twentieth-century Art (New York and London, 1960, rev. 1977)
W. C. Agee: Synchromism and Color Principles in American Painting, 1910–30 (New York, 1965)
E. F. Fry: Cubism (London and New York, 1966)
D. Vallier: L'Art abstrait (Paris, 1967; Eng. trans., New York, 1970)
Painters of the Section d'Or: The Alternatives to Cubism (exh. cat. by R. West, Buffalo, Albright-Knox A.G., 1967)
D. Cooper: The Cubist Epoch (London and New York, 1970)
V. Spate: Orphism: The Evolution of Non-figurative Painting in Paris, 1910–1914 (Oxford, 1979)

HAJO DÜCHTING

OSA [Ob'edineniye Sovremennikh Arkhitektorov; Rus.: Union of Contemporary Architects]

Soviet architectural group, active in Moscow from 1925 to 1930. It was founded by Moisey Ginzburg and Aleksandr Vesnin and it attracted many of Moscow's Modernist architects by arguing for architecture's pivotal role in creating the new Soviet society. OSA's activities passed through several distinct phases in response to changing political circumstances and engaged the public on several fronts: these included an exhibition of contemporary architecture in 1927; architectural conferences in 1928 and 1929; and the bimonthly journal Sovremennaya arkhitektura, which appeared from 1926 to 1930. Disavowing aesthetic and formal considerations, OSA made functional and technical matters pre-eminent. Starting with general reflections about the USSR, OSA architects then analysed the State's building requirements in terms of cost, user profile and building types. The group endorsed a view of architecture as an integral part of the State apparatus, with a role in transforming society, for example by evolving new building types, such as the Workers' Club, and with responsibilities, for example in containing costs by adopting prefabrication methods. Their approach to design was disciplined, with the design process itself being reduced to four distinct phases: the building programme's spatial organization and technical requirements; the volumetric implications of these factors; their physical implementation; and the consolidation of the previous three steps into architectural coherence and unity. This rigorous design method helped OSA to forge its own identity and to create a legacy of designs challenging the best work of other European and Soviet avant-garde groups. The most characteristic designs by architects associated with the group include: the Vesnin brothers' unexecuted projects

for the Palace of Labour (1922–3), Moscow, and the Leningrad *Pravda* Building (1924), Moscow; Grigory Barkhin's *Izvestiya* Building (1925–7), Moscow; Ginzburg's unexecuted project for the Orgametals Headquarters (1926–7); Il'ya Golosov's Zuyev Club (1927–9), Moscow; and Ivan Leonidov's unexecuted projects for the Lenin Institute (1927) and the Ministry of Heavy Industry (1933–4), both Moscow. All of these designs, however, owed as much to the talents of their respective authors as to OSA's design method.

Writings

M. Ginzburg: *Stil' i epokha* [Style and epoch] (Moscow, 1924; Eng. trans., Cambridge, MA, 1982)
Pervaya vystavka sovremennoy arkhitektury [First exhibition of contemporary architecture] (exh. cat., Moscow, 1927)

Bibliography

V. Ye. Khazanova: *Iz istorii sovetskoy arkhitektury, 1926–1932: Dokumenty i materialy* [From the history of Soviet architecture, 1926–1932: documents and materials] (Moscow, 1970)
A. Kopp: *Town and Revolution: Soviet Architecture and City Planning, 1917–1935* (New York, 1970)
S. F. Starr: 'OSA: The Union of Contemporary Architects', *Russian Modernism: Culture and the Avant-Garde, 1900–1930*, ed. G. Gibian and H. W. Tjalsma (Ithaca, 1976), pp. 188–208
S. O. Khan-Magomedov: *Alexandr Vesnin and Russian Constructivism* (New York, 1986)
—: *Pioneers of Soviet Architecture* (New York, 1987)
 K. PAUL ZYGAS

Painters Eleven

Canadian group of painters. It was formed in November 1953 by 11 artists working in and around Toronto: Jack Bush, Oscar Cahén (1916–56), Hortense Gordon (1887–1961), Tom Hodgson (*b* 1924), Alexandra Luke (1901–67), Jock Macdonald, Ray Mead (*b* 1921), Kazuo Nakamura (*b* 1926), William Ronald, Harold Town and Walter Yarwood (*b* 1917). Seven of these artists had shown their work together in October 1953 in *Abstracts at Home*, an exhibition organized by Ronald at a Toronto department store, the Robert Simpson Company; when they agreed to combine forces with four others, they chose a name that reflected their number and also made ironic reference to the Group of Seven, the Ontario-based landscape painters whose influence in the province was still pervasive in the 1950s. The members of Painters Eleven, which disbanded in October 1960, differed widely in background, experience and ambition; they were united by their interest in contemporary international art and in their belief that their need to exhibit their work would be better achieved collectively than individually. They felt isolated from the art of their own time and frustrated by the control exercised over the limited exhibiting possibilities presented by such art societies as the Ontario Society of Artists and the Canadian Group of Painters.

Through Bush, the only member of the group at that time to have a dealer, the group's first exhibition was held at the Roberts Gallery in Toronto in February 1954. The artists continued to exhibit together, at both commercial galleries and public museums, until the dissolution of the group, receiving considerable attention and, in general, strong support in the press. Although Les Automatistes had shown their work in Quebec from the mid-1940s, the exhibitions held by Painters Eleven had a major effect in stimulating awareness of abstract art in Canada and, in particular, in developing the basis of modernist art in Toronto. Painters Eleven gained significant attention after exhibiting with the American Abstract Artists at the Riverdale Museum in New York in April–May 1956.

No manifesto was issued by Painters Eleven, and published statements were limited to brief introductions to exhibition catalogues. Meetings of the group were irregular, called principally to decide on proposals for exhibitions. These meetings generated lively discussion, and there were strong disagreements among the members, often centring on whether the group's function was to develop a unified approach or to support, through collective action, the freedom of individual expression. The disagreements came out strongly over a proposal initiated by Ronald, by then living in New York, to invite Clement Greenberg to visit them in 1957.

Town and Yarwood refused to take part. Greenberg made his trip in May, visiting the studios of seven of the artists. His discussions with them had limited impact except on Bush, with whom he formed a lifelong friendship. The solidarity of the group was severely weakened by the end of 1957; the membership, already reduced to ten by Cahén's death in November 1956, was further depleted in 1957 by Ronald's resignation and by Mead's departure for Montreal. In addition, the opening in Toronto of galleries supporting advanced contemporary work reduced the urgency for collective action. Macdonald expressed a common perception among them when he wrote in 1958 that the group's usefulness had come to an end in the spring of 1957, around the time of Greenberg's visit, and that they no longer had the same unity.

While Painters Eleven welcomed no new members into their ranks, their example was a forceful stimulus to younger artists in Toronto. Through his teaching at the Ontario College of Art, Macdonald was profoundly influential on successive generations of young artists, and the example and presence of the three strongest painters of the group—Ronald, Bush and Town, each totally distinct in their interests and approaches—established the artistic diversity and vitality that emerged in Toronto in the 1960s.

Bibliography

D. Reid: *A Concise History of Canadian Painting* (Toronto, 1973, rev. 1988), pp. 247–72

Painters 11: 1953–1959 (exh. cat. by K. Woods, Oshawa, McLaughlin Gal., 1973)

Painters Eleven in Retrospect (exh. cat. by J. Murray, Oshawa, McLaughlin Gal., 1979)

D. Burnett and M. Schiff: *Contemporary Canadian Art* (Edmonton, Alta, 1983), pp. 41–61

DAVID BURNETT

Perceptismo

Argentine movement initiated in Buenos Aires in 1947 under the leadership of the painter Raúl Lozza (*b* 1911) and the theoreticians Rembrandt Lozza (1915–90) and Abraham Haber (1924–86). It was announced in 1948 by an exhibition and manifesto. Like the ASOCIACIÓN ARTE CONCRETO INVENCIÓN, from whose internal disagreements the movement emerged, it was concerned with the promotion of Constructivism in Argentina. The theories they promulgated were also conveyed through a magazine, *Perceptismo: Teórico y polémico*, published from 1950 to 1953. One of their primary concerns was with the relationship between the quantity (in terms of surface area) and quality of flat colour; they conceived of the surface as a field against which to arrange shapes whose only justification lay in their interrelationships. In rejecting the supposed conflict between pictorial or fictitious space and the physical space in which we move, they proposed that both were equivalent in value. Lozza's use of enamel on wood to create surfaces as polished and perfect as lacquer typified the technical perfection sought by these painters as a means of suppressing any trace of subjectivity that would otherwise distract the observer from the physical presence of the work, as, for example, in *Painting from the Perceptist Period: No. 184* (1984; Buenos Aires, Mus. Mun. A. Plást. Sívori).

Bibliography

C. Córdova Iturburn: *80 años de pintura argentina* (Buenos Aires, 1978), p. 147

N. Perazzo: *El arte concreto en la Argentina* (Buenos Aires, 1983), pp. 109–20

NELLY PERAZZO

Performance art

Descriptive term applied to 'live' presentations by artists. It was first used very loosely by artists in the early 1960s in the USA to refer to the many live events taking place at that time, such as Happenings, Fluxus concerts, Events, body art or (in Germany) *Aktionen* and *Demonstrationen*. In 1969 performance was more specifically incorporated into titles of work in the USA and UK and was interchangeable with 'performance piece' or simply 'piece', as in Vito Acconci's *Performance Test* or *Following Piece* (both 1969), and by many other artists such as Dennis Oppenheim, Yoko Ono (*b* 1933), Dan Graham, Rebecca Horn, Joan Jonas,

Laurie Anderson and Bruce Nauman. It was closely linked to the ideological tenets and philosophy of CONCEPTUAL ART, which insisted on 'an art of which the material is concepts' and on 'an art that could not be bought and sold'; those who made performance pieces did so as a statement against the gallery system and the art establishment.

The term 'performance' was originally adopted in the early 1970s to emphasize the fact that the work was made by artists and to distinguish such events from theatre; the early pieces were esoteric and paradoxical and far from entertaining. The frequent use in the following decade of the term 'live art' was an attempt to explain its connections with the art world. It had connotations of theatre or entertainment, frankly admitting a new tendency towards vaudeville or cabaret, and avowing the fact that in New York, in particular, performances increasingly took place in East Village cabaret settings or, on a few occasions, on television shows.

1. Origins of performance art

The history of performance art in the 20th century is one of a permissive, open-ended medium with endless variables, executed by artists impatient with the limitations of more established art forms and determined to take their art directly to the public. Because the crossbreeding of the arts is fundamental to performance, artists draw on many disciplines and media including literature, poetry, theatre, music, dance, architecture or painting, as well as video, film, slides or narrative for their material. Performance art defies precise or easy definition. In its broadest sense it is any form of 'live art' in a public setting closely related to the fine-art modes of the time. It has been used by artists as a means of confronting the prevailing art establishment or as a way of bringing to life the many formal and conceptual ideas on which the making of art is based.

Such a radical stance against the conventions of art has made performance a catalyst in the history of 20th-century art; whenever a certain school, be it Cubism, Minimalism or conceptual art, reached an impasse, artists turned to performance as a way of breaking down categories and indicating new directions. Most of what is written about earlier art movements (e.g. Constructivism, Dada or Surrealism) continues to concentrate on the art objects produced, but these movements often found their sources and attempted to resolve problematic issues in performance. Most of the original Zurich Dadaists, for example, were poets, cabaret artistes and performers who, before creating Dada objects, exhibited works from immediately preceding movements such as Expressionism. Similarly, most of the Parisian Dadaists and Surrealists were poets, writers and agitators before they began producing objects and paintings.

Performance manifestos, beginning with Futurism, have been the expression of dissidents who have attempted to find other means to evaluate art experience in everyday life. Performance has been a way of appealing directly to a large public, as well as shocking audiences into reassessing their own notions of art and its relation to culture. Conversely, public interest in the medium, especially from the 1980s, stems from an apparent desire to be a spectator to the distinct community of the art world and to be surprised by the unexpected, unorthodox presentations that the artists devise. The work may be presented solo or with a group, with lighting, music or visuals made either by the performance artist or in collaboration, and performed in venues ranging from the art gallery or museum to 'alternative spaces', such as the theatre, café, bar or street. The performer is the artist, seldom a 'character' like an actor in the theatre, and the content rarely follows a traditional plot or narrative. The performance might be a series of intimate gestures or large-scale visual theatre, lasting any time from a few minutes to many hours; it might be performed once or repeated, with or without a prepared script, spontaneously improvised or rehearsed over many months.

(i) Renaissance forerunners. Performances, like tribal dances, medieval Passion plays, Renaissance spectacles or the soirées arranged by artists in the 1920s in their studios in Paris, provide a presence for the artist in society. This presence can be

esoteric, shamanistic, instructive, provocative or entertaining, depending on the nature of the performance. Renaissance examples show the artist in the role of creator and director of spectacles, fantastic triumphal parades that often required the construction of elaborate temporary architecture or performances of allegorical spectacles. Leonardo da Vinci was well known for his 'follies'; Vasari described his demonstration of the flexibility of the intestines of a bullock, inflated by a pair of blacksmith's bellows to fill an entire room. Leonardo also designed the *Festa del paradiso* (1490), in which performers dressed as planets revolved on specially built platforms while reciting verses about the return of the Golden Age. A triumphal procession was designed in 1535 by Polidoro da Caravaggio for Emperor Charles V at Messina; in 1589 Bernardo Buontalenti organized elaborate festivities for the marriage of Christine de Lorraine and Ferdinando I de' Medici in Florence, which included a mock naval battle in the flooded courtyard of the Palazzo Pitti. Gianlorenzo Bernini staged spectacles, for which he wrote scripts, designed scenes and costumes, built architectural elements and achieved daring engineering feats, such as the *Inundation of the Tiber* (1638), in which realistic flood scenes apparently caused the collapse of near by buildings.

(ii) **Futurism.** The history of 20th-century performance art began on 20 February 1909 with the publication of Filippo Tommaso Marinetti's 'Manifeste de fondation du Futurisme' in Paris in *Le Figaro*. This was followed by the first 'Futurist Evening' in January 1910, at the Teatro Rossetti in Trieste, a combination of political rally, poetry, variety theatre and loud readings or declamations by members of the Futurist group. The manifestos celebrated the machine and war and rejected such things as museums, critics and feminism. A successful evening provoked the audience to the point of rioting. The Futurists performed in theatres and piazzas throughout Italy. Their words were shouted or distributed in pamphlet form and reached a broad and extensive audience, making Futurism the first art movement to be publicized by the new techniques of mass communication.

Some extracts from Marinetti's manifesto were published in March 1909 in a Russian newspaper. Young Russian poets and painters, such as Velimir Khlebnikov, Nikolay Kulbin, David Burlyuk and Vladimir Mayakovsky, began publishing their Futurist poetry c. 1912, as a break with Russian Symbolism. They were given the name Futurists by the press although they disputed the Italian connection, insisting instead on their essentially Russian heritage and damning 'Paris and Munich decadence'. (In 1914 Marinetti lectured in Moscow and St Petersburg and emphasized the rift between the Italian and Russian Futurists.) During 1913–14 the Russian Futurists arranged recitals, confrontations and exhibitions and walked the streets in trademark outfits; Mayakovsky wore a yellow blouse, and Burlyuk wore a frock coat with collar trimmed with multicoloured rags, his face painted with a picture of a little dog. They organized a Futurist tour of Russia visiting 17 cities and produced a Futurist theatre festival. This included Alekséy Kruchonykh's opera *Pobeda nad solntsem* ('Victory over the sun', 1913) with sets and costumes by Kazimir Malevich and Mayakovsky's tragedy *Vladimir Mayakovsky* (1913), thus setting the scene for two decades of collaboration between artists of many disciplines in the highly charged social and political atmosphere of the time. Committed to making a revolutionary art for large and often illiterate audiences, based on the current political situation, they took as models the circus, music-hall, variety theatre, eurhythmics, Japanese theatre and the puppet-show. Constructivist and Suprematist artists, architects, dramatists, film makers and composers were involved in the creation of revolutionary theatre. Agit-trains and agit-ships travelled across the country, stopping at remote villages and quay-sides to perform. The overtly political Blue Blouse group used 'living newspapers', theatre, film and dance to relate its message and eventually involved more than 100,000 members who joined clubs all over the country. Momentous events such as the *Storming of the Winter Palace* (1920) directed by Nikolay Yevreinov and involving 8000 citizens re-created that occasion three years later. The announcement of a policy of Socialist Realism

as the official and enforceable cultural code at the Writers Congress in Moscow in 1934 ended this freedom of performance.

(iii) Dada. In Zurich, where many artists sought a neutral refuge from World War I, performance took the form of 'literary cabaret' as conceived by former cabaret artiste Emmy Hennings (1885–1948) and her poet lover Hugo Ball. Inspired by cabaret life in Munich and by Marinetti, particularly his 'words in liberty' poetry, they opened Cabaret Voltaire on 5 February 1916 in a small bar on the Spiegelgasse as a 'centre for artistic entertainment'. Ball invited all artists 'whatever their orientation', and on the opening night Marcel Janco and George Janco, his brother, and Tristan Tzara, among others, brought portfolios and pictures, which were immediately hung on the walls. Hennings sang in French and Danish, Tzara read Romanian poetry, and a balalaika orchestra played popular tunes and Russian dance. Cabaret Voltaire was the hub of new poetry, music and dance; according to Ball, they pushed 'the plasticity of the word to the point where it can scarcely be equalled'. Ball invented sound poems with an 'African rhythm', which he recited in costume. Simultaneous poems read by several performers at once were interspersed with lectures, dance and song. Richard Huelsenbeck, Hans Arp, Sophie Taeuber-Arp and other dancers from Rudolph Laban's school read and performed their own and others' verse, amid décor painted by the artists. According to Arp, on some nights there was 'total pandemonium'. After five months, the owner of the bar stopped the cabaret, by which time Ball was 'ready to close shop', and Tzara was preparing to turn Dada into a 'tendency in art'. Dada recitals were given at the Weighhouse (Waag) hall in Zurich (1916), an anthology Collection Dada (Zurich, 1916) was issued, and a Dada gallery opened in January 1917, lasting for 11 weeks, by which time Ball had left Zurich, Huelsenbeck had returned to Berlin and Arp to Cologne, where new and very different Dada groups were emerging. At the end of 1919 Tzara transferred Dada's base from Zurich to Paris.

Berlin Dada was overtly political and anti-Expressionist. Participants, such as Huelsenbeck,

George Grosz, Gerhard Preis, Johannes Baader (1875–1955), Hannah Höch and John Heartfield, called for a 'large-scale Dadaist propaganda campaign with 150 circuses for the enlightenment of the proletariat' and the requisition of churches for their performances. They went on a Dada tour of what was then Czechoslovakia and organized the First International Dada Fair (Berlin, 1920). In Cologne, Max Ernst and Johannes Theodor Baargeld were responsible for the Dada exhibition of April 1920, which had to be entered through the pissoir of a beer-hall. Francis Picabia took the Dada message from Zurich to Barcelona and New York, as did Marcel Duchamp who exhibited his Fountain (a urinal) in 1917 at the first exhibition of the Society of Independent Artists in the Grand Central Palace, New York.

Paris Dada was launched by Tzara, who along with the Littérature group (writers Paul Eluard, André Breton, André Salmon, Max Jacob, Jean Cocteau and Paul Fraenkel) arranged the first of the Littérature Friday meetings on 23 January 1920; there masked figures recited a disjointed poem by Breton, Picabia executed large drawings on a blackboard, and Tzara read an obscene newspaper article, calling it a poem, to the accompaniment of bells and rattles. Simultaneous poems were typical fare, sometimes with as many as 40 people chanting manifestos 'like psalms'. Audiences responded by throwing all sorts of rubbish at the performers, just as Marinetti had encouraged the audiences to do at Futurist performances a decade earlier. The press and public responded enthusiastically. Parade (1917), a ballet with text by Cocteau, music by Erik Satie, costumes by Pablo Picasso and choreography by Léonide Massine, and Guillaume Apollinaire's Les Mamelles de Tirésias of the same year had established a precedent for outraging the critics and the public. Dada festivals and concerts became frequent, and scandals were a regular outcome of events such as the Dada excursion to a church and the trial in absentia of an eminent established writer Auguste-Maurice Barrès.

Enmity between Tzara and Breton soon led to the formation of a breakaway group, the

Surrealists (1924), led by Breton and comprising most of the Dada group. They published the *Manifeste du Surréalisme* (Paris, 1924), formed a Bureau of Surrealist Research and published the first issue of the magazine *La Révolution surréaliste* (1924). Focusing on automatism, simultaneity, chance, the importance of the subconscious and of the dream, their writings gave some indication of the motives behind the seemingly nonsensical Dada performances. Works such as Aragon's *Armoire à glace* (Paris, 1923) or Roger Gilbert Lecomte's *Odyssey of Ulysses the Palimped* (Paris, 1924) were considered typical Surrealist plays, despite their somewhat realistic acting and direction. It was Picabia and Satie's ballet *Relâche*, which opened on 3 December 1924 at the Théâtre des Champs-Elysées, Paris, that fused Dada experiment and Surrealist principles. A brief cinematic prologue was followed by a first act consisting of a series of simultaneous events: downstage a figure (Man Ray) paced up and down, occasionally measuring the dimension of the stage floor; a fireman, chain-smoking, poured water endlessly from one bucket into another, and in the background the Ballet Suédois dancers revolved in darkness, an occasional spotlight revealing a *tableau vivant* of a naked couple representing the *Adam and Eve* of Lucas Cranach the elder. These events were set against an enormous backdrop comprising metal discs, each reflecting a powerful light bulb, that virtually blinded the audience. During the interval Picabia's film *Entr'acte*, shot by René Clair, was shown, ending with the cast breaking through the paper screen to begin the second act. Surrealist performance, with its concentration on language, had the greatest effect on theatre, influencing, for example, Antonin Artaud's Théâtre de la cruauté.

(iv) The Bauhaus. At the Bauhaus, founded in 1919, a theatre workshop was included in the curriculum from the start. Lothar Schreyer (*b* 1886), a former member of the group associated with *Der Sturm* in Berlin, led the workshop in exploring the limits of Expressionist theatre, which resembled religious play acting. Language was reduced to emotionally charged stammering and movement to pantomimic gestures. Sound, colour and light reinforced the melodramatic content of the work. This was in conflict with the Bauhaus's direction, which was clearly stated by the exhibition *Art and Technology—A New Unity*, shown during Bauhaus Week (1923). Oskar Schlemmer took over the Bauhaus theatre workshop in time to give a performance on the fourth day of Bauhaus Week, 17 August 1923, entitled the *Figural Cabinet 1*, which had been performed a year earlier at a Bauhaus party. Many performances began as theme events for the Bauhaus's notorious parties; some were an exploration in 'real space' of Schlemmer's drawing course 'Mensch und Kunstfigur'; others explored the idea of the dancer as a puppet or as a mechanical figure (inspired by Heinrich von Kleist's *Über das Marionettentheater* of 1810). Some performances were presented as lecture demonstrations at Bauhaus exhibitions, and a repertory toured numerous northern European cities in 1929, including the *Slat Dance* (1927), *Gesture Dance* (1926), *Metal Dance* (1929), *Dance of Hoops*, *Chorus of Masks*, *Dance of Forms*, *Dance in Space* or *Game with Building Blocks* (1926; first performed Bauhaus, Dessau). Schlemmer's *Triadisches Ballett* of 1922 and 1926 was performed for the last time at the International Dance Congress in Paris in 1932, shortly before Schlemmer left the Bauhaus. Other artists who created works for the Bauhaus theatre workshop included Vasily Kandinsky, Ludwig Hirschfeld-Mack, Kurt Schmidt and Toni Hergt (with their marionette play *Die Abenteuer des kleinen Buckligen*, 1924), Xanti Schawinsky (1904–79) and Andreas Weininger. The Bauhaus theatre workshop emphasized performance as a means to create equivalents in real painting or sculpture, investigating the relationship between sound, movement, space and light. It held a pivotal position as a meeting-place within the school for all the arts.

(v) Black Mountain College and Happenings. When the Bauhaus was closed in 1933 by the Nazis, many artists who taught there moved to the USA. Josef Albers, who taught at a new experimental school, BLACK MOUNTAIN COLLEGE in North Carolina, from

1933 to 1949, invited his former Bauhaus colleague Xanti Schawinsky to create a stage studies programme there in 1936. Works from the Bauhaus (e.g. *Spectodrama: Play, Life, Illusion*, 1936) were performed. From 1944 Black Mountain College was known for its summer schools, which attracted significant artists from different disciplines, including R. Buckminster Fuller, John Cage and Merce Cunningham. Cage's manifesto, *The Future of Music: Credo* (1937; published New York, 1958), was influenced by the Futurist Luigi Russolo's *D'arte dei rumori* (Milan, 1913). He suggested that 'everyday sounds', such as static between radio stations, should be considered material for experimental music. Merce Cunningham followed a similar principle with dance in using everyday movements such as walking. Cage and Cunningham collaborated with Black Mountain College artists including Robert Rauschenberg, Charles Olsen (1910–70) and David Tudor on a special 'untitled event' in the summer of 1952, which influenced performance art for the next 20 years and was the forerunner to Happenings. Cage taught a composition course at the New School for Social Research in New York from 1956. His students were painters, film makers, musicians and poets such as Al Hansen (*b* 1927), Dick Higgins (*b* 1938), Jackson Mac Low (*b* 1922), George Brecht and Allan Kaprow, all of whom later created Happenings and Fluxus concerts. Allan Kaprow first defined the term as 'Something to take place; a happening' (*Anthologist*, spring 1959). The first public presentation of a Happening was *Intermission Piece* (June 1959) at the Reuben Gallery on Fourth Avenue in New York. For Kaprow, Happenings were 'spatial representations of a multileveled attitude to painting'; for Hansen, 'a form of theater in which one puts parts together in the manner of making a collage'. In spirit they were influenced by photographs and written accounts of Jackson Pollock at work on his action paintings.

The term 'Happening' soon came to be used by numerous artists with different meanings. The painter and sculptor Red Grooms (*b* 1937), citing the circus as his inspiration, created sets that he likened to 'an acrobat's apparatus'; Claes Oldenburg stated his interest in 'objects in motion' (typewriters, hamburgers, ice-cream cones and people) as the basis for his staged performances in *The Store* (1961), a small storefront in downtown New York, where he exhibited work and performed. For Jim Dine, Happenings were an extension of 'acting out everything in everyday life', and for Robert Whitman (*b* 1935) they were a means of exploring time 'in the same way as paint or plaster'. Happenings were also made by Carolee Schneeman (*b* 1939), who termed them kinetic theatre; in France by Robert Filliou and Ben; and in West Germany by Wolf Vostell.

2. Developments from the 1960s

From the early 1960s, events taking place around the world had as participants not only visual artists but also composers, musicians, poets and film makers, such as Henry Flynt (*b* 1940), La Monte Young, John Latham, Joseph Beuys, Philip Corner, Yoko Ono, George Maciunas (*b* 1931), Nam June Paik, Alison Knowles (*b* 1933) and Dick Higgins. Many came together in a series of 'newest music' concerts in New York in March 1961 at the AG Gallery, Madison Avenue. These concerts included a lecture demonstration on concrete music and a festival of electronic music, with works by Maciunas, Mac Low and Higgins, a concert of new sounds and noises, with works by Toshi Tchiyanagi, Mac Low and J. Byrd, and four evenings of film. Soon the term FLUXUS (suggesting art and music in a state of 'flux') came to be used to describe this loosely connected and very large international group of artists experimenting on the edges of numerous disciplines. The International Fluxus Festival of the Newest Music, organized by Maciunas and presented at the Wiesbaden Museum in September 1962, established their ideas in a formal art setting. Other major Fluxus artists who arranged and performed at many festivals in the 1960s in the USA, Europe and Japan were Paik, Giuseppe Chiari (*b* 1926), Beuys, Ben, Schneeman, Knowles, Ono, La Monte Young, Brecht and the Gutai group.

During the late 1960s and early 1970s the art world became a haven for the most provocative and far-reaching experiments in dance, music, film and theatre. Taking Cunningham's earlier

proposals for a more 'natural' dance choreography, as well as the pioneering expressionistic dance concerts of Anna Halprin in San Francisco, a new generation of important figures began to emerge. Simone Forti (*b* 1935), Trisha Brown, Yvonne Rainer (*b* 1934), Lucinda Childs, Meredith Monk and Laura Dean, among others, performed at the Judson Church in New York, as part of a group called Grand Union or individually and in collaboration with such visual artists as Rauschenberg or Robert Morris (ii). Brown developed her signature repetitions, Forti her movements that were based on closely watched animals, Rainer her special brand of sculptural or minimal dances and Dean her spinning dances, reminiscent of whirling dervishes. Musicians such as Philip Glass, Steve Reich and Terry Riley used the art world as the context for their most innovative work.

Highly sophisticated artists such as Yves Klein in Paris and Piero Manzoni in Milan created sensual and charged conceptual art works and performances; Klein's *Anthropometries of the Blue Period* (1960) was an unforgettable evening at the Galerie Internationale d'Art Contemporain in Paris, when nude models, their bodies dripping in blue paint, writhed on canvas. Manzoni eliminated the canvas altogether, making 'living masterpieces' by signing a person or by presenting them with a document that declared them a work of art. 'Body art' could be said to have emerged from these early 1960s presentations. It was based on the notion that the artist's body was indeed an artist's prime material. Greatly varied works were created, emphasizing social and political polemics, violence or aggression, presenting the artist as shaman or the idea of the artist's body as an 'aesthetic object'. In England, Stuart Brisley from 1966 created disturbing socially critical tableaux centred on his own actions, for example *ZL 65 63 95C*, performed at Gallery House, London, in 1972. Chris Burden in Los Angeles was often the willing victim of orchestrated acts of violence, such as being shot at with a gun and live ammunition in Venice, CA, in *Shooting Piece* (1971), as though to reinforce our immunity through frequent exposure to television's endless killings.

English artists Gilbert and George presented themselves as 'living sculptures' in *tableaux vivants* such as *Underneath the Arches* (1969). Urs Lüthi created a series of performances that investigated sexuality and gender, as did Katarina Sieverding (*b* 1944). Luigi Ontani dressed himself as different figures from well-known historical paintings. *Pair Behaviour Tableaux* (1976) by Scott Burton (*b* 1939) illuminated body language between two men in highly stylized, almost motionless performances, while Rudolf Schwarzkogler, Arnulf Rainer and Otto Muehl in Austria used body art to explore the body language of the mentally disturbed. Vito Acconci, Dennis Oppenheim, John Baldessari, Dan Graham and Bruce Nauman were responsible for extraordinary experiments ranging from humour and self-analysis to analysis of the body in space. The exploration of the relationships between artist and spectator that characterized performance art of the 1970s was an essential corollary to conceptual art.

Throughout the 1970s performance art was an essential forum for experiments in sculpture, dance, music, video and film, allowing for the creation of some of the most original cross-overs and multidisciplinary work. It provided the most direct access to artists and their ideas for a public largely baffled by conceptual art's 'non-materialistic' stance. The fact that it could not be bought or sold gave it an added importance within the terms of conceptual art, and it became the ideal vehicle for a generation intent on developing an entirely new aesthetic in art as well as a method of 'exhibiting' that was independent of the commercial-gallery system. A plethora of 'alternative spaces' (usually artist-run exhibition and performance spaces) characterized the 1970s. Eventually museums, art schools and establishment institutions were obliged to respond to the energy and excitement emanating from the alternative spaces, and by the mid-1970s performance events were being organized at the Venice Biennale, at the Hayward Gallery in London and at MOMA in New York.

From the beginning of the 1970s performance took on many forms and styles. 'Body art' and *Aktionen* described actions, usually by individual artists, that were demonstrations of formal ideas

of space as well as more lyrical explorations of cultural metaphors; the term *Aktionen* was usually preferred by German artists who disliked the implication of performance as entertainment in the English language. Joseph Beuys's *Aktionen* described mythological and metaphorical states of German culture in the 1970s; Klaus Rinke, with Monika Baumgartl, illustrated formal ideas of sculpture and space. In Italy, Jannis Kounellis elaborated on imagery culled from art history, and in Paris and Turin, Gina Pane inflicted wounds on herself in a series of masochistic works in which she physically identified with the suffering experienced in society at large. In Vienna, Hermann Nitsch staged ritualistic slaughtering of animals in bloody pageants that recalled Dionysian excess in Greek tragedy. Marina Abramovičj (*b* 1946) created marathon endurance works investigating psychic states. Autobiography emerged as a general reference in the early 1970s and indicated a new direction with its confessional story-telling, which for the first time made performance far more accessible and entertaining. Laurie Anderson, Julia Heyward (*b* 1949), Michael Smith (*b* 1942), Stuart Sherman, Adrian Piper (*b* 1948), Mitchell Kriegman, Bruce McLean and many others made work that attracted attention outside the art world. Other artists used the solo performance for cultural commentary and as an appropriate platform for such issues as feminism. In this area Rebecca Horn, Hannah Wilkie (*b* 1941), Ulrike Rosenbach (*b* 1943), Susan Hiller, Rose English, Arleen P. Schloss (*b* 1943), Suzanne Lacy (*b* 1945), Martha Storey Wilson (*b* 1947), Jacki Apple and Eleanor Antin created powerful and seminal works. Costume performance emerged as a popular theme by the late 1970s with Mr Peanut and General Idea in Toronto and Pat Oleszko with works such as *Coat of Arms* (1976) in New York.

By the late 1970s, with the emergence of punk music and the coming of age of the first fully fledged 'media generation', artists looked to the media for their inspiration. Robert Longo's first performances of the late 1970s and early 1980s, such as *Empire* (1981), combined actual film footage with heroic imagery and scenes that could have been the setting for a Hollywood spectacle.

Laurie Anderson's song *O Superman* enjoyed popular success in Britain in 1981, leading to a record contract, concerts to overflowing audiences and a film and television show by means of which she became a media star. The emergence of performance 'cabaret' took place in the mid-1980s, particularly influenced by Eric Bogosian (*b* 1953) with his searing monologues such as *Men in the Cities* (1982), which consisted of Bogosian, without props or scenery, performing a series of male portraits that described a particular mood of American life in the 1980s. In New York, East Village clubs were the venues for hundreds of performance cabaret artists including John Kelly, the Alien Comic, Karen Finley, Ethyl Eichelberger and John Jesurun, many of whom would move on to make media-related performances, and a few of whom, such as Ann Magnuson, would actually make the cross-over into film, television and theatre.

The 1980s generally were characterized by media-orientated work, which often which often appeared more theatrical and fitted more easily on a proscenium stage than the work of the previous decade. Such artists as Eric Bogosian and Spalding Gray (*b* 1941) came to theatre on their own terms. They wrote, acted and often directed their own work—stages were bare, narratives infrequent—and they still referred to art world concerns rather than those of theatre. The autobiographical monologues by Spalding Gray, from the Performing Garage, typified the ambiguity of definition at this time between theatre and performance art. The wide variety of scale and format of performance allowed for the inclusion of new and vastly different work, such as Butoh, which since the 1960s had been a highly charged and disturbing form of theatrical dance in Japan. Troupes such as Sankai Juko toured Europe and the USA with their Zen-influenced, stylized work, as did German dancer and choreographer Pina Bausch, who created mesmerizing large-scale visual dramas, combining dance, text, sound and extraordinary architecture to tell her eerie tales. In the early 1970s Robert Wilson had created an astonishing 'Theater of Images' with works such as *Einstein on the Beach* (first performed in July 1976 at the Festival d'Avignon), in which he

collaborated with many of the most important per-
formance artists from New York, including Philip
Glass, Lucinda Childs and others; in the 1980s he
continued to make works that played on the edges
of many disciplines. The Ontological Hysteric
Theatre of Richard Foreman (*b* 1937), with its focus
on language that was as concrete as the changing
visual collage of his highly controlled perfor-
mances, became increasingly popular in the 1980s
with the tendency towards more theatrical work.
In England 'living painting' emerged as a reaction
to this theatrical and media-orientated perfor-
mance; Miranda Payne, Stephen Taylor Woodrow
and Raymond O'Daly each created work that
shared an emphasis on the 'art' context of per-
formance, with works comprised of live figures
actually suspended on a wall as living painting.

The apparent co-option of performance by the
popular media in the 1980s led many to question
whether performance could retain its anarchic
ways and still function as a catalyst shaping new
ideas in fine arts. A first history of the medium
appeared in 1979 and performance reached a peak
of acceptance with major annual festivals, spe-
cialist magazines and art-school curricula that
charted its course. In 1986 a Hollywood film even
featured a 'performance artist' and her Hollywood-
style performances (lighting small fires in a large
loft while moaning and writhing) as the underly-
ing theme of an art-world thriller. For the first
time there was a generation of artists who worked
exclusively in performance, whereas before this an
artist was more likely to use performance as an
experimental stepping-stone to mature work in
painting or sculpture. Many performance artists
were building up a body of work over 25 years or
more and making new productions that showed
the evolution of their thinking over that period.
It also became possible for performance artists
to show retrospectives for serious art-historical
review, and, correspondingly, new work could now
be considered in terms of performance history.
Despite the acceptance of the form as a valid genre
with its own history, practitioners and critics,
performance remains an open-ended medium,
without rules and guidelines. The extraordinary
range of material encompassed continues to
defy easy definition and performance continues
to be an important means to break through
the limits or conventions imposed on art activity.
In addition, the lively invention of performance
of the 1970s and 1980s greatly influenced new
movements in theatre, dance and opera of the
1990s.

Bibliography

H. Carter: *The New Spirit in the Russian Theatre,*
 1917–1928 (London, 1929)
W. Gropius, ed.: *The Theater of the Bauhaus* (Middletown,
 CT, 1960)
C. Tomkins: *The Bride and the Bachelors* (London, 1965)
M. Kirby: *Happenings* (New York, 1966)
G. Brecht and R. Filliou: *Games at the Cedilla* (New York,
 1967)
M. Kirby: *The Art of Time* (New York, 1968)
R. Kostelanetz: *The Theatre of Mixed Means* (New York,
 1968)
M. Kirby: *Futurist Performance* (New York, 1971)
Avalanche Mag., 1–6 (1972–4)
H. Ball: *Flight out of Time: A Dada Diary* (New York, 1974)
J. E. Bowlt: *Russian Art, 1875–1975* (Austin, 1976)
—: *Russian Art of the Avant-garde: Theory and Criticism,*
 1902–1934 (New York, 1976)
V. Acconci: Headlines and Image (exh. cat., Amsterdam,
 Stedel. Mus., 1978)
A. A. Bronson and P. Gale, eds: *Performance by Artists*
 (Toronto, 1979)
R. Goldberg: *Performance; Live Art, 1909 to the Present*
 (London, 1979)
G. Battock and R. Nicklas, eds: *The Art of Performance*
 (New York, 1984)
For further bibliography *see* BAUHAUS, DADA, FLUXUS,
 FUTURISM.

ROSELEE GOLDBERG

Phalanx

Exhibiting society founded by Vasily Kandinsky
and others in Munich in 1901 and active until 1904
as an important manifestation of the *Jugendstil*
aesthetic. Founded soon after Kandinsky's depar-
ture from Franz von Stuck's studio, it was the first
group for which he served as the main driving
force. The society was advertised in July 1901 in
the Munich periodical *Kunst für Alle* as having 'set
for itself the task of furthering common interests

in close association. Above all it intends to help overcome the difficulties that often stand in the way of young artists wishing to exhibit their work.' The choice of name itself suggested the idea of a close association and also related to the concept of the phalanx propounded by the French philosopher Charles Fourier (1772–1837) as the basic unit of his Utopian society. This social aspect also reflected the ideas of William Morris and other writers associated with the Arts and Crafts Movement and was an important principle in its structure. The society attempted to redress the sexual inequalities found in the Munich Akademie by allowing men and women equal access to exhibitions and to the school established in the winter of 1901–2 on Kandinsky's initiative.

Contrary to the practice of traditional exhibition systems, in Phalanx both the jurors and the artists' submissions were anonymous in order to ensure fair judgement. The first Phalanx exhibition, which opened on 15 August 1901, was announced in a poster by Kandinsky (see Derouet and Boissel, p. 21) depicting a phalanx of heavily armed Greek foot-soldiers; stylistically it shows the influence of Walter Crane. In addition to Kandinsky the exhibiting painters included the Germans Ernst Stern (1876–1954), Alexander von Salzmann (b 1870), Hans von Hayek (1869–1940), Franz Hoch (1869–1916) and Carl Piepho (1869–1920); there were also two masks produced for the Munich cabaret, the Elf Scharfrichter, by the sculptor and designer Wilhelm Hüsgen (1877–1962). Though some were almost unknown, artists such as von Hayek and Hoch already had established reputations.

Soon after this first exhibition Kandinsky took over the presidency of the society from one of its co-founders, the German painter Rolf Niczky (b 1881). The second Phalanx exhibition in January 1902 included decorative art objects by Peter Behrens and others based at the Darmstadt artists' colony and similar products in a *Jugendstil* idiom from the *Vereinigte Werkstätten* in Munich, including works by Richard Riemerschmid and Bernhard Pankok. Ludwig von Hofmann (1861–1945), one of the

original members of Berlin Secession, was also represented. Kandinsky himself exhibited a number of 'decorative sketches', such as *Twilight* (c. 1901; Munich, Lenbachhaus), reflecting the influence of *Jugendstil* on his own work.

Kandinsky, Hüsgen, the sculptor Waldemar Hecker and the medical student Gustav Freytag (1876–1921) all taught at the Phalanx school. Unusually the courses offered there included a regular modelling class in order to give the pupils a feeling for form, a feature of the school that reflected the *Jugendstil* aesthetic. Kandinsky soon became the most important and popular of the teachers in the school; his pupils there included Gabriele Münter, who became his companion. The school was shortlived and by the end of 1903 was forced to close. The third Phalanx exhibition (spring 1902) was dominated by the work of Lovis Corinth and Wilhelm Trübner, the fourth by Akseli Gallen-Kallela and the seventh (May 1903) by 16 paintings by Monet. The eighth exhibition in late 1903 included works by the German painter Carl Strathmann (1866–1939) and the German printmaker Heinrich Wolff (1875–1940), and at the ninth exhibition the young painter Alfred Kubin was the highlight. The tenth exhibition in 1904, with Neo-Impressionist works by Paul Signac, Théo Van Rysselberghe, Félix Vallotton and Henri de Toulouse-Lautrec, ran concurrently with the eleventh. The twelfth and last Phalanx show, held after Kandinsky's friend Rudolf Treumann (1873–1933) had succeeded him to the society's presidency, took place in Darmstadt in December 1904. Although Kandinsky had planned further exhibitions for Krefeld and Düsseldorf, he then left Munich to travel abroad. Though it had not greatly affected the development of art in Munich, Phalanx was an important stage in Kandinsky's artistic development and in its eclecticism prefigured aspects of the Blaue Reiter.

Bibliography

P. Weiss: *Kandinsky in Munich: The Formative Jugendstil Years* (Princeton, 1979), pp. 57–72

C. Derouet and J. Boissel: *Kandinsky* (Paris, 1984), pp. 20–21

Phantastischer Realismus [Ger.: 'fantastic realism']

Term applied to a group of painters in Vienna, who had met shortly after the end of World War II in the class given by Albert Paris Gütersloh at the Akademie der Bildenden Künste in the 1940s. It was first used by the Austrian art critic Johann Muschik in the late 1950s to describe the group, which included Arik Brauer, Ernst Fuchs, Rudolf Hausner, Wolfgang Hutter (*b* 1928), Gütersloh's illegitimate son, and Anton Lehmden (*b* 1929).

Gütersloh's fantastic images were the starting-point for the work of his former students, who developed a style of painting that can be understood only in the context of the post-war situation. They defined the forms of objects with the precision of the Old Masters and sought to connect a number of the stylistic traditions of Western painting, including Mannerism, Symbolism, Pittura Metafisica, Surrealism and the use of psychoanalysis. The subjects, depicted with realistic attention to detail, emerged from a fantastic world of the mind: dreamlike visions of the subconscious, enigmatic metamorphoses, alienated perceptions of nature in a bizarre cosmos. With a common basis, each artist maintained an independent tone: Brauer's work is dominated by a joy of story-telling reminiscent of the work of Chagall; Fuchs depicted the erotic in mythological guise; Hausner explored psychoanalytical self-representation; Hutter portrayed a vegetable magical world; and Lehmden depicted the traumatic experience of World War II on the landscape.

These paintings, at first received by the public with incomprehension, gradually became popular as more value was placed on the brilliance of the technique rather than the expressiveness of the content. As its main proponents took up teaching posts, *Phantastischer Realismus* became merely a fashionable trend, giving rise to numerous commercially successful works of inferior quality. Later the term was extended to various international trends of fantastic painting and its meaning gradually became relativized.

Bibliography

W. Schmied: *Malerei des Phantastischen Realismus: Die Wiener Schule* (Vienna, 1964)

J. C. Guilbert: *Het fantastisch realisme* (The Hague, 1972)

J. Muschik: *Wiener Schule des Phantastischen Realismus* (Vienna, 1974)

EDWIN LACHNIT

Photo League

American organization of photographers founded in New York in 1936. It was an offshoot of the earlier radical Film and Photo League, and its members were dedicated to urban social imagery. At first they saw the camera as a weapon in the social and political struggles of the time, but towards the end of the 1930s their outlook broadened, although they remained strongly committed to documentary photography. Photo League members later included many renowned photographers whose only common bond was their devotion to the medium as an expressive visual form.

The Photo League maintained darkrooms and meeting space, operated a school under the directorship of the photographer Sid Grossman (1913–55), sponsored workshops and projects (for example the Harlem Document, an in-depth photographic documentation of life in Harlem, led by Aaron Siskind, that lasted for three years) and published *Photo Notes*, a periodical that was praised by Edward Weston as the most provocative photographic reading of its time. The League also provided gallery space for exhibitions, on 21st Street and later on 10th Street. The breadth of its presentations is indicated by a spectrum that included the work of Weegee, Lisette Model, Dorothea Lange, Barbara Morgan (*b* 1900), László Moholy-Nagy, French photojournalism and photographs for the Farm Security Administration (FSA) project.

During the anti-liberal climate that emerged towards the end of the 1940s the Photo League, with its broadly social outlook, found itself listed by the US Attorney-General as a 'subversive' organization. When anti-libertarian ideology became further entrenched and the League was unable to

clear itself—there being no procedure for this—its membership drained away and in 1952 it was forced to cease its activities.

Bibliography

'The Photo League', *Documentary Photography*, Life Library of Photography (New York, 1972), pp. 85–118

Photo Notes: February 1938–Spring 1950 (Rochester, 1977) [A nearly complete record of the original publication]

A. Tucker: 'The Photo League', *Ovo Mag.*, x/40–41 (1981), pp. 3–9

NAOMI ROSENBLUM

Photorealism [Hyper Realism; Super Realism]

Style of painting, printmaking and sculpture that originated in the USA in the mid-1960s, involving the precise reproduction of a photograph in paint or the mimicking of real objects in sculpture. Its pioneers included the painters Malcolm Morley, Chuck Close, Richard Estes, Audrey Flack (*b* 1931), Robert Bechtle (*b* 1932), Robert Cottingham (*b* 1935), Richard McLean (*b* 1934), Don Eddy and the English painter John Salt (*b* 1937), and sculptors such as Duane Hanson and John De Andrea. Though essentially an American movement, it has also had exponents in Europe, such as Franz Gertsch.

In terms both of its imagery of mass-produced objects and suburban life and of the premise of replicating an existing artefact with no apparent comment, Photorealism emerged as an offshoot of Pop art. Despite clear stylistic differences, it is also close to Minimalism in its cool, detached approach and to conceptual art in its concern with the work of art as a physical manifestation of an idea. Its relationship to modernism was, however, somewhat awkward. Many critics attacked it as a betrayal of modernist principles, reactionary in its return to a representational illusionism. As with Pop art, its rejection of élitism, in its apparent appeal to popular taste and to comprehensibility, was judged by many to be anti-modernist. Paradoxically, however, its blatant presentation of a *trompe l'oeil* style and its reliance on photographic images forced to the forefront, in the modernist tradition, a consciousness of the medium as an end in itself. In its meticulous technique and objective rendering of surface appearance Photorealism has a long line of historical predecessors stretching from veristic Surrealism and 19th-century academic painting back to 17th-century Dutch painting and further to the works of Jan van Eyck. Culturally closer are pictures painted in a *trompe l'oeil* manner by American artists such as James Peale, John F. Peto, William Michael Harnett and later by the American Precisionists such as Charles Sheeler.

Morley, in his innovative paintings of ships from 1965 and 1966, such as '*SS Rotterdam*' (1966; London, Saatchi Col., see Lindey, p. 46), used a grid to reproduce the original photographic image in detail, often turning the canvas and photograph upside down to avoid stylization. His main concern in these works was with the colours and style of mechanically produced images from postcards, brochures and so on, subject-matter itself being of no importance. This professed disinterest in subjects was a hallmark of Photorealism. The works invariably depict banal features of the urban environment such as motor-cars, shops, streets and consumer products in a cool, objective manner using ordinary brushes or airbrushes, as in Bechtle's *'71 Buick* (1972; New York, Guggenheim). Human figures are also treated in the same detached fashion, which tends to dehumanize them, as in Close's *Self-portrait* (1968; Minneapolis, MN, Walker A. Cent.), in which no attempt has been made to conceal the distortions of focus present in the original photograph.

Despite frequent denials by the artists, the choice of banal subjects with no centres of interest was almost inevitably read as a commentary on the hollowness of the society from which it derived. Such social references are made all the more specific through the sense of place and culture that pervades Photorealist works: whether through conscious design or otherwise, the paintings are invariably recognizably American. Although a satirical aspect is perhaps most evident in sculptures depicting human figures, such as Hanson's grotesque *Tourists* (polyester and fibreglass polychromed in oil, with accessories,

life-size, 1970; Edinburgh, N.G. Mod. A.), there is a sense of social observation, with a hint of the nostalgia associated with documentary photography, even in paintings apparently dedicated purely to perceptual problems, such as Estes's the *Candy Store* (1969; New York, Whitney).

Photorealist sculpture as produced by Hanson, De Andrea and others follows much the same principles, though it strives to mimic real objects rather than photographs. Wax models and the sculptures of George Segal and Claes Oldenburg provide historical precedents, though their work is less persistently deceptive. Much Photorealist sculpture is cast directly from human figures, a process directly related to that used by Segal, although in place of plaster their preference was for fibreglass, which gave a smoother finish and allowed for a detailed painting of the surface, as in Hanson's *Football Players* (1969; Aachen, Neue Gal.). There are also veristic sculptures of mundane objects, such as *Golf Bag* (1976; New York, O. K. Harris Gal.; see Lucie-Smith, p. 76) by Marilyn Levine (*b* 1935). In the works of Levine or the Japanese sculptor Fumio Yoshimura (*b* 1926) the aim was largely to reproduce objects in unexpected materials, Levine often representing soft objects such as leather jackets in ceramics and Yoshimura producing detailed replicas in wood of such things as a motor-cycle or old typewriter. Unlike most exponents of Photorealism, Hanson admitted to having a social message in his work, pointing through it to the resignation, emptiness and loneliness of suburban existence. He also produced overtly political sculptures, such as *War* (1969; Duisburg, Lehmbruck-Mus.). Largely, however, as in Photorealist painting, the social comment is more concealed, as in De Andrea's *Clothed Artist and Model* (1976; New York, O. K. Harris Gal.; see Lindey, p. 136) and other impassive life-sized figures presented blankly as intrusions of reality all the more shocking for their banal and familiar appearance.

Bibliography

G. Battcock: *Super Realism: A Critical Anthology* (New York, 1975)

E. Lucie-Smith: *Super Realism* (Oxford, 1979)

C. Lindey: *Superrealist Painting and Sculpture* (London, 1980)

L. K. Meisel: *Photorealism* (New York, 1980/R 1989)

O. T. Kozlova: *Fotorealizm* (Moscow, 1994)

Photo-Secession

Group of mainly American Pictorialist photographers founded by Alfred Stieglitz in New York in 1902, with the aim of advancing photography as a fine art. Stieglitz, who chose the organization's name partly to reflect the Modernism of European artistic Secession movements, remained its guiding spirit. Other leading members included Alvin Langdon Coburn, Gertrude Käsebier, Edward Steichen and Clarence H. White. The Secession also exhibited and published work by Europeans, for example Robert Demachy, Frederick H. Evans, Heinrich Kühn and Baron Adolf de Meyer, who shared the Americans' attitude that photography was a valid medium of artistic expression (*see* Pictorial photography).

All participants placed great emphasis on fine photographic printing. Their gum bichromate or platinum prints often emulated paint, pastel or other media, particularly in their use of soft focus, emphasis on composition and texture, and adoption of traditional academic subject-matter; in addition graphic signatures or monograms were often used. The Secession's shifting aesthetic concerns are well documented in the elegant magazine *Camera Work*, which Stieglitz edited (1903–17). From 1905 exhibitions were held regularly in New York at The Little Galleries of the Photo-Secession, 291 Fifth Avenue, later known as 291 (*see* Two ninety one). In order to define photography's position among the arts, it was felt appropriate to exhibit contemporary American and European non-photographic works, and from 1908 there were more exhibitions of paintings than of photographs. After the Secession's last major photographic exhibition in 1910 at the Albright Art Gallery (now Albright–Knox Gallery) in Buffalo, NY, many disaffected Pictorialist photographers left the group, and it disbanded unofficially, although 291 remained open until 1917.

Bibliography

R. Doty: *Photo-Secession: Photography as a Fine Art* (Rochester, 1960; rev. as *Photo-Secession: Stieglitz and the Fine Art Movement in Photography*, New York, 1978)

J. Green, ed.: *Camera Work: A Critical Anthology* (Millerton, 1973)

W. I. Homer: *Alfred Stieglitz and the American Avant-garde* (Boston, 1977)

—: *Alfred Stieglitz and the Photo-Secession* (Boston, 1983)

Camera Work: Process and Image (exh. cat. by C. A. Peterson, Minneapolis, MN, Inst. A., 1985)

BARBARA L. MICHAELS

Pictorial photography

A style of photography and imagery based on an application of the principles of fine art, and, in particular, on ideas of beauty and nature deriving from the Picturesque. Although specifically identified in the late 19th century and the early 20th, the underlying aesthetic was a response to the ongoing debate about photography's scientific and artistic status. In this respect, the term 'pictorial' is defined in Henry Peach Robinson's *Pictorial Effect in Photography* (1869), which recommended adherence to the systemized aesthetic of the contemporary painting Salon.

The creation of Robinson's elaborate *tableaux vivants* involved technical precision, but a different approach predated his work in Hill and Adamson's calotypes of the 1840s and Julia Margaret Cameron's photographs of the 1860s and 1870s, all of which were characterized by shallow focus, chiaroscuro tonality and simple, centralized composition. Reacting against Robinson, P. H. Emerson codified these attributes in a lecture entitled 'Photography: A Pictorial Art' at the Camera Club, London, in 1886. In *Naturalistic Photography for Students of the Art* (1889) he adopted the theory of Hermann von Helmholtz (1821–94) that the human eye focuses on only the centre of the field of vision. Emerson proposed photography's use of a limited depth of field and subordination of extraneous detail.

Although Emerson repudiated his views, a new phase of photography was in evidence at the exhibition of the Photographic Society of Great Britain in Pall Mall, London, in 1890. George Davison's pinhole photograph *The Onion Field* (1889) was the most radical example, but the glossy sepia and purple-black albumen prints were generally superseded by the soft matt greys and browns of gelatin silver and non-silver processes that allowed more control over the final image. Platinum printing, well established by 1885, yielded a subtle range of tones on a variety of textured papers. Bichromated colloids produced permanent images through such processes as carbon printing, gum bichromate, photogravure and, in the early 1900s, bromoil and oil pigment printing. Photographs mim-icked the texture of a charcoal drawing or replicated a watercolour painting in hue and tone, appropriate to the massed, flattened tones of the new aesthetic. Impressionistic effects were enhanced through soft-focus lenses and the use of screens to blur images during exposure or printing.

Photography gained stature as a means of artistic expression through a conscious dissocation from its mechanistic attributes, and its equivalence to other media was fostered by the Art Nouveau emphasis on unified decorative values. Pictorialism, as the first truly international photographic movement, was promoted in the 1890s and early 1900s through numerous multinational groups and associations. In 1891 the newly organized Vienna Camera Club exhibited 600 exclusively 'artistic' photographs selected by painters and sculptors. Work by English photographers was included, and following this, Henry Peach Robinson led a group in secession from the Photographic Society of Great Britain, forming the Brotherhood of the LINKED RING. Their first exhibition, The Photographic Salon (1893), included work by George Davison, Malcolm Arbuthnot (1874–1967) and Francis J. Mortimer (1874–1944). The membership of the Linked Ring embraced American and European photographers, including the Trifolium of the Vienna Camera Club: Hans Watzek, Hugo Henneberg and Heinrich Kühn. The Trifolium also joined the Photo-Club de Paris (1894), founded by Maurice Bucquet, with Robert Demachy and Constant Puyo (1857–1953).

The Club broke away from the Société Française de Photographie, and the jury for its 1894 exhibition included four painters and the National Inspector for the Fine Arts. Das Praesidium, whose members included Theodor Hofmeister (1863–1943) and Oskar Hofmeister (1871–1937), was instrumental in exhibitions at the Kunsthalle in Hamburg (from 1893). The Cercle d'Art Photographique of Brussels (1900) included Léonard Misonne (1870–1943) and Pierre Dubreuil (1872–1944); its exhibitions also embraced non-photographic media. This was not unusual: in 1898 the members of the Munich Secession showed Watzek's large gum bichromates prints alongside paintings. Other notable forums for Pictorial photography included the International Exhibition at Glasgow (1901) and at Turin (1900 and 1903).

In 1900, F. Holland Day (of the Linked Ring) and Alvin Langdon Coburn organized *The New School of American Photography* at the Royal Photographic Society in London. Many of the same photographers exhibited as the Photo-secession at the National Arts Club in New York (1902); the show was organized by Alfred Stieglitz and included works by Gertrude Käsebier, Clarence H. White, Frank Eugene, Edward Steichen (see fig. 36) and Heinrich Kühn. The work was further promoted by Charles Caffin (1894–1918) in his important book, *Photography as a Fine Art* (New York, 1901). The Photo-Secession found its voice in *Camera Work* (1903–17), the elaborate periodical edited by Stieglitz; its critical acclaim far outlasted the aesthetic that inspired it. Other journals fostered art photography, among them *The Amateur Photographer* (London, from 1884), edited from 1893 by Linked Ring member Alfred Horsley Hinton (1863–1908); *Photographic Review* (from 1891) in Lwów, Poland (now L'viv, Ukraine); *Photograms of the Year* (London, from 1895); *Die Kunst in der Photographie* (Berlin, 1897–1908), *La fotografica artistica* (Italy, from 1904); and *Vestnik fotografii* (Moscow), whose director after 1903 was Nikolay Petrov. Charles Holme edited special editions on Pictorial photography (1905 and 1908) for *The Studio* (London).

Outside Europe and the USA, Harold Cazneaux was integral to Australian Pictorialism, while in Canada Sidney Carter (1880–1956) founded The Studio Club (Toronto, 1904), inspired by the Linked Ring. In Japan Ogawa Isshin (1860–1929/30) integrated existing aesthetics with a concern for spiritual values, an approach mirrored in the Pictorialist landscapes of the Indian Sir Pradyot Kumar Tagore (1873–1942) and embodying photography's quest for personal expression.

In 1910 the Photo-Secession organized an international exhibition of 600 photographs at the Albright Art Gallery (now Albright–Knox Art Gallery), Buffalo, NY. In that year a schism with American members of the Linked Ring led to its dissolution, and although George Davison, Malcolm Arbuthnot and Alvin Langdon Coburn organized an exhibition of the London Secession in 1911, that effort had no direct sequel. Coburn joined Gertrude Käsebier, Karl Struss (1886–1980) and Clarence H. White in founding the Pictorial Photographers of America (1915). Although *Camera Work* ceased publication in 1917, the continuing popularity of Pictorial photography in the USA was evident in *Pictorial Photography: Its*

36. Edward J. Steichen: *Self-portrait* (Washington, DC, National Portrait Gallery)

Principles and Practice (1917), by Paul Anderson (1880–1956), and *The Fine Art of Photography: Painting with the Camera* (1919). F. J. Mortimer promoted British Pictorialism well into the 1940s as Director of the London Salon and the Camera Club, President of the Royal Photographic Society and editor of *The Amateur Photographer* (from 1908) and *Photograms of the Year* (from 1912).

World War I brought increasing aesthetic, social and political fragmentation. Post-Impressionism pulled avant-garde photography away from a 19th-century Pictorialist aesthetic towards formalist abstraction, to which Pictorialism's misty romanticism and ideal of intrinsic beauty were irrelevant. Pictorialism's attributes of manipulated photographic media, subjectivity and symbolism have, however, remained guiding principles of photography as art.

Bibliography

H. P. Robinson: *Pictorial Effect in Photography: Being Hints on Composition and Chiaroscuro for Photographers* (London, 1869)

P. H. Emerson: *Naturalistic Photography for Students of the Art* (New York, 1889/R 1972)

Photograms of the Year (London, 1895–)

C. H. Caffin: *Photography as a Fine Art* (New York, 1901/R 1971)

The Studio (1905) [*Art in Photography* issue; ed. C. Holme]

The Studio (1908) [*Colour Photography* issue; ed. C. Holme]

P. Anderson: *Pictorial Photography: Its Principles and Practice* (New York, 1917)

——: *The Fine Art of Photography: Painting with the Camera* (New York, 1919)

S. A. Morosov: 'Early Russian Photography', *Hist. Phot.*, i/4 (1977)

J. Taylor: 'F. J. Mortimer', *Hist. Phot.*, ii/3 (1978)

Pictorial Photography in Britain, 1900–1926 (exh. cat. by J. Taylor, ACGB, 1978)

M. F. Harker: *The Linked Ring* (London, 1979)

P. C. Bunnell, ed.: *A Photographic Vision: Pictorial Photography, 1889–1923* (Salt Lake City, 1980)

A. Sobota: 'Art Photography in Poland', *Hist. Phot.*, iv/1 (1980)

U. F. Keller: 'The Myth of Art Photography', *Hist. Phot.*, viii/4 (1984)

R. H. Krauss: 'Die Kunst in der Photographie', *Hist. Phot.*, x/4 (1986)

For further bibliography *see* LINKED RING and PHOTO-SECESSION.

HOPE KINGSLEY

Pittura Metafisica [Arte Metafisica]

Term applied to the work of Giorgio De chirico and Carlo Carrà before and during World War I and thereafter to the works produced by the Italian artists who grouped around them. Pittura Metafisica was characterized by a recognizable iconography: a fictive space was created in the painting, modelled on illusionistic one-point perspective but deliberately subverted. In de Chirico's paintings this established disturbingly deep city squares, bordered by receding arcades and distant brick walls; or claustrophobic interiors, with steeply rising floors. Within these spaces classical statues and, most typically, metaphysical mannequins (derived from tailors' dummies) provided a featureless and expressionless, surrogate human presence (see fig. 37). Balls, coloured toys and unidentifiable solids, plaster moulds, geometrical instruments, military regalia and small realistic paintings were juxtaposed on exterior platforms or in crowded interiors and, particularly in Carrà's work, included alongside the mannequins. In the best paintings these elements were combined to give a disconcerting image of reality and to capture the disquieting nature of the everyday.

The thinking behind this approach derived from the melancholic personalities of de Chirico and his brother, the writer and composer Alberto Savinio. It was encouraged by their reading (c. 1910) of the German philosophers Friedrich Nietzsche, Arthur Schopenhauer and Otto Weininger. They became interested in Nietzsche's notion of the eternal return and the circularity of time, which supported their own views about the re-enactment of myth. Their central concern was true reality (where the past recurs), which is hidden behind the reality of appearances and visible only to the 'clearsighted' at enigmatic moments. In his paintings de Chirico sought to unmask reality and reveal its mysterious truth. The modification of perspective and depiction of mundane objects provided the appropriate context.

In Paris (1911–15), de Chirico and Savinio became close friends of Guillaume Apollinaire, finding parallels to their understanding of Nietzsche in his conviction that the unifying element in contemporary painting was the idea of 'surprise', suggesting the inevitability of fate.

It was Apollinaire who first called de Chirico's painting 'metaphysical', referring to works produced in 1910 and 1911 (*L'Intransigeant*, 30 Oct 1913). De Chirico had been influenced by the work of the Symbolists and by that of Arnold Böcklin. By 1917, in Ferrara, he was painting in a

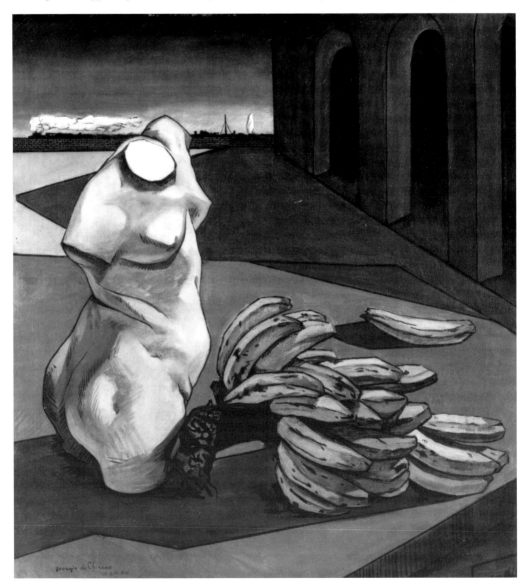

37. Giorgio de Chirico: *The Uncertainty of the Poet*, 1913 (London, Tate Gallery)

simplified manner, in which crisp areas of colour outlined in black and a clear, dry modelling complement the disturbing subject-matter.

Carrà met de Chirico and Savinio for the first time in Ferrara in February 1917. A leading Futurist, Carrà had begun to withdraw from the movement in 1915 as he became interested in the combination of simplicity and monumentality in the work of Giotto and Paolo Uccello. Paring away superfluous detail in his paintings, he applied the structural lessons of these masters to figures and ordinary objects, attempting to reconcile art and nature. His understanding of Giotto's use of a perspective subservient to the pictorial structure prepared him for the destabilizing space used by de Chirico. Carrà's style fluctuated during these investigations, but in the metaphysical style of de Chirico he found a solution. The two painters worked closely for some months in 1917; while theoretical differences remained, their stylistic solution became known as Pittura Metafisica, a term that they were happy to apply to their work.

The Roman periodical *Valori plastici* appeared for the first time in November 1918 and became the proponent of Arte Metafisica, which had widened its activities in the preceding year. Savinio's first book, *Hermaphrodito*, was published in 1918; Carrà held a show in Milan (1917–18), which included his Ferrarese works. De Chirico exhibited in Rome in 1918 (with Carrà) and 1919. During World War I the artists in Ferrara had been in touch with the periodical *La raccolta* in nearby Bologna. Through this connection Giorgio Morandi absorbed the metaphysical style; for a time c. 1918/19 his works came close to Carrà's, in the crisp rendering of a limited group of objects. Morandi's work was illustrated in *Valori plastici*, and he exhibited with de Chirico and Carrà but soon passed on to other considerations.

In 1919 Carrà published *Pittura Metafisica*; the book understated de Chirico's importance in these developments and led to acrimony. A year later Filippo de Pisis, who had been part of the Ferrara group, published his lyrical prose collection about Ferrara, *La città dalle 100 meraviglie*. Although collages survive from 1916, de Pisis began to paint seriously only in 1919, using a soft impressionistic style for his vaguely metaphysical still-lifes. At this time the sculptor Arturo Martini, although dispensing with the characteristic perspective and mannequins, went some way towards reconciling Carrà's Giottesque monumentality with the foreboding of de Chirico's paintings by means of his small, clay figures. Martini's use of the figure was symptomatic of *Valori plastici*'s sympathy towards the so-called post-war 'rappel à l'ordre'. In its years of publication (1918–21), when the theoretical background of Arte Metafisica was being clarified by Savinio, de Chirico and Carrà, the style of both painters shifted radically from the position of 1917 to concentrate on the figure.

Several major artists were attracted by this development: Mario Sironi's totemic mannequins turned into brooding solitary figures; and Felice Casorati used steep perspectives leading to dark interiors as the settings for his models. In Germany the impact of the two *Valori plastici* travelling exhibitions (1921 and 1924) was considerable. Featureless mannequins began to appear in the work of George Grosz, Rudolf Schlichter and Oskar Schlemmer. The effect was felt most profoundly, however, by Max Ernst. On his arrival in Paris in 1922, Ernst's painting reflected the admiration of his poet friends for de Chirico. At that time only one painter, Pierre Roy (a pre-war friend of de Chirico), showed the influence of metaphysical art, but the painters who became Surrealists after Ernst almost all passed through a period of stylistic debt to de Chirico, notably Salvador Dalí and Alberto Giacometti (the leading creators of the Surrealist Object), René Magritte and Paul Delvaux.

These groups—Novecento Italiano in Italy, Magic Realism in Germany and international SURREALISM—carried the style into the 1930s. Although Carrà occasionally painted metaphysical works, it was only in the paintings of Savinio and de Chirico that the philosophical background of Pittura Metafisica persisted.

Bibliography

C. Carrà: *Pittura Metafisica* (Florence, 1919, 2/1945)

F. de Pisis: *La città dalle 100 meraviglie* (Rome, 1920)

M. Carrà, ed.: *Metafisica* (Milan, 1968; Eng. trans., abridged, 1971)

Miti del novecento: Arte e letteratura (exh. cat., ed. Z.
 Birolli; Milan, Padiglione A. Contemp., 1979)
La Pittura Metafisica (exh. cat., ed. G. Briganti and E.
 Coen; Venice, Pal. Grassi, 1979)
La Metafisica: Gli anni venti, 2 vols (exh. cat., ed. R. Barilli
 and F. Solmi; Bologna, Gal. A. Mod., 1980)
Les Réalismes, 1919–1939 (exh. cat., Paris, Pompidou, 1980)
M. Calvesi and E. Coen, eds: *La Metafisica: Museo
 documentario* (Ferrara, 1981)

<div align="right">MATTHEW GALE</div>

Plasticiens, Les

Canadian group of artists based in Montreal,
active from 1955 to 1959. They announced them-
selves with the publication of a manifesto on 10
February 1955 on the occasion of an exhibition at
L'Echourie, a coffee bar in Montreal. The four
signatories, who had begun exhibiting together in
1954, were Louis Belzile (*b* 1929), Jean-Paul Jérôme
(*b* 1928), Fernand Toupin (*b* 1930) and Jauran (pseu-
donym of Rodolphe de Repentigny, 1926–59); the
text was written by Jauran, who was influential as
an art critic for *La Presse*. The manifesto pro-
claimed the need for a return to order in art in
reaction to the prevalence of the subjective ten-
dencies of Abstract Expressionism; the group's
name was chosen in homage to the Neo-Plasticism
of Theo van Doesburg and Piet Mondrian.

Instead of attacking Paul-Emile Borduas's group
Les Automatistes, at that time the most influential
avant-garde group in Quebec, the manifesto cred-
ited them with introducing abstract painting to
the province and affirmed their importance as an
inspiration to the new generation. However, by
extolling Mondrian as the one 'who has freed paint-
ing from its last alienation', they took a more for-
malist stand than Les Automatistes, stressing the
principles then being espoused by the American
critic Clement Greenberg: pure colour, geometric
shapes (and in Toupin's case the use of shaped
canvases) and an emphasis on the flatness of the
picture plane. Toupin's *Area with Reciprocal Arcs*
(1956; Montreal, priv. col.) illustrates the genre
well; painted in red, blue and black, it consists of
horizontal stripes broken by two curves and one
oblique line. While Toupin was perhaps the most
talented of the original group members, he later
abandoned these strict principles to evolve a
more lyrical kind of abstraction using thick and
sumptuous impasto.

The defection of Borduas's disciple Fernand
Leduc from the ranks of Les Automatistes to the
geometric abstraction of Les Plasticiens was
announced by his participation in the exhibition
Espace 55 at the Montreal Museum of Fine Arts
in February 1955, which Borduas condemned as
a reactionary move. For Leduc, who formally
joined Les Plasticiens in 1956, Automatisme was
compromised by its attachment to an illusion of
pictorial depth, which he felt arose from its ori-
gins in Surrealist depictions of a metaphorical
landscape of the mind. Guido Molinari joined the
debate in 1955 in a remarkable article in which he
argued the need for a much more radical form of
painting that would eliminate any vestiges of rep-
resentation and perspective; he supported his the-
ories with an exhibition of black-and-white
geometric paintings such as *The Black Angle* (1956;
Ottawa, N.G.), which he showed at L'Actuelle,
Montreal, in 1956. Shortly afterwards Claude
Tousignant showed monochromes influenced by
American colour field painting. By the time of
Jauran's death in a climbing accident in 1959 the
original group, by then referred to as the 'first'
Plasticiens, had been supplanted by Les Nouveaux
Plasticiens, led by Molinari and Tousignant, who
showed their work to considerable acclaim in exhi-
bitions such as *Art abstrait* at the Ecole des Beaux-
Arts, Montreal, in 1959 and *Espace dynamique* at
Galerie Denyse Delrue, Montreal, in 1960.
Prominent among other painters associated with
Les Nouveaux Plasticiens at that time were Jean
Goguen (*b* 1928), Jacques Hurtubise (*b* 1939), Denis
Juneau (*b* 1925) and Yves Gaucher.

Bibliography

G. Molinari: 'L'Espace tachiste ou situation de l'automa-
 tisme', *L'Autorité* [Montreal] (2 April 1955)
Guido Molinari (exh. cat. by P. Théberge, Ottawa, N.G.,
 1976)
Jauran et les premiers Plasticiens (exh. cat. by A. Parent,
 Montreal, Mus. A. Contemp., 1977)
A. Corneau: *Artistes Plasticiens* (Montreal, 1983)

<div align="right">FRANÇOIS-MARC GAGNON</div>

Pop art

International movement in painting, sculpture and printmaking. The term originated in the mid-1950s at the ICA, London, in the discussions held by the INDEPENDENT GROUP concerning the artefacts of popular culture. This small group included the artists Richard Hamilton and Eduardo Paolozzi as well as architects and critics. Lawrence Alloway (1926–1990), the critic who first used the term in print in 1958, conceived of Pop art as the lower end of a popular-art to fine-art continuum, encompassing such forms as advertising, science-fiction illustration and automobile styling. Hamilton defined Pop in 1957 as: 'Popular (designed for a mass audience); Transient (short term solution); Expendable (easily forgotten); Low Cost; Mass Produced; Young (aimed at Youth); Witty; Sexy; Gimmicky; Glamorous; and Big Business'. Hamilton set out, in paintings such as £he (1958–61; London, Tate), to explore the hidden connotations of imagery taken directly from advertising and popular culture, making reference in the same work to pin-ups and domestic appliances as a means of commenting on the covert eroticism of much advertising presentation.

Paolozzi was a latter-day Surrealist, and his proto-Pop collages of the late 1940s, which served as the basis of his 'Bunk!' lecture at the ICA in 1952, were made as private scrapbook images. They were first shown at his retrospective exhibition at the Tate in 1971 and published in facsimile in 1972. His metamorphosis into a true Pop artist came about only in 1962 in brightly painted, robot-like aluminium sculptures such as City of the Circle and the Square (1963; London, Tate) and in his portfolio of screenprints of 1965, As Is When.

Peter Blake, Richard Smith and Joe Tilson, who studied together in the mid-1950s at the Royal College of Art, London, took separate paths into Pop art. Blake could rightly claim to have been the first British Pop artist, in that his student works directly reflected his love of folk art and popular culture, for example Litter (1955; Sheffield, Graves A.G.). In the late 1950s he made constructions and collage-based paintings that incorporated postcards, magazine photographs and mass-produced objects. Smith was essentially an abstract painter,

but during his stay in New York from 1959 to 1961 he began, in works such as Penny (1960; Belfast, Ulster Mus.), to make reference to the packaging of consumer products, to the film of colour in glossy magazines and to the expansive scale of the cinema screen. This shift was more the result of a sensibility nurtured by the mass media than of a direct use of Pop imagery. Tilson, meanwhile, applied his skills as a carpenter to brightly painted wooden constructions appealing in their simplicity, such as Space Trophy (1961–2; AC Eng).

The most cohesive group of British Pop artists, and those to whom the label was first consistently applied, emerged at the Royal College of Art between 1959 and 1962. It included the American-born R. B. Kitaj as well as younger students such as David Hockney, Allen Jones, Peter Phillips, Derek Boshier and Patrick Caulfield. Although Kitaj and Hockney in particular were quick to shun the Pop label, they all shared a detached and ironic attitude towards style and imagery, regarding both as elements that could be appropriated from other sources and quoted at will. Other British artists associated with Pop art later in the 1960s included Clive Barker (b 1940), Anthony Donaldson (b 1939), Gerald Laing (b 1936), Nicholas Monro (b 1936), Colin Self (b 1941) and the American-born Jann Haworth (b 1942).

In the mid-1950s in America, independently of the activities in England, the terms for certain aspects of Pop art were established by Jasper Johns and Robert Rauschenberg. The irony and anti-art gestures of their work initially attracted the term 'neo-Dada'. Johns took as his imagery 'things the mind already knows', such as the American flag, maps, targets, arabic numerals and the alphabet (see fig. 38). By changing the format, colour and medium, he demonstrated the formal and philosophical possibilities of an austere and direct presentation of blandly familiar images. Rauschenberg's self-styled 'combines' such as Monogram (1955–9; Stockholm, Mod. Mus.) were roughly made paintings and sculptures that incorporated photographs, newspapers and disparate objects collected in the street. Like Johns, Rauschenberg applied techniques from Abstract Expressionist painting to recognizable imagery and

satirized consumer culture, American Pop artists tended to have a more ambiguous attitude towards their subject-matter, nowhere more so than in the mixture of glamour and pathos that characterized Andy Warhol's silkscreened icons of Hollywood film stars, as in *The Marilyn Diptych* (1962; London, Tate).

Compared to the disparate nature of British Pop art, from the early 1960s American Pop art appeared to be a unified movement. Its shared formal characteristics included aggressively contemporary imagery, anonymity of surface, strong, flatly applied colours and a stylistic unity often associated with centralized compositions (see col. pl. XXXIX). Each of the American artists was quick to establish his or her identity, often with the ironic suggestion that the art was like any consumer product or brand name to be marketed. Foremost among them were Warhol's testaments to machine-line production and to capitalism, such as *80 Two-dollar bills* (1962; Cologne, Mus. Ludwig), and Roy Lichtenstein's formalized enlargements of the frames of comic strips, often violent or melodramatic, for example *Drowning Girl* (1963; New York, MOMA). Oldenburg produced sculptural paraphrases of ordinary objects, often on a huge scale, as in *Floor-burger (Giant Hamburger)* (1962; Toronto, A.G. Ont.), while James Rosenquist favoured dream-like combinations of grossly enlarged familiar images, which he painted in the manner of billboard advertisements, such as *I Love you with my Ford* (1962; Stockholm, Mod. Mus.). Tom Wesselmann specialized in provocatively posed female nudes and in domestic still-lifes of consumer products, for example *Still-life #30* (1963; New York, MOMA).

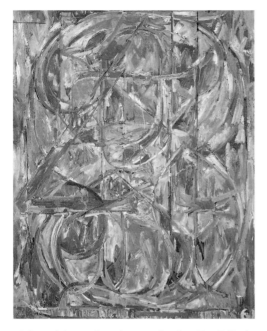

38. Jasper Johns: *0 through 9*, 1961 (London, Tate Gallery)

inspired many artists to dwell on subject-matter drawn from their immediate urban environment.

Another American artist, Larry Rivers, also provided a transition to Pop art in paintings such as *Dougherty Ace of Spades* (1960; Provincetown, MA, Chrysler A. Mus.), basing both format and imagery on ordinary objects such as playing cards, cigarette packets and restaurant menus. Themes from contemporary life were similarly introduced in the Happenings devised in the late 1950s by performance artists such as Allan Kaprow, Claes Oldenburg, Jim Dine and Red Grooms (*b* 1937).

American Pop art emerged suddenly in the early 1960s and was in general characterized by a stark and emblematic presentation that contrasted with the narrative and analytical tendencies of its British counterpart. At its most rigorous, American Pop art insisted on a direct relationship between its use of the imagery of mass production and its adoption of modern technological procedures. Whereas British Pop art often celebrated or

Other painters working in the USA associated with Pop art included Jim Dine, who consistently rejected the term, Richard Artschwager, Billy Al Bengston (*b* 1934), Allan D'Arcangelo, Öyvind Fahlström, Joe Goode (*b* 1937), Robert Indiana, Ray Johnson, Mel Ramos (*b* 1935), Edward Ruscha, Wayne Thiebaud and John Wesley (*b* 1928), as well as the sculptors Marisol and George Segal. Notable among related developments that took place in other countries was Nouveau réalisme in France.

Bibliography

L. Alloway: '"Pop Art" since 1949', *Listener* (27 Dec 1962), pp. 1085–7

The New Generation: 1964 (exh. cat. by D. Thompson, London, Whitechapel A.G., 1964)

M. Amaya: *Pop as Art: A Survey of the New Super-realism* (London, 1965)

R.-G. Dienst: *Pop-art: Eine kritische Information* (Wiesbaden, 1965)

J. Rublowsky: *Pop Art: Images of the American Dream* (London, 1965)

L. Lippard, ed.: *Pop Art* (London, 1966)

C. Finch: *Pop Art: Object and Image* (London, 1968)

——: *Image as Language: Aspects of British Art, 1950–1968* (Harmondsworth, 1969)

J. Russell and S. Gablik: *Pop Art Redefined* (London, 1969)

M. Compton: *Pop Art* (London, 1970)

L. Alloway: *American Pop Art* (New York, 1974)

Pop Art in England (exh. cat. by U. Schneede and F. Whitford, Hamburg, Kstver., 1976)

A. Codognato, ed.: *Pop art: Evoluzione di una generazione* (Milan, 1980)

A. Boatto: *Pop art* (Rome, 1983)

B. Haskell: *Blam!: The Explosion of Pop, Minimalism and Performance, 1958–1964* (New York, 1984)

Pop Art, 1955–70 (exh. cat. by H. Geldzahler, Sydney, Int. Cult. Corp. Australia, 1985)

S. Stich: *Made in USA: An Americanization in Modern Art: The '50s and '60s* (Berkeley, 1987)

Pop Art USA–UK (exh. cat. by L. Alloway and M. Livingstone, Tokyo, Brain Trust, 1987)

T. Osterwold: *Pop Art* (Cologne, 1989)

M. Livingstone: *Pop Art: A Continuing History* (London, 1990)

Pop Art (exh. cat., ed. M. Livingstone; London, RA; Cologne, Mus. Ludwig; Madrid, Cent. A. Reina Sofia; Montreal, Mus. F.A.; 1991–3) [rev. edn for each institution]

Hand-painted Pop: American Art in Transition, 1955–62 (exh. cat., ed. R. Ferguson; Los Angeles, CA, Mus. Contemp. A.; Chicago, IL, Mus. Contemp. A.; New York, Whitney; 1992–3)

MARCO LIVINGSTONE

Post-modernism

Term used to characterize developments in architecture and the arts in the 1960s and after, when there was a clear challenge to the dominance of modernism; the term was applied predominantly from the 1970s to architecture and somewhat later to the decorative and visual arts. It was first used as early as 1934 by Spanish writer Federico de Onis, although it was not then used again until Arnold Toynbee's *A Study of History* in 1938 (published after World War II); Toynbee and others saw the 'post-modern' phenomenon in largely negative terms, as an irrational reaction to modernist rationalism. The term was used sporadically thereafter in the fields of literary criticism and music. In the 1970s, however, it came into wide use in connection with architecture to denote buildings that integrate modernism with a selective eclecticism, often of classical or Neo-classical origin. In painting the term took hold later, peaking in the mid-1980s in the USA to describe work that offered a more biting critique of current cultural values than that offered in architecture. If the attachment of the label itself is ignored, however, the developments may be perceived as continuous with the anti-modernism of the 1960s, which readily related to the growing pluralism in art and architecture that came to be associated with Post-modernism from the early 1980s.

1. Architecture

Early rejection of modernism came in the 1960s most notably in the USA in the work of Robert Venturi and in Europe in that of Aldo Rossi, although they came from markedly different theoretical positions. Venturi's *Complexity and Contradiction in Architecture* (1966) attacked the institutionalized corporate modernism of the International Style, replacing Mies van der Rohe's classic dictum 'less is more' with the sardonic 'less is a bore' and rejecting a 'puritanically moral language' in favour of 'elements which are hybrid rather than "pure" . . . messy vitality . . . richness . . . rather than clarity of meaning'. This statement echoed Claes Oldenburg's declaration of 1961: 'I am for an art that is political-erotical-mystical . . . I am for an art that embroils itself with everyday crap and still comes out on top'. The Venturi practice celebrated these characteristics in such buildings as the Guild House Retirement Home (1960–62; see col. pl. XXX), Philadelphia, and the Vanna Venturi House (1962), Chestnut Hill,

Philadelphia. From the beginning it also accepted and responded to locality, however unremarkable it might be. The work was labelled Post-modern by virtue of perceived historical as well as contextual allusions.

Rossi argued in *L'architettura della città* (also 1966) that the city was an organic work of art, the rhythms, history and context of which must be respected in any new architectural endeavour. This was to be achieved through a new formalism, founded on Renaissance values, the novecento and concepts originating in the Italian Rationalism of the 1920s and 1930s (*see* RATIONALISM; *see also* TENDENZA). Its polemic was aimed at reconciliation of people with their architectural environment: among its few controversial monuments are Rossi's four-storey block of flats (1967–73) at Gallaratese 2, which was part of Carlo Aymonino's Monte Amiata housing development in Milan; and Rossi's San Cataldo Cemetery at Modena, designed in the 1970s (with Gianni Braghieri) but not executed until the early 1980s. Other Europeans subscribing to this paradigm included Oswald Mathias Ungers (work of the 1980s with Josef Paul Kleinhues), Mario Botta, the Krier brothers and Bruno Reichlin; although they contributed to the movement away from Modernism, they are Post-modernists only in the sense that they bring together rationalist and historicist attitudes.

From 1969 in the USA the propulsion towards Post-modernism was closely linked with the beginnings of Pop art. This was the prime motivation in the case of Venturi, and it was influential in the development of mainstream American Post-modernism in the work of Robert A. M. Stern, Charles W. Moore and Michael Graves, who, with Venturi, are referred to by Charles Jencks as the 'Post-Modern School'; Moore's whimsical, collage-like Piazza d'Italia (1977–8), New Orleans, LA, and Graves's abstract, painterly composition for the Public Services Building (1978–82), Portland, OR, as well as the AT&T Building (1978–83; now the Sony Building), New York, by Philip Johnson and John Burgee (*b* 1933), are among the best-known images of this trend, which linked an obvious if abstracted historicism to a modernist technological expression. Even in the USA, however, the posi-

tion was by no means straightforward. There were more literal interpretations of the Pop art scene, for example in the work of James Wines (*b* 1932), whose group SITE was set up in 1970; he produced a number of idiosyncratic anti-rational buildings, for example the Tilt Showroom (1976–8) at Towson, MD.

At the other end of the scale Peter D. Eisenman, influenced by Italian Rationalists of the 1920s and 1930s, built a series of purposely dysfunctional houses (the first completed in 1968) that aimed to realize an aesthetically autonomous architecture, free from all modernist socio-cultural values. There are equally wide-ranging contrasts elsewhere, from the wholly unaligned, often near-surreal work of Hans Hollein in Austria and Germany to the formalism and classical allusions in the work of Ricardo Bofill in France (e.g. Les Espaces d'Abraxas, 1978–83), the neo-vernacular movement in Britain, the work of Kenzo Tange in Japan (e.g. Tokyo City Hall, 1992) and of architects from other countries, such as Sumet Jumsai in Thailand.

With such complexity, concepts of Post-modernism and, perhaps as importantly, anti-modernism, broadened considerably in the 1980s and were disseminated in writings of this period. Jencks, perhaps over-simplifying, defined Post-modernism in terms of double-coding as early as 1977 but began to qualify the label in later writings. There are also balanced historical analyses by Paolo Portoghesi and Heinrich Klotz.

2. Other arts

Oldenburg's dictum of 1961 (*see* §1 above) characterized the ambience in which Pop art returned to the figure, historical allusion and a dialogue with mass culture. It provided models for a break away from modernist principles in architecture as well as art, to which, curiously, the label 'Post-modern' was not attached until somewhat later. As in architecture, it began as anti-modernism, reacting against the formalism exemplified in the writings of the contemporary American critic Clement Greenberg, and it was reinforced by the anti-formalist stance of feminist artists and critics in the early 1970s. The emergence of German Neo-Expressionist painters, for example Georg

Baselitz, Jörg Immendorff and A. R. Penck, and the Italian 'Bad Boys', Francesco Clemente, Enzo Cucchi and Sandro Chia, brought the rediscovery of the pleasures of sensual oil paint. The subsequent overnight successes of American Neo-Expressionists, including Julian Schnabel, prompted charges of 'hype', thus setting the stage for the more critical stance of Post-modernist art in the mid-1980s. The transition can be represented by Mark Tansey's ironic painting *Triumph of the New York School* (1984), in which Clement Greenberg accepts the surrender of the Ecole de Paris on a World War II battlefield as various artists and critics look on.

The movement was centred around artist-run galleries in Manhattan and took much from feminism, performance art, Post-structuralism and deconstruction, calling 'meaning' itself into question. Cindy Sherman dressed and posed herself in photographs modelled self-consciously on film-stills; Troy Brauntuch used images of war atrocities in shadowy pencil drawings on black paper; Robert Longo juxtaposed low-reliefs based on clothing advertisements with pencil portraits of writhing dancers; Sherrie Levine confronted the hopelessness of original representation, rephotographing works by other artists. As in architecture, the growing range of motivations tended to outgrow the Post-modern label, except insofar as all polemic arguments united to gainsay the hypocrisies of the modernist position.

Bibliography

R. Venturi: *Complexity and Contradiction in Architecture* (New York, 1966, 2/1977)

A. Rossi: *L'architettura della città* (Padua, 1966; Eng. trans., Cambridge, MA, 1982)

C. Jencks: *The Language of Post-modern Architecture* (London, 1977, rev. 4/1985)

—: *Late Modern Architecture and Other Essays* (London, 1980)

J. Habermas: 'Modernity and Post-modernity', *New Ger. Crit.*, 22 (1981), pp. 3–14

P. Portoghesi: *Postmodern* (Milan, 1982); Eng. trans. as *Postmodern: The Architecture of the Postindustrial Society* (New York, 1983)

H. Foster, ed.: *The Anti-aesthetic: Essays on Post-modern Culture* (Port Townsend, WA, 1983)

F. Lyotard: *The Postmodern Condition: A Report on Knowledge* (Minneapolis, MN, 1984)

H. Klotz: *Moderne und Post-Moderne: Architektur der Gegenwart 1960–1980* (Wiesbaden, 1984); Eng. trans. as *The History of Postmodern Architecture* (Cambridge, MA, 1988)

B. Wallis, ed.: *Art after Modernism: Rethinking Representation* (New York, 1984)

I. Hassan: *Postmodern Turn: Essays on Postmodern Theory and Culture* (Columbus, OH, 1987)

CAROLINE A. JONES

Post-painterly Abstraction

Term devised as an exhibition title in 1964 by the critic Clement Greenberg to describe a new trend in American abstract painting that emerged in reaction to Abstract Expressionism. Extending to contemporary art the distinction made by Heinrich Wölfflin between painterly and linear art, Greenberg postulated that the most recent painting, although still owing something to its immediate forebears, was in contrast moving towards a greater linear clarity and/or a physical openness of design.

Of the 31 artists included by Greenberg in his exhibition, he stated that most held in common a high-keyed and lucid colour, a tendency to shun thick paint and tactile effects, and a preference for a relatively anonymous execution. Given the wide spectrum of individual styles first canopied under the term, Post-painterly Abstraction was subsequently used to describe works made by a variety of methods: the HARD-EDGE PAINTING of artists such as Ellsworth Kelly, Larry Poons, Frank Stella and Jack Youngerman; pictures produced by means of softer staining techniques by such painters as Helen Frankenthaler, Jules Olitski and the WASHINGTON COLOR PAINTERS Morris Louis and Kenneth Noland; and the more 'painterly' style of artists such as Sam Francis. In general, however, these many, different painters, at least during the 1960s, tended to aim at an art of purely optical colour, often using acrylics, and to repudiate the associative appeal of images, personalized facture and the apparent spontaneity of action painting.

Bibliography

C. Greenberg: 'After Abstract Expressionism', *A. Int.*, vi/8 (1962), pp. 24–32

Towards a New Abstraction (exh. cat. by B. Heller, New York, Jew. Mus., 1963)

Post-painterly Abstraction (exh. cat. by C. Greenberg, Los Angeles, Co. Mus. A., 1964)

Three American Painters: Noland, Olitski, Stella (exh. cat. by M. Fried, Cambridge, MA, Fogg, 1965)

Systemic Painting (exh. cat. by L. Alloway, New York, Guggenheim, 1966)

M. Fried: 'Shape as Form: Frank Stella's New Paintings', *Artforum* (Nov 1966), v/3, pp. 18–27

B. R. Collins: 'Clement Greenberg and the Search for Abstract Expressionism's Successor: A Study in the Manipulation of Avantgarde Consciousness', *A. Mag.* (May 1987), lxi, pt 9, pp. 36–43

I. Sandler: *American Art of the 1960s* (New York, 1988)

J. A. Jones: *Clement Greenberg: His Critical and Personal Relationships with Jackson Pollock and Selected Post-painterly Abstractionists* (diss., New York U., 1988)

ANNA MOSZYNSKA

Praesens Group

Polish group of artists and architects, active in Warsaw in 1926–39. Its members included the painters and sculptors J. Golus, Katarzyna Kobro, K. Kryński, Maria Nicz-Borowiak (1896–1944), Kazimierz Podsadecki (1904–70), Andrzej Pronaszko (1888–1961), Zbigniew Pronaszko, Henryk Stażewski, Władysław Strzemiński and Romuald Kamil Witkowski (1876–1950), and the architects Stanisław Brukalski (*b* 1894), B. Elkonnen, Bohdan Lachert, J. Malinowski, Szymon Syrkus and Józef Szanajca. Following the dissolution of the BLOCK GROUP almost all its members, with the exception of Miecysław Szczuka and Teresa Żarnower (*d* after 1945), whose strongly held political views had precipitated the break-up, joined Praesens. The group arose from an initiative on the part of Syrkus. Although invariably associated with the history of Polish Constructivism, the group was perceived by the artists, calling themselves 'modernists', as having a somewhat different orientation from that of Block. Although more prolific in terms of the range and number of exhibitions, Praesens was never as intensively active as the short-lived Block group.

The Praesens group's activities began with the publication of the first issue of the periodical *Praesens* in June 1926 and an exhibition in the Zachęta Gallery, Warsaw, in September 1926. Architectural problems dominated the group. An architectural functionalism was proposed, which was based more in projects and theoretical texts than in practice. The significance of modern technology and construction was highlighted, and the work of Le Corbusier, the Bauhaus and De Stijl was publicized. Projects were proposed for cheap housing blocks constructed from prefabricated elements, in which, however, uniformity was subordinated to the individual needs of their inhabitants. The notion of function was allied to the principle of open architectural construction integrated with its surroundings and responsive to a variable, fluid composition of internal divisions. Emphasis was placed on close cooperation between architect and painter in projects utilizing the simplest geometrical forms and primary colours. The social pragmatism and technological orientation prevalent in Praesens resulted in 1929 in the departure of Kobro, Stażewski and Strzemiński (who then set up the A. R. group), and the group began to decline in significance during the 1930s.

Bibliography

Constructivism in Poland (exh. cat., ed. R. Stanisławski and others; Essen, Mus. Flkwang, 1973) [trilingual text: Eng., Pol., Ger.]

Z. Baranowicz: *Polska awangarda artystyczna, 1918–1939* [The Polish artistic avant-garde, 1918–1939] (Warsaw, 1975)

A. Turowski: *Konstruktywizm polski: Próba rekonstrukcji nurtu, 1921–1934* [Polish Constructivism: an attempt to reconstruct its development, 1921–1934] (Wrocław, 1981)

EWA MIKINA

Prairie school

Term given to an American group of architects. Inspired by Louis Sullivan and led by Frank

Lloyd Wright, they practised in the American Midwest between 1890 and 1920. Included in the group were Barry Byrne, George Robinson Dean (1864–1919), William E. Drummond, George Elmslie, Hugh Garden (1873–1961), Walter Burley Griffin, Marion Mahony Griffin, Arthur Heun (?1864–1964), Myron Hunt (1868–1962), Birch Burdette Long (1878–1927), George W. Maher, George C. Nimmons (1865–1947), Dwight Perkins, William Purcell, Howard Van Doren Shaw (1869–1926) and Robert C. Spencer jr. Originally these architects were called the Chicago school, but in 1914 Wilhelm Miller, a professor at the University of Illinois, proposed the separate term, because of the visual associations with the broad, level character of the American prairie that he discerned in the residential work of many of these architects. Even so, the term did not come into general use until the 1960s, when *The Prairie School Review* (1964–76), a journal entirely devoted to the work of these architects, was founded.

These architects were bound by their rejection of revivalist styles and by their goal of evolving new architectural vocabularies for expressing what they believed were the true qualities of life in their region and nation. Although there was no conscious effort to produce a common style, it was inevitable that the group's work should develop similar features, for example the elongated, horizontal massing of their houses. Some, like Drummond, worked in a manner influenced by Wright, while others, like Maher, evolved more individual idioms. Interest by clients in the ideas of the architects of the Prairie school began to wane just before World War I as the tide of East Coast historicism swept the Midwest. By the mid-1920s the Prairie school no longer existed.

Bibliography

T. Tallmadge: 'The Chicago School', *Archit. Rev.*, xv (1908), pp. 69–74; repr. in *Architectural Essays from the Chicago School*, ed. W. Hasbrouck (Park Forest, 1967), pp. 3–8

H. Brooks: 'The Early Work of the Prairie Architects', *J. Soc. Archit. Hist.*, xix (1960), pp. 2–10

—: '"Chicago School": Metamorphosis of a Term', *J. Soc. Archit. Hist.*, xxv (1966), pp. 115–18

T. Karlowicz: 'The Term Chicago School: Hallmark of a Growing Tradition', *Prairie Sch. Rev.*, iv (1967), pp. 26–30

H. Brooks: *The Prairie School: Frank Lloyd Wright and his Midwest Contemporaries* (Toronto, 1972)

B. A. Spencer, ed.: *The Prairie School Tradition* (New York, 1979) [good illus.]

PAUL E. SPRAGUE

Praxis

Nicaraguan group of painters and sculptors based in Managua and active from 1963 to 1972. It was centred on an art gallery of the same name that served not only as a cooperative studio and exhibition space for avant-garde art but also as a focal point for Nicaragua's intelligentsia. The inaugural exhibition in 1963 consisted of 37 abstract or semi-abstract oil paintings by 15 artists, most of whom were former students of Rodrigo Peñalba at the Escuela Nacional de Bellas Artes in Managua. Among them were Alejandro Aróstegui (*b* 1935), Arnoldo Guillén (*b* 1941), Omar De León (*b* 1929), César Izquierdo (*b* 1937), Genaro Lugo (*b* 1946), Efrén Medina (*b* 1949), Roger Pérez de la Roche (*b* 1949), Leoncio Sáenz (*b* 1936), Orlando Sobalvarro (*b* 1943), Luis Urbina Rivas (*b* 1937) and Leonel Vanegas (*b* 1942).

As the first avant-garde visual arts movement in Nicaragua, Praxis was founded with the express intention of assimilating elements from Western modernism while also arriving at a distinctive national vocabulary of form. The exclusive emphasis on formal experimentation that initially characterized work by group members was soon balanced by a commitment to the vanguard politics of the Sandinista Front and to an examination of the relationship between art and society. These concerns were promoted in two publications (1963 and 1964) bearing the group's name. They allied themselves both to Matter painting in Spain, which was identified with opposition to the Fascist government of General Franco, and to the artistic traditions of pre-colonial Nicaragua that were largely ignored if not suppressed in the period of General Somoza's dictatorship.

Lugo's *Head of a Bird* (1964; Managua, Banco Cent. Nicaragua) is typical in its heavily impastoed surface, sombre colours and organic imagery.

Bibliography

J. E. Arellano: *Tres apéndices más a la obra pintura y escultura en Nicaragua* (Managua, 1978), pp. 55-65

Pintura contemporánea de Nicaragua: Segundo aniversario del triunfo de la Revolución Popular Sandinista (exh. cat., Mexico City, Inst. N. B.A., 1981)

R. Murillo: 'Arnoldo Guillén, Orlando Sobalvarro, Santos Medina y Leonel Vanegas', *Ventana* (3 July 1982), pp. 2-7

B. LaDuke: 'Six Nicaraguan Painters', *A. & Artists*, xii/8 (July 1983), pp. 9-13

Pintura contemporánea de Nicaragua, Unión Nacional de Artistas Plásticas (Managua, 1986), pp. 7-9

D. Craven: *The New Concept of Art and Popular Culture in Nicaragua since the Revolution in 1979* (Lewiston, NY, 1989), pp. 20-23

A. Aróstegui and others: *Maestros del Grupo Praxis: Primera generación (Managua, 1991)*

M. D. G. Torres: La modernidad en la pintura nicaragüense *(Managua, 1995), pp. 55-91*

DAVID CRAVEN

Precisionism

Term applied from the 1920s to painting that was sharply defined, with geometric forms and flat planes. It originated in critical writings of the 1920s that discussed the precision of the images. Precisionists were not an organized society but rather artists who shared a common aesthetic.

Precisionism was analogous in some ways to Purism, in that it reflected the machine age, but it employed American themes. After World War I, American artists chose subject-matter that glorified the country's modern technology as well as nostalgically harking back to the past. The Precisionists most often depicted architecture that was typical of the USA—skyscrapers, bridges, docks, chimney-stacks and barns.

In formal terms Precisionism was based on Cubism, which offered a reductivist, formal aesthetic of clarity, geometry and order. The Precisionists sought to depict an idealized world,

in an absolute order and time frame. Their scenes, usually devoid of figures, were highly structured arrangements. Atmospheric effects, painterly surfaces and sensual colours were usually avoided. Precisionism, however, remained more tied to realistic representation than Cubism.

Charles Sheeler, Georgia O'Keeffe and Charles Demuth were the most significant Precisionists. Of the three, Sheeler created the archetypal Precisionist images, his subjects ranging from Bucks County barns and still-lifes with folk objects to views of industrial plants or of Manhattan, for example *Offices* (1922; Washington, DC, Phillips Col.). O'Keeffe preferred to depict enormous flowers, for example *White Flower* (1929; Cleveland, OH, A. Mus.), and the architecture of the Southwest. Her use of colour was also more sensual than the other Precisionists. Demuth painted the landscape of his native Lancaster, PA, as in *Lancaster* (1921; Buffalo, NY, Albright-Knox A.G.), treating his geometric forms more as crystalline planes and enriching them with details. His approach revealed an element of Dada.

George Ault (1891–1948), Elsie Driggs (*b* 1898), Preston Dickinson (1891–1930), Stefan Hirsch (1899–1964), Louis Lozowick (1892–1973), Niles Spencer and Joseph Stella all produced Precisionist paintings, focusing primarily on the city and factories. Although they shared similar themes, they expressed different attitudes, from Lozowick's dynamic glorification of the city, to Ault's interpretation of the city as a lonely, desolate place (e.g. *New Moon, New York*, 1945; New York, MOMA). Hirsch and Ault reduced the world to the simplest, mere blocks and cylinders. Ault and Spencer often portrayed the city romantically, at night; Stella's nocturnal scenes reflected more of a Futurist fascination with the electrically-lit modern city, as in *Coney Island* (c. 1915; New York, Met.).

Although the peak of Precisionism was during the 1920s, the aesthetic continued into the 1940s; the second generation included Ralston Crawford and Edmund D. Lewandowski (*b* 1914). During the 1930s, the movement showed a slight shift to greater realism, most evident in the art of Sheeler and Crawford. Sheeler's shift may have been related to his extensive work in photography. Peter

Blume and O. Louis Guglielmi (1906–56) infused the Precisionist aesthetic with a surreal note.

During the 1920s the group was sometimes referred to as the Immaculates. In the 1940s Milton Brown (*b* 1911) coined the term 'Cubist-Realism', thereby stressing the European heritage of the aesthetic. However, Cubist-Realism never gained general currency and, from the 1950s, Precisionism was the preferred name.

Bibliography

M. Brown: 'Cubist-Realism: An American Style', *Marsyas*, iii (1943–5), pp. 139–60

The Precisionist View in American Art (exh. cat. by M. L. Friedman, Minneapolis, MN, Walker A. Cent., 1960)

The Precisionist Painters, 1916–1949 (exh. cat. by K. Lockridge and S. Fillin-Yeh, Huntington, NY, Heckscher Mus., 1979)

A. A. Davidson: *Early American Modernist Painting, 1910–1935* (New York, 1981), pp. 182–228

Images of America: Precisionist Painting and Modern Photography (exh. cat. by K. Tsujimoto, San Francisco, CA, MOMA, 1982)

ILENE SUSAN FORT

Prisme d'Yeux [Fr.: 'prism of eyes']

Canadian group of painters founded in 1948, largely on the initiative of Alfred Pellan, to counteract the rising influence of LES AUTOMATISTES and active for about 18 months. Participants in the group's first exhibition (Montreal, Mus. F.A., 1948) ranged from disciples of Pellan such as Léon Bellefleur (*b* 1910) and Albert Dumouchel to more conservative artists such as Goodridge Roberts and Gordon Webber (1909–65).

Since their aim primarily was to oppose the perceived dogmatism of Les Automatistes, they encouraged a diversity of styles without proposing any specific aesthetic. In their manifesto of 1948, written by Jacques de Tonnancour and signed by 15 artists, they described themselves as 'a movement of various movements, diversified by life itself' and called for 'No new, special and specializing aesthetic'. The manifesto, however, went on to espouse somewhat conservative attitudes: 'Prisme d'Yeux is open to all painting of traditional manifestation and expression. We think of painting which is subject solely to its deepest

spiritual needs while respecting the material aptitudes of pictorial plastic art'. New members were not recruited by a leader, as there was no such figure, but would be accepted by a majority vote. In a similarly democratic vein, there was no jury for exhibitions, with artists merely selecting those works they wished to be included. Their chief significance, paradoxically, was in reflecting the dominance at the time of Les Automatistes.

Bibliography

Frontiers of our Dreams: Quebec Painting in the 1940s and 1950s (exh. cat. by A. Davis, Winnipeg, A.G., 1979)

D. Reid: *A Concise History of Canadian Painting* (Toronto, 1988)

□

Process art

Form of art prevalent in the mid-1960s and 1970s in which the process of a work's creation is presented as its subject. The term is of broad reference, encompassing in particular aspects of Minimalism, Post-Minimalism and performance art, but in its narrowest sense it refers primarily to the work of American sculptors such as Richard Serra, Robert Morris, Barry Le Va (*b* 1941), Keith Sonnier (*b* 1941) and Eva Hesse. The seeds of process art were in action painting: the drip paintings of Jackson Pollock, for example, clearly conveyed to the viewer the creative process that lay behind them (see fig. 2), further emphasized by the publication of numerous photographs and films showing Pollock at work. These earlier paintings, however, were intended to be seen as expressive of the artist's psyche, with the stripping bare of the creative process merely as a by-product of the artist's ingrained individualism and reliance on his or her emotions.

Another important predecessor, rather than exponent, of process art was Yves Klein, for example in his painting display *Anthropometrics of the Blue Period* (Paris, Gal. Int. A. Contemp., 1960), in which women rolled in blue paint and then pressed themselves on to canvas. Klein claimed this to be a means 'to tear down the temple veil of the studio . . . to keep nothing of

my process hidden' (R. Goldberg: *Performance Art*, London, 1988, p. 147). The end result, however, was a painted canvas that in Klein's view embodied the intangible spiritual quality that only an artist possessed and could give to a work. The process, though public and unusual, was thus not of overriding importance.

The spirit of process art is characterized by a list of words compiled in 1967–8 by Serra. It consists merely of a list of verb infinitives, for example 'to scatter, to arrange, to repair, to discard', mingled with a number of intangible abstracts, 'of simultaneity, of tides, of reflection, of equilibrium' (quoted in 1980 exh. cat., pp. 10–11), suggestive of actions with no purpose or justification other than as actions in themselves. Similar actions were also alluded to in the titles of temporary works such as *Splashing* (1968), paradigmatic pieces of process art made by hurling molten lead against the interface of the wall and floor of a gallery and leaving it to solidify. In hardening, the lead embodies its process of creation, inviting the viewer to make an imaginative reconstruction of it. Characteristically Serra attempted to sever the work from traditional art categories and criticism by effecting a Minimalist reduction of composition and content. This required some care: on occasions he displayed several pieces of splashed lead out of context, which had the unsatisfactory effect of inviting aesthetic appreciation of the work as a sculpture. Film, as a time-based medium, provided a better means of concentrating on processes. In 1968 Serra produced a short black-and-white film, *Hand Catching Lead*, showing just that: a hand catching successively falling pieces of lead.

In order to attract attention to the finished work as the product of particular actions, process artists often relied on unconventional materials, particularly those that in their malleability most clearly recorded the traces of their material production. For this reason there are links with the soft art produced by sculptors such as Hesse (for example in latex); Morris (using felt) and Barry Flanagan (for instance in works made of folded cloth). Certain land artists, too, such as Robert Smithson in his *Spiral Jetty* (1970) at Great Salt Lake, UT, made large-scale works in which actions performed on natural materials such as earth are presented as the dominant elements of structures exposed by their very nature to the possibility of further change. This sense of the work as temporary and mutable in form is one of the prime features of process art, which is otherwise bound by no particular techniques or stylistic categories.

Robert Morris's installation, *Continuous Project Altered Daily*, exhibited in 1969 in New York at the warehouse of the Leo Castelli Gallery, represented another attempt to incorporate the temporal aspect of processes into a work. It consisted initially of piles of mixed materials, including earth, heaped on tables. Each day some aspect of the work was changed. Invariably something was taken away, leaving little on the last day of the exhibition; the materials were of no intrinsic value, nor were they expected to acquire any through being parts of a work of art. The viewer was merely allowed to witness the process of change and diminution. The ephemeral, intangible nature of much process art was especially evident in Morris's *Untitled* (1968–9; see 1971 exh. cat., p. 122), which consisted merely of a cloud of steam in the process of diffusion. The temporality and insubstantiality of such works bear comparison with performance art events, for which photographic documentation again serves as the sole record. Allan Kaprow's *Sweet Wall*, for example, executed near the Berlin Wall in 1970, entailed little more than a process of construction and destruction: a wall was constructed with bricks held together with pieces of bread and jam and then simply taken down.

By its emphatic focus on what is traditionally the background of art, process art stands as yet another manifestation of modernist introversion. Through its public presentation, however, of banal materials and processes, it has something of the subversive quality of Dada.

Bibliography

When Attitudes Become Form (exh. cat. by H. Szeeman and C. Harrison, Berne, Ksthalle; Krefeld, Kaiser Wilhelm Mus.; London, ICA; 1969)

Robert Morris (exh. cat. by M. Compton and D. Sylvester, London, Tate, 1971)

L. R. Lippard: *Six Years: The Dematerialization of the Art Object* (New York, 1973)

Richard Serra: Interviews, etc., 1970–1980 (exh. cat., ed. C. Weyergraf; New York, Hudson River Mus., 1980)

Richard Serra: Sculpture (exh. cat. by R. E. Krauss, New York, MOMA, 1986)

K. Baker: *Minimalism* (New York, 1988)

The New Sculpture, 1965–1975: Between Geometry and Gesture (exh. cat., ed. R. Armstrong and R. Marshall; New York, Whitney, 1990)

☐

Proletkul't [from Rus. *Proletarskaya kul'tura*: 'proletarian culture']

Russian mass cultural and educational organization dealing with amateur activity in various forms of art and study for the proletariat. It was founded in Petrograd (now St Petersburg) in September 1917. By the early 1920s it had around 150 sections, with up to 400,000 members, and it published over 20 magazines. The theorists behind Proletkul't included Aleksandr Bogdanov, Pavel Lebedev-Polyansky (1881/2–1948) and V. F. Pletnyov, who affirmed the dominant role and separate nature of 'proletarian culture' and rejected cultural heritage. Members of Proletkul't incorporated in their work a complex of sociological dogma mixed with fanatical political ideas and often with downright demagogy. The Bolshevik government subjected Proletkul't to severe criticism both for its aggressively limited approach and for its ideological dissension from party policy. From the end of 1920 Proletkul't was mainly occupied with study and teaching programmes, bringing in well-known artists such as Pavel Kuznetsov and Sergey Konyonkov to teach in its studios. With time, the organization's efforts in the sphere of fine art tended more towards design. By the second half of the 1920s Proletkul't had lost its mass character, and in 1932 it was abolished along with other artistic organizations. From the start, Proletkul't's tendency towards a mass approach and democracy in art was a distorted version of the concept of 'proletarian exclusivity'; it was marked by intolerance and regimented thinking.

Bibliography

V. Gorbunov: *Lenin i Proletkul't* [Lenin and Proletkul't] (Moscow, 1974)

MIKHAIL GUERMAN

Psychedelic art

Term used to describe art, usually painting, made under the influence of hallucinogenic drugs. It was particularly identified with the early 1960s, when the use of such drugs was at its height. Various artists, mostly in isolation, took 'mind-expanding' drugs such as peyote and more especially LSD (lysergide) to heighten their awareness and enlarge their mental vision with images. The mental state of the person who took the 'trip' (a mental state not necessarily known to that person) determined whether the experience was favourable and enjoyable or frightening and liable to lead to psychosis; thus the creators of psychedelic art did not know what type of work or what specific images would be produced under the influence of the drugs, until the 'trip' had ended and the effects of the drug had worn off. With no particular philosophy other than an interest in seeing what might be produced, and with no attempt by its creators to band together for the purpose of exhibiting, psychedelic art died out by the end of the 1960s, particularly as the negative properties of hallucinogenic drugs became known. An example of psychedelic art is the poster style of painting associated with hippie culture, especially in San Francisco, CA, in the late 1960s. This painting is characterized by sinuous patterns, the use of erotic imagery and by 'day-glo' fluorescent colours, whose anti-naturalistic shades could be seen as a reference to the changing states of consciousness induced by drugs.

Bibliography

J. Yalkut: 'Psychedelic Revolution: Turning on the Art Trip', *A. Mag*, xli (Nov 1966), pp. 22–3

A. Myers: 'Psychedelic Revolution: The New Culture', *A. Canada*, xxiv (June–July 1967)

N. Gosling: 'Snakes in the Grass', *A. & Artists*, iv (Dec 1969), pp. 26–31

DAVID M. SOKOL

Purism

French movement in painting and architecture. Purism was an aesthetic programme initiated *c.* 1918 by Amédée Ozenfant and Charles-Edouard Jeanneret (known as Le Corbusier in his architectural work after 1920–21) as a reaction to Cubist painting and ideas that dominated avant-garde art in France before World War I. Above all, Purist philosophy is characterized by an admiration for the beauty and purity of the form of the machine. Ozenfant and Le Corbusier advocated a *rappel à l'ordre* in response to what they perceived to be the distortions and excesses of later, particularly Synthetic Cubism. While they embraced much Cubist subject-matter, particularly the celebration of the ordinary, mass-produced object, they emphasized the geometry, simplicity, proportion and harmony of those objects, rather than their dissection or analysis. The Purists perceived the golden section to be an ideal governing rule in the depiction of form. They preferred that form be presented with unbroken contours and smoothly polished surfaces.

1. Painting

Ozenfant and Le Corbusier were introduced in 1918 by Auguste Perret. Both had already produced work that was engaged with ideals central to Purism. In 1915 Ozenfant began to publish the journal *L'Elan*, which contained many articles outlining future directions for painting after Cubism. In his architectural work, Le Corbusier had already designed the Villa Schwob in his native La Chaux-de-Fonds (1916–17), with its heavy reliance on classically inspired Renaissance and Roman forms. By September 1918 the two resolved to publish writings and exhibit together. Le Corbusier claimed that he had begun to paint in this year, producing his first canvas, *The Chimney* (Paris, Fond. Le Corbusier). In November 1918 Ozenfant and Le Corbusier published in Paris *Après le Cubisme*, a book that stated their genuine support of Cubism and charted a post-Cubist course that highlighted the classical aspects of the earlier art. The publication of the book coincided with the armistice of World War I, and the authors emphasized that the war had demonstrated the importance of the machine. They advocated a fusion of the classical values of Cubism and the pure, beautiful forms of the machine and its products within the parameters of a structured, defined theory.

The first Purist exhibition occurred one month after the appearance of *Après le Cubisme* at the Galerie Thomas at 5, Rue de Penthièvre, Paris, a space owned by Ozenfant's patron, Germaine Bongard (sister of Paul Poiret), from 22 December 1918 to 11 January 1919. It presented the work of Ozenfant and Le Corbusier. A second Purist exhibition featuring their paintings was held at the Galerie Druet on the Rue Royale, Paris, from 22 January to 5 February 1921. From 1921 the two also exhibited in group exhibitions organized by Léonce Rosenberg, who represented Léger, Gris and other artists who had been associated with Cubism. Ozenfant and Le Corbusier's third and final joint exhibition took place at Rosenberg's Galerie de l'Effort Moderne, Rue de la Baume, Paris, from 28 January to 23 March 1923.

Shortly thereafter Ozenfant and Le Corbusier became involved with the publication of *L'Esprit nouveau*, a journal launched in 1920 by the poet and writer Paul Dermée and subsequently directed and owned by the two artists for a total of 28 issues until it folded in 1925. *L'Esprit nouveau* included articles written by Ozenfant and Le Corbusier, under various pseudonyms, as well as other contributors from artistic, literary, architectural and scientific circles. It included the principal manifesto of the Purist movement, 'Le Purisme', which was published in the issue of January 1921. In this article, Ozenfant and Le Corbusier declared that a work of art 'should induce a sensation of a mathematical order'. While they applauded Cubism's use of objects, they declared that it showed only their 'accidental aspects . . . Cubism made square pipes to associate with matchboxes, and triangular bottles to associate with conical glasses'. Instead, Purist painting was to be addressed to the 'elevated faculties of the mind' and was to be 'an art free of conventions which will utilize plastic constants and address itself above all to the universal properties of the senses and the mind'.

Within Purist paintings, the number of objects included gradually increased, in part influenced by

photography of mass-produced commercial items, many of which were included in *L'Esprit nouveau*. Le Corbusier's compositions relied heavily on moderately bold colours and a strongly architectural, horizontal–vertical framework, often with considerable overlapping, as in *Still-life: 'Léonce Rosenberg'*. Ozenfant's images were characterized by strong contours, a soft palette, and by their flatness. By November 1923 Ozenfant and Le Corbusier began to sign separate articles in *L'Esprit nouveau*, which was indicative of the beginning of differences of opinion, with Ozenfant expressing some criticism of the machine-made. By 1926 Ozenfant and Le Corbusier had parted ways sufficiently for Purism to appear to be at an end. Ozenfant began incorporating figures into his paintings, imagery that had been absent from his work since 1916. Le Corbusier's paintings shifted away from the strong restraints imposed by Purist theory toward relatively organic imagery and increasingly jarring colour contrasts. The influence of Purism nevertheless remained highly influential in architectural developments (*see* §2 below).

Bibliography

A. Ozenfant and C.-E. Jeanneret: 'Le Purisme', *Espr. Nouv.*, iv (Jan 1921), pp. 369–86; Eng. trans. in *Modern Artists on Art*, ed. R. L. Herbert (Englewood Cliffs, 1964), pp. 58–73

Léger and Purist Paris (exh. cat., ed. J. Golding and C. Green; London, Tate, 1970–71)

Le Retour à l'ordre dans les arts plastiques et l'architecture,1919–25, U. Saint-Etienne, Centre Interdisciplinaire d'Etudes et de Recherche sur l'Expression Contemporaine, Travaux VIII (Saint-Etienne, 1975)

K. E. Silver: 'Purism: Straightening up after the Great War', *Artforum*, xv/7 (1977), pp. 56–63

F. Ducros: 'Amédée Ozenfant et l'esthétique du Purisme: Une Géometrie de l'objet', *Cah. Mus. N. A. Mod.*, xii (1984), pp. 269–83

C. Green: *Cubism and its Enemies* (New Haven and London, 1987)

K. E. Silver: *Esprit de Corps: The Art of the Parisian Avant-Garde and the First World War, 1914–1925* (Princeton, 1989)

On Classic Ground: Picasso, Léger, de Chirico and the New Classicism 1910–1930 (exh. cat., ed. E. Cowling and J. Mundy; London, Tate, 1990)

JUDI FREEMAN

2. Architecture

The formative and long-lived influence of Purism on the development of the Modern Movement in architecture and on the International Style stemmed from the series of mainly domestic buildings designed by Le Corbusier in the 1920s and from his book *Vers une architecture* (1923), derived largely from material originally published in *L'Esprit nouveau*. There is a chapter on 'Regulating Lines' with a preamble that asserts the 'organic inevitability' of the golden section. The forms of ships, aeroplanes and motor-cars are held up as a basis of comparison with architecture and with housing in particular; the 'Manual of the Dwelling' appears (pointedly) in the sub-chapter on aeroplanes and contains the most famous (and most misunderstood) aphorism of the many in the book: 'The house is a machine for living in'. The sub-chapter with a heading that might have become the Purist credo—'Architecture, the Pure Creation of the Mind'—is followed by a lengthy chapter illustrating Le Corbusier's own solutions to the problems of 'mass-production houses' and by a brief one stressing the vital role of housing to the family in a settled society. Both the latter chapters prefigure the spirit of the Modern Movement in the later 1920s and 1930s.

In 1923 Le Corbusier and his brother Pierre Jeanneret designed a home-studio for Ozenfant on the Avenue Reille in the 14th arrondissement in Paris. Completed in 1924, it consists of strongly cubic geometric forms. By this date Le Corbusier and Ozenfant were discovering that their views were beginning to diverge somewhat. Nevertheless, the esteem in which Purist ideas were held at the centre of the European Modern Movement may be judged from the fact that Walter Gropius included Le Corbusier's Citrohan designs in the *Haus am Horn* exhibition at the Bauhaus on the occasion of the Deutscher Werkbund meeting at Weimar in 1923. The same housing systems, developed as the 'immeuble-villa', also appeared in 1925 in the highly influential Pavillon de l'Esprit Nouveau (destr. 1926) at the Exposition des Arts Décoratifs et Industriels Modernes in Paris. The two-storey structure was intended to be the house of a 'cultivated man of today'. Its interior included

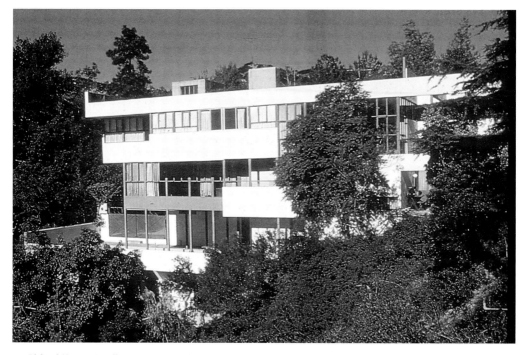

39. Richard Neutra: Lovell House, Los Angeles, CA, 1927–9

Thonet and other examples of mass-produced furniture, manufactured objects, paintings by Ozenfant, Le Corbusier and Fernand Léger and sculptures by Henri Laurens and Jacques Lipchitz, all selected to demonstrate how the Purist aesthetic could be applied within a domestic environment. Le Corbusier's 'immeuble-villa' system appeared also in single and aggregated form at the Werkbund-organized housing exhibition (1927) at Weissenhof, Stuttgart (see col. pl. XVII; *see also* MODERN MOVEMENT, §4). Le Corbusier's industrial housing at Pessac (1925–8) and elsewhere is Purist in feeling, but it was the development of the unmistakable personal style—abstract, geometric, white, flat-roofed, spatially sophisticated—in a series of private houses in Paris between 1923 and 1927 that produced symbols of Purist architecture, raised and intellectually justified by Le Corbusier. From the simplicity of Ozenfant's studio house on the Avenue Reille, they developed into the pristine external forms and Purist interiors of the Villa Stein–de Monzie (1926–7), Garches, Paris and, after a break that marked the virtual end of the Purist period, the Villa Savoye (1929–31; see col. pl. XXIII).

The remarkable formal and aesthetic consistency of the Weissenhofsiedlung at Stuttgart (rectilinear forms, white unbroken wall surfaces), in which 16 of the leading architects of the European Modern Movement took part, emphasizes the power of the Purist ambience in the Neue Sachlichkeit image of the Modern Movement as it assumed the wider mantle of the INTERNATIONAL STYLE after the MOMA exhibition of 1932 in New York. By far the greatest proportion of the New York exhibits were of this kind, including five of the private houses by Le Corbusier and the Tugendhat house (1928–30; restored; see fig. 22), Brno, by Ludwig Mies van der Rohe, as well as a number of white German *Siedlungen*. Significant, too, as a measure of the burgeoning influence of

the style, were the appealing examples of radically simplified form that helped to set the character of modernist architecture worldwide for more than a quarter of a century: they included such buildings as Louis Herman De Koninck's Lenglet house (1926), Brussels, the Lovell house (1927–9; see fig. 39), Los Angeles, by Richard Neutra and Joseph Emberton's Royal Corinthian Yacht Club (1931; with George Fairweather, 1906–86) at Burnham-on-Crouch, England.

Bibliography

Le Corbusier: *Vers une architecture* (Paris, 1923, rev. 1924; Eng. trans., London, 1927)

H. -R. Hitchcock and P. Johnson: *The International Style: Architecture since 1922* (New York, 1932, rev. 2/1966)

P. R. Banham: *Theory and Design in the First Machine Age* (London, 1960), pp. 205–13, 220–46

E. F. Fry: *Cubism* (London, 1966)

C. Jencks: *Modern Movements in Architecture* (London, 1973, rev. 2/1985), pp. 141–8

G. Gresleri and F. Alison: *L'Esprit nouveau* (Milan, 1979)

T. Benton: *Les Villas de Le Corbusier, 1920–1930* (Paris, 1984; Eng. trans., New Haven, 1987)

W. Curtis: *Le Corbusier: Ideas and Forms* (London, 1986)

JOHN MUSGROVE

Puteaux group [Puteaux-Courbevoie group; Salon Cubists]

Term applied from the mid-20th century to a group of artists associated with CUBISM who came to prominence in the wake of their controversial showing in room 41 of the Salon des Indépendants in spring 1911. The name given to them, in order to distinguish them from the narrower definition of Cubism developed by Picasso and Braque from 1907 to 1910 in the Montmartre district of Paris, is that of the suburban village west of Paris where two of the core members of the group, Jacques Villon and his brother Raymond Duchamp-Villon, held regular gatherings.

Villon had moved in 1906 to the Rue Lemaître in Puteaux, where he was the neighbour of František Kupka; Duchamp-Villon arrived soon after, and their brother Marcel Duchamp later lived in nearby Neuilly. Their family gatherings in Puteaux on Sundays were enlarged after their participation in the Salon des Indépendants in spring 1911, and from that time they were often received on Mondays by another Cubist painter, Albert Gleizes, at his studio in the garden of his family home in another adjoining suburb, Courbevoie. Jean Metzinger, Henri Le Fauconnier, Robert Delaunay and Fernand Léger (who was already known to the brothers) were among the regular visitors, in addition to Kupka, and from autumn 1911 Francis Picabia, Walter Pach, Marie Laurencin, Guillaume Apollinaire, Joachim Gasquet, Roger Allard, Henri Valensi, André Mare (1885–1932), André Salmon, Roger de La Fresnaye and the poet Alexandre Mercereau were also frequently in attendance.

As an informal group these artists represented the melding together of several tendencies that had previously been only dimly associated with each other. One tendency had already coalesced under the rubric of the Société Normande de Peinture Moderne, the name chosen in 1910 by an association founded in Rouen in 1907 by Pierre Dumont as Les XXX, a literary and artistic organization that held occasional manifestations in Paris; all the painters originating from Normandy belonged to this group. Another tendency may broadly be said to have originated from the community of artists known as the ABBAYE DE CRÉTEIL, with which Gleizes, Allard, Henri-Martin Barzun (b 1881), Mercereau and Le Fauconnier had been associated as early as 1906. Two artists, Delaunay and Metzinger, had shared an intense Neo-Impressionist phase around 1908, when they were already close friends, while Apollinaire, Salmon and Metzinger were all familiar with the Montmartre Cubism of Picasso and Braque.

The meetings at Puteaux may also be regarded as an extension of the post-Symbolist literary gatherings that were held on Tuesdays at the Closerie de Lilas in Montparnasse, organized by the poet Paul Fort (1872-1960). The change of venue, together with a broader appeal in terms not only of style but also of generation and medium, demonstrated a sense of solidarity about the adventure of modernism along with an awareness of its immediate sources.

In September 1912 the artists of the Puteaux group held their first meeting at a café in the Place de l'Alma in the Passy district. Although all serious modernists remained welcome, this change of venue represented a conscious challenge to the exclusivity of both Montmartre and Montparnasse as avant-garde centres and a statement that the upper-middle classes, too, could produce and understand advanced art. For these reasons they are sometimes referred to as 'artists of Passy' or as Right-bank Cubists. The involvement of the architects Perret, Auguste Perret and his brother Gustave, who hosted gatherings at their audacious block of flats on the Rue Franklin, provided the contact through which Le Corbusier was first introduced to Cubism. The magistrate Joseph Granie, one of the shrewdest of the critics who supported Cubism, was also regularly in attendance.

Two major events developed in the circle of the Puteaux group: the Maison Cubiste displayed at the Salon d'Automne of 1912, on which many of the artists of the group participated under the leadership of Duchamp-Villon and Mare; and the exhibition in October 1912 known as the *Salon de la Section d'Or* (*see* SECTION D'OR), which involved the artists who identified with the structural and proportional attributes of Cubism. Two publications were also prompted in some way by the discussions of the Puteaux group: the sole issue of the journal *Section d'Or*, in which Maurice Raynal made his début as a champion of Cubism, and a widely read and influential book, *Du Cubisme* (Paris, 1912; Eng. trans., London, 1913), by Gleizes and Metzinger, parts of which were read in manuscript and discussed at Puteaux and Courbevoie during the summer and autumn of 1912.

Writings

A. Gleizes and J. Metzinger: *Du Cubisme* (Paris, 1912; Eng. trans., London, 1913)

Bibliography

Albert Gleizes and the Section d'Or (exh. cat. by D. Robbins and W. Camfield, New York, Leonard Hutton Gals, 1964)
Les Duchamps (exh. cat. by O. Popovitch, Rouen, Mus. B.-A., 1967)
Painters of the Section d'Or (exh. cat. by R. V. West, Buffalo, NY, Albright-Knox A.G., 1967)
Roger de La Fresnaye (exh. cat., texts B. Dorival, C. Derouet and P. Chabert; Troyes, Mus. A. Mod., 1983)
For further bibliography *see* CUBISM and SECTION D'OR.

DANIEL ROBBINS

Quadriga

German group of painters founded in 1952 in Frankfurt am Main and active until 1954. The four members were Karl Otto Götz, Otto Greis, Heinz Kreutz and Bernard Schultze. When they exhibited their most recent works under the label of neo-Expressionism at the Zimmergalerie Franck, Frankfurt am Main, in December 1952, the writer René Hinds (1912–72) coined the name Quadriga, alluding to a Roman triumphal chariot. Impressed by the spontaneity and form-shattering power of the paintings, Hinds compared the works to a team of four fiery racehorses in their victory parade. There was also the analogy of the four artists breaking through audaciously after nearly 20 years of isolation from the international avant-garde. With European and American movements such as Abstract Expressionism and Tachism in Paris and the work of the Cobra group sharing so many qualities, shortly after 1950 *Art informel* developed as a universal language. The importance of Quadriga was in the members' roles as pioneers of *Art informel* in Germany. However, the fairly loose connections between the members led them to develop in different directions and resulted in the group's dissolution.

Bibliography

Heinz Kreutz, Bernard Schultze, Otto Greis, Karl Otto Götz (exh. cat., ed. R. Hinds; Frankfurt am Main, Zimmergal. Franck, 1952)
L. B. Döry: 'Quadriga 52—Tachismus in Frankfurt', *Quadriga 52* (exh. cat., ed. G. Bott; Frankfurt am Main, Hist. Mus., 1959), pp. 9–22
U. Geiger: *Die Maler der Quadriga—Otto Greis, K. O. Götz, Bernard Schultze, Heinz Kreutz—und ihre Stellung im Informel* (Nuremberg, 1987)
K. Winkler: 'Neuexpressionisten (Quadriga)', *Stationen der Moderne* (exh. cat., foreword J. Merkert; W. Berlin, Berlin Gal., 1988), pp. 416–25

URSULA GEIGER

Rationalism

Term applied to architecture of the 20th century that is characterized by a scientifically reasoned but ethical attitude to design, accompanied by a desire to adopt the most rational possible built form in relation to structure and construction. It evolved in reaction against 19th-century eclecticism and the apparent failure of Art Nouveau to replace it, while admiration for the imaginative use of materials and techniques in engineering works of the same century led to a concern with the integrity of style in relation to construction. The term encompasses much of the architecture of the Modern movement and International style but has often been confused with Functionalism, to which similar origins and implications are often ascribed. In addition to its more general architectural meaning, the term has been applied in a special way to Italian modernism of the 1920s and 1930s (*Razionalismo*) and, after 1966, still more specifically to the architecture and urban design movement Tendenza initiated by Aldo Rossi.

Rational attitudes to design that emerged in Europe in the 18th and 19th centuries had been particularly linked with the exposition of new materials and construction techniques in the later writings of Eugène-Emmanuel Viollet-le-Duc and, at the turn of the 19th century, by Auguste Choisy and Julien Azais Guadet at the Ecole des Beaux-Arts, the seat of academicism in France. The structural rationalism in architecture that became apparent at this time in the works of Antoni Gaudí, Victor Horta, Héctor Guimard and, particularly, H. P. Berlage, has been traced directly to the influence of Viollet-le-Duc (see Frampton, pp. 64–73). Although Rationalism gained ground and was fused with a growing sense of social responsibility in the architectural profession, in moving towards the exciting aesthetic possibilities opened up by the Futurist and Cubist movements in art (*see* Futurism, §2, and Cubism, §II) its proponents admitted no debt to academicism and indeed included anti-academic rhetoric in their manifestos. There were, however, obvious ideological links between Rationalist ideals and the declared principles of the Deutscher Werkbund, as well as with the growing clamour of contemporary polemic, such as that of Adolf Loos, who had seen the extraordinary, brief, early flowering of a version of Rationalism in Chicago. On his return to Vienna in 1896 he took up the Rationalist position expounded by Otto Wagner before the turn of the century and added his own arguments against the use of ornament. The Rationalists were concerned also to raise the scale of contemporary architectural debate to the level of urbanism, and in this they had before them the social and aesthetic aims expressed in the designs of Tony Garnier and Antonio Sant'elia.

Throughout the 1920s Rationalist polemic posited design as a social act in the interests of radical improvement in living and working environments for the growing urban populations. Form was intended to be the rational outcome of logically compiled briefs, no longer with national, regional or—still less—individual aesthetic overtones, but astylar and hence international. Despite this, the images of early European Rationalism demonstrate how quickly a style developed. Almost from the beginning, confusion arose in the classification of buildings as Rationalist: in the first 15 years or so of the 20th century such buildings included the concrete-framed flats (1903–5) in Rue Franklin, Paris, by the Perret brothers; the Kunstgewerbeschule (1905–6) by Henry Van de Velde and the Steiner House (1910; see fig. 40) by Loos, both in Vienna; and the glass-and-steel Fagus Factory (1911–13; see col. pl. XXXI) by Walter Gropius and Adolf Meyer at Alfeld on the Leine. With the support of such figures as Ludwig Mies van der Rohe, Le Corbusier, J. J. P. Oud and Gerrit Rietveld, the movement grew in influence and realized a number of major works that did aspire to the original definition of its meaning. These were mainly the housing estates of the mid- and late 1920s, for example at the Hook of Holland (1922–7), at Dessau (1925–8; by Gropius), and especially in the Weissenhofsiedlung (1927) at Stuttgart (see col. pl. XVII). This was an open international exhibition of Rationalist socio-cultural principles brought together in the work of a number of distinguished architects under the direction of Mies van der Rohe in order to realize

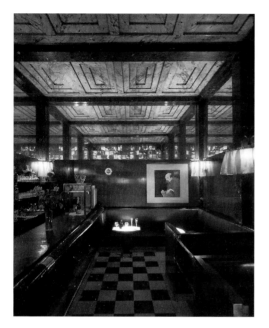

40. Adolf Loos: Steiner House, Vienna, 1910

a single rational brief (for further discussion *see* DEUTSCHER WERKBUND).

From this time, however, buildings of the Rationalist persuasion tended towards a truer Cartesian interpretation of the word as opposed to the derived meaning, and it was also about this time that it became confused with the logic of function as opposed to reason. The rational attitudes that formed the basis of most modern architecture after World War II seemed to stem only from innate knowledge, perhaps best expressed in relation to architecture by Le Corbusier, who wrote: 'Technical processes are the very abode of lyricism. There is a modern spirit which is a process of thought' (see Sharp, ed., p. 73). This neatly linked the creative, aesthetic basis of design with both reason and function, appearing only to neglect the continuity of historic reference.

Italian Rationalism or *Razionalismo*, on the other hand, probably in deference to the artistic as well as the political climate of the day, from the beginning accepted that the past and present were not incompatible. The first manifesto (1926) of

GRUPPO 7, the affiliation of young Milanese architects with whom *Razionalismo* began, refers to the need to maintain links with their national heritage; unlike the more northerly Europeans, they also wished overtly to initiate a style and hoped to establish it as the official manner of the new political era of Fascism. Their polemic against individualism referred to the need to develop a closed range of building types. Some of the group's work was exhibited at the Werkbund exhibition at Stuttgart in 1927 and then at the first Esposizione dell'Architettura Razionale (1928) in Rome, organized by Adalberto Libera and the critic Gaetano Minnucci. Its success led to the establishment of the Movimento dell'Architettura Razionale (MAR) and, in 1930, the Movimento Italiano per l'Architettura Razionale (*see* MIAR), which, for a short time, tried to reconcile its aims with those of the establishment. Such attempts ended during the movement's second exhibition in Rome (1931), where the 'table of horrors' (*la tavola degli orrori*) containing caricatures of establishment buildings brought down the wrath of the Italian union of architects. Rationalist architecture was denounced by Marcello Piacentini, the established classicist and official architect of Fascism.

The first important Rationalist building in Italy was Terragni's five-storey Novocomum flats (1927–8) in Como, a simple, white, continuously balconied building with four storeys cut away at each corner to reveal glass cylinders of substantial diameter. In spite of his short working life, Terragni—a founder-member of Gruppo 7—was the most influential architect of the *Razionalismo* movement, of which his Casa del Fascio (1932–6; now the Casa del Popolo), Como, became the epitome. Other important Rationalists in northern Italy included the designer–critic Edoardo Persico and the architect Giuseppe Pagano, from 1930 contributor and editor respectively of the pro-Rationalist journal *Casabella*; two other founder-members of Gruppo 7, Luigi Figini and Gino Pollini; Luciano Baldessari, who collaborated with Figini and Pollini on some of their early buildings; and Alberto Sartoris. The partnership of Figini and Pollini and that of BBPR were among the most prolific Italian Rationalists in the 1930s. There

were other regional groups, for example that led by Giovanni Michelucci in Florence; by Sartoris, Pietro Lingeri and Cesare Cattaneo in Como (with the painter Mario Radice); by Libera and a few others in Rome; and by Luigi Cosenza (*b* 1905) and Giuseppe Samonà in the south. By 1936, however, Italian Rationalism had, to a large extent, atrophied. It was compromised or bypassed in the award of official commissions, which for over a decade precluded anything other than the watered-down historicism of Novecentismo or the traditional classical mode of Piacentini's monumentalism. The influence of Italian *Razionalismo* and particularly of Terragni lived on, however. In the early 1970s and after it was the specific subject of study for the Institute for Architecture and Urban Studies in New York, especially for Peter D. Eisenman; his work, as well as that of other members of the New York Five, reflects in no small measure Terragni's later designs and projects.

The basis for a new rational architecture was first propounded by Aldo Rossi in his *L'architettura della città* (1966), followed in 1967 by Giorgio Grassi's *La costruzione logica dell'architettura* (see TENDENZA). Rossi returned to some of the original characteristics of *Razionalismo*, giving place to specific historical reference (the 18th century), but he proposed a limited range of building types to be integral with and dependent upon a new urban order. Grassi proposed a system of internally consistent rules for architectural composition. Both were concerned to encourage the development of an autonomous set of values for architectural design referring to the spatio-cultural fabric of cities. The movement produced relatively few buildings in Italy in the 1970s, notably Rossi's controversial San Cataldo Cemetery (1971–6; 1980–85), Modena, and his contribution to the Gallaratese 2 housing complex (1973), Milan, and Grassi's student residences (1976–8) at Chieti, all abstracted analogues of architectural archetypes. A housing development (1981–9) for the Internationale Bauausstellung (IBA) in Berlin, and significant public buildings in the late 1980s in Italy, for example in Perugia (1982–90) and Genoa (1983–91),

all by Rossi, continued to influence urban design through the work of such architects as the Krier brothers. The movement's growing impact on architecture in Italy also spread to Switzerland, where a Rationalist school developed after 1960 in the work of Mario Botta, Aurelio Galfetti, and Rossi's students Bruno Reichlin and Fabio Reinhart.

See also POST-MODERNISM, §2.

Bibliography

P. R. Banham: *Theory and Design in the First Machine Age* (London, 1960), pp. 23–34

A. Rossi: *L'architettura della città* (Padua, 1966)

G. Grassi: *La costruzione logica dell'architettura* (Venice, 1967)

R. Giolli: *L'architettura razionale* (Bari, 1972)

L. Patetta, ed.: *L'architettura in Italia, 1919–1943: Le polemiche* (Milan, 1972)

E. Bonfanti and others: *Architettura razionale* (Milan, 1973)

A. Rossi: *Scritti scelti sull'architettura e la città* (Milan, 1975)

M. Patetta, ed.: *Materiali per l'analisi dell'architettura moderna: Il MIAR* (Naples, 1976)

Il razionalismo e l'architettura in Italia durante il fascismo (exh. cat., ed. S. Danesi and L. Patetta; Venice, Biennale, 1976)

D. Sharp, ed.: *The Rationalists* (London, 1978)

K. Frampton: *Modern Architecture: A Critical History* (London, 1980, rev. 1985), pp. 203–9, 294–301

D. D. Doordan: *Building Modern Italy: Italian Architecture, 1914–1936* (New York, 1988), pp. 45–148

R. A. Etlin: *Modernism in Italian Architecture, 1890–1940* (Chicago, 1992)

JOHN MUSGROVE

Rayism [Rayonism; Rus. *Luchizm*]

Term derived from the word for 'ray' (Rus. *luch*), used to refer to an abstract style of painting developed by the Russian artist Mikhail Larionov. Larionov himself claimed that he had painted his first Rayist work in 1909, but modern scholarship has shown his first Rayist works to date from the latter half of 1912. These included *Glass: Rayist Method* (New York, Guggenheim) and *Rayist*

Sausage and Mackerel (Cologne, Mus. Ludwig). In 1913 Larionov began to expound and elaborate his theory in a series of manifestos.

Initially the theory of Rayism was fairly simple. Larionov declared that when light rays are reflected from the surface of an object they intersect each other, creating 'intangible spatial forms' that the artist is able to paint. Early works such as *Glass: Rayist Method* expound the first stage of this theory, where objects reflect bold clusters of light rays that shatter and fragment the picture space. By the summer of 1913 Larionov was prepared to abolish the object from the picture altogether. His manifesto *Luchizm* (1913) argues for a 'non-objective approach' to art, and his paintings and drawings began to depict only the reflected rays and the shifting planes created by their intersection.

The move into non-objectivity allowed Larionov to emphasize the formal aspects of colour, shape and texture, which he tried to orchestrate on the canvas. In works such as *Rayist Composition: Domination of Red* (*c.* 1913; New York, MOMA), the dynamism of line and the brilliance of colour have a powerful and expressive force. This is a typical work, in which the rays evoke different timbres according to the depth and extent of coloration. The musical analogy is further emphasized by the bars of notes to the left and in the lower middle section of the painting.

Scientific and metaphysical themes also played a role in the formation of Rayism. Larionov studied X-rays and radioactive rays and in particular associated his world of intersecting rays with that of the Fourth dimension, which provided a topical and philosophical justification for his non-objective work.

Larionov's colleague, the artist Natal'ya Goncharova, also painted in a Rayist style. Especially notable are *Cats: Rayist Perception in Rose, Black and Yellow* (1912; New York, Guggenheim) and a series of magnificent Rayist paintings on the theme of the forest, such as *Green and Yellow Forest* (1913; Stuttgart, Staatsgal.). During 1913 and 1914 Rayist works by both artists were shown in Moscow, Berlin, Rome and Paris, and they continued to practise and develop the style until 1915 when they moved to the West to work with Diaghilev and the Ballets Russes.

Rayism was the first non-objective style of painting in Russia and influenced the development of Popova and Rodchenko in the early 1920s. Initially, however, Larionov and Goncharova had few Rayist followers, and their Russian contemporaries were cynical and dismissive about the style, the poet Benedikt Livshits observing: 'Rayism, with which Larionov tried to outstrip the Italians, fitted into Boccioni's waistcoat pocket.' Rayism was indeed close to Italian Futurism, which clearly inspired several of its stylistic devices, Larionov's 'ray-lines' sharing characteristics with Futurist 'lines of force'. Guillaume Apollinaire, however, recognized in Rayism a genuine aesthetic discovery, a highly individual and distinctive response to contemporary Western developments.

Bibliography

M. Larionov: *Luchizm* [Rayism] (Moscow, 1913)

—: 'Luchistskaya zhivopis' [Rayist painting], *Oslinyy khvost i Mishen'* [Donkey's tail and target] (Moscow, 1913), pp. 91–100

—: 'Le Rayonnisme pictural', *Montjoie!*, 4/5/6 (1914), p. 15

B. Livshits: *Polutoraglazy strelets* (Leningrad, 1933); Eng. trans. by J. Bowlt as *The One-and-a-half-eyed Archer* (Newtonville, MA, 1977), p. 200

M. Dabrowski: 'The Formation and Development of Rayonism', *A. J.* [New York], xxxiv/3 (1975), pp. 200–07

A. Parton: 'Russian Rayism: The Work and Theory of Mikhail Larionov and Nataliya Goncharova, 1912–14', *Leonardo*, xvi/4 (1983), pp. 298–305

M Draguet: 'Mikhail Larionov et l'abstraction: Le Pneumo-Rayonnisme dans la peinture européenne des années 1910', *An. Hist. A. & Archéol.*, x (1988), pp. 67–86

A. Parton: *Mikhail Larionov and the Russian Avant-garde* (Princeton and London, 1993)

ANTHONY PARTON

Rebel Art Centre [Cubist Centre]

Meeting-place for a group of British artists. It was founded and managed by Wyndham Lewis in March 1914 at 38 Great Ormond Street, London, and was intended to rival Roger Fry's OMEGA WORK-SHOPS in the cooperative production of abstract

fine and applied art. It was also planned as a club for the discussion of revolutionary art ideas and as a teaching studio for non-representational art. The original members, Lewis, Frederick Etchells, Cuthbert Hamilton and Edward Wadsworth, were a group of painters who had recently resigned from the Omega Workshops and had signed a well-circulated round robin condemning Fry. They adopted a militant Futurist stance and decided to meet on Saturday afternoons to discuss their mutual art ambitions. These meetings led to the birth and development of VORTICISM.

With financial backing from the painter Kate Lechmere (1887–1976), the Rebel Art Centre, also called the Cubist Centre, officially opened in April 1914, in hotly coloured rooms decorated with a rigid geometric mural by Lewis (see Cork, p. 196) and Futurist-inspired screens by Christopher Nevinson. The sculptor Henri Gaudier-Brzeska exhibited work there and Ezra Pound lectured on Vorticism. Although the prospectus promised lectures by Filippo Tommaso Marinetti and an ambitious art school, the Rebel Art Centre proved to be little more than a meeting-place for the radical artists who became the nucleus of the Vorticists and who planned to publish *Blast*, a review of the new English art. The group produced very little art together. At the Allied Artists' Exhibition (June 1914) they exhibited a few fans, boxes and scarves described by Gaudier-Brzeska as 'vigorous' and 'capable of great strength and manliness of decoration'. The art school never materialized, and the 'rebels' obtained no major commissions. By the summer of 1914, the Rebel Art Centre was officially closed.

Bibliography

H. Gaudier-Brzeska: 'Allied Artists' Association, Ltd',
 Egoist, i/12 (June 1914), pp. 227–8

W. Lewis and others: 'Round Robin, October 1913', *The
 Letters of Wyndham Lewis*, ed. W. K. Rose (London,
 1963), pp. 47–50

C. Harrison: *English Art and Modernism, 1900–1939*
 (London, 1981)

R. Cork: *Art beyond the Gallery in Early 20th Century
 England* (London, 1985)

FRANCINE MILLER KOSLOW

Re-figuración

Paraguayan art movement active in the 1970s. It produced a form of figurative art based on the exploration of the nature of pictorial signs, yet also with a strong expressive quality. The movement investigated the mechanism of representation and the relationship between reality and image, without abandoning the vital dramatic sense that marks the best figurative work in Paraguay. It was related to the wider development of the visual arts in Paraguay in the 1970s, which was characterized by a reflective mood connected with the prevalence of conceptual art. The most representative artists of Re-figuración were Osvaldo Salerno (*b* 1952), Bernardo Krasniansky (*b* 1951) and Luis Alberto Boh (*b* 1952), but the movement also had a considerable effect on the work of such other artists as Carlos Colombino, Olga Blinder, Susana Romero and a whole generation of young artists working at that time.

Bibliography

O. Blinder and others: *Arte actual en el Paraguay*
 (Asunción, 1983)

T. Escobar: *Una interpretación de las artes visuales en el
 Paraguay* (Asunción, 1984)

TICIO ESCOBAR

Refus global

Canadian manifesto launched on 9 August 1948 at the Librairie Tranquille, Montreal. It was written by the painter Paul-Emile Borduas and signed by 15 of his young followers, LES AUTOMATISTES, among whom Jean-Paul Riopelle, Pierre Gauvreau (*b* 1922) and Fernand Leduc were the most important. Four hundred copies were printed. In addition to a major essay by Borduas, a glossary and a short text in which Borduas disassociated Les Automatistes from Surrealism, the manifesto included the texts of two dramas by Claude Gauvreau (1925–71), *Bien-être* and *L'Ombre sur le cerceau*; a piece by Françoise Sullivan (*b* 1927) entitled 'La Danse et l'espoir'; 'L'Oeuvre picturale est une expérience' by Bruno Cormier; and a

proclamation by Fernand Leduc. The cover was designed by Riopelle and Pierre Gauvreau and some photographs of Automatiste works were included.

Protesting against the power of the Catholic church in Quebec, the manifesto proclaimed that anarchy was the only possible political stand. Sales rose with the manifesto's condemnation in *c.* 100 articles in the local press. It marked the end of the conservative ideology based on the defence of French culture and Catholicism and enabled Quebec to become increasingly receptive to modern thought. Borduas paid dearly for his audacity: a few days after the publication of the manifesto he was dismissed from his teaching position at the Ecole du Meuble.

Bibliography

F.-M. Gagnon and D. Young: *Paul-Emile Borduas: Ecrits/Writings, 1942–1958* (Halifax, 1978)

FRANÇOIS-MARC GAGNON

Regionalism

Movement that dominated painting in the USA throughout the 1930s. Originally applied to the novels of everyday life in the South by such writers as John Crowe Ransom and Robert Penn Warren, the term was later used to describe an artistic trend exemplified by realistic depictions of identifiably American subjects, which celebrated the positive aspects of life in the USA. Other artists, such as Ben Shahn and the Soyer brothers, also produced realistic pictures of typically American subjects, but their work, known as SOCIAL REALISM, took a critical approach. These two movements are part of the phenomenon known as AMERICAN SCENE PAINTING.

Three of the best-known Regionalists, Thomas Hart Benton, John Steuart Curry and Grant Wood, were all born in the Midwest, but each had his own distinctive style. Benton painted elongated, curvilinear forms, often depicting farmers hard at work bringing in bountiful crops; Curry favoured images of animals and pastoral landscapes, which he depicted with soft, blurred edges; Wood used a tight, precise technique to produce pictures such

as *Stone City, Iowa* (1930; Omaha, NE, Joslyn A. Mus.), whose relationship to folk art is clear. The artists consciously rejected what they saw as the élitist, foreign influences of abstract art. Instead they considered themselves part of what art critic Peyton Boswell jr (1904–50) had christened the 'American Renaissance' (see *Modern American Painting*, New York, 1939), a flowering of the arts throughout the USA that Boswell believed would diminish the focus on the single cultural centre of New York. In the first decade of the century the Ashcan school had demonstrated that American painters no longer had to look to Europe for subjects, concentrating instead on the world they saw around them. The Regionalists followed their lead, extending their scope far beyond the urban scene.

To bring art into everyday American life, and through the various Federal Art Projects, the Regionalists painted realistic murals of American subject-matter in an easily accessible style, which were displayed in post offices, banks, schools and other public buildings, for example Curry's *Oklahoma Land Rush* (1938; Washington, DC, US Dept Interior). Evolving in the midst of the Depression, Regionalism provided a welcome respite from the harsh economic realities of the day. The movement quickly became popular and remained so for more than a decade. During the 1940s, however, Regionalism waned, due to the approach of World War II. As avant-garde European artists fled to the USA, many Americans came to view Regionalism as a provincial and isolationist phenomenon. While some Regionalists, notably Benton, continued to paint the same way for many decades, the war brought the movement to an end. Although it generated no direct stylistic offshoots, it was art-historically significant for the atmos-phere of self-confidence that it created and the appre-ciation for an American art on American themes.

Bibliography

M. Baigell: *The American Scene: American Paintings of the 1930s* (New York, 1974)

NANCY G. HELLER

Revolt group [Pol. Bunt]

Polish group of painters, graphic artists and poets based in Poznań between 1918 and 1920. It had close ties with *Zdrój* ('Source'; a fortnightly journal published in Poznań between 1917 and 1920, and in 1922), which reported their exhibitions and devoted a special issue to the group ('Zeszyt Buntu' [Revolt bulletin], April 1918). The Expressionist character of the Revolt group artists' work was shaped by close links with the Berlin journals *Die Aktion* and *Der Sturm* and the work of the artists of Die Brücke. The most important members of the group were the poet and group historian Adam Bederski, the painter, graphic artist, poet and editor of *Zdrój* Jerzy Hulewicz (1886–1941), the poet and graphic artist Stanisław Kubicki (1899–1943), the graphic artists Małgorzata Kubicka (*b* 1891), Władysław Skotarek (1894–1970) and Stefan Szmaj (1893–1974), and the sculptor August Zamoyski. Most of the above made their artistic début in Revolt group exhibitions. The group, which was active during its first year of existence (holding its first exhibition in Poznań in April 1918), subsequently became rather subdued as a result of frequent contacts with the FORMISTS in Kraków and was generally regarded as having developed into an extension of the Kraków artists. The members of the Revolt group often took part in Formist exhibitions. *Die Aktion* also organized two exhibitions in Berlin featuring the group.

Criticized from the outset for their disregard of moral principle, the Revolt group members launched an extensive campaign to popularize and publicize their work involving poetic evenings and lectures. Stylistically the works of the members closely resembled German Expressionism. The wood-engravings of Kubicki, Kubicka, Szmaj and Skotarek exemplify the purest and at the same time the most Germanic type of Expressionism in Polish art. The same may be said of Zamoyski's sculptures; he also experimented with graphic art. Other members, however, favoured a more literal and symbolic approach, distinctly modernist in character. This doubtless stemmed from close cooperation with the *Zdrój* literary journal and the influence in it of Stanisław Przybyszewski (particularly up to mid-1918).

Bibliography

Zdrój, 1–78 (1 Oct 1917 to 1 Dec 1920, 1922)

H. Stępień: 'Bunt', *Polskie życie artystyczne w latach 1915–1939* [Polish artistic life in the years 1915–39], ed. A. Wojciechowski (Wrocław, 1974)

Ekspresjonizm w sztuce polskiej [Expressionism in Polish art] (exh. cat., Wrocław, N. Mus., 1980)

WOJCIECH WŁODARCZYK

Rhythm group [Pol. Rytm; Stowarzyszenie Artystów Plastyków Rytm: Rhythm Association of Plastic Artists]

Polish group of artists that flourished between 1922 and 1932, although Rhythm exhibitions continued to be held after the group's disbandment (11 held up to 1932 by the group itself). Members included the painters Wacław Borowski (1885–1950s), Eugeniusz Zak (1884–1926), Tadeusz Pruszkowski (1888–1942), Zofia Stryjeńska and Romuald Kamil Witkowski (1876–1950), the graphic artists Tadeusz Gronowski (*b* 1894) and Władysław Skoczylas (1883–1934) and the sculptors Henryk Kuna (1885–1945) and Edward Wittig. The Rhythm group had no clearly defined programme. It emerged after the disbanding of Revolt (Bunt) and the Formists, before the advent of colourism and the avant-garde groups, with the aim of organizing exhibitions of a high standard. The Rhythm artists favoured classicism and appreciated stylized drawing, rhythmic compositions and decorative effects. They represented the Polish Art Deco style, and they achieved their greatest success at the Exposition Internationale des Arts Décoratifs et Industriels Modernes in Paris in 1925 and at the 'Fine book exhibition' (Paris 1931).

Although the majority of Rhythm members belonged to other associations with a more clearly defined artistic profile, the group's significance in the history of Polish art goes far beyond the exhibitions it staged in galleries. In commercial

graphic art (particularly banknote, postage-stamp and poster design), as well as in the presentation of exhibitions and the decoration of public buildings, the members of Rhythm created a vivacious style even after World War II. They also received numerous commissions from the state. They were attacked on the one hand by the colourists and avant-garde for their passéism and laissez-faire aestheticism, and also for the national elements of their art; and they were criticized on the other hand by the most conservative tendencies in Polish art, with which they were constantly at odds, for their extravagant policy and abandonment of the 'tradition of great national art'. The Rhythm group enabled its members to fulfil their social ambitions: they founded a private school, popularized art and contributed greatly to the establishment of the Institute of Art Propaganda (Instytut Propagandy Sztuki), the most important exhibiting institution of inter-war Poland.

Bibliography

H. Anders: *'Rytm': W poszukiwaniu stylu narodowego* [Rhythm: in search of a national style] (Warsaw, 1972)

——: 'Stowarzyszenie Artystów Plastyków Rytm' [The Rhythm Association of Plastic Artists], *Polskie życie artystyczne w latach 1915–39* [Polish artistic life in the years 1915–39], ed. A. Wojciechowski (Wrocław, 1974)

WOJCIECH WŁODARCZYK

Riga Artists' group [Latv. Rīgas Mākslinieku Grupa; RMG]

Latvian association of painters and sculptors active from 1920 to 1940. Among its founder-members were Jēkabs Kazaks, Romans Suta and Uga Skulme (1895–1963). From its inception, the group was a small confederation of modernist painters and sculptors devoted to the advancement of avant-garde aesthetics in Latvia. Despite a changing membership, a relatively informal structure and internal disagreements about the specifics of a modernist agenda, the group projected a unified identity in its 13 exhibitions, the earliest of which introduced Latvian interpretations of progressive western European styles to Riga's conservative audiences. Suta and Uga Skulme were among the most vocal defenders of modernism in Latvia, as they competed for the unofficial position of ideologue of the group. The Riga Artists' group was the successor to the Expressionists (Ekspresionisti), who were responsible for the local début of Expressionism during the first significant post-war exhibition in independent Latvia. Most members of the Expressionists, including Kazaks, the leader, became founder-members of the Riga Artists' group, and just as its new, generalized name admitted the possibility of pluralism, members began to explore other styles. The attrition of the Expressionists Aleksandr Drevin, Kārlis Johansons (1892–1929) and Jāzeps Grosvalds may have to some degree limited the range of artistic experimentation, but the group's radical works, provocative methods and early recognition by the Valsts Mākslas Muzejs (State Art Museum) and serious collectors still managed to rankle Riga's traditionalists. Initially, abstraction was the favoured means of exploration, as seen in the mildly geometrized works of Kazaks, Niklāvs Strunke (1894–1966) or Valdemārs Tone (1892–1958), the paintings of Ģederts Eliass (1887–1975) influenced by Matisse (*Reclining Woman*, c. 1919; Jelgava Mus.) or those of Konrāds Ubāns (1893–1981), reminiscent of Cézanne. By 1923 Synthetic Cubism was a predominant influence, notably in the sculptures of Marta Liepiņa-Skulme (1890–1962) and Emīls Melderis (1889–1979) and the paintings of Oto Skulme (1889–1967) and Erasts Šveics (1895–1993; *Woman with Pitcher*, 1923; priv. col.). Ironically, after their so-called Cubist show of 1923–4 and their joint exhibitions with the ESTONIAN ARTISTS' GROUP and the Polish Constructivists of Blok (1924), realism was reappearing as an artistic force, and the members of the group were sharply berated by traditionalists who felt that their influences were outmoded. Shortly after, Suta and Aleksandra Beļcova (1892–1981), the more liberal members, left to undertake projects influenced by Purism and Constructivism, while others turned towards

realism, as did Uga Skulme, who explored NEUE SACHLICHKEIT, or Jānis Cielava (1890–1968) and Jānis Liepiņš (1894–1964), who created lyrical, romantic works. While this reappearance of realism during the 1930s is considered by some to be retardataire, it was yet another local manifestation of a broader European phenomenon.

Bibliography

U. Skulme: 'Viena Paaudze' [One generation], *Senatne & Māksla*, iv (1939), pp. 129–45

R. Bēms and S. Cielava, eds: *Latviešu tēlotāja māksla, 1860–1940* [Latvian fine art, 1860–1940] (Riga, 1986)

J. Siliņš: *Latvijas māksla, 1915–1940* [Latvian art, 1915–40] (Stockholm, 1988–93), i

MARK ALLEN SVEDE

Ring, Der

Organization of architects set up in Berlin in 1923 or 1924 to promote the cause of Modernism. It continued until 1933, when growing opposition from the Nazis forced it to disband. It began with a group calling itself the Zehnerring ('Ring of Ten'), which met at the office shared by Mies van der Rohe and Hugo Häring. The name was chosen to symbolize the fact that the Zehnerring was a democratic union of equals. Apart from Mies van der Rohe and Häring, it included Otto Bartning, Peter Behrens, Erich Mendelsohn, Hans Poelzig, Walter Schilbach, Bruno Taut and Max Taut. Zehnerring's stated purpose was 'to struggle against impractical and bureaucratic resistance for the establishment of a new concept of building'.

In 1926 the architects Hans Luckhardt and Wassili Luckhardt contacted a larger group of Modernist architects, including several based in other German cities. The Luckhardt brothers considered that Zehnerring had not been successful because it was too small, and they suggested establishing an organization that would be more representative of German Modernism as a whole. They also proposed it should run its own magazine, for which they already had received offers from two publishers. There was a keen response to these ideas, and Zehnerring members, believing it would be easiest simply to expand their existing group, set up a general meeting in Berlin. Apart from the original members, this was attended by the critic Walter Curt Behrendt (c. 1885–1945), Richard Döcker, Walter Gropius, Adolf Meyer, Otto Haesler (1880–c. 1950), Adolf Rading and Hans Soeder. Der Ring was officially founded, and Häring was adopted as its paid secretary. A letter setting out the conditions of membership and goals of the organization was circulated, and as a result Der Ring grew to 27 members, including Ludwig Hilberseimer, Arthur Korn, Karl Krayl, Ernst May, Bernhard Pankok, Hans Scharoun, Karl Schneider, Heinrich Tessenow and Martin Wagner.

The aims of Der Ring became more closely defined: to take a stand on building problems of the day, on housing, planning and education; to suggest guidelines for competitions; to publicize the work of its members in the press and in exhibitions; to start a slide library; to collect information on technical questions; and to promote research. This was to be funded by membership fees paid at graded rates according to income. Solidarity in the face of traditionalists who still formed a majority in German architectural practice was considered particularly important. They decided against setting up their own magazine but instead opted to make best possible use of the existing press. Behrendt became editor of the Werkbund magazine *Die Form* and published leading articles by Häring and Rading, while a special issue of *Bauwelt* edited by Häring and Hilberseimer featured the work of members of Der Ring. They voted together in the Bund Deutscher Architekten, which helped Gropius to gain a place on its directorate in 1927. The same year the Weissenhofsiedlung exhibition by the Werkbund took place in Stuttgart. Organized by Mies, the exhibition was dominated by Der Ring. The *Grosse Berliner Bauausstellung*, which brought the group to public notice, was also held in 1927.

Perhaps the greatest impact made by Der Ring was its successful campaign against Ludwig Hoffmann, a Neo-classicist who opposed Modernist efforts at every turn. In 1924 Hoffmann resigned as municipal architect of Berlin and was replaced in 1926 by Martin Wagner, who had led a movement of socialist building trades unions; he

held a major role in the largest building society in Berlin, and he was a pioneer in the development of economic construction. Largely through Wagner's patronage several Modernist housing developments were built in Berlin in the late 1920s by members of Der Ring, including Onkel Tom's Hütte, Siemensstadt and the Hufeisensiedlung. Der Ring became a particular target for anti-Modernist propaganda from the Nazi press. Those members who did not emigrate after the group was disbanded maintained contact with one another, but the circle was not formally revived after World War II.

Bibliography

J. Joedicke and H. Lauterbach: *Hugo Häring: Schriften, Entwürfe, Bauten* (Stuttgart, 1964)

B. M. Lane: *Architecture and Politics in Germany, 1918–45* (Cambridge, MA, 1968)

P. Pfankuch, ed.: *Hans Scharoun: Bauten, Entwürfe, Texte* (Berlin, 1974), pp. 58–61

PETER BLUNDELL JONES

Rot-Blau [Ger.: 'Red-Blue']

Swiss artists' group formed in Basle on 31 December 1924. Its most prominent members were Paul Camenisch (1893–1970), Albert Müller (1897–1926) and Hermann Scherer. They had been loosely affiliated since 1923 as a result of their enthusiastic response to an important retrospective of the work of Ernst Ludwig Kirchner at the Kunsthalle in Basle in June of that year. Camenisch, Müller and Scherer visited Kirchner, who had been living in Davos-Frauenkirch since 1917, and worked under his direction. This resulted in radical changes in their respective styles, evident in such works as Müller's sculpture *Crouching Woman* (1925; Basle, Staatliche Kunstsammlung), and Camenisch's painting *Portrait of a Young Boy* (1931; priv. col.). The Rot-Blau group modelled itself on Die Brücke, of which Kirchner had been a founding member in 1905. As well as a new concern with the artistic treatment of the object, they aimed at recognition for artists working outside the traditional mainstream and better exhibition facilities. The members produced works in all media, including carved wooden furniture, utensils and textile designs. Others, more independent of Kirchner, were Werner Neuhaus (1897–1934) and Otto Staiger (1894–1967). In April 1925 the group came to public attention through a comprehensive exhibition at the Kunsthalle in Basle. Despite critical acclaim in Switzerland, the work was attacked by some as being too derivative of Kirchner's. Though there was a break between Kirchner and Scherer at the end of 1925, the activities of the group fulfilled briefly Kirchner's hopes for a progressive artistic community in Switzerland. These aims were cut short by the early deaths of Müller and Scherer.

Bibliography

Expressionismus in der Schweiz, 1905–1930 (exh. cat. by R. Koella and others, Winterthur, Kstmus., 1975)

B. Stutzer: *Albert Müller und die Basler Künstlergruppe Rot-Blau* (Munich, 1981)

COLIN RHODES

Ruche, La

Artists' collective and studio complex founded in Paris in 1902. It was established by Alfred Boucher (1850–1934), a fireman and sculptor, to help young artists by providing them with shared models and with an exhibition space open to all residents. A rotunda from the Pavillon des Vins at the Exposition Universelle of 1900 was sited at 2, Passage de Dantzig, on land that Boucher had acquired in 1895 in the remote district of Vaugirard near Montparnasse. The 12-sided building originally offered 24 wedge-shaped studios, but a further 140 studios were subsequently built on the site. The first La Ruche salon opened on 12 February 1905 and took place in many pavilions built in the garden around the rotunda. The first painters resident there included Ardengo Soffici and Jean Raoul Chaurand-Naurac (1878–1948), but Boucher generously went along with the more avant-garde tendencies of the next arrivals, such as Léger, Robert Delaunay, Chagall, Soutine, Henri Laurens, Lipchitz, Zadkine, Archipenko and Michel Kikoïne (1892–1968). In spite of the wretched conditions in which they lived, neglecting the building and the garden, it was these

artists of the Ecole de Paris who made La Ruche famous, along with writers such as Apollinaire, Cendrars and Max Jacob.

In the early 1950s La Ruche provided a base for the young and independent artists associated with the Jeune Peinture Française, notably Paul Rebeyrolle, Simone Dat (*b* 1927), René Aberlenc (1920–71) and Bernard Buffet. In 1966 the building was condemned and scheduled for demolition, but a committee was formed to prevent this and to oversee its restoration and conversion. It was reopened in 1978 as the studios of the City of Paris, numbering among its many inhabitants Eduardo Arroyo, Jean-Paul Chambas (*b* 1947) and Ernest Pignon.

Bibliography

J. Chapiro: *La Ruche* (Paris, 1960)

J. Warnod: *La Ruche et Montparnasse* (Paris, 1978)

J. Milner: *The Studios of Paris: The Capital of Art in the Late Nineteenth Century* (New Haven, 1988), pp. 31, 229–31

COLETTE GIRAUDON

St Ives

English coastal town in Cornwall and an artistic centre in the late 19th century and the 20th. A gallery and artists' club had been established in St Ives by the late 1880s, paralleling the establishment of Newlyn, another Cornish coastal town, as an art colony. Its initial attractions seem to have resided as much in establishing a cultural distance from London and other urban centres, confirmed by the preference among artists in St Ives for Cornish landscape and genre subjects, as in the potential of the tourist trade. In 1927 the St Ives Society of Artists was established with its own sales gallery; members also submitted work annually to the Royal Academy in London. Landscapes and seascapes predominated in the work of Borlase Smart (1881–1947), Julius Olsson (1864–1942) and John Park (1880–1962).

As with the Parisian avant-garde's depiction of late 19th-century Brittany as remote from civilization, the myth of St Ives became entwined with the British assimilation of modernist values, such as simplicity of life style, innocence or naivety of vision and the integrity of the handmade. For example, Bernard Leach, in opposition to industrial production of tableware, tried to revive pre-industrial slipware and introduce the processes of Oriental stoneware, when he established his pottery workshop at St Ives in 1920. Financial security for Leach was finally established in post-war years by upper-middle-class metropolitan taste, operating through London department stores and mail-order catalogues. The modernist artists of the late 1920s found their evaluation of innocent vision, acknowledgement of media and innate sense of pictorial form confirmed by the naive paintings of boats and harbours by the ex-fisherman Alfred Wallis, whose work was discovered in St Ives by Ben Nicholson and Christopher Wood in 1928.

By the end of World War II an influx of modern artists had joined the community of traditional artists, although the number of artists' studios had in fact dropped decisively from *c.* 100 to 38. Among the new group were Adrian Stokes, Margaret Mellis (*b* 1914), Barbara Hepworth, Nicholson (see fig. 41), Naum Gabo and Wilhelmina Barns-Graham (*b* 1912). Their presence attracted Terry Frost, Sven Berlin (*b* 1911), John Wells (*b* 1907) and Bryan Wynter (1915–75) to the area. The new arrivals split the St Ives Society of Artists and encouraged the formation of the Penwith Society in 1949. Peter Lanyon, born in St Ives, returned there. Patrick Heron, who had worked at the Leach pottery during 1944 and 1945 and rented a seafront cottage every summer between 1947 and 1955, moved to Zennor in April 1956. Trevor Bell (*b* 1930) and Karl Weschke (*b* 1925) both moved to Cornwall in 1955. Other artists, such as Sandra Blow (*b* 1925), Bob Law, Joe Tilson and Alan Davie, stayed for the summer months or particular periods. One of the last major figures to move to Cornwall was Roger Hilton, who settled in Botallack in 1965, but who had painted in a Newlyn studio over the summer months in the late 1950s. International recognition of the town as an important artistic centre was shown by visits from international artists, critics and dealers, including Mark Rothko in 1958 and Clement Greenberg in 1959. St Ives came to stand for

abstraction moulded by the forces of nature. Meanwhile, younger painters and critics dedicated themselves to an American-influenced professionalism based either on examining the formal considerations of painting, or on appropriating images and qualities from contemporary mass culture. Their reaction against St Ives involved a similar misrepresentation to that used by its apologists, who credited the effect of special natural conditions in accounting for such art. In fact, the idealist overtones of inter-war geometric abstraction were being replaced generally by painterliness affirming individual touch. This often evoked natural spaces and focused on personal motifs handled frequently in a metamorphic or metaphoric way.

In 1993 the Tate Gallery St Ives opened overlooking Porthmeor Beach. Designed by Evans & Shalev, it houses the Tate Gallery's collection of St Ives painting and sculpture including works by Terry Frost, Barbara Hepworth, Patrick Heron, Peter Lanyon, Ben Nicholson and Alfred Wallis.

Bibliography

Cornwall, 1945–1955 (exh. cat., intro. D. Brown; London, New A. Cent., 1977)

T. Cross: Painting the Warmth of the Sun: St Ives Artists, 1939–75 (Guildford, 1985)

P. Davies: The St Ives Years (Wimborne, 1985)

St Ives, 1939–64: Twenty Five Years of Painting, Sculpture and Pottery (exh. cat., ed. D. Brown; London, Tate, 1985)

M. Tooby: Tate St. Ives: An Illustrated Catalogue (London, 1993)

ADRIAN LEWIS

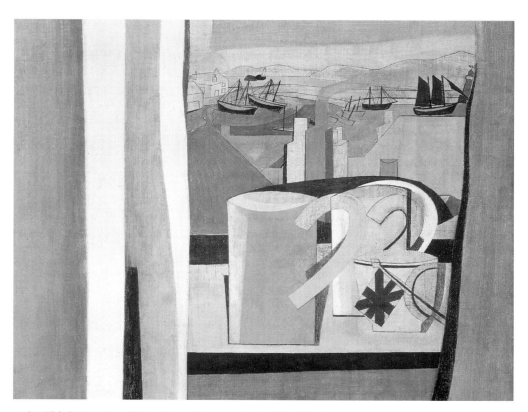

41. Ben Nicholson: 1943–45 (St Ives, Cornwall), 1943–5 (London, Tate Gallery)

Salon des Réalités Nouvelles

French exhibition venue founded in Paris in 1946. It was named after the exhibition of abstract art organized by Fredo Sidès and held at the Galerie Charpentier, Paris, in 1939. In the Salon's first show, work by 73 artists was exhibited. Each Salon was accompanied by a publication. Throughout the post-war period the Salon was the leading centre in Paris for geometric abstraction, attracting such artists as Auguste Herbin, Antoine Pevsner, Alfred Pellan, Jean Gorin and César Domela.

Bibliography

Réalités nouvelles, 1946–1956–Anthologie de H. Lhotellier (exh. cat., Calais, Mus. B.-A., 1980)

☐

Samokov school

Art school in Samokov, near Sofia, Bulgaria, that flourished from the end of the 18th century to the end of the 19th. Initially its centre was Samokov, but some of the artists settled in other towns and villages. Samokov artists worked in painting, printmaking and wood-carving. As in other Bulgarian art schools of that time, whole families were engaged in producing certain artefacts. The best known are the painters of the Dospevski and the Obrazopisov families. Their main field of activity was church decoration and icon painting. They based their style on late medieval traditions and mainly on Creto-Athonite painting. Some of them acquired an artistic education abroad: the founder of the school, Khristo Dimitrov (c. 1745–1819), studied in Vienna at the end of the 18th century, and a half-century later his grandson Stanislav Dospevski (1823–78) studied in Moscow and in St Petersburg. While Dimitrov did not overstep the boundaries of Balkan orthodox themes and style, Dospevski worked under the influence of Russian academic painting. Some of the representatives of the school, including Zakhary Zograph, Dospevski and Nikola Obrazopisov (1828–1911), who produced portraits, landscapes and genre compositions, laid the foundations of secular art in Bulgaria. Some of the Samokov painters specialized in decorative painting. They decorated the façades and interiors of houses, churches and mosques with ornamental compositions and landscapes. Other Samokov artists produced woodcuts and intaglios with pictures of saints, religious scenes and monasteries. They were distributed as drawings and used for illustrating books printed in Samokov. Wood-carving began in Samokov after the wood-carver Atanas Teladur came from Thessaloniki and began teaching. Samokov church wood-carving is a version of the Balkan 'Levantine Baroque' style, which is characterized by the relatively scant attention paid to human figures. Folk motifs strongly influenced the works of some of the wood-carvers of the school. Works from the Samokov school are in the National Art Gallery, Sofia, and the museum of Stanislav Dospevski, Pazardzhik as well as in situ at the monasteries in Rila, Troyan and Preobrazhenski, near Veliko Türnovo.

Bibliography

N. Mavrodinov: Izkustvoto na bălgarskoto văzrazhdane [The art of the Bulgarian Renaissance] (Sofia, 1955), pp. 71–5, 198–203, 207–24, 251–4, 298–313
A. Vasiliev: Bălgarski văzrozhdenski maystori [Masters of the Bulgarian Renaissance] (Sofia, 1965), pp. 313–482
A. Roshkovska: Văzrozhdenska dekorativna stenopis ot samokovski zografi [Renaissance decorative wall painting by Samokov painters] (Sofia, 1982)

IVANKA GERGOVA

Scholle, Die [Gruppe G; Jugendgruppe; Ger.: 'native soil']

German group of artists active in Munich from 1899 to c. 1914. The members, all former pupils of Paul Höcker at the Akademie der Bildenden Künste in Munich, included Reinhold Max Eichler (1872–1947), Fritz Erler, Max Feldbauer (1869–1948), Walter Georgi (1871–1924), Angelo Jank, Walther Püttner (1872–1953) and Leo Putz. When the exhibiting conditions of the Münchener Künstlervereinigung were reformulated shortly before 1900, so that groups would in future be

assigned a room of their own in the Glaspalast, the artists of Die Scholle, who had common interests, banded together as a group, first using the name Gruppe G, then Jugendgruppe (after the periodical *Jugend*), and finally Die Scholle, a name chosen as a symbolic reference to the idea that each member should tend his own 'patch' in an individual way. In spite of differences between the artists, in both their style and their aims, the members of Die Scholle had in common their links with Jugendstil painting, their predilection for symbol-laden content and their closeness to nature. The enthusiasm for Arnold Böcklin in Germany at the turn of the century was reflected among the members of Die Scholle in a tendency towards new idealism; in the depiction of figures such as those of Erler from the world of Germanic saga, there was a tendency towards exaggerated pathos. Besides religious, allegorical and mythological themes and the painting of nudes, such as Putz's *Girl in a Glass* (1903; Munich, Lenbachhaus), landscape was a popular subject. In this regard the members of Die Scholle are comparable to those of the Worpswede colony, trying to elaborate the atmospheric content of nature by the use of markedly contrasting colours and ornamental composition.

Bibliography

G. Biermann: *Die Scholle* (Munich, 1910)

P. Vogt: *Geschichte der deutschen Malerei im 20. Jahrhundert* (Cologne, 1972), pp. 26–7

SEPP KERN

Scottish Colourists

Scottish group of painters active between 1910 and 1930. The name was applied posthumously to S. J. Peploe, Leslie Hunter (1877–1931) and F. C. B. Cadell (1883–1937) by T. J. Honeyman in his study of 1950; later it was extended to include the work of J. D. Fergusson. The Scottish Colourists were the natural successors of the Glasgow Boys, whose free brushwork and instinctive use of colour formed the basis of their early styles. All four Colourists

worked or trained abroad: Hunter visited Paris in 1904 and worked briefly as an illustrator in San Francisco until the earthquake of 1906; Peploe studied in Paris from 1894 at the Académie Julian and the Académie Colarossi; Cadell was in Paris from 1899 to 1903, which included a period spent at the Académie Julian, and in Munich in 1907; and Fergusson, painting in France from the 1890s, settled in Paris *c.* 1907.

Peploe's paintings of the early 1900s showed the influence of Manet in the handling and fluidity of paint, a quality he shared with his friend Fergusson. The formal compositions of landscape and still-life, executed by both artists between 1910 and 1914 (when Peploe was living in Paris) promoted a range of vibrant, high-key colours. In Edinburgh Cadell employed looser compositional structures but an equally sharp freshness of colour in his stylish interiors and portraits such as *The Black Hat* (1914; Edinburgh, City A. Cent.). Although Hunter was enjoying a reputation as an accomplished illustrator in Glasgow at this date, his still-lifes and landscapes remained the most academic in approach, displaying less avant-garde subtle tonalities.

In the early 1920s three of the four artists were based in Scotland: Peploe and Cadell in Edinburgh, and Hunter in Glasgow; Fergusson, who was in close touch with Hunter and Peploe, at this time was living in London. Peploe, Cadell and Hunter exhibited both as a group and with other artists in Britain and France. They showed at the Leicester Galleries, London, in 1923 (and again in 1925 when the catalogue preface was written by Sickert), and at the Galerie Barbazanges, Paris, with Fergusson in 1924. In the late 1920s Peploe, Hunter and Fergusson were all painting in the south of France. Cadell, a founding and later leading member of the Society of Eight in Edinburgh, paid only occasional visits to France and Italy.

Although Scottish and especially Glaswegian collectors began to acquire and promote their work during the 1920s, it was not until an exhibition of 1931 in Paris that the French government purchased representative canvases by Peploe, Hunter and Fergusson. Their Scottish landscapes

presented a daring purity of colour learnt in France. Exotic still-lifes, Peploe's and Cadell's views of Iona, Hunter's Fife scenes and portraits and Fergusson's stylized figural compositions are all characterized by rational form, honest texture and unworked, exuberant colour that heightens the sense of atmosphere. Only Cadell and Peploe were elected members of the Royal Scottish Academy.

Bibliography

T. J. Honeyman: *Introducing Leslie Hunter* (London, 1937)

S. Cursiter: *Peploe: An Intimate Memoir of an Artist and his Work* (London, 1947)

T. J. Honeyman: *Three Scottish Colourists* (London, 1950)

Three Scottish Colourists: Cadell, Hunter and Peploe (exh. cat., intro. W. R. Hardie; Edinburgh, Scot. A. C., 1970)

S. J. Peploe, 1871–1935 (exh. cat., intro. G. Peploe; Edinburgh, N. G. Mod. A., 1985)

R. Billcliffe: *The Scottish Colourists* (London, 1989)

ELIZABETH CUMMING

Scuola Romana [Ecole de Rome; Roman school]

A loosely associated group of artists active in Rome between 1927 and 1940. It originated in 1927 with the painters Mario Mafai, Antonietta Raphael, Gino Bonichi Scipione and the sculptor Marino Mazzacurati (1907–69). They met as students at the Accademia delle Belle Arti in Rome and gathered at Mafai's studio in Via Cavour. In 1929 the art critic Roberto Longhi first termed them the 'Scuola di Via Cavour' in his review of the Prima Mostra del Sindicato Laziale Fascista. The painter Fausto Pirandello was also associated with the group. Apart from Scipione, who painted fantasy subjects tinged with surrealism, members of the group painted in a lyrical, expressionist manner inspired to a large extent by the Ecole de Paris. By the early 1930s their intimate still-lifes, nudes and interiors provided an alternative to the monumental classicism of the Novecento Italiano group and prepared the ground for the artistic rebellion of the Milanese Corrente.

After the premature death of Scipione in 1933, Mafai became the leading figure of the second phase of the group, which consisted of the painters Corrado Cagli, Emanuele Cavalli (1904–81), Giuseppe Capogrossi, Roberto Melli and Alberto Ziveri (*b* 1908). They were named the 'Ecole de Rome' by the French critic Waldemar George in his catalogue text for the exhibition *Capogrossi, Cagli, Cavalli, Sclavi* held at the Galerie Bonjean, Paris, in 1933. Their paintings are characterized by vibrant surfaces and stilled atmospheres created by the juxtaposition of closely related hues, akin to tonal painting and to the work of Giorgio Morandi but with brighter, more strident colours.

While never an official group, the Scuola Romana reached its most cohesive form during the mid-1930s, when the artists exhibited together at the Rome Quadriennale of 1935 (which included a retrospective of Scipione) and the Venice Biennale of 1936. They were also associated with the Galleria della Cometa in Rome which hosted one-man exhibitions of the principal figures between 1935 and 1938.

Bibliography

R. Longhi: 'La mostra romana degli artisti sindicati', *Italia Lett.* (14 April 1929)

G. Castelfranco and D. Durbe: *La Scuola Romana dal 1930 al 1945* (Rome, 1960)

M. Fagiolo dell'Arco: *Scuola Romana: Pittura e scultura a Roma, 1914–1943* (Rome, 1986)

E. Braun: 'Scuola Romana: Fact or Fiction', *A. Amer.*, lxxvi (1988), pp. 128–36

Le Scuole Romane (exh. cat., ed. F. Benzi; Verona, Gal. Civ. A. Mod. & Contemp., 1988)

Scuola Romana (exh. cat., ed. M. Fagiolo; Milan, Pal. Reale, 1988)

EMILY BRAUN

Secession

Term applied to a group of artists who secede from academic bodies or associations in protest at their constraints. The term comes from the Latin *secessio plebis*, the revolt of the plebeians against the patricians. The Secessions in German-speaking Europe in the late 19th century developed out of

the political and literary movement of the 1870s, Die Jungen, which had broken away from the rigidity of historicism (typified by the Ringstrasse style in Vienna), an eclectic synthesis of styles, and sought a modern style for modern living. The three main Secessions were those of Munich, Berlin and Vienna, although others were formed in Dresden, Karlsruhe, Düsseldorf, Leipzig and Weimar. Secessions also took place in other parts of Europe, including Rome (La Secessione, 1913) and Budapest (Szecesszió, 1896–1914), and, under different names, elsewhere, for example in Prague (Mánes Union of Artists, 1895) and Kraków (Sztuka Polish Artists Society). At issue in all areas was control over exhibiting policies and the art market. An underlying problem was the tension between the élite, successful artists and the increasingly large numbers of mediocre and impoverished artists. This tension was exacerbated by experimentation in styles heralded by the French Impressionists and Post-Impressionists and adopted by some though by no means all of the Secessionists.

1. Munich

The Secession of Munich was a social and professional artists' association founded in 1892 primarily to mount art exhibitions. The controversies that led to its establishment took place in the Münchner Künstlergenossenschaft, the largest social and professional society for artists in Bavaria. Founded in 1868 at the height of German liberalism, the Künstlergenossenschaft aimed above all to further the interests of a wide range of artists both in and around Munich. When, however, the juries of the 1889 and 1891 Künstlergenossenschaft salons (most of them future Secessionists) mounted exhibitions that were decidedly biased towards Naturalism, Impressionism and Symbolism, dissent grew. The majority of the association voted to implement regulations proscribing future juries from favouritism of any kind and guaranteeing diversity of outlook at the exhibitions. Over 100 of the most forward-looking artists in Munich refused to accept these new statutes and seceded in

April 1892 to found their own exhibition society. Among the most important participants were Lovis Corinth (see fig. 42), Max Slevogt, Franz von Stuck, Wilhelm Trübner and Fritz von Uhde.

The Munich Secession did not, therefore, arise in a culturally repressive environment, like its successors in Berlin and Vienna; on the contrary, the leading Secessionists held important positions of power in the Munich art community prior to their breakaway from the Künstlergenossenschaft. It was primarily their unwillingness to compromise and the economic uncertainty of the artist's profession in the Munich of the late 1880s and early 1890s that caused the split.

The first president, Bruno Piglhein, died shortly after his election in 1892, to be replaced in 1894 by the Dachau school painter Ludwig Dill (1848–1940), whose political acumen helped the Secession a great deal. The most important subsequent president was Hugo von Habermann, who assumed directorship in 1904. Georg Hirth, champion of liberal causes and owner of the influential daily newspaper *Die Münchner neuesten Nachrichten*, and Adolf Paulus, business manager of the association and trusted confidant of Luitpold, Prince Regent of Bavaria, assisted in the foundation of the group. Through these contacts the group was able to construct an exhibition gallery on a privately owned plot of land near the Englischer Garten, then one of the most prestigious locations in Munich. Completed in 1893, the building housed the association's first five annual exhibitions.

Initially, official response to the Secession was negative, less because of the modernist aesthetics of the group than from the fear that a disunified art community would lead to Munich's downfall as the foremost German art centre, thus giving Berlin an opportunity to supersede the Bavarian capital in cultural affairs. However, once it became clear that the Secession was likely to achieve its aims, Luitpold and other officials gave full support to the association, providing financial aid and purchasing works from its exhibitions. When the Secession's lease expired in 1897, the Bavarian State even permitted the group to use a public building, the Kunstausstellungsgebäude on

Königsplatz, as its administration and exhibition headquarters.

The Secession's founding manifesto stated that aesthetic orientation was not a criterion for membership and solicited for its annual juried salons all work of genuine quality. Nevertheless, the group's early shows (before 1895) were dominated by variants of Naturalism and Impressionism, for example Max Liebermann's portrait of *Carl Friedrich Petersen* (1891; Hamburg, Ksthalle) and George Clausen's *Haying* (1882; Toronto, A.G. Ont.). Thereafter, Symbolist and *Jugendstil* works, such as Leopold Kalckreuth's *Seventy Years is the Span of our Life* (1898; Munich, Neue Pin.) and Richard Riemerschmid's *Apparitions in the Clouds* (1897; Munich, Lenbachhaus), predominated. Notably, however, most of the German and foreign artists chosen to exhibit with the Secession tended to avoid modern life, urban themes and powerful emotive content in their work, preferring instead subject-matter rooted in nature and defined in a lyrical, evocative manner. The most directly expressive artists of the turn of the century, including Paul Gauguin, Vincent van Gogh, Jan Toorop, James Ensor, Henri de Toulouse-Lautrec, Edvard Munch and Ferdinand Hodler, did not participate in the Secession exhibitions of the 1890s. Among those who did were Trübner, Liebermann, Franz von Stuck, Fernand Khnopff and Eugène Carrière. In short, for the Secessionists, quality, allegedly the sole criterion for exhibition with the association, resided primarily in moderately progressive aesthetic orientations; they rejected both the popular and the exceptionally avant-garde. By contrast, the more democratic Künstlergenossenschaft continued to exhibit together both the old and the new, and both academic and avant-garde. In 1898, for example, the academic architects Friedrich von Thiersch and Emanuel von Seidl (1856–1919) designed historicist rooms for the Künstlergenossenschaft exhibition, fitted out with furniture and decorative arts in

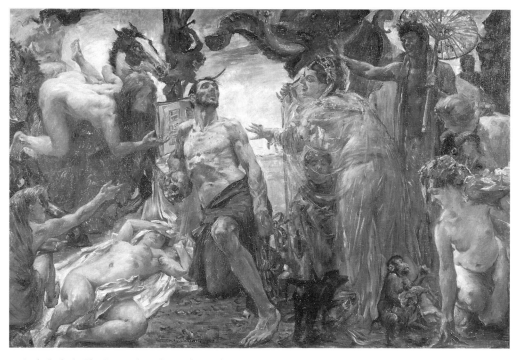

42. Lovis Corinth: *The Temptation of St Anthony after Gustave Flaubert*, 1908 (London, Tate Gallery)

the tradition of the German Renaissance and Classical antiquity. At the same exhibition the progressive architect Theodor Fischer designed a room with *Jugendstil* furniture and objects by some of the most avant-garde artists of the period, including Otto Eckmann, Martin Dülfer, Hermann Obrist, Bernhard Pankok and Riemerschmid.

Despite the various ruptures of the Secession itself, including the foundation of the Freie Vereinigung in 1894 in opposition to Secession policy, the group maintained a changing membership of c. 100–200 members. It was a particularly significant force in Munich during the first decade of its existence, when its annual salons of art were the most progressive in the country, helping to shape the sensibility of artists who were later the representatives of *Jugendstil* and south German Expressionism. In 1938 the association was disbanded by the Nazis, but it was reconstituted in 1946 and continued thereafter to sponsor exhibitions. Although it always showed prints, drawings, sculpture, decorative arts and architectural plans, it remained most committed to painting.

Bibliography

A. Paulus: 'Zwanzig Jahre Münchner Secession, 1893–1913', *Kst: Mhft. Freie & Angewandte Kst*, xxvii (1912–13), pp. 326–36

G. J. Wolf: *Münchner Künstlergenossenschaft und Secession* (Munich, 1927)

E. Betz: *Kunstausstellungen und Tagespresse in München um die Wende des 19. Jahrhunderts: Ein Beitrag zum Kunst- und Kulturleben der bayrischen Hauptstadt* (diss., Munich, Ludwig-Maximilians U., 1953)

Die Münchner Secession und ihre Galerie (exh. cat., essay R. Heise; Munich, Stadtmus., 1975)

R. Hummel: *Die Anfänge der Münchner Secession: Eine kulturpolitische Studie* (MA thesis, Munich, Ludwig-Maximilians U., 1982)

M. Makela: *The Founding and Early Years of the Secession* (Princeton, 1990)

M. Harzenetter: *Zur Münchner Secession: Genese, Ursachen und Zielsetzungen dieser intentionell neuartigen Münchner Künstlervereinigung* (diss., Munich, Ludwig-Maximilians U., 1992)

MARIA MAKELA

2. Berlin

The Berlin Secession was formed in 1898 as an independent exhibiting association, and it successfully challenged imperial art policies at the turn of the century, opening the way for modernist art movements in Germany. The formation of the Berlin Secession was preceded by an informal Gruppe der Elf, artists who successfully exhibited together in a small independent salon (1892–9) while maintaining their connection with the official Berlin salon. The formal break came in 1898, when a landscape by one of the leading members, Walter Leistikow, was rejected by the Grosse Berliner Kunstausstellung. This was, however, only the culmination of a series of encounters between restless artists and the leadership of the Königliche Akademie der Künste, the most notorious being the forced closure of an exhibition organized by the Verein Berliner Künstler of the work of Edvard Munch in 1892. By the turn of the 19th century Emperor William II's conservative art policies were increasingly questioned by new journals established to support avant-garde art, particularly *Pan* (1895–1900), edited by Julius Meier-Graefe, and *Kunst und Künstler* (1903–33), published by Bruno Cassirer (1872–1941) and edited by Karl Scheffler (1869–1951). Influential supporters of German Impressionism included Wilhelm von Bode, Director of Paintings in the royal museums, Alfred Lichtwark (1852–1914), Director of the Hamburger Kunsthalle, and Hugo von Tschudi, Director of the Königliche Nationalgalerie.

In May 1898, 65 artists withdrew from the Verein Berliner Künstler to form the Berlin Secession under the presidency of Max Liebermann, whose career had been marked by controversy over his use of Naturalist and later Impressionist styles, with Walter Leistikow as secretary. The first exhibition in 1899 included entries from sympathetic artists across Germany, among them Lovis Corinth, Max Slevogt, Wilhelm Trübner and Ludwig von Hofmann (1861–1945), and was a commercial success. Supported by the educated, wealthy classes in west Berlin, the Secession was skilfully managed and publicized

by Bruno Cassirer and Paul Cassirer who owned a publishing house and gallery. Its twice-yearly salons—painting in the spring and drawings and graphics in the winter—became fashionable rivals to the official Berlin exhibitions and served as the centre not only for German Impressionist art but also for the introduction of Post-Impressionist French painters to Germany. One effect was Berlin's eclipse of Munich as the centre of the German art world.

Under the leadership of Liebermann, Leistikow, Corinth and Paul Cassirer, the Berlin Secession asserted the freedom of the artist to develop along individualistic and experimental lines and the freedom of art from chauvinistic and parochial concerns. Although many of the Secessionists did not work in Impressionist styles, the exhibitions were marked by an absence of didactic themes, a diversity of styles and a cosmopolitan view of art. Within conservative circles, both artistic and political, the success of the Secession was its challenge to tradition and royal authority, which was anathema. Liebermann, the highly visible leader of this modernist association and a leading German Impressionist painter, was Jewish, which fuelled the opposition and reinforced the sense that the Secession was importing foreign values. The exhibition of French works heightened the perception of the Secession as a foreign and subversive force. Controversies over the participation of the Secession in the World's Fair in St Louis, MO, of 1904 and well-publicized attacks by conservative artists and art historians in 1905 and 1911 indicated the extent to which the Secession had become an influential group and also foreshadowed later right-wing attacks upon modern art in Germany.

Within Germany the Berlin Secession became one of the most successful groups supporting avant-garde styles and challenging traditional royal art policies. As the centre of the newly formed German Empire, the city embodied the imperial policies of William II, Emperor of Germany, who in the 1890s sought to assert his traditional and idealist views of art. Through the Königliche Akademie der Künste and the Verein Berliner Künstler, both headed by his close associate, Anton von Werner, William II asserted the primacy of historical, genre, landscape and portrait painting and of sculptural monuments to edify the people and to glorify the nation state and the Hohenzollern dynasty. These principles guided the awarding of state patronage and prizes, as well as display in the annual salons.

Despite its commitment to stylistic diversity, the leadership of the Secession was not able to accommodate the new Expressionist artists who began to show in its exhibitions after 1903. In 1910 the Secession jury turned down 27 Expressionist works, which led to a series of attacks, resignations and withdrawals. Emile Nolde's *Pentecost* (1910; Berlin, Staatl. Museen) was one of the works at the centre of the row. The Neue Sezession was formed under Max Pechstein's leadership in 1910, and Expressionist exhibitions appeared across Germany in the following year. The Berlin Secessionist salon of 1913, organized by Paul Cassirer, featuring the work of both Cézanne and Expressionists, resulted in a split as the strongest members withdrew to form the Freie Sezession. Although a group of conservative artists retained the old name, the Berlin Secession was effectively ended.

Bibliography

Berliner Sezession (exh. cat., intro P. Paret; Berlin, Neuer Berlin. Kstver.) [n.d.]

R. Pfefferkorn: *Die Berliner Secession: Eine Epoche deutscher Kunstgeschichte* (Berlin, 1972)

W. Doede: *Die Berliner Secession. Berlin als Zentrum der deutschen Kunst von der Jahrhundertwende bis zum ersten Weltkrieg* (Frankfurt am Main, 1977) [useful charts of exhibitors]

P. Paret: *The Berlin Secession: Modernism and its Enemies in Imperial Germany* (Cambridge, MA, 1980) [excellent bibliog.]

N. Teeuwisse: *Vom Salon zur Secession: Berliner Kunstleben zwischen Tradition und Aufbruch zur Moderne, 1871–1900* (Berlin, 1986)

BETH IRWIN LEWIS

3. Vienna

Viennese Secession or Vereinigung Bildender Künstler Österreichs was formed in 1897. Nineteen

artists, including Gustav Klimt (first President of the Secession), Josef Hoffmann, Joseph Maria Olbrich, Kolo Moser and Carl Moll, rejected the conservative attitude toward the arts of the Künstlerhaus, favouring a more modern experimental approach. The Honorary President of the Secession was the painter Rudolf von Alt. The Secession defined itself as a regenerative force, calling its magazine *Ver Sacrum* (Lat.: 'sacred spring'). Schorske (1980) equated their protest action to the Roman ritual of the consecration of youth in times of danger: the young in Vienna took an oath to save culture from their elders. Hermann Bahr composed an explanatory text for the round stained-glass window (destr.) that Moser had designed for the Secession building: 'The artist shows his own world of innate beauty which never was nor will be again.' Professing to have 'no tradition', they demanded instead new aesthetic forms of expression in keeping with modern life.

The first exhibition of the Secession took place in the Gartenbaugebäude, Parkring, Vienna. It was a financial success, and all profits were invested in building a permanent exhibition hall. The City of Vienna donated the site on Karlsplatz, where the building by Joseph Maria Olbrich was constructed at Friedrichstrasse 12 in 1898. A number of patrons, foremost among them the industrialist Karl Wittgenstein, supplied the additional financial means. The building was open to verbal attacks by an unsympathetic public who called it 'the house with the golden cabbage head' and 'the blast furnace'. Over the doorway of the building is an inscription: 'To each age its art, to art its freedom', which was composed by the art critic Ludwig Hevesi, who supported the Secession through his writing.

Olbrich's Secession building represents all of the group's modern ideals: the walls are glistening white, pure and pristine, and the exterior is decorated by a frugal use of geometric and ornamental plant and animal motifs. Bahr praised the building as a true revival of Greek simplicity: the vestibule is solemn but festive; it cleanses visitors of earthly sordidness and prepares them for the eternal. The interior, which Bahr described as

the 'quiet cloisters of the soul', is lit by natural lighting from the glassed, pitched roof and can be partitioned off into display rooms of different sizes. Olbrich designed a modern, functional and economical exhibition building, whose architectonic form became the symbol of protest against the historical architecture of late 19th-century Vienna. In a formal sense the Secessionist style was a flat, decorative one. The frequently used term *Stilkunst* refers to the Secessionists' demand for the total aesthetic refurbishing of life. As Hugo von Hofmannsthal wrote, 'The only reality is in the arts, everything else is just a reflection in the mirror.' The Secessionist style reflected the idealistic hope of the young to create new ways of expression. Egon Schiele felt that there was only one style in art that was constantly being reborn. In its typical form Viennese Secessionist architecture and furniture is rectangular, box-like and rectilinear. Its simplicity possesses an inner logic much related to the philosophical works of Ludwig Wittgenstein. In painting, particularly in the works of Klimt, the ornamental element becomes charged with an expressive power that can only be explained in connection with the contemporary theories of Freud.

Twenty-three exhibitions took place in the Secession building between 1898 and 1905. The Secessionists endeavoured to present a clear picture of modern art to the Viennese public. They sought to train the public's eye so that its criteria of aesthetic judgement would mature. Ferdinand Hodler and George Minne first gained international recognition in the 12th (1901) and 15th (1903) exhibitions of the Secession. The French Impressionist exhibition (16th, 1903) presented works by Manet, Monet, Cézanne, Degas, Vuillard and Bonnard. The 7th exhibition (1900) caused a scandal instigated by Gustav Klimt's *Philosophie* (destr. 1945; see Schorske, p. 229). In 1894 the Austrian Ministry of Education had invited Klimt to design three ceiling paintings for the aula of the university on the Ringstrasse. As Schorske concluded, the ensuing crisis developed into an ideological and political issue. The 14th exhibition (1902) was dedicated to Beethoven and more particularly to Max Klinger's monumental sculpture

of *Beethoven* (Leipzig, Mus. Bild. Kst.). Josef Hoffmann designed the architectural framework, transforming Olbrich's hall into a veritable sanctuary for Klinger's statue. In the Beethoven show all the major Secession artists were united in one effort to celebrate Klinger's achievement of a *Gesamtkunstwerk*. Gustav Klimt created a frieze (1902; Vienna, Secession; now Geneva, Erich Lederer priv. col., on dep. Vienna, Belvedere, Österreich. Gal.; rest. 1985; see col. pl. XXXII), which liberally reinterpreted Beethoven's Ninth Symphony into a statement of Secessionist thought. The Secessionists made important acquisitions in connection with their exhibitions. They funded the purchase of art works, intended to be part of a modern gallery of art—a dream never, however, realized. Rodin's bust of *Rochefort*, Giovanni Segantini's *Wicked Mothers* and Vincent van Gogh's *Wheatfields of Auvers-sur-Oise* were among the works that were procured.

The monthly art periodical of the Secession, *Ver Sacrum*, began in 1898: the first six issues were edited by Hermann Bahr and Dr Max Burckhard (Director of the Burgtheater, Vienna); the following six were edited by Alfred Roller (1864–1935) and published by Gerlach and Schenk. From 1899 the editorial offices were in the Secession building. The 12 issues of 1899 were published by E. A. Seemann in Leipzig, and the artists' committee was made up of Friedrich König, Kolo Moser and Olbrich. The 24 issues of 1900, published by the artists' association itself, were smaller and entitled *Mitteilungen*. These issues advertised the Secession's exhibitions, and they contained important documentary information on Secessionist works. The editors were Ferdinand Andri (1871–1956) and art historian Dr Hermann Dollmayr. Specific editors were not mentioned in the issues of 1901–3. The following artists were members of the editorial board: Klimt, J. M. Auchentaller (1865–1949), Adolf Böhm (1861–1927), Moser, Wilhelm List (1864–1918), Leopold Bauer, Ferdinand Schmutzer (1870–1928), Leopold Stolba (1863–1929) and Max Kurzweil. For every issue an exclusive special edition (*Luxusausgabe* or *Gründerausgabe*) was published. The list of subscribers is unknown. The *Luxusausgabe* was characterized by its iridescent, metallic-coloured cover. Each copy was numbered and contained supplements of original graphic works designed by the Secessionists.

Klimt and his followers, known as the Klimtgruppe, broke with the Secession in 1905: the group included Böhm, Hoffmann, Adolf Hölzel, Max Kurzweil, Richard Luksch, Franz Metzner, Carl Moll, Felician von Myrbach (1853–1940), Emil Orlik, Alfred Roller and Otto Wagner as well as Klimt himself. They believed in the unity of art and commerce. Differences of opinion between the Klimtgruppe and the Naturalists under the leadership of Josef Engelhart (1864–1941) led to a division of the Secessionists. The Naturalists or *Nur-Maler* of the Secession propagated a return to the fine arts. During the preparations for the World's Fair in St Louis, MO, 1904, the Klimtgruppe wanted to reduce the Secession's contribution to four works by Klimt and other entries by Franz Metzner, Ferdinand Andri, Maximillian Lenz (1860–1948) and Friedrich König. However, when a ballot was taken, the Klimtgruppe was defeated by one vote.

Around the mid-1930s the Secession began to suffer under Nazism. In 1939 the merger of the Secession with the Künstlerhaus entailed a temporary dissolution of the association until after World War II. The building also suffered the effects of war: bomb damage caused the glass roof to collapse. The exhibition programme of the 1950s and 1960s included all of the major tendencies of contemporary Austrian art. In 1950 the first exhibition of the Art Club was held in the Secession building. In 1961 several young artists, later known as Wiener Aktionisten (*see* AKTIONISMUS), including Otto Muehl and Hermann Nitsch, staged their first real 'action', *Blutorgel* (Ger.: 'blood organ'), in the Perinetgasse, Vienna (1962), which first introduced their work to the public.

In the 1970s the Secession organized a number of biennial exhibitions of graphic art. The *Expansion* exhibition of 1979 attracted particular attention. Spatial installations by Joseph Beuys and Oswald Oberhuber, performances by Arnulf Rainer and demonstrations by Japanese tattoo artists strove to express the spirit of an expansive

transcending of boundaries. The presentation of the *Running Fence* by Christo in 1979 and the exhibition *Wasserwerk* by Klaus Rinke in 1980 were of particular importance. In 1985 a total renovation and modernization of the large exhibition hall began under the architect Adolf Krischanitz, in keeping with Olbrich's spatial concept. A permanent exhibition space was created for the *Beethoven* frieze by Gustav Klimt.

Bibliography

L. Hevesi: *Acht Jahre Secession* (Vienna, 1906)

C. M. Nebehay: *Ver Sacrum, 1898–1903* (Munich, 1973; Eng. trans., New York, 1977)

N. Powell: *The Sacred Spring: The Arts in Vienna, 1898–1918* (London, 1974)

P. Vergo: *Art in Vienna, 1898–1918: Klimt, Kokoschka, Schiele and their Contemporaries* (London, 1975)

Wiener Stilkunst um 1900 (exh. cat., Vienna, Hist. Mus., 1979)

C. E. Schorske: *Fin-de-siècle Vienna* (New York, 1980)

Die Wiener Moderne (Stuttgart, 1981) [anthol. of lit. and art]

Le arti a Vienna (exh. cat., Venice, Pal. Grassi, 1984)

Wien, 1870–1930: Traum und Wirklichkeit (exh. cat., Vienna, Kstlerhaus, 1985)

Vienne, 1880–1938: L'Apocalypse joyeuse (exh. cat., ed. J. Clair; Paris, Pompidou, 1986)

Vienna, 1900: Art, Architecture and Design (exh. cat., ed. K. Varnedoe; New York, MOMA, 1986)

S. Forsthuber: *The Vienna Secession* (Vienna, 1988)

CYNTHIA PROSSINGER

Section d'Or

A large group exhibition of artists identified with Cubism, held 10–30 October 1912 at the Galerie la Boëtie, Paris, and entitled *Salon de la Section d'Or*. Organized by the PUTEAUX GROUP, the participants included the Duchamp brothers—Jacques Villon, Raymond Duchamp-Villon and Marcel Duchamp (who showed *Nude Descending a Staircase, No. 2*)—as well as Juan Gris, Léger, Picabia, Roger de la Fresnaye, Albert Gleizes, Auguste Herbin, André Lhote, Louis Marcoussis, Jean Metzinger and André Dunoyer de Segonzac. The inaugural address was given by Guillaume Apollinaire. *Section d'Or* also refers to the catalogue of that exhibition, with a preface by René Blum, and to the single issue of a review that accompanied the show. The title was the suggestion of Jacques Villon, who had been reading Leonardo's *Trattato della pittura* in a translation (1910) by Joséphin Péladan. Péladan attached great mystical significance to the Golden section and to other, related geometric configurations. Villon and his Cubist friends chose the title for two reasons. First, it symbolized their belief in tradition and order, for it embodied patterns and relationships occurring in nature. Second, the term involved a pun, dear to the humour of the Duchamp family: '*Section*' also has the meaning of a group of adherents, in this case 'the golden band', derived from a series of smaller and earlier group manifestations ranging from the review *Bandeaux d'or* to the Société Normande de la Peinture Moderne, to which the Duchamp brothers had belonged since 1909.

Section d'Or also refers to an attempt in 1919–20 by Léopold Survage, Gleizes, Villon and others to rally geometric abstract artists who believed in a return to classical order to form a loosely affiliated group. Their *Exposition de la Section d'Or* was held in Paris, Rotterdam, The Hague, Arnhem, Amsterdam, Antwerp and Brussels, closing in Rome in April 1921. The effort had distinct anti-Dada overtones. A few years later a final *Salon de la Section d'Or* was staged in Paris by Galerie Vavin-Raspail from 12 to 30 January 1925.

Bibliography

Albert Gleizes and the Section d'Or (exh. cat. by W. A. Camfield and D. Robbins, New York, Leonard Hutton Gals, 1964)

Painters of the Section d'Or—The Alternatives to Cubism (exh. cat. by R. V. West, Buffalo, NY, Albright-Knox A.G., 1967)

Cubism & La Section d'Or (exh. cat. by R. S. Johnson, Washington, DC, Phillips Col.; Dallas, TX, Mus. A.; Minneapolis, MN, Inst. A.; 1991)

DANIEL ROBBINS

Semana de Arte Moderna

Series of events held at the Teatro Municipal in São Paulo from 11 to 18 February 1922, which

marked the arrival of modernism in Brazil. The year 1922 was the centenary of Brazilian independence and a time of economic prosperity centred in São Paulo. The Semana marked the cultural emergence of a Brazilian bourgeoisie, with financial support from enlightened businessmen and politicians such as Paulo Prado, Oscar Rodrigues Alves and Alberto Penteado. The antecedents of the Semana date back to a startling exhibition of works by the São Paulo painter Anita Malfatti (1896–1964), held in São Paulo in December 1917. She had studied in Berlin and New York between 1914 and 1916, and her paintings were practically the first examples of Expressionism to be seen in Brazil, provoking the initial break with weak academic traditions inherited from the 19th century. Inspired by the polemical slogans if not by the art of Marinetti's Futurism, the scandalous Semana of 1922 permitted the lukewarm provincial and academic traditions in Brazilian art to be openly challenged. The Semana consisted of concerts, including pieces written and conducted by the composer Heitor Villa-Lobos; the reading of texts and poems by writers such as Mário de Andrade, Ronald de Carvalho, Oswald de Andrade, Guilherme de Almeida and Merotti del Picchia; and an exhibition of paintings, drawings, sculptures and architectural projects by 15 artists including Anita Malfatti, Emiliano di Cavalcanti (the leading light in its organization), Victor Brecheret, Antonio García Moya (1891–1956) and Georg Przyrembel (1885–1956). The inaugural lecture, 'A emoção estética na arte moderna', was given by Graça Aranha, a writer, diplomat and member of the Brazilian Academy of Letters who had direct contact with Europe and with the new movements in international art, especially the *esprit nouveau*. Underlying the introduction of modernist ideas to Brazil through the Semana's events was a desire to create a modernism that would be rooted in Brazilian soil.

This introduction of modernism gained further impetus later in the decade through the activities of the poet and critic Oswald de Andrade and the painter Tarsila, both from São Paulo. These activities reached a climax in Oswald's *Manifesto antropófago* (São Paulo, 1928), inspired by Tarsila's recently finished painting *Abaporu* (Ind.: 'cannibal'; São Paulo, Dantas de Souza Forbes priv. col., see Bardi, p. 201). Both represented an earthy primitivism and a cosmopolitan Surrealism that provided the materials for building further on the influential events of the Semana.

Bibliography

E. Di Cavalcanti: *O testamento da alvorada*, i of *Viagem di minha vida* (Rio de Janeiro, 1955)

M. S. Brito: *Antecedentes da Semana de Arte Moderna*, i of *História do modernismo brasileiro* (Rio de Janeiro, 1964)

A. Amaral: *Artes plásticas na Semana de 22* (São Paulo, 1970)

M. R. Batista and others: *Brasil: 10 tempo modernista, 1917–1929* (São Paulo, 1972)

A. Avila: *O modernismo* (São Paulo, 1975)

P. M. Bardi: *História de arte brasileira* (São Paulo, 1975)

A. Amaral, ed.: *Arte y arquitectura del modernismo brasileño* (Caracas, 1978)

P. Rivas, ed.: 'Le Modernisme brésilien', *Europe* (1979) [special issue]

R. Pontual: *Entre dois séculos: Arte brasileira do século XX na Coleção Gilberto Chateaubriand* (Rio de Janeiro, 1987)

A. Amaral: Arts in the Week of '22 *(São Paulo, 1992)*

——: 'Stages in the Formation of Brazil's Cultural Profile', J. Dec. & Propaganda A., *xxi (1995)*, *pp. 9–25*

ROBERTO PONTUAL

Semantic art

Form of painting associated primarily with the Italian artist Luciano Lattanzi and the German Werner Schreib. The term was launched in 1957 in a manifesto written by Lattanzi for his exhibition at the New Vision Centre Gallery in London and was coined to draw a parallel between their art and the forms of language. The manifesto enumerated 'eight propositions' and claimed that semantic art marked the decline of individualism in art and abolished the distinction between animate and inanimate objects. Prompted by ACTION PAINTING and indirectly by Surrealism, it was based on Automatism. The artist was required to

execute drawings or paintings without conscious intervention, so tapping the unconscious. The resulting work would then comprise largely 'natural signs', which could be contemplated and deciphered by the artist. As products of an intelligible, rational universe, these natural signs are comprehensible, although some might be so complex as to defy adequate interpretation. Unlike action painting, which used spontaneous means to unleash the individual psyche, semantic art was designed to probe the universal structure common to all objects. As in a language, the works are composed of signs, the meanings of which depend on their context and arrangement. These plastic signs are, however, more 'vital' than their linguistic counterparts. The typical style of semantic art in drawing and painting is a densely worked pattern of such abstract shapes as circles, lines, spirals and organic forms, for example *Semantic Painting* (1963; priv. col., see 1964 exh. cat., pl. 11) and *Semantic Drawing* (1963; priv. col., see 1964 exh. cat., pl. 4), both by Lattanzi. Schreib obeyed the same aesthetic but often impressed abstract designs on to thick paste using a stamp, producing such works as *Arithmetic Organization* (1963; priv. col., see 1969 exh. cat.).

Bibliography

L. Lattanzi: *Semantic Paintings and Drawings* (Carrara, 1958)

——: *La Peinture sémantique* (Paris, 1962)

Lattanzi (exh. cat. by F. Russoli, Frankfurt am Main, Gal. Sydow, 1964)

Werner Schreib: Arbeiten einer Dekade: Graphik, Objekte, Bilder, 1958–1968 (exh. cat., Frankfurt am Main, Haus Hess. Rundfunks, 1969)

☐

Septem group

Finnish group of painters founded in 1909 and named after the number of its co-founders. The leaders were Alfred William Finch and Knut Magnus Enckell, and the other members were Yrjö Ollila (1887–1932), Mikko Oinonen (1883–1956), Juho Rissanen, Ellen Thesleff and Verner Thomé (1878–1953). The formation of the group was prompted by the poor reception of a Finnish exhibition in Paris in 1908, with critics claiming that Finnish art was dull and gloomy. Its inspiration came from a Franco-Belgian exhibition held in Helsinki in 1904. This comprised Impressionist and Neo-Impressionist works by Paul Signac, Henri Edmond Cross, Théo Van Rysselberghe and Finch among others, these styles being virtually unknown in Finland at the time. Finch himself had been one of the co-founders of Les XX in Belgium and had since 1897 been living in Finland, where he had been invited to run the ceramics department of the Iris factory at Porvoo. He had also been a friend of Signac and Georges Seurat and was therefore well placed to introduce these artistic innovations into Finland.

It was largely Impressionism that proved influential in the group together with some of the more conservative aspects of Neo-Impressionism. This resulted in a style that was somewhat akin to that of the British Camden Town Group, with a brighter palette than traditionally found in Finnish art. Characteristic of this are Enckell's *A Music Hall in Paris* (1912; Helsinki, Athenaeum A. Mus.) and Ollila's *Shepherdess* (1915; Helsinki, Athenaeum A. Mus.). Thomé was one of the few artists to absorb Neo-Impressionism, which led to such works as *Bathing Boys* (1910; Helsinki, Athenaeum A. Mus.). The group's first exhibition was not held until 1912, and they continued to hold group shows until 1928, exercising a revolutionary influence on Finnish art. The group was also important because of the public exposure it gave to younger artists.

Bibliography

J. B. Smith: *Modern Finnish Painting* (London, 1970)

M. Levanto: *Ateneum Guide* (Helsinki, 1987)

☐

7 & 5 Society

British exhibiting society formed in 1919 by a group of 18 painters and sculptors, many of them ex-servicemen who had been art students at the outbreak of World War I. A total of 87 artists were

variously involved in its 14 exhibitions. Ivon Hitchens was among those represented in the first show at Walker's Galleries in 1920, and it was he who recruited Ben Nicholson four years later. Elected chairman in 1926, Nicholson was to dominate the 7 & 5 for the rest of its existence. Winifred Nicholson joined in 1925, Christopher Wood in 1926, David Jones in 1928 and Frances Hodgkins in 1929. The work of these six painters best represents the type of work associated with the 7 & 5 at the end of the 1920s. In paintings on moderately modernized still-life and landscape themes, they cultivated freshness of colour and touch and a superficially disingenuous, primitive approach to the intellectual problems of representation.

In the early 1930s the 7 & 5 reflected an acceleration in the modernizing of British art. The society's growing avant-garde nature was greatly strengthened by the recruitment of Barbara Hepworth and Henry Moore, who first showed in the exhibition of 1932 at the Leicester Galleries in London. In 1934 Nicholson engineered a vote that only non-figurative works should be shown. The exhibition of 1935 at Zwemmers has been described as the first all-abstract show in London. It was also the last public appearance of what was by then designated simply the '7 & 5'. Vacantly catholic in its origins, the society foundered once the interests of its strongest member had been satisfied.

Bibliography

D. Farr: *English Art, 1870–1940* (Oxford, 1978)

The Seven and Five Society, 1920–35 (exh. cat., London, Parkin Gal., London, 1979)

C. Harrison: *English Art and Modernism, 1900–1939* (London, 1981)

☐

Siebenerklub [Ger.: 'Club of the seven']

Austrian group of young artists founded in 1895 at Magdalenenstrasse 32, Vienna. They introduced a distinctively modern tendency into the arts of *fin-de-siècle* Vienna. They met at the Gasthaus zum blauen Freihaus and at the Café Sperl in Vienna, and their ideas led to the founding of the Secession, although the latter's first exhibition in 1897 marked the dissolution of the group. The group's informal meetings were frequented by the architects Leopold Bauer, Max Fabiani, Josef Hoffmann, Jan Kotěra, Friedrich Pilz, Joseph Maria Olbrich and Otto Wagner, the painters Sigmund Walter Hampel (1867–1949), Leo Kainradl, Adolf Kapellus, Gottlieb Theodor von Kempf-Hartenkampf, Max Kurzwei! and Kolo Moser, and the sculptors Josef Grünhut, Arthur Kaan and Carl Schwager. The group produced two small publications.

Bibliography

R. Waissenberger: 'Hagenbund, 1900–1938: Geschichte der Wiener Künstlervereinigung', *Mitt. Österreich. Gal.*, 60 (1972)

P. Vergo: *Art in Vienna: Klimt, Kokoschka, Schiele and their Contemporaries* (London, 1975)

Der Hagenbund (exh. cat., Vienna, Hist. Mus., 1975)

CYNTHIA PROSSINGER

Situation

Title of an exhibition of British abstract painting held in 1960 at the Royal Society of British Artists Galleries, London. It resulted from discussions between several artists grouped around critic and exhibition organizer Lawrence Alloway (1926–90) about staging their own display of American-influenced, large-scale abstract paintings, which established commercial art galleries had been unwilling to handle. William Turnbull brought other artists into this circle through his association with the Central School of Art. The 18 artists finally exhibited from the catalogued list of 20 included Turnbull and Gillian Ayres, Bernard Cohen, Harold Cohen (*b* 1928), Robyn Denny (*b* 1930), John Hoyland and Bob Law; Richard Smith was also due to participate, but his paintings did not arrive from the USA in time. Characteristic of the works shown, and one of the most clearly influenced by the large scale and flat areas of colour in American COLOUR FIELD PAINTING, is Bernard Cohen's *Painting 96* (1960; Liverpool, Walker A.G.).

The exhibition was poorly attended but made a powerful impression on the British art world and led Marlborough's New London Gallery to show 16 of these painters as well as the sculptor Anthony Caro in 1961. Shortly afterwards the Arts Council organized a touring exhibition, including 18 of the original list. Although the painters had banded together primarily for professional purposes, they shared an interest in recent American art and especially in the making of large paintings as 'real objects' that defined an environmental space as a means of drawing in the spectator. The emphasis in Roger Coleman's catalogue essay on the removal of external references and personally distinctive brushwork did not apply, however, to all the artists; in spite of their professed opposition to the abstraction associated with St Ives, for example, Ayres and Henry Mundy (*b* 1919) still owed a debt to that school. Coleman made a distinction between the two types of abstraction, by stressing the 'total abstraction' of Situation works and their far larger scale (*c*. 9 sq. m). The artists associated with the Situation exhibitions never developed into an official group, although some of the concerns represented in their joint exhibitions, characterized by a play of smooth surfaces and perceptual ambiguities, for example, continued to be elaborated by such abstract painters as Paul Huxley (*b* 1938), Jeremy Moon (1934–1974) and Bridget Riley.

Bibliography

Situation: An Exhibition of British Abstract Painting (exh. cat. by R. Coleman, London, Royal Soc. Br. Artists Gals, 1960)

L. Alloway: 'Situation in Retrospective', *Archit. Des.*, xxxi/2 (1961), pp. 82–3

New London Situation: An Exhibition of Abstract Art (exh. cat., London, Marlborough F.A., 1961)

Situation: An Exhibition of Recent British Abstract Art (exh. cat., ACGB, 1962–3) [incl. artists' statements]

C. Meaker: *The Situation Exhibitions 1960–63* (MPhil diss., U. London, Courtauld Inst., 1981)

The Sixties: Art Scene in London (exh. cat. by D. Mellor, London, Barbican A. G., 1993)

ADRIAN LEWIS

Socialist Realism [Rus. Sotsialisticheskiy Realizm]

Term used to describe the idealization of the dictatorship of the proletariat in the arts, apparently first used in the Soviet journal *Literaturnaya Gazeta* on 25 May 1932. After the cultural pluralism of the 1920s in the Soviet Union, and in line with the objectives of the Five-year plans, art was subordinated to the needs and dictates of the Communist Party. In 1932, following four years of ideological struggle and polemic among different artistic groups, the Central Committee of the party disbanded all existing artistic organizations and set up in their place party-led unions for individual art forms. In the summer of 1934, at the First All-Union Congress of Soviet Writers, Socialist Realism was proclaimed the approved method for Soviet artists in all media. Andrey Zhdanov, who gave the keynote address at the Congress, was Stalin's mouthpiece on cultural policy until his death in 1948. In the words of his leader, the artist was to be 'an engineer of the human soul'. The aim of the new creative method was 'to depict reality in its revolutionary development'; no further guidelines concerning style or subject-matter were laid down. Accordingly, the idea of what constituted Socialist Realism evolved negatively out of a series of cultural purges orchestrated by Zhdanov in the pages of *Pravda*, the party newspaper, and enforced at local level by the union branches. Such words as 'formalism' and 'intuitivism' were used as terms of abuse in the search for cultural enemies.

The large public campaign against formalism coincided with the first show trials in 1936. The building of heavy industry and the collectivization of agriculture were typical artistic subjects of the mid-1930s, while by the end of the decade the personality cult of Stalin had begun to make itself evident in a proliferation of large-scale paintings, sculptures and monuments. The initial period of intense persecution drew to a close in 1938 when Aleksandr Gerasimov, Stalin's 'court' painter (see fig. 43), declared to the Artists' Union that 'enemies of the people, Trotskyist-Bukharinite rabble, Fascist agents who have been active on the art front and who have attempted in every way to

brake and hinder the development of Soviet art, have been unmasked and neutralized by our Soviet secret service' (Sokol'nikov, p. 40).

The second cultural purge, called *Zhdanovshchina* after its instigator, began in 1946. This had a nationalistic, particularly Russian, agenda and veiled its anti-Semitism under attacks on 'rootless cosmopolitanism'. In the patriotic afterglow of the war the insistence on national roots led to suspicion of all foreign artistic influence. French Impressionism, in particular, was denounced and examples collected before the Revolution were removed from display in the museums. Previously respected realist artists such as Aleksandr Deyneka and Martiros Sar'yan were criticized at this time for foreign influences that could be discerned in their work. This campaign further eroded the idea of the individuality of the artist and was associated with the tense atmosphere of the Cold War. Not wishing to take risks, many younger artists, such as Boris Lavrenko (*b* 1920), Aleksandr Laktionov

and Vyacheslav Mariuspolski (1906–86), reverted to an academic style of genre painting based on the critical realism of the 19th century. In this as well as in its heroic form, Socialist Realism was promoted as the official art of those countries of central Europe that had newly joined the Soviet bloc.

After Stalin's death in 1953, and his repudiation by Nikita Khrushchov in 1956, artists were able to work with more freedom, and a younger generation, including such painters as Viktor Popkov and Nikolay Andronov (*b* 1929), championed a form of ugly realism known as the Severe style (Rus. *Surovyy stil'*). National styles began to reassert themselves in the satellite countries where the influence of Soviet art was actively rejected. From the late 1960s and particularly during the demise of Communism in Eastern Europe and the Soviet Union in the 1980s, a number of artists made ironic use of the styles and tenets associated with Socialist Realism in order to subvert Communist ideology (*see* SOTS ART).

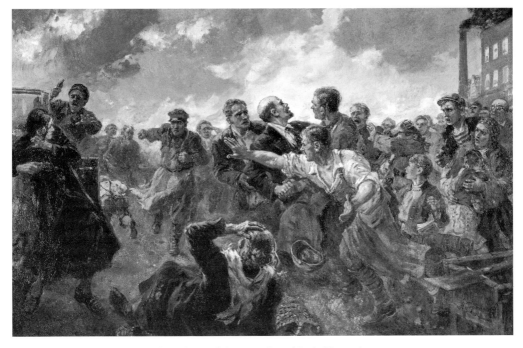

43. Aleksandr Gerasimov: *The Attack on the People* (Moscow, Central Lenin Museum)

Socialist Realism was, however, enthusiastically adopted in China during the rapprochement of the mid-1950s and continued to be officially approved until the death of Mao Zedong in 1976 and the end of the cult of personality associated with him. Communist regimes in Southeast Asia, such as those in Vietnam and North Korea, developed their own brands of Socialist Realism.

The theorists of Socialist Realism sought precedents in the work of the realist painters of the late 19th century, in particular in that of Il'ya Repin and the Wanderers. Following the example of Courbet, they declared that art should lay bare the ills of society. It was argued, however, that after the Revolution these ills had been removed and the function of art now lay in an idealization of the benefits of the dictatorship of the proletariat. Neither Karl Marx nor Friedrich Engels had in their writings provided an adequate basis for aesthetic discussion, and the ideas in Lenin's essays 'On Party Organization and Party Literature' (1905) and 'In Memory of Herzen' (1912) were therefore used selectively to provide a theoretical framework within which the cultural policy of the party could evolve.

As Socialist Realism was seen as a method of creation rather than a style, its theorists concentrated on abstract definitions of the kind of political consciousness that art had to reflect and through which its success or failure could be judged. The first of these, *narodnost'*, centred on the relationship of the work to popular ideas and sentiments as well as to the ethnic origins of the people it depicted. *Klassovost'* related to the class awareness of the artist and how he or she depicted such concerns. *Partiynost'* was the expression of the central and leading role of the party in all aspects of Soviet life, and *ideynost'* was the introduction of new thinking and attitudes, first approved by the party, as the central content of the art work. *Tipichnost'* referred to the typical nature of the situation and types portrayed. Apart from ideology, however, the most obvious attributes of Socialist Realism are its monumental scale, heroic optimism and eclectic realism as well as its dependence on the personality cult

of the leader. In this way the movement may be viewed more broadly as a manifestation of the art of dictatorships and as an integral part of the governing apparatus of the Communist Party.

Bibliography

V. I. Lenin: 'On Party Organization and Party Literature', *Novaya Zhizn'*, no. 12 (13 Nov 1905)

——: 'In Memory of Herzen', *Sotsial Demokrat*, no. 26 (8 May 1912)

A. Zhdanov and others: *Problems of Soviet Literature: Reports and Speeches at the First Soviet Writers' Congress* (New York, 1935)

M. Sokol'nikov: 'Ivan Golikov i yego rabota nad "Slovom o polku Igoreve"' [Ivan Golikov and his work on 'The Lay of Igor's Campaign'], *Iskusstvo*, no. 4 (1938), pp. 31–47

C. Vaughan James: *Soviet Socialist Realism: Origins and Theory* (London, 1973)

S. Fitzpatrick, ed.: *Cultural Revolution in Russia, 1928–31* (Bloomington, 1978)

D. Elliott: *New Worlds: Art and Society in Russia, 1900–1937* (London, 1986)

B. Groys: *Gesamtkunstwerk Stalin: Die gespaltene Kultur in der Sowjetunion* (Munich, 1988); Eng. trans. as *The Total Art of Stalinism: Avant-garde Aesthetic Dictatorship and Beyond* (Princeton, 1992)

M. Cullerne Bown: *Art under Stalin* (Oxford, 1990)

I. Golomstock: *Totalitarian Art* (London, 1990)

H. Günther, ed.: *The Culture of the Stalin Period* (London, 1990)

C. Lindey: *Art in the Cold War* (London, 1990)

Engineers of the Human Soul: Russian Socialist Realism, 1930–1960 (exh. cat., ed. M. Cullerne Bown and D. Elliott; Oxford, MOMA, 1991)

R. Robin: *Socialist Realism: An Impossible Aesthetic* (Stanford, 1992)

Agitatsiya za schast'ye: Sovetskoye iskusstvo stalinskoy epokhi [Agitation for happiness: Soviet art of the Stalin epoch] (exh. cat., St Petersburg, Rus. Mus., 1994)

DAVID ELLIOTT

Social realism

Term used to refer to the work of painters, print-makers, photographers and film makers who draw attention to the everyday conditions of the working classes and the poor, and who are critical of the social structures that maintain these conditions. In general it should not be confused with SOCIALIST REALISM, the official art form of the

USSR, which was institutionalized by Joseph Stalin in 1934, and later by allied Communist parties worldwide. Social realism, in contrast, represents a democratic tradition of independent socially motivated artists, usually of left-wing or liberal persuasion. Their preoccupation with the conditions of the lower classes was a result of the democratic movements of the 18th and 19th centuries, so social realism in its fullest sense should be seen as an international phenomenon, despite the term's frequent association with American painting. While the artistic style of social realism varies from nation to nation, it almost always utilizes a form of descriptive or critical realism (e.g. the work in 19th-century Russia of the Wanderers).

Social realism's origins are traceable to European Realism, including the art of Honoré Daumier, Gustave Courbet and Jean-François Millet. In 19th-century England the Industrial Revolution aroused a concern in many artists for the urban poor. Throughout the 1870s the work of such British artists as Luke Fildes, Hubert von Herkomer, Frank Holl (e.g. *Seat in a Railway Station—Third Class*, wood engraving, 1872) and William Small (e.g. *Queue in Paris*, wood engraving, 1871) were widely reproduced in *The Graphic*, influencing van Gogh's early paintings. Similar concerns were addressed in 20th-century Britain by the ARTISTS INTERNATIONAL ASSOCIATION, Mass observation and the KITCHEN SINK SCHOOL. In photography social realism also draws on the documentary traditions of the late 19th century, as in the work of Jacob A. Riis and Maksim Dmitriyev; it reached a culmination in the worker–photographer movements in Europe and the work by Dorothea Lange, Walker Evans, Ben Shahn and others for the Farm Security Administration (FSA) project in the USA in 1935–43.

In the USA during the first decades of the 20th century, ASHCAN SCHOOL painting, including George Luk's *Breaker Boy* (1921; Minneapolis, MN, Walker A. Cent.) and John Sloan's *Sixth Avenue Elevated at Third Street* (1928; New York, Whitney), depicted the unattractive reality of city and working life. The Ashcan school influenced the art of the Depression era, for example Thomas Hart Benton's mural *City Activity with Subway* (1930; Williamstown, MA, Williams Coll. Mus. A.). The scale and commitment of these works were inspired by the example of the muralists active in Mexico after the Revolution of 1910. Their murals, which were largely propagandizing, emphasized a revolutionary spirit and a pride in the traditions of the indigenous peoples of Mexico. Diego Rivera's *History of Mexico from the Conquest to the Future* (1929–30, 1935; Mexico City, Pal. N.), José Clemente Orozco's *Catharsis* (1933; Mexico City, Pal. B.A.) and David Alfaro Siqueiros's *The Strike* (fresco, 1957; Mexico City, Mus. N. Hist.) are characteristic of the movement. Their example also encouraged social realism in other Latin American countries, from Ecuador (e.g. Oswaldo Guayasamín, *The Strike*, 1940; Quito, Mus. Fund. Guayasamín) to Brazil (e.g. Cândido Portinari, *Coffee*, 1935; Rio de Janeiro, Mus. N. B.A.).

In Europe, the symbolic style used by such socially critical artists as František Kupka at the beginning of the 20th century gave way to Expressionism, particularly in Germany. There Käthe Kollwitz, for instance, expressed concern for victimized women, as in *Raped Woman* (etching, 1907; Hannover, Sprengel Mus.). More caustic social criticism was characteristic of NEUE SACH-LICHKEIT of the Weimar Republic era, as portrayed in George Grosz's *Teutonic Day* (1921; Hamburg, Ksthalle) or the work of Otto Dix and Max Beckmann. A related realism was also evident in the Netherlands in the work of Charley Toorop (e.g. the *Friends' Meal*, 1932–3; Rotterdam, Mus. Boymans–van Beuningen), Pyke Koch and others. Even in France the rural images of Maurice de Vlaminck and Roger De la Fresnaye, and the more critical works in the 1930s of Jean Fautrier and Francis Gruber, pursue social realist objectives. With the political polarization of the period the distinction from Socialist Realism became increasingly blurred, as exemplified by the position in Italy of Renato Guttuso. After World War II social criticism was absorbed by Socialist Realism in Eastern Europe, while in the USA and Western Europe it became overshadowed by the dominance of abstract art movements, though it continued to be important in cinema.

Bibliography

A. M. Reed: *The Mexican Muralists* (New York, 1960)

D. Shapiro: *Social Realism: Art as a Weapon* (New York, 1973)

M. Baigell: *The American Scene: American Painting of the 1930s* (New York, 1974)

E. Valkenier: *Russian Realist Art* (Ann Arbor, 1977)

L. Lincoln, ed.: *German Realism of the Twenties: The Artist as Social Critic* (Minneapolis, 1980)

H. G. Vierhuff: *Die Neue Sachlichkeit: Malerei und Fotografie* (Cologne, 1980)

Les Réalismes, 1919–1939 (exh. cat., ed. P. Hutten and J. Clair; Paris, Pompidou; Berlin, Staatl. Ksthalle; 1981)

F. Spalding: *British Art since 1900* (London, 1986)

J. Treuherz: *Hard Times* (New York, 1987)

JAMES G. TODD JR

Société Anonyme, Inc.

Association founded in New York in 1920 by Katherine Sophie Dreier and Marcel Duchamp to promote the work of the international avant-garde. With the initial support of Man Ray they organized an extensive series of exhibitions, lectures, symposia and publications and established a reference library and acquisitions programme. Dreier modelled the association on the broad-ranging events and contemporary art exhibitions sponsored by Herwarth Walden's Sturm-Galerie in Berlin. The name Société Anonyme was suggested by Man Ray to emphasize the association's commitment to treating artists and art movements with impartiality. Following the group's decision to form a corporation, making them the Société Anonyme, Inc., there was an obvious redundancy in their name that underscored their early links to Dada. This aspect of the association's character waned with the departure of Duchamp and Man Ray to Paris at the end of the first year.

In their absence Dreier assumed a more central, and eventually the sole, position of authority within the association. She established important contacts with leaders of the European avant-garde, and her deep belief in the social and spiritual significance of the modern movement determined the Société Anonyme's distinctive public face. The Société Anonyme's exhibitions were noteworthy both for the breadth of their coverage of the international modern movement and for their concentration on non-French practitioners. They exhibited the work of the German Expressionists, contemporary Soviet artists, the artists of the Bauhaus, De Stijl, Dada and International Constructivism, in addition to important Cubists, contemporary Italian artists and American modernists.

When a chronic lack of funds and dwindling membership forced the Société Anonyme to abandon its small gallery in the early 1920s, the association continued to exist by staging exhibitions and holding lectures in various clubs, galleries, museums, and municipal and university centres in New York and other cities throughout the USA. By means of these infrequent and intermittent programmes the Société Anonyme maintained its public presence for nearly 20 years.

The association's largest and most impressive single undertaking, known officially as the *International Exhibition of Modern Art*, was held at the Brooklyn Museum in 1926–7. Comprising over 300 works of art by just over 100 artists representing 23 countries, the exhibition constituted the largest and most important display of international avant-garde art held in the USA in the 1920s. The quality and contemporaneity of the show, like that of other Société Anonyme exhibitions, depended greatly on Dreier's periodic trips to Europe and her personal contacts with leading European modernists, including Duchamp, Vasily Kandinsky, Kurt Schwitters, Piet Mondrian and Fernand Léger. The exhibition introduced the work of many artists, including Mondrian, Joan Miró and the Surrealists, to the USA and marked the first public showing of Duchamp's work, *The Bride Stripped Bare by her Bachelors, Even (The Large Glass)* (1918–23; Philadelphia, PA, Mus. A.).

The Société Anonyme's activities waned in the 1930s, and in 1941, following the association's last independent exhibition, Dreier and Duchamp presented the Société Anonyme's impressive art collection to Yale University. Works from Dreier's private estate were added to this following her death, increasing its size to just over 1000 paintings, prints, sculptures and drawings. The collection's strength, like that of the association that

amassed it, is best measured not only in the recognized stature of the artists represented and the high quality of individual works of art but also in the catholicity with which it documents the creative endeavours of a broad spectrum of modernists active throughout Europe and the USA in the 1920s and 1930s.

Bibliography

Some New Forms of Beauty, 1909–1936: A Selection of the Collection of the Société Anonyme—Museum of Modern Art: 1920 (exh. cat., ed. K. S. Dreier; Springfield, MA, Smith A. Mus., 1939)

M. Duchamp and K. S. Dreier: *Collection of the Société Anonyme: Museum of Modern Art, 1920* (New Haven, 1950)

Selected Publications: Société Anonyme, 3 vols (New York, 1972) [*R* of 14 Société Anonyme pubns pubd between 1920 and 1944]

R. L. Bohan: *The Société Anonyme's Brooklyn Exhibition: Katherine Dreier and Modernism in America* (Ann Arbor, 1982)

R. L. Herbert, E. S. Apter and E. K. Kenney, eds: *The Société Anonyme and the Dreier Bequest at Yale University: A Catalogue Raisonné* (New Haven, 1984)

RUTH L. BOHAN

Society of Easel Painters [Rus. Obshchestvo khudozhnikov-stankovistov; OST]

Russian exhibiting society formed in 1924, active until 1930. It included some of the most talented artists of the post-revolutionary generation and was influential in the 1920s. David Shterenberg, its chairman and guiding spirit, defined its aims as opposing abstraction and the genre pictures associated with the Wanderers, rejecting 'pseudo-Cézannism' and 'sketchiness', while advocating technical mastery, 'revolutionary contemporaneity' and 'unambiguous subject-matter'. Like the Constructivists, the members of the Society of Easel Painters were keenly aware of the impact of technical and industrial progress on the arts, but they were committed to a Revolutionary Socialism that strongly rejected non-representational painting; in practice, however, abstract art was tolerated. The work of the Society was clearly influenced by Dada, German Expressionism and early Surrealism: the working men and women of the proletarian world who lived in modern housing blocks were austerely presented with spiky angularity in clear colours.

The Society held its first exhibition in Moscow on 26 April 1925; three more were held there. Although a few older artists such as Ivan Klyun contributed, most of the exhibitors were brilliant young graduates from Vkhutemas, among them Pyotr Vil'yams, Yury Pimenov, Nisson Shifrin (1892–1961), Andrey Goncharov (1903–79), Aleksandr Tyshler, Ivan Kudryashev (1896–1972) and Aleksandr Labas (1900–83). Aleksandr Deyneka was possibly the finest artist of the group; his painting of the *Defence of Petrograd* (1927; Moscow, Tret'yakov Gal.) best exemplifies the spirit of the society in its dedication to the propagation of Soviet ideas by painting, although Deyneka had left the Society after the 1926 exhibition. Several members, such as Goncharov, turned to book illustration, while others, including Vil'yams, Tyshler and Shifrin, worked on stage design.

Bibliography

V. Kostin: *OST* (Leningrad, 1976)

C. Douglas: 'Übergangsbedingungen: Die erste Diskussions-Ausstellung und die Gesellschaft der Staffeleimaler', *Die grosse Utopie: Die russische Avantgarde, 1915–1932* (exh. cat., Frankfurt am Main, Schirn Ksthalle, 1992), pp. 181–97

O. L. Leikind and D. Ya. Severukhin: *Zolotoy vek, 1820–1932* [The golden century, 1820–1932] (St Petersburg, 1992)

ALAN BIRD

Society of Independent Artists [SIA]

Group of American and European artists founded in New York in December 1916 to sponsor regular exhibitions of contemporary art without juries or prizes. Among the most important artist-founders of the SIA were Katherine S. Dreier, Marcel Duchamp, William J. Glackens, Albert Gleizes, John Marin, Walter Pach, Man Ray, John Sloan and Joseph Stella. The managing director was Walter Arensberg (1878–1954). Modelled on

the French Société des Artistes Indépendants, a group founded in 1884 that exhibited until World War I as a kind of institutionalized Salon des Refusés, the SIA held its first exhibition, The Big Show, in April 1917. This offered artists an opportunity to exhibit for a small yearly fee, regardless of style or subject-matter. This exhibition, held at the Grand Central Palace in New York, was not only the largest exhibition in American history (about 2500 paintings and sculptures by 1200 artists) but one of the most controversial: it drew criticism for its no-jury policy and its innovative alphabetical installation, adopted to preclude judgements of a hanging committee. The exhibition coincided with the entry of the USA into World War I, a context that underlined the SIA's dedication to democratic principles as part of a larger struggle. The SIA's commitment extended to all of the arts; film screenings, lectures, poetry readings and concerts supplemented the exhibitions. Although none was as sensational as the first, exhibitions accompanied by catalogues continued on an annual basis under Sloan's long tenure as president from 1918 until 1944 when the last exhibition was held.

Bibliography

F. Naumann: 'The Big Show: The First Exhibition of the Society of Independent Artists: Parts I and II', *Artforum*, xvii (1979), pp. 34–9, 49–53
C. S. Marlor: 'A Quest for Independence: The Society of Independent Artists', *A. & Ant.*, iv/2 (1981), pp. 74–81
—: *The Society of Independent Artists: The Exhibition Record 1917–44* (Park Ridge, 1984)

<div align="right">SUSAN S. WEININGER</div>

Soft art

Term that gained currency in the late 1960s to describe any form of sculpture made from pliable materials and consequently not absolutely fixed in its shape. As an art form its origins can be traced particularly to the 'soft sculptures' devised by Claes Oldenburg as early as 1962. Precedents can be found, however, in earlier 20th-century art, beginning with Dada, for example in Marcel Duchamp's presentation of a typewriter cover as a ready-made entitled *Traveller's Folding Item* (1917; untraced; replica, 1964; see *Marcel Duchamp*, exh. cat., New York, MOMA, 1973, p. 280) and in object collages by Man Ray (e.g. the *Enigma of Isidore Ducasse*, 1920; see *Man Ray photographie*, exh. cat., Paris, Pompidou, 1981, p. 134). Sculptures made by Surrealists, such as those shown in Paris at the Galerie Charles Ratton (1936) and at the Exposition Internationale du Surréalisme (Paris, Gal. B.-A., 1938), made particular use of malleable materials, often with a strong erotic aspect; Meret Oppenheim's *Object* (1936; New York, MOMA), a fur-covered cup, saucer and spoon, is perhaps the most notorious example. The Surrealists displayed such a predilection even in their paintings, as in Salvador Dalí's the *Persistence of Memory* (1931; New York, MOMA), with its soft watches as an image of the fleeting nature of time.

As a consistent and more historically specific phenomenon, however, soft art can be said to originate with the large-scale soft sculptures shown in Oldenburg's one-man exhibition at the Green Gallery, New York, in 1962, such as *Floor Cone* (acrylic on canvas filled with foam rubber and cardboard boxes, 1962; New York, MOMA). In such works the fabrication of replicas of familiar objects in materials such as canvas, cloth or vinyl called attention to the process of transformation and to the formal properties of the resulting sculpture as an object in its own right; as in much of the soft art that followed, the shape of the object is subject to change, dictated by its position and by the pull of gravity on the materials (see fig. 44). The effect in Oldenburg's work is often to give the sculptures the quality of animated human figures, but other artists active during the same period were more intent on calling attention to the non-associative formal properties of the material as an end in itself; this is the case with Christo's use of polythene or cloth in 'wrapped objects', such as *Wrapped Seamstress's Mannequin on a Car-rack* (1962; Rotterdam, Mus. Boymans–van Beuningen; see also fig. 25), or with the assemblages of fabrics or items of dress made by another proponent of Nouveau Réalisme, the French sculptor Gérard

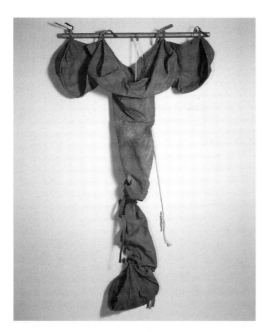

44. Claes Oldenburg: *Soft Drainpipe—Blue (Cool) Version*, 1967 (London, Tate Gallery)

Deschamps (*b* 1937), for example in *Plastic with Carpet-beater* (1961; Toulon, Mus. Toulon).

Soft art has no particular stylistic affinities, and it is not limited to any distinct kinds of materials. The variety of approaches even in the 1960s includes reliefs made early in the decade by Lee Bontecou, using canvas stretched over a metal armature; stuffed figures by the Surrealist sculptor Dorothea Tanning and by Jann Haworth (*b* 1942), the American Pop sculptor active in England; and installations made of felt and fat, the ultimate soft material, by Joseph Beuys. Much of the work produced under the aegis of PROCESS ART is malleable in form. Notable examples include sculptures made of rubber by Richard Serra and of foam rubber by John Chamberlain (e.g. *Mannabend Ra*, 700×1320×1220 mm, 1966; New York, Guggenheim); wall-hanging felt sculptures by Robert Morris, such as *Untitled* (h. 1.8 m, 1967–8; Detroit, MI, Inst. A.); installations by Eva Hesse suggestive of organic growth, such as *Rope Piece* (1970); and cloth sculptures by Barry

Flanagan, ranging from quirky stuffed objects (in biomorphic shapes made of stitched hessian) to mundane bundles of folded cloth, such as *Pile (3)* (1968; London, Tate). After the 1960s artists continued to produce a wide range of works, abstract and figurative, free-standing and wall-bound, within the terms of soft art.

Bibliography

D. Z. Meilach: *Soft Sculpture and Other Soft Art Forms: With Stuffed Fabrics, Fibers, and Plastics* (London, 1974)

Weich und Plastisch: Soft Art (exh. cat., ed. E. Billeter; Zurich, Ksthaus, 1979)

ERIKA BILLETER

Solentiname primitivist painting

Style of painting practised from 1968 by a Nicaraguan group of rural labourers on the island of Mancarrón in the Solentiname archipelago of Lagos de Nicaragua. The style took its name from the parish in which it arose with the encouragement of Padre Ernesto Cardenal (*b* 1925), a priest, poet and man of letters who in 1979 became the Minister of Culture in Nicaragua. This community of 1000 impoverished labourers was established in 1965 around the basic precepts of liberation theology, with its emphasis on social justice and communal sharing being predicated on a type of Christian Socialism. Motivated by these egalitarian ideals and a deep involvement with the arts, Cardenal invited the painter Roger Pérez de la Roche (*b* 1949) to Solentiname to introduce the populace to the fine arts.

Pérez de la Roche's arrival in 1968 stimulated a general interest in oil painting, so that within a few years a high percentage of the population in Solentiname, including entire families such as the Aranas, the Guevaras and the Silvas, had become part of a distinctive new school of naive or primitivist painting that had recourse to imagery from popular art forms such as weaving and painted gourds. Solentiname paintings, such as Alejandro Guevara's *Lagos de Nicaragua* (*c.* 1980; see Cardenal, 1980, p. 29), generally depict local landscapes accented by various aspects of daily life:

workers in the fields, well-known sites, leisurely interchange in villages and glimpses of the animal kingdom. Some works feature biblical episodes interpreted according to liberation theology, as in Gloria Guevara's *Crucifixion* (*c.* 1979; see Valle-Castillo, p. 184), which depicts Christ neither as a transcendental entity nor as a superhuman historical force but as an ordinary labourer.

By means of overlapping forms, even lighting and a non-hierarchical disposition of figures in relation to each other and to nature, Solentiname primitivist paintings do not so much depict the life of the area's rural inhabitants as evoke an almost tactile sense of the material fabric of the place and of its social relations. Following the involvement of several labourers from Solentiname in an uprising against General Somoza in 1977, the dictator ordered the complete destruction of the parish, including all its artworks and its library. The suppression of this art continued until the overthrow of Somoza by revolutionary forces in 1979, at which time it began again to occupy an important place in national cultural developments.

Bibliography

E. Cardenal: 'Lo que fue Solentiname', *Casa Américas*, 108 (1978), pp. 158–60
——: *Tocar el cielo* (Managua, 1980)
I. Rodríquez Prampolini: 'Ante una exposición de Solentiname', *Casa Américas*, 118 (1980), pp. 114–15
E. Cardenal: *Nostalgia del futuro* (Managua, 1982)
J. Valle-Castillo: 'Los primitivistas de Nicaragua', *Nicaráuac*, vi/12 (1986), pp. 161–85
D. Craven: *The New Concept and Popular Culture in Nicaragua since the Revolution in 1979* (Lewiston, 1989), pp. 15–20

DAVID CRAVEN

Sots art [Sotz art]

Term used from 1972 to describe a style of unofficial art that flourished in the USSR from *c.* 1970 to *c.* 1985–8. The term itself is formed from the first syllable of *Sotsialisticheskiy realizm* (Rus.: 'Socialist Realism') and the second word of Pop art and is attributed to the art historian Vladimir Paperny. Sots art takes the style of SOCIALIST REALISM, with its mass ideological implications, as a legitimate object of investigation, intending to deconstruct the ideological system through its own visual language. It forms a criticism of Socialist Realism by unofficial Russian artists as reflecting the ideological myths underpinning Soviet society. The means of ideological propaganda are thus investigated in terms of their relation to the national mentality and their consumption as objects of mass culture. The main artists producing works of this type were Komar and Melamid, Erik Bulatov (e.g. *Horizon*, 1971–2; Paris, priv. col.), and, since the mid-1970s, Il'ya Kabakov, Dmitry Prigov (*b* 1940), the sculptors Aleksey Kosolapov (*b* 1948) and Leonid Sokov (*b* 1941) and the group Gnezdo (Rus.: 'Nest'), founded in 1975. The first prominent exhibition of Sots art was held at Ronald Feldman Fine Art, New York, in 1976. There was a second wave of Sots art in Moscow, comprising work by the group Mukhomory (Rus.: 'Toadstool'), founded in 1978, which included the sculptor Boris Orlov (*b* 1941) and the painters Grigory Bruskin (*b* 1945) and Rostislav Lebedev (*b* 1946). Artists who had emigrated and continued to work in this style in New York (Komar, Melamid, Sokov, Kosolapov) used it to criticize not only Soviet but also American ideological myths and institutions.

Bibliography

Sotz Art: Russian Mock-heroic Style (exh. cat., ed. M. Tupitsyn; New York, Semaphore Gal., 1984)
Komar and Melamid (exh. cat., ed. P. Wollens; Oxford, MOMA, 1985)
Eric Bulatov (exh. cat., New York, New Mus. Contemp. A., 1986)
Sotz-art (exh. cat., ed. M. Tupitsyn and J. E. Bowlt; New York, New Mus. Contemp. A.; Calgary, Glenbow–Alta Inst.; Syracuse, NY, Everson Mus. A.; 1986)
M. Tupitsyn: *Margins of Soviet Art* (Milan, 1989)
O. V. Khotmogorova: *Sots-art* (Moscow, 1994)

YEKATERINA ANDREYEVA

Spatialisme

Term coined in 1954 in a manifesto signed by the Belgian painters Jo Delahaut (*b* 1911) and Pol Bury

and the writers Jean Séaux and Karel Elno to describe the work of Belgian abstract artists who had been associated with ART ABSTRAIT. The concept of Spatialisme arose largely from Delahaut's initiative and was expressive of his ideas, which were absorbed into another group, Formes, founded by him in 1956. The artists associated with the term never exhibited as a group. The manifesto, which defined Spatialisme as 'a concerted construction of forms tending to give them a life and poetry of their own', rejected both Tachism and Abstract Expressionism as 'disguised returns to tradition'. Though claimed as entirely new, it was close in spirit to Constructivism, calling for an abolition of the barrier between major and minor arts and for the social and economic integration of the artist.

Bibliography

Jo Delahaut (exh. cat. by B. Kerber and others, Ludwigshafen, Hack-Mus. & Städt. Kstsamml., 1981)
K. J. Geirlandt: L'Art en Belgique depuis 45 (Antwerp, 1983)

□

Spazialismo [It.: 'spatialism']

Italian art movement founded by Lucio Fontana c. 1947 in Milan. The theory of Spazialismo was anticipated in the Manifiesto blanco (Buenos Aires, 1946), which was produced by Fontana and colleagues during his time in Argentina during World War II. Subsequently six manifestoes were produced (1947–52), including a Manifesto tecnico dello spazialismo (Milan, 1951). Fontana and his associates felt that the time had come to move away from the flat surface and illusory space of the canvas and towards an art that was a synthesis of colour, sound, movement, time and space: an art, moreover, that took account of new techniques made possible by scientific progress (e.g. television, neon lighting). In keeping with this regard for scientific discovery was Fontana's proposal that matter should be transformed into energy and invade space in dynamic form. This view resulted in various temporary constructions (e.g. Spatial Environment, Milan, Gal. Naviglio,

1949), which anticipated such developments as environmental and performance art. Fontana's attempts to get away from the flat surface of canvas led to paintings in which the canvas was pierced by holes or slashes, sometimes made more three-dimensional by the application of objects or materials, such as coloured glass, as in his Spatial Concept of 1955 (Milan, Civ. Mus. A. Contemp.).

Bibliography

M. Tapié: Devenir de Fontana (Turin, 1965)
Luciano Fontana, 1899–1968 (exh. cat., Barcelona, Cent. Cult. Fund. Caixa Pensions, 1988)
Luciano Fontana: Paintings (exh. cat., Cologne, Gal. Karsten Greve, 1988)
Fontana e lo Spazialismo (exh. cat., Osaka, Kodama Gal., 1988)
D. Marangon: Spazialismo: Protagonisti, idee, iniziative ([Italy], 1993)
Spazialismo: Arte astratta. Venezia 1950–1960 (exh. cat., Vicenza, Cent. Int. Stud. Archit. Palladio, 1996)

□

Sphinx, De

Dutch artists' society founded in Leiden on 31 May 1916 as a continuation of De Anderen (The Others), the artists' society that had collapsed as a result of conflicts between the 'bewusten' ('conscious') and the 'intuïtieven' ('intuitives'). J. J. P. Oud was appointed chairman, and Theo van Doesburg became the second secretary. De Sphinx wanted more cooperation with architects and practitioners of other art forms. Cultural evenings were organized, at which van Doesburg read his poetry.

In January 1917 the first exhibition in Leiden was organized. In addition to van Doesburg and Oud, Harm Kamerlingh Onnes (b 1893), Bernard Canter (1871–1956), Bernard Toon Gits (1891–1918), Laurens van Kuik (1889–1963) and Jan Sirks (1885–1938) submitted work. Emil Filla and Jan Wils were also invited. A similar conflict to the one that had separated De Anderen, between artists who worked in a geometric and those who worked in an expressionistic style, arose, however. Van Doesburg distanced himself from the expressionist tendency, which was geared

towards the expression of individual emotions, instead trying to find a universal, impersonal language. A few months after the first exhibition he withdrew from the society to publish the *De Stijl* magazine.

In October 1916 the Rotterdam faction of De Sphinx—Canter, Gits and van Kuik—had exhibited under the name De Volstrekt Modernen (The Absolute Moderns); this show gave the initial impetus to De Branding (The Wave), one of the most important artists' groups in Rotterdam in the period between the World Wars.

Bibliography

J. F. Heybroek: 'Het korstondig bestaan von de Leidse kunstclub "De Sphinx" ' [The short existence of the Leiden art club 'The Sphinx'], *Leids Ksthist. Jb.* (Leiden, 1980), pp. 155–62

G. Imanse: 'Het ontstaan van de abstracte kunst in Nederland *c.* 1900–1918 en het artistieke klimaat in die periode' [The origin of abstract art in the Netherlands *c.* 1900–1918 and the artistic climate in that period], *Van Gogh bis Cobra: Hollandische Malerei, 1880–1950* (exh. cat. by G. Imanse and others, Stuttgart, Württemberg. Kstver.; Utrecht, Cent. Mus.; Bonn, Rhein. Landesmus.; 1980–81), pp. 93–135 [also pubd in Dut.]

JOHN STEEN

Spur [Ger.: 'track']

German group of painters and sculptors founded in Munich in 1958 and active until 1966. The group's foundation followed a joint exhibition held in autumn 1957 in the Pavillon im Alten Botanischen Garten in Munich by the painters Heimrad Prem (1934–79), Helmut Sturm (*b* 1932), Hans-Peter Zimmer (*b* 1936) and the sculptor Lothar Fischer (*b* 1933). They devised the group's name in January 1958 when thinking about the tracks of their own footprints in the snow. Their shared goals related to their criticism of *Art informel*, which they regarded as devoid of content and too private. With their aspirations towards collaborative working and inclination towards the figural as conveyed by the traces left by gestures, Spur advocated art that asked itself social questions. Conflicts between people as well as areas of social taboo were represented and chosen as themes in an expressive and sensual way. For their models, Spur used the dynamic portrayals of human suffering in Late Gothic and Baroque paintings of the Passion and the Expressionism of the Blaue Reiter and Die Brücke. In the 21 points of their first manifesto of November 1958 they rejected aestheticism, technique as an end in itself and abstraction in art. The members of Spur were encouraged and helped by Asger Jorn, who in 1959 introduced them to the Galerie Van de Loo in Munich, which thereafter exhibited and supported the group, as did the artist and art critic Hans Platschek. In 1959 Spur was accepted by the International Situationists in Paris, and in 1961 the group wrote their *Januar-Manifest*. The Bavarian Ministry of Culture refused to allow an exhibition by them in the Haus der Kunst in Munich. Six issues of their magazine *Spur* were impounded. In February 1962 they were expelled by the International Situationists, and in the same year there were two court hearings resulting in prison sentences for supposed blasphemy. In 1965 they painted collaborative gouaches, and started to cooperate with the Wir group; in spring 1966 the two groups were amalgamated to form the Geflecht group. However, Prem and Fischer withdrew. In 1967 the Geflecht group (H. M. Bachmayer, R. Heller, F. Köhler, H. Naujoks, H. Rieger, Sturm and Zimmer) exhibited *Anti-objects* at the Kunstverein, Freiburg im Breisgau, and participated in political Happenings. Differences of opinion led to the dissolution of the Geflecht group that same year.

Writings

Manifest (Munich, 1958)
Spur, i–vii (1960–61)
Januar-Manifest (Munich, 1961)

Bibliography

Gruppe Spur, 1958–1965: Eine Dokumentation, 2 vols (Munich, 1979–88)
Gruppe Spur, 1958–1965 (exh. cat., Regensburg, Städt. Gal., 1986)

ULRIKE LEHMANN

Stichting Architecten Research [SAR; Dut.: Architects' Research Foundation]

Dutch architectural foundation established in 1964 for research into occupant participation in housing design. It was founded by ten architectural firms and the Bond van Nederlandse Architecten.

Writings

Het ontwerpen van inbouwpaketten [The design of built-in kits] (Rotterdam, n.d.)

SAR 65: Ontwerpmethodiek voor drager en inbouw [SAR 65: Design methodology for support and installation] (Voorburg, 1965)

SAR 73: Het methodisch formuleren van afspraken over de directe woonomgeving [SAR 73: The methodological formulation of agreements on the immediate living environment] (Eindhoven, 1973)

Reisgidsje: Wegwijzer naar tien in Nederland gerealiseerde woningbouwprojecten met weefsel- en dragerkenmerken [Travel guide: companion to ten realized projects with tissue and support characteristics in the Netherlands] (Eindhoven, 1981; Eng. trans., 1981)

MARLOES KLEIJN

Stijl, De [Dut.: 'the style']

Dutch periodical founded by Theo van Doesburg in 1917 and published in Leiden until 1932; the name was also applied from the 1920s to a distinctive movement and to the group of artists associated with it. The periodical's subtitle, *Maandblad voor de beeldende vakken* (Monthly Journal of the Expressive Professions), indicates the range of artists to which it was appealing, and van Doesburg's intention was that it be a platform for all those who were concerned with a new art: painters, sculptors, architects, urban planners, typographers, interior designers and decoratve artists, musicians, poets and dramatists. The search for a *nieuwe beelding* (new imagery) was characterized by the elementary components of the primary colours, flat, rectangular areas and only straight, horizontal and vertical lines. Former ideals of beauty had to be relinquished in favour of a new consciousness to represent the spirit of the times.

It has been assumed that the periodical's name *De stijl* was taken from the writings of the German architect Gottfried Semper, which were drawn upon frequently by H. P. Berlage and others. It must also be said, however, that from 1910 many young artists had argued that a new style had to be found. The term *nieuwe beelding* was frequently used at this time. Van Doesburg considered that the MODERNE KUNSTKRING led by Cornelis Kikkert (1882–1965) in 1910 was the early stage of international modernism in the Netherlands, and *De stijl* was founded to continue this tendency. Before World War I works of Expressionism, Cubism and Futurism, the newest tendencies in Germany, France and Italy respectively, had been exhibited in the Netherlands; *De stijl* was established in deliberate contrast with these movements. Although most of those involved with *De stijl* felt a connection with Cubism, they also believed that the movement had become obscured by more fashionable aesthetic principles, and that its original tenets could be realized through *De stijl* and its associated movement.

The periodical's first three years (1917–20) were fundamentally distinct from the subsequent years. These first 36 issues had a standard format (245×185 mm or 260×195 mm), and most were printed on grey-white paper, sometimes with a green or grey cover. The motif on the cover was taken from a woodcut by Vilmos Huszár. Illustrations were scarce: occasionally a colour illustration was provided as a separate insert; advertisements were carried only on the inside of the cover pages. The exact print run is not known but is estimated at several hundred. With few exceptions, each issue was in Dutch, and circulation was virtually exclusively in the Netherlands; the Italian periodical *Valori plastici* made reference to it only in 1919. The contents included editorials by van Doesburg, who was also frequently the author of polemical articles. Many contributions were by architects, including J. J. P. Oud, Jan Wils, Gerrit Rietveld and Robert van 't Hoff, the last-named being responsible for the periodical's financing. Piet Mondrian was, however, responsible for around 70% of the contents of these early issues. His series on 'De nieuwe beelding in de

schilderkunst' was followed by one on 'Natuurlijke en abstracte realiteit'. *De stijl* gave Mondrian the opportunity to publish the aesthetic theories that he had attempted to articulate from 1909; the later impression that he and *De stijl* were synonymous results from his huge contribution to these early issues.

Probably influenced by Futurism, van Doesburg discovered the manifesto as a means of succinct dissemination of his ideas and those of his associates. The first of these appeared in the first issue of 1918 as a call to all those who wished to launch a new art and culture to unite. It was published in Dutch, French, German and English and was signed by van Doesburg, Mondrian, Huszár, Georges Vantongerloo (see fig. 45), van 't Hoff, Wils and the poet Antony Kok. The second manifesto, published in April 1920 in Dutch, French and German, focused on 'word painting', and it was signed by Kok, van Doesburg and Mondrian; van Doesburg was the most outspoken representative of the new 'visual' poetry, and in the next issue he published his first poems under the pseudonym I. K. Bonset.

The periodical changed completely in its fourth year. It took on a 'landscape' format (190×255 mm or 210×260 mm) and completely new typography and logo. The name 'De stijl' was printed in black over the red letters 'NB' (*nieuwe beelding*). The new design by Mondrian and van Doesburg became *De stijl*'s international face. Even the sub-title changed, to *Internationaal maandblad voor nieuwe kunst, wetenschap en kultuur* (International Monthly for New Art, Science and Culture). The word 'international' was emphasized by the inclusion of the places of publication (Leiden, Antwerp, Paris, Rome). When visiting Paris in June 1919 Mondrian realized that *De stijl*'s ideas were virtually unknown beyond the Netherlands. He had the ambitious idea of outlining the main points in personal statements, and became convinced that his aesthetic theories would only be disseminated if published in French. With the help of the dealer Léonce Rosenberg, a collection of these statements was published under the title of *Le Néo-plasticisme* (*see* NEO-PLASTICISM). Mondrian urged van Doesburg

to leave the Netherlands to publicize *De stijl*, which by a great effort on the latter's part (travelling, giving lectures, classes, etc) was achieved within a few years.

Changes to *De stijl* were also apparent in its content. It became entirely the instrument of van Doesburg, reflecting his activities and ideas. Through his self-publicity he was also able to publish in other (often French) periodicals. Dada also began to play a part in his ideas, particularly in relation to words in visual compositions. In several appearances in Dutch towns in 1923, with his companion the pianist Nelly van Doesburg, Huszár and Kurt Schwitters, he confronted the public in person with his ideas, having organized appearances in Germany a few months previously. Having adopted a second pseudonym of Aldo Camini to publicize his other literary activities, he followed Schwitters's example with *Merz* and founded a separate periodical for these interests, *Mécano*, edited by 'I. K. Bonset and Theo van Doesburg', with the

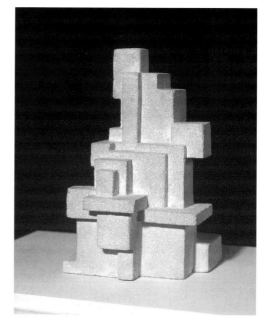

45. Georges Vantongerloo: *Interrelation of Volumes*, 1919 (London, Tate Gallery)

subtitle of *Internationaal tijdschrift voor geestelijke hygiene, mechanische esthetiek en neo-Dadaism* (International Periodical for Spiritual Hygiene, Mechanized Aesthetics and Neo-Dadaism); four issues appeared between 1922 and 1923.

Single issues of *De stijl* were often dedicated to a particular subject; the first of these (1921) was an overview of I. K. Bonset's poetry, the second a report on the Constructivist International, an artists' congress held in Cologne in August 1922 (*see* CONSTRUCTIVISM, §2). Several months later in 1922 an issue appeared with a Dutch translation of El Lissitzky's typographical poem for children 'Pro dva kvadrata' (Of two squares). On the fifth anniversary of the periodical's foundation van Doesburg collected the most important articles or excerpts from them in an *Anthologie, 1917–1922*. The tenth anniversary of *De stijl* was celebrated with an exceptional cover design, intended to mark the periodical's influence. On the front cover was a grey portrait photograph of van Doesburg, with a laudatory text by Sigfried Giedion printed in blue; on the back cover, also in blue, the development of *De stijl* was symbolized by a grey tinted photograph of a globe, with 'Neo-plasticism', the starting point of *De stijl*, printed horizontally, and 'Elementarism' printed diagonally across it.

The popularization and acceptance of *De stijl*'s ideas were largely due to van Doesburg's ideas on architecture and the role of primary colours. Van Doesburg's visit to the Weimar Bauhaus in 1922 was crucial for the dissemination of his ideas. His meeting in Berlin with the young architect Cornelis van Eesteren was also significant, particularly in his ideas regarding axonometry. In 1923 van Doesburg organized an exhibition at Léonce Rosenberg's Galerie de l'Effort Moderne in Paris of *Les Architectes du groupe De Stijl*; the periodical published the accompanying manifesto 'Vers une construction collective'. The show prompted an intensive debate on *De stijl* in Parisian architectural circles. Some months later various objects were displayed at a group exhibition at the Ecole Spéciale d'Architecture in Paris, which were the work of previous and current contributors to

the periodical. This was the only time in van Doesburg's lifetime that special issues of such French periodicals as *L'Architecture vivante* and *L'Art et l'architecture aujourd'hui* were devoted to *De stijl*, but again, mainly to its architectural theories. For van Doesburg this meant not only recognition but also new commissions. The most important of these was the redecoration of the Café de l'Aubette in Strasbourg (1928), where he collaborated with Hans Arp and Sophie Taeuber-Arp. The introduction of ELEMENTARISM, in which the diagonal played an essential role, was by 1924 responsible for a definite break with Neo-plasticism and with its greatest exponent, Mondrian. The last issue of *De stijl* issued by van Doesburg was dedicated to his Elementarist work at the Café de l'Aubette. The publication of such competing periodicals as *I 10* and *Cercle et carré* forced van Doesburg to evolve new ideas about the visual arts and architecture, and in 1931 he brought together a group of like-minded people, who published *Art concret*. The final issue of *De stijl* (1932) was a memorial to van Doesburg, who had died in 1931.

Bibliography

An index to *De stijl* is printed in *Die Form*, Dec 1967 and March 1968.
H. L. C. Jaffé: *De stijl, 1917–1931: The Dutch Contribution to Art* (Amsterdam, 1956/R London, 1986)
De stijl, 1917–1931, 2 vols (Amsterdam, 1968) [R of all issues]
M. Friedman, ed.: *De Stijl: Visions of Utopia* (Minneapolis, 1982)
F. Bach-Dandrieú and J. Sprenkels-ten Horn: *Index op de stijl/Index of De Stijl* (Amsterdam, 1983)
C. Boekraad, ed.: *De Stijl: Neo-plasticism in Architecture* (Delft, 1983) [inc. an Eng. trans. of Theo van Doesburg's 'Der Kampf um den neuen Stil', first pubd in *Neue Schweizer Rundschau*, 1929]
N. Troy: *The De Stijl Environment* (Cambridge, 1983)
Y. A. Bois and others: *De Stijl à Paris et l'architecture en France* (Liège and Paris, 1985)
C. Blotkamp, ed.: *De Stijl: The Formative Years* (Cambridge, 1986)
C. Boekraad, ed.: *Essays from 'Het Bouwbedrijf', 1924–1931* (Boston, MA, 1990)
P. Overy: *De Stijl* (London, 1991)

H. HENKELS

Straight Ahead [Pol. Wprost]

Polish group of artists established in 1966 by five graduates from the Academy of Fine Arts in Kraków: Maciej Bieniasz (*b* 1938); Zbylut Grzywacz (*b* 1939); Barbara Skąpska (*b* 1938), who participated only in the first exhibition; Leszek Sobocki (*b* 1934), a member of the group until 1986, and Jacek Waltoś (Jacek Buszyński) (*b* 1938). They were inspired by the metaphorical paintings of Adam Hoffmann (*b* 1918), their teacher at the Academy, and considered Andrzej Wróblewski as an influential precursor. Two published manifestos (1966, 1969) clearly defined their programme: the representation of all subjects, no matter how brutal or unpleasant, in a manner unrestricted and unveiled by any conventions. They aimed to speak openly and straightforwardly about existence and emotions, using a simple artistic language and rejecting both abstraction and the Colourism of the followers of the Kapists. Early works that showed a concern for figuration, such as Grzywacz's *The Forsaken* (oil, 1973–4; Warsaw, N. Mus.), gave way to a form of realism in which the creative technical process was deliberately revealed, giving an unfinished appearance to their work, as in Waltoś's sculptures in the form of hollow moulds. A form of allegory often co-existed with this harsh realism in the group's work, for example in Bieniasz's dull Silesian cityscapes and Sobocki's self-portraits (e.g. *Tattoo*, oil, 1978) and prints (e.g. *Blood*, linocut, 1971; both Warsaw, N. Mus.).

Writings

I Wystawa Grupy Wprost [First exhibition of the Straight Ahead group] (exh. cat., Kraków, Pal. A., 1966) [incl. the group's manifesto of 1966, signed by the five original members]

VI Wystawa Grupy Wprost [Sixth exhibition of the Straight Ahead group] (exh. cat., Zakopane, Office A. Exh. Gal., 1969) [incl. the group's second manifesto]

Bibliography

T. Gryglewicz: 'Rzeczywistość i nierzeczywistość w twórczości grupy *Wprost*' [Reality and unreality of the art of the Straight Ahead group], *Sztuka polska po 1945 r.*, Materiały Sesji Stowarzyszenia Historyków Sztuki [Polish art after 1945, papers of the conference of the Association of Art Historians] (Warsaw, 1984), pp. 255–68

ANNA BENTKOWSKA

Stupid group

German group of artists founded in Cologne in 1920 by Franz Seiwert (1894–1933), Anton Räderscheidt, Marta Hegemann (1894–1970), Heinrich Hoerle (1895–1935), Angelika Hoerle (née Fick, 1884–1923) and Willy Fick (1893–1967). During 1918 and 1919 they had participated in Cologne Dada, contributing to *Der Ventilator* and to the catalogue *Bulletin D*. However, they had distinguished themselves by their explicitly Communist response to the volatile political situation, demonstrated in the folio of linocuts *The Living Ones* (1919), by Räderscheidt, Seiwert, Angelika Hoerle and Peter Abelen (1884–1962), which portrayed such political martyrs as Rosa Luxemburg. After internal disagreements, they distanced themselves from the 'Dada Weststupidien 3' (Max Ernst, Johannes Theodor Baargeld and Hans Arp) to form the Stupid group. They established a permanent exhibition in Räderscheidt's studio at Humboldplatz 9 and published their only catalogue, *Stupid 1*. The break with Dada was inconclusive and contacts continued, but under Seiwert's guidance the group proposed a 'proletarian' art inspired by the work of children and by 15th-century painting in Cologne. No homogeneous style was established, but they began to set simplified figures in flattened geometric structures (e.g. Seiwert, *Workman I*, 1920; Cologne, Kstgewmus.). Although reflecting friendships that persisted into the 1930s, the name Stupid was not reused after 1920; however the group constituted a preliminary phase for the Gruppe progressiver künstler.

Writings

Stupid 1 (Cologne, 1920)

Bibliography

Vom Dadamax bis zum Grüngürtel: Köln in den zwanziger Jahren (exh. cat., ed. W. Herzogenrath; Cologne, Kstver., 1975), pp. 30–54, 74–6, 97–8

Franz W. Seiwert (1894–1933): Leben und Werk (exh. cat. by U. Bohnen, Cologne, Kstver.; Münster, Westfäl. Kstver.; W. Berlin, Kstamt Kreuzberg; Ludwigshafen, Hack-Mus. & Städt. Kstsamml.; 1978), pp. 28–31

Heinrich Hoerle: Leben und Werk (1895–1936) (exh. cat. by D. Backes, Cologne, Kstver., 1981–2), pp. 20–36, 100–108, 289–306

Willy Fick, ein Kölner Maler der zwanziger Jahre wiederentdeckt (exh. cat. by W. Herzogenrath, D. Teuber and A. Littlefield, Cologne, Kstver., 1986), pp. 7–50

The Dada Period in Cologne: Selections from the Fick-Eggert Collection (exh. cat. by A. Littlefield, Toronto, A.G. Ont., 1986)

MATTHEW GALE

Sturm, Der

Magazine published in Berlin from 1910 to 1932 which promoted the avant-garde in Germany. It is particularly well known for its reproduction of original Expressionist graphics and woodcuts. It was founded and edited by Herwarth Walden, who had worked for brief periods as editor for the journals *Der neue Weg* and *Das Theater* (1908–10), before founding *Der Sturm*, the Sturm-Galerie (1911–27) and the Sturm publishing house. *Der Sturm* was an important carrier of the work and ideas of leading German and European modernist writers and painters before World War I and introduced the work of the Italian Futurists and French Cubists to Germany; it also, however, included articles on a wide variety of topical issues, including birth control, women's rights and legal cases. The use of daily-newspaper format (three columns in bold Roman type) meant that artistic affairs appeared as 'news', allowing *Der Sturm* to play a polemical role in contemporary debates. Walden's own editorials were mostly satirical, including vicious attacks on German cultural nationalism, the parochial tastes and prejudices of the German bourgeoisie, and, above all, art criticism.

During its first year *Der Sturm* carried quarter- and half-page *Jugendstil* caricatures of recognizable literary figures or imaginary social types by relatively unknown artists, including Samuel Fridolin, Joe Loe and Harry Jeager-Mewe. These were gradually replaced by the stark Expressionist woodcuts and linocuts which, by 1913, characterized the journal. Among the artists who contributed illustrations were Oskar Kokoschka, Marc Chagall, Paul Klee and Rudolf Bauer (1889–1953), members of *Die Brücke* (Max Pechstein, Erich Heckel, Ernst Ludwig Kirchner, Karl Schmidt-Rotluff, Emil Nolde) and Der Blaue Reiter (Vasily Kandinsky, Franz Marc, Gabriele Münter, August Macke); work by less well-known German and European artists such as Heinrich Campendonck, Conrad Felixmüller and Jacoba van Heemskerk van Beest was also published.

The magazine promoted the work of artists exhibiting in the Sturm-Galerie, which was situated on the Potsdamerstrasse in commercial western Berlin. For almost 20 years the Sturm-Galerie showed the work of avant-garde artists, beginning in April 1911 with works by the Blaue Reiter group and by the Italian Futurists. One of the most ambiguous exhibitions was the Erster deutscher Herbstsalon from September to November 1913, which included 366 works by 75 artists from 12 different countries and was sponsored by the banker Bernhard Koehler, Macke's uncle by marriage.

Der Sturm also published short stories (often serialized), prose, and poems by writers such as Else Lasker-Schüler, Alfred Döblin, Kurt Heynicke, Paul Scheerbart and August Stramm, and critical essays by Salomon Friedländer, Rudolf Kurtz, Adolf Behne, Peter Behrens and others. During World War I the visual content of *Der Sturm* diminished considerably. Walden's own editorials and obituaries commemorating artists who had fallen in combat, including Marc, dominated the issues. After the war Walden turned his attention to the Low Countries and, above all, to the eastern European avant-garde; he published essays on subjects as diverse as cabaret, Henri Bergson and Soviet economic policy. During the 1920s the visual element of *Der Sturm* was sustained by geometric, abstract graphics by artists such as Oskar Nerlinger (1893–1969), Jozef Peeters, László Moholy-Nagy, László Peri, Alexandra Exter and Oskar Fischer (1892–1955); Kurt Schwitters's *Merz*

drawings and stage-sets and costumes designed by Lothar Schreyer (1886–1966), Mikhail Larionov and Natal'ya Goncharova were also published. After 1929 there were few illustrations.

Although issues before 1918 reveal a sophisticated if ambiguous attitude towards contemporary socio-political and cultural matters, *Der Sturm* did not take a clear political stance until after World War I and the Spartacist Revolt (1919). The Communist-influenced theoretical slant of *Der Sturm* after 1920, notably in essays by Walden and William Wauer (1866–1962), is distinguished by its utopian view of Marxist world Socialism, as is Walden's euphoric celebration of post-Revolutionary Russia. Publication of *Der Sturm* became increasingly irregular after Walden's first visits in 1927 to Moscow, to which he emigrated in June 1932. After 1930, issues were devoted to his curious comments on medicine.

The term *Sturm* is also used to describe members of the fluctuating circle of artist-intellectuals who gathered around Walden and the *Sturm* offices (the *Sturm-Kreis*) and to refer to the many activities associated with *Der Sturm*: the *Sturmkunst-Abende* (cabaret evenings from 1916); the *Sturmschule* (1916–32; after 1920 the *Sturmkunsthochschule*) whose staff included Walden, Schreyer, Georg Muche, Bauer, Klee, Campendonck, Heemskerk van Baes and Münter; and the *Sturmbühne* (initially *Kampfbühne*, 1917–21) founded by Schreyer and Dr John Schikowski.

Bibliography

W. Rittich: *Kunsttheorie, Wortkunsttheorie und lyrische Wortkunst im 'Sturm'* (Griefswald, 1933)

N. Walden and L. Schreyer: *Der Sturm: Ein Erinnerungsbuch an Hewarth Walden und die Künstler aus dem Sturmkreis* (Baden-Baden, 1954)

R. F. Allen: *Literary Life in German Expressionism and the Berlin Circles* (Göppingen, 1974), pp. 204–78

M. R. Shields: *A Study of the Periodical 'Der Sturm' with Special Reference to its Situation within Literary Expressionism* (diss., Norwich, U. E. Anglia, 1978)

G. Brühl: *Hewarth Walden und 'Der Sturm'* (Leipzig, 1983)

M. S. Jones: *Der Sturm: A Focus of Expressionism* (Columbia, 1984)

HELEN BOORMAN

Supports-Surfaces

French group of painters, active from 1967 to 1972. The group began to evolve through the discussions of Claude Viallat, Daniel Dezeuze (*b* 1942) and Patrick Saytour (*b* 1935). Reacting against the notion of the artist as an image maker and illusionist, they concentrated upon the very materials that underpinned painting. Dezeuze, for example, produced works whose main component was a canvas stretcher, either painted or, as in *Frame* (1967; Paris, Pompidou), covered with transparent plastic. In 1969 the three artists exhibited at the Ecole Spéciale d'Architecture in Paris, together with Marcel Alocco (*b* 1937), Noël Dolla (*b* 1945), Bernard Pagès (*b* 1940) and Jean-Pierre Pincemin (*b* 1944). The group acquired its name in 1970 with the first Supports-Surfaces exhibition at the Musée d'Art Moderne de la Ville de Paris. The name was whimsically suggested by one of its participants, Vincent Bioulès.

In 1971 there were two Supports-Surfaces exhibitions, the first at the Théâtre de la Cité Universitaire, Paris, and the second at the Théâtre Municipal de Nice. Louis Cane was one of the newcomers at these, though he had been associated with the group earlier. That year Cane, Marc Devade (1943–83), Dezeuze and Bioulès founded the review *Peinture/Cahiers théoriques*, designed as the group's mouthpiece. Viallat's paintings of this period mainly consisted of unstretched, free-hanging canvases, such as *5 Overlapping Canvases* (1971; see 1982 exh. cat., p. 57), complementary to Dezeuze's uncovered stretchers. In May 1971 Viallat officially resigned from the group, though he did exhibit at the Théâtre Municipal de Nice show in June. This brought about a split in the group, with Bioulès, Cane, Dezeuze, Devade and François Arnal (*b* 1924) appropriating the title Supports-Surfaces. The last exhibition under this name took place at the booksellers Les Idées et Les Arts in Strasbourg in 1972. Dezeuze resigned soon after this, in June, leaving no coherent group. The ideas embodied in Supports-Surfaces nevertheless remained influential on its participants even after the demise of the group.

Bibliography

Daniel Dezeuze (exh. cat. by B. Ceysson, Saint-Etienne,
 Mus. A. & Indust., 1980)
Viallat (exh. cat. by B. Ceysson and others, Paris,
 Pompidou, 1982)
Claude Viallat (exh. cat. by D. Dobbels and others, Nîmes,
 Mus. A. Contemp., 1988–9)
J. Pijaudier and others: *Daniel Dezeuze* (Paris, 1989)

□

Suprematism [Rus.: Suprematizm]

Term coined in 1915 by Kazimir Malevich for a new
system of art, explained in his booklet *Ot kubizma
i futurizma k suprematizmu: Novyy zhivopisnyy
realizm* ('From Cubism and Futurism to Suprema-
tism: the new realism in painting'). The term itself
implied the supremacy of this new art in relation
to the past. Malevich saw it as purely aesthetic and
concerned only with form, free from any political
or social meaning. He stressed the purity of shape,
particularly of the square, and he regarded
Suprematism as primarily an exploration of visual
language comparable to contemporary develop-
ments in writing (see col. pl. XXXIII). Suprematist
paintings were first displayed at the exhibition
*Poslednyaya futuristicheskaya vystavka kartin:
0.10* ('The last Futurist exhibition of paintings:
0.10') held in Petrograd (now St Petersburg) in
December 1915; they comprised geometric forms
which appeared to float against a white back-
ground. While Suprematism began before the
Revolution of 1917, its influence, and the influ-
ence of Malevich's radical approach to art, was per-
vasive in the early Soviet period.

Malevich traced the origins of Suprematism to
his sets and costumes for the Russian Futurist
opera *Pobeda nad solntsem* ('Victory over the
sun'), given in St Petersburg in December 1913. His
designs reflected the complex synthesis of Russian
and west European art that reached its height on
the eve of World War I. The opera exemplified the
collaboration of poets and painters that was a car-
dinal feature of Russian Futurism and reflected
the strong irrational trend of pre-war Russian
Futurist work. In September 1913 Malevich had
collaborated with Velimir Khlebnikov, Aleksey

Kruchonykh and Yelena Guro (1877–1913) on the
book *Troye* ('The three'), in which Kruchonykh
used the term *zaum* ('transrational language')
to describe sound poetry. The radical analysis
of poetic language provided a precedent for
Malevich's own reassessment of pictorial lan-
guage, and he subsequently adopted the term
zaum to describe his own work. In October 1913,
with Ol'ga Rozanova, Malevich had illustrated
Slovo kak takovoye ('The word as such'; Moscow,
1913) by Kruchonykh and Khlebnikov, and this col-
laboration was at its closest with the production
of *Pobeda nad solntsem*, for which Kruchonykh
wrote the libretto and Mikhail Matyushin
provided the music. Malevich's costumes were
stiff constructions, and some of the backdrops
employed Cubist motifs reinterpreted to incor-
porate Russian Futurist ideas. One backdrop,
however, consisted of a simple square divided
diagonally into black and white areas surrounded
by a rudimentary framing motif (designs in St
Petersburg, Theat. Mus.).

For an unrealized production of *Pobeda
nad solntsem* in 1915, Malevich proposed a black
square as a backdrop. At the exhibition *0.10*, the
Black Square (1915; Moscow, Tret'yakov Gal.),
painted on a square canvas surrounded by a
margin of white, was hung across the corner of
the separate room where works by Malevich and
his followers were displayed; it was announced as
the essential Suprematist work. On the one hand
it was radically nihilistic and could be interpreted
as a gesture of rejection, providing no narrative,
theme, composition or picture space, apparently
rejecting all pictorial conventions and offering a
canvas of unprecedented blankness; on the other
hand suspension across the corner of a room was
a common way to display domestic icons, and by
referring to this tradition its rejection of conven-
tion was not total. Followed by the *Black Circle*
(one version after 1920; St Petersburg, Rus. Mus.)
and the *Black Cross* (Paris, Pompidou), the *Black
Square* can be related to an icon tradition that sur-
vived so strongly in Russia, using ancient forms
that were increasingly admired by Russian artists
seeking to exert their independence from western
European traditions. A large exhibition of icons

had been held in Moscow in 1913 to celebrate the Romanov dynasty, and in April of that year, also in Moscow, Mikhail Larionov exhibited icons and *lubki* (popular folk prints). In icon painting the illusion of pictorial space was minimal; figures were frequently centrally placed and frontally presented, the head of Christ sometimes set against a symmetrical cross, circular halo and square format.

Malevich declared that the *Black Square* constituted the 'zero of form', an end to old conventions and the origin of a new pictorial language. The forms of this language were strictly geometrical, but they rapidly evolved into increasingly complex paintings in which the geometrical elements employed richer colours and inhabited an ambiguous and complex pictorial space. Despite its reference to the icon tradition, the *Black Square* presented no recognizably Christian image, but for Malevich himself Suprematism remained a mystical experience associated with concepts of the Fourth dimension and the nature of time, as explored in the mystical speculations of Pyotr Uspensky. Malevich entitled several Suprematist works in comparable terms, such as *Pictorial Realism of a Footballer—Pictorial Masses in Four Dimensions* (c. 1915; Amsterdam, Stedel. Mus.). During 1915 Malevich also produced paintings relying solely on the textural manipulation of white, a development also considered mystical by Aleksandr Rodchenko and other followers.

At *0.10* Malevich formed a Suprematist group, Supremus, with Ivan Puni (Jean Pougny), Mikhail Menkov, Ivan Klyun, Kseniya Boguslavskaya (1892–1972) and Ol'ga Rozanova; Nadezhda Udal'tsova also collaborated on the projected magazine *Supremus*. Malevich's rejection of representational imagery was widely influential, and his study of the dynamics of geometrical form in pictorial space had an investigative element, as did the subsequent non-objective art pursued by Lyubov' Popova, Gustav Klucis, Rodchenko, Klyun and El Lissitzky in particular. In the early years following the Revolution of 1917, Suprematism was widely explored, discussed and developed, dominating the avant-garde in Russia. The pervasive influence of Malevich's work was seen in

particular at the exhibition *X Gosudarstvennaya vystavka: Bespredmetnoe tvorchestvo i suprematizm* ('Tenth state exhibition: non-objective creation and Suprematism'), held in Moscow in 1919. Later that year Malevich moved to Vitebsk and formed the Unovis group, converting El Lissitzky to Suprematism and opening the way to Suprematist design. In 1922 Malevich moved, with his followers, to Inkhuk in Petrograd, where he worked on three-dimensional Suprematist works, his *arkhitektony*, studies in architectural form independent of specific commissions. Although it created a pictorial language that could be developed into designs ranging from posters to buildings and ceramics, for Malevich, Suprematism remained primarily a system of painting preceding specific utilitarian demands. When in 1921 Productivist artists and theorists at Inkhuk promoted utilitarian purposes for art and condemned easel painting, Malevich, who had appeared nihilistic with the *Black Square*, appeared to defend the supremacy of art over practicality and politics.

In 1922 El Lissitzky, who had worked closely with Malevich at Vitebsk, left Russia for western Europe. The re-establishment of diplomatic relations with western European countries ended eight years of cultural isolation and intense ferment for Russian artists, during which every aspect of artistic activity had been called into question in relation to the aims of Communism. In western Europe Suprematist works were assessed simply against developments in abstract art. Such an assessment was encouraged by El Lissitzky from the time of his arrival in Berlin in 1922, where he helped to install the *Erste russische Kunstausstellung* at the Van Diemen Galerie. Suprematism was well represented, and Lissitzky himself designed the catalogue cover. He continued to follow his own development of Suprematism, his *Proun* works, in Germany, while establishing contact with many groups of artists across Europe. He formed links with De Stijl in the Netherlands and with the Bauhaus in Germany, where his work particularly impressed László Moholy Nagy and possibly even Kandinsky. In Weimar he met Dadaists, including Tristan Tzara,

Kurt Schwitters and Hans Arp, and with Arp he published *Die Kunstismen—Les ismes de l'art—The Isms of Art* (Zurich, 1925), a survey of artistic groups including Suprematism. Lissitzky worked on exhibition displays and also published a series of designs for a puppet version of *Pobeda nad sol-ntsem* (Hannover, 1923), before returning to the Soviet Union in 1925, the year in which the promotion of recent Soviet art reached its peak in the Soviet pavilion at the Exposition des Arts Décoratifs et Industriels Modernes in Paris.

Among Malevich's closest Suprematist followers were Il'ya Chashnik (1902–29), Nikolay Suetin (1897–1954), Vera Yermolayeva (1893–1938) and Lev Yudin (1903–41), who were members of Unovis and who followed him to Petrograd in 1922. Yermolayeva developed a particular interest in folk art and children's books. On becoming Rector of the Art Institute in Vitebsk she collaborated closely with Malevich, and she headed the colour laboratory at Inkhuk in 1923. Suetin and Chashnik applied Suprematist principles to porcelain design after moving to Petrograd and worked at the Lomonosov porcelain factory. From 1924 they also collaborated with Malevich on his *arkhitektony*. In 1925–6 Chashnik worked with Suetin and with the architect Aleksandr Nikolsky. Suetin, who became director of the Lomonosov porcelain factory (1932–52), designed Suprematist cups, saucers and other utilitarian ceramic objects as well as architecture. He painted the Suprematist black square on Malevich's coffin in 1935.

Malevich himself made his only visit to the West in 1927, taking with him a substantial retrospective exhibition of his Suprematist canvases, which were to form the source of much interest in his work after his death, particularly after their installation at the Stedelijk Museum in Amsterdam. In Warsaw, Malevich met artists of the Blok group, including Władysław Strzemiński and Katarzyna Kobro, who had both studied under him at Vitebsk. Their own movement, Unism, owed much to Malevich's textured monochrome paintings. While Strzemiński produced heavily textured monochrome compositions, another member, Henryk Stażewski, explored simple geometric divisions of the canvas. Kobro made constructions that approached architectural forms in their planar division of space. Malevich's only Western publication of Suprematist theory, *Die gegenstandslose Welt*, was published in Munich in 1928 as Bauhausbuch No. 11. Although Malevich later returned to representational painting, Suprematism had an undoubted impact on the development of abstract art in the Soviet Union and in Western Europe, an impact that has been increasingly studied since the 1950s.

Writings

K. S. Malevich: *Ot kubizma i futurizma k suprematizmu: Novyy zhivopisnyy realizm* [From Cubism and Futurism to Suprematism: the new realism in painting] (Petrograd, 1915, rev. 3/1916)

—: *Die gegenstandslose Welt*, Bauhausbücher 11 (Munich, 1928)

Bibliography

T. Andersen, ed.: *K. S. Malevich: Essays on Art*, 4 vols (Copenhagen, 1968–78)

A. B. Nakov, ed.: *Malévitch: Ecrits* (Paris, 1975)

L. Schadowa: *Suche und Experimente: Aus der Geschichte der russischen und sowjetischen Kunst zwischen 1910 und 1930* (Dresden, 1978); Eng. trans. as L. Zhadova: *Malevich: Suprematism and Revolution in Russian Art, 1910–1930* (London, 1982)

J.-H. Martin and P. Pedersen: *Malévitch: Oeuvres de Casimir Séverinovitch Malévitch, 1878–1935, avec en appendice les oeuvres de Nicolai Souétine, 1897–1954*, Paris, Pompidou, cat. (Paris, 1980)

E. F. Kotvun: 'Kazimir Malevich', *A. J.* [New York], xli/3 (1981), pp. 234–41

L. Folgarait: 'Art-State-Class: Avant-garde Art Production and the Russian Revolution', *A. Mag.*, lx/4 (1985), pp. 69–75

C. Douglas: *Malevich* (New York, 1994)

JOHN MILNER

Surrealism

International intellectual movement, which was centred mainly in Paris and occupied with the problems of thought and expression in all their forms. The Surrealists perceived a deep crisis in Western culture and responded with a revision of values at every level, inspired by the psychoanalytical discoveries of Freud and the political

ideology of Marxism. In both poetry and the visual arts this revision was undertaken through the development of unconventional techniques, of which Automatism was paramount. The Parisian poets who formulated Surrealist theory and orientation were officially identified by André Breton's *Manifeste du surréalisme* (1924), the essay 'Une Vague de rêves' (October 1924) by Louis Aragon and the periodical *La Révolution surréaliste*, published two months later. Under Breton's guidance, the movement remained potent up to World War II, surviving until his death in 1966. Of the original members, the core had participated in Parisian DADA and contributed to the periodical *Littérature* (1919–24), edited by Breton, Aragon and Philippe Soupault. They included the poets Paul Eluard, Benjamin Péret, René Crevel, Robert Desnos, Jacques Baron, Max Morise, Marcel Noll, Pierre Naville, Roger Vitrac, Simone Breton and Gala Eluard, and the artists Max Ernst, Man Ray, Hans Arp and Georges Malkine (1901–69). They were joined by the writers Michel Leiris, Georges Limbour, Antonin Artaud and Raymond Queneau, and the artists André Masson and Joan Miró, all of whom had gathered at 45 Rue Blomet during 1922–4. A third group, centred on 54 Rue du Château, included the writers Marcel Duhamel and Jacques Prévert and the painter Yves Tanguy.

I. 1917–30

1. France

(i) Origins, theory and politics. The term '*surréalisme*' was coined in 1917 by the poet Guillaume Apollinaire in relation to the ballet *Parade* (by Erik Satie, Jean Cocteau and Picasso) and his own play *Les Mamelles de Tirésias*. It was variously interpreted by those abandoning Dada in the early 1920s, such as Ivan Goll and Paul Dermée, who published the single-issue *Surréalisme* in October 1924. As the successful claimant of the term, Breton chronicled the experiments that marked the *Littérature* group's transition from an attack on prevalent values, in Dada, to their proposition of an alternative, in Surrealism.

Although Apollinaire had left the term's meaning quite vague, he seems to have understood not only a form of expression exceeding realist effects (*sur-réel*) but also one that involved a strong element of surprise. This was to be achieved through unexpected juxtapositions, of which the most fertile were not the result of conscious deliberation. In an attempt to suspend conscious control, Breton turned to 'automatic writing', which precluded any preconceived subject or style (syntax, grammar, correction etc), to facilitate the flow of images from the subconscious. The first experiments took place in 1919, with his and Soupault's joint text 'Les Champs magnétiques'. This established automatism as a central principle for the *Littérature* group during the two years of uncertainty (known as the *époque floue*), which followed the collapse of Dada in 1922. Their experiments were reinforced by two antecedents.

One was the kind of automatic writing practised by spiritualist mediums. In 'Entrée des médiums', Breton described the experiments initiated by Crevel. Participants fell, at will, into a self-induced hypnotic 'sleep', in which they could speak, draw and answer questions, 'communications' that lay outside the normal constraints of logic and reason. Language and images seemed to be suspended from their utilitarian functions and to allow glimpses of deeper levels of meaning. After the experiments were terminated in 1923, this interest persisted, although with one crucial distinction: while the mediums claimed that their 'automatic messages' came from elsewhere, the Surrealists, eschewing mysticism, recognized only an internal psychic origin.

The second source was the example of Freudian techniques. In the manifesto of 1924 Breton explained that the experiment that resulted in 'Les Champs magnétiques' had been inspired by his wartime experience as a medical auxiliary specializing in psychiatry, when he had tried out psychoanalytical techniques on victims of shell-shock. His interest was prompted by the reserves of imagination revealed in the apparently irrational monologues. When he and Soupault turned the technique on themselves, they produced poetic images of a quality surpassing those produced consciously. A measure of the importance of automatism was its place in the manifesto, in

which Breton defined Surrealism as 'psychic automatism in its pure state, by which it is intended to express, either verbally, or in writing, or in any other way, the true functioning of thought. Thought expressed in the absence of any control exerted by reason, and outside all moral and aesthetic considerations'. Sigmund Freud's influence dominated the manifesto. His importance lay in the overwhelming power he accorded the unconscious, which could have as great an influence on waking life as the conscious. It is perhaps unsurprising that Freud himself had little sympathy with the Surrealists' work, as their interest was not in the psychoanalytical means to cure neurosis, but in finding routes to the psyche as the seedbed of the imagination, and in the poetic value of dreams in their own right. The manifesto focused therefore upon dreams, childhood and madness, as states in which the imagination was accepted and free of utilitarian considerations.

The Surrealists contrasted their experimental work with 19th-century philosophical rationalism and literary realism. Significantly, the definition in the manifesto occurred within an alternative literary genealogy including the Marquis de Sade, Jonathan Swift, romantic and 'diabolist' writers, such Gothic novelists and poets as 'Monk' Lewis, Baudelaire, Joris-Karl Huysmans, de Nerval, Alfred Jarry and Isidore Ducasse, the Comte de Lautréamont (author of Les Chants de Maldoror). In no sense a fixed list (Rimbaud and Apollinaire passed out of favour), it nonetheless emphasized Surrealism's adherence to a literature of the imagination. Where the Surrealists differed from these 'ancestors' was in their acceptance that the marvellous might be encountered as easily in the street as in fantasy or dreams. As a result, they put considerable faith in the poetry of chance encounters, the trigger for books such as Aragon's Le Paysan de Paris (1926) and Breton's Nadja (1928). In this spirit, the Bureau de Recherches Surréalistes was opened daily in late 1924 in Paris as a point of contact with the public at large; wanderings, collecting of inexplicable objects, or suicide reports all provided evidence of the tensions underlying 'rational' existence.

Such evidence was disseminated through the generously illustrated periodical La Révolution surréaliste (1924–9). Its appearance, modelled on scientific magazines, lent credence to the seriousness of its contents: Surrealist texts and dream accounts; theoretical and political articles; poems (particularly by Eluard and Desnos); and linguistic experiments (by Leiris). Its manifestos ranged from Artaud's exhortation to unlock the asylums (no. 3, April 1925), to the group's defence of Charlie Chaplin ('Hands off Love', no. 9/10, Oct 1927). These texts were forged in the daily meetings in cafés or Breton's studio and cemented the shared nature of their experience. They demanded total commitment, and infringement of their principles brought denunciation.

This dedication complicated the movement's political position. After rather romantic beginnings, they condemned France's colonial war in Morocco in late 1925; in so doing they established a dialogue with the Marxist periodical Clarté, edited by Jean Bernier, Marcel Fourrier and others. Together they issued La Révolution d'abord et toujours!, recognizing the need for social revolution. However, the Surrealists insisted on retaining their autonomy, and this continually raised the question of their wholehearted commitment to political action. In La Révolution et les intellectuels (1926), Pierre Naville declared Surrealism incompatible with Marxism and abandoned the movement to join Clarté. Breton's response, 'Légitime défense' (1926), argued that while unreservedly on the side of the revolution, they could not see why they should not continue their experiments until it happened. To underline this commitment, he, Aragon, Eluard, Péret and Pierre Unik joined the French Communist Party in 1927.

(ii) **Visual arts.** There was always a certain ambivalence within Surrealism regarding the visual arts. Breton simultaneously defended painting as a Surrealist activity and yet called it a 'lamentable expedient'. However, a footnote to the literary genealogy in the manifesto suggested a comparable genealogy in painting, traced to Paolo Uccello and Gustave Moreau and, among the living, Pablo

Picasso, Paul Klee, Marcel Duchamp, Francis Picabia and Giorgio de Chirico, whose works were extensively collected by Eluard, Breton and others. Each was admired for his ability to expose a further facet of reality; in particular, Duchamp's disruption of the distinction between 'art' and 'non-art', and de Chirico's dream-like imagery. They did not join the movement; instead, it was the three younger artists listed, Ernst, Man Ray and Masson, who (together with Arp, Miró and Tanguy) established the major areas of dream imagery and automatism explored in visual Surrealism (although Miró never 'officially' joined the group) (see fig. 46).

Ernst produced the most compelling dream-related images. The juxtapositions of unrelated objects in his early collages and photomontages disrupted stable relations of time and space. Breton's preface to the catalogue of his exhibition of 1921 (Paris, Au Sans Pareil) remarked on the spark generated by the contact of the objects' separate realities; this offered a visual parallel to Lautréamont's influential metaphor, 'as beautiful as the chance encounter of a sewing-machine and an umbrella on a dissecting table'. Ernst invested his 'proto-Surrealist' canvases (1922–4) with this disorientation to reflect his immersion in the experiments with hypnotic trances; the iconoclastic *Pietà or Revolution by Night* (1923; London, Tate; see fig. 47) in particular, combined a kind of visual manifesto of the dream with a homage to Freud's Oedipus theory.

Unexpected juxtapositions had featured in the Dada objects and rayographs by Man Ray. The unforeseeable results of the rayographs brought this close to qualifying as an automatic process. His more orthodox photographs undermined the objectivity of their medium (often through their

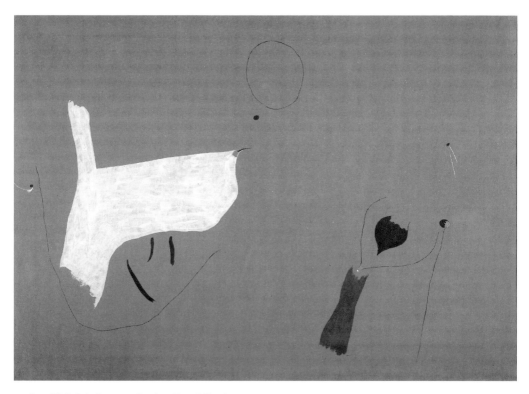

46. Joan Miró: *Painting*, 1927 (London, Tate Gallery)

sexual charge), securing their importance in *La Révolution surréaliste*. The periodical also carried Masson's drawings, which established a direct visual equivalent to automatic writing. They consisted of hasty webs of fine lines, out of which enlaced and truncated bodies (animal and human) emerged, implying themes of desire and death. His fellow Surrealists immediately acclaimed the power of these drawings, whose lines hover between pre-linguistic chaos and order, for example *Furious Suns* (1925). Together with popular art and film stills, these works contributed to a mixture of images in *La Révolution surréaliste* that lacked any conventional governing aesthetic and reflected the debate over the whole visual condition of Surrealism. Morise addressed these problems in 'Les Yeux enchantés' (*Révol. Surréaliste*, no. 1), questioning the type of dream painting represented by de Chirico and Ernst. He argued that memory, inherent in such works, acted as the agent of conscious control, so that 'the images are Surrealist, their expression is not'. He believed that such expressions had to be free of conscious intention, illustrating the article with one of Masson's drawings, and citing those by mediums or the mentally ill and Man Ray's rayographs.

These difficulties were confronted more aggressively by Naville, in a short text, ironically entitled 'Beaux Arts', in *La Révolution surréaliste*. He denied the possibility of any Surrealist painting, accepting 'only the street, the cinema, newspaper photographs'. Breton could not accept this denial of the value of individual expression. He took over editorial control of the periodical from Naville and Péret (from no. 4, July 1925), and published the series 'Le Surréalisme et la peinture'. Although rejecting the pursuit of art for its own sake, he justified his support for artists for their direct experience of alternative realities. Before Masson, Ernst and Man Ray, he placed Picasso, whose Cubism he considered the most daring break with external visual appearances. Breton's argument with de Chirico's new style was also exposed, as he claimed the early work for Surrealism. The crucial thing in each case was the search for an internal model, although the way in which this might be pursued was left open.

47. Max Ernst: *Pietà or Revolution by Night*, 1923 (London, Tate Gallery)

As part of his response Breton presented the wealth of visual Surrealism. First, important works by Ernst and Miró (e.g. *Catalan Landscape* (*The Hunter*), 1923–4; New York MOMA), as well as Picasso's *Demoiselles d'Avignon* (1907; New York, MOMA) and *The Dance* (1925; London, Tate), dominated the issue's illustrations. Second, with Desnos, he organized the first group exhibition (*La Peinture surréaliste*, Paris, Gal. Pierre, Nov 1925), which included work by de Chirico, Klee and Picasso alongside Arp, Ernst, Masson, Miró, Man Ray, Malkine and Pierre Roy. Third, the Galerie Surréaliste was founded under Noll's direction (March 1926), to show members' work, often drawn from the poets' collections. The opening show of paintings by Man Ray and sculptures from the Pacific Islands established a juxtaposition (reflecting the Surrealists' interest in and collection of indigenous art from Melanesia, Mexico and Eskimo lands) repeated for Tanguy's show with sculptures from North and South America the

following year. Although Malkine and Arp exhibited in 1927, and early de Chiricos were shown in 1928, the gallery closed that year.

These developments heralded a growing diversity of automatic techniques. Ernst developed *frottage* and collaged the results into images that transformed the original substance; Masson combined free line with texture, by pouring sand on to his canvases of 1926–7, for example *Battle of the Fishes* (1926; New York, MOMA); and Miró located biomorphic forms in fields of saturated colour in such works as *Person Throwing a Stone at a Bird* (1926; New York, MOMA). With Man Ray, Lee Miller developed solarization, giving portrait photographs unexpected auras. At the same time, however, the disjunctive illusionism of work by such artists as Malkine and Roy was reinforced by Tanguy's poetically titled and spatially subaquatic images, for example *Mama, Papa Is Wounded!* (1927; New York, MOMA).

2. Belgium

An autonomous group formed in Brussels in 1925 and became official in 1926, bringing together two groups of friends. On one side were the editors of the Dada-orientated periodicals *œsophage* (1925) and *Marie* (1926), the musician, poet and artist E. L. T. Mesens and the painter René Magritte; on the other, were the contributors to *Correspondance* Paul Nougé (1895–1967), Marcel Lecomte (1900–66) and Camille Goemans (1900–60), as well as the musician André Souris. In 1927 they were joined by the writer Louis Scutenaire. *Correspondance* consisted of single tracts on individual writers published every ten days (Nov 1924–5). In 1925 the contributors began to collaborate with Paris, and Nougé and Goemans signed *La Révolution d'abord et toujours!* Despite being a founder of the Belgian Communist Party, Nougé was dubious about the Party's attitude towards writers, and the Belgians maintained their distance from the French group's difficulties. Nevertheless, in 1927, both Goemans and Magritte moved to Paris and frequented Breton's circle. The former established the Galerie Goemans, which took the place of the Galerie Surréaliste in 1929–30. Magritte, inspired by the example of de Chirico in such works as the

Threatened Assassin (1926), also absorbed the lessons of Ernst's collages; he stayed until 1930, contributing to *La Révolution surréaliste*, but his work was not immediately appreciated.

II. 1930–40

1. Theory and politics

In 1929 the satellite group around the periodical *Le Grand Jeu*, including Roger Gilbert-Lecomte, Maurice Henry (*b* 1907) and the Czech painter Josef Šíma, was ostracized, while Breton's 'Second manifeste du surréalisme' excluded those reluctant to commit to collective action: Leiris, Limbour, Morise, Baron, Queneau, Prévert, Desnos, Masson and the photographer Jacques-André Boiffard (1902–61). They gravitated towards the periodical *Documents* (1929–30), edited by Georges Bataille, whose anti-idealist materialism had produced a hybrid Surrealism that exposed the baseness of man's instincts (e.g. 'Abattoirs', *Documents*, no. 6, 1929, photographs by Eli Lothar). *Documents* discussed popular arts, used Boiffard's disconcerting photographs (e.g. *Untitled/Hand and Foot*, 1929; Paris, Pompidou) and included articles on ethnography and art by Leiris, Limbour, Carl Einstein and others.

New members invigorated Surrealism in 1929–30, contributing to the new periodical, *Surréalisme au service de la révolution* (*SASDLR*; 1930–33). These included the former Dada leader, Tristan Tzara, as well as the writers René Char, Georges Sadoul, André Thirion and Maurice Heine, the artists Salvador Dalí, Luis Buñuel, Alberto Giacometti and Valentine Hugo (1887–1968). Alongside Breton and Eluard's essays simulating neurotic and psychotic states ('L'Immaculée Conception', *SASDLR*, no. 2, 1930), contributions included Heine's consideration of Sade (no. 2, 1930) and Tzara's 'Essai sur la situation de la poésie' (no. 4, 1932). Their concerns remained deeply political. The second manifesto had detailed their attempts to undermine definitively the dominating ideas of patriotism, family and religion. Their commitment to the Third Inter-national tried to pacify the Party in the face of the group's growing admiration for Leon Trotsky (newly exiled from Moscow). This

overshadowed Surrealism's political position throughout the 1930s, as they steered an independent course through a series of ill-fated anti-Fascist alliances, which precipitated internal schisms. In 1932 Aragon left to join the Party as a result of his enforced rejection of Freudianism and Trotskyism while representing Surrealism at the International Congress of Revolutionary Writers in Khar'kov in 1930; Sadoul, Unik, Maxime Alexandre and Buñuel followed him. In 1933 the Surrealists' assertion of the impossibility of a 'proletarian literature' within a capitalist society led to their break with the Association des Écrivains et Artistes Révolutionnaires (AEAR) and the expulsion of Breton, Eluard and Crevel from the Communist Party; Crevel's suicide in 1935 was partially associated with an inability to reconcile the two doctrines.

The group's politics were largely divorced from their art by their contribution to the beautifully illustrated review *Minotaure* (1933–9), which lay outside their control. This confirmed their public image as an artistic movement, ignoring such alliances as the Contre-Attaque movement (1935–6; with Bataille and the Front Populaire). On his trip to Mexico in 1938 (reported in *Minotaure* no. 12–13), Breton discovered affinities with Surrealism in the work of Frida Kahlo (e.g. *The Two Fridas*, 1939; Mexico City, Mus. A. Mod.) and the photographer Manuel Alvarez Bravo (e.g. *Daydreaming*, 1931); he also met Trotsky, with whom he and Diego Rivera founded the short-lived Fédération Internationale de l'Art Révolutionnaire Indépendant (FIARI). However, Eluard broke personally with Breton that year, precipitating the departure of Ernst and Man Ray.

2. Visual arts

In March 1930 Aragon's 'La Peinture au défi' was the preface for the catalogue of the important *Collages* exhibition at the Galerie Goemans, proposing juxtaposition as the central tenet underlying automatism and dream imagery. The latter gained ground through the work of Magritte (e.g. the *Daring Sleeper*, 1928; London, Tate), Tanguy and Dalí, who arrived in a welter of controversies. His début exhibition (Paris, Gal.

Goemans, Nov 1929) followed the première of *Un chien andalou*, made with Buñuel, which demonstrated film's compelling potential to simulate dreams. Although he contributed little to Buñuel's *L'Age d'or* (1930), its combination of irresistible love (*l'amour fou*) and anticlericalism ensured that it was banned.

Dalí's obsessional paintings drew on the Freudian notion that the 'manifest' façade of the dream concealed the latent content of the dreamer's, often sexual, desires. In such works as *Illuminated Pleasures* (1929; New York, MOMA) he expressed these anxieties in a minutely detailed, visual language that paralleled the space and juxtaposition of objects in dreams. He then developed the 'paranoiac-critical' method ('L'Ane pourri', *SASDLR*, no. 1, 1930); linked to paranoia (in which the world is interpreted according to an obsessional idea), it capitalized upon the capacity to read a single configuration of forms in several different ways (e.g. *Metamorphosis of Narcissus* (1937; see col. pl. XXXIV). Dalí's fertile contribution disguised the danger that his fantasies, which replaced the 'real' world, had also obscured Surrealism's concern with the interpenetration of unconscious and conscious realities. His concern with highly saleable commodities and his political unreliability led to a split in the 1930s.

One of Dalí's most important initiatives was to recognize the disturbing potential of objects, having seen Giacometti's suggestive sculptures, especially *Suspended Ball* (1930–31; Basle, Kstmus.). Several members produced 'symbolically functioning objects' (repr. in *SASDLR*, no. 3, 1931), and production reached its height around the *Objets* exhibition (Paris, Gal. Charles Ratton, 1936). There Giacometti's work appeared alongside Duchamp's ready-mades and the ultimate Surrealist object, Meret Oppenheim's *Object* (1936; New York, MOMA), a fur-covered cup and saucer. Women, widely idealized but marginalized creatively within the movement until the 1930s, found object-making open to them, perhaps because of its ambiguous artistic status. Gala, Valentine Hugo and Jacqueline Breton seized upon this.

The independent positions of senior artists (Ernst, Miró, Man Ray) encouraged new recruits

in 1932–5. The writers included Maurice Henry, Marcel Jean, Georges Hugnet, Pierre Mabille, the Peruvian César Moro and the 14-year old Gisèle Prassinos. As well as Oppenheim, the artists included Raoul Ubac, Clovis Trouille (1889–1975), Oscar Domínguez, Victor Brauner, and the Germans Wolfgang Paalen, Richard Oelze and Hans Bellmer; Paul Delvaux frequented the Belgian group. Most employed illusionism (e.g. *Pink Bows*, 1937), although Paalen and Domínguez invented the new automatic techniques of *fumage* (drawing with smoke) and *decalcomania* (pressing paint between sheets of paper) respectively. In addition, Picasso, with his automatic writing (1933–4), and Duchamp (from 1935) came into the Surrealist orbit; in 1936 Masson was readmitted.

The influx of foreign artists coincided with the internationalization of the movement. The activities in Belgrade of Marco Ristitch (*b* 1902) culminated in a declaration (*SASDLR*, no. 3, 1932) that brought government suppression. In 1933 the Prague Devětsil group, comprising the writers Karel Teige, Viteslav Nezval (1900–58) and Jindrich Heisler (1914–53), and the painters Jindřich Štyrský and Toyen, declared their adherence (*SASDLR*, no. 5, 1933). In the mid-1930s a Surrealist group was formed in Cairo by the poet Georges Henein, while the Japanese poets Shūzō Takiguchi and Chiruo Yamanaka, and such painters as Harue Koga also established contact with Paris.

The process was accelerated by a series of exhibitions beginning with *Minotaure* at the Musée d'Art Moderne in Brussels (1934) mounted by Nougé and Mesens, and *Kubisme-Surrealisme* in Copenhagen (1935) organized by the painters Vilhelm Bjerke-Petersen and Wilhelm Freddie. In March 1935 Breton, Eluard and Šíma travelled to Prague for the first Exposition Internationale du Surréalisme, establishing the special link that sustained Surrealist activity in Prague beyond World War II. The conjunction of a bilingual *Bulletin* and exhibition was repeated in May in Santa Cruz de Tenerife, where (at Domínguez's invitation) Breton and Péret met the *Gaceta del árte* group including the critic Eduardo Westerdahl, Domingo Pérez Mink and Augustin Espinosa. Although suppressed under Franco, the group helped to disseminate Surrealism in Latin America. In 1936, after a further Belgian exhibition (Brussels, La Louvière, Aug 1935), a fourth exhibition (complete with *Bulletin*) was held in London (New Burlington Gals). The English group, formed by the poet David Gascoyne and the painter Roland Penrose, temporarily attracted Herbert Read, Humphrey Jennings, Henry Moore and Paul Nash; more permanent were Eileen Agar, John Banting, Grace Pailthorpe, Ithel Colquhoun and Conroy Maddox. In 1938 Mesens arrived to direct the London Gallery and to edit the *London Gallery Bulletin* (1938–40; with Penrose), supported by the French writer and film maker Jacques Brunius (1906–67).

In Paris Breton re-emphasized automatism and, in *L'Amour fou* (Paris, 1937), reaffirmed the potential of chance encounters. During 1937–8 further adherents included Patrick Waldberg (*b* 1913) and Julien Gracq (*b* 1910), and the painters Kurt Seligmann, Esteban Francés, Roberto Matta, Gordon Onslow-Ford, Jacques Hérold, Leonora Carrington and Léonor Fini, although Fini did not join the movement officially. With the exception of the last two, all the painters explored automatism, expanding in scale and adopting Tanguy's deep space (e.g. Onslow-Ford's *Without Bounds*, 1939; San Francisco, CA, MOMA). The short-lived Galerie Gradiva (1937–8) confirmed the movement's commercial difficulties, but the exhibitions culminated in the Exposition Internationale du Surréalisme at the Galerie des Beaux-Arts, Paris, 1938. This pioneered a disconcerting environment for the works, including eerie laughter, coal sacks attached to the ceiling by Duchamp and a pond by Paalen; the group's unified activity was underscored by each artist adorning a shop mannequin.

III. 1940–46

Coherent Surrealist activity ceased in Europe during World War II, apart from the London group (irredeemably split between Mesens and Toni del Renzio in 1942), and Noël Arnaud and Jean-François Chabrun's La Main à Plume group in occupied Paris. The German members (Ernst, Brauner, Wols) had been interned in 1940, and

many prepared for exile to the USA through the influence of Peggy Guggenheim, leaving former colleagues (Aragon, Eluard, Tzara and Desnos) to work in the Resistance. A number of Surrealists, including Wilfredo Lam, sought shelter in Marseille in 1940. Paalen, his wife, the painter Alice Rahon, and Moro were already in Mexico City, where they organized the Exposición Internacional del Surrealismo (Galeria de Arte Mexicano, 1940), which included artists with whom Surrealism found common ground: Rivera, Kahlo, Alvarez Bravo, Roberto Montenegro, Guillermo Meza (b 1919) and others. This encouraged the southward spread of the movement, notably to Peru and the Mandragora group in Chile. In Mexico Paalen drew away from the movement's political intrigues to establish the periodical DYN (1940–45), and, after visiting British Columbia, he became interested in indigenous American cultures. Other Surrealists arrived in Mexico: Onslow-Ford, Péret, his wife, the painter Remedios Varo and Carrington, who together developed a mystical pictorial imagery, seen in such works as Carrington's *Pomps of the Subsoil* (1947; Norwich, U. E. Anglia, Sainsbury Cent.).

In 1941 Breton sailed with Lam for Martinique, meeting the poet Aimé Césaire, and then to Santo Domingo, Dominican Republic, meeting the painter E. F. Granell; all three disseminated Surrealist ideas in the Caribbean. Continuing to New York with Masson, he rejoined Ernst, whose new *decalcomonias* included *Europe after the Rain* (1940–42), as well as Matta, Seligmann, Tanguy and Kay Sage in a larger group of refugees. The first Surrealist group show in the USA had taken place in 1931–2 at the Wadsworth Atheneum, Hartford, CT, travelling to the Julien Levy Gallery, New York. A historical survey in 1936 (*Fantastic Art, Dada, Surrealism*, MOMA, New York), though outside Surrealist control, had introduced their work to a wider audience, but in 1942 the movement's arrival was marked by the *First Papers of Surrealism* exhibition (451 Madison Avenue). With an installation by Duchamp (a mile of string wrapped round the exhibits), it included such local artists as Robert Motherwell, William Baziotes and David Hare, the editor of the Surrealist periodical *VVV* (1942–4). The

galleries of Peggy Guggenheim, Julien Levy and Pierre Matisse favoured Surrealism and encouraged new recruits, notably Dorothea Tanning, Enrico Donati (who had already assisted in organizing the show in Paris in 1937), Jérome Kamrowski, Frederick Kiesler and Joseph Cornell. Breton's emphasis on automatism in 'Genèse et perspective artistique du surréalisme' (written 1941) was taken up by Jackson Pollock and Arshile Gorky (e.g. *Garden at Sochi*, 1941; New York, MOMA), who responded to the techniques of Masson and Matta. During this exile, Breton also became interested in establishing parallels between Surrealist thought and the magic and mysticism of Native American and Eskimo peoples. Ethnographic work by Claude Levi-Strauss appeared in *VVV*, and Breton's *Prolegomena to a Third Manifesto of Surrealism or Not* (1942) called for the formation of a new myth. Prior to his return to Europe these interests were reinforced by the experience of Voudou in Haiti, where he met Mabille, Lam and the painter Hector Hyppolite.

IV. 1946–66

After the war, Breton renewed Surrealist activity in Paris in 1946 but faced criticism of idealism from Tzara (*Le Surréalisme de l'après guerre*), the younger Surréalisme Révolutionnaire group (headed by Christian Dotremont) and from Jean-Paul Sartre (*Situation de l'écrivain en 1947*). He responded with *Rupture inaugurale* and the magic-oriented *Surréalisme en 1947* exhibition (Paris, Gal. Maeght, 1947), although the movement had lost ground to Existentialism in literature and gestural abstraction in painting. Alongside the likes of Brauner, Hérold, Toyen and Heisler (newly arrived from Prague), a number of new automatist artists emerged, such as Jean-Paul Riopelle and, in the 1950s, Jean Degottex, Marcelle Loubchansky and Endre Rozsda. The work of such 'outsiders' as Adolf Wölfli, Aloys Zötl and Scottie Wilson were included in exhibitions, following Breton's activities in Jean Dubuffet's *Compagnie de l'Art brut* from 1947.

Lam and Matta's totemic paintings spurred the interest in magic and Breton collaborated with

Gérard Legrand on the work *L'Art magique* between 1953–7. Legrand was one of the younger writers, along with Sarane Alexandrian, Adrien Dax and especially Jean Schuster, contributing to the string of Surrealist periodicals: *NÉON* (1948–9), *Médium* (1952–5) and *Surréalisme même* (1956–9). They were illustrated by a new wave of dream-imagery works by Simon Hantai (e.g. *Oil on Canvas*, 1952; Paris, Pompidou), Judit Reigl, Max Walter Svanberg, Pierre Molinier, Yves Laloy, Jean Benoît and Jean-Jacques Lebel, who also contributed to the group's *EROS* exhibition (1959–60, Paris, Gal. Daniel Cordier). The later periodicals, *Bief: Jonction surréaliste* (1958–60) and *La Brèche* (1961–5), introduced José Pierre and Robert Benayoun, and the artists Jean-Claude Silbermann, Konrad Klapheck, and the South Americans Alberto Gironella, Jorge Camacho and Augustín Cárdenas. These activities confirmed that, despite its post-war decline, Surrealism maintained its moral and intellectual urgency and breadth of concern.

Breton's death in 1966 left no heir who could impose cohesion, although some activity continued in Brussels (with Marcel Mariën and the painters Jane Graverol and Félix Labisse), Prague (with the artists Jiří Kolář, Josef Istler, Eva Svankmajerova and the film maker Jan Svankmajer) and Chicago (coordinated by Franklin Rosemont). Surrealism's longevity had ensured its place within wider cultural currents, becoming as much of a seedbed of inspiration as the unconscious and suppressed part of the psyche it had exposed.

Writings

A. Breton and P. Soupault: 'Les Champs magnétiques', *Littérature*, 8 (Oct 1919), pp. 4–10; 9, pp. 2–7; 10, pp. 9–16; repr. as book (Paris, 1920; Eng. trans., London, 1985)

A. Breton: 'Entrée des médiums', *Littérature*, n. s., 6 (Nov 1922), pp. 1–16

L. Aragon: 'Une Vague de rêves', *Commerce*, 1 (Oct 1924), pp. 89–122

A. Breton: *Manifeste du surréalisme—poisson soluble* (Paris, 1924)

—: *Les Pas perdus* (Paris, 1924)

—: 'Le Surréalisme et la peinture', *Révolution Surréaliste*, 4 (1925), pp. 26–30; 6 (1926), pp. 30–32; 7 (1926), pp. 3–6; 9–10 (1927), pp. 36–43; repr. as book (Paris, 1928, rev. 3/1965; Eng. trans., London and New York, 1972)

P. Naville: 'Beaux Arts', *Révolution Surréaliste*, 3 (1925), p. 27

L. Aragon: *Le Paysan de Paris* (Paris, 1926; Eng. trans., London, 1971, 2/1980)

R. Crevel: *Babylone* (Paris, 1927; Eng. trans., 1985, 2/1988)

A. Breton: *Nadja* (Paris, 1928, 2/1964; Eng. trans., New York, 1960)

—: 'Le Second Manifeste du surréalisme', *Révolution Surréaliste*, 12 (1929), pp. 1–17; repr. as book (Paris, 1930)

—: *Les Vases communicants* (Paris, 1932)

D. Gascoyne: *A Short Survey of Surrealism* (London, 1935, 2/1970)

A. Breton: *L'Amour fou* (Paris, 1937; Eng. trans., Lincoln, NE, and London, 1987)

Dictionnaire abrégé du surréalisme (exh. cat. by A. Breton and P. Eluard, Paris, Gal. B.-A., 1938)

R. Penrose: *The Road Is Wider than Long* (London, 1939, 2/1970)

A. Breton: *Anthologie de l'humour noir* (Paris, 1940, 3/1966)

—: 'Genèse et perspective artistique du surréalisme', *Art of This Century*, ed. P. Guggenheim (New York, 1942)

M. Leiris: *Aurora* (Paris, 1946, 2/1973; Eng. trans., London, 1990)

T. Tzara: *Le Surréalisme de l'après guerre* (Paris, 1947)

M. Ernst: *Beyond Painting* (New York, 1948)

A. Breton: *Entretiens* (Paris, 1956)

—: *Manifestes du surréalisme* (Paris, 1962; Eng. trans., Ann Arbor, 1969)

L. Aragon: *Les Collages* (Paris, 1965)

J. Arp: *Jours effeuillés*, ed. M. Jean (Paris, 1966); Eng. trans. as *Arp on Arp* (New York, 1969, 2/1972); rev. as *Collected French Writings, Poems, Essays, Memories* (London, 1974)

G. Bataille: *Documents* (Paris, 1968)

A. Thirion: *Révolutionnaires sans révolution* (Paris, 1972; Eng. trans., 1976)

P. Naville: *Le Temps du surréel* (Paris, 1977)

A. Breton: *What is Surrealism?*, ed. F. Rosemont (London and New York, 1978)

M. Mariën: *L'Activité surréaliste à Bruxelles et en Wallonie (1924–1950)* (Brussels, 1979)

J. Pierre, ed.: *Tracts surréalistes et déclarations collectives, 1922–1982*, 2 vols (Paris, 1980–82)

L. Aragon: *Ecrits sur l'art moderne*, ed. J. Leenhardt (Paris, 1981)

R. Desnos: *Ecrits sur les peintres*, ed. M. C. Dumas (Paris, 1984)

G. Bataille: *Visions of Excess: Selected Writings, 1927–1939*, ed. A. Stoekl (Minneapolis and Manchester, 1985)

A. Breton: *Oeuvres complètes*, ed. M. Bonnet, i (Paris, 1988)

B. Péret: *Death to the Pigs: Selected Writings*, ed. R. Stella (London, 1988)

J. Pierre, ed.: *Archives du surréalisme*, 4 vols (Paris, 1988–92)

Bibliography

periodicals

Littérature (1919–24; facs., Paris, 1978)

Révol. surréaliste (1924–9; facs., Paris, 1975)

Documents [Paris] (1929–30)

Surréalisme Serv. Révolution (Paris, 1930–33; facs., Paris, 1976) [SASDLR]

Gac. A. (1932–6)

Minotaure (1933–9; facs., Geneva, 1981)

London Bull. (London, 1938–40)

View (1940–47; facs., Lichtenstein, 1969)

DYN (1942–4)

VVV (1942–4)

NÉON (1948–9)

Médium (1952–5)

Surréalisme Même (1956–9)

Bief (1958–60)

La Brèche (1961–5)

general

M. Nadeau: *Histoire du surréalisme* (Paris, 1945, 2/1964; Eng. trans., New York, 1965)

M. Jean and A. Mezei: *Histoire de la peinture surréaliste* (Paris, 1959; Eng. trans., London and New York, 1960)

P. Waldberg: *Surrealism* (Cologne, 1965; Eng. trans., London, 1965)

W. S. Rubin: *Dada and Surrealist Art* (New York and London, 1969)

A. Balakian: *Surrealism: The Road to the Absolute* (Oxford and New York, 1970)

M. A. Caws: *The Poetry of Dada and Surrealism* (Princeton, 1970)

E. Crispolti: *Surrealismo* (Milan, 1970); Eng. trans. as *Ernst, Miró and the Surrealists* (London, 1989)

D. Ades: *Dada and Surrealism* (London, 1974)

F. Smejkal: *Surrealist Drawings* (Prague, 1974; Eng. trans., London, 1974, 2/1982)

R. Passeron: *Encyclopédie du surréalisme* (Paris, 1975; Eng. trans., Oxford, 1978)

G. Picon: *Surréalisme, 1919–1939* (Geneva, 1977; Eng. trans., London, 1977; 2nd edn as *Surrealists and Surrealism, 1919–1939* (London, 1983)

M. Haslam: *The Real World of the Surrealists* (New York, 1978)

M. Jean, ed.: *Autobiographie du surréalisme* (Paris, 1978; Eng. trans., New York, 1980)

A. Biro and R. Passeron: *Dictionnaire général du surréalisme et de ses environs* (Paris, 1982)

specialist studies

A. Kirou: *Le Surréalisme au cinéma* (Paris, 1963)

J. Vovelle: *Le Surréalisme en Belgique* (Brussels, 1965, rev. 1972)

I. Rodríguez-Prampolini: *El surrealismo y el arte fantástico de México* (Mexico City, 1969, rev. 1983)

C. B. Morris: *Surrealism and Spain, 1920–1936* (Cambridge, 1972)

G. Rondolino, ed.: *L'occhio tagliato: Documenti del cinema dadaista e surrealista* (Turin, 1972)

M. Bonnet: *André Breton: Naissance de l'aventure surréaliste* (Paris, 1975, 2/1988)

F. Rosemont: *André Breton and the First Principles of Surrealism* (London and New York, 1978)

H. Finkelstein: *Surrealism and the Crisis of the Object* (Ann Arbor, 1979)

W. Chadwick: *Myth in Surrealist Painting, 1929–39* (Ann Arbor, 1980)

F. Rosemont, ed.: *Surrealism and its Popular Accomplices* (San Francisco, 1980)

J.-C. Gateau: *Paul Eluard et la peinture surréaliste, 1910–1939* (Geneva, 1982)

E. Jaguer: *Les Mystères de la chambre noire: Le Surréalisme et la photo* (Paris, 1982)

P. Kral: *Le Surréalisme en Tchécoslovaquie* (Paris, 1983)

V. Linhartová: 'La Peinture surréaliste au Japon, 1925–1945', *Cah. Mus. N. A. Mod.*, 11 (1983), pp. 130–43

W. Chadwick: *Women Artists and the Surrealist Movement* (London, 1985)

G. Charbonnier: *Entretiens avec André Masson* (Paris, 1985)

E. Cowling: '"Proudly we Proclaim him as One of us": Breton, Picasso and the Surrealist Movement', *A. Hist.*, viii/1 (1985), pp. 82–104

J. Mundy: 'Surrealism and Painting: Describing the Imaginary', *A. Hist.*, x/1 (1987), pp. 492–508

J. Pierre: *L'Aventure surréaliste autour d'André Breton* (Paris, 1987)

K. Tsékénis and N. Vakoritis, eds: *Surréalistes grecs* (Paris, 1991)

exhibition catalogues

Dada, Surrealism and their Heritage (exh. cat. by W.
Rubin, New York, MOMA; Los Angeles, CA, Co. Mus. A.;
Chicago, IL, A. Inst.; 1968)

Cinéma dadaïste et surréaliste (exh. cat., ed. M. Debard;
Paris, Pompidou, 1976)

Dada and Surrealism Reviewed (exh. cat. by D. Ades,
ACGB, 1978)

Permanence du regard surréaliste (exh. cat., ed. E. Jaguer;
Lyon, Espace Lyon. A. Contemp., 1981)

Paul Eluard et ses amis peintres (exh. cat., ed. G. Viatte
and S. Zadora; Paris, Pompidou, 1982–3)

In the Mind's Eye: Dada and Surrealism (exh. cat., ed.
T. A. Neff; Chicago, IL, Mus. Contemp. A.,
1985)

L'Amour fou: Photography and Surrealism (exh. cat.
by R. Krauss, J. Livingstone and D. Ades, Washington,
DC, Corcoran Gal. A.; London, Hayward Gal.; 1985);
Fr. trans. as *Explosante-fixe: photographie et
le surréalisme* (exh. cat., Paris, Pompidou,
1985)

*Angels of Anarchy and Machines for Making Clouds:
Surrealism in Britain in the 1930s* (exh. cat. by A.
Robertson, M. Remy, M. Gooding and T. Friedman,
Leeds, C.A.G., 1986)

*La Planète affolée—surréalisme—dispersion et influences,
1938–1947* (exh. cat., ed. G. Viatte; Marseille, Cent.
Vieille Charité, 1986)

Surrealismen in Danmark, 1930–1950 (exh. cat. by
B. Irve and M. Helm, Copenhagen, Stat. Mus. Kst,
1986)

Surrealism in England, 1936 and After (exh. cat. by T. del
Renzio, D. Scott and M. Remy, Canterbury, Kent Inst. A.
& Des., Herbert Read Gal., 1986)

La Femme et le surréalisme (exh. cat., ed. E. Billeter and J.
Pierre; Lausanne, Pal. Rumine, 1987–8)

I surrealisti (exh. cat. by A. Schwarz, Milan, Pal. Reale,
1989)

El surrealismo entre viejo y nuevo mundo (exh. cat. by J.
M. Bonet and others, Las Palmas de Gran Canaria,
Cent. Atlantic. A. Mod., 1989–90)

Anxious Visions, Surrealist Art (exh. cat. by S. Stich,
Berkeley, U. CA, A. Mus., 1990)

André Breton: La Beauté convulsive (exh. cat., ed. A.
Angliviel de la Beaumelle, I. Monod-Fontaine and C.
Schweisguth; Paris, Pompidou, 1991)

Surrealism: Revolution by Night (exh. cat., ed. M.
Lloyd, T. Gott and C. Chapman; Canberra, N.G.;
Brisbane, Queensland A.G.; Sydney, A.G. NSW;
1993)

DAWN ADES, with MATTHEW GALE

Sydney Group

Australian group of artists, founded in 1945 and
active until *c.* 1957. Their intention was to reverse
the obvious decline of the New South Wales
Society of Artists, which had become a repository
for the most conservative forces in the Sydney art
world. Those exhibiting at the first group exhibi-
tion included the painters Jean Bellette (*b* 1909)
and her husband Paul Haeflinger (1914–82), David
Strachan (1919–70), Francis Lymburner (1916–72),
Eric Wilson (1911–46), Wallace Thornton (*b* 1915),
Wolfgang Cardamatis (*b* 1917), Justin O'Brien,
Geoffrey Graham and the sculptor Gerald Lewers
(1905–62). Bellette, a prominent female artist in
what was still a prevalently male domain, exer-
cised considerable polemical skill in advancing
the aims of the group, while developing as a
fine neo-classicist; Haeflinger shared in forcing
through change. There was little else in common
between Strachan, Lymburner, Wilson, Thornton,
Lewers, Graham and the Berlin-born Cardamatis,
other than a high professionalism and a degree
of figurative work that represented the non-
abstract traditions of early modernism and a
respect for historical development in other parts
of the world. Strachan favoured still-life or
figure painting; Wilson was a landscape painter
who admired Purism and the work of Amédée
Ozenfant; and O'Brien is thought to have been
influenced by Byzantine traditions. A continuing
restlessness with the inhibitions of the post-war
cultural climate led Bellette and Haeflinger to
move to Europe in 1957, precipitating the group's
demise.

□

Sydney 9

Australian group of artists active between 1960
and 1962. The principal members were John Olsen,
Stanislaus Rapotec (*b* 1913), Leonard Hessing (*b*
1931), William Rose (*b* 1930), Clement Meadmore,
Eric Smith (*b* 1919), Peter Upward (*b* 1932), Hector
Gilliland (*b* 1911) and Carl Olaf Plate (1909–77). The
group held two major exhibitions, in Sydney and
Melbourne (1961). At the opening exhibition Olsen
exhibited *Journey into You Beaut Country* (1961;

Melbourne, N.G. Victoria). Rapotec had abandoned figurative work in the 1950s and was by 1960 the leading abstract painter in Sydney. Smith, Meadmore and Rose also had a firm commitment to non-figurative art, although Rose gave priority to a compositional method linking structure and concept. Upward, following a visit to the USA, became an action painter but was also influenced by Asian calligraphy, producing very large black-and-white paintings (e.g. *June Celebration*, 1961). Gilliland, who was based in Tasmania, deployed large geometrical forms in an abstract mode. Plate was initially influenced by André Masson, but when exhibiting with the group appeared as a fully-fledged Abstract Expressionist. The Sydney 9, which included several Melbourne-based artists, represented a wider spectrum of Australian artists than the Antipodean group, but in some ways both groups were simply part of a larger international movement. Indeed the lack of a clear and distinct intellectual position led to the Sydney 9's demise. Despite evident talent, not least that of Olsen, the group were chastened to learn that Clement Greenberg expressed a greater admiration for the work of the Antipodeans.

JANET SPENS

Sydney school

Term referring to buildings designed by a number of architects active in Sydney between *c.* 1953 and 1970. It was first coined in 1962 and subsequently popularized in critical writings by Robin Boyd and Jennifer Taylor. The term is used predominantly for domestic architecture and particularly for buildings designed to be in sympathy with bush-land sites. There were three principal, sometimes contradictory, approaches. The first was a light-weight, open post-and-beam architecture comple-menting nature in a Miesian or Japanese manner, as seen in Sydney Ancher's own house (1958) at Coffs Harbour and in Russell Jack's work. Bill and Ruth Lucas pushed this lightweight idiom to its limit in their house (1957) at Castlecrag, an open platform of steel, timber and glass can-tilevered from four slender columns, intended to minimize physical damage to the site. The second approach was an earth-hugging architecture drawing from Frank Lloyd Wright's organic theo-ries, for example Bruce Rickard's Usonian-inspired Cohen House (1959), Middle Cove, and Peter Muller's house (1954) at Whale Beach, where he opened up the living room ceiling to the sky and incorporated tree branches and boulders into the interior. The third approach used such European models as Alvar Aalto, the later work of Le Corbusier and English New Brutalism, notably in houses by Richard Norman Johnson in Chatswood (1963) and Ken Woolley in Mosman (1962). These houses were more cave-like in char-acter, partly in response to Sydney's rocky terrain, and they typically incorporate unequal or mono-pitch roofs. They form by far the most consistent and influential grouping most readily identified with the Sydney school label. Woolley, Don Gazzard and others designed a series of develop-ers' project homes after 1961, which led to the lasting absorption of this idiom into the suburban vernacular.

Public buildings in the style include the C. B. Alexander Presbyterian Agricultural College (1966), Paterson, by Philip Cox and Ian McKay, influenced by nearby colonial homesteads; the Aalto-like Clubbe Hall (1967), Mittagong, by Allen Jack & Cottier; and the Students' Union (1965–9), University of Newcastle, by Ancher, Mortlock, Murray and Woolley, all in New South Wales. Sydney school architects delighted in materials in their raw state, especially exposed brickwork and stained, sawn timber, inside and out. The sensitive adjustment of buildings to bushland sites contin-ued in larger complexes, for example the Kuring-gai College of Advanced Education (1976), Sydney, with its off-form concrete, Brutalist forms, designed by the New South Wales Government Architect's office. The Sydney school was not an isolated phenomenon. In other states architects were producing work with similar concerns. Some of these developments were independent, but there is little doubt that critical attention on the Sydney school ensured that it had considerable influence in other cities, including Adelaide, Brisbane and Melbourne.

Bibliography

J. Taylor: *An Australian Identity: Houses for Sydney,*
　　1953–63 (Sydney, 1972, rev. 1984)
S. Fung: 'The Sydney School', *Transition* [Austral.], iv/3
　　(1985), pp. 38–43
J. Taylor: *Australian Architecture since 1960* (Sydney, 1986,
　　rev. 1990)
W. Callister: 'Dealing with the Sydney School: Perspectives
　　on Australian Architecture in the 1950s and 1960s',
　　Transition [Austral.], 21 (1987), pp. 6–12

RORY SPENCE

Writings

K. Jürgen-Fischer: 'Was ist komplexe Malerei?', *Klaus*
　　Jürgen-Fischer (exh. cat., Karlsruhe, Gal. Rottlof, 1963)

Bibliography

Syn (exh. cat., Wiesbaden, Nassau. Kstver., 1967)
Erwin Berchtold (exh. cat. by J. Langner, Mannheim, Städt.
　　Ksthalle, 1988)
Bernd Berner (exh. cat. by S. Meier-Faust and H.-J. Buderer,
　　Mannheim, Städt. Ksthalle; Göppingen, Kstver.; 1991)

□

Syn

German artists' group formed in 1965 in Stuttgart
by Bernd Berner (*b* 1930), Klaus Jürgen-Fischer
(*b* 1930) and Eduard Micus (*b* 1925). They were
joined in 1966 by the painter Erwin Bechtold
(*b* 1925). The driving force behind the group was
Jürgen-Fischer, who had worked on the editorial
staff of *Das Kunstwerk* and had written an existen-
tialist philosophical work *Der Unfug des Seines*
(1955). In 1963 he published a manifesto 'Was ist
komplexe Malerei?' (see 1963 exh. cat.), establish-
ing the theoretical basis of Syn. Its members,
three of whom (Berner, Jürgen-Fischer and
Micus) had studied under Willi Baumeister at the
Kunstakademie in Stuttgart, shared a common
background in abstraction. Their work ranged from
Berner's highly individual colour field paintings
(e.g. *Index of Work 793*, 1961; see 1991 exh. cat.,
p. 38) to Bechtold's hard-edge abstraction, which
combined geometric shapes and amorphous forms
(e.g. *Orgina Organa 66–31*, 1966; Mannheim, Städt.
Ksthalle). The group's purpose was to redefine
the elements and means of painting to enable the
controlled use of often extreme techniques within
the context of an art that was to be seen as self-
referential. These principles were given voice in the
journal *Syn*, edited by Jürgen-Fischer, and eventually
set down in programmatic form in 12 points in the
catalogue of their exhibition at the Nassauischer
Kunstverein, Wiesbaden, in 1967. The group's mem-
bership was not fixed and the core members were
joined from time to time by other non-figurative
artists, such as Kumi Sugai and Wilhelm Loth. The
group stopped exhibiting together in 1970.

Synchromism

Style of painting based on the theory that colour
provides the basis for both form and content. It
was conceived in Paris shortly before World War I
by Morgan Russell and Stanton Macdonald-Wright.
It was Russell's idea that paintings could be
created based on sculptural forms interpreted two-
dimensionally through a knowledge of colour
properties. Synchromist paintings, stressing an
emphasis on colour rhythms, were composed of
abstract shapes, often concealing the submerged
forms of figures, for example *Synchromy in Blue*
(1916; New York, Whitney) by Macdonald-Wright.
The two artists first attracted attention at the
Neue Kunstsalon in Munich in June 1913. Their
second exhibition of Synchromist painting was at
the Bernheim-Jeune gallery in Paris from October
to November 1913.

Both Russell and Macdonald-Wright had
attended the classes held by Ernest Percyval Tudor-
Hart (1873–1954) in Paris; he taught them colour
theory through his own musical system of colour
harmony based on a purely psychological rather
than a physical group of equivalents. Russell's
ambition to invent a new and influential style of
modern painting accompanied by manifestos was
prompted by his visit to the Futurist exhibition
at the Bernheim-Jeune gallery in February 1912.
In the catalogue of their exhibition in Munich,
Russell and Macdonald-Wright competitively
attacked the Futurists for 'subordinating the static
element in favor of movement'.

Synchromist paintings, such as *Abstraction on
Spectrum (Organization No. 5)* (1914; Des Moines,

IA, A. Cent.) by Macdonald-Wright, were often compared with the Orphist paintings by Robert Delaunay and Sonia Delaunay. In fact, years later Sonia Delaunay claimed to have invented the term. She did employ the phrase 'représentation synchrome' as early as 1913, while Robert Delaunay referred to 'action synchromique' in his article 'La Lumière', written in 1912 but first published in translation in *Der Sturm* in early 1913. The first use of the term 'Synchromism', however, appears to be Russell's reference in a notebook of October 1912, where he emphasized the importance of 'forms, spaces or volumes'; this aspect of Synchro-mism related to Cubism, and an awareness of Cubism seems very apparent in works such as *Synchromy in Orange: To Form* by Russell. The Delaunays were more interested in the simultaneous perception of luminous coloured light, while the Synchromists stressed using colour to express form.

The first American exhibition of Synchromism was held at the Carroll Galleries, New York, in March 1914. The promotion of Synchromism in the USA was orchestrated by Willard Huntington Wright, the brother of Stanton Macdonald-Wright, whose critical writings attacked other styles of modern art. He was instrumental in the committee that was responsible for the organization and catalogue of the *Forum Exhibition of Modern American Painters* in March 1916. Among the 15 artists who participated along with Russell and Macdonald-Wright, several had briefly come under the influence of Synchromism. This was most apparent in the work of Thomas Hart Benton and Andrew Dasburg (1887–1979), both of whom painted abstractions for just this brief period. Indeed, even Russell and Macdonald-Wright abandoned this colourful style of abstract painting and returned to representation, although after Russell's death in 1953, Macdonald-Wright resumed painting Synchromies.

Writings

Ausstellung der Synchromisten Morgan Russell, S. Macdonald-Wright (exh. cat. by M. Russell and S. Macdonald-Wright, Munich, Neue Kstsalon, 1913)

Les Synchromistes S. Macdonald-Wright et Morgan Russell (exh. cat. by S. Macdonald-Wright and M. Russell, Paris, Bernheim-Jeune, 1913)

Bibliography

W. Huntington Wright: 'Impressionism to Synchromism', *Forum*, 1 (1913), pp. 757–70

—: *Modern Painting: Its Meaning and Tendency* (New York, 1915)

—: 'Synchromism', *Int. Studio*, lvi (1915), pp. xcvii–c

W. C. Agee: *Synchromism and Color Principles in American Painting: 1910–1930* (New York, 1965)

G. Levin: 'The Tradition of the Heroic Figure in Synchromist Abstractions', *A. Mag.*, li/10 (1977), pp. 138–42

—: *Synchromism and American Color Abstraction, 1910–1925* (New York, 1978)

GAIL LEVIN

Systems art

Term loosely applied to art produced by means of a systematic or highly organized approach to an image or concept. It is often manifested by repetition, series, simplification and progressive variation. Other related terms include systemic or systematic painting, one-image or serial art. It is perhaps rooted in Cubism and its exponents' objective of exploring the notion of painting as its own independent system. Systems art was further explored in Constructivism. Artists who may be associated with the term include Josef Albers, Donald Judd, Carl André, Sol LeWitt, Gerhard Richter, Mario Merz, Kenneth Martin and Mary Martin, among many others.

Bibliography

Serial Imagery (exh. cat. by J. Coplans, Pasadena, CA, A. Mus., 1968)

Systems: Works by 12 Artists (exh. cat. by S. Bann, London, Whitechapel A.G.; U. Manchester, Whitworth A.G.; Sheffield, Graves A.G.; Birmingham, A.G.; and elsewhere; 1972–3)

E. Chaplin: 'Social Science and Systematic Constructivism: 23 Systematic Constructive Artists, a Methodological Experiment', *Constr. Forum*, 5 (1987), pp. 2–26

□

Szentendre colony

Hungarian artists' colony founded in 1928 in Szentendre on the Danube Bend near Budapest. Its

founder-members had all been pupils of István Réti, a member of the Nagybánya colony and, though designed as a centre for the creation of a national art, it soon incorporated an eclectic variety of styles, from Neo-classicism to Surrealism. Its more interesting developments came from the influence of such international movements as Constructivism and Surrealism, although in both cases these received a peculiarly Hungarian interpretation. Jenő Barcsay joined soon after the foundation of the colony and later arrivals included Antal Deli (1886–1960), Miklós Göllner (b 1902), Pál Milháltz (b 1899), János Kmetty and Vilmos Pelrott-Csara (1880–1955). In addition to the artists in the colony itself, there was an equally significant number who worked in the town either permanently or in the summer, such as Béla Czóbel, Lajos Vajda and Imre Amos.

Among the variety of styles present in the Szentendre colony was a strong Post-Impressionist tendency, most notably represented by Czóbel. His *Back of a Nude* (c. 1930–35; priv. col., see Fehér, pl. 32), for example, was characteristically painted using areas of largely unmodelled, dark colours. Barcsay adopted a more modern style in his work and was initially influenced by Cubism, as shown in *Hilly Landscape* (1934; Budapest, N.G.), which used Cubist fragmentation and flattening of space. After 1945 a clear constructivist influence was evident in Barcsay's work, and a Constructivist grouping grew up around him at the colony. Typical of this style is *Street* (1947; Budapest, N.G.), in which Barcsay built up the townscape from simple geometrical forms. However, this Hungarian form of Constructivism was distinguished from its Western counterpart by its concentration on traditional subject-matter and a continued reliance on easel painting.

The third important artistic strand in the Szentendre school is represented by the work of Vajda and Amos. Both of these artists adopted an approach to reality moulded by Surrealism, but, rather than exploiting automatist techniques, they derived their subject-matter from the Hungarian environment. Vajda drew his style from Cubism and Constructivism, yet his *Houses at Szentendre with Crucifix* (1937; priv. col., see Németh, pl. 93), for example, is rooted in the native religious tradition and the landscape of Szentendre, while using an associative, Surrealist manipulation of elements. Amos's style owed more to Post-Impressionism, although *The Dreamer* (1938; priv. col., see Németh, pl. XXVIII) used a subject dear to Surrealism. The influence of Surrealism is more apparent in his fantastic drawing *Yellow Patch* (1939; priv. col., see Németh, p. 125). The Szentendre colony was an important site for the development of Constructivism and Surrealism in Hungarian art, and, although it continued beyond this, it was at its most vital up to the 1940s.

Bibliography

L. Németh: *Modern Art in Hungary* (Budapest, 1969), pp. 118–30

Z. D. Fehér and G. O. Pogány: *Twentieth-century Hungarian Painting* (Budapest, 1975)

☐

Szolnok colony

Hungarian painters' colony at Szolnok, c. 100 km south-east of Budapest. It began with regular visits to Szolnok by the Austrian painter August von Pettenkofen for over 30 years from 1851, to paint lowland landscapes, the market and gypsies. He was followed by a number of Austrian, German and Hungarian painters, mostly from the Parisian circle of Mihály Munkácsy, such as Gyula Aggházy (1850–1919) and Lajos Deák-ébner. Szolnok was frequented primarily by *plein-air* and genre painters. From 1875 to 1887 Deák-Ébner worked between Szolnok and Paris, painting some landscapes but mostly village genre scenes. From the mid-1870s there developed at Szolnok a new socially conscious, Realist style of genre painting, significant examples of which are Lajos Deák-Ébner's *Men Towing a Barge* (c. 1885; Budapest, N.G.) and the work of Adolf Fényes, and this heralded a new era in the colony. Capitalizing on such promising beginnings, the Szolnok Art Association was founded in 1901, and artists' studios were built by the following year. The official application for establishing an artists' colony

was signed by János Vaszary (1867–1939), Károly Kernstok and László Mednyánszky, among others. The colony's houses were given to artists already working there, such as Fényes and Sándor Bihari (1855–1906), and to newcomers. The Szolnok artists, like their counterparts in the Nagybánya colony, painted *en plein air*, especially in the early 1900s, and were interested in subjects offered by the lowlands environment and its people. From the 1910s their work became more decorative.

Sándor Bihari spent considerable time at Szolnok. He was a genre painter mostly concerned with the problems of large-scale *plein-air* figure compositions (e.g. *Preparing Supper*, 1886; Budapest, N.G.). At the beginning of the century Dániel Mihalik (1869–1910), Lajos Szlányi (1869–1949) and Ferenc Olgyay (1872–1939) shared similar tastes and artistic goals and painted in bright, lively colours. Lajos Zombory (1867–1933), while also undertaking architectural studies, remained a member of the colony until his death. Izsák Perlmutter (1866–1932) worked there frequently; his landscapes and genre paintings are exceptional in their expressive use of colour, as in *Girl Sitting in a Room* (Budapest, N.G.). József Koszta, one of the most individual artists of the lowlands, also worked at Szolnok. The most outstanding personality of the colony, however, was Adolf Fényes. Influenced by Weimar *Arme Leute Malerei*, he painted many significant works there. After the turn of the century his work became brighter and more decorative, and from 1913 he turned to biblical subjects. Fényes exerted a great influence on the other artists working in the colony.

From 1905 important educational work began at Szolnok when several young artists studied there on state scholarships. The Academy of Fine Arts in Budapest often sent its pupils to Szolnok for summer practice, during which Fényes taught figure drawing, Szlányi taught landscape painting and Zombory taught animal painting. Between the world wars artists at the colony included Fényes and Vilmos Aba-Novák, who painted some expressive and dynamic works there (e.g. *Pot Sale*; Szolnok, Damjanich Mus.). Several important exhibitions were held in Szolnok in 1924 and 1927, and in the latter year Szolnok artists also exhibited in Budapest. In 1933 a permanent exhibition hall was opened in Szolnok, and the colony continued its artistic and educational activities from then on.

Bibliography

J. Némethy: 'Szolnok és művészete' [Szolnok and its art], *OMKT évkönyve* (1929), pp. 25–39

L. Végváry: *Szolnoki művészet, 1852–1952* [Art in Szolnok, 1852–1952] (Budapest, 1952)

M. Egri: *A szolnoki művésztelep* [The Szolnok artists' colony] (Budapest, 1977)

A szolnoki művésztelep jubiláris kiállítása, 1902–1977 [Jubilee exhibition of the Szolnok artists' colony, 1902–1977] (exh. cat., foreword G. Kaposváry and G. Ö. Pogány; Szolnok, Damjanich Mus.; Budapest, N.G.; 1977–8)

KATALIN GELLÉR

Tachism

Term often used interchangeably with ART INFORMEL or Lyrical Abstraction and applied to the movement in abstract art that flourished in Europe, especially in France, in the late 1940s and 1950s. As early as 1899 Félix Fénéon referred to the work of the Impressionists as 'tachiste' to distinguish it from the more studied technique of the Neo-Impressionists, and in 1909 Maurice Denis applied the term to Fauvism, but in its narrower sense it came into use only in the 1950s: the French writer Pierre Guégan spoke of Tachist painting in 1951, while another French writer, Charles Estienne, set a precedent in 1954 for the application of the term to the technique employed by certain artists involved with *Art informel*. Derived from the French word signifying a blot, stain or mark, the term emphasizes the spontaneous gestural quality that characterizes much of this work. It thus refers more specifically to the branch of *Art informel* closest in spirit and technique to Automatism, in that the painted marks are presented as virtually unmediated by the conscious mind, and as a direct counterpart to the work of American Abstract Expressionists such as Jackson Pollock, Franz Kline and Sam Francis. Though often used more generally, thus defined the term best describes the work of artists such as Hans Hartung, Wols), Georges

Mathieu, Henri Michaux (see fig. 5) and Pierre Soulages. Mathieu, for instance, adopted a gestural, calligraphic style in works such as *Capetians Everywhere* (1954; Paris, Pompidou). By contrast other painters associated with *Art informel*, for example Jean Bazaine, Alfred Manessier and Serge Poliakoff, favoured a more controlled approach both in their composition and in their use of colour.

Bibliography

G. Mathieu: *Au delà du Tachisme* (Paris, 1963)
W. Haftmann and others: *Abstract Art Since 1945* (London, 1971)
For further bibliography *see* Art INFORMEL.

□

Taller de Gráfica Popular

Printmaking workshop in Mexico City. It was founded in 1937 by the Mexican printmakers Leopoldo Méndez, Pablo O'Higgins and Luis Arenal on the dissolution of the plastic arts section of the Liga de Escritores y Artistas Revolucionarios, which had operated from 1934. Méndez was its first director, holding that position until 1952. A number of other artists joined this original core, including Raúl Anguiano, Alfredo Zalce, Jean Charlot, Alberto Beltrán and Mariana Yampolsky.

Adopting a form of social realism in response to the conditions under the government of General Lázaro Cárdenas (1934–40), the workshop's members, who worked as a collective and most of whom belonged to the Mexican Communist Party, maintained a resolutely political stance. In addition to woodcuts and linocuts they produced posters, pamphlets and magazine illustrations in support of trade unions or denouncing Fascism. Among the foreigners who collaborated with the Taller was Hannes Meyer, who directed their publishing house, La Estampa Mexicana, while living in Mexico City from 1939 to 1949. Their most important publications included *Estampas de la Revolución mexicana*, Juan de la Cabada's *Incidentes melódicos del mundo irracional* (1946), illustrated by Méndez, and *El sombrerón* by Bernardo Ortiz. The Taller de Gráfica Popular established an international reputation through its many exhibitions abroad and through the establishment of associated workshops elsewhere in Mexico (in Uruapan and Pátzcuaro), in the USA (New York and San Francisco), Brazil and Italy.

Bibliography

M. C. García Hallat: *Ubicación social y artística del Taller de Gráfica Popular* (MA thesis, Mexico City, U. Iberoamer., 1970)
J. Gutiérrez, N. Leonardini and J. Stoopen: 'La época de oro del grabado en México', *Hist. A. Mex.*, 101 (1982)
El Taller de Gráfica Popular: *Sus findatores (Guadalajara, 1989)*
D. Ades: *Art in Latin America: The Modern Era, 1820–1980 (London, 1989), pp. 181–94*
Green, J. R.: 'Taller de Gráfica Popular ', Lat. Amer. A. Mag., iv/2–3 (1992), pp. 65–7; 85–7
El Taller de Gráfica Popular en México, 1937–1977 *(exh. cat. by H. Prignitz, Mexico City, Inst. N. B.A., 1992)*
A. A. Casas: 'Graphic Design in Mexico: A Critical History', Print *(Jan/Feb 1997), pp. 98–104*
D. Craven and K. S. Howe: A Partisan Press with Revolutionary Intent: The Work and Legacy of TGP *(in preparation)*

LEONOR MORALES

Taller Torres García [Torres García Studio]

Uruguayan group founded in Montevideo in 1944 by Joaquín Torres garcía. It was conceived by the artist as part of an exhaustive programme of art education initiated by him on his return to Uruguay in 1934 after living in Europe for 43 years. The group, which organized mixed exhibitions and published its own official magazine, *Removedor*, until it disbanded in 1963, included among its members Torres García's sons Augusto Torres (1913–92) and Horacio Torres (1924–76), along with Julio Alpuy (*b* 1919), José Gurvich (1927–74), Francisco Matto (1911–95), Gonzalo Fonseca and Manuel Pailós (*b* 1918). Guided by their direct contact with Torres García, who directed them more in terms of ideas than of techniques, they were instrumental in establishing abstract art and modernism in Uruguay. As the membership included not only other artists but

also sympathetic intellectuals such as the poet Esther de Cáceres, the psychiatrist Alfredo Cáceres and the writer Juan Carlos Onetti, their influence stretched beyond the visual arts to the cultural life of the country in general.

Writings

Removedor, 1–28 (1944–63)

Bibliography

J. P. Argul: *Las artes plásticas del Uruguay* (Montevideo, 1966); rev. as *Proceso de las artes plásticas del Uruguay* (Montevideo, 1975)

F. García Esteban: *Artes plásticas del Uruguay del siglo XX* (Montevideo, 1968)

La escuela del Sur (exh. cat., ed. M. C. Ramirez; Madrid, Mus. N. Cent. A. Reina Sofía, 1991)

C. A. Petrella: *La propuesta educativa del Taller Torres García, 1942–1949 (Montevideo, 1995)*

ANGEL KALENBERG

Team Ten [Team 10; Team X]

International group of architects that emerged from CIAM (Congrès Internationaux de l'Architecture Moderne) in 1956. The group developed from the committee of younger members of CIAM, including Jacob Bakema, Georges Candilis, Rolf Gutmann, William Howell (1922–74), Alison and Peter Smithson, Aldo van Eyck, John Voelcker and Shadrach Woods, who were responsible for preparing the agenda for CIAM X (1956) at Dubrovnik (*see* CIAM). In place of the generalized, mechanical and rigid functionalism of the Athens Charter evolved at CIAM IV (1933), the members of Team Ten wished to promote individual concepts of architectural and social identity, scale and meaning—ideas that they had seen realized in concrete terms in Moroccan housing projects by ATBAT-Afrique presented at CIAM IX (1953), Aix-en-Provence, by Candilis and Woods. Following CIAM IX and the recognition of a shared way of thinking, Bakema, Hovens Greve, the Smithsons, Voelcker, D. van Ginkel and van Eyck met at Doorn in January 1954 to develop their ideas; these were formalized in the Doorn Manifesto, which emphasized the importance of human association in the urban environment and the necessity for considering every community in relation to its environmental context. In 1954 the younger group was established as the CIAM X Committee (calling itself Team Ten), and it adopted the Doorn Manifesto in its draft proposals, approved by Le Corbusier in 1955. At the CIAM X meeting, however, the gulf between the older generation and the new became apparent, and the old constitution of CIAM was broken up. A further meeting of CIAM was held in 1959 at Otterlo, organized by Bakema, Ernesto Nathan Rogers, Alfred Roth, Voelcker and André Wogensky (*b* 1916), from which the older generation—except for Roth—were conspicuous by their absence. Although only one third of the architects present at Otterlo belonged to what later came to be known as the Team Ten Family, the direct criticism directed against the 'old' CIAM by this minority was sufficiently effective to result in the formal dissolution of CIAM at the meeting.

The Team Ten Family, whose members practised independently, functioned without a hierarchical structure. While its composition varied over the years, other members included José Antonio Coderch, Giancarlo de Carlo (*b* 1919), Ralph Erskine, Guillermo Jullian de La Fuente, Gier Grung, Amancio Guedes, Charles Pologni, Manfred Schiedhelm, Jerzy Sołtan and Stefan Wewerka (*b* 1928). Important meetings of Team Ten were held at Royaumont (1962), with guests including James Stirling and Christopher Alexander, and Urbino (1966), with guests including Balkrishna V. Doshi, Herman Hertzberger, Hans Hollein, Joseph Rykwert and Oswald Mathias Ungers. The principles of Team Ten were 'anti-heroic' compared to the 'heroic' age of the pioneers of the Modern Movement, although Le Corbusier remained a powerful influence for its members (*see* BRUTALISM). Team Ten's approach was essentially humanistic, concerning association and the growth and change of communities; this was seen in such concepts as cluster housing, as in the plan for Toulouse-le-Mirail (1964–77), while the Smithsons' Robin Hood Gardens housing estate (1972), London, incorporated 'streets in the air' that were intended

to reflect the community atmosphere of traditional streets of terraced housing. Members of Team Ten also believed that architects should offer differentiated forms to express the needs of a building's occupants or of a community, seen particularly in the work of van Eyck, for example the Burgerweeshuis (1957–60).

Team Ten continued to meet irregularly until 1981, although several of its surviving members remained active after that time. The discussions they had initiated marked the beginnings of a new pluralism in Modernism. They were, in comparison with other platforms for architectural debate, so well and eloquently argued that the majority of innovative viewpoints that formed a polemic with the ideas of Team Ten can be traced back to it—either directly, in the work of Stirling, Hollein, Ungers and Alexander, or indirectly, in the work of Robert Venturi and Aldo Rossi. The teaching activities of many of its members and its publication, *Team 10 Primer* (1968), which first appeared in *Architectural Design* (1962), were enormously influential on the next generation of students.

Writings

A. Smithson, ed.: *Team 10 Primer* (London, 1968)

Bibliography

Archit. Des., xxx (1960) [whole issue]

O. Newman, ed.: *CIAM '59 in Otterlo* (Stuttgart, 1961)

'The Work of Team 10', *Archit. Des.*, xxxiv (1964) [whole issue]

'Team 10 + 20', *Archit. Aujourd'hui*, 117 (1975) [special issue], pp. 1–66

'Team 10 at Royaumont', *Archit. Des.*, xlv/11 (1975), pp. 664–89

A. Smithson, ed.: *The Emergence of Team 10 out of CIAM* (London, 1982) [facs. copies of contemp. doc.]

JOS BOSMAN

Ten American Painters [The Ten]

Group of American painters who exhibited together from 1898 to 1918. In 1897 ten New York- and Boston-based artists withdrew from the Society of American Artists, the most progressive art organization of the period. Their common interest was not the promotion of a new art, but rather the improvement of the quality of their exhibitions. The Ten—a shortened version of the name given to them by the press—was organized by John H. Twachtman, Julian Alden Weir and Childe Hassam. The other members were Frank Weston Benson, Joseph Rodefer De Camp, Thomas Dewing (1851–1938), Willard Leroy Metcalf, Robert Reid (1862–1929), Edward E. Simmons (1852–1931) and Edmund C. Tarbell. There was in fact a total of 11 members, for William Merritt Chase was asked to join when Twachtman died.

The group was usually identified with Impressionism, since its organizers ranked as America's leading Impressionists, and most of its other members painted in an Impressionist style. Dewing, however, was not a true Impressionist, and Simmons and Reid were major muralists of the period. All the members were well established and some highly successful.

The Ten decried the overcrowded walls of the established annual exhibitions, feeling that their paintings would be better seen in smaller shows where all the exhibits were of a similar, harmonious character. Their desire for an installation that would inspire an air of quiet contemplation derived from ideas initiated by Whistler and artists of the Aesthetic Movement, who believed that principles of good taste should be applied to the display of paintings. In the Ten's exhibitions each artist was allocated ample wall space, and all paintings were hung so that they could be easily seen; even the colour of the walls was chosen to be compatible with the exhibits. The group exhibited annually in New York and occasionally in other American cities. All exhibitions were selected by the members themselves, and no prizes were awarded.

Bibliography

A. Hoeber: 'The Ten Americans', *Int. Studio*, xxxv/137 (1908), pp. xxiv–xxix

K. Haley: *The Ten American Painters: Definition and Reassessment* (diss., Binghamton, SUNY, 1975)

W. A. Gerdts: *American Impressionism* (New York, 1984), pp. 171–86

ILENE SUSAN FORT

Tendenza

Term applied to an architectural stylistic tendency that emerged in the late 1960s in several Italian and Swiss universities under the influence of Aldo Rossi, Giorgio Grassi (*b* 1935) and Massimo Scolari (*b* 1943) among others. Although *Tendenza* never became an official movement, its theoretical principles were set out in three main texts by Rossi (1966), Grassi (1967) and Ezio Bonfanti (1937–73) and others (1973), all of which articulate a position in continuity with pre-World War II Italian and European Rationalism and in contradiction to populist or High Tech architecture. The earliest use of *Tendenza* as a proper stylistic term was in 1973 in Scolari's essay, 'Avanguardia e nuova architettura' (see Bonfanti and others). The *Tendenza* was brought to international attention by Rossi's work for the XV Triennale in Milan (1973), whereupon the term became increasingly used as a generic label and was ultimately repudiated by its original users.

The *Tendenza* stressed the relative autonomy of architecture as a formal discipline based on rules of design derived from the study of the city as an artefact and aimed to develop a method of typological and morphological analysis that might provide norms for new building and planning. In line with the work of French urban geographers such as Maurice Halbwachs, it postulated an 'ontology' of cities, based on a distinction between primary elements or conspicuous monuments, and a uniform residential fabric; this concept was similar to the Anglo-American distinction between 'foreground' and 'background' buildings. The *Tendenza* rejected Functionalism as well as other operational definitions of architecture, seeking instead formal and typological structures beyond the particularities of site or programme. This approach involved a return to academic theories of type and model set forth by Antoine Quatremère de Quincy; it was also seen as a way to resist the commercialization of architecture by the professional class, and indeed most of the group's adherents built relatively little. However, the *Tendenza*'s insistence on the autonomy of architecture was meant to assert its relative freedom from negative political and economic forces and did not imply a formalist Art for Art's Sake position. The *Tendenza* tried to articulate a neo-Marxist critique of deterministic models of base and superstructure, and in the context of the social unrest of the late 1960s it found many sympathizers, particularly among students. In practice the *Tendenza* developed an effective if rudimentary syntax, based on a limited formal repertory and strict rules of composition. The best-known executed works include Rossi's Gallaratese 2 housing complex near Milan (1967–73) and San Cataldo cemetery, Modena (from 1971), and Grassi's student residence complex, Chieti (from 1976).

Bibliography

A. Rossi: *L'architettura della città* (Padua, 1966; Eng. trans., Cambridge, MA, 1982)

G. Grassi: *La costruzione logica dell'architettura* (Padua, 1967)

E. Bonfanti and others: *Architettura razionale* (Milan, 1973), pp. 153–87

Controspazio, 5–6 (Dec 1973) [special issue devoted to the XV Milan Triennale]

See also RATIONALISM.

LIBERO ANDREOTTI

Tryavna school

Art school in Tryavna, northern Bulgaria, that flourished from the end of the 17th century to the end of the 19th. The organization of the educational process was medieval in character and skills and traditions were handed down from father to son, so that whole families were occupied with art. The first Tryavna artists worked in the environs of the neighbouring town of Tărnovo, the last capital of the independent Bulgarian state. They were the heirs of medieval Bulgarian orthodox traditions, which they developed and modernized. Representatives of the school worked in religious painting, wood-carving and architecture over a wide area of north and south-east Bulgaria and Romania. In Tryavna several extensive families were occupied with religious painting, including the Vitanov (e.g. Vitan Tsonyuv (*d* 1820s): *Jesus Christ*, icon, 1748, Sofia, N.A.G.; and Simeon

Tsonyuv (*c.* 1790–1853): *St Nicolas*, icon, 1798, Sofia, N.A.G.), Zakhariev (e.g. Krustyo Zakhariev (*c.* 1785–1850): *St Pachomios*, icon, 1824; Tsanyu Zakhariev (*c.* 1790–1886); and Zakhari Tsanyuv (*c.* 1816–86)) and Minev (e.g. Peter Minev (*c.* 1800–59) and Nikola Genkov (*b c.* 1825)) families. They confined themselves almost exclusively to icons, creating a distinct style using light, warm colours to produce calm, clear faces and balanced movements of the figures, and using ornament frugally. Tryavna church wood-carving (e.g. Church of St John the Baptist, Gabrova, see Drumev, figs 40, 51; Church of the Holy Archangels, Tryavna, see Drumev, figs 2–10; and Church of the Prophet Elijah, Sevlievo, see Drumev, figs 52–72) developed during the 18th and 19th centuries, the artists producing iconostases and church furniture, and in some cases even building wooden churches. Their characteristically symmetrical compositions featured deeply cut and abundant plant motifs, which sometimes included birds and animals and only rarely religious scenes. Some compositions show elements of Baroque, Rococo and Empire style. Most of the Tryavna builders were also sculptors. They decorated the churches and bridges with stone reliefs and the interiors of the houses with wood-carvings.

Bibliography

D. Drumev: *Trevnensko rezbarsko izkustvo* [Tryavna wood-carving] (Sofia, 1962)

A. Bozhkov: *Trevnenska zhivopisna shkola* [Tryavna painting school] (Sofia, 1967)

A. Bozhkov, ed.: *Trevnenska khudozhestvena shkola* [Tryavna art school] (Sofia, 1985)

IVANKA GERGOVA

291

American art gallery founded in New York in 1905 by Alfred Stieglitz and Edward J. Steichen. It was located at 291 Fifth Avenue and soon came to be known simply as 291 ('Two ninety-one').The gallery at 291 was an important early centre for modern art in the USA. Originally called the Little Galleries of the Photo-Secession, it was founded to promote photography as an independent art form. In their first exhibition, Stieglitz and Steichen featured the work of the PHOTO-SECESSION group. However, their concentration on photography was brief, and they soon broadened the scope of the gallery to include exhibitions of avant-garde painting, sculpture and graphic arts.

Aptly described by Marsden Hartley as 'the largest small room of its kind in the world', the gallery became a pioneering force in bringing European modern art to American attention, even before the Armory Show of 1913. Following the first American exhibition of Auguste Rodin watercolours (1908), similar début exhibitions were held for Henri Matisse (1908), Toulouse-Lautrec (1909), Henri Rousseau (1910), Paul Cézanne (1911), Pablo Picasso (1911), Francis Picabia (1913), Constantin Brancusi (1914) and Gino Severini (1917). Equally important was Stieglitz's promotion, through the gallery, of contemporary American artists. He staged the first exhibitions for Pamela Coleman Smith (1877–1925; exhibition in 1907), John Marin (1909), Alfred H. Maurer (1909), Arthur B. Carles, Arthur G. Dove, Marsden Hartley and Max Weber (a group show of 1910), Abraham Walkowitz (1880–1965; exhibition in 1912), Oscar Bluemner (1915), Elie Nadelman (1915), Georgia O'Keeffe (1916) and Stanton Macdonald-Wright (1917). Stieglitz also organized at the gallery what were possibly the first exhibitions of children's art in 1912 and, in 1914, of African sculpture as art rather than anthropological material. (In 1915–16 the gallery gave its name to the short-lived Dadaist magazine *291*, edited by Stieglitz and emulated later in the title of Picabia's magazine, *391*). Over 70 exhibitions had been held at 291 by 1917, when the building's scheduled demolition forced Stieglitz to close it down.

Bibliography

R. Doty: *Photo-Secession: Photography as Fine Art* (Rochester, 1960; rev. as *Photo-Secession: Stieglitz and the Fine Art Movement in Photography*, New York, 1978)

D. Norman: *Alfred Stieglitz: An American Seer* (New York, 1973)

W. Homer: *Alfred Stieglitz and the American Avant-garde* (Boston, 1977)

The Eye of Stieglitz (exh. cat., New York, Hirschl & Adler Gals, 1978)

R. L. Harley: 'Edward Steichen's Modernist Art-Space', *Hist. Phot.*, xiv/1 (Jan–March 1990), pp. 1–22

W. Rozaitis: 'The Joke at the Heart of Things: Francis Picabia's Machine Drawings and the Little Magazine 291', *Amer. A.*, viii, 3–4 (Summer–Fall 1994), p. 42–59

C. McCabe and L. D. Glinsman: 'Understanding Alfred Stieglitz' Platinum and Palladium Prints: Examination by X-ray Flourescence Spectrometry', *Stud. Hist. A.*, li (1995), pp. 70–85

M. B. Parsons: 'Pamela Colman Smith and Alfred Stieglitz: Modernism at 291', *Hist. Phot.*, xx (Winter 1996), pp. 285–92

M. de Zayas and F. M. Naumann, ed.: How, When and Why Modern Art Came to New York *(Cambridge, MA, and London, 1996)*

ROGER J. CRUM

Ugly Realism

Term coined to describe the work of a number of artists working in Berlin in the 1970s. These artists combined the fine draughtsmanship of Otto Dix and George Grosz with an iconographical treatment of the 'ugly': this could be a pimple, a deformed limb or a terrorist with a machine-gun, all rendered with a chilling photographic clarity that pointed to the brutality, shallowness, alienation and perversion of modern urban humanity. The objects and figures presented to the observer in such detail were designed to provoke in him a mixture of disgust, revulsion and distaste as well as a reluctance to recognize what was being portrayed. Many of the artists associated with Ugly Realism were originally members of the artists' co-operative gallery in Berlin, Grossgörschen 35, founded in 1964. In 1966 a rift developed between the expressionist faction represented by K. H. Hödicke, Markus Lüpertz and Koberling and the so-called critical realists, Ulrich Baehr (*b* 1938), Charles Diehl, Wolfgang Petrick and Peter Sorge (*b* 1937), who later made the Galerie Eva Poll home to this new brand of realism.

Petrick's work is typical of the genre: he combined photographic images from medical books with obsessive pencil and paint work to depict the alienation of the individual from an environment created by the machine. Indeed, his figures are weighed down by contemporary gadgets. In a pencil drawing entitled *Den Vansinniga, blyerts, Furgpenna* (1973; see 1978–9 exh. cat., p. 269), an elderly woman with a monstrous foot is marooned in a tiled kitchen with an iron, some pliers and a portable television, her moronic expression indicative of her isolation from her physical surroundings. Klaus Vogelgesang also created work belonging to the ugly realist category. His microscopic rendering of material surfaces such as leather, silk, steel and flesh produced an uncomfortable sensation of artificiality, as in *Good Morning* (1980), where the surfaces and smiles hide a shallowness, unnaturalness and perversion that reflects bleakly on the moral vacuity of contemporary life.

Bibliography

Berlin: A Critical View. Ugly Realism '20s–'70s (exh. cat., London, ICA, 1978–9)

Realism and Expressionism in Berlin Art (exh. cat., Los Angeles, UCLA, Wight A.G., 1980–81)

DEBORAH NASH

Union des Artistes Modernes [U.A.M.]

French group of architects and designers founded in Paris in 1929 and active until 1958. Its founder-members included Charlotte Perriand, Robert Mallet-Stevens, Francis Jourdain, René Herbst (1891–1982) and Jean Puiforcat. During the group's existence membership varied widely. The activities of the U.A.M. may be divided into two periods. Between 1929 and 1939 the group represented a centre of activity for a broad range of tendencies within the French avant-garde, from advanced technology to fine craftsmanship. Although spokespersons for the group at times claimed to be creating a 'movement', in reality the U.A.M. was not doctrinaire; it was essentially devoted to the idea of the unity of the arts common to the ideology of applied arts reform from the mid-19th century. Le Corbusier was a member of the U.A.M., and his Pavillon de L'Esprit Nouveau for the Exposition Internationale des Arts Décoratifs et Industriels Modernes (Paris, 1925), intended as a

mass-produced dwelling, was in keeping with the U.A.M.'s aim to design prototypes for mass production.

The world economic crisis hit France in 1931 at the exact moment when the U.A.M. was formulating its identity and social role, thus limiting important design commissions and forcing the group to become a defender of modernism against bitter attacks by the designer Paul Iribe (1883–1935) and the critics Thiébault-Sisson, Camille Mauclair and Waldemar George, among others. Critics claimed that the clean lines and smooth surfaces of modern architecture and design were responsible for the crisis in French building and decoration industries. In response to these criticisms, the group published *Pour l'art moderne: Cadre de la vie contemporaine* (1934), one of the few manifestos published by French artists in the 1930s. It praised modern art's accessibility, claiming it to be a socially aware art. Despite financial difficulties and attacks by conservative critics, the group organized an important series of exhibitions during the 1930s, both independently (1930–33) and within the Salon d'Automne (1934, 1936) and the Salon de la Lumière (1935). The U.A.M. was also responsible for a steel-and-glass pavilion in the *Exposition internationale des arts et techniques dans la vie moderne* (Paris, 1937).

The second period of the U.A.M.'s activities (1944–58) was animated principally by the architects Georges-Henri Pingusson and André Hermant (1908–78), as well as Herbst and Perriand. Post-war reconstruction fostered a change in the orientation of the U.A.M. towards a stricter emphasis on technology and series production marked by the formation of a new section of the group: Formes Utiles. From 1949 to 1958 the latter's annual exhibitions, held in the Salon des Arts Ménagers, Paris (beginning in 1951), formed the group's principal activity. Each year the group chose a specific task related to domestic equipment, such as 'the Easy Chair' (1957), presenting a selection of the best international design solutions. As the Formes Utiles section progressively dominated the U.A.M. to the exclusion of exhibitions of new works by U.A.M. members, the original ideals of

the group were lost. The U.A.M. became increasingly disunited and disbanded in 1958.

Writings

F. Jourdain: 'Origin and Raison d'Etre of the New Society: The First Salon of the Union des Artistes Modernes at the Pavillon Marsan', *Creative A.*, vii (1930), pp. 368–71

L. Cheronnet: *Pour l'art moderne: Cadre de la vie contemporaine* (Paris, 1934) [manifesto]

'U.A.M.', *Archit. Aujourd'hui* (1937) [issue devoted to the U.A.M. and the exhibition of 1937; articles by R. Mallet-Stevens, F. Jourdain and M. Barret]

G.-H. Pingusson: *Manifeste* (Paris, 1949) [second manifesto]

Bibliography

A. Barré-Despond: *Union des artistes modernes* (Paris, 1987)

Les Années UAM, 1929–1958 (exh. cat., Paris, Mus. A. Déc., 1988)

SUZANNE TISE

Union of Russian Artists [Rus. Soyuz Russkikh Khudozhnikov]

Russian exhibiting society, active from 1903 to 1923. It was set up when the WORLD OF ART group, based in St Petersburg, amalgamated with the Moscow artists who had participated in the Exhibitions of the Work of 36 Artists held in Moscow in December 1901 and 1902. United by their hostility to old forms and the desire for exhibitions that were not controlled by juries, the two groups nevertheless embraced widely divergent aesthetic stances. While former World of Art artists, such as Alexandre Benois and Léon Bakst, attacked the Wanderers, some Moscow artists, including Abram Arkhipov and Konstantin Korovin, continued to exhibit with them. The Union's exhibitions were held in Moscow. Inevitably, they were not stylistically unified: academically lyrical landscapes by Nikolay Klodt (1865–1918) and Arkady Rylov were shown alongside 'impressionist' paintings by Igor' Grabar', 'symbolist' canvases by Viktor Borisov-Musatov, more experimental works by Valentin Serov and Mikhail Vrubel', as well as elegantly decorative pictures by Ivan Bilibin and Konstantin Somov. After the seventh exhibition in 1910 the Union

split precisely because of such aesthetic differences, exacerbated by Benois's review of the show, which praised the St Petersburg artists but castigated the majority of works as 'fussy, tasteless and lifeless'. The Moscow artists remained within the Union, but the St Petersburg artists seceded and began to exhibit again under the name World of Art. By 1917 the Union represented outdated artistic concerns: it held its 18th and final exhibition in 1923, after which many former members, including Rylov, Arkhipov and Isaak Brodsky, joined AKhRR, the ASSOCIATION OF ARTISTS OF REVOLUTIONARY RUSSIA.

Bibliography

V. P. Lapshin: *Soyuz Russkikh Khudozhnikov* [The Union of Russian Artists] (Leningrad, 1974)

<div align="right">CHRISTINA LODDER</div>

Union of Youth [Rus. Soyuz Molodyozhi]

Association of Russian avant-garde painters, active in St Petersburg from 1910 to 1914. It was financed by the businessman Lerky Zheverzheyev, who was also its president. The core of the group comprised the artists Pavel Filonov, Ol'ga Rozanova, Iosif Shkol'nik (1883–1926) and Eduard Spandikov (1875–1929) and the painter and art critic Vladimir Markov (Waldemar Matvejs, 1877–1914). The musician and painter Mikhail Matyushin and his wife, the poet Yelena Guro (1877–1913), were also associated with the group, as were the artists Kuz'ma Petrov-Vodkin (in 1910), Jean Pougny (1912–14) and Natan Al'tman and Ivan Klyun (both 1913–14). The Union functioned principally as an exhibiting society, holding five annual exhibitions in St Petersburg and one in both Riga and Moscow. A reaction against the conservatism of the contemporary art and exhibition societies, Union of Youth was the first major organized group of young avant-garde painters in Russia. Members of the Union had a rather free aesthetic ideology in distinction to other groups of the period (such as Donkey's Tail) and painted in a variety of styles. Pavel Filonov's Neo-primitivism and Rozanova's Cubo-Futurism with Rayist elements typified the breadth of stylistic aspirations within the group. The Union

was a microcosm of the rich and varied picture of Russian avant-garde art in the pre-war years.

The importance and strength of the Union lay in its ability to harness the forces of the Russian avant-garde as a whole and to organize collaborative ventures. It succeeded in particular in drawing together the warring factions of the Muscovite avant-garde. Both the Jack of Diamonds and Donkey's Tail groups were invited to exhibit with them in 1912. In fact Mikhail Larionov, Natal'ya Goncharova, Kazimir Malevich, Vladimir Tatlin, David Burlyuk and Il'ya Mashkov frequently exhibited with the group and could be counted as supporting members. The Union also provided a neutral forum for debates on contemporary art and publicized the views of Donkey's Tail and Jack of Diamonds.

In 1912 the Union published two numbers of an important literary and artistic journal edited by Markov. The first was devoted to eastern art forms and contemporary Russian painting, while the second dealt with contemporary western art and included translations of two Italian Futurist manifestos, a text by Le Fauconnier and an article on van Dongen. Markov's important essay 'The Principles of the New Art' was also serialized in these two numbers. Acting as spokesman for the group, Markov advocated 'the principle of free creation'—the artist's right to paint intuitively according to his inner impulses rather than the dictates of stylistic convention. The Union was always ready to collaborate with other avant-garde groups and in 1913 invited David Burlyuk and his group of poets, including Vladimir Mayakovsky, Aleksey Kruchonykh (1886–1969) and Velimir Khlebnikov (1885–1922), to participate in its third journal. Rozanova's essay 'The Bases of New Creation', a reply to the critics of the avant-garde, was published here, as was Matyushin's influential review of Albert Gleizes's and Jean Metzinger's book *Du Cubisme* (Paris, 1912).

Before its demise in 1914, members of the Union also collaborated with other poets and painters in illustrating and publishing more than a dozen Russian Futurist books. It also extended its activities into the theatre, financing and organizing both the opera *Victory over the Sun* (with

score by Matyushin, libretto by Kruchonykh and designs by Malevich) and the play *Vladimir Mayakovsky: A Tragedy* (written and performed by Mayakovsky himself, with stage designs by Shkol'nik and painted properties by Filonov). These were performed in the Luna Park Theatre in St Petersburg in December 1913.

Writings

Obshchestvo khudozhnikov 'Soyuz Molodyozhi' [The society of artists 'Union of Youth'], i, ii (1912)

'Soyuz Molodyozhi' pri uchastii poetov 'Gileya' ['Union of Youth' with the participation of the 'Hylaean' poets], iii (1913)

Bibliography

Soyuz Molodyozhi [Union of Youth] (exh. cats, St Petersburg, 1910, 1911, 1912, 1913, 1914; Riga, 1910; Moscow, 1912)

C. Douglas: 'Birth of a Royal Infant: Malevich and *Victory over the Sun*', *A. America*, lxii/2 (1974), pp. 45–51

V. Markov: 'The Principles of the New Art', *Russian Art of the Avant-garde*, ed. J. Bowlt (New York, 1976), pp. 23–37

O. Rozanova: 'The Bases of the New Creation', *Russian Art of the Avant-garde*, ed. J. Bowlt (New York, 1976), pp. 102–10

J. Howard: *The Union of Youth: An Artists' Society of the Russian Avant-garde* (Manchester, 1992)

ANTHONY PARTON

Unit One

English group of architects, painters and sculptors. The group was formed in London in 1933 after discussions between Paul Nash, Wells Coates, Henry Moore and Ben Nicholson. In 1932 Nash had described the need for a 'sympathetic alliance between architect, painter, sculptor and decorator' (*The Listener*, 16 March 1932), which would further the modernization of British artistic culture according to the precedents of the European Modern Movement. The other members were John Armstrong (1893–1973), John Bigge (1892–1973), Edward Burra, Barbara Hepworth, Colin Lucas (1906–84) and Edward Wadsworth. Frances Hodgkins was a member for only a very short time and was later replaced by Tristram

Hillier (1905–83). The name of the group was chosen by Nash to express both unity (Unit) and individuality (One).

Nash announced the formation of Unit One in a letter to *The Times* (12 June 1933), describing the group as 'a solid combination standing by each other and defending their beliefs'. Exhibition space and offices were provided by the Mayor Gallery, London. Herbert Read was the group's spokesman and Douglas Cooper its secretary. The members had little in common, however, other than an interest in modern European art and architecture. A book of statements and photographs, *Unit 1*, was edited by Read and published to coincide with the group's only exhibition in London in 1934 at the Mayor Gallery. A tour of municipal galleries in England, Ireland and Wales attracted considerable publicity and served to polarize opinion about modern art in general, although by the time the tour ended in 1935 the sense of common cause had dissipated, and the group had effectively ceased to exist.

Writings

H. Read, ed.: *Unit 1: The Modern Movement in English Painting, Sculpture and Architecture* (London, 1934)

Bibliography

Unit 1 (exh. cat., Portsmouth, City Mus. & A.G., 1978)

C. Harrison: *English Art and Modernism, 1900–1939* (London, 1981)

Unit One: Spirit of the '30s (exh. cat., London, Mayor Gal., 1984)

☐

Unovis [Rus. Utverditeli Novogo Iskusstva: 'Affirmers of new art']

Russian group of artists and designers gathered around Kazimir Malevich at Vitebsk (Viciebsk), Belarus', from 1919–20. Vera Yermolayeva (1893–1938), who became director of the Art Institute in Vitebsk in 1919, appointed Malevich (who had been invited by Marc Chagall) to head a teaching studio. The group, known as Posnovis (Posledovateli Novogo Iskusstva: 'Followers of new art') in January 1920, was soon renamed Unovis and was formed to

explore Malevich's concept of SUPREMATISM. Their work reflected Constructivist techniques and was characterized by mathematical forms, such as the parabola, and by suggestions of construction. This is seen in the work of el Lissitzky, who had studied under Yermolayeva's predecessor, Marc Chagall, before becoming a convert to Suprematism. Lissitzky gave to his paintings and prints the name *Proun* ('Affirmation of the new'). He printed 1000 copies of Malevich's book *O novykh sistemakh v iskusstve* ('On new systems in art') at Vitebsk in December 1919, and this was followed in 1920 by Malevich's *Suprematizm: 34 risunkov* ('Suprematism: 34 drawings'). Theatrical productions played an important role in Unovis, and both Vladimir Mayakovsky's *Misteriya-Buff* and Aleksey Kruchonykh's opera *Pobeda nad solntsem* ('Victory over the sun'; February 1920) were produced there. The work of Unovis also extended to utilitarian designs and could incorporate explicit political commitment. The Unovis design for a Lenin tribune (1920; see Kueppers-Lissitzky, pl. 129) and Lissitzky's civil war poster *Beat the Whites with the Red Wedge* (1919; repr. 1960; Eindhoven, Stedel. Van Abbemus., see Kueppers-Lissitzky, pl. 40) are examples of this. Other members of the group included Yermolayeva, Il'ya Chashnik (1909–29), Nikolay Suetin (1897–1954) and Lev Yudin (1903–41). Lazar' Khidekel (1904–86) was also associated with the group. Unovis published two journals, *Aero* (1920) and *Unovis* (1920–21), and organized numerous exhibitions. Branches were organized in Moscow, Petrograd, Smolensk, Orenburg, Saratov, Samara, Perm and Odessa.

Lissitzky moved to Moscow in 1921 and then to Western Europe as an emissary of Russian revolutionary art (1922–5). Malevich and the remaining group, forced out of the Vitebsk Art Institute following disagreements with the authorities over methods, moved to INKHUK at Petrograd, working there on architectural forms and producing designs for the Lomonosov porcelain factory.

Bibliography

S. Kueppers-Lissitzky: *El Lissitzky: Life, Letters, Texts* (London, 1968)

The Suprematist Straight Line: Malevich, Suetin,

Chashnik, Lissitzky (exh. cat., London, Annely Juda F.A., 1977)

JOHN MILNER

Valori plastici

Italian magazine edited by the critic and painter Mario Broglio (1891–1948), published in 15 issues in Rome between 1918 and 1921 in both Italian and French editions. Following its first issue, dated 15 November 1918, it was published monthly until September 1920 and then bi-monthly; the final issue, dated September–October 1921, was distributed in 1922. It also served as a publishing house and as a focal point for a loose association of artists who exhibited together in Berlin, Dresden and Hannover in 1921 and in Florence in 1922. Broglio's closest collaborators were his wife, the Lithuanian painter Edita Walterowna zur Muehlen (1886–1977), Roberto Melli, Alberto Savinio, Giorgio de Chirico and Carlo Carrà.

There were many affinities between *Valori plastici* and other journals concerned with the creation of a language based on solid 'classical' foundations in opposition to the rapid succession of styles that characterized the avant-garde. There were particularly close parallels with literary journals such as *La Ronda* in Italy and with art magazines such as *L'Esprit nouveau* in France and *De Stijl* in the Netherlands, but *Valori plastici* was far less homogeneous in its approach, providing a platform for lively polemics and disputes among its collaborators. Its strongest and most positive element, however, was provided by de Chirico, Carrà and Savinio, all of whom were involved at that moment with the creation of PITTURA METAFISICA as a way of escaping the banality of naturalistic mimicry by embracing the mystery of everyday objects. Their position attracted artists already linked with the magazine, such as Giorgio Morandi and Arturo Martini, and went on to exercise a vast influence in Italy and elsewhere in Europe.

Valori plastici's other important contribution lay in its new way of understanding tradition. While Futurism and the avant-garde in general had given the impression of wanting to burn the

bridges linking contemporary art with the past, *Valori plastici* proposed to use antique art as a powerful vehicle for the new. The complexity of tradition in this sense was well reflected in the variety of the magazine's related publishing activities: a series of monographs on the Old Masters, from Byzantine painting to Giotto, from Piero della Francesca to Titian; a series devoted to heterodox traditions, looking towards African, Chinese and Mexican art; and lastly a series on modern art from the 19th century to the latest developments in Cubism and Expressionism. In their art as well as in their writings the artists associated with *Valori plastici* showed a tremendous freedom in their interpretation of the past. The renewed passion for geometry and craft led them all back to the Italian Quattrocento and other historical sources, but each in his own way and without imitating academic models: de Chirico preferred the nervous style of Signorelli and Hans Holbein the younger, Carrà looked back to Giotto, Martini explored the Etruscan world, and Morandi in his still-lifes evoked Ingres.

Gino Severini, Jean Cocteau, André Breton, Louis Aragon, Theo van Doesburg and Vasily Kandinsky were among the notable contributors to *Valori plastici* during its brief existence. They were among the many artists and writers who became associated with the magazine and its return to classicism, sometimes referred to as a 'rappel à l'ordre' in Cocteau's words, after having participated in the evolution of various avant-garde movements.

Bibliography

M. Carrà: *Gli anni del ritorno all'ordine* (Milan, 1967)
M. Fagiolo dell'Arco: *Giorgio de Chirico: Il tempo di 'Valori plastici', 1918/1922* (Rome, 1980)
P. Fossati: *Valori plastici, 1918–22* (Turin, 1981)

VALERIO RIVOSECCHI

Verein Berliner Künstler [Association of Berlin Artists]

German group of artists. It was founded in 1814 as the Berlinischer Künstler Verein (BKV) in response to the feeling that the end of the War of Liberation (1813) against France marked the beginning of a new era in art, requiring all forces to work together towards joint action. Initially there were 32 members; this number soon rose to 45. The moving force behind BKV was the architect Louis Catel (1776–1819), but its dominant personality was Johann Gottfried Schadow. Its purpose was 'friendly teaching, advice and conversation about art and art objects'. From the outset the association's activities also included social gatherings. A collection of over 600 drawings (Berlin, Berlin Mus.) documents the artistic activity at the weekly meetings. The BKV accepted younger members in the years that followed, but despite this in 1825 several of them banded together to form the Verein Jüngerer Berliner Künstler (which later included Adolph Menzel), where enjoyment and sociability were given much more emphasis. That group remained in existence until 1847.

The arrival in Berlin in 1841 of Peter Cornelius, on whom Wilhelm Hensel and some young, conservatively minded artists grouped around him pinned great hopes, led to the foundation in the same year of the Verein Berliner Künstler (VBK). The BKV gradually merged with it. The VBK, which initially had no eminent members, developed slowly at first. Its main purpose was to provide mutual support in the deteriorating economic situation. The twice-yearly parties played an important role in keeping the group together. The revolutions of 1848 strengthened the artists' self-confidence, but it was only after the foundation of the German Reich (1871) that the VBK developed into an institution whose impact on Berlin artistic life was on a par with that of the Akademie der Künste.

In 1866 the VBK had 145 members. By 1872 it had 274 ordinary and 98 extraordinary members. It endeavoured to increase state patronage of the arts and to gain influence over the purchasing policy of the Nationalgalerie. It organized its own exhibitions, including a permanent display, and supported its members through an emergency assistance fund. It built up a library and a collection of costumes and weaponry and organized a dispatch service for works of art. Above all, however, it improved commissions for artists by

developing their relations with the rich middle classes. The *Gründerzeit* (1871–3), a period of rapid industrial expansion, promoted the formation of private collections of art; the imperial family were also patrons of the association.

The VBK reached the height of its influence in 1891 when it held an international exhibition to mark its 50th anniversary. From 1893 it collaborated with the Akademie in organizing the Grosse Berliner Kunstausstellung; it was now officially recognized as representing the artistic community of Berlin. Among the festivities it staged in this period was the Pergamonfest (1886), held to celebrate the successes of German archaeology in Pergamon and Olympia; imperial Germany saw itself as the heir to antiquity, as was demonstrated by the concurrence between contemporary art, tradition and science in official cultural and educational policies.

Anton von Werner (President, 1887–95, 1899–1901, 1906–7) was principally responsible for the VBK's powerful position. As early as 1892, however, deep divisions were manifested in a controversy between attitudes to official art and to modern, revolutionary art; this mirrored a general debate in society between conservative and liberal reforming forces. In 1892 Edvard Munch was invited to hold an exhibition, but his work was perceived as provocative, and a proposal by members that the exhibition should be closed down was carried by a narrow margin. This row led to the formation of the breakaway Freie Künstlervereinigung; even before this, in 1892, the 'Vereinigung der Elf' (also called 'Gruppe der Elf'), which included Max Liebermann, Walter Leistikow and Franz Skarbina, had called for a renewal of art and the acceptance of Impressionist ideas.

The Berliner Secession, founded in 1898, was the most significant of other generally short-lived artists' groups in opposing the conservative stance of the VBK (*see* SECESSION, §2). The construction of grand premises (inaugurated 1898) on Bellevuestrasse failed to stem the gradual decline in the power of the VBK; it chose not to oppose the absolutist art policy of William II (*reg* 1888–1918) and made the material welfare of artists its principal concern; such new concepts as Art Nouveau were accepted in moderation. After World War I the VBK opened up to the democratic structures of artistic life as well as to newer art movements, but it nonetheless continued to be strongly bound up with tradition, as the large exhibition *Hundert Jahre Berliner Kunst* (1929) showed. The association's opulent premises were vacated in 1930 in exchange for a more modest building in Lützowplatz, so that the proceeds could be used to honour social commitments. After 1933 the association's conservative stance helped it to remain in existence. It did not, however, comply totally with the demands of the Nazis.

The VBK's new offices were destroyed by bombing in World War II. In 1949 the association was granted permission to resume its activities, but it was confined to the western sector of Berlin. Its first post-war exhibition was held in 1950. The VBK moved to new premises, on Schöneberger Ufer, in 1964. Its most important task by the late 20th century was to exhibit members' work. When it celebrated its 150th anniversary in 1991, its membership consisted of 122 painters, sculptors and architects from a variety of artistic styles.

Bibliography

L. Pietsch, ed.: *Verein Berliner Künstler: Festschrift zur Feier seines fünfzigjährigen Bestehens, 19 Mai 1891* (Berlin, 1891)

Hundert Jahre Berliner Kunst im Schaffen des Vereins Berliner Künstler (exh. cat. by G. J. Kern and M. Osborn, Berlin, Ver. Berlin. Kstler, 1929)

100 Jahre Verein Berliner Künstler (exh. cat., Berlin, Ver. Berlin. Kstler, 1941)

'. . . Und abends in Verein': Johann Gottfried Schadow und der berlinische Künstler-Verein, 1814–1840 (exh. cat., Berlin, Berlin Mus., 1983)

Verein Berliner Künstler: Versuch einer Bestandsaufnahme von 1841 bis zur Gegenwart (Berlin, 1991)

HELMUT BÖRSCH-SUPAN

Video art

Term used to describe art that uses both the apparatus and processes of television and video. It can take many forms: recordings that are broadcast, viewed in galleries or other venues, or distributed

as tapes or discs; sculptural installations, which may incorporate one or more television receivers or monitors, displaying 'live' or recorded images and sound; and performances in which video representations are included. Occasionally, artists have devised events to be broadcast 'live' by cable, terrestrial or satellite transmission. Before video production facilities were available, some artists used television receivers and programmes as raw material, which they modified or placed in unexpected contexts. In 1959 the German artist Wolf Vostell included working television sets in three-dimensional collage works. In the same year Nam June Paik began to experiment with broadcast pictures distorted by magnets. He acquired video recording equipment in 1965, after moving to New York, and began to produce tapes, performances and multi-monitor installations (e.g. *Moon is the Oldest TV*, 1965, reworked 1976 and 1985; Paris, Pompidou). Paik is generally acknowledged to be the single most important figure in the emergence of video art, but he was not alone in grasping the artistic potential of electronic media. Several American independent film makers, including Stan Vanderbeek (*b* 1927) and Scott Bartlett (*b* 1943), made use of video processes to develop new kinds of imagery, although the end result was usually a projected film. Others, such as Steina and Woody Vasulka, used electronic skills to produce elaborate transformations of television camera images on videotape.

By 1969, when the Howard Wise Gallery, New York, presented the landmark exhibition *TV as a Creative Medium*, a fascination with electronic effects and complex imagery had been joined by other concerns. With the rise of CONCEPTUAL ART, many artists who explored relationships between themselves, the physical world and other people used video as a convenient medium for recording events. Bruce Nauman employed both film and video for his explorations of the relationship between the body and the spaces of the room and screen, while William Wegman brought the form of the television comedy sketch into the service of his own distinctive sensibility. Terry Fox (*b* 1943) used household objects in close-up in *Children's*

Tapes (1974) in order to enact tiny melodramas demonstrating the laws of physics. Some artists engaged themselves with the specific qualities of video and the equipment involved, such as the camera, microphone and monitor. Joan Jonas made performance tapes in which the properties of video were made to interact with her own activity in front of the camera. *Organic Honey's Vertical Roll* (1972) features the insistent rhythmic jump of her image on a 'wrongly' adjusted monitor.

In Europe, until *c.* 1970, when video recorders became available outside commercial and scientific institutions, artists' concern with video was largely either theoretical and speculative or dependent on broadcast television as a foil and means of production. In the former Federal Republic of Germany, Gerry Schum (*d* 1974) developed the notion of a 'Gallery on TV', in which avant-garde artists could present their work in purely televisual terms, free from the distractions of physical artefacts or of programme narration or interpretation. The artists performed or directed activity for the camera, keeping in mind the eventual context of the television screen, creating not a film about the artist but a work by him or her. Schum produced two 'TV Gallery' compilations, *Land Art* (1968) and *Identifications* (1969). In 1970 he established the Videogalerie Schum in Düsseldorf, where he made and sold video-art tapes. In 1971 David Hall's *Seven TV Pieces* appeared on Scottish Television, interrupting regular programmes without announcement or explanation. In each, the filmed event emphasized the physical presence of the television set with which it was viewed, as when the set appeared to fill with water, which then drained away at a totally unexpected angle. In subsequent video installations and tapes, Hall drew attention to the illusory nature of television images, placing video art in confrontation with broadcast television.

In the 1970s a number of artists in Europe and the USA shared a commitment to video art as an autonomous form, rather than as documentation or a source of abstract imagery. An aesthetic evolved associated with conceptual art, which was

concerned with ideas as well as images: it was characterized by real rather than edited timescales and by the use of closed-circuit, multi-monitor installations. This tendency, typified by the installation of Dan Graham, was prominent in the exhibitions *Projekt '74* at Cologne; *The Video Show* (1975) at the Serpentine Gallery, London; a show at the Tate Gallery, London (1976); and at the Kassel *Documenta* of 1977.

In the late 1970s work by Bill Viola (*b* 1951), Kit Fitzgerald and John Sanborn suggested a reaction against the self-referential tendency, accompanied by an advance in video production techniques. Their tapes often deployed broadcast facilities provided by television companies and demonstrated a sophistication in the montage of image and sound that would become standard during the next decade. Dara Birnbaum, with her use of edited fragments of 'found' television material combined with rock music soundtracks, influenced the later British genre of 'Scratch Video', a style made popular by George Barber and the Duvet Brothers and quickly appropriated by directors of television programmes and popular music videos.

During the 1980s video art established its own context of production, exhibition and criticism, with organizations emerging in North America and western Europe to support and promote 'video culture'. Television producers began to buy and commission work from artists, and specialist venues, festivals, courses and workshops for video proliferated. Many artists made work addressing social, sexual and racial issues, renewing links with what survived of the 'community video' movement of the 1970s. By 1990 video installations had featured in several large international exhibitions and were a familiar presence in galleries and museums, assuming fresh authority through the work of such artists as Gary Hill and Marie-Jo Lafontaine. Artists making single-screen work exhibited increasingly on television, and the medium of video was merging with that of the computer. Video art, no longer novel nor wholly dependent on a gallery context, had become part of an increasingly elaborate network of electronic communication.

Bibliography

Video Art (exh. cat. by D. Antin and others, Philadelphia, U. PA, Inst. Contemp. A., and elsewhere; 1975)

D. Hall, ed.: *Studio Int.* (May–June 1976) [special issue on video art]

I. Schneider and B. Korot, eds: *Video Art: An Anthology* (New York and London, 1976)

Het lumineuze beeld: The Luminous Image (exh. cat. by D. Mignot, Amsterdam, Stedel. Mus., 1984)

J. G. Hanhardt, ed.: *Video Culture: A Critical Investigation* (New York, 1986)

R. Payant, ed.: *Vidéo*, Artextes (Montreal, 1986)

W. Herzogenrath and E. Decker, eds: *Video-Skulptur: Retrospektiv und aktuell, 1963–1989* (Cologne, 1989)

D. Hall and S. J. Fifer, eds: *Illuminating Video: An Essential Guide to Video Art* (New York, 1990)

MICK HARTNEY

Vkhutemas [Vysshiye (Gosudarstvennyye) Khudozhestvenno-Tekhnicheskiye Masterskiye; Rus.: Higher (State) Artistic and Technical Workshops]

Soviet school of art and architecture, active in Moscow from 1920 to 1930. It was established by state decree on 29 November 1920, on the basis of the first and second State Free Art Studios (Svomas), which had themselves been set up in December 1918 by fusing the old Moscow School of Painting, Sculpture and Architecture with the Stroganov School of Applied Art. The Vkhutemas was conceived explicitly as 'a specialized educational institution for advanced artistic and technical training, created to train highly qualified master artists for industry, as well as instructors and directors of professional and technical education'. Official concerns reflected contemporary artistic discussions on the role of art in the new society and its participation in industrial production; this was called 'production art', although the term covered a wide range of approaches, from applied and decorative art to the emerging concept of design promoted by the First Working Group of Constructivists, who were committed to the fusion of the artistic, ideological and industrial (*see* CONSTRUCTIVISM, §1).

These various attitudes were reflected in the composition and teaching of the school.

The history of the Vkhutemas corresponds to the tenures of its three directors. From 1920 to 1923, under Yefim Ravdel', the staff and teaching inherited from the State Free Art Studios were adapted to the new task of industrial design. The government reform in higher education of 1923 led to a revision of the teaching programmes, and under Vladimir Favorsky (from 1923 to 1926) workshops undertook commissions from external bodies to establish more concrete links with industry. Pavel Novitsky (1888-1971), Director from 1926 to 1930, reorganized the school in 1927–8 into a more narrowly industrial and technological training institute. The artistic content of courses was reduced, new statutes were drawn up and the name changed to the Vkhutein (Higher (State) Artistic and Technical Institute).

Originally there were seven faculties: Painting, Sculpture, Textiles, Ceramics, Architecture, Woodwork and Metalwork; but in 1926 Woodwork and Metalwork were amalgamated. Although the relative lengths of the overall training and the introductory or Basic Course altered under the various directors, the Basic Course remained fundamental to the ideas behind the school's teaching. Originally highly open to change and dedicated to a 'new synthetic art', it employed various innovative artists to teach its five disciplines: Lyubov' Popova (Colour), Aleksandr Osmyorkin and German Fyodorov (Form and Colour), Aleksandr Drevin (Form, Colour and Plane), Ivan Klyun (Colour and the Plane or Suprematism) and Aleksandr Rodchenko (Construction). By 1922 the disciplines were reduced to four: Colour Construction (Aleksandr Vesnin and Popova), Spatial Construction (Nikolai Ladovsky, Nikolay Dokuchayev and Vladimir Krinsky), Graphic Construction (Rodchenko, Viktor Kiselyov and Ivan Yefimovy) and Volumetric Construction (Anton Lavinsky). By 1923 these were reorganized into three areas: Plane and Colour, Volume and Space, and Space and Volume. In 1929 the categories became Space, Volume, Colour and Graphics. Inevitably the detailed content and exercises of the courses changed but all were rigorously analytical.

The Woodwork and Metalwork Faculty (Dermetfak) was the most Constructivist in orientation. Its staff included Rodchenko, Gustav Klucis, Lavinsky, Vladimir Tatlin and El Lissitzky, and its students were trained as 'engineer–artists': designers capable of devising interiors for clubs, transport centres, trains and buses, as well as producing smaller objects such as light fittings. Its products combined an economic use of materials with multi-functional capacities, typified by the designs by Boris Zemlianitsyn (*b* ?1897) for a cupboard the door of which came down to form a table (see Lodder, pl. 4.25) and for a fold-away chair.

The Architecture Faculty was the leading architectural school in Russia during the 1920s and contained both Rationalist and Constructivist contingents. The Rationalists (members of Asnova, the Association of New Architects) Ladovsky, Krinsky and Dokuchayev were responsible for the first two years of the course, concerned with the aesthetic and formal problems of contemporary architecture. The Constructivists of OSA (the Association of Contemporary Architects) Moisey Ginzburg and the Vesnin brothers (Aleksandr, Leonid and Viktor) taught the final two years, promoting a functional method that involved analysing the political, social and economic factors of the architectural brief and that was intended to minimize the individualistic and aesthetic factors in the design process. A third grouping was established in 1922 by Konstantin Mel'nikov and Il'ya Golosov to occupy a central position between the innovators and the more traditional members of staff, such as Ivan Zholtovsky.

The Painting Faculty initially included major avant-garde figures such as Klyun, Rodchenko, Popova, Aleksandr Vesnin and Vladimir Baranoff-Rosiné, but by 1923 it was orientated towards more figurative aesthetic concerns, with teachers such as David Shterenberg, Robert Fal'k, Drevin, Il'ya Mashkov and Nadezhda Udal'tsova. Its graduates included artists such as Aleksandr Deyneka and Yury Pimenov. The Sculpture Faculty also moved from experimentation with Cubism in 1920 to figurative and monumental work by 1923 under teachers such as Sergey Konyonkov and Ivan Yefimov. The Graphics Faculty, divided into litho-

graphy, engraving and book-printing departments, included former members of the avant-garde such as Pyotr Miturich and Lev Bruni, as well as more conventional artists, for instance Favorsky, Novitsky and Ignaty Nivinsky. The Textiles and Ceramics faculties were more orientated towards production. Textiles was divided into weaving and printing departments, but both produced essentially figurative designs using mechanical and industrial elements. Although Varvara Stepanova taught there between 1924 and 1925, she does not seem to have been able to introduce her innovative ideas involving the relation of textile design to function and clothing design. The Ceramics Faculty established a close relationship with the Dulevsky factory, where many students acquired practical experience of industrial processes and where many graduates, such as Aleksey Sotnikov (b 1904) and Sergei Kozhin, were ultimately employed. Tatlin worked in the faculty (1927–30) producing designs for tableware, which were based on an appreciation of natural forms and the organic quality of the materials.

In 1930 the school closed, and the various departments formed the basis for, or were absorbed into, existing specialist institutes.

Bibliography

S. O. Chan-Magomedov: *Pioniere der sowjetischen Architektur* (Dresden, 1983); Eng. trans. as S. O. Khan-Magomedov: *Pioneers of Soviet Architecture* (London, 1987)

C. Lodder: *Russian Constructivism* (New Haven, 1983)

S. O. Khan-Magomedov: *Rodchenko: The Complete Work* (London, 1986)

CHRISTINA LODDER

Vopra [Vsesoyuznoye Ob'yedineniye Assotsiatsii Proletarskikh Arkhitektorov; Rus.: All-Union Alliance of Associations of Proletarian Architects]

Russian architectural group, active from 1929 to 1932. It was one of several 'proletarian' cultural organizations that came into being in every branch of art in the late 1920s and served to criticize Constructivism and the avant-garde from the viewpoint of proletarian class ideology. Organizations particularly attacked by Vopra were OSA (Association of contemporary architects) for its Constructivism, ASNOVA (Association of new architects) for its rationalist formalism, and MAO (Moscow architectural society) for its eclecticism and stylizations. Vopra's chairman was the art historian Ivan Matsa (1893–1974), while other prominent members included the architects Karo Alabyan (1897–1959), Vasily Simbirtsev, Arkady Mordvinov (1896–1964), Aleksandr Vlasov, Gevork Kochar (1901–73), Abram Zaslavsky (1899–1962) and Viktor Baburov (1903–77), many of whom were recent graduates from Vkhutein (Higher (state) artistic technical institute; see VKHUTEMAS), Moscow. In its Declaration published in *Stroitel'stvo Moskvy* in 1929, Vopra denounced the Constructivists for their 'mechanical approach' and proclaimed that 'the new proletarian architecture must develop its theory and practice on the basis of an application of the method of dialectical materialism', which was to be combined with critical use of historical experience and the latest technological achievements. Disseminating its ideas through the unofficial organ *Sovetskaya arkhitektura* ('Soviet architecture'), it also sought to consolidate young Communist Party members who were architects on the grounds of Marxist–Leninist theory and the 'Party general line'. By 1930 Vopra had 49 members in its Moscow section and had also organized branches in the Ukraine, Georgia, Armenia, Leningrad (now St Petersburg) and Tomsk. Teams of architects from the organization took part in many open competitions in 1930 and 1931, for example that for the Palace of Soviets, Moscow. Although its members were able to realize very little during the Vopra period, not least because this was abruptly curtailed in 1932 with the dissolution of the group and the foundation of the all-embracing Union of Soviet Architects, many went on to assume dominant positions in the latter and as a result became successful Soviet architects.

Bibliography

'Deklaratsiya vserossiyskogo obshchestva proletarskikh arkhitektorov' [Declaration of the All-Russian Society of Proletarian Architects], *Stroitel'stvo Moskvy*, viii (1929), pp. 25–6

Iz istorii sovetskoy arkhitektury, 1926–1933 [From the history of Soviet architecture, 1926–1933] (Moscow, 1984)

A. V. Ikonnikov: *Russian Architecture of the Soviet Period* (Moscow, 1988)

JEREMY HOWARD

Vorticism

British artistic and literary movement, founded in 1914 by the editor of *Blast* magazine, Wyndham Lewis, and members of the REBEL ART CENTRE. It encompassed not only painting, drawing and printmaking but also the sculpture of Henri Gaudier-Brzeska and Jacob Epstein and the photographs of Alvin Langdon Coburn. Notable literary allies were Ezra Pound, who coined the term Vorticism early in 1914, and T. S. Eliot. T. E. Hulme's articles in *The New Age* helped to create a climate favourable to the reception of Vorticist ideas.

The arrival of Vorticism was announced, with great gusto and militant defiance, in a manifesto published in the first issue of *Blast* magazine, which also included work by Edward Wadsworth, Frederick Etchells, William Roberts and Jacob Epstein. Dated June 1914 but issued a month later, this puce-covered journal set out to demonstrate the vigour of an audacious new movement in British art. Vorticism was seen by Lewis as an independent alternative to Cubism, Futurism and Expressionism. With the help of Pound, Gaudier-Brzeska and others, he used the opening manifesto pages of *Blast* to launch an uninhibited attack on a wide range of targets. Britain was blasted first 'from politeness', and its climate cursed 'for its sins and infections, dismal symbol, set round our bodies, of effeminate lout within'. The Vorticists wanted to oust all lingering traces of the Victorian age, liberating their country from what they saw as the stultifying legacy of the past. In giant black letters, *Blast*'s inventive typography roared: 'Blast years 1837 to 1900.' Using humour 'like a bomb' to ridicule British inertia, which was preventing any realization that a new century demanded a bracing and innovative art, *Blast* cried, 'We are Primitive

Mercenaries in the Modern World . . . a movement towards art and imagination could burst up here, from this lump of compressed life, with more force than anywhere else.'

Ezra Pound declared in *Blast* that 'the vortex is the point of maximum energy. It represents, in mechanics, the greatest efficiency. We use the words "greatest efficiency" in the precise sense— as they would be used in a text book of Mechanics.' Wyndham Lewis put it another way when he recommended that a friend should think 'at once of a whirlpool. At the heart of the whirlpool is a great silent place where all the energy is concentrated. And there, at the point of concentration, is the Vorticist' (D. Goldring: *South Lodge* (London, 1943), p. 65). The 'stillness' of Lewis's definition is significant. It sets Vorticism up in adamant opposition to Italian Futurism, although the British movement owed a considerable debt to Filippo Tommaso Marinetti for inspiring the exuberant typography of *Blast* and for realizing the importance of making art interpret the rapidly changing character of the modern world. The Vorticists wanted to place the machine age at the very centre of their work, and *Blast* proposed that they fill their art with 'the forms of machinery, factories, new and vaster buildings, bridges and works'. They criticized the Futurists for making their paintings 'too "picturesque", melodramatic and spectacular, besides being undigested and naturalistic to a fault'. They also abhorred the rhapsodic romanticism of the Italian movement and rejected the Futurists' emphasis on blurred movement in their attempts to depict the sensation of speed. Lewis and his allies sought clarity of definition, enclosing their forms with strong contours that often gave Vorticist pictures an almost sculptural solidity (e.g. Wyndham Lewis, *Workshop*, c. 1914–15; London, Tate; see fig. 48; and William Roberts, *Study for Two-step*, 1915; London, BM). The containing line was a crucial element in Vorticism; even when the compositions took on an explosive force that threatened to burst the bounds of the picture-frame, the harsh lucidity of Vorticist design ensured that order prevailed. Exhilaration was an important part of their art, and Pound emphasized that the vortex itself was 'a radiant

node or cluster ... from which, and through which, and into which, ideas are constantly rushing'.

Familiarity with the results of the Industrial Revolution made the Vorticists view the machine world with far less eager excitement than the Futurists. Their undoubted involvement with the age of mechanization was coupled with an awareness of its darker side. There is a curious innocence about Marinetti's admiration for the racing automobile, whereas Lewis saw the machine-age metropolis as an 'iron jungle', a severe and ferocious place where city dwellers were dehumanized and diminished, as exemplified in *The Crowd* (*c.* 1915; London, Tate). Vorticist images possess a cool, clear-cut consciousness of the impersonal harshness of the 20th-century world, and in this respect they prophesy the destructive machine power that became so horrifyingly evident in World War I.

The onset of war meant that the Vorticists had very little time in which to implement the bold artistic programme they had outlined in *Blast*. But from 1914 to 1916 they did manage to produce an impressive range of images, which substantiated their claim to revitalize British art. Seven members of the movement contributed to the main section of the June 1915 Vorticist Exhibition at the Doré Gallery, London: Jessica Dismorr, Frederick Etchells, Lewis, Gaudier-Brzeska, William Roberts, Helen Saunders (1885–1963) and Edward Wadsworth, who exhibited *Enclosure*. Several other artists were included in another section called 'Those Invited To Show', including Lawrence Atkinson, David Bomberg, Jacob Kramer (1892–1962) and the British Futurist Christopher Nevinson. Jacob Epstein was not represented but did have his drawings reproduced in *Blast*. Sculptures such as *Rock Drill* (1913–16) and *Doves* (1913; both London, Tate; see col. pl. XXXV) show his affinity with the Vorticists' preoccupations. In July 1915 the second issue of *Blast* appeared, a 'War Number' with an appropriately harsh monochrome cover bearing Lewis's grim drawing *Before Antwerp*, and containing reproductions of works such as Helen Saunders's *Atlantic City* (untraced, see *Blast*, 2

48. Wyndham Lewis: *Workshop*, *c.* 1914–15 (London, Tate Gallery)

(1915), p. 57). However, with the death of Gaudier-Brzeska in the war and most of the other Vorticists away on active service, British Vorticism found itself overwhelmed by the conflict raging in Europe.

Pound tried to keep the spirit of the movement alive in London by writing supportive articles, publishing *Gaudier-Brzeska: A Memoir* (London, 1916) and encouraging Alvin Langdon Coburn's ingenious attempts to develop a form of abstract photography called Vortography. He also persuaded the New York collector John Quinn to purchase Vorticist works in considerable quantities and eventually to stage a Vorticist exhibition at the Penguin Club in New York in January 1917. When Lewis returned from the trenches, he hoped to revivify the Vorticist spirit, planning a third issue of *Blast* and regaining contact with old allies. But the whole context of pre-war experimentation had been dispersed by the destructive power of mechanized warfare, which persuaded most of the former Vorticists to pursue more

representational directions thereafter. By 1920 even Lewis was obliged to admit that the movement was dead.

Writings
P. Wyndham Lewis, ed.: *Blast*, 1 (1914) [facs., Santa Barbara, 1981]

E. Pound: 'Vorticism', *Fortnightly Rev.* (1 Sept 1914), pp. 46–71

P. Wyndham Lewis, ed.: *Blast*, 2 (1915) [facs., Santa Barbara, 1981]

Bibliography
J. Thrall Soby: *Contemporary Painters* (New York, 1948)

W. C. Wees: *Vorticism and the English Avant-garde* (Toronto and Manchester, 1972)

Vorticism and its Allies (exh. cat. by R. Cork, London, Hayward Gal., 1974)

R. Cork: *Vorticism and Abstract Art in the First Machine Age*, 2 vols (London, 1975–6)

——: 'What Was Vorticism?', *Wyndham Lewis*, ed. J. Farrington (London, 1980), pp. 23–9

——: 'Vorticism', *Futurismo & futurismi* (exh. cat., ed. P. Hulten; Venice, Pal. Grassi, 1986)

 RICHARD CORK

Washington Color Painters

Group of American painters based in Washington, DC, who from the mid-1950s responded to Abstract Expressionism by producing non-gestural, totally abstract canvases that stressed the optical effects created by the interrelationships of various colours. Named retrospectively in a survey exhibition held in 1965, they worked in a number of different styles including those loosely referred to as POST-PAINTERLY ABSTRACTION, HARD-EDGE PAINTING and COLOUR FIELD PAINTING, but all used acrylic paints. One of the most influential of the painters, Morris Louis, moved in 1952 from his native Baltimore to Washington, DC, where he met several like-minded artists at the Washington Workshop for the Arts, founded by local painter Leon Berkowitz (1915–87). Following the example of Helen Frankenthaler, Louis began in the early 1950s to pour extremely thin acrylic paints directly on to unprimed canvases to produce 'stains' of over-lapping, translucent colours. The work of most of his colleagues, however, and particularly that of Kenneth Noland, was characterized by hard-edged, geometric abstract forms and especially by repeating patterns, such as concentric circles and chevrons, from which Noland produced series of works. The third principal group member was Gene Davis (1920–85), a native of Washington, who began painting in 1958 and quickly developed his signature approach of narrow, vertical stripes of colour that covered the entire canvas surface from edge to edge. The other painters who participated in the exhibition of 1965 and continued to be associated with the group were Thomas Downing (*b* 1928), Howard Mehring (*b* 1931) and Paul Reed (*b* 1919).

Bibliography
E. Stevens: 'The Washington Color Painters', *Arts* [New York], xl (Nov 1965), pp. 29–33

The Washington Color Painters (exh. cat., essay G. Nordland; Washington, DC, Gal. Mod. A., 1965)

 NANCY G. HELLER

Wiener Werkstätte [Ger.: 'Viennese workshop']

Viennese cooperative group of painters, sculptors, architects and decorative artists founded by Josef Hoffmann and Kolo Moser in 1903 and active until 1932.

1. Influences and aims

The group was modelled upon C. R. Ashbee's Guild of Handicraft. Under the artistic direction of Hoffmann and Moser and with the financial patronage of the industrialist Fritz Wärndorfer (*b* 1868), they sought to rescue the applied arts and artistic craftwork from aesthetic devaluation brought on by mass production. Their aim was to re-establish the aesthetic aspect of the everyday object. As a long-term goal they strove to promote the cultivation of general public taste by bringing the potential purchaser in close contact with the designer and craftsworker. The offices, studios and workshops at Neustiftgasse 32 were designed by Moser with that purpose in mind.

The Wiener Werkstätte believed that artistic endeavour should permeate all aspects of everyday life; no object was so menial that it could not be enhanced by beauty of form and execution. It was postulated that this maxim, rooted in the work of William Morris and the Arts and Crafts Movement, gave direction to cultural progress. The moral and social aspect of the workshops was also influenced by the credo derived from John Ruskin and Morris, and adopted by Ashbee, that the craftsworker should work under humane conditions and in an artistic atmosphere. The profits of the cooperative were shared by not only the financier but also the designer and executor. Charles Rennie Mackintosh also influenced the group, which is evident in the puristic simplicity and geometric austerity of their early objects, for example a brass candlestick by Moser (c. 1904; Brussels, Gal. Galuchat; see fig. 49). Mackintosh and Margaret Macdonald had exhibited work to the Viennese public in the eighth exhibition held at the Secession (1900). Hoffmann and Moser were intrigued with the elegance and sensibility of their creations.

The Japanese-inspired components of the workshops' products were also important. The Secession had dedicated their sixth exhibition (1900) to Japanese art, and in Vienna in 1901 the Österreichisches Museum für Kunst und Industrie (now Österreichisches Museum für Angewandte Kunst) exhibited the woodcuts of Katsushika Hokusai. The textile patterns and inlay designs of Hoffmann and Moser share strong similarities with Japanese stencils and prints (see col. pl. XXXVI). The distinctive trademark of the Wiener Werkstätte included the initials of both the designer and the executing craftsworker. The fine arts and the applied arts were awarded the same level of importance. The primary concern of the group was to respect the inherent decorative and functional qualities of the material used and to work within its natural properties.

2. Major designs and commissions

The works of the Wiener Werkstätte were made known to the public through various local and international exhibitions: the exhibition at the Hohenzollern-Kunstgewerbehaus in Berlin (1904), the show at the Galerie Miethke in Vienna (1905), the Imperial Royal Austria exhibition at Earl's Court, London (1906), and the Kunstschau in Vienna (1908) were the most celebrated. Early articles published in Deutsche Kunst und Dekoration (1904) and The Studio (1906) furthered their popularity. The projects of the group in which all aspects of their art came into play provided the foundation of their fame: the sanatorium at Purkersdorf (1903–5), the Modesalon Flöge in Vienna (1904; destr.), the Palais Stoclet in Brussels (1905–11) and the Fledermaus Cabaret in Vienna (1908; destr.). These projects were important for the development of the modern interior. In the sanatorium the clear, simple lines of Hoffmann's cubistic architecture set the tone for the hygienic austerity of the interior rooms, which were designed by Moser. Comfort and luxury, practicality and functionality formed an aesthetic whole. In the case of the Modesalon Flöge, the rooms and their furnishings were designed by

49. Kolo Moser: Candlestick with Ashtray and Match Holder, c. 1904 (Brussels, Galerie Galuchat)

Hoffmann and Moser so cooperatively that individual ascriptions do not hold.

The Wiener Werkstätte were given complete financial freedom by Baron Adolphe Stoclet for the decorations (*in situ*) for his house in Brussels, which was designed as a Gesamtkunstwerk; every detail was designed with great care and with its integral relationship to the aesthetic whole in mind. The ceramic tiles and maiolica were executed by Bertold Löffler and Michael Powolny, who had founded the Wiener Keramik workshop in 1906; their distribution was taken over by the Wiener Werkstätte in 1907. Ludwig Heinrich Jungnickel painted an animal frieze for the nursery, and Carl Otto Czeschka furnished the breakfast room. Gustav Klimt designed a mosaic frieze for the dining-room, for which he used unconventional materials, placing precious metals and stones, inexpensive materials and ordinary objects side by side. As part of the Fledermaus commission, over 1000 postcards representing witty themes were printed. Artists including Oskar Kokoschka, Czeschka, Rudolf Kalvach and Egon Schiele were responsible for their exceptional artistic quality. Powolny and Löffler were responsible for the wall and floor tiles.

The Wiener Werkstätte gained new artistic stimulus under the influence of Dagobert Peche. He was appointed manager of the artists' workshops in 1915, and in 1917 he became the director of the branch in Zurich. In 1919 he became artistic director. The sale-rooms were furnished according to his designs. His extremely delicate and elegant ornamental forms, his sense of noble colour contrasts of white with gold and his feeling for an original, wilful use of floral motifs brought a new spontaneity into the workshop. Early designs for useful household utensils had been made of simple, inexpensive white-lacquered and perforated sheet metal with glass inserts. Fruit baskets, flower-holders, sugar and jam containers took on different variations of basic geometric shapes well suited for everyday use. However, despite functionalism being one of the foremost objectives of the group, some of the designs seemed so bizarre to the purchasing public that it was decided to have the finished products photographed in use for didactic purposes. Hoffmann eventually came to the conclusion that it was impossible to convert the masses aesthetically and recognized that inevitably they were catering to an élitist few.

3. Financial difficulties and dissolution

The Wiener Werkstätte were constantly faced with irresolvable financial problems. The idealistic programme, which called for the costly production of handmade, unique objects, was unprofitable. In addition, commissioners often refused payment because of technicalities or deadline difficulties. Moser left the group in 1907 because Wärndorfer had approached Moser's wealthy wife, Editha Mautner-Markhof, for financial assistance without prior consultation with him. Although the circle of customers included such affluent and influential names as the Wittgenstein family, Broncia and Hugo Koller, Hans Böhler (?1884–1961) and Carl Moll, the enterprise was liquidated for the first time in 1914. Wärndorfer was forced to leave the cooperative under pressure of debts. In 1915 the banker and industrialist Otto Primavesi became the new business manager. Under his direction and with his international connections, the Wiener Werkstätte opened up branches in Berlin (1916), Marienbad (1916–17), Zürich (1917), New York (1922) and Velden at Wörthersee (1923). In 1913 the Wiener Keramik was taken over by Gmundner Keramik. However, the branch in Karlsbad, founded in 1909, had to close down its women's fashion department due to unprofitability. Eduard Josef Wimmer-Wisgrill (1882–1961), then the Director, suggested that women's accessories be sold. Wimmer-Wisgrill had succeeded Czeschka as Director, who in turn had accepted a professorship at the Kunstgewerbeschule in Hamburg but still submitted designs to the group. The deeply rooted misunderstanding of its cause was partly responsible for economic failure and ultimate liquidation of the Wiener Werkstätte in 1932. A public brought up on the historicist style created by Hans Makart and steeped in the opulent interiors of the palaces and public buildings on the Ringstrasse could not easily condition itself to the new functional purism of the Wiener

Werkstätte, which did not fulfil the public's need for self-representation and display.

Bibliography

L. Hevesi: *Acht Jahre Secession* (Vienna, 1906)

W. Müller-Wulckow: *Wiener Werkstätte, 1903–1928* (Vienna, 1928)

Die Wiener Werkstätte: Modernes Kunsthandwerk von 1903 bis 1932 (exh. cat. by W. Mrazek, Vienna, Mus. Angewandte Kst, 1967)

D. Baroni and A. d'Auria: *Josef Hoffmann e la Wiener Werkstätte* (Milan, 1981; Ger. trans., Stuttgart, 1984)

W. Neuwirth: *Die Keramik der Wiener Werkstätte*, i (Vienna, 1981)

W. J. Schweiger: *Wiener Werkstätte: Kunst und Handwerk, 1903–1932* (Vienna, 1982; Eng. trans., London, 1984)

Wiener Mode und Modefotografie: Die Modeabteilung der Wiener Werkstätte (exh. cat. by A. Volker, Vienna, Mus. Angewandte Kst, 1984)

Traum und Wirklichkeit: Wien, 1870–1930 (exh. cat., Vienna, Kstlerhaus, 1985)

J. Kallir: *Viennese Design and the Wiener Werkstätte* (New York, 1986)

CYNTHIA PROSSINGER

Workshop for the Restoration of Unfelt Sensations [Latv. Nebijušu Sajūtu Restaurēšanas Darbnīca; NSRD]

Latvian association of artists, architects and designers, active from September 1982 until 1989. It introduced video and computer art, new music and hybridized art genres to a conservative public in Latvia towards the end of the Soviet period. Its very name implied preconditions of stricture and privation, and its multidisciplinary methods served to expand critical discourse when Latvian cultural identity and collective political consciousness were undergoing a symbiotic revival, with the restoration of independence as a goal. NSRD founders Juris Boiko (*b* 1954) and Hardijs Lediņš (*b* 1955), both self-taught artists, organized Actions that some critics considered to be subtle acts of political dissent. Their *Walk to Bolderāja*, an annual pilgrimage begun in 1982 to an off-limits Soviet submarine base (representing thwarted access to the West), took place along railroad tracks that recalled the mass deportations of Balts to Siberia during the 1940s, to which Boiko's parents fell victim. Workshop members included Aigars Sparāns (*b* 1955), Dace Šenberga (*b* 1967) and Imants Žodžiks (*b* 1955). Together they produced numerous video projects, music recordings and performances, and three exhibitions. Much of this work was created under the rubric Approximate Art, an admixture of Zen Buddhism and Californian high-tech philosophy originated by Lediņš that is also associated with the artist Miervaldis Polis (*b* 1948). In keeping with its global focus NSRD pursued international contacts and collaborations, which members continued in their subsequent individual careers.

Bibliography

'Werkstatt zur Restauration nie empfundener Gefühle', *Riga: Lettische avantgarde* (exh. cat., W. Berlin, Staatl. Ksthalle, 1988), pp. 68–73

'Ungefähre Kunst in Riga: Gespräch zwischen der "Werkstatt zur Restauration nie verspürter Empfindungen" und Eckhart Gillen', *Niemandsland*, 5 (1988), pp. 32–50

MARK ALLEN SVEDE

World of Art [Rus. Mir Iskusstva]

Group of Russian artists and writers active 1898–1906, revived as an exhibiting society, 1910–24. Serge Diaghilev provided the motive force for the formation of the group in St Petersburg in 1898, and for the publication of its journal, *Mir Iskusstva*, from 1898 to December 1904. The Nevsky Pickwickians, grouped around Alexandre Benois, preceded the World of Art and formed its initial core. In the first issue of the journal Diaghilev, who with Benois had a wide knowledge of recent western European art, declared his commitment to a renaissance of Russian art, avoiding pale reflections of foreign trends yet also resisting a narrow nationalism. The World of Art provided a focus for Symbolist and Aesthetic tendencies in Russia, but its diversity of talents meant that it had only a limited degree of stylistic coherence.

World of Art group members stressed vigour and elegance simultaneously, a combination well illustrated in the work of Léon Bakst. They also

emphasized individualism and a sense of decoration, and they openly embraced exoticism allied to Post-Impressionist or Symbolist techniques, design and themes. The World of Art also sought an interaction of the arts. The colour experiments of the composer Aleksandr Skryabin (1872–1915) and the Symbolist work of the Lithuanian painter–composer Mikalojus Čiurlionis were much admired within the group. Ultimately this striving for a synthesis of the arts found vigorous expression in the production of Diaghilev's Ballets Russes, founded in 1909. Here the designers were equal in importance to the composers, choreographers and dancers as contributors to the spectacle.

Diaghilev had begun to organize exhibitions in 1897, and he had sole responsibility for the first World of Art exhibition. This opened at the Stieglitz School of Technical Drawing in St Petersburg on 22 January 1899. Entitled *Mezhdunarodskaya vystavka kartin zhurnala 'Mir Iskusstva'* ('International Exhibition of Paintings from the "World of Art" Journal')—the only international exhibition held by the World of Art—it assembled over three hundred works from nine countries. The Russian contingent included Bakst, Benois and Konstantin Somov from St Petersburg as well as such Moscow painters as Konstantin Korovin, Isaak Levitan, Mikhail Nesterov and Mikhail Vrubel'. Foreign contributors provided a spectacular if inconsistent display, with works by Arnold Böcklin, Eugène Carrière, Degas, Akseli Gallen-Kallela, Monet, Gustave Moreau, Puvis de Chavannes and Whistler. Diaghilev also had sole responsibility for organizing the World of Art exhibition of 1900, but from 1901 there was an exhibitions committee comprising Diaghilev, Benois and Serov. Submission was by invitation, and the exhibitors formed the core of the World of Art: Bakst, Benois, Ivan Bilibin, Viktor Vasnetsov, Yevgeny Lansere, Isaak Levitan, Filipp Malyavin, Mikhail Nesterov, Anna Ostroumova-Lebedeva, Konstantin Somov, as well as Aleksandr Golovin, Konstantin Korovin, Sergey Malyutin and Mariya Yakunchikova.

Moscow artists increasingly dominated the exhibitions, which in 1902 included Mikhail Vrubel''s colossal *Demon Downcast* (1901: St

Petersburg, Rus. Mus.). Other exhibitors included Pavel Kuznetsov, Nikolay Sapunov and Leonid Pasternak. The exhibition of 1902–3, held in Moscow, incorporated 17 works by Valentin Serov and 24 by Vrubel', and was the début of Nicholas Roerích. In 1903 Mstislav Dobuzhinsky also exhibited. A number of the artists went on to form the exhibiting society UNION OF RUSSIAN ARTISTS. After the closure of the journal a final exhibition opened in St Petersburg in 1906 incorporating a retrospective of Viktor Borisov-Musatov as well as works by the newcomers Mikhail Larionov, Alexei Jawlenski and Nikolay Milioti. The World of Art disbanded in 1906, having diversified and lost its tenuous unity. Many of the former members subsequently contributed to *Apollon*, the magazine edited by Sergey Makovsky from 1909.

In 1910 Benois revived the World of Art as an exhibition society. From then until 1924 it held 21 exhibitions in St Petersburg (Petrograd), Moscow, Kiev and Rostov-on-Don. While it continued to exhibit work by early World of Art members, it increasingly responded to new trends and ultimately to distinctly Soviet developments. Among new members it included Natan Al'tman, Chagall, Kandinsky, El Lissitzky, Kuz'ma Petrov-Vodkin, Tatlin and Georgy Yakulov.

Bibliography

C. Spencer and P. Dyer: *The World of Serge Diaghilev* (London, 1974)

N. Lapshina: *Mir Iskusstva* (Moscow, 1977)

J. E. Bowlt: *The Silver Age: Russian Art of the Early Twentieth Century and the 'World of Art' Group* (Newtonville, MA, 1979, rev. 2/1982)

JOHN MILNER

Worpswede colony

Colony of German artists founded in 1897 in the village of Worpswede near Bremen. In 1889 the painters Fritz Mackensen, Otto Modersohn (1865–1943) and Hans am Ende (1864–1918) moved to the village where they painted in the *plein-air* tradition of the Barbizon school. From the beginning they were closely connected with Carl Vinnen (1863–1922), who lived on his farm at Ostendorf,

Bremerhaven. In 1892 they were joined by Fritz Overbeck (1869–1909) and in 1894 by Heinrich Vogeler.

Mackensen, the most academic of the Worpswede painters, had his first success with large figure paintings, such as *Religious Service on the Moor* (1886–95; Hannover, Hist. Mus. Hohen Ufer). The ideological elevation of the peasant class appears more intensely in his work than in that of the other Worpswede artists. Am Ende's importance lay in his graphic work, for example *Cottage on the Moor* (1895; Bremen, Ksthalle). He also taught Vogeler, Overbeck and Mackensen the technique of etching. Modersohn was more concerned than the other artists with an analysis of art history and modern painting. His early paintings, such as *Cloud* (1890; Fischerhude, Otto-Modersohn-Mus.), reproduce a very independent vision of form and colour. The period of collaboration with Paula Modersohn-Becker, whom he married in 1901, gave them both artistic impetus. Landscape was always Modersohn's most important subject. The large number of sketches, which were preparations for paintings, express a poetic relationship with nature within a solid pictorial structure and have a great deal of painterly value, for example *Autumn Evening on the Moor* (1904; Essen, Mus. Flkwang). In his paintings and graphic work, Overbeck sometimes emphasized the elemental forces of nature.

Vinnen, who did not live in the village, was not a member of the narrower circle of the Worpswede painters, nor was Vogeler. The latter did not seek the primeval character of nature and the plain simplicity of the peasant population, but projected his longings into the landscape in the form of dream-like, stylized fairy-tale figures. Wholly committed to Jugendstil in his early works, he was influenced by the Pre-Raphaelites, Aubrey Beardsley and William Morris, and produced a large body of graphic work. As well as this he worked as an architect and made art and craft designs; in 1908 he founded, with his brother, the Worpsweder Werkstätten carpentry workshop.

In 1895 the Worpswede artists exhibited in the Kunsthalle, Bremen, and then in the Glaspalast, Munich, which was particularly successful. By 1897, however, when they officially founded the Künstlervereinigung Worpswede, the first tensions already existed between the friends. In 1899 Modersohn left the organization, which he found restricting, as did Overbeck and Vogeler. The differences between these artists and Mackensen and am Ende finally led in 1901 to the breaking of relations. Despite these tensions, Worpswede became an attraction for other artists: in 1899 Karl Krummacher (1867–1955) came to the village and continued the tradition of the first Worpswede artists; in 1902 Walter Bertelsmann (1877–1963) stayed in Worpswede, having been a pupil of am Ende.

Of all the Worpswede painters, Paula Modersohn-Becker was the only one who, despite her short life, won recognition far beyond Worpswede. She had moved there in 1898, full of admiration for the artists' group, and had become a pupil of Mackensen, although she was more influenced by the painting of Otto Modersohn. Once she had dealt artistically with the lyrical and escapist regional art, she found the village restricting and developed her abstract vision of the visible world through a study of French art in Paris, resulting in works such as *Self-portrait with Hand on Chin* (1901; Hannover, Niedersächs. Landesmus.). During his years in Worpswede, Vogeler's property Barkenhoff became the centre of a circle of artists and writers, including Modersohn and Modersohn-Becker, the sculptor Clara Rilke-Westhoff (1878–1954) and the writers Rainer Maria Rilke, Carl Hauptmann, Rudolf Alexander Schröder and Alfred Walter Heymel. In 1903 Rilke was commissioned to write the *Worpswede Monographie*. Worpswede soon lost its primeval character at the edge of a large moor and became an artists' village and tourist attraction.

Bibliography

R. M. Rilke: *Worpswede: Monographie einer Landschaft und ihrer Maler* (Bielefeld, 1903)

Worpswede: Aus der Frühzeit der Künstlerkolonie (exh. cat., Bremen, Ksthalle, 1970)

H. Wohltmann: *Worpswede: Die ersten Worpsweder Maler und ihre Bedeutung für die deutsche Kunst* (Worpswede, 1971)

H. W. Petzet: *Heinrich Vogeler: Von Worpswede nach Moskau* (Cologne, 1972)

O. *Modersohn* (exh. cat., Hannover, Kstver.; Münster, Westfäl. Landesmus.; 1978)

Worpswede: Eine deutsche Künstlerkolonie um 1900 (exh. cat., Bremen, Ksthalle, 1980)

Worpswede: Eine deutsche Künstlerkolonie um 1900 (exh. cat., Vienna, Künstlerhaus; Hannover, Niedersächs. Landesmus.; 1986)

HANS GERHARD HANNESEN

Young Estonia [Est. Noor-Eesti]

Term used from 1912 to describe a broad cultural movement in Estonia that lasted from *c.* 1902 until 1917. It generated new literary and artistic traditions for a people seeking independence from the Russian empire. Young Estonia was one manifestation of the phenomenon of national awakenings occurring throughout *fin-de-siècle* northern and eastern Europe, being particularly akin to those in Finland and Latvia. Its ideologist, the poet Gustav Suits (1883–1956), preached a synthesis of individualism and socialism, wherein culture could be nationalistic as long as it transcended chauvinism. His literary programme called for the assimilation of the best of European culture, and this expansive view soon affected Estonian visual arts, theatre and linguistics. Calendars and a periodical, *Noor-Eesti*, published in 1905–15 and 1910–11 respectively, promulgated and refined Young Estonia's philosophy. During this period, the first formal exhibition of Estonian painting and sculpture opened in Tallinn in 1906, and in 1909 the Folk Museum (now Museum of Ethnography) was established in Tartu, largely as a result of the organizing efforts of Kristjan Raud, Estonia's foremost National Romanticist. Older than most Young Estonia artists, Raud worked in a progression of styles, from realistic renderings of folk subjects to the modified Symbolist manner of his cycle celebrating the legendary national hero *Kalevipoeg*.

Estonia's artistic vanguard received much of its revolutionary impetus from studying abroad and adapting foreign idioms. Konrad Mägi, Aleksander Tassa (1882–1957) and Nikolai Triik (1884–1940), for example, were influenced by the Symbolist, Fauvist and Post-Impressionist art they saw in Paris, elements of which later informed their work. Mägi often painted Estonian landscapes in a vivid Neo-Impressionist mode, sometimes even indulging in Art Nouveau decoration. Triik was more inclined to Symbolism, having admired Edvard Munch and Ferdinand Hodler's work during visits to Norway and Berlin, and his paintings are among Young Estonia's most allegorical. Other artists associated with this movement were August Jansen (1881–1957), Roman Nyman (1881–1951), Paul Burman (1888–1934) and Peet Aren (1889–1970). While Estonian landscapes were a subject common to all—and appropriate vehicles for nationalistic sentiments—these artists had marked differences in stylistic approach, even within their own oeuvres. Of this group, Aren was most attracted to Expressionism, and his art anticipates works by certain members of the modernist ESTONIAN ARTISTS' GROUP. Jaan Koort was the principal sculptor of this milieu, again representing local subjects in a variety of international styles.

Bibliography

V. Vaga: *Eesti Kunst* [Estonian art] (Tallinn, 1940)

MARK ALLEN SVEDE

Young Ones [Swed. De Unga]

Swedish group of artists active from 1907 to 1911. The members included Isaac Grünewald, Leander Engström, Birger Jörgen Simonsson (1883–1930), Gösta Sandels, Tor Sigurd Bjurström (1888–1966), Carl Magnus Ryd (1883–1958), Nils Tove Edward Hald (1883–1980) and Ejnar Nerman (1888–1983). At their first exhibition, in Stockholm (1909), they were described by the critic August Brunins as 'Men of the Year 1909' ('*1909 års män*'). The group had two more exhibitions, both in Stockholm (1910, 1911), after which the group disbanded to form the short-lived group The Eight (De åtta), containing several of the original members of the Young Ones, as well as Einar Jolin, Nils Dardel and Sigrid Hjertén. The Eight had only one exhibition, in 1912, before drifting apart.

Most of these young artists had studied with Matisse, and they were influenced individually by Fauvism, as well as by the expressive realism of the work of van Gogh and Munch. The groups represented the development of the first Swedish expressionism. Their modernistic, colourful, chiefly French-inspired painting aroused great debate. Albert Engström (1869–1940), an older, traditional painter and writer, was particularly negative in his criticism of the young art. Works such as the *Red Blind* (1916; Stockholm, Mod. Mus.) by Hjertén were considered provocative.

Bibliography

G. Lilja: *Det moderna genombrott i svensk kritik, 1905–1914* [The modern breakthrough in Swedish criticism, 1905–1914] (Malmö, 1955)

——: *Den första svenska modernismen* [The first Swedish Modernism] (Kristianstad, 1986)

Modernismens genombrott: Nordiskt måleri, 1910–1920 [The breakthrough of Modernism: Scandinavian painting, 1910–1920] (exh. cat., ed. C. T. Edam, N.-G. Hökby and B. Schreiber; Göteborg, Kstmus., 1989–90)

JACQUELINE STARE

Zebra

German artists' group formed in Hamburg in 1965 by the painters Dieter Asmus (*b* 1939), Peter Nagel (*b* 1942), Nikolaus Störtenbecker (*b* 1940) and Dietmar Ullrich (*b* 1940). They were all graduates of the Hochschule für Bildende Künste in Hamburg and shared a common interest in Photorealism. Their work was characterized by the setting of objects and figures against an indistinct background. Despite the precise delineation of objects, sometimes approaching *trompe l'oeil* in the work of Nagel, their paintings were not naturalistic. Colour and form were used in an anti-realistic way, and the artists sometimes adopted the convention of using monochrome for figures and bright, arbitrary colours for inanimate objects, as in Asmus's *Vitamin-Bomb* (1976; Bochum, priv. col., see 1978-80 exh. cat., pl. 8). From photography they took the device of cutting off figures and objects, thus robbing their images of tradi-

tional compositional structure. Störtenbecker, in particular, employed a precise, minutely detailed realism that gave his work the impression of being a photograph, rather than a painted image. In the work of all four artists there was a tendency to suppress dramatic and expressive content by means of an apparently objective manner and by their attempts to dissociate their subjects from any 'meaning' that might have attached to them. This is as true of Ullrich's paintings featuring sport (e.g. *Swimmer*, 1970–71; Neuss, Clemens-Sels-Mus.), which give the impression of a freeze-frame camera, as it is of Nagel's isolated, oversized technological fragments (e.g. *Red Tent*, 1972–4; see 1978-80 exh. cat., pl. 33). The members of Zebra exhibited widely in Germany and elsewhere both independently and as a group.

Bibliography

Zebra (exh. cat. by H. R. Fischer, London, Fischer F.A., 1975)

Gruppe Zebra (exh. cat. by W.-D. Dube, Bremen, Ksthalle; Rome, Pal. Espos.; Leverkusen, Kulthaus; and elsewhere; 1978–80)

☐

Zen 49

German association of non-objective artists, founded in the Galerie Otto Stangl in Munich on 19 July 1949. Its seven founder-members were the painters Willi Baumeister, Rolf Cavael (1898–1979), Gerhard Fietz (*b* 1910), Rupprecht Geiger, Willi Hempel (1905–85), Fritz Winter and the sculptor Brigitte Matschinsky-Denninghof. Originally called the Gruppe der Ungegenständlichen, the group took the name Zen 49 in 1950 and saw itself as keeper of the traditions of the Blaue Reiter in Munich and of the Bauhaus, taking up artistic positions that had been vilified by the Nazis as 'degenerate'. The new name of Zen 49 was inspired by a general understanding of Zen Buddhism rather than by any intensive preoccupation with the subject. Through Eugen Herrigel's *Zen in der Kunst des Bogenschiessens* (Konstanz, 1948) and Daisetz Taitaro Suzuki's *Die grosse Befreiung* (Leipzig, 1939; 3rd edn, Konstanz, 1948), Zen was known as a spiritual pathway, along which the

unconscious was made conscious, and the group's name was chosen in reference to the philosophy's open and non-specific character. The date of foundation was affixed in order to indicate that the group was not to be identified exclusively with the oriental philosophy.

Zen philosophy had already interested such artists as Adolf Hölzel, Oskar Schlemmer and Johannes Itten, all spiritual forefathers of Zen 49, and Zen appeared as an underlying theme of Baumeister's *Das Unbekannte in der Kunst* (1947) as a process of unconscious form-finding. This publication and the lectures and exhibitions by Zen 49 may be seen in the broadest sense as stating the theoretical principles binding the group together. There was never a true group manifesto, however, and the only common goal was the advancement of abstract art. In post-war Germany especially, this was seen to represent an ideological programme with abstraction as the expression of an artistic stance aiming at freedom and pluralism. The group was attacked accordingly, although it was supported by the British consul, John Anthony Thwaites, and members of the American military administration in Munich, and in April 1950 it opened its first exhibition as Zen 49 in the Central Art Collecting Point of the Amerikahaus in Munich. Works exhibited included Geiger's *76E* (1948; Hagen, Osthaus Mus.), Baumeister's *Schwarzer Drachen und Blau* (1950; Strasbourg, Mus. A. Mod.) and Winter's *Composition* (1950; Munich, Staatsgal. Mod. Kst). Further exhibitions were held with increasing numbers of participants in 1951, 1953 and 1955, with lecture series and discussions on abstract art. Artists connected with the group in the 1950s included Julius Bissier and many artists associated with *Art informel*, such as Hans Hartung and Pierre Soulages. In 1956–7 Zen 49 organized the first group exhibition of German abstract artists to be held in the USA after World War II, before ceasing activities in 1957.

Writings

W. Baumeister: *Das Unbekannte in der Kunst* (Stuttgart, 1947)

Bibliography

Zen 49: Erste Ausstellung im April 1950 (exh. cat. by F. Roh and J. A. Thwaites, Munich, Amerikahaus, 1950) [15 pp.; does not incl. reproductions]

Die ersten zehn Jahre: Orientierungen: Zen 49 (exh. cat., ed. J. Poetter; Baden-Baden, Staatl. Ksthalle, 1986–7) [incl. facs. of 1950 cat.]

M.-A. v. Lüttichau: 'Zen 49', *Stationen der Moderne* (exh. cat., ed. E. Roters; W. Berlin, Berlin. Gal., 1988), pp. 378–85

CLAUDIA BÜTTNER

Zero

International group of artists founded in Düsseldorf and active from 1958 until 1966. Membership of this informal association varied, but the core of the group was made by Heinz Mack, Otto Piene and Günther Uecker. The range of art produced by Zero members ran from monochrome painting to Nouveau Réalisme, and to object art via kinetic art and light art. The common element was found in young artists who wanted to overcome the subjective expression inherent in Tachism and *Art informel*, which was still strongly characterized by post-war intellectual movements such as Existentialism. By challenging the artistic ideas of the 1920s again (e.g. Suprematism and Constructivism), it was hoped to find a way of revitalizing and spiritualizing 'concrete' means of expression that did not reproduce the old world but rather opened up new forms of perception and levels of consciousness.

The group's history is linked to that of the eponymous journal, of which only three issues were published (1958–61). The first, published on 24 April 1958, contained texts by Yves Klein, Heinz Mack and Otto Piene, and the poem 'Voyelles' by Arthur Rimbaud. Its publication coincided with the seventh evening exhibition in Mack and Piene's studios in the yard of an old factory building at 69 Gladbacher Strasse, Düsseldorf, entitled *Das rote Bild (Bilder, deren bestimmende Farbe Robe ist)*, which included 45 artists. These evening exhibitions began on 11 April 1957 and provided

the subject for much dispute amongst the artists of the Düsseldorf-based Gruppe 53. Thereafter discussions centred on the planned new journal that was inspired mainly by Yves Klein, whose work was shown for the first time in West Germany in the newly opened Alfred Schmela Gallery in Düsseldorf at the end of May 1957. According to Piene the name 'Zero' was not meant to reflect an 'expression of nihilism', but rather '. . . the immeasurable zone in which an old condition develops into an unknown new one'.

Zero 2 was published in October 1958 to accompany the eighth evening exhibition, *Vibration*, and contained manifestos by Mack ('Die Ruhe der Unruhe') and Piene ('Die Reinheit des Lichts'). The exhibition, which included work by Oskar Holweck (*b* 1924), Adolf Zillmann, Almir Mavignier (*b* 1925), Mack and Piene, had the theme of visual movement. The field was then open to kinetic art and to light art. By 1959 exchange and criticism of ideas occurred on an international level. Jean Tinguely's exhibition at the end of January 1959 in the Schmela Gallery, for which Yves Klein wrote the opening speech 'La Collaboration entre artistes créateurs', led to joint work. Tinguely dropped 150,000 leaflets of his manifesto *Für Statik* over Düsseldorf. In Uecker's studio in Düsseldorf there was a three-day artists' festival for Tinguely and Klein, with a blue and a red room. In March 1959 the Hessenhuis, the port storehouse in Antwerp, became an international meeting place through the exhibition *Vision in Motion— Motion in Vision* initiated by Tinguely with Paul van Hoeydorck, Pol Bury and Daniel Spoerri; its title was in homage to László Moholy-Nagy. As well as Mack, Piene and Uecker, ten other artists took part in the show. A common theme emerged of new dynamic phenomena used in art to expand human perception.

In the Festival d'art d'avantgarde in Paris in 1960 a distinction between the movements 'Zero— The New Idealism' and 'Nouveau Réalisme' was first drawn. It was not, however, until July of the following year at the *Zero— Edition, Exposition, Demonstration* exhibition in the Schmela Gallery in Düsseldorf that the first joint action of the core of the group took place. The collaboration between Mack, Piene and Uecker determined further joint projects up to 1966. The exhibition, for which *Zero 3* was published, led to the first Happening-like action in Düsseldorf. The gallery was nailed up, the street in front was painted with a large white circle and a hot air balloon was released. A further *Zero-Festival* was held in the following year on the Rheinwiesen in Düsseldorf. Zero as a movement represented the energy and imagination that was unfolding in society with the aim of a more beautiful, better world. Nature and technology were to meet harmoniously in this vision. The optimistic outlook of that time, in which political obstacles began to give way and in which new perspectives seemed possible, found a visual expression in the Zero projects.

In 1962 important international Zero exhibitions took place in Antwerp, Brussels and Ghent, and in particular the *Nul = Zero* exhibition at the Stedelijk Museum, Amsterdam. For these the Düsseldorf Zero artists created many joint 'Zero rooms' in which physical gravity seemed to be suspended. In 1964 one of these optical-kinetic rooms was presented as 'Hommage à Fontana' at the *Documenta III* in Kassel (now in Düsseldorf, Kstmus.). In the same year the Zero artists went to London (McRoberts and Tunnard Gallery) and to New York (Howard Wise Gallery) and Philadelphia. International success and diverging artistic content and interests led, however, to the group's dissolution. The group appeared one last time at the Städtisches Kunstmuseum in Bonn in 1966. In 1973 a retrospective Zero room was installed in the Kunstmuseum in Düsseldorf to encapsulate the international Zero movement.

Writings

O. Piene: 'The Development of Group "Zero"', *TLS* (3 Sept 1964), pp. 812–13
Zero (Cologne, 1973) [reprint of *Zero 1* to *3*]

Bibliography

Mack, Piene, Uecker (exh. cat., foreword P. Wember; Krefeld, Mus. Haus Lange, 1963)
Zero: Mack, Piene, Uecker (exh. cat., New York, Howard Wise Gal., 1964)
Heinz Mack, Otto Piene, Günther Uecker (exh. cat., Hannover, Kestner-Ges., 1965)

Zero in Bonn: Mack, Piene, Uecker (exh. cat., Bonn, Städt. Kstmus., 1966)

Zero-Raum (exh. cat., article by G. Storck; Düsseldorf, Kstmus., 1973)

Zero: Bildvorstellungen einer europäischen Avantgarde, 1958–1964 (exh. cat., articles by U. Perucchi-Petri, H. Weitemeier-Steckel and E. Gomringer; Zurich, Ksthaus, 1979)

Zero Internationalen Antwerpen (exh. cat., articles by J. F. Buyck, W. van Mulders and H. Verscharen; Antwerp, Kon. Mus. S. Kst., 1980)

A. Kuhn: *Zero: Eine Avantgarde der sechziger Jahre* (Frankfurt am Main, 1991)

Zero: Eine europäische Avantgarde (exh. cat., Essen, Gal. Neher; Munich, Gal. Heseler; Koblenz, Mittelrhein-Mus.; 1992) [articles by A. Kuhn and O. Piene]

STEPHAN VON WIESE

Black and White Illustration
Acknowledgements

We are grateful to those listed below for permission to reproduce copyright illustrative material. Every effort has been made to contact copyright holders and to credit them appropriately; we apologize to anyone who may have been omitted from the acknowledgements or cited incorrectly. Any error brought to our attention will be corrected in subsequent editions.

Anthony Scibilia/Art Resource, NY Fig. 34
Art Resource, NY Figs 10, 29
Erich Lessing/Art Resource, NY Figs 22, 28, 40, 49
Erich Lessing/Art Resource, NY/© ADAGP, Fig. 7
Paris and DACS, London 2000
Erich Lessing/Art Resource, NY/© DACS, 2000 Fig. 18
Foto Marburg/Art Resource, NY Fig. 6
Giraudon/Art Resource, NY Fig. 25
Giraudon/Art Resource, NY/© ADAGP, Figs 14, 15, 19, 20, 35
Paris and DACS, London 2000
National Portrait Gallery, Smithsonian Fig. 36
Institution/Art Resource, NY
Nimatallah/Art Resource, NY Fig. 17
Robert M. Craig Figs 3, 11, 23, 30, 32, 39
Scala/Art Resource, NY Figs 8, 9
Scala/Art Resource, NY/© DACS, 2000 Fig. 43
Tate Gallery, London/Art Resource, NY Figs 24, 33, 42, 44, 48

Tate Gallery, London/Art Resource, NY/© ADAGP, Paris and DACS, London 2000 Figs 4, 5, 16, 46, 47
Tate Gallery, London/Art Resource, NY/© Angela Verren-Taunt. All Rights Reserved, DACS, 2000 Fig. 41
Tate Gallery, London/Art Resource, NY/© ARS, Figs 2, 13
NY and DACS, London 2000
Tate Gallery, London/Art Resource, NY/© Carl Andre/VAGA, New York and DACS, London 2000 Fig. 27
Tate Gallery, London/Art Resource, NY/© DACS, 2000 Figs 12, 31, 37, 45
Tate Gallery, London/Art Resource, NY/Art © Donald Judd Estate/VAGA, New York and DACS, London 2000 Fig. 26
Tate Gallery, London/Art Resource, NY/© Jasper Johns/VAGA, New York and DACS, London 2000 Fig. 38
Tate Gallery, London/Art Resource, NY/© Willem de Kooning Revocable Trust/ARS, NY and DACS, London 2000 Fig. 1
Vanni/Art Resource, NY Fig. 21

Colour Illustration
Acknowledgements

Andy Warhol Foundation Inc./Art Resource, NY/© The Andy Warhol Foundation for the Visual Arts, Inc/ARS, NY and DACS, London 2000 Plate XXIX
Anthony Scibilia/Art Resource, NY Plate XXIII
Anthony Scibilia/Art Resource, NY/© DACS, 2000 Plate XIV
Art Resource, NY Plate XX
Cameraphoto/Art Resource, NY/© Succession Marcel Duchamp/ADAGP, Paris and DACS, London 2000 Plate XVI
Erich Lessing/Art Resource, NY Plates XVII, XXXII, XXXIII, XXXVI
Erich Lessing/Art Resource, NY/© ADAGP, Paris and DACS, London 2000 Plate XXVIII
Erich Lessing/Art Resource, NY/© DACS, 2000 Plate XXVI
Giraudon/Art Resource, NY Plate IX
Giraudon/Art Resource, NY/© ADAGP, Paris and DACS, London 2000 Plate V
Giraudon/Art Resource, NY/© Succession Picasso/DACS, 2000 Plate XV
Newark Museum/Art Resource, NY Plate VII

Robert M. Craig Plates IV, XI, XXII, XXV, XXX
Scala/Art Resource, NY Plate VIII
Scala/Art Resource, NY/© Succession H. Matisse/DACS, 2000 Plate XIX
Tate Gallery, London/Art Resource, NY Plates I, VI, X, XII, XXI, XXXV
Tate Gallery, London/Art Resource, NY/© ADAGP, Paris and DACS, London 2000 Plates XVIII, XXIV
Tate Gallery, London/Art Resource, NY/© ARS, NY and DACS, London 2000 Plates XIII, XXVII
Tate Gallery, London/Art Resource, NY/© Kate Rothko Prizel and Christopher Rothko/ARS, NY and DACS, London 2000 Plate III
Tate Gallery, London/Art Resource, NY/© Mondrian/Holzman Trust, c/o Beeldrecht, Amsterdam, Holland/DACS, 2000 Plate II
Tate Gallery, London/Art Resource, NY/© Salvador Dalí - Foundation Gala-Salvador Dali/DACS, 2000 Plate XXXIV
Vanni/Art Resource, NY Plate XXXI

Appendix A
LIST OF LOCATIONS

Every attempt has been made to supply the correct current location of each work of art mentioned, and in general this information appears in abbreviated form in parentheses after the first mention of the work. The following list contains the abbreviations and full forms of the museums, galleries and other institutions that own or display art works or archival material cited in this book; the same abbreviations have been used in bibliographies to refer to the venues of exhibitions.

Institutions are listed under their town or city names, which are given in alphabetical order. Under each place name, the abbreviated names of institutions are also listed alphabetically, ignoring spaces, punctuation and accents. Square brackets following an entry contain additional information about that institution, for example its previous name or the fact that it was subsequently closed.

Aachen, Neue Gal.
 Aachen, Neue Galerie [Sammlung Ludwig]
Aarau, Aargau. Ksthaus
 Aarau, Aargauer Kunsthaus
Ålborg, Nordjyllands Kstmus.
 Ålborg, Nordjyllands Kunstmuseum
Amersfoort, Zonnehof Mus.
 Amersfoort, Zonnehof Museum
Amsterdam, Nieuwe Kerk
Amsterdam, Stedel. Mus.
 Amsterdam, Stedelijk Museum
Antwerp, Kon. Mus. S. Kst.
 Antwerp, Koninklijk Museum voor Schone Kunsten
Atlanta, GA, High Mus. A.
 Atlanta, GA, High Museum of Art
Avignon, Mus. Calvet
 Avignon, Musée Calvet
Baden-Baden, Staatl. Ksthalle
 Baden-Baden, Staatliche Kunsthalle Baden-Baden
Bagnols-sur-Cèze, Mus. Bagnols-sur-Cèze
 Bagnols-sur-Cèze, Musée de Bagnols-sur-Cèze [Fondation Léon Alègre]
Barcelona, Cent. Cult. Fund. Caixa Pensions
 Barcelona, Centre Cultural de la Fundació Caixa de Pensions
Barcelona, Gal. Dalmau

Barcelona, Galería Dalmau
Barcelona, Gal. Maeght
 Barcelona, Galería Maeght
Basle, Ksthalle
 Basle, Kunsthalle Basel
Basle, Kstmus.
 Basle, Kunstmuseum [incl. Kupferstichkabinett]
Belfast, Ulster Mus.
 Belfast, Ulster Museum
Belgrade, Mus. Contemp. A.
 Belgrade, Museum of Contemporary Art (Muzej Savremene Umetnosti)
Berkeley, CA, Imogen Cunningham Trust
Berkeley, U. CA, A. Mus.
 Berkeley, CA, University of California, University Art Museum
Berlin, Akad. Kst.
 Berlin, Akademie der Künste [formed by unification of former Preussische Akademie der Künste & Deutsche Akademie der Künste der DDR]
Berlin, Alte N.G.
 Berlin, Alte Nationalgalerie
Berlin, Altes Mus.
 Berlin, Altes Museum [formerly Museum am Lustgarten; houses Kupferstichkabinett; Sammlung Zeichnungen und Druckgraphik; Wechselausstellungen]

Berlin, Bauhaus-Archv
 Berlin, Bauhaus-Archiv
Berlin, Bauhaus-Archv, Mus. Gestalt.
 Berlin, Bauhaus-Archiv, Museum für Gestaltung
Berlin, Berlin. Gal.
 Berlin, Berlinische Galerie [in Gropiusbau]
Berlin, Berlin Mus.
 Berlin, Berlin Museum
Berlin, Brücke-Mus.
 Berlin, Brücke-Museum
Berlin, Kstamt Kreuzberg
 Berlin, Kunstamt Kreuzberg
Berlin, Neue N.G.
 Berlin, Neue Nationalgalerie
Berlin, Neuer Berlin. Kstver.
 Berlin, Neuer Berliner Kunstverein
Berlin, Staatl. Ksthalle
 Berlin, Staatliche Kunsthalle
Berlin, Staatl. Museen Preuss. Kultbes.
 Berlin, Staatliche Museen Preussischer Kulturbesitz [admins Ägyp. Mus.; Alte N.G.; Altes Mus.; Antikenmus.; Bodemus.; Gal. Romantik; Gemäldegal.; Gipsformerei; Kstbib.; Kupferstichkab.; Mus. Dt. Vlksknd.; Mus. Ind. Kst; Mus. Islam. Kst; Mus. Ostasiat. Kst; Mus. Vlkerknd.; Mus. Vor- & Frühgesch.; Neue N.G.; Pergamonmus.; Schinkelmus.; Schloss

Charlottenburg; Schloss Köpenick; Skulpgal.; Staatsbib.; Tiergarten, Kstgewmus.]

Berlin, Ver. Berlin. Kstlr
 Berlin, Verein Berliner Künstler
Berne, Ksthalle
 Berne, Kunsthalle
Berne, Kstmus.
 Berne, Kunstmuseum
Bielefeld, Städt. Ksthalle
 Bielefeld, Städtische Kunsthalle
Binghamton, SUNY
 Binghamton, NY, State University of New York
Birmingham, A.G.
 Birmingham, City of Birmingham Art Gallery [name changed to Mus. & A.G. in 1939]
Bochum, Mus. Bochum, Kstsamml.
 Bochum, Museum Bochum, Kunstsammlung
Bologna, Gal. Com. A. Mod.
 Bologna, Galleria Comunale d'Arte Moderna
Bonn, Rhein. Landesmus.
 Bonn, Rheinisches Landesmuseum [Rheinisches Amt für Bodendenkmalpflege mit Regionalmuseum Xanten und Archäologischer Park Xanten]
Bonn, Städt. Kstmus.
 Bonn, Städtisches Kunstmuseum Bonn
Bordeaux, Gal. B.-A.
 Bordeaux, Galerie des Beaux-Arts
Boston, MA, Mus. F.A.
 Boston, MA, Museum of Fine Arts
Bremen, Ksthalle
 Bremen, Kunsthalle
Brighton, A.G. & Mus.
 Brighton, Art Gallery and Museum
Brit. Council Col.
 British Council Collection
Brno, Morav. Gal.
 Brno, Moravian Gallery (Moravská Galerie v Brn.)
Brno, Morav. Mus.
 Brno, Moravian Museum (Moravské Muzeum)

Brussels, Crédit Com. Belg.
 Brussels, Crédit Communal de Belgique
Brussels, Mus. A. Mod.
 Brussels, Musée d'Art Moderne
Brussels, Musées Royaux A. & Hist.
 Brussels, Musées Royaux d'Art et d'Histoire [Koninklijke Musea voor Kunst en Geschiedenis]
Brussels, Musées Royaux B.-A.
 Brussels, Musées Royaux des Beaux-Arts de Belgique/Koninklijke Musea voor Schone Kunsten van België [admins Mus. A. Anc.; Mus. A. Mod.; Mus. Wiertz]
Brussels, Pal. B.-A.
 Brussels, Palais des Beaux-Arts, Société des Expositions
Budapest, House Creative Artists
 Budapest, House of Creative Artists (Alkotás Müvészház)
Budapest, Lajos Kassák Mem. Mus.
 Budapest, Lajos Kassák Memorial Museum (Kassák Lajos Emlékmúzeum)
Budapest, N.G.
 Budapest, Hungarian National Gallery (Magyar Nemzéti Galéria)
Budapest, N. Mus., Dept Mod. Hist.
 Budapest, National Museum, Department of Modern History [formerly Mus. Hung. Labour Movement]
Buenos Aires, Bohemio Club, Gal. Pacífico
 Buenos Aires, Bohemio Club, Galería Pacífico
Buenos Aires, Inst. Fr. Estud. Sup.
 Buenos Aires, Instituto Francés de Estudios Superiores [Van Riel]
Buenos Aires, Salón Altamira
Buffalo, NY, Albright-Knox A.G.
 Buffalo, NY, Albright-Knox Art Gallery [formerly Albright A.G.]
Calais, Mus. B.-A.
 Calais, Musée des Beaux-Arts et de la Dentelle
Calgary, Glenbow-Alta Inst.
 Calgary, Glenbow-Alberta Institute

Cambridge, MA, Busch-Reisinger Mus.
 Cambridge, MA, Busch-Reisinger Museum
Cambridge, MA, Fogg
 Cambridge, MA, Fogg Art Museum
Caracas, Mus. A. Contemp.
 Caracas, Museo de Arte Contemporáneo de Caracas
Charleroi, Mus. Com. B.-A.
 Charleroi, Musée Communal des Beaux-Arts
Chicago, IL, A. Inst.
 Chicago, IL, Art Institute of Chicago
Chicago, IL, Mus. Contemp. A.
 Chicago, IL, Museum of Contemporary Art
Chur, Bündner Kstmus.
 Chur, Bündner Kunstmuseum
Cincinnati, OH, A. Mus.
 Cincinnati, OH, Cincinnati Art Museum
Cleveland, OH, Mus. A.
 Cleveland, OH, Cleveland Museum of Art
Cologne, Gal. Gmurzynska
 Cologne, Galerie Gmurzynska
Cologne, Gal. Karsten Greve
 Cologne, Galerie Karsten Greve
Cologne, Josef-Haubrich-Ksthalle
 Cologne, Josef-Haubrich-Kunsthalle [Kunsthalle Köln]
Cologne, Kstgewmus.
 Cologne, Kunstgewerbemuseum [name changed in 1989 to Mus. Angewandte Kst]
Cologne, Kstver.
 Cologne, Kunstverein
Cologne, Mus. Ludwig
 Cologne, Museum Ludwig
Como, Mus. Civ. Stor. Garibaldi
 Como, Museo Civico Storico G. Garibaldi
Copenhagen, Kstindustmus.
 Copenhagen, Danske Kunstindustrimuseum
Copenhagen, Ordrupgaardsaml.
 Copenhagen, Ordrupgaardsamlingen

Copenhagen, Stat. Mus. Kst
 Copenhagen, Kongelige
 Kobberstiksamling, Statens
 Museum for Kunst
Copenhagen, Stat. Mus. Kst
 Copenhagen, Statens Museum for
 Kunst
Dachau, Gemäldegal.
 Dachau, Gemäldegalerie
Dallas, TX, Mus. A.
 Dallas, TX, Dallas Museum of Art
Darmstadt, Ausstellhallen
Mathildenhöhe
 Darmstadt, Ausstellungshallen
 Mathildenhöhe
Darmstadt, Inst. Mathildenhöhe
 Darmstadt, Institut
 Mathildenhöhe
Dayton, OH, A. Inst.
 Dayton, OH, Dayton Art
 Institute
Des Moines, IA, A. Cent.
 Des Moines, IA, Art Center
Duisburg, Lehmbruck-Mus.
 Duisburg, Wilhelm-Lehmbruck-
 Museum
Düsseldorf, Kstmus.
 Düsseldorf, Kunstmuseum im
 Ehrenhof
Düsseldorf, Kstsamml. Nordrhein-
Westfalen
 Düsseldorf, Kunstsammlung
 Nordrhein-Westfalen
 [Landesgalerie]
Düsseldorf, Kstver.
 Düsseldorf, Kunstverein für die
 Rheinlande und Westfalen
Edinburgh, City A. Cent.
 Edinburgh, City Art Centre
Edinburgh, N.G.
 Edinburgh, National Gallery of
 Scotland
Edinburgh, N.G. Mod. A.
 Edinburgh, National Gallery of
 Modern Art
Edinburgh, Scot. A.C.
 Edinburgh, Scottish Arts
 Council
Edmonton, Alta, A.G.
 Edmonton, Alta, Edmonton Art
 Gallery

Eindhoven, Stedel. Van Abbemus.
 Eindhoven, Stedelijk Van
 Abbemuseum
Essen, Mus. Flkwang
 Essen, Museum Folkwang
Evanston, IL, Northwestern U.
 Evanston, IL, Northwestern
 University
Fischerhude, Otto-Modersohn-Mus.
 Fischerhude, Otto-Modersohn-
 Museum
Fort Worth, TX, Kimbell A. Mus.
 Fort Worth, TX, Kimbell Art
 Museum
Frankfurt am Main, Gal. Sydow
 Frankfurt am Main, Galerie Sydow
Frankfurt am Main, Haus Hess.
Rundfunks
 Frankfurt am Main, Haus des
 Hessischen Rundfunks
Frankfurt am Main, Hist. Mus.
 Frankfurt am Main, Historisches
 Museum
Frankfurt am Main, Kstver.
 Frankfurt am Main, Frankfurter
 Kunstverein
Frankfurt am Main, Schirn Ksthalle
 Frankfurt am Main, Schirn
 Kunsthalle
Frankfurt am Main, Zimmergal.
Franck
 Frankfurt am Main,
 Zimmergalerie Franck
Frederikssund, Willumsens Mus.
 Frederikssund, J. F. Willumsens
 Museum
Genazzano, Castello Colonna
Göppingen, Kstver.
 Göppingen, Kunstverein
Gorzów Wielkopolski, Distr. Mus.
 Gorzów Wielkopolski, District
 Museum (Muzeum Okregowe)
Göteborg, Kstmus.
 Göteborg, Göteborgs
 Konstmuseum
Grenoble, Mus. Peint. & Sculp.
 Grenoble, Musée de Peinture et de
 Sculpture [name changed to Mus.
 Grenoble in 1986]
Haarlem, Frans Halsmus.
 Haarlem, Frans Halsmuseum

Hagen, Osthaus Mus.
 Hagen, Karl Ernst Osthaus
 Museum [formerly housed
 Folkwang Museum]
The Hague, Gemeentemus.
 The Hague, Haags
 Gemeentemuseum [houses Oude
 en Moderne Kunstnijverheid;
 Haagse Stadgeschiedenis; Moderne
 Kunst; Museon;
 Muziekinstrumenten; Nederlands
 Kostuummuseum]
Halle, Staatl. Gal. Moritzburg
 Halle, Staatliche Galerie
 Moritzburg Halle
Hamburg, Ksthalle
 Hamburg, Hamburger Kunsthalle
 [incl. Kupferstichkabinett]
Hamburg, Kstver.
 Hamburg, Kunstverein Hamburg
Hamburg, Mus. Kst & Gew.
 Hamburg, Museum für Kunst und
 Gewerbe
Hannover, Fernsehgal. Gerry Schum
 Hannover, Fernsehgalerie Gerry
 Schum
Hannover, Hist. Mus. Hohen Ufer
 Hannover, Historisches Museum
 am Hohen Ufer
Hannover, Kestner-Ges.
 Hannover, Kestner-Gesellschaft
Hannover, Kstmus.
 Hannover, Kunstmuseum
Hannover, Kstver.
 Hannover, Kunstverein Hannover
Hannover, Niedersächs. Landesmus.
 Hannover, Niedersächsisches
 Landesmuseum [Niedersächsische
 Landesgalerie; formerly called
 Provmus.]
Hannover, Sprengel Mus.
 Hannover, Sprengel Museum
 [Kunstmuseum Hannover mit
 Sammlung Sprengel]
Helsinki, Athenaeum A. Mus.
 Helsinki, Athenaeum Art Museum
 (Ateneumin Taidemuseo) [Museum
 of Finnish Art in the N.G.]
Humlebæk, Louisiana Mus.
 Humlebæk, Louisiana Museum of
 Modern Art

Los Angeles, UCLA
 Los Angeles, University of
 California
Ludwigshafen, Hack-Mus. & Städt.
Kstsamml.
 Ludwigshafen, Wilhelm Hack-
 Museum und Städtische
 Kunstsammlungen
Lugano, Villa Malpensata
Lund, Ksthall
 Lund, Konsthall
Lyon, Mus. B.-A.
 Lyon, Musée des Beaux-Arts
Madrid, Bib. N.
 Madrid, Biblioteca Nacional
 [housed with Mus. Arqueol. N.;
 incl. Sala de la Biblioteca
 Nacional]
Madrid, Cent. A. Reina Sofia
 Madrid, Centro de Arte Reina
 Sofia
Madrid, Gal. Nebli
 Madrid, Galería Nebli
Madrid, Mus. N. Cent. A. Reina Sofia
 Madrid, Museo Nacional Centro de
 Arte Reina Sofia
Madrid, Prado
 Madrid, Museo del Prado [Museo
 Nacional de Pintura y Escultura]
Madrid, Soc. Amigos A.
 Madrid, Sociedad de Amigos de
 Arte
Malmö, Ksthall
 Malmö, Konsthall
Malmö, Kstmus.
 Malmö, Konstmuseum
Managua, Banco Cent. de Nicaragua
 Managua, Banco Central de
 Nicaragua
Manchester, C.A.G.
 Manchester, City Art Gallery
Mannheim, Städt. Ksthalle
 Mannheim, Städtische Kunsthalle
 Mannheim [Städtisches Museum]
Marseille, Gal. Faïence
 Marseille, Galerie Faïence
Marseille, Mus. Cantini
 Marseille, Musée Cantini
Melbourne, Monash U., A.G.
 Melbourne, Monash University,
 Art Gallery

Melbourne, N.G. Victoria
 Melbourne, National Gallery of
 Victoria [Victorian A. Cent.]
Mexico City, Inst. N. B.A.
 Mexico City, Instituto Nacional de
 Bellas Artes
Mexico City, Mus. N. Hist.
 Mexico City, Museo Nacional de
 Historia, Castillo de Chapultepec
Mexico City, Pal. B.A.
 Mexico City, Palacio de Bellas
 Artes [houses Mus. Pal. B.A.]
Mexico City, Pal. N.
 Mexico City, Palacio Nacional
Mexico City, U. Iberoamer.
 Mexico City, Universidad
 Iberoamericana
Middlesbrough, Cleveland Gal.
 Middlesbrough, Cleveland Gallery
Milan, Civ. Mus. A. Contemp.
 Milan, Civico Museo d'Arte
 Contemporanea [in Pal. Reale]
Milan, Famiglia A.
 Milan, Famiglia Artistica
Milan, Gal. Naviglio
 Milan, Galleria del Naviglio
Milan, Olivetti Italia
Milan, Padiglione A. Contemp.
 Milan, Padiglione Arte
 Contemporanea
Milan, Pal. Permanente
 Milan, Palazzo della Permanente,
 Società per le Belle Arti ed
 Esposizione Permanente
Milan, Pal. Reale
 Milan, Palazzo Reale
Minneapolis, MN, Inst. A.
 Minneapolis, MN, Minneapolis
 Institute of Arts
Minneapolis, MN, Walker A. Cent.
 Minneapolis, MN, Walker Art
 Center
Modena, Musei Civ.
 Modena, Musei Civici [admins
 Archv Stor.; Bib. Civ. Stor. A.; Bib.
 Estense; Bib. U; Gal. Campori; Gal.
 & Mus. Estense; Gal. Poletti; Mus.
 Archeol. Etnol.; Mus. Lapidario;
 Mus. & Medagliere Estense; Mus.
 Risorgimento; Mus. Stor. & A. Med.
 & Mod.]

Montreal, Mus. A. Contemp.
 Montreal, Musée d'Art
 Contemporain
Montreal, Mus. F.A.
 Montreal, Museum of Fine Arts
 [Musée des Beaux-Arts]
Moscow, Bakhrushin Cent. Theat. Mus.
 Moscow, Bakhrushin Central
 Theatre Museum (Tsentral'nyy
 Teatral'nyy Muzey Imeni A. A.
 Bakhrushina)
Moscow, Cent. Lenin Mus.
 Moscow, Central Lenin Museum
 [closed] (Tsentral'nyy Muzey V.I.
 Lenina)
Moscow, Rodchenko Archv
 Moscow, Rodchenko Archive
 (Arkhiv Rodchenko)
Moscow, Tret'yakov Gal.
 Moscow, Tret'yakov Gallery
 (Tret'yakovskaya Galereya)
Munich, Amerikahaus
Munich, Gal. Heiner Friedrich
 Munich, Galerie Heiner
 Friedrich
Munich, Gal. Heseler
 Munich, Galerie Heseler
Munich, Haus Kst
 Munich, Haus der Kunst
Munich, Lenbachhaus
 Munich, Städtische Galerie im
 Lenbachhaus
Munich, Neue Kstsalon
 Munich, Neuer Kunstsalon
Munich, Neue Pin.
 Munich, Neue Pinakothek
Munich, Staatsgal. Mod. Kst
 Munich, Staatsgalerie Moderner
 Kunst [in Haus der Kunst]
Munich, Stadtmus.
 Munich, Münchener
 Stadtmuseum
Munich, Villa Stuck
Münster, Westfäl. Kstver.
 Münster, Westfälischer
 Kunstverein [in Westfäl.
 Landesmus.]
Münster, Westfäl. Landesmus.
 Münster, Westfälisches
 Landesmuseum für Kunst und
 Kulturgeschichte

Neuss, Clemens-Sels-Mus.
　Neuss, Clemens-Sels-Museum
Newcastle upon Tyne, Laing A.G.
　Newcastle upon Tyne, Laing Art
　Gallery
New Haven, CT, Yale Cent. Brit. A.
　New Haven, CT, Yale Center for
　British Art
New Haven, CT, Yale U. A.G.
　New Haven, CT, Yale University
　Art Gallery
New York, Bartók Archvs
　New York, Bartók Archives
New York, Bronx Mus. A.
　New York, Bronx Museum of the
　Arts
New York, Brooklyn Mus.
　New York, The Brooklyn Museum
New York, Cult. Cent.
　New York, Cultural Center
New York, Dia A. Found.
　New York, Dia Art Foundation
New York, Finch Coll. Mus. A.
　New York, Finch College Museum
　of Art
New York, 49th Parallel Gal.
　New York, 49th Parallel Gallery
New York, Guggenheim
　New York, Solomon R.
　Guggenheim Museum
New York, Hirschl & Adler Gals
　New York, Hirschl and Adler
　Galleries, Inc.
New York, Howard Wise Gal.
　New York, Howard Wise Gallery
New York, Hudson River Mus.
　New York, Hudson River Museum
　at Yonkers
New York, Jew. Mus.
　New York, The Jewish Museum
New York, Leonard Hutton Gals
　New York, Leonard Hutton
　Galleries
New York, Met.
　New York, Metropolitan Museum
　of Art
New York, MOMA
　New York, Museum of Modern Art
New York, New Mus. Contemp. A.
　New York, New Museum of
　Contemporary Art

New York, Rachel Adler Gal.
　New York, Rachel Adler Gallery
New York, Semaphore Gal.
　New York, Semaphore Gallery
New York, Sidney Janis Gal.
　New York, Sidney Janis Gallery
New York, Whitney
　New York, Whitney Museum of
　American Art
Nîmes, Mus. A. Contemp.
　Nîmes, Musée d'Art Contemporain
Oakland, CA, Mus.
　Oakland, CA, Oakland Museum
Odense, Fyn. Stiftsmus.
　Odense, Fyns Stiftsmuseum
Omaha, NE, Joslyn A. Mus.
　Omaha, NE, Joslyn Art Museum
Osaka, Kodama Gal.
　Osaka, Kodama Gallery
Osaka, Seibu-Takatsuki Gal.
　Osaka, Seibu-Takatsuki Gallery
Oshawa, McLaughlin Gal.
　Oshawa, Robert McLaughlin
　Gallery
Oslo, Mus. Samtidskst
　Oslo, Museet for Samtidskunst
Oslo, Norsk Kultråd
　Oslo, Norsk Kulturråd [Norwegian
　Cultural Council]
Ostrava, A.G.
　Ostrava, Art Gallery (Galerie
　V4tvarnéuho Um.ní)
Ottawa, N.G.
　Ottawa, National Gallery of
　Canada
Oxford, MOMA
　Oxford, Museum of Modern Art
Padua, Mus. Civ.
　Padua, Museo Civico
Paris, Fond. Le Corbusier
　Paris, Fondation Le Corbusier
Paris, Fonds N. A. Contemp.
　Paris, Fonds National d'Art
　Contemporain
Paris, Gal. Charpentier
　Paris, Galerie Charpentier
Paris, Gal. Colette Allendy
　Paris, Galerie Colette Allendy
　[closed]
Paris, Gal. Denise René
　Paris, Galerie Denise René

Paris, Gal. Int. A. Contemp.
　Paris, Galerie Internationale d'Art
　Contemporain
Paris, Gal. J
　Paris, Galerie J
Paris, Gal. Luxembourg
　Paris, Galerie du Luxembourg
Paris, Gal. Montparnasse
　Paris, Galerie Montparnasse
Paris, Gal. Nina Dausset
　Paris, Galerie Nina Dausset
Paris, Gal. Paris
　Paris, Galerie de Paris
Paris, Gal. René Drouin
　Paris, Galerie René Drouin
Paris, Grand Pal.
　Paris, Grand Palais [Galeries
　Nationales d'Exposition du Grand
　Palais]
Paris, Mus. A. Déc.
　Paris, Musée des Arts Décoratifs
Paris, Mus. A. Mod. Ville Paris
　Paris, Musée d'Art Moderne
　de la Ville de Paris [Musée de la
　Ville de Paris; Pal. Luxembourg
　col.]
Paris, Mus. N. A. Mod.
　Paris, Musée National d'Art
　Moderne
Paris, Mus. Orsay
　Paris, Musée d'Orsay
Paris, Mus. Picasso
　Paris, Musée Picasso
Paris, Petit Pal.
　Paris, Musée du Petit Palais
Paris, Pompidou
　Paris, Centre Georges Pompidou
　[admins Mus. Cinema; Mus.
　Homme; Mus. Mar.; Mus.
　Matériaux; Mus. Mnmts Fr.;
　Pompidou; Centre National d'Art
　et de Culture Georges-Pompidou.
　Pompidou houses Bibliothèque
　Publique d'Information; Centre de
　Création Industrielle; Institut de
　Recherche et Coordination
　Acoustique/Musique; Mus. N. A.
　Mod.]
Paris, Salon Réalités Nouv.
　Paris, Salon des Réalités
　Nouvelles

Pasadena, CA, A. Mus.
 Pasadena, CA, Pasadena Art
 Museum [name changed to Norton
 Simon Mus. in Oct 1975]
Pasadena, CA, Baxter A. Mus.
 Pasadena, CA, Baxter Art Museum
Pasadena, CA, Norton Simon Mus.
 Pasadena, CA, Norton Simon
 Museum
Pau, Mus. B.-A.
 Pau, Musée des Beaux-Arts
Pécs, Pannonius Mus.
 Pécs, Janus Pannonius Museum
 (Janus Pannonius Múzeum)
Pesaro, Pal. Ducale
 Pesaro, Palazzo Ducale
Pforzheim, Schmuckmus.
 Pforzheim, Schmuckmuseum
 Pforzheim im Reuchlinhaus
Philadelphia, PA Acad. F.A.
 Philadelphia, PA, Pennsylvania
 Academy of the Fine Arts
Philadelphia, PA, Mus. A.
 Philadelphia, PA, Museum of Art
Pittsburgh, PA, Buhl Sci. Cent.
 Pittsburgh, PA, Buhl Science
 Center
Pittsburgh, PA, Carnegie
 Pittsburgh, The Carnegie [admins
 Carnegie Lib.; Carnegie Mus. A.;
 Carnegie Mus. Nat. Hist.; Carnegie
 Music Hall; Carnegie Sci. Cent.]
Pittsburgh, PA, Carnegie Mus. A.
 Pittsburgh, PA, The Carnegie
 Museum of Art
Pontoise, Mus. Pissarro
 Pontoise, Musée Pissarro
Portsmouth, City Mus. & A.G.
 Portsmouth, City Museum & Art
 Gallery
Poznań, N. Mus.
 Poznań, National Museum
 (Muzeum Narodowe w Poznaniu)
Prague, Mánes Exh. Hall
 Prague, Mánes Exhibition Hall
 (Iýstavní síň Mánes) ['SVU'; Mánes
 Union of Artists]
Prague, N.G.
 Prague, National Gallery (Národní
 Galerie) [admins Convent of St
 Agnes; Convent of St George;

Czech & Eur. Graph A.; Mun. Lib.;
 Šternberk Pal.; Trade Fair Pal.;
 Vald'tejn Riding Sch.; Zbraslav
 Castle]
Prague, N.G., Mun. Lib.
 Prague, National Gallery,
 Municipal Library
Prague, N.G., Valdstejn Riding Sch.
 Prague, National Gallery, Vald'tejn
 Riding School (Vald'tejnská
 Jízdárna)
Provincetown, MA, Chrysler A. Mus.
 Provincetown, MA, Chrysler Art
 Museum
Quito, Mus. Fond. Guayasamín
 Quito, Museo Fundación
 Guayasamín
Regensburg, Städt. Gal.
 Regensburg, Städtische Galerie
Rennes, Maison Cult.
 Rennes, Maison de la Culture
Rennes, Mus. B.-A. & Archéol.
 Rennes, Musée des Beaux-Arts et
 d'Archéologie
Reykjavik, Hafnarfjsrdur Cult. & A.
Fund.
 Reykjavík, Hafnarfjörðr Culture
 and Art Fund (Menningar og
 Listasjoður Hafnarfjarðar)
Richmond, VA Mus. F.A.
 Richmond, VA, Virginia Museum
 of Fine Arts
Rio de Janeiro, Mus. N. B.A.
 Rio de Janeiro, Museu Nacional de
 Belas Artes
Rochester, NY, Int. Mus. Phot.
 Rochester, NY, International
 Museum of Photography at George
 Eastman House
Rome, Gal. Anna d'Ascanio
 Rome, Galleria Anna d'Ascanio
Rome, G.N.A. Mod.
 Rome, Galleria Nazionale d'Arte
 Moderna [e Arte Contemporanea;
 in Palazzo delle Belle Arti]
Rome, Pal. Espos.
 Rome, Palazzo delle Esposizioni
Roslyn, NY, Nassau Co. Mus. F.A.
 Roslyn, NY, Nassau County
 Museum of Fine Arts
Rotterdam, Mus. Boymans-van

Beuningen
 Rotterdam, Museum Boymans-van
 Beuningen [houses Stichting
 Willem vander Vorm]
Rouen, Mus. B.-A.
 Rouen, Musée des Beaux-Arts
Saarbrücken, Saarland Mus.
 Saarbrücken, Saarland Museum
Saint-Etienne, Maison Cult.
 Saint-Etienne, Maison de la
 Culture
Saint-Etienne, Mus. A. & Indust.
 Saint-Etienne, Musée d'Art et
 d'Industrie
St Petersburg, Hermitage
 St Petersburg, Hermitage Museum
 (Muzey Ermitazh)
St Petersburg, Rus. Mus.
 St Petersburg, Russian Museum
 (Russkiy Muzey)
St Tropez, Mus. Annonciade
 St Tropez, Musée de l'Annonciade
San Francisco, CA, MOMA
 San Francisco, CA, Museum of
 Modern Art
San Francisco, CA, Mus. A.
 San Francisco, CA, Museum of Art
 [name changed to MOMA in 1976]
Seattle, WA, A. Mus.
 Seattle, WA, Seattle Art Museum
Seattle, U. WA, Henry A.G.
 Seattle, WA, University of
 Washington, Henry Art Gallery
Sheffield, Graves A.G.
 Sheffield, Graves Art Gallery
Silkeborg, Kstmus.
 Silkeborg, Kunstmuseum
Sofia, N. Acad. A.
 Sofia, National Academy of Arts
 (Natsionalna Hudozhestvena
 Accademia)
Sofia, N. Gal. Dec. & Applied A.
 Sofia, National Gallery of
 Decorative and Applied Arts
 (Nacionalen Galerija na
 Dekorativno-Prilozhi Izkustva]
Southampton, C.A.G.
 Southampton, City Art Gallery
Springfield, MA, Smith A. Mus.
 Springfield, MA, George Walter
 Vincent Smith Art Museum

Appendix B
LIST OF PERIODICAL TITLES

This list contains all of the periodical titles that have been cited in an abbreviated form in italics in the bibliographies of this book. For the sake of comprehensiveness, it also includes entries of periodicals that have not been abbreviated, for example where the title consists of only one word or where the title has been transliterated. Abbreviated titles are alphabetized letter by letter, including definite and indefinite articles but ignoring punctuation, bracketed information and the use of ampersands. Roman and arabic numerals are alphabetized as if spelt out (in the appropriate language), as are symbols. Additional information is given in square brackets to distinguish two or more identical titles or to cite a periodical's previous name.

A. America
 Art in America [cont. as *A. America & Elsewhere; A. America*]
A. & Ant.
 Art and Antiques
A. & Artists
 Art and Artists
A. & Australia
 Art and Australia
A. Brut
A. Bull.
 Art Bulletin
A. Canada
 Arts Canada [prev. pubd as *Can. A.*]
Acta Hist. A. Acad. Sci. Hung.
 Acta historiae artium Academiae scientiarum Hungaricae
A. & Des.
 Art and Design
A. Hist.
 Art History
A. Int.
 Art International
A. J. [London]
 Art Journal [London]
A. J. [New York]
 Art Journal [New York; prev. pubd as *Coll. A. J.; Parnassus*]
A. Mag.
Amer. A.
 American Art
Amer. A. Rev.
 American Art Review

Amer. Q.
 American Quarterly
A. Mthly
 Art Monthly
An. Hist. A. & Archéol.
 Annales d'histoire de l'art et d'archéologie
A + U
 A plus U [Architecture and urbanism]
Apollo
Apollon
A. Q. [Detroit]
 Art Quarterly [Detroit]
A. Q. [London]
 Art Quarterly [prev. pubd as *NACF Mag.*]
Archit. Aujourd'hui
Archit. Des.
 Architectural Design
Architects' J.
 Architects' Journal
Architect's Y-b.
 Architect's Year-book
Archit. Forum
 Architectural Forum
Archit. Rec.
 Architectural Record
Archit. Rev. [Boston]
 Architectural Review [Boston]
Archit. Rev. [London]
 Architectural Review [London]
Archit. Viv.
Artforum
Artists News-sheet

ARTnews
Artscribe
Avalanche Mag.
 Avalanche Magazine
A. Work
 Art Work
A. Yb.
 Arts Yearbook
Bief
 Bief: Jonction surréaliste
Bild. Kst
 Bildende Kunst
Blind Man
Block
Brit. J. Aesth.
 British Journal of Aesthetics
Burl. Mag.
 Burlington Magazine
Cabaret Voltaire
Cah. Mus. N. A. Mod.
 Cahiers du Musée national d'art moderne
Camera Craft
Casa Américas
 Casa de las Américas
Casabella
Casabella Cont.
 Casabella continuità
Cerc. & Carré
 Cercle et carré
Club Dada
Cobra: Bull. Coord. Invest. A.
 Cobra: Bulletin pour la coordination des investigations artistiques

Oxford A. J.
Oxford Art Journal
Perspecta
Phototechniques
Possibilities
Prairie Sch. Rev.
Prairie School Review
Proverbe
Quad. Arquit. & Urb.
Quaderns d'arquitectura i
urbanisme [prev. pubd as *Cuad.
Arquit.; Cuad. Arquit. & Urb.*]
R
Rass. It.
Rassegna italiana
Raum & Handwk
Raum und Handwerk
Rev. Apollo
Revue Apollo
Révol. Surréaliste
La Révolution surréaliste
Rhythm
Rongwrong
Rus. Lang. J.
Russian Language Journal
Sat. Rev.
Saturday Review
Shipovnik
S. I. C.
SIC [Paris]
SIC [Venezuela]

Sirius
Slav. & E. Eur. Rev.
Slavonic and East European
Review
Slav. Rev.
Slavic Review
Soirées Paris
Soirées de Paris
Sov. Arkhit.
Sovetskaya arkhitektura
Sov. Isk.
Sovetskoye iskusstvoznaniye:
Sbornik statyey [Soviet art study:
collection of articles]
Sov. Zhivopis'
Sovetskaya zhivopis' [Soviet
painting]
Space Des.
Space Design
Spur
Stroitel'stvo Moskvy [Construction of
Moscow]
Stud. Hist.
Studime historike
Studio Int.
Studio International
Surréalisme Même
Surréalisme même
Surréalisme Serv. Révol.
Surréalisme au service de la
révolution

Tableau
The Architect
391 [Three nine one/Trois cent quatre-
vingt-onze]
The Studio
Time
TLS
The Times Literary Supplement
Transatlantic Rev.
Transatlantic Review
Trans. RIBA
Transactions of the Royal Institute
of British Architects
Troços
291 [Two nine one]
Ulbandus Rev.
Ulbandus Review
Ventilator
Der Ventilator
Vesy
VIA [Journal of the Graduate School of
the Fine Arts, University of
Pennsylvania]
View
Wendingen
Werk & Zeit
Werk und Zeit
Z
Zdrój
Zenit
Zero